The Body in Early Modern Italy

The Body in Early Modern Italy

Edited by Julia L. Hairston
and Walter Stephens

The Johns Hopkins University Press
Baltimore

The editors heartily thank MJ Devaney for her excellent copy editing.

This book has been brought to publication with the generous assistance
of the Office of the Dean of Research and Graduate Education,
Krieger School of Arts and Sciences, The Johns Hopkins University.

The Johns Hopkins University Press
2715 North Charles Street
Baltimore, Maryland 21218-4363
www.press.jhu.edu

Library of Congress Cataloging-in-Publication Data
 The body in early modern Italy / edited by Julia L. Hairston and Walter
Stephens.
 p. cm.
 Includes bibliographical references and index.
 ISBN-13: 978-0-8018-9414-5 (alk. paper)
 ISBN-10: 0-8018-9414-x (alk. paper)
 1. Human body in literature. 2. Human body (Philosophy). 3. Italian
literature—History and criticism. 4. Italian literature—To 1400—History
and criticism. 5. Italian literature—15th century—History and criticism.
6. Italian literature—16th century—History and criticism. 7. Human figure
in art. 8. Art, Renaissance—Italy. I. Hairston, Julia L. II. Stephens, Walter,
1949–
 PQ4053.B64B63 2010
 850.9′3561—dc22 2009018104

A catalog record for this book is available from the British Library.

*Special discounts are available for bulk purchases of this book. For
more information, please contact Special Sales at 410-516-6936 or
specialsales@press.jhu.edu.*

The Johns Hopkins University Press uses environmentally friendly book
materials, including recycled text paper that is composed of at least
30 percent post-consumer waste, whenever possible. All of our book
papers are acid-free, and our jackets and covers are printed on paper with
recycled content.

Contents

Part 3: Gendered Corporeality

Part 4: The Body Involved

Introduction

Defining "*the* body" for any cultural time and place is always a vexed endeavor: bodies serve much more as means of differentiation than as common denominators. The very notion of identifying a specific person depends on individuation among bodily features, beyond all possible commonalities of race, gender, complexion, and dress. Moreover, the body as it appears in the social context of street, workplace, worship, or celebration may show little affinity with the body in childbirth, on the surgeon's table, in bed, or in a pitched battle. While all these interactions may appear to take place automatically, without conscious expenditure of thought, they all depend on the transmission of tradition and convention, all of it highly codified.

Study and reflection have complicated this picture many times over. From the introduction of writing and the diversification of the arts during Roman times through the conscious revival of ancient learning in the Renaissance, the drive to equal or exceed the "Ancients" in wisdom and technique added a further dimension of specialized representation to the already complicated substrate of social interaction. The body and its parts as subject of discourse and representation took many forms, refracted through epistemology and ethics, painting and poetry, sculpture and sacrament, theater and classroom debate, music, metaphor, and legislation.

Moreover, "the body" was not necessarily or exclusively a human body: St. Francis and his followers revered the sub- or nonhuman body of the animals, domestic and wild. Nor was this the only ontological boundary. The intellectual heirs of Bonaventure and Aquinas shared with illiterate peasants a consuming interest in the bodies of demons and angels, which might be visible or not, and theorized their interactions with witches, saints, and—indeed—brute beasts. Peasants and theologians discussed whether humans might become animals, either in reality or through powerful illusions; at least one greyhound became a saint; other animals were tried and executed for crimes against humanity; men were thought to become wolves, women, screech owls and cats. More disquietingly still to some,

women and men might exchange identity, through either performance or physiology.

The disembodied and hyperembodied—ghosts and the possessed—could not be discussed—and they were discussed frequently—without reference to the limits and function of corporeality. Earthly life, the realm of bodily interaction, represented only a fourth, or perhaps a fifth, of conceivable human activity: heaven and hell and (for Catholics after 1200) purgatory and limbo constituted realms of purely spiritual interaction. Yet how to consider these realms without some reference to the body? Aeneas traveled "in the body" to the afterlife, Paul and Dante intimated that they did so as well, and Dante imagined the souls of hell and purgatory endowed with temporary bodies that allowed them to suffer. At the end of time, after the Last Judgment, all humans would again be embodied—but in what sense would an individual's resurrected body be "identical" to the one that had exulted, suffered, and eventually died? Monsters, both human and animal, were thought to have significance, to *signify*, in fact, by portending social or cosmic disasters; miracles wrote themselves out on the bodies of those who experienced them. The bodies of witches and comparable deviants bore other stigmata, including the seal or signature of the devil himself. Prostitutes, Jews, and criminals were marked by their clothes and, at times, by their scars. And there were positive stigmata as well, which visibly (and sometimes invisibly) marked the bodies of the saintly.

Over the past several decades, scholars have explored various forms of attention to the body in early modern Italy and in other times and places. Since the pioneering essay of Joan Kelly, the study of gender has been the discipline that has most frequented the realms and dimensions of the body. The study of women has inspired a complementary inquiry into "masculinities" in addition to work on the history of sexuality in general and the varieties of same-sex love. Gender study has inflected the histories of literature, art, science and medicine as well as political history, microhistory, and the history of common people. In every field of study and from every angle, "the body" has been configured—for now, until or unless we evolve further ways of looking at it—as a construct, a representation, or a performance rather than a given, as an artifact of culture rather than a fact of nature. The increased critical interest in the warrior women of Ariosto, Tasso, and other heroic poets has shown in great detail the extent to which gender can be conceptualized as the bodily performance of certain actions, while studies of armor demonstrate that it, like freestanding sculpture, exalted the male body, at least as icon of bestial or godlike belligerence.

Gender is of course not the entire story. As the studies of Norbert Elias and

others have shown, performing the body involves other disciplines and practices besides those that fit easily under the rubric of gender. Concepts of deportment in public and private spaces ran a gamut from Castiglione and Della Casa to Machiavelli; mystical and magical techniques that exploited the interdependence of the mind and the body and stressed the mediatory role of the imagination linked figures as diverse as Marsilio Ficino, Ignatius Loyola, and Giulio Camillo Delminio. Gymnastics commanded respect as a discipline of the body, as did the arts of warfare, dueling, and the hunt; Castiglione and Rabelais attest that such arts were as important to the modern male as to mythic heroes like Orlando and Rinaldo.

The early modern body as structure comes into its own through painting, sculpture, and anatomical dissection, and the care of the body finds explicit justification elsewhere than in its role as vehicle for an immortal soul under constant scrutiny. At the same time, the body comes to be conceptualized more explicitly as a participant in eternal salvation: after the Council of Trent, the Roman Catholic sacraments as performance come to involve the layperson more explicitly, or, conversely, are repudiated by various dissident sects as priestly hocus-pocus that involves the layperson's body only. One of the greatest and most durable controversies involved the deceptively simple question of what *kind* of body the Eucharist was: was it a real body (*corpus verum*) rather than a mere commemorative symbol of Christ's Passion and atonement? If real, by what process did the Eucharist become so, and how did human agency affect that process? "Virtual" pilgrimage sites allowed the layperson to have a bodily surrogate for the experience of Jerusalem and the foundational events of Christianity.

Defining the body was at times an explicit obligation: did the body stand in a direct, "one-on-one" relation to the soul? Medical tradition and the revival of neo-Platonic thought prevented any overly "Cartesian" divide between body and soul, defining blood-borne "spirits" and an "astral" body, as well as the imagination, as intermediate components of the total person, neither strictly body nor purely soul. The role of beauty in neo-Platonism further complicates that picture, as it does the role of gender in any body talk.

This volume gathers essays presented at the Johns Hopkins University in October 2002 under the auspices of the Romance Languages Department (now German and Romance Languages) and Villa Spelman, the Charles S. Singleton Center for Italian Studies, which for over thirty years hosted PhD-level programs in Florence. The intent of the conference was well expressed in its title: "The Body in Early Modern Italy." The inclusiveness suggested by the title was the mandate of the conference. As organizers, we, the editors of this volume, wished to expand the

horizon of studies concentrating on aspects of the body and corporeality in early modern Italy and to create the maximum dialogue between and among academic disciplines, departments, and outlooks. Above all, it was not to be about gender, or literature, or the history of art or science, or political or social history, but about topics that united and permeated disciplines, subjects, and discourses. The conference was, in short, to be truly interdisciplinary. Despite its title, the conference aimed at demonstrating the *plurality* of "the body" in Italy between about 1300 and 1700. Perhaps a better title would have been: "What Constituted a Body in Early Modern Italy?"

The resulting collection embraces a variety of perspectives on the corporeal, sexual, and gendered aspects of bodies and the disciplines early modern men and women deployed in order to perform, discuss, and hypothesize these aspects of having, being, inhabiting, or disciplining a body or any part of it. From the great classics of the trecento to relative unknowns in later centuries, from rarified scholars to "ordinary" pilgrims, gymnasts, and midwives, from poets to demonologists, from mythic heroes to self-effacing nuns, from the hypermasculine to the hyperfeminine, people of early modern Italy reveal facets of embodiedness that, with the help of incisive scholarship in the best tradition of humanist inquiry, allow us to observe them and, by contrast, ourselves, with the eye of an anthropologist.

Part 1 / Petrarchan *Corpora*

Fetishizing the Veil

Petrarch's Poetics of Rematerialization

Margaret Brose

> sì mi governa il velo
>
> (thus the veil controls me)

The Temporal Body

Any consideration of the representation of the body in early modern Italy must begin with Petrarch inasmuch as bodies are the obsessively dissected subjects of the *Canzoniere*.[1] Laura's body, as well as those of Italy and of Petrarch himself, will be configured as sites of anxiety and betrayal, at once the object of our earthly erotic cathexis and the constant reminder of our mired aspiration toward transcendence. In the *Rime sparse* rather than a soul, the body houses a nexus of emergent psychological and theological instabilities; this is especially evident in Petrarch's treatment of the body-soul duality. The traditional body-soul duality pertains to the well-articulated medieval structures of analogy, of microcosm and macrocosm, of temporality and eternity. The concept of the body as veil of the soul provides a rhetorical figure for the sacred interface between the temporal and the infinite, the material and the spiritual. Thus it becomes one of the dominant metaphors employed to illustrate the orthodoxy of the church and its mysteries.

I want to propose that we read Petrarch's anxiety-laden representations of the body as a response to his apprehension of the weakening of its prior sacramental relationship to the soul. As a necessary and divinely ordained constituent of the

sacramental body-soul duality, the human body awaits a double transformation: to be lost at death and then to be regained at the Last Judgment. Fears of the flesh, its putrefaction and its sexualization, will cease when the prison of the body releases the soul; the body defined as *carcere* (prison) recurs six times in the *Canzoniere* (26, 264, 306, 325, 349, 364). To grasp the relationship between the body and the soul, Petrarch and his contemporaries had to abandon logic and accept the mysteries of the sacrament. Without this sacramental movement of transubstantiation along the vertical axis of meaning, the body is nothing but the sign and site of human transience. Such intimations of mortality subtend the individual poems and the larger structure of Petrarch's *Canzoniere* and signal what Thomas Greene calls a "pre-Humanistic shift."[2] The concerns about the body in the *Canzoniere* are at all times concerns about temporality and life's transience. In another space, we might dilate on how Petrarch's Stoicism, intensified by his assiduous readings of Seneca, was at odds with the frisson that the fear of transience created in the bodily sensorium.

Petrarch also problematized another aspect of temporality, that is, historical temporality; the poet portrayed himself living on a temporal fault line. We commonly attribute to him the beginning of a new historical sensibility; whatever the actual referent of his notion of the Dark Ages, Petrarch lived in a discontinuous relationship to that past. The present constituted for him primarily the locus between the classical past and a future yet to be shaped. Augustine's famous meditation on the experience of lived time (in book 11 of *Confessions*) was well known to Petrarch. Yet Augustine did not experience his own historical temporality as ruptured; indeed, for him the historical past was continuous with the present. It was the temporality of Augustine's soul that underwent a seismic shift.

Petrarch's complex consciousness of historical temporality pervaded his every endeavor. He was fully cognizant that what he was doing was rediscovering or reinventing classical literature and culture. He was equally cognizant of Dante's shadow over his shoulder, although in his famous letter to Boccaccio (*Fam.* 21.15) Petrarch will attempt to deny this particular anxiety of influence.[3] He entered the field of lyric poetry after the rapid flourishing of the Provençal courtly and Italian Sicilian, Tuscan, and stilnovistic traditions. Petrarch had fully mastered these vernacular traditions, and they do not assume for him the weight of the classical *auctores*.

Canzone 70 offers a breathtaking example of how Petrarch acknowledges his vernacular lyric predecessors. In a series of transumptive one-liners, he employs as the last verse of each strophe the citation of an incipit from one of his poetic pre-

decessors (Arnaut Daniel, Guido Cavalcanti, Dante, Cino da Pistoia). Petrarch has, of course, the last word: the final citation is taken from Petrarch's own poem 23, the famous canzone of the metamorphoses, which is itself an intertextual minefield. The future of the past is inscribed in this crafty maneuver, inasmuch as verse 50—"nel dolce tempo del la prima etade" ("in the sweet time of my early age")—which closes canzone 70, is the first verse of canzone 23. Petrarch has led us seamlessly into the labyrinth of his own corpus and his own autobiography, here projected as the natural trajectory of the entire Romance vernacular lyric tradition. This is just one of the numerous audacious examples of self-citation in the *Rime sparse*. Rather than as fathers, Petrarch will cast these vernacular poets as siblings in his personal family romance. Meanwhile, at a farther remove, classical models such as Vergil, Horace, Cicero, and Ovid—as well as Augustine—will be refamiliarized (as the title *Rerum familiarum libri* suggests) and transferred into Petrarch's present as corporeal interlocutors and pen pals. Indeed, Petrarch's most bodily relationship is with Cicero's texts.[4]

Petrarch's problematic relationship to his own times and to living within time is manifested in all of this writings, but it is above all in the *Rime sparse* that the poet scrutinizes the action of time on the body. In the *Canzoniere*, the metaphor of the body as veil of the soul resides in a troubling new temporality, one without the sure promise of eternity. As in the *Canti* of Giacomo Leopardi, Petrarch's true poetic father, poetry's rhetorical structures will be harnessed to undo time's corrosive power. As a result, in the *Rime sparse* the temporal spectrum as a whole will be collapsed into the present of the poetic utterance; this unique "textual present" forestalls the recognition of the erosion that the future and the past inevitably reveal.

If Petrarch's *Canzoniere* remains suspended in a lyrical present, Petrarch's well-known letter to Giovanni Colonna di San Vito describing his visit to Rome (*Fam.* 2.14) offers another form of temporal shortsightedness. In contrast to the omnipresent "textual present" of the *Rime*, in this letter Petrarch refuses to see the historical present (in this case, the wilderness of ancient Rome). While Petrarch wanders through the uncultivated vegetation that once was the glory of ancient Rome, he treats the present as merely an opaque film—a veil—under which lies the palpable past. The urban Roman landscape that the poet projects onto this wasteland supplants the historical present; the many deictics of place indicating "here" (*hic*) refer to the perdurance of the glory of Rome's past in Petrarch's imagination. Of course, it was precisely Petrarch's alienation from the present that allowed him to critique his own times and, we might say, to excavate a new ontology for early

modernity. However, while it may be possible to absent oneself from one's cultural present, it is more difficult to repress one's bodily present. The letters contain many poignant references to Petrarch's own bodily processes.

In the lyrics of his *Canzoniere* the present occupies all space. The poems of the *Rime* evade temporality other than the present, the *hic et nunc,* which is able to contain the flow of time (the memory of the past and the fear of the future) and, as a consequence, Petrarch's obligation to alter his soul. The "iterative present tense," as Greene terms it, will become the dominant verbal tense of the *Rime sparse.*[5] The tribulations of the self will circulate, repeat, metamorphose, but always return to the subject. The lesson of the *Canzoniere* is that unruly bodies can be kept in control only when relegated to the textual present, even if the refigured memory of the body cannot but reveal time's passage.

Transience may well be the single subject of the *Canzoniere,* and the body is the text on which that transience is writ. In the effort to stay time, Petrarch utilizes several rhetorical techniques to simulate a "tempus interruptus." On the one hand, as Petrarch learned from Ovid, the structure of metamorphosis itself redirects the temporal or narrative flow. On the other hand, Petrarch is able to distance himself from himself and from the threatening content of his own poetic imagery by a self-induced out-of-body experience that I call "auto-oblio" (auto-oblivion)—a technique of remembering so as to forget. This is connected to Petrarch's innovative use of the *inciso*—the parentheses and the interpolated clause. Both are syntactic techniques for establishing distance between the speaking subject and the scene of disavowal, to use psychoanalytic terms (to which I return), thus destabilizing the threat of mortality.[6]

Canzone 126, "Chiare fresche et dolci acque" ("Clear, Fresh, and Sweet Waters"), offers a prime example of these techniques. Petrarch constructs an eroticized oneiric sequence, as he imagines Laura returning to a shared landscape only to find the poet dead. The scenario is interrupted by two commentaries on memory. The first, "gentil ramo ove piacque / (con sospirar mi rimembra) / a lei di fare al bel fianco colonna" ("gentle branch where it pleased her / (with sighing I remember) / to make a column for her lovely flank"), occurs in the center of verses 4–6. The second comment on memory occurs in the middle of verses 40–42: "da' bei rami scendea / (dolce ne la memoria) / una pioggia di fior sovra 'l suo grembo." ("From the lovely branches was descending / (sweet in memory) / a rain of flowers over her lap"). Interestingly, the two parenthetical comments are embedded in intensely erotic descriptions of Laura's body. Despite or because of this bodily propinquity, this is an out-of-body experience for the poet: he is "così carco d'oblio" ("so laden

with forgetfulness") (56) that he is "diviso / da l'immagine vera" ("divided / from the true image") (59–60). Confused, Petrarch asks himself: "Qui come venn'io, o quando?" ("How did I come here and when?") (62). The content of the memory is displaced by the poet's interest in the memorial process itself and its ensuing disruptions. Giuseppe Mazzotta calls this move "a temporal dislocation"; it reveals the poetic experience to be filtered through memory and accounts for "the dematerialization of the landscape."[7] It may be equally apt to see this scene as one in which the landscape cedes to a rematerialization of the body. Laura's body parts have become rooted within the landscape. Experiences captured in memory become activated in the poet's "memorial present"; as a result, the threat of transience is distanced and the poet is, we might say, eternally caught off balance, in the dislocation of his own making. The temporal dislocations in the *Rime* occur at those crucial moments when the body and its transience most threaten the poet.

Taking Ovid one step further, Petrarch turns himself into the subject of his own metamorphoses, luxuriating in the present tense of the transformation without having to confront the consequences of change. In the so-called "canzone delle metamorfosi" ("canzone of the metamorphoses") (23), the hallmark present tense reflexive verb captured in the syntagm "mi trasformo" ("I transform myself") (159) signals this continuous intertwining of subject and object in a narcissistic knot, or better still, a Moebius strip.

> Vero dirò (forse e' parrà menzogna)
> ch' i' i' sentí trarmi de la propria imago,
> ed in un cervo solitario e vago
> di selva in selva ratto mi trasformo
> ed ancor de' miei can fuggo lo stormo.

> (I shall speak the truth (perhaps it will appear a lie)
> For I felt myself drawn from my own image,
> And into a solitary wandering stag
> From wood to wood I quickly am transformed
> And still I flee the belling of my hounds.) (156–60)

This section exhibits a delicate web of temporalities. The parenthetical meta-commentary—problematizing truth versus fiction or *menzogna* (lie)—disrupts the temporal flow; it pulls the poet out of the narrated past into the present of the utterance, a safer place to reside. The action is past (*sentì* in the *passato remoto* verbal tense), and yet it is compressed into the reiterative and tautological present

of the enunciation: *mi trasformo* and *fuggo*.[8] At the outer edges of this present lie death and mutilation: Acteon will be ripped apart by his own hounds. The poet as Acteon is still fleeing his own *sparagmos*.

Both the body of Laura and the body of Italy, dual female protagonists of the *Canzoniere*, have been the subject of critical attention. The body of Laura *in vita* is dismembered—scattered and recollected by the male poet—in a move that mirrors the larger pattern of the composition of the *Canzoniere*.[9] So too, the body of Italy is dismembered in Petrarch's famous political canzone 128, "Italia mia."[10] Interestingly, the reification and scattering of the female bodies of Laura and Italy do not forestall the anxiety Petrarch continually displays over his own aging body; the two subjects are mutually implicated. The body parts of Laura *in vita* will be disseminated as dissociated objects: golden hair, starry eyes, ivory hand, pearly fingers, marble foot.[11] The body is refracted into shards of mineral and rooted into limbs of flora. Laura alive is portrayed as a congeries of totems, relics, and fetishes. Conversely, the persona of Laura *in morte* appears quite integrated. Her death unifies the structure of the collection, and her physical attributes are reunified after death.[12] The earlier representations of the body of Laura in nature are associated with beauty and its ephemerality. This symbiotic relationship with nature is threatening unless the poet can halt nature's transience (as we have seen in canzone 126)—and thus time itself. Laura, in her postmortem state chatting at Petrarch's bedside, no longer threatens the status of the body-soul duality. As a result, his attention turns to his own aging. The emotional, erotic, and structural tensions of the *Canzoniere* all revolve around Petrarch's desire for (and fear of) change, and yet the poet's inconstancy and ambivalence do not effect true change. It is only Laura who changes, thus completing her metamorphosis.[13] The tension between change and stasis, another duality, will remain unresolved in the *Rime*. As Durling notes, "The stasis that Petrarch desires is both an intensification of the [sexual] fantasy and an evasion of the idea of activity."[14]

The Sacramental Body

The body in Petrarch's *Canzoniere* serves as the site of his temporal anxiety. Nonetheless, the redemptive potential of the body-soul duality remains central to Petrarch's *Rime sparse* and accounts for his fascination with the image of the veil. As body is to soul, human writing is to the book of nature written by the hand of God, just as historical time—the days of a year, the years of a human life, the ages of men—is to eternity. The macrocosmic/microcosmic pattern inherent in these

dualities stabilizes the relationship between human endeavor and the cosmos conceived as a whole. Moving upward on a vertical axis of signification, all such dualities will dissolve, as will human temporality itself. Indeed, duality, paradox, and antithesis exist as states of disjunction (or incompletion) only when contemplated from the perspective of human time and space. The dominant metaphors used to describe the relationship between the terrestrial and the eternal inherent in these medieval dualities were the veil (*integumentum*) and the mirror (*speculum*).

Central to my argument is the contention that "reading by the *mysterion*"— reading along this verticality of sacramental exegesis—is no longer a viable solution for Petrarch. Although it may still be a cultural and theological model, certainly informing Dante's understanding of the body in the *Divina commedia*, it cannot contain the temporal uncertainties and fears experienced by Petrarch.[15] Thomas Greene describes the epistemic shifts that appear in Petrarch as a series of falls: the fall into shadow, the fall into oxymoron, and the fall into ontology.[16]

My concern in the following comments is to show how Petrarch's *Rime sparse* is marked by this crisis and how the devolution of the sacramental relationship between body and soul gives rise to the evolution of the lexeme *velo* ("veil") as material fetish. If the body no longer serves as the veil of the soul, what then of the metaphor of the veil? The body exhibits its empty core, a container without a contained and shockingly corruptible. The veil is only fabric, or a lexeme wrapped in a dead metaphor, unless it is reendowed with another form of value, psychological rather than theological.

The Christian body-soul duality constitutes a sacramental, redemptive possibility. The *sacramentum* is described by the Christian church as "the outward and visible sign of an inward and spiritual grace, given unto us, ordained by Christ Himself, as a means whereby we receive the same and pledge to assure us thereof."[17] The main factor determining Christian usage of this term is its employment in the Latin New Testament to render the Greek term *mysterion*. I want to suggest that Petrarch's poetry seeks to understand a body that is no longer intimately tied to the *mysterion* or to the anagogic plan of God's universe. The separation of the body from the sacramental structures of the universe displaces a complex series of antitheses that still inform Dante's world: form-content; body-spirit; visible-invisible; container-contained; part-whole; outward-inward; mortal-immortal; time-eternity; *chronos-kairos*; literal-figurative; attribute-substance. I suggest that these antitheses are transformed into the hallmarks of Petrarch's style: oxymoron, antithesis, reduplicative syntagms, geminated adjective structures (*le coppie*), polysyndeton and asyndeton, hendiadys, parallel and chiastic clauses, anaphora.[18]

Rather than extrinsic formulaic patterns, these rhetorical structures are intrinsic to Petrarch's attempt to retain, or revaluate, the dyadic transcendence of Christian sacramentality. Many of these stylistic devices feign forward movement and change; spiritual transubstantiation is replaced by syntactic aggregation and repetition. The stylistic devices mimic plenitude and presence. The two poles of the body-soul relationship must therefore be rendered coextensive on the same plane of phenomena and time: duality without redemption. So too the dual constituents of the oxymoron and antithesis exist on the same plane of valuation within time.[19] Verticality cedes to horizontality; the paradigmatic cedes to the syntagmatic.[20]

Needless to say, Petrarch inherits antithesis and oxymoron from many sources, from the Latin to the Provençal poets, in a venerable rhetorical *translatio*. Yet the sheer quantity, frequency, and redundancy of Petrarch's doublings exceed anything handed down by the tradition of *ornatus*. Let me offer just a few examples, beginning with the first quatrain of sonnet 134:

> Pace non trovo et non ò da far guerra,
> e temo et spero; et ardo et son un ghiaccio;
> et volo sopra 'l cielo et giaccio in terra;
> et nulla stringo, et tutto 'l mondo abbraccio.

> (Peace I do not find and I have no wish to make war,
> and I fear and hope; and burn and am of ice;
> and I fly above the heavens and lie on the ground;
> and I grasp nothing and embrace all the world.) (1–4)

The syntagms in this poem are connected by polysyndeton, producing a rapid and melic flow, and the oxymorons work primarily on the semantic level. However, antithetical adjectives often modify the same substantive, or an adjective establishes an antithetical relation with its substantive, as in this example from 126: "torni la fera bella et mansueta" ("the lovely and gentle wild one will return") (29). We can look to the first sonnet of the *Canzoniere* for a more complex instance of doubling: "fra le vane speranze e 'l van dolore" ("between vain hopes and vain sorrow") (6). The repetition of the same adjective (*vane, van*) creates parallelism between the antithetical substantives (*speranze, dolore*). The oppositions often assume a chiastic structure, as in the closing verse of canzone 264: "Veggio 'l meglio et al peggior m'appiglio" ("I see the better, but I lay hold to the worse"). Or, returning to 134: "Veggio senza occhi et non ò lingua e grido" ("I see without eyes and have no tongue yet cry out") (9). The paralleled, opposed, or aggregated terms may be sub-

stantives, adjectives, or verbs; they may describe Petrarch's or Laura's psychological states or the aspiration toward the absolute and the eternal versus the recognition of the relative and the terrestrial. While the variations of these stylemes are almost infinite, the underlying message is but one: the awareness of the fleeting quality of earthly pleasure. It is important to note that in the *Canzoniere* the semantic and syntactic dualities, contrasts, or antitheses tend to be resolved by metric and euphonic harmonization.

Petrarch will thus attempt to produce a verbal plenitude so to mask the apprehension of absence. A sacramental conception of the universe (which characterizes many mythic or archetypal societies, not only that of Christianity) positions that absence within an overarching system of potential presence and ultimate fulfillment: in Christianity, the bread transubstantiated into the body of Christ, wine into blood. The visible sign contains and makes possible the invisible grace, if the ritual of transformation is performed under the proper orthodox circumstances. The centuries-long debate over the exact number of the sacraments, now resolved as seven, centered on those thought to have been performed by Christ and therefore as having effected a true transformation of substance, not merely of attribute.

The Oxford Dictionary of the Christian Church defines the lexeme "body" as: "the natural or human Body which the Lord took of Mary, and which, according to orthodox Christian theology was *changed but not abandoned* at the Resurrection and remains for ever His in heaven."[21] The sacramental promise lies precisely in the formula "changed but not abandoned."[22] Doubts about the efficacy of this promise lie at the base of Petrarch's consciousness; but he will disavow that doubt. This formula also informs the Ovidian metamorphosis, but the change occurs on the horizontal plane. Daphne is first woman, then tree, in successive temporal frames, but the content remains the same despite the degraded change in form: lady or laurel, she is always Daphne. The change on the horizontal plane is neither transcendence nor transubstantiation, nor is it a figure and fulfillment relationship. The metamorphosis most often brings a literalization and materialization.[23] Dante intuits that the rhetorical structure of the Ovidian metamorphosis resembles the logic of the Christian *contrappasso*, but Petrarch seizes on it as the alternative to true conversion: change without the need for abandonment.[24] In Ovid, metamorphosis moves from one form of earthly incorporation to another, along the diachronic axis, thus replicating the doctrine of metempsychosis itself.

Bodies alive and dead have always been at the center of Christianity. Christian antiquity through the Fourth Lateran Council in 1215 debated the meaning of bodily resurrection: would the body in heaven continue and sublimate or al-

ter or reverse the earthly body? As Caroline Walker Bynum states: "Dead bodies remained central to religious practice, and the oxymorons *'impassible body'* and *'incorruptible matter'* were repeatedly defended as being at the heart of the Christian promise."[25] This oxymoronic ontology defines the operations of grace as well as those of erotic passion. Both Aquinas and Dante wrestled with the doctrine of resurrection. Is the process natural? How will the risen or spiritual body be gloried? For both scholastic thinkers, it is the soul that *desires* the resurrection of the flesh, that is, the soul desires its own dead body (and those of loved ones).[26] The love affair between the body and the soul may be the oldest love story on earth.

Fetishism and Disavowal

How does the image of the veil evolve into a fetish? We can begin by considering Petrarch's relationship to the body in the *Rime* as an example of what traditional psychoanalysis calls "disavowal." In Petrarch's case, it is the apprehension of the loss of the sacramental power of the body that must not be acknowledged by the poet. Disavowal motivates the transfer of the erotic cathexis to a fetishized or fragmented part—in this instance, the veil (and elsewhere in the *Rime*, the hand, the eyes, the hair, etc.). That there is nothing under the veil will be the uncanny recognition haunting the lyrics of the *Canzoniere*.

The process of disavowal, according to Freud, is intimately connected to fetishism. Fetishism originates in the perception of the loss of what the male child has always assumed the existence of, namely, the mother's phallus. The disavowed perception is of an unacceptable "otherness," for the male child refuses to understand the female body in its own terms. The male child must see the woman's body as sameness, not difference, that is, as a mirror of itself.[27] So too, in Petrarch's *Rime sparse* subject and object mirror each narcissistically, and Laura is crafted in the image of the male poet.

Loss implies some normative standard or sense of plenitude, in relation to which absence is perceived and then immediately disavowed. We might say that the absence of spiritual plenitude accounts for Petrarch's fixation on the materiality of the body as veil. The poet fixates all the more intensely the more he disavows, so as to maintain the appearance of a belief, held in opposition to the fearful knowledge of loss. For Freud both disavowal and fetishism require a "splitting" of the ego, the division into an antithetical set of attitudes toward reality, one of which will be disavowed and replaced by an object of desire. The two attitudes persist side by side

without influencing each other.[28] Splitting, I suggest, is the semantic and syntactic hallmark of the *Rime sparse*.

In his important essays on the problem of the fetish, William Pietz indicates that the fetish functions to translate and to transvalue objects.[29] The most essential characteristic of the fetish object is its "*irreducible materiality*." Pietz avers that "the truth of the fetish lies in its status as a material embodiment; its truth is not that of the idol, for the idol's truth lies in its iconic resemblance to some immaterial model or entity."[30] This distinction between idol and fetish allows us to understand how the image of the veil in the *Rime*, precisely in its noniconicity, is able to perform as a fetish object. The intense and unrepeatable event that constitutes the fetish (the scene of disavowal) is however permanent in memory, and, according to Pietz, marked on a geographical locality or "on the surface of the human body." The fetish is always incommensurable with "the social value codes within which the fetish holds the status of a material signifier." Pietz describes this clash of incommensurable difference as "*disavowals*." Finally, Pietz notes that the fetish is not a material signifier referring beyond itself but "acts as a material space gathering an otherwise unconnected multiplicity into the unity of its enduring singularity."[31] This formulation is perfectly applicable to Petrarch's system of autoreferential semiosis. It is, we might say, an operation of centripetal rather than centrifugal construction. Laura and her veil are signifiers that do not point beyond themselves. In fact, the fetish serves to *veil* the loss of transcendent meaning.

The concepts of idolatry, fetishism, narcissism, and fragmentation in the *Rime sparse* have been the focus of several twentieth-century critics, crucially in seminal essays by John Freccero and Robert Durling.[32] Freccero's essay, "The Fig Tree and the Laurel," sets up a distinction between the fig tree, denoting the Augustinian allegorical semiosis wherein all referentiality returns to God, and Petrarch's laurel considered as a mirror or circular pattern of autoreflexive style. Petrarch's poetic strategy, according to Freccero, "corresponds, in the theological order, to the sin of idolatry. Idols, as the Jews understood them, like fetishes, were a desperate attempt to render *presence*, a reified sign, one might almost say a metaphor."[33] For both Durling and Freccero, the lyrics to Laura are idolatrous in the Augustinian sense. Durling's analysis of sestina 30 underscores this verse: "l'idolo mio scolpito in vivo lauro" ("my idol sculpted in living laurel") (30.28).[34]

I would like to apply these considerations about the cultural and psychological nature of the fetish to Petrarch's linguistic practice in the *Rime*. We might consider calling this practice "linguistic fetishism," insofar as specific lexemes, syntagms,

metaphors, or phonemes are isolated from previous cultural or theological semiosis and rematerialized.[35] The lexeme is isolated by a disavowal of its previous semantic field of reference.

I think it would be helpful to frame this notion with some of the observations by Gianfranco Contini in "Preliminari sulla lingua di Petrarca," which draws a sharp distinction between Dante's *plurilinguismo* ("plurilingualism") and Petrarch's *unilinguismo* ("unilingualism").[36] Contini describes Petrarch's vernacular stylistic register as *medio* ("middle"), with its marked "unità di tono e lessico" ("unity of tone and lexicon"). He notes that Petrarch's poetry in the *Rime* exhibits "il filo della stasi e inattività" ("a thread of stasis and inactivity") and thus manifests a "valore emblematico e simbolico, non allegorico" ("an emblematic and symbolic value, not an allegorical one"). Contini remarks that for the most part the verbs are intransitive and that they therefore lend themselves readily to substantivization. He stresses again that "Petrarch is not allegorical, he is emblematic," noting that *poiesis* in Dante is allegorical, while in Petrarch it is emblematic.[37] Contini's felicitous set of terms (allegory-emblem) parallels John Freccero's discussion of fetishism symbolized by the fig tree, on the one hand, and the laurel, on the other. This corresponds to what I have been calling the sacramental verticality of medieval Christianity versus the horizontality manifested in the *Rime sparse*. The body-soul relationship remains perfectly allegorical in Dante. However, in Petrarch's vernacular lyrics, oppositions and antitheses are proliferated along the horizontal axis, each term assuming emblematic, that is fetishistic status.

Stefano Agosti reads the fetishism of Petrarch in Lacanian terms. The semantic value of a word is, according to Agosti, emptied out, or *defunzionalizzata* ("defunctionalized"); this "parola vuota" ("empty word") has neither communicative nor expressive value.[38] The word registers the psychic history of the Subject: "la separazione del Soggetto dall'oggetto del desiderio, o, in altri termini, la struttura del desiderio in quanto relazione a una mancanza fondamentale" ("the separation of the Subject from the object of desire, or, in other terms, the structure of desire understood as a relationship to a fundamental lack"). This produces a catalogue of fetishizied parts, avers Agosti, by means of the processes of "isolation or totalizing, engrandizing of one of its parts, in the dissemination of the name [of Laura] and in the equivocal status that the name maintains with other objects." For Agosti the partialized or fetish object is a pure verbal object, a *material* equivalent of the fantasmatic object, "un equivalente *materico*." The fetish is the structural alternative of lack (*manque*): "È un simulacro di una pienezza parziale, contrapposto al manque che segna una totalità" ("It is a simulacrum of a partial fullness, as opposed to the

lack that signals a totality"). Agosti recalls here Freud's statement that the fetish is a monument to memory, and he reminds his readers that Freud describes melancholy as "the shadow of the object" that falls on the ego.[39]

Reading the Veil: The Shadow of the Object

One of the most significant examples of Petrarch's linguistic fetishism in the *Rime* centers on the recurrent use of the image of the veil.[40] Numerous poems examine the dialectic of revealing-concealing, of reading beneath the veil, of reading as a revelation, of veiling as erotic provocation. Etymologically, the Anglo-Saxon root *weg* signifies the act of weaving a web. Latin *velum* comes to mean "a sail, a curtain, a veil" and secondarily "a fine parchment made from the skins of calf, lamb, or kid and used for the pages and binding of fine books."[41] Theologically the veil (*integumentum*) refers to the earthly body that encloses the eternal soul, but it signifies as well Petrarch's own veiled understanding (his ignorance) of the true meaning of Laura. As the Jews of the Old Testament saw through a glass darkly, so does Petrarch; but unlike the Jews, he is aware both of the veil and of what lies beneath and, importantly, of his own failure and stasis as poet and Christian.

To be sure, the veil enters Petrarch's poetic realm bearing its own semantic history. The most famous veil in the Western tradition covered the Holy of Holies in the Temple of Jerusalem. It divided a priestly elite from a public disallowed access to the inner mysteries of the faith. Veils covered women in many religions (Islamic, Jewish, and Christian), keeping them invisible from public view, reinscribing relations of ownership and familial control.[42] Veils are often associated with origins or founding moments of laws, people, and religions; think of, for example, the veiling of the radiant face of Moses. Veils bind, mark boundaries, separate objects from their representations. Like the Veronica, a veil may bear a literal trace or sign of pure spirit. What is more, the rhetorical figure of the veil has traditionally been used to describe the relationship between form and content and the embellished speech of poets and orators. Proper language use itself was ineluctably clothed in veils.

Beyond this, the veil comes to represent in Petrarch a psychological (erotic) condition of ambiguous revealing and concealing of emotions, language, bodies, and desire. Because the veil that separates the antithetical (but mutually dependent) domains of body and soul cannot be lifted in this mortal life, Petrarch creates a fully controllable function for this image. The veil gathers into itself the libidinal and spiritual valence of the antithetical realms and becomes an erotic fetish. Fully

rematerialized, *il velo* stands in an ironic relationship to its former function as the separator between two realms or as the covering or skin enclosing the eternal part of humankind. The veil that hides Laura and her eyes, her hair, her smile (and its counterpart, the glove that veils her hand) becomes the object of Petrarch's cathexis: a synecdochic condensation of the unattainable earthly and heavenly attributes pursued by him. The laurel and its many paranomasias function as fetishes as well. Just as the laurel tree becomes Apollo's sign or *figura* of poetry, the figure of the veil becomes an emblem for Petrarch. Emblems, unlike allegories, are consistently interchangeable, as Contini and Agosti have suggested. Thus Petrarch asserts in *ballata* 11, with a certain masochistic frisson, that he is "governed by the veil" ("mi governa il velo") (12).

Because of its theological semantic history, the veil is an especially important fetish for Petrarch. But we should remember that fetishism appears in many forms in the *Canzoniere*, and a similar analysis can be applied to the many instances of the blazon of the *corps morcelé*: the hand, the glove, the eyes, the hair, the face. The process, however, remains the same. Crucially, the "bel nome di Laura" ("beautiful name of Laura"), which Petrarch incredulously denies having invented in his letter to Giacomo Colonna (*Fam.* 2.9), is itself fetishized and disseminated throughout the *Rime* as pure sound, especially in the phonemic dissemination of the syllables of Laura's name in sonnet 5.[43] The first verse of the initial sonnet of the *Canzoniere*—"voi ch' ascoltate in rime sparse il suono" ("you who listen in scattered rhyme to the sound")—may be seen as a declaration of this particular *ars poetica*.

Let us begin to trace the history of Petrarch's veil by examining in detail poem 11, the first of the *Canzoniere* to use the lexeme *velo*. This *ballata* contains three instances of the veil, the highest concentration in a single poem: *velo* (1, 12) and *velati* ("veiled") (9). The poem is addressed to Laura, whom Petrarch states he has never seen "put aside her veil for sun or for shadow" ("Lassare il velo per sole o per ombra,/ Donna non vi vid'io") (1–2). The poem presents a dialectic pattern of revealing and concealing: as long as Petrarch conceals his passion for Laura, she reveals her "pietate" (pity) (7) on her face. But as soon as he reveals his passion, Laura conceals her "biondi capelli" ("blonde hair") (9) and her loving look (14). In this poem the antitheses of passion are flattened out into two sets of temporal constants, each one described by an antithesis: Laura *always* remains veiled, "per sole o per ombra" ("for sun and for shadow") (1), and Petrarch *always* suffers from love, "al caldo et al gielo" ("in both hot and icy weather") (13). The veil, the nemesis, thus separates the poet from that which he most desires. In this primal encounter with the veil, Petrarch seems to be saying that if you cannot remove it, fetishize it!

There are twenty-five occurrences of the lexeme *velo* in the *Canzoniere* (and three in the *Trionfi*).[44] Despite its semantic permutations, the term is at all times attended by its Christian exegetical history, even when, or especially when, that transumptive possibility is threatened. The Petrarchan usage of the term thus signals ironically the very point at which the sets of oppositions fail to resolve: the invisible does not become visible; the corporeal does not cede to the spiritual. In the *Canzoniere* the term is equally imbued with its Ovidian subtext, especially the Acteon and Diana myth, the second of the foundational myths of Petrarch's corpus, after Daphne and Apollo. Acteon sees Diana nude bathing in a fountain, and, the goddess, fearful that he will speak of what he has seen, changes him into a stag. He is then dismembered by his own hounds, which do not recognize their former master. Acteon sees the taboo object and is transformed by that object, now become subject—Acteon is objectified, reified, and cannot speak his own name. He strains to say "I am Acteon," the verbal formula which will stay his hounds and his own execution. Petrarch's entire corpus is poised at this crucial moment, between the seeing and the nonsaying. In canzone 23, the poem of the metamorphoses, Petrarch as Acteon halts his own metamorphosis so that he might both see and say.

The myth of Acteon returns in *madrigale* 52, in which Laura the shepherdess is compared to Diana the goddess, and the poet casts himself as an Acteon figure who voyeuristically "sees unseen."[45]

> Non al suo amante più Diana piacque,
> Quando per tal ventura tutta ignuda
> la vide in mezzo de le gelide acque,
>
> ch'a me la pastorella alpestra et cruda
> posta a bagnar un leggiadretto velo,
> ch'a l'aura il vago et biondo capel chiuda,
>
> tal che me fece, or quand'egli arde 'l cielo
> tutto tremar d'un amoroso gielo.
>
> (Not so much did Diana please her lover
> when, by a similar chance,
> he saw her all naked amid the icy waters,
>
> as did the cruel mountain shepherdess please me,
> set to wash a pretty veil
> that keeps her lovely blond head from the breeze;

so that she made me, even now when the sky is burning,
all tremble with a chill of love.)

Rather than splashing water in Acteon's face (an aqueous veil) or bathing her whole body, Laura fetishistically washes the veil: ". . . la pastorella alpestra et cruda / posta a bagnar un leggiadretto velo" (5–6). The veil, diaphanous and seductively thin (note its diminutive form), does not cover or separate the body but has supplanted it; that is, it has transvalued the body. As fetish, this small portable piece of fabric synecdochically gathers the full erotic charge of the body as a whole. The veil usually binds "il vago et biondo capel" (6) from the breeze, *l'aura*, a narcissistic phonemic replication of Laura. The veil has abrogated its role as peripheral covering to assume center stage. The icy waters (3) in which Diana bathes and Laura washes her veil are introjected, and the poet is soon trembling with that very iciness. In an almost chiastic, certainly doubling, relationship, the "*tutta* ignuda / la vide in mezzo de *gelide* acque" of verse 3 is transformed in the last verse of the poem into an echo of Dante's lustful Francesca: "*tutto* tremar d'un amoroso *gielo*" (8, my emphasis).[46] Thus, Laura spied in the middle of icy water is transformed into the veil, which causes icy trembling in the interior, the middle, of the poet. While Acteon may have scopophilically gazed on Diana's nudity, Petrarch prefers to gaze on the veil, the fetish. As Mazzotta notes, "The prominent figure in madrigal 52 is precisely the veil which Diana has put aside and Petrarch stretches over her nakedness" (68–69). This entire scene, cast in full summer and possibly at high noon, trembles with erotic voyeurism.

Petrarch's use of *velo* may be in certain instances a gloss on its appearances in Dante. It seems clear that Petrarch's dream sequence in the famous canzone 126, "Chiare, fresche et dolci acque" ("Clear, Fresh, and Sweet Waters")—which features the erotically charged scene of Petrarch spying on Laura weeping at his grave—owes much to the unveiling of Beatrice at the top of Mt. Purgatory (*Purg.* 30). Beatrice appears in a cloud of flower petals, scattered by angels; Laura is imagined by Petrarch in a similar but naturalized scene. Despite their erotic evocation of Dante's youthful passion in the *Vita nuova*, the references to the veiling of Beatrice's face in *Purg.* 30 depend for their meaning on their allegorical relationship to the traditional body-soul duality.[47]

As we examine several instances of Petrarch's veil, we should bear in mind that this lexeme is never weighted with the allegorical hermeneutic imperative we find in Dante. Petrarch will never instruct the reader to lift the veil and decode the meaning of "the doctrine hidden beneath the strange verses" as Dante the poet

instructs his readers to do: "Mirate la dottrina che s'asconde / sotto 'l velame de li versi strani" (*Inf.* 9.62–63). To the contrary, Petrarch seems to advise the reader to leave the veil over the eyes, that is, to read materially, by emblem, and not by allegory. Yet at all times the poet seeks to allude to the theological import of the metaphor as well. For example, the two instances of the lexeme *velo* that appear with the verb *squarciare* (28.362) ("to rend," "to tear aside") evoke the rending of the veil in the temple at the time of the crucifixion and gesture to the lost sacramentality of the Christian duality. In canzone 28, addressed to Giacomo Colonna, Petrarch urges a resumption of the Crusades and employs the *velo* as a figure for that ignorance which has covered the eyes of Christendom. In sonnet 362, Petrarch encounters Laura in one of their postmortem trysts; the poet imagines that he has ascended to Heaven, having left behind his "squarciato velo" (4), that is his body separated from its soul by Death. This is the final occurrence of the lexeme *velo* in the *Canzoniere*, and the veil has, by this point, been significantly emptied of all allegorical possibilities.

Sonnet 38, addressed to the Roman nobleman Orso dell'Anguillara, provides an interesting example of the permutations of *il velo*. The opening *terzina* enumerates by excessive anaphoric repetition of *né* ("neither") the many veils in nature that occlude vision: *fiumi, stagni, mare, rivo, muro, poggio, ramo, nebbia* ("rivers," "pools," "sea," "stream," "wall," "hill," "branch," "fog"). Petrarch continually laments that these obfuscating natural veils fade in comparison to the unnatural *velo* shading Laura's two eyes: "un vel che due begli occhi adombra" ("a veil that shades two lovely eyes") (7). Even more, the veil is now anthropomorphized by prosopopoeia: the hostile embodied veil seems to say to Petrarch that he will "or ti consuma et piagni" ("now suffer and weep") (8). The frustrated poet adds that—while he is at it—he'd like to launch a complaint against another veil, a white hand, "una bianca mano" (12), which perversely also shades Laura from Petrarch's gaze (14). This fascinating series of transferences contains a reductio ad absurdum in its progression from nature to culture, from the many to the one. The veil is detheologized, fragmented into discrete natural objects; next, the veil is reduced synecdochically to the fetish object that veils Laura's eyes but also takes on magical powers of will and speech and openly declares itself Petrarch's nemesis. And then by another rhetorical transfer, the veil becomes instantiated in the hand of Laura, actively now blocking Petrarch's vision. The original valence of the veil in the theological duality of body and soul has been obliterated. Each image operates as static emblem—hence the facile slippage from veil to hand. In canzone 72 the veil and hand join forces again as dual barriers that block the poet from gazing at Laura's beauty:

Torto mi face il velo
et la man che sì spesso s'atraversa
fra 'l mio sommo diletto
e gli occhi . . .

(Your veil does me wrong
and your hand, they so often come between
my highest delight
and your eyes . . .) (55–58)

In the first of the pair of sonnets on the painting of Laura by Simone Martini (77 and 78), the traditional body-soul antithesis returns: "ove le membra fanno a l'alma velo" ("where the body is a veil to the soul") (11). Here the *velo* refers to the body as cover of the soul. Another example is sonnet 122, an anniversary poem, signaling the poet's seventeen years of enslavement to love. At such a temporal marker the "heavy veil" of Petrarch's body casts a "bitter shadow" ("l'ombra ria del grave velo") (8).

In the sonnet series on the glove—a mini-handbook on the fetish (199–201)— the glove is the veil to the hand of Laura, that is, a fetishization of a fetish. This sequence follows the equally fetishizing series of sonnets that paranomastically play on the proper name of Laura and the wind *l'aura* (194–98, with the exception of 195). Peter Stallybrass and Ann Rosalind Jones have proposed that we reexamine the fetish of the glove in precapitalist societies. Gloves, they note, not only materialized status, "gentling" the hand of the gentry, but also functioned as "external organs of the body," organs that could be transferred from beloved to lover, from monarch to subject, from master to servant. Gloves thus "materialized the power of people to be condensed and absorbed into things and of things to become persons." Further, the single glove "conjured up the hand as the corporeal site of agency for Aristotle, Galen, and their followers." The Renaissance eroticization of the glove involves the male lovers imagining themselves "as the hollow forms (necklaces, shoes, shifts, gloves) into which the female beloved enters" (128).[48] Such gender reversal allows the male, as container, to be penetrated.

It is not surprising that with Laura dead, the playful *jouissance* of the veil as fetish decreases (and the glove and hand also depart). Laura in heaven leads to a literalization of the veil as the mortal body. In sonnet 277, Petrarch pens this perfectly Leopardian verse: "che 'l desir vive e la speranza è morta" ("desire lives though hope is dead") (4). Since Laura the true one is in heaven, she shines through to Petrarch's heart, not to his eyes, which are veiled with tears and aging: "agli occhi

no, ch' un doloroso velo / contende lor la disiata luce / et me fa sì per tempo cangiar pelo" ("not to my eyes, not, since a sorrowful veil / robs them of the light they desire / and makes my hair change so early") (12–14). In sonnet 302, Laura speaks to Petrarch from the third heaven where she waits for him and, quite poignantly, for the return of her own body, her "il mio bel velo" ("beautiful veil") (11). In 313, Petrarch expresses his desire to be freed, "disciolto dal mio mortal velo" ("freed from his mortal veil") (12).

Naturally, Petrarch still feels some ambivalence about the shed body of Laura. In sonnet 319 he vehemently rails against the miserable and instable world that has taken Laura's body and turned it to dust: "tal ch' è già terra et non giunge osso a nervo" ("one who is now dust and does not join bone to muscle") (8). Despite this anatomically acute description he is able to acknowledge that he loves her "forma miglior"—"better form" (9)—which still lives. Yet this better form, her soul, only makes him more in love with her physical beauties. As Petrarch ages (a *velo / pelo*, or "veil / hair," rhyme), he thinks obsessively about seeing Laura's delicate veil: "il suo leggiadro velo" (4). In sonnet 329, *velo* alludes to the theological notion of a form of ignorance covering the poet's eyes:

Ma 'nnanzi agli occhi m'era post' un velo
che mi fea non veder quel ch' i' vedea,
per far mia vita subito più trista. (12–14)

(but before my eyes was placed a veil
that made me not see what I saw,
in order to make my life suddenly more sorrowful.)

The *velo* rhyme patterns in the *Rime* involve only four lexemes, and the patterns are flattened out into a monotonality: *velo / gielo / cielo / pelo* ("veil / ice / heaven / hair"). Further, these four lexemes often seem to bear a chiastic semantic relationship to each other.[49] In the poems after Laura's death, *in morte*, the lexeme *velo* rhymes more frequently with *pelo*, referring to the whitening of Petrarch's hair and his ever-intensifying anxiety about aging, a rhyme that even further rematerializes the veil. Before her death, in the erotic death fantasy of canzone 126, Laura is imagined "asciugandosi gli occhi con bel velo" ("drying her eyes with her beautiful veil") (39), a condensation of the two fetishes of the eyes and the veil. Here, as always *in vita*, the fetish carries an erotic materialized valence. In 264, which marks the *limine* between Laura *in vita* and Laura *in morte*, Petrarch cannot perceive the day of his death owing to his own "corporeo velo" ("bodily veil") (114), which here

again rhymes with *pelo*. We witness a tripartite displacement: the original theo-
logical connotation of the veil is rematerialized into the erotic association of the
veil covering and binding the golden hair of Laura *in vita*. This image of the veil is
next prosaically reduced to the veil of Petrarch's own body, still unshucked, conve-
niently rhyming with *pelo*, to signal his own aging process. In canzone 331, another
instance of the *velo/pelo* rhyme, Petrarch laments not having followed Laura to
heaven to witness her throne being prepared. Indeed, he fantasizes that he could
have been released from his body in her very presence, imagined as a "dolcemente
sciolto," a sweet seductive striptease dance:

> Questo intendendo, dolcemente sciolto
> in sua presenza del mortal mio velo
> et di questa noiosa et grave carne,
> potea innanzi lei andarne
> a veder preparar sua sedia in Cielo:
> or l'andrò dietro omai con altro pelo.

> (Understanding that, and sweetly shaking off
> in her presence my mortal veil
> and this noisome heavy flesh,
> I could have gone on before her
> to watch her throne being prepared in Heaven:
> now I will follow her with changed hair.) (55–60)

The tripartite rhyme *velo/cielo/pelo* underlines the ineluctable materiality of
Petrarch's transcendental aspirations. In 352, Laura's mortal body, now abandoned,
is described as "quel soave velo" ("that soft veil") (10). And, as we noted above,
in sonnet 362 Petrarch's own aged body, his rent veil, his "squarciato velo" (4),
becomes a final and melancholic testimony to the sacramental Christian possibil-
ity—"changed but not abandoned"—here still unfulfilled.

In conclusion, I suggest that the very instability of the lexeme *velo* in the *Rime
sparse* mirrors Petrarch's apprehension of the instability of the body itself. In ex-
amining the trajectory of the image of the veil we noted the copresence of the de-
materializing of the sacramental structures of Christianity and the rematerializing
aspects of the notion of the fetish. Consequently, Petrarch's stylistic register in the
Canzoniere exhibits a state of splitting of the ego in the psychoanalytic sense. The
traditional theological figure of the duality of body and spirit weakens, undergoes
its own splitting and dissemination. As a result, the figure of the veil assumes the

power of an erotic fetish, a reductive and rematerialized site of desire. The duality of splitting is manifest in all of the stylistic techniques of the *Rime sparse* and in the relationships obtaining between individual poems and between sequences of poems. The tension between what is acknowledged and what is disavowed produces the disequilibrium and doubt that inform Petrarch's particular sensibility; this in turn engenders the "subjectivity effect" of the *Rime sparse,* which will come to characterize the modern Western psyche. No longer transcendental, the body haunts the subject. In his search for self-expression, Petrarch changed the body into an aftereffect of his own volatile personality.

The Metaphor of the *Corpus Carcer* in Petrarch's *Canzoniere* and in the Lyrical Tradition

Luca Marcozzi

In Francesco Petrarch's *Rerum vulgarium fragmenta*, the metaphor of the *corpus carcer* appears eight times, more frequently in the last poems. The extended usage of this metaphor is one among the numerous ways Petrarch introduces into his *Canzoniere* some philosophical statements, mediated by patristic diction, which are characterized not only by their sapiential density but also by their formal elegance and imaginative power.

The application of this metaphor to the field of lyric is an absolute novelty that Petrarch brings to Italian poetry. Nothing similar is to be found in Dante, not in the lyric poet of the *Rime*, not even in the *Divine Comedy*, where the absence of this metaphor is much more astonishing, because Dante's conception of sin and of corporeal metamorphosis as a perverse parody of human existence seems a revival of the underlying Platonizing dialectic between the perfection of the soul and the fall of the body into a state of sin.

It could be asserted that in the "gravity" of the sinners' bodies, and in the bond to earth and matter that marks the infernal representations, Dante wanted to give plasticity and visibility to the idea of the souls' incorporation in a terrestrial prison, but the fact is that in the *Commedia* there is no patent trace of *corpus* as *carcer*. No

clear statement of this motif appears either in Dante's lyric poetry or in Cavalcanti's philosophical poems. The same is true of the earliest Italian lyrical poetry, in which the *corpus carcer* metaphor is never noted.

This metaphor has a long history, the main features of which I retrace briefly, paying particular attention to its appearances in poetry. The image of the body as a prison of the soul dates very far back: the Homeric representation of the unity of the body and soul was replaced by the Orphic-Pythagorean concept in which the soul was conceived as an independent being that fulfilled its destiny purely and fully only in an incorporeal existence.[1] Pythagoreans believed that man was essentially *soul*, of divine and eternal nature and that therefore its union to the body (σῶμα) had to be regarded as punishment for sins committed in a previous life, whence the concise expression σῶμα σῆμα, the body as grave. The Orphics believed that the body was the prison or even the grave of the soul; this dualistic dialectic of body and soul, common to Orphism and Pythagorism, depicted the soul as a demon of divine nature and the body as a prison, a tomb, a place of expiation. Plato took up and commented on this disposition in the *Cratylus* (400c) and the *Phaedrus* (62b–67d).[2] The image then had an important neo-Platonic revision, above all in Macrobius.[3]

In the neo-Platonic and Stoic tradition, the substance of the soul is a part of the celestial substance, identified with the ether, the subtlest part of fire, which was lighter than air. The soul, an igneous substance locked up in the body at birth, is, according to this theory, destined to return to heaven after death. The imprisonment of the soul was considered in neo-Platonism and Stoicism a fall, consequent on individual or collective guilt, to be atoned for through contamination with matter and its impurities (including the passions).[4] In Macrobius's commentary on Cicero's *Somnium Scipionis*, this doctrine is stated with the help of some verses from Vergil (the same ones that Petrarch mentions in the *Secretum*), in which the soul is defined as celestial in origin, weighed down by the body and by limbs destined to die. According to Vergil, souls are blunted by their earthly organs; they fear and covet, suffer and enjoy, nor do they know, being enclosed in the blindness of their dark prison, how to look at the sky.[5]

The image of the *corpus carcer* was very widespread during the Middle Ages, and not only in literature, philosophy, and moral speculation.[6] The symbol of the dove shut in a cage on the right side of the apsidal mosaic of the basilica of San Clemente in Rome, which seems to epitomize the Orphic myth of the soul as prisoner of the body, is a perfect example of the diffusion and notoriety of the emblem (though this interpretation remains controversial).[7]

The metaphor did not just often embody the classical theme of *contemptus mundi*; it also seemed to the church fathers to be an apt way of explaining the body's condition of decay owing to original sin and of interpreting two famous passages of St. Paul and the Psalms.[8] The image was used often by Augustine, and by St. Ambrose, St. Jerome, Prosper of Aquitaine, Cassiodorus, Boethius, Gregory the Great, Bede the Venerable, Isidorus of Seville, Raban Maur, and many others. It is true that medieval philosophical and encyclopedic literature (especially in Isodorus and Raban Maur) is frequently derivative and repetitive in nature. However, some slight differences are nevertheless present in the use of the same image among the several authors. In the *consolatio* to the martyrs, Tertullian uses the image of the prison in a very concrete comparison, binding it to the obscurity of this life, and he reminds the martyrs in prison that the prison of the world is darker than their punishment.[9] The early fathers propose a philosophical speculation on this theme, free from metaphorical accretions; for their part, Ambrose, Augustine, and Isidorus, having used the metaphor of the *corpus carcer* over and over again, often insist on intimations of luminescence, on comparisons linked to the theme of light, on the obscurity of the terrestrial prison (Augustine's *tenebrosum carcerem*), thus repeating the neo-Platonic motif of the corporeal opacity that obstructs our vision of celestial essences.[10] The same motif is present in Boethius: in opposition to divine substances on high, who enjoy total immobility and an uncorrupted will, human souls did not remain in contemplation of the divine intelligence and fell into the body, the prison of their terrestrial limbs.[11] According to Isidorus, the soul possesses, by its own nature, a great brightness, blurred unfortunately by its admixture with the flesh.[12] By contrast, other authors, such as Bede, and in general all those of monastic provenance, more influenced by texts of liturgical derivation than by speculative works, frequently recall the image of the bondage (*laqueos, vincula*) caused by sin: therefore, it is not the nature of the body itself that holds back the soul but rather *vitium*, moral distortion and sin. The *carcer* is not physical but moral. The metaphor is, in this latter sense, largely present in liturgical literature.[13] The difference is that the erudite and physical-naturalistic strain, neo-Platonic in origin, foresees a fundamental irreconcilability, an animosity of sorts, between body and soul; by contrast, the liturgical and moral line—conditioned to view every divine creation, including the body, as perfect creation—assumes instead a concord between body and soul, on the grounds that the prison is not constructed, for the most part, by the body and by its opacity but by individual sins. The two lines often face off and merge within the same authors, as in the later

Augustine, who implies that the worldly prison is not found in the flesh but in its corruption.[14] Moreover, Augustine had opined that the corruption of the body is not the cause but the consequence of original sin: indeed, his conciliation between neo-Platonism and Christianity considered that sin should be ascribed to the soul rather than to the body.[15] On the other hand, a certain measure of dignity was assigned to the body by Cassiodorus, who believed that by living with the body, the soul would end up loving it.[16] A similar declaration of the dignity of the body was expressed by Thomas Aquinas, who disputed, on a logical basis, the motif of the enmity between body and soul: the soul cannot either exist or seek its end (i.e., knowledge) without the support of the body and the senses.[17] Basing himself on Origen, Thomas claimed that souls are enclosed in bodies, which constitute their prison, not in a state of innocence but as a consequence of original sin.[18] Besides, Christian orthodoxy could not accept the neo-Platonic hypothesis of the soul as a "spark of stellar fire" ("scintilla stellaris essentiae") divine in nature, implanted in bodies; the soul must instead have been created at the same time as the body.[19]

Except perhaps for Tertullian or Cassiodorus, I have only being referring to passages that could have been recalled by Petrarch; as is well known, his memory performed a continuous *contaminatio* among the sources at his disposal. In particular, Augustine and Boethius played a decisive role in this, as they did in other circumstances of Petrarch's philosophical and moral culture.

There are no signs of attention on manuscripts owned by Petrarch to the various appearances of the prison metaphor in Macrobius and Isidorus and in Augustine's *Enarrationes*, nor to representations of the *corpus* as *carcer*. However, in a branch of Isidorus's textual tradition that Petrarch came across, specifically the *Etymologiae* in the Parisian Latin ms. 7595, he could have read the following regarding *daemonas*, in a variant that I italicize:

> *Daemonas* a Grecis dictos aiunt, quasi δαήμονας, id est peritos ac rerum scios. Praesciunt enim futura multa. . . . Hi corporum aeriorum natura vigent. Ante transgressionem quidem caelestia corpora gerebant. Lapsi vero in aeriam qualitatem conversi sunt, nec aeris illius puriora spatia, sed ista caliginosa tenere permissi sunt, qui *eis quasi carcer est* usque ad tempus iudicii.

> (They say demons (*daemon*) are so called by the Greeks as if the word were δαήμων, that is, experienced and knowledgeable in matters, for they foretell many things to come. . . . They flourish in accordance with the nature of aerial bodies. Indeed, before they fell they had celestial bodies. Now that they have

fallen, they have assumed an aerial quality; and they are not allowed to occupy the purer expanses of the air but only the murky regions, which are like a prison for them, until the Day of Judgment.)[20]

Petrarch's use of the church fathers and philosophical texts, which moderns generally believe unsuitable to his lyric production, is peculiar, but one of the reasons he draws on them is that it is possible to obtain pleasant sounds and sighs, *callide iuncturae*, from the fathers' texts as well. But because his interest in these texts was aural, the intertexts or borrowed symbols appear decontextualized when compared to the thematic density of their source.[21]

However, when the Augustinian *tenebrosum carcerem* is inserted in a discourse of complex philosophical ancestry as source of the metaphor of *Tr. mor.* 2.34, "La morte è fin d'una pregione oscura / all'anime gentili" ("Death is the end of dark inprisonment / for gentle souls"), decontextualization does not occur, and the poetic text alludes recognizably to its sources.[22] This passage is indeed the "most irradiant philosophical core of the whole work," in which appear—although not perfectly congenial to Petrarch's poetry—the most intense philosophical and eschatological remarks of all his vernacular poetry.[23] Platonic themes of death as true life—from the *Phaedo*—are reproposed, and this is an obligatory stage in the complex movement of the *Triumphi*, in the abandonment of earthly *fictiones* in favor of the contemplation of what lies under the veil of appearances. The same direct allusion to philosophical sources appears in canzone 264, where, alongside Boethius, the image of the soul flying toward its nature also suggests the presence of Lactantius.[24]

Petrarch's sources for the metaphor of *corpus carcer*, therefore, seem to be mainly philosophical, whereas his poetical sources include only Vergil; then again, the *Aeneid* itself, according to Petrarch, is a text "cui moralis supponuntur," of which it was possible to conduct an allegorical-moral reading and by which Vergil's work acquired philosophical attributes.[25]

It is not possible, however, to find precedents for the *corpus carcer* metaphor in the vernacular. The lyrical use of the *corpus carcer* metaphor is a Petrarchan innovation that has no predecessors, not even in allegorical poems. This is a further admonition to consider some often neglected interpretative tendencies when approaching philosophical notions expressed in lyric. First and foremost, the *Fragmenta*, just like Petrarch's ascetic and moral works, ought to be ascribed to the "genus philosophie ethice idest moralis," that is, to moral philosophy; secondly, Petrarch's allegory can be discovered even where the didactic-moral intent may

be less evident; lastly, the philosophical density of the senses hidden beneath the literal, which usually escapes comment, is also present in his lyrical expression. Petrarch is very different, in this sense, from the already mannerist tradition of the late stilnovo, which brings poetry back to an exclusively lyrical realm; he differs from the tradition, for example, of Cino da Pistoia, who never allows such philosophical presences to undermine the amorous solidity of his poetry. Nor does Cino ever discuss—as the absence of philosophical and other spiritual themes from his poetry might suggest—the salvation of his own soul.

In religious poetry, metaphors of the same philosophical density as Petrarch's are nowhere to be found, even though the contrast between body and soul is a rather trite theme there. A battle between body and soul is found in Iacopone, presented as a *contrasto*; the idea of sin as the death of the soul emerges because, just as death takes color, beauty, and shape away from the body, so sin takes away the beauty with which the soul had been invested by God.[26] On an intermediate horizon, between religious poetry and worldly lyrical language, namely in Dante's *Commedia*, the *iunctura* of the "obscure prison" could derive directly from Augustine, but it refers twice to hell, not to the soul.[27] In Cino da Pistoia's poetry, the dialectic between body and soul is richly exhibited but without any moral reference; rather, the disembodiment of the soul owes solely to reasons of love.[28] A mention of the *scura prigione* ("obscure prison") of humankind, noted by the Virgin Mary, is found in a *lauda sacra* of Fazio degli Uberti.[29]

But Petrarch is the first Italian poet ever to versify the delicate philosophical theme and its corresponding intense image, revealing, through this and other metaphors, the debt of his poetry to Christian Platonism. In the *Rerum vulgarium fragmenta*, indeed, are present both the philosophical dualistic conception, Platonic in origin and developed by the naturalistic strain of Platonism and by Boethius, who considers the body the eternal enemy of the soul because corporeal opacities prevent contemplation of the divine, and—above all in the second part of the work—a conception of liturgical and moral origin, according to which the jailer of the soul is not a corporeal taint but actual sin, while the chains and *vincula* are passions and lust. The first conception is perhaps more productive from a poetic standpoint because it provides the main metaphorical motifs that circulate in the work: the dialectic between mortal darkness and hyperuranian luminescence and the flight of the soul to its empyrean birthplace. But it is the second elaboration that, on the spiritual plane, adheres more vigorously to the program of moral perfection and *mutatio animi* ("change of mind") expounded in Petrarch's ascetic works, particularly in the *Secretum*.

The same dialectic between body and soul is present in Petrarch's ascetic and moral works, in which the direct derivation from Augustine and Isidorus is diluted by the presence of sin and *egritudo animi* ("soul sickness"), which is assigned the role of jailer. In the *De otio religioso*, the body is the prison in conformity with the naturalistic tradition: "Viventes in corpore quasi iam membrorum ergastulo evasissent" ("They escaped from their living bodies almost as from the imprisonment of their limbs").[30] Nevertheless, within the same work, the "moral" version of the metaphor occurs as well, according to which the prison is the *mundus* and the *peccatorum vincula* hold us down, Petrarch observing that "ego, qui peccatorum vinclis in mundo velut in carcere adhuc sum" ("I am restrained so far in earthly bondages of sin as in a jail").[31]

In the Latin works, there are many examples of the metaphor of the prison; the image is fully developed, with speculative zeal, in *Secretum* 2.16: "Nempe vos carcerem vestrum et nostis et amatis, ah miseri! Et mox vel educendi certe vel extrahendi heretis in eo exornando soliciti quem odisse decuerat" ("Well, you poor humans know and love your prison; and although you are on the point of leaving it or being dragged out of it, you cling to it and worry about decorating what you ought to hate").[32] In the *De vita solitaria*, the corporeal prison lends itself to a moral remark in contemplation of the last day, on the pattern of the remark that will appear in the Boethian canzone 265 of the *Fragmenta*.[33] But it is in *De remediis utriusque fortune* that the image of the body acquires the most subtle metaphorical meanings and where the metaphor recurs most frequently: in 2.64, *sub voce carcer*, Ratio states that "nullus carcer turpior [est], et angustior nullus quam iste corporeus, quo usque adeo delectaris, atque unde tantopere solvi times" ("No prison [is] filthier or narrower than the bodily one, from which you took so much delight that you fear for leaving it").[34] A little later in the same work, in 2.68, it is again Ratio who claims that "omnes corpus quod tantopere colitis et amatis: ille vos carcer arctissimus circumcingit atque obsidet obsidione perpetua" ("All the bodies that you love and care for: it is a fortified prison that surrounds and besieges you with a perpetual siege"). And again, in the *De remediis* 1.5, to Gaudium, who brags about the body's strength, Ratio observes: "Cogita vero quantarum ipse sis virium; iste enim non tue sunt, sed hospitii, immo carceris tui vires" ("Think about your strength: it's not yours, it's owned by your host, even better by your prison"). Again in the *De remediis*, death is "ceci carceris exitum" ("coming out from a blind jail") (2.64). *Carcer* is used in a metaphorical sense many times within the same work, which dedicates a whole chapter to the theme. The image recurs in the *Epystole* as

well, in many gradations, among which is the very meaningful 2.15.210, 214–16 to Giovanni Colonna, in which Petrarch addresses Death:

> Exiliumque levas, et carceris ostia frangis. . . .
> A primo prefixa die, tu cunta quieto
> Ferre iubes animo, promisso fine laborum
> Te sine supplicium vita est carcerque perennis.

> (You cheer the exile, and break prison's doors. . . .
> Established since the first day, you order men
> To sustain everything with a patient soul,
> Because an end to his strains has been pledged yet;
> Without you, our life would be a torture, and an eternal prison.)[35]

It also appears in 1.5.92 ("carcere corporeo et mortalibus . . . vinclis") ("in bodily jail and mortal . . . ties"), in 1.14.123–24 (the *mortalis carcer*, "mortal prison," is opposed to *celo,* "sky"), and in the Latin work linguistically closest to the vernacular poems, the *Bucolicum carmen*, in which the dying Galatea is described as a woman who "e carcere fugit amato" ("escaped from the beloved prison") (11.88).[36] In the *Familiares*, Petrarch deploys the Stoic sources of the *corpus carcer* conception in 17.3.8, providing a long evaluation of similar passages in Seneca. In 14.3.7, as well as in *Fam.* 15.14.3, 15.14.7, and elsewhere, the soul, freed from the "corporeal prison," platonically "virtutis suis comitantibus astris accredit" ("approached the stars along with the virtues").

In short, Petrarch was willing to conform to a certain Platonic disposition of this poetic and literary theme. However, the notion of the simultaneous creation of the soul and body entailed a subtle and delicate theological problem. By granting, under the guidance of the neo-Platonics and Stoics, that the soul was an ether of celestial origin infused in bodies, Petrarch was compelled to deny that the soul was created by God together with the body. And, after all, Petrarch's admiration for the ancients was not unconditional: sometimes, especially on such burning issues, he would encounter insurmountable barriers. Petrarch would acknowledge the neo-Platonics' and Stoics' theories only when they could reinforce his moral message, as in the *De otio religioso* and even then, he would not adhere to them too overtly (as in the *Secretum*). But on more than one occasion, we can see him refuse or belittle doctrines about the infusion of the soul and its celestial origin in favor of a clear adherence to orthodox Christian views. Thus, in *Fam.* 15.4.13, he reduces Vergilian,

Ciceronian, and Senecan examples of the embodiment of the soul following the creation of the body, under the stars' mediation and under celestial influences, to the rank of similes and traces the origin of the soul to God:

> Non dicam: celestem originem animarum . . . , neque . . . animum nobis datum ex illis sempiternibus ignibus quos sidera et stellas appellamus, ut . . . ex ignium volubilitate celestium animarum inde nascentium volubilitas excusetur; sed hoc dico, creatas simulque corporibus infusas animas a Deo esse.

> (I'm not saying that the soul has a celestial origin . . . , nor that our soul has been assigned us from those eternal fires that we call stars and skies, . . . so that the mobility of rising souls could be explained by the mobility of celestial fires; I say, indeed, that souls are created by God and instilled at the same time in bodies.)[37]

And again, on the margin of the Ambrosian Vergil, next to Vergil's verses regarding the soul, Petrarch cites the authority of Augustine, who claims that flesh does not corrupt the soul but that the sinning soul corrupts the flesh.[38] On this and other similar issues, Petrarch ultimately referred to Augustinian syncretism; therefore, in his work, as in Augustine, two tendencies confront each other, one that considers imperfect the "opaque" nature of the body and another that attributes to the soul the vicious moral disposition inherited from original sin.

Despite this adherence to Augustinian dictates, Petrarch keeps on recovering definitions and similitudes from the classics: death that is called life, a verdict from Cicero's *Tusculanae disputationes* as well as from Macrobius, is present also in *Varia* 69 (*Miscellanea* 8), and Vergil's "hazy prison" is found again in *Senilis*.[39] In the *Seniles*, many of whose passages deal with the topic of the soul and the body in consonance with the *Canzoniere*'s ending, the theme is widely treated (see, for example, 2.8, 6.6, 8.2, 9.1, and 9.2). Finally, in the gothic enumeration of the thousand metaphors describing human life in *Sen.* 11.11, the *tenebrosum carcerem* ("obscure prison") has its own special place.

As for the *Canzoniere*, we find two prisons there, one elegiac and the other sapiential. The thematic continuity between the prison of love and the prison of the soul is one of the allegorical keys to the work and also one of the poetic motifs whose development constitutes the fulcrum of the work's diegesis. From beginning to the end of the *Canzoniere*, the repetition of metaphoric figures, accompanied by a profound variation in their allegorical meanings, allows a thematic progression in their preponderant values, from the pervasive *Triumphus cupidinis*

of the first part, built on a refined eroticism, to the ascetic palinode of the second part, inflected by a Stoic quest for spiritual perfection. The presence of the *carcere* (a presence mainly, it seems, of the early poems) in the first part and the theme of love is linked to slavery and bonds of love, since falling in love is depicted through the image of the trap: thus the "rope" (*canape*) of *Tr. cup.* 3.172 and the long series of bonds, nets, and snares in which the lover remains enmeshed.[40] The presence of the image of the prison in *RVF* 26.6–8—"Né lieto più del carcer si disserra/chi 'ntorno al collo ebbe la corda avinta/di me" ("He who has the rope already round his neck/is no happier to be freed from his prison/than me")—is therefore a simple comparison, appearing as it does right after the wreckage metaphor (the same wreck-prison sequence is to be found in the first book of *De vita solitaria*). The *carcer*, in its first appearances in the *Canzoniere*, is still elegiac in style: this sonnet, like the preceding one, indeed seems juvenile (even though there is no conclusive proof that it was written during the author's youth), and the *carcer* that is described is essentially that of love.[41]

In the same way, *giogo, lacci, catene,* and *ceppi* ("yoke," "bonds," "chains," and "logs") are among the attributes of love, and they describe the tools by which the god of love has incarcerated the poet: thus in *RVF* 89.1–2, the poet is "fuggendo la pregione ove Amor m'ebbe/molt'anni a far di me quel ch'a lui parve" ("fleeing the prison where Love for many years/had done with me whatever it was he wished") and in *RVF* 76.2 makes reference to the *prigione antica* ("ancient prison") of love (both these poems are dated, also without conclusive evidence, to the end of the 1330s). Again, in *Tr. cup.* 4.149, the prison into which one voluntarily enters from a state of freedom, the "carcer ove si vén per strade aperte" ("a prison entered by wide-open gates"), is one of the numerous romance rewrites of the elegiac *ser-vitium amoris*. Despite its elegiac origin, even the love prison of the *Triumphus cupidinis* is susceptible to sapiential definitions, because its gloominess must derive from the Augustinian *tenebrosum carcerem*—"tanti spirti e sì chiari in carcer tetro" ("so many souls, so bright in a dark prison") (4.164)—and from the Vergilian souls "clausae tenebris" ("closed in darkness"), a verse transformed into the "tenebrosa e stretta gabbia" ("dark and narrow cage") of *Tr. cup.* 4.157. It is not certain that this philosophical apposition carries the same allusive meanings that the metaphor implies in the source. In fact, although Petrarch refers to those sources for the *iuncturae*, the motif of the prison of love is in all these cases (and in many others I do not quote, for example, *RVF* 121.7, 134.5) of direct elegiac origin. The lyric motif of the prison of love also has troubadouric precedents; the topos, so suitable for the courtly expression of love devotion, is repeated by important Provençal poets,

including Aimeric de Peguilhan.[42] A strong resemblance to the use that the lyric Petrarch makes of the topos of the prison of love is shown by the other distinguished imitator of Ovid, Boccaccio, who refers to an *amorosa pregion* ("amorous prison") and a *prigion d'amore* ("love prison").[43] Nor there is a lack of other Italian examples (Nicolò de' Rossi, for instance).[44]

In the *Rerum vulgarium fragmenta*, the first appearance of the image of the body as prison in its tropological-moral sense is in *RVF* 72.16–21. It is a song from Petrarch's Avignon period but that was apparently deeply revised in the 1350s, at which time the metaphor presents itself in a Platonic and Boethian guise:

> Io penso: se là suso,
> onde 'l motor eterno de le stelle
> degnò mostrar del suo lavoro in terra,
> son l'altr'opre sì belle,
> aprasi la pregione, ov'io son chiuso,
> et che 'l camino a tal vita mi serra.

> (I think: if there are other works
> as finè above, where the eternal Mover
> of the stars leaned down to reveal
> his labours to the earth,
> open the prison where I am confined,
> that shuts from me the road to such life.)

In this context, densely woven from philosophical motifs and lexemes, the body's opacity essentially prevents the poet from seeing the beauty of creation and of the first essences, according to a motif picked up by the naturalistic strain of neo-Platonism; on this occasion, the metaphor reflects, without any aporia, Boethius's doctrine—derived from Cicero and Macrobius—of the degradation of the body as compared to the divine substances.

It is the first appearance in a long series. In *RVF* 86.5–6 (also, perhaps, an early poem) one reads: "Ma 'l sovrastar ne la pregion terrestra / cagion m'è, lasso, d'infiniti mali" ("And surviving in this earthly prison / causes me infinite pain, alas"). The metaphor appears almost formulaic and does not seem to hint at hidden meanings, except in the topos of lovesickness that leads the lover to long for death. In *frottola* 105, line 63—"e la pregione oscura ov'è il bel lume" ("a dark prison where there is much light")—the metaphor refers to Laura and her body; given the particular nature of the *canzone frottolata*—and given the semantic oppositions on

which the poetic language of Petrarch is founded—the dialectic seems at variance. What is indicated by luminescence? *Veritas?* Or the soul, in counterdistinction to the body? It is not clear: but in any case, this occurrence must also be placed in the Ambrosian-Augustinian category of *tenebrosum carcerem.*

The second part of the *Rerum vulgarium fragmenta* opens on a note of renewed morality, calling for the pursuit of terrestrial salvation, to be reached by renouncing the lures of earthly love: both love for a terrestrial creature in itself and that love through which a terrestrial creature may lead one to God. This second kind of love is ambiguous, since pursuing it is liable to subvert order and the doctrine of God as *summum bonum*: this is the topic of the third book of the *Secretum.*[45] The underlying question of the value of this kind of love is not resolved in the dialogue, nor does it seem to be in the *Fragmenta*. But renunciation of the first kind of love, that of appetite and concupiscence, is complete. In keeping with this obligatory choice, which is concordant with the great moral archetype of St. Augustine's *Confessions*, in the second part of the *Fragmenta* the prison of love is destined to disappear and be replaced by the prison of the soul. In the poems after Laura's death, such as *RVF* 296.3, death becomes an *onesta pregion* ("true prison"); in the same way, the obstacles that interfere with accomplishing the speaker's moral trajectory are no longer attributed to love, that is, to sin, but to his own *egritudo animis* ("soul sickness") or, at worst, to the imperfections of mortal bodies: both are *vitia*, "vices," one moral and the other physical. In the latter sense, the bonds that prevent the poet from flying toward moral perfection are essentially corporeal impediments. Thus, in *RVF* 264.7–8 ("Mille fiate ò chieste a Dio quell'ale / co le quai del mortale / carcer nostro intelletto al ciel si leva" ["I've asked God a thousand times for those wings / with which our intellect / can rise from this mortal prison to heaven"]) and in the same song at 113–14, there is another Boethian presence: the impediment to the poet's prophecy of his dying day owes to corporeal opacity ("né posso il giorno che la vita serra / antiveder per lo corporeo velo" ["nor through the corporeal veil can I / anticipate the day that ends my life"]). Here, the *mortale carcer* ("mortal prison") is no longer formulaic but reveals acceptance of, or at least alludes to, a neo-Platonic tradition, tempered by Christian developments in St. Thomas and St. Bonaventure, in which the faculties necessary to escape the terrestrial prison of the soul—and in particular of its most ethereal part, the intellect or *apex mentis* ("mind's peak")— are a gift of faith and God's grace.[46] In this case, more than to the Augustinian *tenebrosum carcerem*, the main allusion must be to Boethius's motif of the *pennae mentis* ("mind's feathers"), of the mind's flight along the *scala naturae*, linked, in a "profane" context, to the motif—peculiar to naturalistic neo-Platonism—of the

soul's lightness, which is present in Cicero and quoted by Macrobius. The disposition of this image is syncretic: the conceit of escaping by flying from the corporeal prison is equally Macrobian and Ambrosian and not foreign to Lactantius. On the other hand, if the soul has fallen into a body on account of the weight of its concupiscence, it can only arise again by flying toward the celestial spheres, which are its natural seat and destination.[47]

The same source—Boethius—seems to be at the root of *RVF* 287.3. In the sonnet on Sennuccio del Bene's death ("Sennuccio mio, benché doglioso et solo / m'abbi lasciato, I' pur mi riconforto, / perché del corpo ov'eri preso e morto / alteramente se' levato a volo" ["O my Sennuccio, though you've left me / grieving and alone, I'm still comforted, / since you have taken flight on high, / from the dead flesh that held you"]), the metaphor of the *corpus carcer* has its most distinct development and its clearest formulation. Here the influence of Macrobius is paramount: indeed, the dialectical opposition between the real life (eternal) of the soul and the apparent life (but real death) of the body comes from the *Somnium Scipionis* (it also appears in Cicero's *Tusculanae disputationes*). Petrarch reads the *Phaedo* too late to exploit Plato's work directly as a source of this powerful image at the time of Sennuccio's death (1349).[48]

A simple appearance, almost formulaic, of the *corpus carcer* image is in *RVF* 306.3–4, in which a "sun" (Laura, or spiritual love) shows the path to reach the "sommo Sole" ("supreme sun", that is, God). The poet says that Laura's death trapped "in pochi sassi" ("beneath a little stone") " 'l *suo* lume e 'l suo carcer terrestro" ("*his* light and her terrestrial prison"). This is another reference to Laura's body through periphrasis; Laura's body is indeed mentioned in the second part of the *Fragmenta* but most often through allusion. A similar allusion, based on a periphrasis of philosophical derivation, is present in *RVF* 325.9–10: "Ne la bella pregione, onde or è sciolta / poco era stata anchor l'alma gentile" ("Within that prison she's now freed from, / her gentle soul had only been a little while"). Thus, Petrarch shows—while accepting the interdiction of desiring her beautiful body— the youth of Laura. Although the body is even more *bello*, "kind," later on, in *RVF* 325.101 ("quel suo bel carcer terreno" ["her lovely earthly prison"]), the use of the periphrasis (and the spiritual allusions it elicits) diminishes the force of the memory and transforms the desire of the first part of the *Canzoniere* into an eminently spiritual concupiscence.

Finally, at the time of the work's last modifications, the author's weariness must have been very real, and his desire to escape from the *terreno carcere* ("earthly

prison") keen; he wishes for it once more, with an Augustinian excitement and referring at 349.9–14 to light:

> O felice quel dì che, del terreno
> carcere uscendo, lasci rotta et sparta
> questa mia grave et frale et mortal gonna,
> et da sì folte tenebre mi parta
> volando tanto su nel bel sereno,
> ch'i' veggia il mio Signore et la mia donna.

> (Happy the day, when, issuing from this
> earthly prison, leaving my weak, and heavy,
> and mortal dress broken and scattered,
> departing from such dense shadows,
> flying so far into the blue serene,
> I'll see my Lord, and that lady of mine.)

In this case as well, the Ambrosian and Augustinian origin of the metaphor seems clear.

Of different origin, conversely, is the metaphor of the *corpus carcer* in *RVF* 364.12–14. In conformity with the liturgical tone of the conclusive phase of the work, and in accordance with the invocation made by the sonnet at line 8 to the "alto Dio" ("high God"), the *carcer* here still represents the body, though it does not allude to its natural flaw, the physical imperfections that prevent discerning the intelligible but rather to moral sin, or *egritudo:* "Signor che 'n questo carcer m'ài rinchiuso / tràmene, salvo da li eterni danni / ch' i' conosco il mio fallo, et non lo scuso" ("Lord, who imprisoned me in this jail, / release me, save me from eternal harm, / because I know my fault and don't excuse it").

The *corpus carcer* metaphor in the *Rerum vulgarium fragmenta,* therefore, establishes a compact figurative system, quite important in the structure of the work, since it determines the transition to a higher system of spiritual values. Its absence from the stilnovo and previous traditions contributes to demonstrating the uniqueness of Petrarch's poetic and spiritual experience as compared to that of his Latin and Romance predecessors. The very incomplete acceptance of this metaphor in the lyric poetry of the fifteenth and sixteenth centuries demonstrates Petrarch's difference even from his epigones, who extensively imitate his forms and his poetical language but do not much understand the hidden meanings of his

lyric. If we exclude a few cases with a moral or religious subject, the *corpus carcer* metaphor is almost completely absent: in particular, it will prove to be unsuitable for imitation in the lyrics of fifteenth and sixteenth century courtiers, who, with rare exceptions, only catch the erotic repertoire of Petrarch's vernacular, trivializing it. The philosophical implications of Petrarch's *corpus carcer* and the moral meanings that undergird the image are almost never recognized and put into verses. Conversely, the elegiac image of the prison of love once it is revived, will be diffuse. For most of the poetry of the fifteenth and sixteenth centuries, Petrarch serves as a model at a superficial level, and this precocious imitation and grammaticalization of Petrarch's poetical language contributed to dulling the sensitivity of his successive readers.

This prison of love is one of the stereotypes of the Petrarchist imitation, one of the favorite recurring motifs—with many differences in its use—in the lyrics of the sixteenth century. The presence of the metaphor within lyrics of Petrarchan derivation serves almost as indicator of the philosophical and sapiential level that poetry like this reaches. The sixteenth-century lyric—and not only the courtly one—omits almost totally (with the significant exception of Michelangelo and few other Platonizing poets) the second prison in the *Fragmenta*, the spiritual one that relates to the corporeal and moral impediment to perfection and acknowledges for the most part only the imaginative force of the first one, the elegiac.

However, the Platonizing poets of Bembo's circle reserve a philosophical status for the metaphor of the prison: in Vittoria Colonna in particular the topic is treated through a series of Petrarchan contrasts, in a sonnet that is one of the brightest examples of the philosophical elaboration of the metaphor. The sonnet is entirely organized around a periphrasis:

Cara unïon, con che mirabil modo
per nostra pace t'ha ordinata il Cielo,
che lo spirto divino e 'l mortal velo
leghi un soave ed amoroso nodo!

Io la bell'opra e 'l grande auttor ne lodo,
ma, d'altra speme mossa e d'altro zelo
separata vorrei prima che 'l pelo
cangiassi, poiche' d'essa io qui non godo.

L'alma rinchiusa in questo carcer rio

come nimico l'odia, onde smarrita
né vive qua né vola ov'io desio.

Vera gloria saria vedermi unita
col lume che die' luce al corso mio,
poi sol nel viver suo conobbi vita.

(My dear unity, in what a wonderful way
did the heavens order you for our peace,
so that the divine spirit and the mortal veil
may be wrapped in a light, amorous knot!

I praise this work and its greatest maker;
but, moved by a different hope and zeal
I'd like to be separated before I change
my appearance, because I don't enjoy it here.

The soul, shut in this wicked prison
hates it as evil, and lost,
it does not live here nor fly where I desire.

True glory it would be to be in union
with the lamp that gave light to my life,
because only in his life I knew real life.)[49]

In short, the motif is more welcomed in the Platonizing circle around Bembo and Vittoria Colonna than it is in other sixteenth-century Italian poetry, and it is strongly connected with its original speculative *vis*. Other Petrarchan poets, such as Veronica Franco, detached from the intellectual elitism exhibited in the *Asolani*, do not cite the metaphor at all or else, like Gaspara Stampa, they do not use it much (and when they do, then only in an elegiac sense), or they do not catch the implications. An example of misunderstanding is found in Tansillo, who in his anxious cento confuses the cause with the effect, the Petrarchan knots (Laura's braids that enmesh him) with the prison *tout court*: "Fur mia prigion due trecce, le più belle / che mai coprisse velo" ("My prison were two plaits, the finest / ever covered by a veil").[50] The Petrarchan allegorical system, built on subtle internal cross-references and continuous correspondences in the prolongation of single metaphors, is completely misrepresented. This means that in Italian poetry there is no univocal Petrarchism but rather that Petrarch's poetical language becomes,

in differing degrees of richness, common heritage both to the poetry of high spiritual involvement and elevated philosophical participation and to the poetry that repeats wearily the erotic motifs contained in the first part of the *Fragmenta*. The absence of the *corpus carcer* metaphor and of other sapiential motifs from Petrarch in this philosophically—though not stylistically—"low" Petrarchism of the Cinquecento, demonstrates how, except in some structural revivals of the sin and repentance dialectic and of the palinodic form of the *Canzoniere*, the work's profound moral sense was not understood and reveals how far the imitators turned Petrarch's poetry into an Arcadia, reducing its philosophical richness to a sort of reservoir of metaphors and its stylistic features to a repertoire.

In the sixteenth century, the most significant lyrical example of the adoption of the *corpus carcer* metaphor in its sapiential and philosophical degree (but not in an ethical or tropological sense) also belongs to a poet of Vittoria Colonna's circle. It is found in Michelangelo, in a sonnet that is hard to date, but which is among the latest to be printed, number 106 of Girardi's edition:

> Per ritornar là donde venne fora,
> l'immortal forma del tuo carcer terreno
> venne com'angel di pietà sì pieno,
> che sana ogni intelletto e 'l mondo onora.

> (As one who will reseek her home of light,
> Thy form immortal to this prison-house
> Descended, like an angel piteous,
> To heal all hearts and make the whole world bright.)[51]

This sonnet also has a Platonic foundation, built as it is on a series of comparisons between mortal and celestial things. God shows himself to the poet in a body, a "mortal velo" ("mortal veil") (l. 13) that Michelangelo still loves because God reflects himself in it.

It certainly cannot be argued that the complex Petrarchism of Michelangelo refers directly to the model; it could be asserted instead that in his use of the metaphor, Michelangelo proves to be original and, so to speak, "secular" compared to the lyrical tradition. The Platonism of the fifteenth century had already made the image of *corpus carcer* familiar, not on the ground of an abstract Petrarchan model but on the expressive level, where it still possessed a vigorous vitality. A vitality even more fecund since Michelangelo seems to adhere to the idea of physical con-

templation of the divine and does not miss the opportunity to go beyond the metaphor in verbal art by making it plastic:

> The ... beauty of his figures ... reflects—and it is reflected by—his Neoplatonic faith that what the enraptured mind admires in the "mirror" of individual forms and spiritual qualities is but a reflex of the one, ineffable splendour of the light divine in which the soul has revelled before its descent to the earth, which it longingly remembers ever after, and which it can temporarily regain "*della carne ancor vestita*." And when Michelangelo speaks, as so many others had done and continued to do, of the human body as the "*carcer terreno*," the "earthly prison," of the immortal soul, he carried out this much used metaphor in tortured attitudes of struggle or defeat. His figures symbolize the fight waged by the soul to escape from the bondage of matter. But their plastic isolation denotes the impenetrability of their prison.[52]

Thus Panofsky, from whom we infer that, from an ideal point of view, Michelangelo drifts away from the lyrical model, since he considers the corporeal forms a repetition of the celestial ones, and in this sense he welcomes them, admires them, does not condemn their opaque imperfection, but elects them as model (in the *Prigioni* for Julius II's funeral monument.) The corporeal forms, although imperfect compared to the deity, have their own earthly and human perfection, which is the only one that can be celebrated poetically and plastically. Staunch Platonist, Michelangelo does not notice the moral doubt of Petrarch's lyric model, which is irresolvable; in Michelangelo both body and soul share a fundamental identity: the enslavement of the soul is dignified by both song and effigy.

Petrarch's Lame Leg and the Corpus of Cicero

An Early Crisis of Humanism?

Ronald L. Martinez

For Petrarch, Marcus Tullius Cicero was not only an icon of republican Rome and the supreme exemplar of Latin eloquence but in many respects an alter ego. Although Petrarch writes in the *Triumphus fame* of Cicero and Vergil as the two "eyes" of the Latin language, he displays a recurring and insistent preference for Cicero.[1] An example is how Petrarch, writing to Vergil in the last book of the *Familiares*, praises him in the terms of Cicero's self-serving assessment of the Mantuan as great Rome's *other* literary hope, "magne spes altera Rome."[2] If Augustine of Hippo functioned (especially in the *Secretum*) as Petrarch's frequently frowning superego, the dedicatory letter to the *Familiares* makes it clear that Petrarch, though he acknowledges no share in Cicero's civic commitment, consciously supposed he had a close resemblance to Cicero as a writer and personality.[3] In Petrarch's formulation, the relationship demonstrates the rhetorical trappings of intimacy: to the best of my knowledge, in apostrophizing classical or other authors Petrarch used the familiar possessive only for Cicero; we find instances of "mi Cicero" ("my Cicero"), but I have not found "my Vergil" or, heaven forbid, "my Augustine."[4]

During Petrarch's long, bookish, and self-documented life, he often records as significant milestones his encounters with texts of Cicero. Several of these are re-

counted in the late letter to the jurist and papal secretary Luca da Penna (*Sen.* 26.1). Passing through Liège in 1333 Petrarch discovered and transcribed in his own hand the oration, hitherto unknown to him, *Pro Licinio Archia*.[5] Conceived in defense of a Greek poet living in Rome, the oration includes an impassioned defense of the inspired nature of poetry. Petrarch cited Cicero's text explicitly in the coronation oration of 1341, so that Cicero's defense became closely associated with Petrarch's epochal achievement of world celebrity.[6] Shortly thereafter, in 1345, Petrarch made perhaps his most dramatic rediscovery of an ancient text, copying by his own hand a volume from the cathedral chapter library of Verona that included Cicero's letters to Atticus, Brutus, and Quintus and the pseudo-Ciceronian Letter to Octavian.[7] The experience was decisive in diverting Petrarch's attention (permanently, as it happened) from his project currently in hand, the encyclopedic *Rerum memorandarum libri*, and to the idea of fashioning a collection of his prose epistles; eventually, of course, these would add up to almost 500 familiar letters (the 122 letters of the *Seniles* plus the 350 of the *Familiares*) and would constitute perhaps his most characteristic body of work. Although Petrarch wrote in his dedication to Ludwig van Kempen in the first letter of the *Familiares* that he hoped to someday provide a finished portrait (or rather portrait bust) of himself in the form of the *Epystula posteritati*, the fragmentary form in which that missive was left means that it was the collection of familiar letters that remained to furnish the fullest surviving effigies and simulacrum of the poet's mind.[8]

Looking back in *Sen.* 26.1 on his lifelong experience with Cicero's books, Petrarch wrote that he had reveled in the euphoniousness of Cicero's Latin periods even before he could understand them. In this same letter, Petrarch confesses to a primal scene that ensued upon his father Ser Petracco's discovery, probably about 1319, of the cache of books Petrarch had so far collected.[9] Petracco, having declared the books obstacles to his son's fledgling legal studies, burned them, and only a *Rhetoric* of Cicero and a copy of Vergil—the former for practical and the latter for recreational reasons—were saved by Petracco from the holocaust:

> All of Cicero's works that I had been able to acquire, along with those of poets, as though enemies of lucrative studies, were pulled in my presence from the hiding places where I had put them, fearing what did soon happen: and they were cast on the flames like heretical books, a sight at which I groaned just as if I myself had been tossed on the same fire.[10]

Watching the immolation of his first humanistic library, Petrarch felt as if his own person was on fire. His account includes a suggestive verbal allusion to Ovid's ac-

count in the *Metamorphoses* of the hero Meleager, whose life, magically bound up in a piece of kindling, was cast on the fire by the Fates and ignited; he was only saved when his mother, Althea, snatched it out ("flagrantem mater ab igne / *eripuit ramum*") (*Met.* 8.456–457; my emphasis). But Petrarch's allusion also calls up a later part of the episode, when Althea, horrified at Meleager's murder of her brothers, avenges her family honor by returning the piece of wood to the fire and ending Meleager's life by remote control, so that though far away he feels the pains of death:

> . . . dextraque aversa trementi
> funereum torrem medios *coniecit* in ignes.
> aut dedit, aut visus *gemitus* est, ipse dedisset
> stipes et invitis *conreptus* ad ignibus arsit.
> Inscius atque absens *flamma* Meleagros ab illa
> uritur et caecis torreri viscera sentit
> ignibus. . . .[11]

We can compare Petrarch's text in the *Seniles*, linked to Ovid's chiefly through Petrarch's cry of pain and his father's snatching of the two books from the fire:

> Quo spectaculo non aliter *ingemui*, quam si ipse ijsdem *flammis inijcerer*. Proinde pater . . . subito duos libros, pene iam incendio adusto *eripuit*.

> (At which sight I groaned just as if I myself had been tossed on the same fire. I recall that my father . . . thereupon quickly grabbed two books, already nearly burned by the fire.)[12]

We can infer from Petrarch's vicarious pain at the burning of his library that he saw his own vitality fetishistically bound up in the life of his books. He may also have been remembering his Dante, who in the *Purgatorio* furnishes the example of Meleager's life force displaced into a piece of kindling in order to illustrate how the airy shades of purgatory could become thin even though having no real need of food.[13] In this context the book appears as a virtual, exoteric body, an alternative to the natural body of flesh and bone, and its existence suggests—in Petrarch's admittedly retrospective view of his literary career—how the mind of the writer, preserved in written texts, survives extinction. This view is of course also consistent with the genealogical metaphors Petrarch notoriously relied on for discussing the transmission of literary influence, a subject I take up later in this chapter.

Petracco's book burning also marked a second traumatic birth for the young

humanist, who in that same first letter of the *Familiares* lingers on the dangers he underwent as an infant born to a family in exile.[14] In staging the rescue of the vital books from the fire so that they are saved by the father's hand, rather than, as in Ovid's story, by the mother's, the literary allusion emphasizes the episode as at once paternal initiation and chastisement through an ordeal by fire. Although Petracco's immediate reason for burning young Petrarch's books is presented as motivated by practical considerations, Petrarch's father was himself a man of literary ability, from whom Petrarch had inherited books such as the codex that would become the famous Ambrosian Vergil; and thus in some sense the order into which Petrarch was being initiated was arguably the demanding order of literature itself.[15]

This pattern of simultaneous initiation and chastisement was one Petrarch, in all likelihood inspired by the accounts of Vergil's desire that the unfinished *Aeneid* be burned after his death, had described another book burning much earlier in the proemial letter to the Cicero-inspired *Familiares*.[16] In that letter, Petrarch describes himself aggressively consigning a number of his works to the correction of the flames (*Vulcano corrigendas*) but staying his hand when the dedicatees of the projected metrical and prose collections, respectively Barbato da Sulmona and Ludwig van Kempen, appear to materialize, one on the left, one on the right—like the two books in Ser Petracco's hands—to plead for the books dedicated to them.[17] On this occasion, presumably occurring about 1350, Petrarch has himself assumed the place of the exacting and punishing patriarch, chastising and purifying his literary legacy and sparing works only when the bonds of friendship intervene.

There is yet a third recurrence of this pattern, which furnishes the immediate subject of this chapter. In 1359 Petrarch had an encounter, at the door of his library in Milan, with the tall, massive volume that contained the collection of Cicero's letters that Petrarch had copied in Verona. The encounter took a curiously traumatic turn that I attempt to analyze as an episode in a larger history, one that yet remains to be written, concerning Petrarch's literary and human legacy in relation to the book and the human body.

The two letters describing the encounter with Cicero's epistolary corpus, *Fam.* 21.10 to Neri Morando, a diplomat serving the Venetian republic, and dated the Ides of October 1359, and *Dispersa* 46 to Petrarch's friend and professed disciple Giovanni Boccaccio, dated August 18, 1360, are distinct but complementary.[18] Discussion of the episode in the letter to Boccaccio, written nearly a year after the event, is brief and allusive, as Boccaccio by then had already written to Petrarch consoling him on his book-inflicted injury. The earlier letter to Neri Morando, giving the fuller account of the incident and its sequel, was written on the occasion

of Neri's recovery from illness and opens by congratulating him on his improvement. Turning to his own medical news, Petrarch begins by reasserting his admiration for Cicero, and—despite St. Jerome's celebrated nightmare of being hauled up before the Almighty and damned as a Ciceronian rather than a Christian—proudly acknowledges himself a *ciceronianus*.[19] Despite, too, we might recall, the burning of his "heretical" classical texts in Ser Petracco's *auto da fé*, Petrarch is then emboldened to go further, asserting that "Christ is our god, Cicero rather the prince of eloquence; I confess they are different, but I deny they are opposed." In the same vein Petrarch transfers to Cicero the assessment Paul had traditionally made of Vergil, that if he had known Christ he would have embraced Christianity and, Petrarch adds of his Cicero, "been one of its most eloquent defenders." This displacement of Vergil, the poet who was Dante's guide, for the prose writer who is Petrarch's, which we have already seen adumbrated in Petrarch's identification with Cicero's self-serving praise of Vergil, is a characteristic gesture of Petrarch's, and I will return to it.

The accident itself is urbanely narrated to Neri Morando as a practical joke played on Petrarch by "his" Cicero, personified or incarnate in the physical codex itself: "In what way he played [*luserit*] with me, you will now hear." Indeed, the codex was so large—it contained many letters—that it had to be stood on end at the entrance to Petrarch's study ("in bibliothecae ostio"). When Petrarch went to enter his library, the hem of his gown ("togae fimbria") caught the corner of the volume, making it fall against his left shin (*crus*) just above the ankle. Lifting the book back to its vertical position, Petrarch asked, joking, "Quid rei est, mi cicero, cur me feris? Ille nichil" ("What's the reason, my Cicero, why you strike me? He was silent"). What is surprising and intriguing is that despite the severity of the blow, Petrarch permitted it to be often repeated ("Lesus iterum atque iterum expergiscor"), so that the original injury developed into a suppurating wound. When aggravated by neglect and by Petrarch's refusal to alter his active habits of walking and riding ("nec equestri vectatione, nec pedestri itinere temperavi") the injury, which Petrarch personifies, describing it as someone who swells in resentment in the face of neglect ("quasi se spernens dolore vultus intumuit"), brought him to the point of risking permanent and severe injury to his leg.[20]

Although it is Petrarch's leg that was attacked, the episode in its entirety can be seen, especially in light of the spatial setting and the implicit and explicit references to literary work, as involving Petrarch's body comprehensively. Petrarch relates that he copied the codex *manu propria* even though he was still suffering from an injured arm, thanks to a risky escape from Visconti-besieged Parma in the train of

Azzo da Correggio (narrated in *Fam.* 5.10 to Barbato da Sulmona). Not only does this exploit underscore Petrarch's fortitude; it also establishes the intimate relation with the book that can only come from having copied it oneself.[21] He endured the discomfort because "love and pleasure and the desire of acquisition overcame"— making the acquisition of Cicero's letters an instance of that "insatiabilis librorum fames" ("insatiable hunger for books") that Petrarch professedly shared with, among others, Cicero.[22] The letters had to be copied by Petrarch's own hand because they were impenetrable to other scribes—whether because written in scarcely legible ancient or Carolingian scripts or because the library itself, notoriously difficult of access, was closed to them.[23] But in either case Petrarch's copying of the text manifests his entry, thanks to personal prestige and contacts or merely skill, to privileged secrets of antiquity and, in this case, to the largest extant cache of Cicero's private letters, affording intimate, sometimes unflattering, pictures of the morals and the politics of the father of Roman eloquence. Petrarch treated the volume he produced as something "familiar" as well, keeping it "at hand" (*ad manum*) for easier use, which led to it being stood up outside the entrance to his study and so to the accident. The size and erect posture of the volume contributed to the ease with which Petrarch personified the volume, addressing it as "his" Cicero—in this bringing to a rhetorical, and probably also thematic, culmination his long-standing habit of speaking of his books as if they were the persons who wrote them.[24] On this occasion, the book had virtually come alive and lashed out at the astonished disciple, though not of course without the disciple's cooperation.

That Petrarch dislodged the volume with the hem of his long cloak excites a number of suggestive resonances. In a merely empirical sense, Petrarch's gown, which he used to keep warm during late-night study sessions, was an unmistakable trademark of his humanist pursuits, and he left money in his testament to Boccaccio for one like it.[25] But of course the toga also evokes the Roman *toga virilis*, the assumption of which announced the coming-of-age of the Roman male adolescent and was also the garment that distinguished the Roman advocate from the soldier, as Cicero himself had formulaically recalled in crowing over his own successes to his son ("cedant arma togae").[26] Even more to the point, Petrarch had used the image of a well-fitting toga to speak of his personal literary style, so that the cloak comes to stand, by synecdoche, for Petrarch's literary identity itself:

> I much prefer that my style be my own, rude and undefined, perhaps, but made
> to the measure of my mind, like a well-cut gown [*in morem toge habilis*], rather
> than to use someone else's style, more elegant, ambitious, and ornamented, but

suited to a greater genius than mine. . . . An actor can wear any kind of garment [*omnis vestem historionis decet*]; but a writer cannot adopt any kind of style. He should form his own and keep it.[27]

That Petrarch's collision, via his toga, with his copy of Cicero calls for interpretation in the terms of a literary trial or *paragone*, however jocular or amicable, could not be more sharply suggested.

Yet in Petrarch's medieval cultural milieu the gown also invokes the "garment of flesh" familiar from scenes of moral decision such as Augustine's conversion (when temptations pluck at his "fleshly garment" ("*succutiebant vestem meam carnem*") and Dante's Brunetto Latini episode, during which the old pedagogue first plucks Dante's garment and then walks behind Dante at his hem.[28] Such an implication of the toga as "fleshly garment" also returns us conveniently to the symbolism of the leg in medieval discourse both visual and written, from its use, in fourteenth-century illustrations of the prose *Lancelot*, for example, as a not very displaced graphic substitute for the erect male member, to its signification, when lamed and halt, of the concupiscent will wounded by lust, as in *Inferno* 1 or indeed in Petrarch's own *Canzoniere*, passages to which I return below.[29] These moralized associations of the body and its peskier, self-willed parts raise, however, larger questions regarding the interpretation of the episode, for it is one in which numerous forms of interpretation are deployed, discussed, and aroused—Petrarch's own, that of his correspondents and friends, especially Boccaccio, and of course those of Petrarch's readers, including ourselves. In responding so elaborately to Boccaccio's hypotheses regarding the injury with elaborations of his own, Petrarch authorizes the desire of his readers to further interpret the episode.

Petrarch's leg had, itself, a long and illustrious history, if I may so put it. In the letter to Neri Morando, Petrarch mentions that one of his witty servants routinely joked about the master's "ill-starred leg" (*tibia fortunarum*).[30] Indeed, longstanding troubles with the left leg, dating back to adolescence, had made Petrarch half a believer, as he reports, in current medical doctrines regarding astrological determination on the destiny of parts of the body, the traditional *melothesia*.[31] And in fact elsewhere in his letters, Petrarch describes injuries to his leg at other critical junctures in his life; for example, he hurt it when he was thrown from a horse as he traveled to Rome for the great jubilee of 1350, and he was to find himself bedridden again with an ulcer on his leg in 1368.[32] The body is fate, then, or at least a site where fate works out her designs, and in the case of Cicero's voluminous tome, fate had decreed an attack on Petrarch's "infaustam et sinistram tibiam" ("unlucky

left leg") by the corpus of his favorite writer—although Petrarch hastens to add, in concluding his paragraph, that fate is another word for Providence. In any case, Petrarch's underscoring of his vulnerability marks out his shin as a site of analytic overdetermination.

It is Boccaccio's interpretation of the episode, which Petrarch both absorbs and mirrors in answering his friend's lost letter of commiseration, that brings to the fore the richer literary and cultural dimensions of the accident. In the lost letter, Petrarch reports, Boccaccio had trenchantly observed that we are always hurt by those things closest and dearest to us; Petrarch would not have been "attacked," Boccaccio had joked, by a volume of Hippocrates or Albumasar.[33] In what is clearly intended as a flattering analysis, Boccaccio evidently confirms Petrarch's intimate familiarity with Cicero as well as his preference for classical texts at the expense of medieval *auctores*, even medical ones. Boccaccio's reported opinion also suggests the parameters of what we can take to be Petrarch's own interpretation of the attack, which is offered in the letter to Neri and functions as the conclusion of his two accounts of the episode: that the marking of Petrarch externally by Cicero's corpus manifests how Cicero's text had long since impressed itself indelibly on his mind. Writing to Neri, Petrarch concludes: "So my beloved Cicero, who had long since wounded by heart, now wounded my shinbone."[34] In the letter to Boccaccio, written after a scar had formed, the terms are still more suggestive: "My Cicero [*Cicero . . . meus*] affixed to my memory an indelible mark [*indelebilem notam*] and to my body a permanent brand [*stigma perpetua*]."[35] If the language of the wounded heart evokes the devotional commonplace of hearts pierced with love of Christ, the precise terms here, especially "stigma," evoke a ritual initiation and a sacramental sealing, marking Petrarch as Cicero's apostle even as Christ had marked Paul's body with stigmata (Gal. 6.17). And again the attachment is ratified with the familiar possessive, "mi Cicero."[36] Petrarch's language sketches out a liturgy of humanistic initiation, one that fully justifies Petrarch's references to himself in the letter to Neri as a transgressive and impenitent *ciceronianus* in Jerome's terms.[37]

Or, more precisely, the episode may appear a humanistic mystery play, a *ludus*. For it is also in the letter to Boccaccio that Petrarch acknowledges that the sequel has undermined his earlier jocose construction of the episode: alluding to Biblical topics such as the sorrows of Job and the fall of Jerusalem, Petrarch announces that play and joking have turned to mourning ("regarding that Ciceronian wound of which I used to joke, my play [*ludum*] has now turned into mourning [*luctum*]").[38] Yet one has only to consider the language of the two letters to see that the literary game and the play of wit remain persistently afoot. In the earlier letter to

Neri Morandi, Petrarch juxtaposes Cicero's joke, the *lusus*, to his leg that is *lesus*, injured, and rounds out the series with his discussion of the vicissitudes that strike on or from the left, *levum*.[39] From *lusus* and *lesus*, the letter to Boccaccio makes the easy step to *ludum* and *luctum* but does not for that give up joking. Discussing how he is progressing by small, tentative steps toward regaining the health he had lost by great strides ("ad salutem ipsam, unde magnis passibus discesseram, pedetentim redeo"), Petrarch jocundly keeps the focus on his leg and its motion. But such punning is serious play, *serio ludere*, and the episode becomes a scene of ambivalence and anxiety that invites further analysis: not only of its witty and jocular sprezzatura but also of the aggressive action attributed to the Ciceronian codex, as well as of the peculiar, not to say grotesque, personification of the ulcerated wound itself, inflated with injured pride at being neglected.[40] Adding to the already conspicuous prosopopoeia of the codex itself, Petrarch's rhetorical treatment of the wound, presented as both an external injury and the manifestation of an mental malady or fixation, makes it perhaps the first literary personification of a psychological *symptom*.[41]

To naively rephrase the question Petrarch puts to his Cicero, why does he strike his pupil and devoted follower ("Cur me feris")? Like the original initiation by Ser Petracco, the scene involves both election and reproach. The book propped upright outside the library door, guarding the entrance like a Cerberus or Dante's Cato, means Petrarch run a gauntlet to enter his library and, as things fall out, suffer chastisement. Given the contents of the letters in the Verona codex, we can hypothesize that Petrarch engages in ritual self-punishment because he has discovered unflattering, even shocking, truths about "his" Cicero and indeed has taken his idol to task for inconstancy of character and political miscalculation. This scolding occurs not only in the letter to Cicero in the last book of the *Familiares*, supposedly first written in 1345 upon transcribing the codex, where Petrarch draws on several of the letters he had transcribed in Verona to reproach Cicero's fatal political fickleness, but in the later proem of the *Familiares* as well.[42] In fact Petrarch uses the passage of *Fam.* 1.1 which reproaches Cicero's character, to announce the genesis of the *Familiares* themselves, so that the origin of the epistolary collection may be seen as inseparable from Petrarch's complex, ambivalent response to his chief literary exemplar. The passage both emphasizes Petrarch's outrage and asserts his conformity to his model, even in its vicissitudes:

> Cicero shows such weakness in the midst of his troubles that as much as I love
> his style I am offended by his sentiments. Add to that his contentious letters, his

quarrelsome, fickle abuse of distinguished men whom he had just been applaud-
ing to excess. When I read these I was so shocked and upset that, anger guiding
my pen, I couldn't help writing to him as to a contemporary friend, with the fa-
miliarity of long acquaintance, to reprove him for what offended me in his writ-
ings, as if forgetting the passage of time. This experience inspired me to write to
Seneca[.] . . . [A]s Cicero was submerged in his troubles, so was I in mine.[43]

By this hypothesis, Petrarch's agency in perpetuating the attack—as I note above,
he repeatedly reset the book in the same position—is a form of self-chastisement
for having blemished the memory of the great orator who embodies the classical
ideal itself, the psychic price Petrarch pays for having, as de Nolhac suggested,
initiated a more critical view of the lives and mores of classical authors.[44] But not
only that. Given the powerful identification with Cicero, to the point that Petrarch
reoriented his career in the direction of epistolary collections at the expense of
the Latin poetry that had earned him the laurel, the self-chastisement through the
codex might be seen as a masochistic punishment for having compromised his
own self-image.[45] Although attractive, this hypothesis does not explain why it took
almost fifteen years for Petrarch's ambivalent appreciation of Cicero to precipitate
a crisis that manifested itself in an episode of masochistic self-wounding. What
other factors might have been at work?

A more indirect and contextual approach to the episode may be helpful at this
juncture. In the letter to Boccaccio in late summer of 1360 in which he announced
that the wound was finally healing, Petrarch was still settling issues that had been
raised when Boccaccio had visited him in Milan before the accident, in the spring
of 1359. Their discussions had included the project of translating Homer into Latin,
which came to fruition almost a decade later when Giovanni Malpaghini com-
pleted Petrarch's fair copy of the *Iliad* and *Odyssey* in Leonzio Pilato's translation.
What is more, in the letter to Boccaccio the discussion of Homer necessarily called
up Cicero's own regrettably lost Latin translation, which brought Cicero, who was
not much of a poet, into the question of what for Boccaccio and Petrarch were the
classical origins of the poetic genius itself.[46] And there were other urgent matters
still pending between the two friends. Among these, if *Fam.* 21.15 may be taken as
witness, was Boccaccio's contention that Petrarch was envious of Dante.[47] Thus if
fundamental questions of literary history, imitation, and filiation had been much
in the air in the fall of 1359 and the winter, spring and summer of 1360, during the
time when Petrarch was suffering the slow improvement of his wounded leg, it
is plausible to suppose that Dante's influence on Petrarch, so evasively and am-

biguously treated in the response to Boccaccio, might also have been much on Petrarch's mind. As such it may have weighed on his leg as well, for as I have intimated, the *piè fermo* of concupiscence impeding Dante's pilgrim in the *Inferno* is plausibly recalled in sonnet 212 of the *Canzoniere* in the image of the poet as a slow-gaited ox, lame and infirm in the pursuit of Laura ("un bue zoppo e 'nfermo e lento"), though the immediate evocation of Arnaut Daniel's signature masks the association with Dante's foot in *Inferno* 1.30 ("so that my halted foot [*piè fermo*] was always the lower").[48]

But the claim I am making here can be more directly sustained by reference to the close association in Petrarch's mind of his discipleship of Cicero with Dante's discipleship of Vergil, as I have also already suggested. When Petrarch attacks Cicero in book 24 of the *Familiares*, accusing him of failing to observe his own precepts in his political choices, the orator is compared to a torchbearer who lights the way for others but himself falls unenlightened in the ditch.[49] Vittorio Rossi long ago pointed out the echo here of Dante's Statius speaking of Virgil, who observed that he had pointed the way to salvation but had himself remained in the dark.[50] It is striking, then, that when Petrarch writes to Boccaccio protesting his lack of envy of Dante, he begins by ostentatiously insisting that the younger writer is doing nothing wrong in taking Dante as his "first guide to studies, and first torch" ("primus studiorum dux et prima fax") to brighten his way on the literary road, although the warmth of Petrarch's approval is tempered, at the end, by yet another barb at Dante's popular reputation:

> Continue, therefore, not with my sufferance alone but with my approval to honor and cherish that beacon of your intellect [*ingenii tui facem*] who has afforded you ardor and light for this pathway [*in hoc calle . . . ardorem prebuit ac lucem*] that you have been treading with giant steps toward a glorious goal: raise high with sincere praise worthy alike of you and of him that torch long buffeted and, I would say, wearied by the windy applause of the multitude.[51]

But in thus adapting a whole series of key terms from Statius's testimonial to Virgil offered in the *Purgatorio*, from the claim that Virgil first led Statius to the craft of poetry (*Purg.* 22.64–66: "You first sent me to Parnassus to drink from its springs, and you first lit the way for me [*m'alluminasti*] toward God") to the assertion that the *Aeneid* fired his early enthusiasms (*Purg.* 21.94–96: "The seeds to my ardor were the sparks from which I took fire, of the divine flame that has kindled [*allumati*] more than a thousand: of the Aeneid, I mean . . . ") and by adding in, of course, the image of the torch lighting the literary path (*Purg.* 22.61–62: "What sun

or what candles dispelled your darkness"), Petrarch also suggests, with elegant and malicious indirection, that just as Vergil had fallen short in Dante's scheme of salvation, so Dante was a failing light that would fall short as the sole preceptor of Boccaccio's literary vocation. From this perspective, Petrarch's closing section (21.15.26–29) fulsomely remembering his first meeting with Boccaccio when approaching Florence in 1350, sketches out the more fruitful discipleship that the younger writer would be well advised now to cultivate.

Dante is of course never far from Petrarch's literary anxieties, but even anxiety over Dante may not be enough to fully account for Petrarch's repetition-compulsion in compounding his injury by the codex of Cicero. I say "compulsion" because Petrarch's text warrants it; Petrarch not only underlines his repeated recreation of the circumstances so as to ensure repeated blows to his leg but also describes these blows as a *crebra concussio*, a repeated and frequent percussion.[52] This last formula itself recalls Petrarch's exclamation, on the flyleaf of what would be the Ambrosian Vergil, after the three deaths that he recorded in the summer of 1361 (Philippe de Vitry, Ludwig van Kempen, his Socrates, and Petrarch's natural son, Giovanni): "Heu mihi, nimis *crebrescunt* fortune vulnera" ("Woe is me, too much do the wounds of fortune increase in frequency").[53] In notifying Guglielmo da Pastrengo—the man that had opened to Petrarch the treasures of the Verona chapter library, including Cicero's letters to Atticus—Petrarch adopts the same formula of Fortune's repeated blows, but he also, in an assessment whose callousness has shocked readers, avers that Giovanni's death was a thankful liberation from travail.[54] That Petrarch interpreted the near simultaneity of Giovanni's death with the death of Socrates, the dedicatee of the *Familiares*, as marking the close of an epoch may be inferred from Petrarch's decision to place his laments over these losses in the opening letters of the new collection, the *Seniles* and his final letter about Giovanni (though the boy's name is not given) in the penultimate book of the *Familiares* (the last book was reserved for the letters to classical authors, planned from the earliest stages of the collection). Nelli, the dedicatee of the *Seniles*, was also closely associated with Giovanni, as we will see momentarily. The question then is this: when recording Giovanni's death in the summer of 1361 as one of the sharp and repeated blows of Fortune and as a sharp and painful wound to his heart ("et acri dolore moriens vulneravit"), is Petrarch also remembering his still recent collision with, and wounding by, the codex of his literary father, Cicero? The two events appear linked thematically by questions of filiation and legacy, for Petrarch's crisis with the Cicero was one of discipleship, and the poet had seen in Giovanni Petrarca a possible successor.

As a partial answer to my rhetorical question, I would like to propose in the last part of this chapter a possible connection between the attacks of Petrarch's Cicero in the early summer of 1359 and the drama of Giovanni's tormented return—after having been expelled from the paternal home in the summer of 1357—to Petrarch's household in December 1360, thus not long after Petrarch's full recovery from his accident in the fall of 1360. Petrarch's failure as a father to Giovanni emerges from the dozen or so letters that trace how the boy's increasing resistance to paternal authority culminated in the crisis of 1357 and Giovanni's expulsion.[55] The last two letters written while Giovanni was still alive, which document the final phases of Petrarch's decision to relent and readmit Giovanni to his home, bracket the period of Petrarch's suffering with his leg wound: in the first of these, written about 1360, Petrarch reproaches himself for his leniency but announces his forgiveness of Giovanni; in the second, written in 1360–61, he proclaims his resigned endurance of the boy's hostility and imperviousness to literary training.[56] Especially significant for my purposes is that the second letter, *Fam.* 23.12, lingers with considerable intensity on Cicero's difficulties with his own son, Marcus (the "mi Cicero" of the *De officiis*) who likewise did not follow in paternal footsteps and regarding whom Cicero wrote to Atticus, also blaming Marcus's bad behavior on a too-lenient upbringing.[57] It is thus arguable that Petrarch, who had seen himself sharing Cicero's troubles in the proem to the *Familiares*, came to see his own troubles with Giovanni as resembling those of Cicero with his son.[58] If Petrarch's internal debate over allowing Giovanni's return in any sense informed the contemporaneous compulsive behavior that seconded his chastisement by "his" Cicero, the question remains whether he was punishing himself for his lack of affection toward his son or for his culpable leniency in disciplining him. Given Cicero's analysis of his failure with Marcus and the inveterate Roman preference for harsh measures, one is forced to conclude that it was probably the latter. In any case Petrarch, despite having pontificated about parental "tough love," assigned his own failures with Giovanni to excessive leniency.[59] Writing to Giovanni directly, Petrarch accuses his son of pride and draws repeatedly on the language of swelling and inflation that resonates with the account of the swollen ulcer on Petrarch's leg—his personified "symptom."[60]

From Petrarch's letters, it is apparent that Giovanni Petrarca's chief offense was his fiercely hostile disinterest in books: Petrarch mentions it twice.[61] But that a contemporary could consider Petrarch's treatment of his son strict and ungenerous is attested by the letters of Francesco Nelli, who kept company with and assisted Giovanni when the young man fled to Avignon.[62] Though normally an obsequi-

ous disciple of Petrarch, Nelli openly disapproved of Petrarch's severity toward his son and several times wrote to Petrarch praising the boy as a son worthy of such a father.[63] By Nelli's own account these letters went unanswered by Petrarch during the two years immediately after Giovanni's banishment, the period 1357–59.[64] After Giovanni's death of the plague in the early summer of 1361, Nelli consoled Petrarch, not only comparing the boy to Vergil's doomed Marcellus with a black cloud around his head but insisting that when he gazed on Giovanni, Petrarch's paternal features, which Nelli kept ever-present in his mind, were discernible ("in eo sepius inspiciebam, quam semper vigilantibus mentis oculis, effigiem cerno").[65] It would be tempting to take Nelli's reference to father-son resemblance as an allusion to Petrarch's account of literary imitation as family resemblance and thus as a shrewd jab by Nelli against Petrarch's neglect of Giovanni in favor of scholarly obsessions, but for the fact that Nelli's letter predates by some three years Petrarch's enunciation of this theory in the famous epistle addressed to Boccaccio:

> An imitator must take care to write something similar yet not identical to the original, and that similarity must not be like the image to its original in painting where the greater the similarity the greater the praise for the artist, but rather like that of a son to his father. While often very different in their individual features, they have a certain something our painters call an "air," especially noticeable about the face and eyes, that produces a resemblance; seeing the son's face, we are reminded of the father's [*viso filio, patris in memoriam nos reducat*].[66]

An alternative hypothesis, though preliminary and requiring further investigation, is that Nelli's evocation of the resemblance of father and son in his *consolatoria* informs, if it did not necessarily directly inspire, Petrarch's account of successful imitation as family resemblance. In this way, Petrarch's formulation of his views regarding literary imitation would be marked with the trace of his ambivalent mourning for his son.[67] What is certain is that Petrarch's enunciation of his views on imitation coincide, and are directly stimulated by, his experience with another Giovanni, the copyist Giovanni Malpaghini, who, as Pierre Blanc has pointed out, functioned in Petrarch's mind as an idealized filial replacement for the book-loathing Giovanni Petrarca.

As Blanc underscores, for the egotistic and narcissistic Petrarch, Giovanni's unpardonable sin was his failure to imitate his progenitor.[68] It was, on the other hand, the apparent perfection of this resemblance in the scribe Giovanni Malpaghini of Ravenna that recommended him to Petrarch. Writing in the same letter to Boccaccio, Petrarch extolled Malpaghini as a nearly ideal copyist, endowed with an

elegant and superior writing hand.[69] Here was the ideal heir of Petrarch's literary intellect, the true son he had not found in his natural offspring. And by copying by his own hand in fair copy the letters of the *Familiares* that constitute the poet's private effigies, as well as much of the *Canzoniere* into the Vatican 3195 manuscript, Giovanni Malpaghini of Ravenna did to a great extent for Petrarch what Petrarch had done in part for Cicero: reproduce his "autobiographical" corpus. But such reiterated reproduction of the master proved too much for this Giovanni, who bolted and at one point seemed headed to Constantinople and the study of Greek, perhaps because that language had resisted Petrarch's efforts to learn it.[70]

In this failure to retain a disciple, only six years after losing a natural son, Petrarch again ran afoul of his persisting literary anxieties and attendant demons. After Giovanni Malpaghini departed for Naples and the Angevin court, Petrarch, writing to Donato Albanzani (Malpaghini's former grammar teacher), observed bitterly that in going to the city where Vergil was buried the boy intended "to raise from the Mantuan ashes a new Vergil from Ravenna." Unsurprisingly, Petrarch is dismissive of Giovanni's ambitions to be a second Vergil. Still, the coincidence in the letter of language suggesting necromantic conjuring with mention of the notorious birthplaces of both Vergil and Dante is highly suggestive. Petrarch seems to fear that Giovanni might stir up the specters of both Vergil *and* Dante—the disciple of Vergil whose dust and ashes rested in Ravenna—in reproach of a Petrarch too besotted by Cicero and too strident a denier of Dante.[71]

With the death of his son, Giovanni, of plague in 1361 and the second, definitive flight of Giovanni Malpaghini in 1367, followed in 1369 by the death of the much-loved Franceschino da Brossano, Petrarch's grandson by his daughter, Francesca, and his son-in-law, Francescolo da Brossano, Petrarch's direct lineage by male descent is checked both literally and symbolically. As Petrarch observes in the letter announcing Franceschino's death, the little boy not only renewed, or should one say reproduced, Petrarch's first name (bringing to four the total of instances, for Petrarch's daughter's name was Francesca, and her husband's Francescolo) but so resembled Petrarch as to be taken for his son: indeed, Petrarch reiterates, in reporting that he can see himself in his own grandson, both his own account of imitated texts "recalling" their exemplars and Nelli's remarks about having discerned the lineaments of Petrarch in the features of Giovanni Petrarca:

> What I would call his worst feature was so like my face [*sic me ore referebat*] that those who did not know his mother would have simply taken him for my son.

Everyone said so, and I remember you once declared to me in a letter, when he was hardly a year old, that you had seen my face in his [*in illius vultu mam faciem te vidisse*] and that from this you had conceived some great hopes for him. This resemblance, so striking despite the difference in age [*similitudo, in tanta aetatum distantia*] had made him dearer to his own parents and dear to everyone around.[72]

True, Petrarch's granddaughter Eletta, who renewed the name of Petrarch's mother, was still left to him, and a number of additional grandchildren (including several grandsons) were subsequently born to Francesca and Francescolo da Brossano; but there is every reason to conclude that the loss of Franceschino was a grievous wound to Petrarch's onomastically inflected narcissism.[73]

In the view of Pierre Blanc, whose psychoanalytic reading of Petrarch's career is comprehensive and incisive, the falling out with Giovanni in 1359 had been instrumental in Giovanni's being left behind in Milan when Petrarch, avoiding the plague, moved himself and the rest of his family to Padua in the spring of 1361; by this hypothesis Petrarch would have had a hand, so to speak, in cutting off his own lineage.[74] From this perspective the attack of Cicero on Petrarch, if accepted as a displaced scenario for Petrarch's complex ambivalence about fatherhood, filiation, and literary imitation, was not merely a ritual circumcision of the leg as penis substitute, performed upon initiation, but the herald of a more thorough and permanent self-truncation. Such a conclusion goes beyond the evidence, to be sure. Still, the specter of a lost lineage, figurative as well as literal, intellectual as well as genealogical, humanistic as well as human, haunts Petrarch's last recorded words about his son in his letter to Boccaccio (*Sen.* 1.5) dissuading him from abandoning literature and getting rid of all his books. Turning to the destiny reserved for his own books, Petrarch remarks that his plans for them had changed "after the passing of him who I had hoped [*speraveram*] would take up my studies." Foresti underscores the pathos of the past perfect, the recall of hopes once held and subsequently lost.[75] In the end, as we know, despite Petrarch's plan for a public library in Venice, no single library or patron received Petrarch's legacy of books, and the collection was dispersed, to await the reconstitution of our knowledge of its contents by scholars from Pierre de Nolhac and B. L. Ullman to Giuseppe Billanovich and his students.[76] Petrarch's great discovery, the Verona codex, was lost, as was the copy Petrarch made from it.[77] In Blanc's argument, the disasters with the two Giovannis were the price of the humanist project as Petrarch fashioned it, a narcissistic

investment in literature and personal glory at the expense of family, social, and political responsibilities.[78] Nevertheless, the curious episode of Cicero's aggressive codex, understood as both initiation and chastisement, suggests Petrarch was in some sense aware of the stakes involved in his obsessions, even if, once again characteristically, both the immediate agent and immediate recipient of the symbolic action of Cicero's book was Petrarch himself.

Part 2 / Scientific and Philosophical Physiologies

Holy Autopsies

Saintly Bodies and Medical Expertise, 1300–1600

Katharine Park

Like the myth that before Columbus's first voyage to the Caribbean, Europeans thought the earth was flat, the myth that the medieval Christian church prohibited human dissection is remarkably persistent. Both myths were the product of nineteenth-century historiography and perform similar cultural work by postulating a sharp break between medieval and "modern" ways of understanding the natural world. In both, the Renaissance of the fifteenth and sixteenth centuries is identified as the seedbed of modernity, conceived in terms of what Jacob Burckhardt called a new, secular "thirst for knowledge," which privileged "the discovery of the world and of man."[1] In the case of the myth regarding human dissection, the church embodies "medieval" religious resistance to the aspirations of "modern" secular science, personified in the physical sciences by Galileo Galilei, champion of Copernicanism, and in medicine by Andreas Vesalius, professor of anatomy at the University of Padua and author of the early dissection-based anatomical textbook *De corporis humani fabrica* (1543). The most assiduous propagator of these ideas was Andrew Dickson White, whose massive and influential book, *A History of the Warfare of Science with Theology in Christendom* (1896), includes a heroic and completely fictional account of Vesalius "battling" Christian obscurantism.[2]

As has long been known to historians of anatomy, this attractive narrative has little basis in historical fact. As White himself was aware, human dissection—together with its sister practice, autopsy—was a medieval innovation that drew on a very short-lived Hellenistic precedent.[3] Although Pope Boniface VIII issued a bull in 1299 that banned the boiling of human corpses in order to transport them long distances for burial, there is little evidence of ecclesiastical resistance to autopsy and dissection in late medieval Italy; indeed, embalming by evisceration, the precursor practice to dissection in both Hellenistic Egypt and late thirteenth-century Italy, was most commonly used to preserve the bodies of popes and of local holy men and women so that their corpses might lie in state and serve as a focus of public devotion.[4]

The most striking evidence against the existence of an ecclesiastical prohibition on opening human bodies in late medieval and Renaissance Italy, however, comes from what I call "holy autopsy": the practice of inspecting the internal organs of a holy person shortly after death for corporeal signs of sanctity that might be invoked as evidence in hagiographical texts and, eventually, in the formal inquests necessary for papal canonization. The first known autopsy of this sort dates from 1308, when Chiara of Montefalco, an Umbrian abbess of Franciscan inspiration and a well-known mystical visionary, was opened by the nuns of her own monastery. As we know from the women's testimony at Chiara's canonization procedure ten years later, they found that her heart contained a small crucifix and miniature instruments of the Passion, while her gallbladder yielded three stones, which they read as referring to the Holy Trinity. Despite the nuns' testimony, together with that of the many beneficiaries of her miracles, the inquest ended inconclusively in 1319, and no papal ratification of Chiara's sainthood was issued before she was canonized much later, in 1881.[5] Perhaps as a result of the failure of Chiara's case, this practice was used only intermittently and infrequently during the next two hundred years, and apparently only on the bodies of holy women; I have found four cases of this sort: two in the early fourteenth century (Chiara and Margherita of Città di Castello, who died in 1320) and two in the early sixteenth century (Colomba of Rieti, who died in Perugia in 1501, and Elena Duglioli, who died in Bologna in 1520). Beginning in the middle of the sixteenth century, however, the practice gained increasing currency, as Nancy Siraisi and Jean-Michel Sallmann have shown.[6] At the same time, it was extended to the bodies of holy men as well as holy women; the most famous such autopsies in the first century of the Counter-Reformation were in fact those of Ignatius of Loyola, who was inspected by the

famed anatomist Realdo Colombo in 1556; Carlo Borromeo, who died in 1584; and Filippo Neri, who died in 1595.

This chapter focuses on the earlier history of holy autopsy, when it was confined to the bodies of holy women, and compares the two early fourteenth-century cases (Chiara and Margherita) with the two from the early sixteenth century (Colomba and Elena). I argue that the two pairs were very different from one another in both the circumstances under which their bodies were opened and the findings of those who examined them. Those findings in turn raise broader questions about evidence and proof, on the one hand, and contemporary understandings of the nature and properties of holy bodies, on the other. The first two cases showcased the bodies of holy women as matrices that produced supernatural objects—a crucifix, stones with impressed images—that resembled the products of human artifice, raising the specter of fraud. The next two, in contrast, concerned bodies whose signs of holiness were more subtle and ambiguous: organs that did not look the way they ought to, especially after their owners had been dead several days or months. Such cases required the medical and philosophical experts who pondered them to distinguish less between miracle and artifice than between supernatural and natural processes—they were compelled to make elaborate and uncertain judgments that relied both on experience with autopsy and dissection and on subtle understandings of physiology and the interpretation of natural signs.

These two moments in the early history of holy autopsy correspond to important moments in the broader history of human autopsy and dissection. The examinations of Chiara and Margherita in the early fourteenth century belongs to the earliest phase of human dissection as a continuously utilized and institutionally grounded medical technique; practiced briefly in Hellenistic Alexandria and sporadically in the Byzantine and Islamic worlds, it made its first Western appearance in the last decades of the thirteenth century, in northern and central Italy, where it was quickly accepted and institutionalized as a technique for understanding the nature and structure of human bodies. By 1300, it was being used in a variety of contexts, including not only public health and criminal justice but also medical research and teaching.[7] The autopsies of Chiara and Margherita coincided with the career of Mondino de' Liuzzi at the University of Bologna, who is famous for composing the first textbook of anatomy based on human dissection around 1316.[8]

Although there were medical resonances to the openings of Chiara and Margherita—Margherita was eviscerated by surgeons, and Chiara's gallbladder was examined by the monastery's physician—their autopsies should not be seen as the

extension of a medical technique into the sphere of Christian religious practice. The logic was, if anything, the other way around: in all the cases I discuss, the autopsies followed the opening of the bodies for the purposes of embalming. Only after their entrails had been removed for this purpose and their embalmed corpses had generated an outpouring of local devotion were the viscera separated and examined. Indeed, the testimony concerning both Chiara and Margherita presents the opening and examination of their internal organs, and the discovery of the holy objects inside them, largely as an afterthought. The nuns in Chiara's monastery had buried her entrails several days before they thought of examining them to see if, as she had often claimed, she in fact had Jesus in her heart.[9] Similarly, the Dominican friars who had custody of the body of Margherita (a Dominican tertiary) had stored her viscera in an earthen jar. Only after her embalmed body had worked two miracles did they decide to transfer them to a golden reliquary, at which point, apparently by accident, they found that her heart contained three small stones impressed with images of the holy family: the Virgin Mary, the infant Jesus in a cradle surrounded by cattle, and Joseph and the Holy Spirit, in the form of a dove.[10]

The autopsies of Colomba and Elena, in the early sixteenth century, also piggy-backed on their embalming, but the medical context had by this time dramatically changed. The opening of their bodies was contemporary with a remarkable expansion of the practice of human autopsy and dissection in Italy. This expansion was particularly marked in the case of academic medicine. Dissection had previously functioned primarily as a teaching technique—and a relatively infrequent one at that, given the difficulty of procuring corpses for public dismemberment. In the last couple of decades of the fifteenth century, however, it began to be used in the service of anatomical inquiry. Inspired in part by the example of Galen, whose lost treatise on anatomy had been recently rediscovered, professors of medicine began to perform increasingly frequent dissections in hopes of improving their understanding of the structure and operations of the human body, and several gained extensive experience in this realm.[11] Thus whereas Bartolomeo of Montagnana boasted of having opened at least fourteen bodies in the first half of the fifteenth century, by the 1520s, Jacopo Berengario of Carpi, lecturer on anatomy at the University of Bologna, claimed to have anatomized several hundred.[12]

During this same period, autopsy began to appear in the context of private medical practice, where it was increasingly performed at the request of families and their physicians to determine cause of death.[13] In Florence, for example, the physician Antonio di Ser Paolo Benivieni (d. 1507) produced an extensive set of

manuscript notes documenting more than two hundred noteworthy cases that he had encountered or heard of in the course of more than three decades of medical practice; of these, sixteen involved autopsies.[14] By the early sixteenth century, particularly in centers of medical study and practice such as Bologna, Padua, and Florence, autopsy and dissection were practices familiar to elite patients and their doctors. Such cities had a number of barbers or surgeons with experience in opening dead bodies and physicians with experience in inspecting them and drawing conclusions from the appearance of their internal organs.

These developments frame the differences between the autopsies of Chiara and Margherita, on the one hand, and Colomba and Elena, on the other. The most obvious of these differences had to do with the much greater role played by doctors in the sixteenth-century cases. When Chiara was opened by five of her nuns in 1308, there were no doctors present at all. The only medical men referred to in the women's testimony were the apothecary who supplied the embalming supplies— described as "balsam, myrrh, and other preservatives"—and the monastery's physician, Simone of Spello, who refused to have any part in opening Chiara's organs, because "he did not feel himself worthy."[15] The role played by doctors in the autopsy came weeks after the fact and was mentioned only incidentally in Chiara's vita. "After lengthy examination of [the objects found in her organs]," according to her hagiographer, Béranger of St.-Affrique, "physicians and experts in the study of nature [*medicorum et naturalium*] issued the opinion that they could not have been naturally formed, but only by divine power."[16]

Given the artificial appearance of the objects found in Chiara's heart, however, it is clear that contemporaries were primarily concerned about the possibility of human fraud. The only hostile witness to testify in her canonization procedure, a Franciscan friar named Tommaso di Bono of Foligno, expressed grave doubts on this score, saying he had heard troubling reports from various Franciscans, including Giovanni Polcino of Mevania, a chaplain in Chiara's monastery. "From these," he declared, "I have the violent suspicion that, as it is said, the signs in her heart were made artificially by a nun from Foligno, . . . who created them skillfully with her hands."[17]

In Margherita's case in 1320, medical men played a more prominent role. According to the author of her first vita, city officials commissioned two surgeons to eviscerate and embalm her body, and three doctors were present, together with many clerics and town notables, when the three figured stones fell out of her heart.[18] Even here, however, the doctors did not participate actively in the process; the cutting was done by a Dominican friar. The doctors were simply witnesses to

the event, among many others, and no mention is made of their opinions about what they had seen.[19]

The sixteenth-century cases of Colomba of Rieti and, especially, Elena Duglioli of Bologna are quite different. A Dominican tertiary and a visionary, founder and leader of a paramonastic community, Colomba was opened for embalming by a medical man, described by Sebastiano Bontempi, her erstwhile confessor and author of her vita, as a "most experienced physician [*peritissimo physico*]."[20] (Bontempi was personally present at the event.) And whereas in the cases of Chiara and Margherita the examination of their entrails was separate from, and incidental to, their evisceration, in the case of Columba, it is clear that the physician who opened her body had been asked to perform a simultaneous autopsy. He found, first, that her stomach and intestines were almost empty, which confirmed reports that she lived exclusively from the Eucharist, and, second, that her heart was bathed in uncongealed blood. In Bontempi's words, this was "liquid, full of life, bright and pure, as if it had flowed from the throat of a living dove," while the heart itself was "like a wax pouch, solid, dry, and empty inside."[21] Throughout his description of Colomba's autopsy, Bontempi refers to the professional expertise of the anonymous physician who performed the whole procedure, calling him "egregius Magister physicus" ("eminent master physician") and even "peritissimus Magister anatomista" ("most experienced master anatomist"). This man is not only established as an expert in the structure of the human body by Bontempi's honorifics, but he is also described as guiding the reactions of inexpert witnesses as they struggled to come to terms with the sight and smell of Colomba's entrails. When one of the priests present reacted with horror to the stench of the scant feces in her intestines, the physician reassured him, saying, "Father, it is her natural smell."[22]

The role of medical expertise is even more extensive and explicit in the anonymous vita of Elena Duglioli, a pious laywoman from Bologna, who, like Colomba, was celebrated for her prophecies and ecstatic visions. Initially renowned for her chastity—like St. Cecilia, she had reportedly remained a virgin while sharing her husband's bed for many years—she later developed even more extraordinary spiritual gifts on the model of the Virgin Mary; although she had never been pregnant, she began to lactate (and to menstruate) in later life and would nourish her followers with her milk, allowing them to suckle from her breasts.[23] On her death in 1520, her body was eviscerated for embalming by two surgeons, Battista and Damiano—the latter the nephew and eventual heir of the eminent anatomist and surgeon Jacopo Berengario da Carpi—in the presence a physician, Girolamo of Firenzuola, who also happened to be one of Elena's followers. Citing the prec-

edent of Chiara of Montefalco, her confessor, Pietro Ritta, ordered an autopsy. This immediately yielded extraordinary results: in the place of Elena's heart was a pale, flat, and flaccid mass, which the author of her vita described as being "like a piece of soft liver." Indeed, he noted, invoking the expertise of the several medical men present, it was "so unlike a heart that someone familiar with that human organ [*pratico di tal humana parte*] would never have recognized it as a heart. And the doctors in attendance said that it was a very strange thing and that they had never heard of anything like it."[24] Ritta presented this finding as confirming Elena's claims that Jesus had taken her heart to be with him in heaven, thereby ending the intense pain she had experienced in that organ, which had left her bedridden for fifteen years.[25]

At this point, however, the general train of events departed from the model established by the cases of Chiara, Margherita, and Colomba, for, once buried, Elena's body was not allowed to rest in peace. There was considerable local resistance to her cult from both Dominicans, who were allied with Elena's political enemies, the Baglioni, and from monks promoting the cult of Caterina Vigri, who saw Elena as an undesirable rival.[26] In the interests of convincing such skeptics and of confirming her prophecy that the milk in her breasts would last to the end of the world, her corpse was twice exhumed for further examination over the course of the three months following her death.[27] Unlike the first autopsy, the second and third ones focused on Elena's breasts, source of her virginal milk. The first, undertaken in early November, was conducted by three medical men: a surgeon, Angelo of Parma, who was directed to open her left breast, and two physicians, Girolamo of Firenzuola, who was present at the initial autopsy, and Ludovico Leone, professor of medicine at the University of Bologna. These men offered even more detailed opinions than had been supplied at the first autopsy regarding the state of corruption of the body and the contents of her breast.

On these matters, as the author of her vita noted, "there was discord and difference of opinion among the doctors."[28] One, Girolamo (already identified as a follower of Elena's), judged her breasts to be supernaturally incorrupt, in contrast to the rest of her body; he noted that their state of preservation was "marvelous and worthy of amazement," for he had never seen the like in a body dead more than ten or fifteen days. The other two doctors strongly disagreed. They were unconvinced that the incorruption of her breasts was due to supernatural causes, arguing that their relatively good, though far from perfect, condition resulted "naturally from the complexion and disposition of that part [of the body]"; in addition to being full of nerves and arteries, which carried animal and vital spirits, the vehicle of

the bodily heat that prevented corporeal corruption, Elena's breasts had been preserved by their proximity to the myrrh, aloes, and alum with which her abdominal cavity had been filled.[29] Furthermore, they denied that the apparent whiteness of the flesh of the breast could come from milk, since, as they put it, "the causes of this had ceased, being the menses and natural heat"; as evidence, they noted that the white substance underneath the skin of the breasts was solid rather than liquid.[30]

At this point, the priors of S. Giovanni in Monte, who were promoting Elena's cult, consulted with additional experts at the universities of Padua and Bologna, to whom they communicated the findings of this second autopsy. These experts included two eminent natural philosophers, Pietro Pomponazzi and Lodovico Boccadiferro, both teaching at Bologna, and two professors of medicine, Niccolò of Genoa (also known as Niccolò de' Passeri), from the university of Padua, and the anatomist Jacopo Berengario of Carpi. All concurred that Elena's breasts were uncorrupted, although both Boccadiferro and Berengario judged that the white substance they contained, while certainly milk, was not supernatural in origin, but rather the product of a natural process of coagulation as a result of the body's original heat.[31]

After this ambiguous outcome, Elena's supporters exhumed her body yet again, in late December, in hopes of generating a more convincing consensus. The forty witnesses included six doctors: the three who had been present at the second autopsy, together with Berengario, the physician Virgilio of Modena, and an unnamed colleague. As before, the focus was on Elena's state of preservation and the contents of her breasts. (This time the surgeon was ordered to cut open her right breast.) As before, opinions differed concerning the results; the doctors, who according to the author, "are always hostile to miracles and have recourse to the works of nature," claimed that the incorruption of the breast was due to "natural causes, which they did not know."[32] Elena's supporters, on the other hand, continued to maintain the supernatural state of her remains. In the end, it was decided to send a piece of her breast to Rome, "so that the Roman doctors might pronounce judgment on the oracle of the conserved milk."[33]

In Elena's case, in other words, we see the culmination of a process whereby men with medical training and experience were increasingly acknowledged as experts regarding the nature and limits of natural phenomena and natural causation and hence regarding the dividing line between natural and supernatural effects. This issue did not even arise in the case of Margherita of Città di Castello, and although it did in that of Chiara of Montefalco, even in her case, very little was made of the doctors' expertise, at least as concerned the objects found in her body; most of the

medical men who testified in her canonization inquest addressed the issue of her miraculous cures.[34] The "master anatomist" who autopsied Colomba of Rieti was more specific regarding what he expected and did not expect to see inside a dead body: he registered with surprise the emptiness of her digestive organs and the waxy texture of her heart, surrounded by liquid blood, but Bontempi, Colomba's principal supporter, devoted only a paragraph to these events. When Elena was opened, however, the doctors were called in repeatedly, in ever increasing numbers, to mull over a variety of problems that required not only familiarity with the appearance of the interior of the human body but also a great deal of physiological and natural philosophical knowledge.[35] Given that decomposition was a gradual process, how much change was necessary before a body was declared to be corrupt? What natural and artificial conditions could slow or halt this process? Heavy vascularization? The presence of preservatives? If so, to what degree could such things preserve a body? How was milk produced inside the breast, and why did it flow outside the breast but not inside it? What was the role of the body's natural heat in this process? The questions multiplied with each successive autopsy, generating increasing amounts of documentation—including six full folios in Elena's anonymous vita—and calling forth increasing displays of technical expertise.

There is no doubt that the prominence and complexity of these sorts of questions in Elena's case reflected the special circumstances in Bologna: the presence of numerous natural philosophers and medical men at the university, Elena's unusual claims of virginal lactation, and a high degree of skepticism regarding her holiness on the part of influential political and ecclesiastical parties. But the novel elements in her autopsy relative to the early fourteenth-century cases of Chiara and Margherita were not idiosyncratic; they established patterns that would characterize Counter-Reformation autopsies as well. One of these was the importance of extensive medical testimony; the attaching of significance to such testimony persisted and even intensified in the later sixteenth century, when the physicians who conducted autopsies began not only to communicate their opinions to the relevant ecclesiastical authorities but also to issue them in print to a broader public. Whereas Realdo Colombo only touched on Ignatius of Loyola's bladder stones in his *De re anatomica* (1559), published three years after the Jesuit leader's death, Carcano Leone, professor of anatomy at the University of Pavia, published a treatise describing the results of his autopsy of Carlo Borromeo in 1584, as did the Milanese physician Angelo Vittori concerning the autopsy of Filippo Neri in 1595.[36]

At the same time, the nature of the findings in holy autopsies had changed. Whereas the bodies of Chiara of Montefalco and Margherita of Città di Castello

produced *objects*—a crucifix, the instruments of the Passion, marvelous figured stones—the bodies of the sixteenth-century holy men, like those of Colomba and Elena, produced *evidence.* This evidence might take the form of purely natural signs, as in the case of Colomba's emaciation and empty stomach, which bespoke her intense asceticism. (The same was true of Carlo Borromeo.) Or it might potentially be the result of supernatural processes, as in the case of Elena's uncorrupted and milk-filled breasts, the bright, liquid blood in Colomba's chest, and the peculiar appearance of both women's hearts. (A later example was the enlarged heart and pulmonary artery of Filippo Neri, which the doctors present at the autopsy attributed to the extraordinary activity of his heart in ecstatic contemplation and the unusual quantity of vital spirits this required.)[37] While the first type of finding—objects that resembled devotional artifacts—was relatively easy to evaluate, the latter raised complicated problems concerning the limits of natural causation and could, as happened with Elena, inspire widely differing judgments on the part of the medical authorities involved. This shift from bodies producing thaumaturgic objects to bodies producing anatomical evidence reflected the coexistence of the new interest in anatomy and the traditional belief in God's ability to intervene directly in the physical world.

This shift makes sense in the context of the history of contemporary medicine, given the increasing currency of autopsies in private practice, the growing prestige of anatomy, and the intense interest of sixteenth-century physicians in medical semiology, as described by Ian Maclean.[38] But none of this explains the most puzzling change, the change in the gender of the subjects of holy autopsy from women (in the period before the Counter-Reformation) to both women and men. In his study of saints and their cults in eighteenth-century Naples, Jean-Michel Sallmann describes distinct differences between the autopsies of holy men and those of holy women. He notes that the autopsies of the men were often unsystematic—a cursory extension of the evisceration of the corpse for public display—and the results typically confined to signs inscribed naturally on the body by pious practices, such as fasting, flagellation, and the wearing of hair shirts. On occasion they also revealed previously undiagnosed illnesses, like gall- or bladder stones, which testified to their subjects' tolerance for suffering. While lying in state, the bodies of holy men were the object of more intense displays of popular devotion than those of holy women, and they were more likely to be dismembered and their relics scattered.

The autopsies of women's bodies, on the other hand, were more systematic, focusing on their hearts as a seat of mystical phenomena; these might show signs of heat or burning or even produce objects, on the model of Chiara of Montefalco

and Margherita of Città di Castello. But their corpses generated less enthusiasm on the part of their supporters and were thus more likely to remain intact. Sallmann explains this difference by hypothesizing that

> the perception of sanctity operated as a function of the mental schemes that define the sexual division of labor in representations of daily life. The male saint remains a man; his body becomes prey to centrifugal forces that destine him to dispersion, to appropriation, and thus, to a certain extent, to the pursuit of a public life that expresses itself in the wonder-working power of his relics. The female saint remains a woman, vowed to interior life, which is manifested in the highly ritualized practice of autopsy and the opening of the heart—burning with passionate love for her husband and performing only rare miracles through simple contamination by the male model.[39]

Sallmann is certainly correct in looking to contemporary intuitions about gender and about the differing lives appropriate to men and women, as well as to the relative lack of avenues for the public expression of female piety, but the pattern he notes holds only approximately for the earlier cases I have described. While it is true that Ignatius of Loyola's and Carlo Borromeo's autopsies revealed only natural signs of unusual piety and virtue, Filippo Neri's heart—enlarged enough to break two ribs—conformed more to Sallmann's feminine mold, as Siraisi has noted. Similarly, although the autopsies of all of my holy women, from Chiara to Elena, focused on phenomena related to their hearts, Colomba's emaciation and the thaumaturgic power of Chiara's relics also partake of Sallmann's male model. Thus the differences seem to have more to do with varieties of piety than with gender itself; unusual structures or internal signs inside the holy person's body, whether female or male, were correlated with the interior experiences of mystical contemplation. As Nancy Caciola has recently shown, in the case of visionaries and others possessed by powerful spiritual forces during the later Middle Ages, God was thought to take up residence in the heart, while demons, on the other hand, were believed to reside in the bowels; this set of ideas generated a profusion of heart-related images, metaphors, and experiences in late medieval religious texts.[40] This form of spirituality was associated particularly strongly with women, who had fewer other outlets for their spiritual energies than men, a fact that helps to account for the initial focus of holy autopsies on women's bodies and on the heart.

Perhaps the most striking theme in the autopsies of holy women, however, is not the emphasis on their hearts per se but the constancy of the characteristics attributed to their hearts, which were always described, in one way or another, as

soft and yielding, apt to take impressions from God. (Contrast such accounts with the description of the heart of Filippo Neri as enlarged and solid enough to break two ribs.) In the cases of Colomba and Elena, their impressionability was described literally: Elena's heart had been replaced by something that resembled soft liver, while Colomba's was surrounded by fluid blood and had the consistency of wax. The author of her vita drew special attention to these facts, relating them to Ps. 22: "I do not know any other cause of this mystery, except that she could truly have said, 'My heart has been made like melting wax in the middle of my belly.'"[41]

Although the less anatomically informed descriptions of the autopsies of Chiara and Margherita did not deal with the appearance and texture of their hearts, the nature of the things they produced nonetheless suggested that they had been literally marked with the objects of their devotion and contemplation. Margherita's stones were, for example, described as "having various images impressed on them" ("diversas ymagines impressas habentes").[42] This trope of impressionability—of soft wax taking the seal—appeared frequently in texts describing the mystical experience of women. It evoked, on the one hand, ideas concerning female physiology as cool, moist, soft, and porous and, on the other, one of the most fundamental themes of feminine virtue, the bending of one's will to a superior masculine force.[43] Just as the good wife submitted to her husband, and the menses submitted to the impression of the male seed in generation, so the heart of the holy woman took the images imparted to her by God and imprinted them on her very flesh.

The powerful association of women with the body (and the concomitant association of men with mind and soul) together with related tropes of female impressionability and the heart as the habitation of God seem to have provided the initial impetus to holy autopsy. These ideas pressed contemporaries, men and women alike, to explore the hearts of holy women and structured what they saw and how they interpreted it. Initially this practice was confined to female bodies. In time, however, as these autopsies were integrated into an increasingly medical framework, yielding evidence concerning not only the supernatural phenomenon of divine possession but also the natural effects of extreme asceticism, they began to be performed on holy men as well. This seems to have created some pressure to rewrite the history of the practice, to provide a male precedent for the general practice of holy autopsy and for the specific discovery in the heart of signs of divine habitation. Explaining his decision to open Filippo Neri's heart in 1597, the physician Antonio Porto said that he was remembering not only the example of Chiara of Montefalco but also that of Bernardino of Siena (d. 1444), in whose heart "was found the good Jesus, because [Bernardino] never spoke of anything else."[44]

Although Bernardino was certainly embalmed, there is no evidence, either in the acts of his canonization process (1445–48) or in his vitae, that his viscera were ever inspected.[45] Thus Porto's offhand remark suggests the degree to which, by the end of the sixteenth century, holy autopsy had become detached from the female body and accepted as common practice—appropriate for the bodies of both holy women and holy men.

At the same time, it would be a mistake to see the increasing currency of holy autopsy as an index that the church had abandoned a "medieval" resistance to the opening of the human body. As I have argued, there is no sign of any such resistance, let alone any kind of blanket prohibition, in the earlier period. Rather, the development of embalming by evisceration, which was fostered by the cult of relics, seems to have encouraged and helped to disseminate the related practices of autopsy and dissection. Over the course of the three centuries between 1300 and 1600, the increasing reliance on autopsy within the church paralleled the increasing currency of autopsy in private medical practice, but the conviction that divine possession left its signs on both the inside and the outside of the human body did not change.

Habeas Corpus

Demonic Bodies in Ficino, Psellus, and *Malleus maleficarum*

Walter Stephens

More than embodiedness, corporeality is the agency of embodiedness. If we define corporeality according to a human norm, as the essays in this volume do, we imply the consciousness of having a body, and thereby a degree of performativity. In this sense, corporeality during the Renaissance—and indeed for much of European history—cannot be limited to humans, but must also include angels and demons. Like significant percentages of modern Americans, early modern Italians, both educated and not, assumed that contact and interaction took place between humans and intelligent beings of a superior species.[1] But clerics, lawyers, physicians, and other highly educated men differed from the uneducated masses—as well as from educated men of previous centuries—by assuming that if humans could encounter angels, demons, or other "spiritual" creatures, such beings must necessarily be embodied and that such embodiment was potentially problematic. In their ordinary state, angels, demons, and ghosts were "separate spirits," divested of bodies, and thus could not be perceived by human senses.[2] So how might the necessary embodiment take place?

Embodiment

From late antiquity through early modernity, the antinomy spiritual / corporeal does not appear important among the uneducated, so far as evidence recorded by literate magistrates, confessors, and inquisitors indicates. Not only angels and demons, but such nontheological or folkloric creatures as ghosts, elves, and fairies might appear and disappear suddenly, but otherwise behaved as if embodied.[3] Illiterate people seem not to have normally asked themselves whether encounters with such beings took place by means of corporeal interaction or in some other manner. Even their dreams appear to have presupposed interactions considered physically real, as dreams do in Homer and other ancient sources.[4]

Contemporary Americans also imagine encountering spirits with unreflective ease, yet such beings' embodiedness is a potential oxymoron in everyday semantics. The *Random House Dictionary of the English Language*, a major authority for North American usage, gives "incorporeal" as the primary meaning of "spiritual." An opposition governs its definitions of "spirit":

> **1.** the principle of conscious life . . . in humans, animating the body or mediating between body and soul. **2.** the incorporeal part of humans: *present in spirit though absent in body.* **3.** the soul regarded as separating from the body at death. **4.** conscious, incorporeal being, as opposed to matter: *the world of spirit.* **5.** a supernatural, incorporeal being . . . *evil spirits.* **6.** a fairy, sprite, or elf. **7.** an angel or demon.[5]

If "corporeal" and "incorporeal," "spiritual" and "material" are now antonymic, it is owing to early modern literate men, those magistrates, confessors, and inquisitors just mentioned.

Theologians first expressed keen and constant interest in whether and how "spiritual" beings could be or become embodied and in why they would. Literate early moderns generally acknowledged the problem: in *De occulta philosophia* (1510–33) Heinrich Cornelius Agrippa noted that "The more recent theologians have a strong disagreement with philosophers over the bodies of demons." As Agrippa observed, modern theologians even disagreed with church fathers, including St. Augustine and St. Basil.[6] The problem of corporeality arose in the twelfth century among early Scholastic commentators on the Bible.[7] In *Four Books of Sentences*, written about 1150, Peter Lombard posed the problem of "whether angels have bodies, as has seemed to some writers." The question was important, for a number of passages in the Bible treated angels as having a physical presence as well

as being "present to the mind" of a human interlocutor: angels not only appeared to Abraham, Lot, Peter, Paul, and others but wrestled with Jacob and even shared meals with Abraham and Tobias.[8] Moreover, any activity that an angel performed a devil could also carry out. Ancient, medieval, and early modern usage assumed no ontological difference between angels and devils, only a moral one: devils were fallen angels. Thus, just as an angel transported Habakkuk from Judea to Babylon to deliver a meal to Daniel, likewise Satan carried Jesus bodily atop the Temple and a high mountain.[9]

Peter Lombard puzzled over angelic and demonic corporeality because he had noticed St. Augustine assuming that God created bodies for the angels: all angelic bodies had been "subtle and spiritual" before Satan's fall, but "since then, the evil angels' bodies have become grosser so as to enable them to suffer."[10] Augustine was reacting to neo-Platonic definitions of spiritual beings related by the Roman writer Apuleius of Madaura. Apuleius defined all gods, humans, and *daemones* as "animal," or ensouled, beings. Thus "daemons are of an animal nature, passive [susceptible to suffering and emotion] in soul, rational in mind, aerial in body, eternal in time." Therefore, Augustine paraphrased,

> if the daemons are animals as to genus, this is common to them . . . with men, . . . with the gods, and with beasts; if they are rational as to their mind, this is common to them with the gods and with men; if they are eternal in time, this is common to them with the gods only; if they are passive as to their soul, this is common to them with men only; if they are aerial in body, in this they are alone.[11]

Augustine's discussion (*City of God*, bk. 8, chap. 14 through bk. 9, chap. 13) systematically paraphrased the neo-Platonic doctrine of being, which presumed that daemons (Latin *daemones*, Greek *daimonia*; I refer to "daemons" except when citing Christian, post-Augustinian usage, since Latin *daemon* can refer either to "devils" or to pagan, especially Platonic and neo-Platonic, *daimonia*) could be morally good, exploiting their commonality with both gods and men in order to serve as messengers (*angeli*, from Greek *aggeloi*) between them. Augustine wrote the *City of God* to expose the gods of polytheism as "malicious devils," "astute and wicked spirits" who had counterfeited divinity and seduced pagans into sin.[12] Polytheists wrongly distinguished between gods and daemons, for all were devils: the more successful had used "wonderful and lying signs . . . deeds or . . . predictions" to pose as gods and enslave their worshippers' minds, while others "have not been

able to persuade [humans] that they are gods, and so have feigned themselves to be messengers [*internuntios*] between the gods and men."[13] After Augustine, Latin Christian usage gave *daemon* and *daemonium* purely negative connotations: fallen angel, evil spirit, devil.[14]

Augustine's demons were anything but disembodied.[15] Rather than oppose Apuleius's opinion that daemons had a body composed of air, he declared that Christians should not "suppose that demons are better than men, because they have better bodies." Indeed, "divine providence gave to them bodies of a better quality than ours . . . that we should learn to despise the bodily excellence of the demons compared with goodness of life," confident "that we too shall have immortality of body." In fact, "those aerial animals . . . are only rational that they may be capable of misery, passive that they may be actually miserable, and eternal that it may be impossible for them to end their misery!"[16] Still, Augustine had no doctrinaire interest in the corporeality of demons. Later in the *City of God*, he argued that even if demons have no bodies, they will be punished in hellfire and concluded that "if anyone maintains that the devils have no bodies, this is not a matter either to be laboriously investigated, or to be debated with keenness."[17] As he showed in related questions about Old Testament giants, Augustine's relative indifference to suprahuman corporeality derived from a preference for moral teaching over the technical niceties of natural philosophy.[18]

Gareth Roberts recently observed that other early Christian writers, such as Irenaeus, Eusebius, and Tertullian, "allowed angels bodies, not bodies of flesh, but subtle bodies appropriate to their spiritual substances (*corpora subtilia*) which are not material in any way we might normally understand materiality."[19] The topic of angelic corporeality did not become truly controversial until after 1250. Thomas Aquinas and Bonaventure of Bagnoregio, the twin pillars of Scholasticism—and exact contemporaries, both dying in 1274—differed over the application of Aristotelian metaphysics to the Christian categories of being. Hylomorphism, the doctrine that being requires both form and matter, sharply divided their conceptions about angels. As David Keck remarks, paraphrasing Étienne Gilson,

> While [Bonaventure] approaches the idea of "matter" from the perspective of the metaphysician, Aquinas defines "matter" as a physicist. For Aquinas, matter is equivalent to corporeality; he considers matter as it is already in existence in the world. For Bonaventure, matter is a metaphysical construct that is equivalent to indeterminate potency, something capable of being rendered into existence by

being joined to a form. Thus for him matter is capable of being either spiritual (if joined to a spiritual form) or corporeal (if joined to a corporeal form), whereas for Aquinas "matter" is always corporeal.[20]

This disagreement, which inspired our cliché of angels dancing on the head of a pin to symbolize futile pedantry, was not, however, without serious consequence. Bonaventure's notion of "spiritual matter" had a long pedigree, stretching back to St. Paul's promise that a "spiritual" body would be granted humans at the resurrection.[21] For his part, Aquinas could cite Paul's reputed disciple, who said that angels were "purifi[ed] from corruption and from death, from corporeality and from the process of birth," were "immun[e] to motion, to flux, and to . . . change," and were completely "bodiless and immaterial."[22] By the late seventeenth century, Aquinas's theory had become dominant, to the point that at least one edition of the *Index of Prohibited Books* censored subject indexes indicating references to demonic bodies in Augustine's works.[23]

The difference between the two theologians' angelic physiology was negligible in practice, since, even if Bonaventure's "spiritual matter" existed, it was too ethereal to be perceived by human senses. Thus, anyone who thought hard about how angels and demons might become perceptible necessarily concluded that they would have to confect artificial or virtual bodies. The consensus emerged that demons or angels compressed air and vapors into a compact, solid mass—a kind of lifelike statue—and imparted motion to animate it, creating the convincing illusion of a living, functioning body.[24]

Thus, demonic corporeality was nothing but pure performativity. A "virtual" demonic body had to materialize and *perform* for a human "audience," whether or not Bonaventure's "spiritual matter" underlay the illusion. Angelic / demonic performativity or impersonation was so inherently theatrical that a number of writers, particularly in England during the reign of King James VI / I, denounced theater as the devil's playground.[25]

Witchcraft

The mechanics of demonic performativity interested few but the most systematic Scholastic thinkers for two centuries after Aquinas and Bonaventure. But it assumed increasing cultural importance at the turn of the fifteenth century, becoming the epistemological foundation for the concept of demonic witchcraft. Theologians began defining witches as a revolutionary species of heretic who knowingly

became accomplices of demons. Together, witches and demons were increasingly perceived as responsible for the gravest societal problems, especially infant and livestock mortality, human and animal infertility, and crop failure.

Illiterate common people had feared and hated witches since prehistoric times; ancient and early medieval law codes often prescribed punishments for witchcraft. The church had combatted witch beliefs as unchristian superstition throughout much of the Middle Ages. But around 1400, witches were redefined as demons' accomplices. Clerics, secular magistrates, and other literate men took the concept increasingly seriously, hunting down, prosecuting, and not infrequently execut- ing both men and women as witches. From the eleventh century onward, during the ceaseless doctrinal disputes that fragmented Western Christendom, any num- ber of clerics came to the conclusion that heretics were the knowing accomplices of Satan, willingly encountered him "in person," and interacted corporeally with him. Cathar heretics, for example, supposedly owed their name (*katharoi*) to their practice of worshiping the devil embodied as a cat (*cattus*).[26] Even before 1400, such human-demon interaction was often imagined as sexual in trial records and treatises, foreshadowing later accusations against witches. Descriptions became increasingly violent and exaggerated over time, impressing many modern scholars as essentially pornographic.

Thus Gareth Roberts examines "the question of the corporeality of demons" exclusively as an exercise in "the management of sexual fantasy."[27] For Roberts, "the general point is that stories about incubi and succubi" (male- and female-gendered demons who had sexual relations with unwilling victims or willing witches) "were vehicles for sexual fantasies."[28] As he states, by the twelfth century, discussions of incubi and succubi had raised the question whether such encounters were purely imaginary, hallucinations or illusions caused by the affected human's overpower- ing feelings of lust, or a side effect of bodily disease. In fact, the question of the imagination was paramount in all discussions of witchcraft and other forms of human-demon interaction, particularly after 1400.[29] Hence, Roberts opines that stories of sex with demonic partners might function as an instrument of social control, "sometimes managed with the intention of regulating varieties of sexual- ity, just as some commentators have suggested that witchcraft discourse generally was used to regulate women. . . . The fantasy is regulatory as it allows sex but not pleasure, just as food at the Sabbat was supposedly tasteless or horrible." Despite the misogyny of such fantasies, Roberts regards them as potentially subversive, of- fering women "fantasies of release and escape" and "of satisfaction and freedom." Early modern English theater often includes "humour and burlesquing of demon-

ological theory," and witches frequently "have all the things [ordinary] women . . . do not have: community, agency, freedom, and fun, or at the very least . . . similar lives on much better terms."[30]

Educated men's obsessive attention to demonic corporeality and sexual relations with incubi and succubi may well have expressed a desire to regulate sexual behavior, and their violent fantasies about demonic sexual excess might have infiltrated women's fantasy. But beyond misogyny and repressed sexuality, witch hunting and what Stuart Clark calls witch hating expressed urges and preoccupations that are either foreign to modern mentalities or expressed in a radically different "vocabulary."[31]

In the earliest documents defining the core concept of demonic witchcraft, fantasies of demonic copulation were marked by the recognition that a perceptible demonic body must be an *artifact* of "virtual reality" and sheer performativity.[32] Documents make explicit that, for theologians and other educated men, a major attraction of the artificial demonic body was its confirmation of the real, though otherwise imperceptible, existence of a demon. The investigation of demon-loving heretics was neither incidentally nor metaphorically *a hunt for evidence of the demonic body* defined by theologians.

Proof was compelling only to the extent that it could deceive the senses—not of an inquisitor or magistrate but of an illiterate layperson, preferably a woman, who could *unwittingly* experience the strength of the illusion created by the virtual demonic body. The most prized confirmation came through sexual relations: one early witchcraft theorist declared that only sex fully engages human senses; another confidently affirmed that sexual enjoyment cannot take place during sleep.[33] After half a century of theorists' imagining witches as paramours of demons, the *Malleus maleficarum* (1486/87) concluded that they were not merely criminal defendants but—paradoxically—expert witnesses. At their trials, women provided expert testimony (*experta testimonia*) to the real existence of demons by swearing to the intensity of their sensations when copulating with demons. Ignorant of the true nature of demonic corporeality, deceived by appearances but not by sensations, witches testified to the "virility" of embodied demons by describing their own ecstatic delectation. If, conversely, they described demonic sexual performance as horribly painful or nauseatingly sordid, their proof of demonic reality was equally valuable, since physical suffering demonstrated the overpowering sexual *agency* of demons. According to this forensic model, reiterated in thousands of "confessions" exacted under torture, only men and demons performed sex; women, though supposedly sexually voracious, *submitted* to sex. Probably for this reason, testimony

of women about incubi was far more common, and evidently more prized, than men's testimony about succubi.[34]

Virility and virtuality enshrine aspects of the Latin *virtus*, which is etymologically expressive of manliness (from *vir*) and power. Something *virtual* has the same effect as that which it mimics but without sharing its substance or essential nature. Thus witches' "expert testimony" that demons produced the effects of corporeality constituted important empirical proof of an otherwise undemonstrable theological theorem. Whether demons were real or imaginary had been a deeply important question for Western Christian intellectuals since Aquinas, and increasingly since around 1400. Despite confidently analyzing demonic nature in several works, Aquinas occasionally admitted that Aristotelian philosophers did not accept the reality of demons and that Aristotle himself had never mentioned them.[35] By the fifteenth century, Thomas's parenthetical concessions explicitly premised the earliest witchcraft treatises. Their authors quoted, usually verbatim, Aquinas's paraphrase of Aristotelian skepticism: "Demons do not exist, except in the imagination of the common people," who either misinterpret natural phenomena or take fright at apparitions dredged from their own overactive imaginations.[36]

A demonic body defined uniquely through performativity was the only acceptable alternative to admitting that demons were empirically unverifiable and hence potentially nonexistent. The implications of the idea that demons might be imaginary are evident from the fact that, after 1560, and down to the late 1700s, witches were repeatedly invoked, even by theologians who abhorred violent persecution, as the last best proof that the world of spirit—angels, devils, the immortal human soul, and ultimately God himself—was not imaginary. King James, Henry More, Joseph Glanvill, Cotton and Increase Mather, and John Wesley are among the better-known proponents of the contention that, as Wesley said in 1769, "the giving up of witchcraft is the giving up of the Bible" and the whole spiritual world it described. For such men, the reality of demons was nonnegotiable: *nullus Deus sine diabolo* ("no belief in God without belief in devils").[37]

Scholars of seventeenth- and eighteenth-century witchcraft discourse are familiar with the fear that widespread "Sadducism," or disbelief in spiritual reality, was a prelude to atheism. However, the fear did not arise suddenly. When the *Malleus maleficarum* declared on its first page that it would prove the existence of demons by demonstrating the reality of witchcraft, it was repeating a commonplace exordium from earlier treatises. Since at least 1460, discussions of this "new heresy" had begun by railing against Sadducees, Epicureans, and radical Aristotelians for assuming that only matter was real.[38]

Modern scholarship has neglected this prehistory for two understandable reasons. First, changes in print culture made the interdependence of witchcraft and belief in spirits vastly more noticeable after 1560, when witchcraft authors generally switched from Latin to the European vernaculars. Moreover, many of the earliest witchcraft texts are still unavailable except in incunabula or scarce sixteenth-century editions, and modern scholars have rarely published excerpts from them and have often left reprinted passages in Latin. Partial translations excerpted the more sensational and less theoretical aspects of witchcraft, lending the textual tradition a deceptive reputation of quaint perversity. Although the *Malleus maleficarum* and a few other early Latin works were given complete translations after 1900, their preoccupation with spiritual reality was obscured by linguistic imprecision, anachronism, and tendentious socially "relevant" presentations.[39] Only recently have reliable facsimiles, editions, and translations begun appearing, and much remains to be done.[40]

Secondly, from the 1960s until quite recently, social historians dominated the study of witchcraft, defining it through post-Enlightenment conceptions of politics, social class, gender, and interpersonal power relations. Such categorization distorted witchcraft discourse as "medieval," un- or antitheological, credulous, obscurantist, cynically opportunistic, or pornographic. Seen in historical perspective, it is clear that it was instead exquisitely theological in its underpinnings, philosophical in its reasoning, empirical and protoscientific in its outlook.

Ficino's Alternative

Imagining the diabolical witch was one means literate early modern Europeans discovered for managing their disquiet over the accumulating evidence that Biblical ontology and Aristotelian philosophy were incompatible. The demonic body held similar attractions for philosophers who, without condoning persecution, found demonic corporeality useful or indeed essential for thinking with. Fifteenth-century explorations of Platonic, neo-Platonic, and Hermetic philosophy motivated a discourse on demonic corporeality in a moral tenor antithetical to the cruelty of witchcraft discourse.

Marsilio Ficino was active during the same years, about 1460 to 1500, that saw the consolidation of witchcraft theory as proof that spirits were real. He translated Plato's dialogues, the pseudo-Egyptian wisdom of the *Corpus hermeticum,* and several neo-Platonic philosophers, all of which share ontological and corporeal concerns with witchcraft discourse. Ficino's own works defended two ideas—the

immortality of the human soul and the common properties that should enable humans to communicate with higher spiritual beings and receive benefits from them through magical rituals—with great tenacity. While witchcraft theorists aspired to verify the reality of the spiritual world by proxy, Ficino's works document a quest to experience it for himself.

Ficino was not immune to the temptations of proof, and just when the *Malleus* was invoking witches' "expert testimony" that demons existed *because* they could be tangibly embodied, Ficino somewhat distorted the words of Plotinus to argue something analogous: "[Plotinus] adds that once the wise men of Egypt, who were also priests, *since they were unable to persuade the people by reasoning that there were gods* [*deos*], that is, certain spirits [*spiritus*] superior to mankind, thought up this magical lure [*illicium*] through which they could allure daemons into the statues *and thereby show that divinities exist.*"[41] In its reference to attempts to animate statues by enticing spiritual beings into them, this passage reveals that Ficino's interest in theurgy was related to the question of spiritual reality that witchcraft theorists discussed.[42] Whereas they imagined spirits animating virtual bodies of compressed air, Ficino envisioned them inhabiting statues of stone or other materials, and functioning as oracles.

Despite this functional similarity, Ficino's emotional and intellectual investment in Platonism and neo-Platonism ensured his commitment to the idea that spiritual beings were by nature corporeal rather than bodiless, as Aquinas had maintained. However, Ficino could not recruit Augustine as an ally. Augustine had insisted that, being evil "demons," daemons and "gods" could only harm humans. Besides, demonic corporeality, even if real, was superfluous; humans were related to the one true God through a single incarnate Mediator, who was both fully human and fully divine. Anyway, Christ's mediation was less a matter of corporeality—an unworthy criterion—than of atonement for sin.[43]

Ficino, however, lived at a time when ancient texts, many of them scientific, were just returning to circulation in large numbers. Thanks to his own Latin translations and the new art of printing, Ficino himself made widely available Greek texts that were sometimes as disruptive as Aristotle for Christian ontology. In particular, both the *Corpus hermeticum*, printed sixteen times between 1471 and 1500, and Ficino's translations of neo-Platonic texts, printed comparably often, discussed in greater detail ideas about daemons that Augustine had condemned for fomenting idolatry and magic.[44]

Like the passage from Plotinus, some of the writings explicitly anathematized by Augustine suggested that the corporeality of spiritual creatures could be enhanced

to the point that it would become humanly perceptible. Flouting Augustine and Christian consensus, Ficino adopted some condemned techniques but insisted that the beings he wished to encounter were not devils. If his *Three Books on Life* (1489) are a reliable guide to his personal practice, Ficino frequently performed rituals intended to facilitate direct interactions with spiritual beings.[45] Since church and secular authorities had condemned necromancers' use of ritual to communicate with spirits since the thirteenth century, Ficino was not implausibly suspected of necromancy, though he was never punished.[46]

Ficino's numerous references to daemons in the third of his *Books on Life* are highly suggestive. As Carol Kaske observes, "[I]n Books 1 and 2 of *De vita*, the single mention of a demon is clearly in the orthodox [Christian] bad sense of the term. . . . In Book 3, although he knew how the Church felt about daemons, Ficino takes pains to insist that daemons are among his agents. . . . In *De vita* 3, he mentions them seventy-two times, and most of these are favorable."[47] Given the enthusiasm with which Western Christian intellectuals had been speculating about *demonic* bodies over the previous century, Ficino's daemons provide another indication that curiosity about embodied spirits and the hope of interacting with them was powerfully attractive.

Psellus

While the ideas and practices Ficino adopted from the *Corpus hermeticum* have long been familiar to scholars, the influence on Renaissance demonology of his collected translation of minor neo-Platonic treatises (1497) is less known. One text, the shortest and most modern, offers disturbing parallels to contemporary witchcraft literature. Around 1485, Ficino came across a late fourteenth-century epitome of *Timotheus; or, On the Operations of Demons*, a dialogue by Michael Psellus, a Byzantine cleric (fl. 1070). Ficino translated the condensed treatise into Latin but shortened it even further. As Enrico Maltese observes,

> His translation, somewhat defective, completed the process that had altered the structure of the original dialogue, and in addition, owing to some boldly executed cuts, had the effect (perhaps not unintended) of concentrating the text around questions concerning demonic corporeality, the anatomy and physiology of the demon, his pathology and sexuality.[48]

In contrast with the regnant Thomistic demonology of Ficino's time, the Greek Orthodox Psellus declared that demons (like the daemons of neo-Platonism) have

bodies of their own, which allow them to interact perceptibly with humans. In fact, Ficino begins translating at the point, nearly one-third of the way through the original treatise, where Psellus declares that, "By nature, demons are not without body; rather, they do have bodies, and they interact with other bodies."[49] Under Ficino's scissors, Psellus's treatise concerns the corporeality of demons more than their activities.

Maltese forcefully describes the importance of Ficino's dozen pages for late fifteenth-century culture:

> We are in the presence of something which, rather than a mere coincidence, appears to be an eloquent sign of the times. Ficino's operation falls in the same years when Heinrich [Kramer] and Jakob Sprenger were busily elaborating the text that was destined to constitute the Bible of the antisatanic Inquisition[,] . . . the *Malleus maleficarum*, the *Hammer of Witches*. . . . That is, the fundamental text of secular demonology in the 1500's and 1600's [i.e., Ficino's translation of Psellus] and the sacred text of repressive religious demonology [the *Malleus*] are born at the same time. The roots and objectives of the two works could not have been more different, but the fundamental nucleus of their argumentative structures appears identical. Both Psellus and the *Hexenhammer* mobilize, in different ways and with different arguments, to combat the facile error of the skeptics: that the devil is a fantasy, an imaginary projection, a delirium or a disturbance of consciousness. The demon exists, is alive, and acts concretely: the whole *quaestio prima* of the first part of the *Malleus* maintains it in programmatic terms, relying on a mature medieval tradition of biblical exegesis, magic, and natural philosophy, from Augustine to Isidore of Seville, to Albertus Magnus, Saint Thomas Aquinas and others; Psellus asserts the same thing, through a careful combination of Neoplatonic wisdom, orthodox doctrine, and folkloric beliefs.[50]

As Maltese observes, Ficino's translation was "the fundamental text" of a Renaissance demonology founded on philosophical principles, conducted without any intent to persecute witches. Moreover, "the knowledge of Psellus's demonology in Europe of the sixteenth and seventeenth centuries is based almost entirely on [Ficino's] translation, which nonetheless, for various reasons, furnishes a somewhat altered idea of the original."[51]

However, Maltese draws an unsustainable demarcation in Renaissance demonology, first, by maintaining that Psellus is somehow more systematic than "inquisitional" demonologists like Heinrich Kramer and, secondly, by treating Psellus as "the only" demonologist to "confront the problem in philosophical terms, without

a predetermined submission to the truths of faith."[52] In fact, this distinction is largely imaginary. "Inquisitional" demonologists were extremely systematic and usually demonstrated an extensive familiarity with philosophical traditions.[53] Indeed, numbers of "inquisitional demonologists" cited Psellus to corroborate their theories, from Lambert Daneau, Jean Bodin, and Torquato Tasso in the 1570s and 1580s to Nicolas Rémy in 1595, Martín Del Rio in 1599, Henri Boguet in 1602, Francesco Maria Guazzo in 1626 and Ludovico Maria Sinistrari in 1700.[54] Likewise, Johann Weyer, the greatest opponent of witch hunting, began his massive condemnation by citing Psellus and the other neo-Platonic authors Ficino had translated, and he quoted Psellus repeatedly.[55] These demonologists did not exaggerate Psellus's relevance to their concerns: despite living before the Inquisition and in a territory beyond its reach, Psellus invoked the devil's heretical human accomplices just as enthusiastically as the early modern authors who quoted him. Although he lacked an inquisitional apparatus for interviewing demonolatrous heretics firsthand, he attributed most of his evidence about demons to the experience of a converted heretic.[56]

Ficino's interest in Psellus presents something of a dilemma, to both him and us. Ficino's own daemonology, as revealed in his theoretical treatises and his rather vague descriptions of his practices, appears solitary, personal, gentle, and reminiscent of modern "new age" rituals. Yet the passages he selected and translated from Psellus contain doctrines and descriptions disturbingly similar to those of Kramer's *Witch Hammer*. Like Kramer, Ficino valued eyewitness testimony, as the rest of his first sentence reveals: "By nature, demons are not without body; rather, they do have bodies, and they interact with other bodies, as reverend fathers of our religion have adjudged; *and there are those who assert that demons have appeared to them by presenting their own bodies.*"[57]

Indeed, for Ficino, the daemonic body was nothing less than the *copula mundi*, the crucial link in the Great Chain of Being, the bond that guaranteed a means of communication between humanity and the divine and even provided a basis for their union. The phrase *copula mundi*, "that which unites the world," was used by Giovanni Pico to designate the knot of body and soul in man, by which he meant an idealized male, as the meeting point of spirit and matter, animal and angel, upper and lower worlds.[58] But Ficino located the "knot" that unites the universe in a mediating, daemonic body. This is revealed both in his selective translation from Psellus and in *De vita coelitus comparanda* (the third of his *Three Books on Life*), describing the practices a scholar should employ to replenish his life forces

through magic. Ficino redefines spirit as "a very tenuous body, as if now it were soul and not body, and now body and not soul" ("[Spiritus] est corpus tenuissimum, quasi non corpus et quasi iam anima, item quasi non anima et quasi iam corpus"). The introduction of the third term, *anima*, allows Ficino to restate the body / spirit problem as a hiatus between body and immaterial *soul*, redefining "spirit" as a neutral, mediating term. The "tenuous corporeality" of *spiritus* should allow corporeal and incorporeal entities—as well as levels of being within the same human person—to communicate.[59]

Spiritus

Psellus's concept of an inherent demonic corporeality enabled Ficino to draw analogies between medical and metaphysical definitions of *spiritus*, which had co-existed somewhat uneasily since at least the twelfth century.[60] For metaphysicians, *spiritus* was a synonym for "soul" or "substance," that is, a form of being, so that in 1576 Francesco de' Vieri could entitle a treatise *Intorno a' dimonij volgarmente chiamati spiriti* (*On the Demons Popularly Known as Spirits*). But physicians defined spirits medically as a component of human corporeality, making perception and other vital functions possible. Medical spirits were of several types, and they circulated somewhat in the way subsequently associated with the circulation of blood. For Ficino, medical spirits were precisely that "body not a body, as it were," that mediated between the human body and soul, resolving their contradictions and binding them together. This medical definition also allowed the corporeality of daemons to remain "natural" rather than virtual: the tenuousness of daemonic bodies permitted them to interact "seamlessly" with the human body's own medical spirits.

Ficino resolved the double bind that "inquisitional" demonology imperfectly addressed: demons could not have natural, intrinsic bodies if they were to cause spirit possession (since two bodies cannot occupy the same space), yet their objective, nonimaginary existence could only be confirmed through corporeal interaction.[61] By assimilating natural daemonic bodies to the medical spirits, Ficino created a de facto compromise, eliminating the virtual demonic body of contemporary ontology, with its lingering dichotomy between matter and spirit. The "body not a body" was now real, not artificial. Owing to their natural similarity, daemons, the human medical spirits, even the spirits of stars and the cosmos itself could interact directly, creating a vast "quasi-corporeal" web of sympathy and influence.

D. P. Walker and Carol Kaske have demonstrated the centrality of medical spirits to Ficino's peculiar variety of magic, which he defended as daemonic but not demonic.[62] As Carol Kaske asks,

> What led [Ficino] to mention daemons so often and so favorably as to call his own orthodoxy into question? It is precisely Ficino's mental habit of postulating more mediators into a hierarchy. . . . In Neoplatonism, contrary to Christian theology, [daemons] always have bodies, bodies which are similar in composition to the human medical spirit. . . . As immortal but at least emotionally passible beings they fill a rung of the scale of nature above mortal, passible man, but below immortal, impassible gods.[63]

Arthur O. Lovejoy demonstrated in *The Great Chain of Being* that Western thought since Plato has assumed that, for the world to be *perfectus* (complete) and *ornatus* (beautiful), a *kosmos* rather than a *chaos*, there must be a continuum of being, descending by degrees from the incorporeal God to the simplest, most material forms of being. In the playfully serious fiction of Giovan Battista Gelli's *La Circe* (1549), the scale of corporeal being began with the oyster, a kind of barely sentient rock and progressed to the elephant, closest to man in intellect.[64]

Gelli's dialogue, based on Circe's transformation of Odysseus's companions, would have left Ficino cold, but it supported his assumption that no mediation could exist between humanity and divinity unless bodies, as well as minds or souls, were gradated. Otherwise there would not be one chain of being but two, the corporeal and the incorporeal. Torquato Tasso best expressed this idea in his *Messaggiero* (composed 1580–87), written under the direct influence of Ficino's translation of Psellus.

> Since the soul of man is intermediate between the soul of brute beasts and the angelic intelligences, by the same token, if man were the perfect intermediary between those two natures [i.e., angel and beast] his body would have to resemble the body of animals in part and in part the celestial bodies; but since the human body is no less subject to all passions and all accidents and is no less corruptible than the bodies of brutes, it follows that there must be a body interposed between the celestial body and that of the brutes, having the proper commonality [*partecipazione*] with each: and this is the body of daemons, which is capable of suffering like those of animals and men, yet incorruptible like the celestial bodies (because daemons never die, although some have believed that they die after a very long while). . . . Thus I conclude that man is not the perfect

link [*legamento*] between the lower things and the higher, as many have believed, but that the nature of daemons is interposed between human nature and that of the gods. . . .[65]

More explicitly than Ficino, Tasso explains why the incorporeal angels of Christian theology could never function as ontological intermediaries between God and man. For the cosmos to preserve the possibility of *participation* or sharing of qualities—and hence of communication—between man and God, corporeality, as well as soul, must exist on a scale: there could be no "leap" between mortally embodied humans and immortally disembodied angels.[66] This need for numerous, imperceptibly gradated species may be the deepest reason why, to quote Michael Allen, "from Ficino's strictly philosophical viewpoint the angel has lost its necessary functions and powers," becoming essentially "absent." God has not created man "a little lower than the angels," as the Bible says, but *a lot lower*.[67] As incorporeal or only virtually corporeal beings, the angels and devils of Christianity have no means of "connecting" embodied humanity to the immaterial God.

If the daemonic corporeality of neo-Platonism filled the ontological gap that Christian angels could not, Psellus's version was particularly appealing: it posited six gradations, ranging from terrestrial to etherial demons. Accordingly, Ficino's translation omits the several pages separating Psellus's declaration of inherent demonic corporeality from his discussion of its six degrees.[68] Psellus's gradations corroborate Angus Fletcher's observation that the category of the daemonic expresses a desire for infinite gradation.[69] To the extent that both witch theorists and neo-Platonists were seeking the *copula mundi*, "a body not a body" in which the dichotomy between matter and spirit disappeared, we can say that all were looking for a truly *daemonic* body.

Ficino discussed witches only en passant, but sixteenth-century witchcraft theorists cited passages he translated from Psellus to describe heretics who foreshadowed witches or were identical with them.[70] Aside from taking on this unsavory afterlife, Ficino's Psellus translation raises other paradoxes. In his own writings, Ficino habitually refers to neo-Platonic daemons rather than Christian demons, preferring to think that contact with such creatures was not reprehensible because their character is no more predetermined than human character. Yet Psellus gave him no authorization for such a contention: although Psellus's demons are naturally embodied in the same way as neo-Platonic daemons, they are uniformly evil, in contrast to Platonic and neo-Platonic daemons.

Moreover, Psellus's demons are not particularly impressive: they have none

of the awesome power of suprahuman beings in the Christian tradition. Some of Psellus's six species are extremely stupid. Thus he must concentrate on spirit possession rather than on more dramatic feats. In the final passage that Ficino translates, demons vindicate their reality by possessing humans and attest to their corporeality by fleeing exorcists who brandish swords and knives, threatening physical "solution of continuity."[71] As physician and priest, Ficino could appreciate the ambiguity of *spiritus* that allowed a medical, material explanation of malaise to coexist with vindications of spiritual reality.

There is another irony, though. Psellus was resolutely antimedical. Prefiguring Thomas Aquinas, he argued that medical explanations of a malady could not exclude the reality and agency of a demon. Like Aquinas, Psellus posited spirit possession as the most convincing evidence against materialistic causality. "Physicians," he wrote, "try to convince us . . . that illnesses of this type are not caused by demons but rather by the torments of humidity or dryness or of the various [medical] spirits; so they try to heal them with drugs and diet rather than exorcisms or purifications. And it is no wonder," he continues, "that physicians speak this way, because they know nothing except what they perceive with their senses, and they pay attention only to bodies."[72] Unable to disprove the materialistic arguments of physicians, Psellus rebuts that they cannot disprove demonic agency. The strongest proof, for Psellus as for Aquinas, that "someone else" is present in a possessed person is when such a person makes utterances demonstrating knowledge that he or she should not possess or predicts the future.[73]

The great Western European epidemics of spirit possession began around the time Psellus was first published independently of Ficino, in the 1570s.[74] Although the most famous outbreaks are from the 1600s—Loudun, Louviers, Salem, and so on—one outbreak, at Pisa, provoked Vieri's treatise on spirits as well as another by the physician Andrea Cesalpino.[75] This may be coincidental, but I suspect that the popularity of Psellus among demonologists of this period derived both from his insistence on demonic corporeality and from his hostility to medical explanations.

Psellus offers yet another clue to the ideological utility of demonic corporeality. Christ, says Psellus, declared that devils will suffer forever in hellfire: but how can this be if they have no real body? The problem had worried theologians since Augustine, but Psellus faced it head-on. For the Bible to make sense, demons must have bodies. No incorporeal being can suffer corporeal harm. Thus, if demons will undergo infernal punishment, they must have real bodies.[76] Psellus goes on, in assertions Ficino translated, to argue that the involuntary suffering of possessed

people and heretics' voluntary abominations assure us that demons are real. Prefiguring the hypocritical moralistic posturing of witchcraft theorists half a millennium later, Psellus declares, "I have learned many things from persons who cultivated visions of demons, because, personally, I have never seen such things, and I hope it never happens that I see the hideous apparitions of demons."[77]

Ficino was not a witchcraft theorist, but like them, and like other intellectuals of the fifteenth and sixteenth centuries, he craved contact with presences intermediate between the human and the divine. His miscellany of neo-Platonic texts, and particularly the excerpt from Psellus, assured him that such contact might be possible.

The Penis Possessed

Phallic Birds, Erotic Magic, and Sins of the Body, ca. 1470–1500

Anthony Colantuono

In his Windsor anatomical notebooks, probably ca. 1500, Leonardo da Vinci drew a remarkable cross-section of two lovers in the act of coition, illustrating a traditional view of how the soul is infused into the embryo at conception (fig. 6.1). The male figure has penetrated the female, and following assumptions synthesized from Galen, Hippocrates, and Avicenna, the artist has shown not one but two canals within the penis—the lower for sperm and urine, and the upper containing a nerve originating at the base of the spine; it was believed that in the act of procreation, the animating spirit was conducted through the spine and via this nerve into the penis's upper channel, issuing forth in proximity to the semen, and thus enlivening the newly conceived embryo.[1] In this commonplace theory, the virile member played an essential yet fundamentally passive part in the procreative process, providing a neutral passage through which both semen and spiritual essence were delivered to the very threshold of the uterus.

Leonardo would ultimately reject this scenario in favor of the Lucretian theory that the seeds of both male and female were required for the creation of life. He also questioned several other then widely accepted beliefs pertaining to the functions of the male sex organs. For example he disproved the previously unques-

Fig. 6.1 Leonardo da Vinci, *Anatomical Drawings, including a Cross Section of Lovers in the Act of Coition*, ca. 1500 (Windsor Castle, Q III, 3v). Illustration courtesy of the Royal Collection, Windsor Castle

tioned view the penis became erect via inflation with the element of air (having observed that the penises of men who died in a state of sexual arousal were flushed with blood, he thought this heavier humor could more effectively explain both the rigidity and the density of the erect male member).[2] However, amid his Windsor anatomical notes, we also find some indication that he was genuinely mystified by the workings of this often unruly bodily organ, which sometimes seemed not merely a neutral instrument of masculine love and desire but rather like an independent being with a mind and desires of its own:

> [The male member] confers with the human intelligence and sometimes has intelligence of itself, and although the will of the man desires to stimulate it,

it remains obstinate and takes its own course, and moving sometimes of itself without licence or thought by the man, whether he is sleeping or waking, it does what it desires; and often the man is asleep and it is awake, and many times the man is awake and it is asleep; many times the man wishes it to practice, and it does not wish it; many times it wishes it and the man forbids it. It seems therefore that this creature has often a life and intelligence separate from the man, and it would appear that the man is in the wrong in being ashamed to give it a name or to exhibit it, seeking the rather constantly to cover and conceal what he ought to adorn and display with ceremony as a ministrant.[3]

The idea that the virile sex organ might possess a mind or soul distinct from that of the body to which it is attached is ancient, with precedents in Plato and Aristotle.[4] Leonardo's suggestion that the penis might not only be given a name of its own but should even be recognized as its owner's true master is surely meant to be playful, yet in its manuscript context the quoted passage relates directly to the most serious sort of medical enquiry. For example, in the immediately preceding paragraph, Leonardo wonders how the testicles might cause the "ardor" that characterizes male behavior, observing that even the most ferocious animals are rendered meek by castration, and in the paragraph immediately following, he observes that the lung is the only bodily organ that can be made to suspend its autonomic functions by the conscious force of will—a point manifestly related to his adjacent discussion of the penis's involuntary movements.[5] Nonetheless, in the quoted passage, Leonardo's argument is cast neither in purely medical nor in natural-philosophical terms but rather crosses definitively into the realm of moral discourse: to say that the male member has a will of its own is not merely to enquire about its physiological functions but also to ask, with satiric intent, whether a man is truly responsible for his penis's actions.

The vivid image of the male reproductive organs as an independent being possessed of separate consciousness recurs elsewhere in Leonardo's notebooks but in a radically different context. In the course of conservation work on Leonardo's *Codex Atlanticus*, in the late 1960s, it was discovered that some of the sheets glued into the volume had drawings on the reverse—drawings that had not seen the light of day since Pompeo Leoni assembled the codex in 1590. Two such drawings, spread over the versos of what was once a single sheet of fortification studies dating to ca. 1503–4, must have stunned their discoverers, for they not only included the image of a machine inescapably resembling a primitive bicycle but also included additional sketches that, when joined together, form another, less frequently re-

produced, image of two practically identical penis creatures, parading from left to right (fig. 6.2).[6] These drawings are executed in an extremely crude manner, certainly not by Leonardo's hand. Although not immediately connected with Leonardo's anatomical and physiological enquiries, they do recall the master's remarks pertaining to the capricious movements of the virile member and the consequent implication that the male sex organ is in effect a conscious being with its own intelligence and identity. Indeed, the phallic creatures in the *Codex Atlanticus* sketch have separated from their normal nesting place on the male body and have been transformed into free-ranging animals. They have legs joined to their testicular haunches; they have horizontally oriented "mouths"; and they have long tails that curve slyly upward to reveal their hind quarters. Although they lack wings, their two-legged bodies and three-pronged feet suffice to impart an unmistakably bird-like quality. Moreover, these twin phallic "birds" seem to act with conscious intent: the first of them is preparing to insert its "beak" into an oval aperture, above which is written "*salaj*"—that is, the name of Leonardo's beloved, if famously troublesome, pupil and companion. As Carlo Pedretti has observed, it therefore appears that this oval form, scored around its circumference with short strokes suggesting a hairy or possibly wrinkly texture, must have been intended to represent Salaì's anus.[7]

The significance of this drawing is by no means self-evident. For in spite of its seeming crudeness, the image poses extraordinarily complex interpretative problems, not least that of identifying the genre of images to which it belongs: is this really just an informal, childishly obscene "doodle," as modern eyes may wish to see it, and if so, on what terms might we interpret it? On a very fundamental level, the drawing appears to have originated within a particular narrative, the outlines of which are well known. Since we know that Leonardo and Salaì were close companions, and all but certainly lovers, scholars have reasonably concluded that these drawings alluding to the same-sex penetration of Salaì's body were invented by another young male who had access to Leonardo's studio—someone who wished to injure Salaì with the accusation of sodomy.[8] The artist's defamatory purpose is perhaps underscored by the presence of not one but two phallic monsters, the second of which seems to sniff at the rear end of the first, even as the first prepares to penetrate the "anal" aperture at the right. The appearance of two such randy phallic beasts might serve to increase what we tend to read as an intentionally comic effect, but it could also be understood to serve the artist's injurious intent, insinuating with dark satire that Salaì is not only guilty of sodomy but in fact entertains a host of lustful, perverted lovers.[9]

Fig. 6.2 Anonymous, sketches of phallic birds in Leonardo da Vinci, *Codex Atlanticus*, fols. 132v and 133v, early sixteenth century. Reproduced by permission of the Veneranda Biblioteca Ambrosiana, Milan

While the visual argument in which these phallic creatures participate does indeed seem to belong to a species of satire or parody—in this respect, too, they seem akin to Leonardo's above-quoted comments—such species necessarily also belong to a larger genus of moral discourse: however humorous, such an attack would work by means of an implicit appeal to the Judeo-Christian proscription against sodomy and to the collateral notion that sodomy and sexual perversion in general are direct results of demonic influence—that is to say, the devil was thought to have taken possession of the sodomite's soul and thus also of his body. The image of the penis as a sexually ravenous bird, invoked by Salaì's presumed assailant, was understood by Renaissance beholders, I suggest, not only to figure the demonic possession of the male genitalia but also to imply that this infection of diabolical lust had been imposed by means of witchcraft or "erotic magic."

Both Walter Stephens and Malcolm Jones have connected the image of the phallic bird with the subject of witchcraft, specifically with reference to a passage in Heinrich Kramer's *Malleus maleficarum* (1486) which asserts in the course of providing an account of the harmful spells employed by witches that a malicious witch could in some sense "steal" her male victims' private parts, rendering the men sexually impotent and transforming their enchanted sex organs into birdlike monsters:

> And what, then, is to be thought of those witches who . . . sometimes collect male organs in great numbers, as many as twenty or thirty members together, and put them in a bird's nest, or shut them up in a box, where they move themselves like living members, and eat oats and corn, as has been seen by many and is a matter of common report? . . . For a certain man tells that, when he had lost his member, he approached a known witch to ask her to restore it to him. She told the afflicted man to climb a tree, and that he might take whichever member he liked out of a nest in which there were several members.[10]

Kramer's peculiar description of the bewitched male sex organs living in nests amid the branches of trees, moving about, and eating grain conjures a verbal image of what would appear to be the same sort of birdlike phallic monster that the anonymous *Codex Atlanticus* artist has portrayed in his own cartoonish visual language. But should we conclude on this basis alone that when he sketched the image of the two penis birds, the artist specifically intended an allusion to witchcraft, with the aim of casting Salaì himself as a kind of demon who had enchanted and taken possession of his victims' sex organs. And viewing this image, would some of his contemporaries have perceived such an allusion?

Although the *Codex Atlanticus* drawing could easily be dismissed as little more

than a puerile, meaningless obscenity, I propose a more serious critical intervention in which we consider the possibility that the image embodies a coherent argument and (whether or not motivated by simple juvenile jealousy) that it betrays the moral character of the artist's discourse. In the absence of evidence for the reception of this image—we cannot even know whether Salaì or Leonardo ever saw it—the proposed intervention can nonetheless proceed on the purely deductive grounds of iconographic philology: if Kramer's image of the penis bird alludes to the witches' diabolical control over the male sex organ, and if the *Codex Atlanticus* sketch portrays the same kind of phallic creature that Kramer describes, it is reasonable to think that the birdlike qualities that inform the errant sex organs in that drawing are indeed a sign of diabolical possession, representing the male member in the grip of lust. Moreover, it can be shown that the visual image of the phallic bird was not merely the artist's invention but rather was an iconographic commonplace that recurs in other works more certainly alluding to erotic magic and the diabolical corruption of the male body.

Precisely this sort of evidence is to be found in a remarkable image engraved by an anonymous north Italian artist around 1470–80 on the verso of a copper plate preserved in the National Gallery of Art in Washington, DC (fig. 6.3).[11] The worn but still legible plate portrays a nude male youth seated on a bench with a female lover positioned on his lap, her arms softly embracing him about the neck and her legs straddling his body. Their lips are locked in a passionate kiss. The male grasps the female's buttocks, pushing back her gown as he penetrates her vagina, and she spreads and lifts her legs to take pleasure in his erect member. The couple are so thoroughly involved that they seem completely unaware that a large phallic "bird" is creeping up on them. This bizarre monster is indeed close kin to those we encounter in the *Codex Atlanticus*. Its "head" has the same, oddly expressionless, horizontal "mouth"; it similarly has a tail, though longer and more horselike than that which appears in the *Codex*. And its two testicles similarly double as legs or buttocks: one has a lionlike, clawed foot, while the other has a long shank and a vaguely leonine paw. In the *Codex Atlanticus* drawing, the two-legged form of the phallic creatures suffices to suggest their avian nature, but the Washington engraver makes this birdlike quality even more explicit through the addition of feathered wings.

Naturally, the engraving presents some fairly daunting interpretative problems of its own. But as with the *Codex Atlanticus* sketch, it is safe to say the Washington artist has placed the image of the phallic bird in a context having something to do with the sin of lust. Indeed, even if the image of the phallic creature were absent,

Fig. 6.3 Anonymous, *Lovers with Phallic Bird* (*Purinega tien duro*), later fifteenth century. *Allegory on Copulation (verso),* Rosenwald Collection, image courtesy of the Board of Trustees, National Gallery of Art, Washington, DC

the coital posture of the lovers in the Washington engraving would have sufficed to indicate that the young and presumably unwed lovers are not at all concerned with the Christian duty of producing legitimate offspring but rather with a purely lustful indulgence in the delights of the body. As Bette Talvacchia has demonstrated in the somewhat later case of Marcantonio Raimondi's *I Modi* (e.g. fig. 6.4), engraved in 1524 after Giulio Romano's inventions, the broader public of Renaissance beholders tended to interpret images of love making within a moralistic framework established by ecclesiastical and medical authorities, who condemned as perverse and evil virtually every sexual posture other than the man-on-top "missionary" position.[12] On this basis alone, the contemporary beholder would have been entitled to conclude that the Washington engraving represents an act of lust and perversion and that the phallic bird lewdly hovering near the amorous couple is meant to amplify the theme of sinful fornication.

Several other iconographic traits strongly reinforce such a conclusion. Most fundamentally, the inscription on the long banderole that unfurls about the male figure indicates that the sexual encounter here represented is something less than an ideal love. The inscription is more than a little difficult to interpret—the spe-

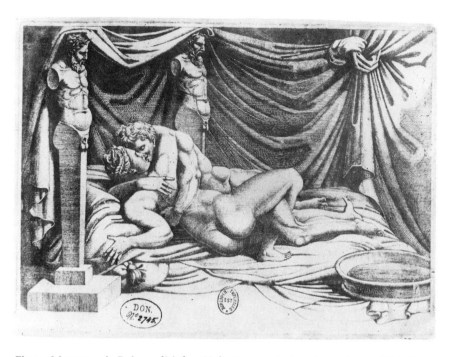

Fig. 6.4 Marcantonio Raimondi (after Giulio Romano), *Copulating Lovers* (*I Modi*, position 1), early sixteenth century. Reproduced by permission of the Bibliothèque nationale de France, Paris

cialists in Italian linguistics with whom I have consulted have found it extremely puzzling—but it is quite certainly written in a north Italian dialect of the fifteenth century, a fact that squares with the artist's stylistic tendencies.[13] Although one's interpretation of the artist's imagery depends in large part on one's reading of the inscription, at least one aspect of the inscription's meaning can be gleaned, conversely, from its juxtaposition with a portrayal of lovers engaged in sexual intercourse: for the phrase "tien(e) duro" taken literally means "he, she, or it stays hard" and therefore constitutes an obvious allusion to the erect status of the male lover's sex organ—a reference underscored by the presence of the phallic monster. In the north Italian dialects as in modern Italian, the phrase "tien(e) duro" also has the figurative sense of "he, she, or it persists," with the implication that such persistence is accompanied by a certain adversity or danger.[14] In this case, one concludes that the lovers are somehow imperiled on account of their sexual encounter and that they persist in spite of the danger.

More serious philological obstacles lie in the grammar of the remaining word,

purinega. I propose (with much support from linguistic specialists) that what the artist has written as a single word is in fact three words, slurred together according to standard tendencies of the northern Italian dialects: *purinega* can be read as *pur* (meaning "also," "even if," or "although"), plus *i* (the characteristically north Italian direct object pronoun, third-person plural, meaning "them"), plus *annega*, from the verb *annegare*, that is "to drown," or, in a more universal figurative sense, "to destroy."[15] The conjunction *pur* in Tuscan would normally generate the subjunctive *anneghi*, but in dialect the analogous form is in fact *anega*, so that *pur-i-nega* forms a perfectly coherent dependent clause: "even if (something) may destroy them."

Although the sentence lacks an explicitly stated subject, it is thus more or less grammatically complete. In Tuscan it might read: "Pur . . . li anneghi, . . . tiene duro," or in English, "Even if (something) may destroy them, (something) persists / stays hard." However, since the verb *tien* in this grammatical context might more properly be taken as a subjunctive, we must also consider the further possibility that we are to read this as the expression of a potentially malicious wish or desire, that is, "Even if it may destroy them, *may [something] persist / stay hard.*" What is the unstated subject of this sentence? What is the thing that might destroy the couple and that nonetheless should "persist" or "stay hard"? In this rhetorico-logical construction, composed of both words and images, the subject of the sentence must be "the virile member." For not only is "the virile member" the subject of the punning expression "tien duro," referring to the fact that the male lover's sex organ "stays hard"; it is also the male sex organ itself, as personified in the birdlike phallic monster at the right, that is most obviously poised to harm the couple. Yet the resulting sentence still seems an enigma: "Even if it may destroy them, [his virile member] persists / stays hard," or "*may [his virile member] stay hard.*" What exactly is this supposed to mean? The former reading has the sound of a mocking, moralizing commentary, chiding the fornicating male for persistently requiring sexual gratification, which will inevitably lead to both lovers' destruction—presumably their *spiritual* destruction. The latter strictly optative reading has a slightly different resonance, for it takes the form of a malicious wish or a curse—one that dooms the male figure to an insatiable sexual longing of a kind that might again lead to the lovers' spiritual ruin.

Some modern beholders have wanted to view this engraving as little more than meaningless pornography, but there is no getting around the ominous tenor of the inscription, which perfectly complements the notion of sinful fornication implicit in the lovers' coital posture. Likewise, the requirements of conceptual unity

demand that the figure of the penis monster must similarly also respond to the theme of lust and its spiritual consequences, but exactly what were its connotations in the later fifteenth century? The image of the phallic bird has most often been interpreted as visualizing a verbal conceit, common in the European vernaculars, in which the virile sex organ was referred to as the "bird."[16] This is unquestionably relevant, but A. M. Koldeweij has shown that the Washington artist more specifically modeled his image of the phallic bird on a type of lead-tin badge mass produced in northwestern Europe in the fourteenth and fifteenth centuries: the resemblance is too precise to be a coincidence, for the badges in question represent exactly the same kind of winged, long-tailed, two-legged phallic monster, and, most tellingly, the phallic monsters in these badges often wear spherical jingle bells about the neck—exactly like that worn by the creature in the Washington engraving (fig. 6.5).[17] The phallic creatures in the *Codex Atlanticus* sketch were ultimately modeled on similar badges, which evidently were also known in northern Italy. As both Koldeweij and Jean Baptiste Bedaux have observed, those badges formed in the image of the phallic monster were themselves modeled on a common type of ancient Roman fertility votive and were probably believed to provide amuletic or apotropaic protection, bringing good fortune or averting evil—particularly those forms of evil that threatened the male wearer's capacity for sexual intercourse and procreative fertility.[18]

That the phallic creature represented in the Washington engraving should so closely resemble a type of talismanic badge believed to protect or inspire the wearer's sexual potency is intriguing indeed, for this reinforces a theme likewise implicit in the artist's portrayal of the lovers passionately engaged in sexual intercourse and made verbally explicit in the punning expression "*tien duro.*" The philological convergence is impossible to ignore, for if the artist's invention contains three subordinate images (two visual and one verbal) each independently alluding to the aroused state of the male lover's sex organ, there ought to be little doubt that the image was consciously designed to express a coherent argument revolving around the theme of procreative power or erectile stamina. But since the phallic monster shown in the engraving of course differs from the badges in that it is not shown as a personal adornment, but as a real monster, and since this image functions within a more complex graphic argument, it is not immediately evident how we are to interpret its relationship to the amuletic, quasi-magical function that the badges are believed to have performed: we cannot yet be certain whether the monster is here to protect the lovers or to harm them.

Indeed, how can we reconcile the association of the phallic creature with the

Fig. 6.5 Phallic Badge, Netherlandish, fourteenth or fifteenth century. Reproduced by permission of the Stichting Middeleeuwse Religieuze en Profane Insignes, Cothen

sin of lust on the one hand, and, on the other, with the amuletic function suggested by the fashion of wearing such images as badges or brooches? The image of the phallic bird itself, as it appears in these badges, may originally have signified something fundamentally positive—a healthful enhancement of sexual potency or stamina *tout court*; quite probably, the badges made in this image were specifically intended to protect against malicious witchcraft, which was widely regarded as the most common cause of male sexual dysfunction.[19] Yet by its very nature such a symbol could easily be transformed into a signifier of unbridled, excessive, and spiritually unhealthful lust—particularly in the hands of a pious Christian artist unsympathetic to the use of erotic magic: indeed, in the culture of the period, the practitioners of such magical arts were widely believed to have obtained their powers through intercourse with the devil.[20] I believe that the male lover in the Washington engraving has been represented not as someone who benefits from the powers of love magic but rather as the victim of a malicious spell designed to drive him wild with self-destructive sexual desire; in this context, the phrase "Even if it destroys them, may [his penis] stay hard" written on the banderole surrounding the male lover reflects the content of the spell or curse that has been imposed on him. Finally, I submit that the image of the phallic bird here would again (as in the *Codex Atlanticus* drawing) have been taken to figure the monstrous lust that has possessed the bewitched male genitalia.

Guido Ruggiero has reconstructed some remarkable narratives involving erotic magic dating mostly from the later sixteenth century, when inquisitorial authori-

ties began to crack down on these centuries-old practices, interrogating accused witches and creating a rich archival record of their magical techniques.[21] Even though dating from a century later than the Washington engraving, one such case seems to connect yet another seemingly irrational feature of the artist's invention with the notion that witchcraft could either destroy a man's capacity for sexual intercourse or stimulate his sexual appetite to a dangerous level: the as-yet un-explained presence of the tree trunk or log that appears under the lovers' bench, more or less directly beneath the figures of the lovers themselves.

Ruggiero examines the story of a widow named Apollonia Madizza, from Lati-sana on the northeastern border of the Veneto—a "healer" who was accused of witchcraft and interrogated by the Holy Office in 1591. Among her other activities, Apollonia had aroused suspicion by using techniques of sympathetic magic to cure cases of impotence believed to be caused by malicious spells, and in the course of her interrogation, she gave the following account of her methods:

> The technique that I used for unbinding those who cannot have intercourse with their wives is as follows: for some, I have them put under the bed the blade of a plow, that is, the metal with which one plows the fields; for others I have them put there the hoe and the shovel which are used for burying the dead; for others I have them take a ring with which a young virgin was married and which has been placed in holy water, then they must urinate through this ring.[22]

As Joanne Ferraro has demonstrated in a recent study, this last method of "un-binding" the impotent virile sex organs, that of having the victim urinate through a ring, was known and used across western Europe in the sixteenth century and is probably also reflected, at least in terms of general principles, in a well-known painting by Lorenzo Lotto dating to ca. 1520, now in the Metropolitan Museum of Art in New York (fig. 6.6).[23] Here we see a lascivious Cupid pissing through a circu-lar, ringlike wreath, his flux falling in the lap of a voluptuously reclining Venus. The painting itself functions as an amuletic sign; it, like the act of urinating through an actual ring, was intended to protect the sexual potency of the painting's owner from maliciously cast spells.[24] Since the Washington engraving similarly contains multiple allusions to the male lover's sexual stamina, I would argue that Apol-lonia's second technique of "unbinding" the bewitched male genitalia and of re-storing erectile function—the placement of certain objects beneath the bed where intercourse is to take place—similarly suggests an explanation for the presence of the heavily pruned log visible beneath the lovers' bench.

Apollonia did not invent the technique of placing spell-bearing objects un-

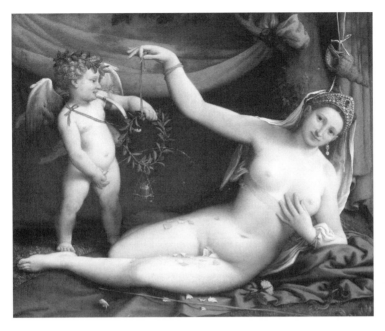

Fig. 6.6 Lorenzo Lotto, *Venus and Cupid*, ca. 1520, oil on canvas. Image © The Metropolitan Museum of Art, New York

der the bed as a means of influencing a man's sexual performance, for similar techniques were demonstrably known to the Washington artist's contemporaries. However, it is crucial to understand that the presence of the log beneath the lovers' bench in the Washington engraving could signify a curse or harmful magic spell just as easily as a cure. A fifteenth-century Latin text on witchcraft preserved at Montepellier speaks of those men who, "impeded by diabolical spells, are unable to have intercourse with their wives" and mentions that objects bearing such spells were often placed under the bed: "Some spells are made of animated substances such as the testicles of a cock. *If they are put under the bed* with blood of the cock, they bring it about that *the people lying on the bed cannot have intercourse*."[25] Likewise, the anonymous author tells us, "If we wish to extirpate the spell properly, we must look out: *if the above-mentioned spell is under the bed, it must be removed*."[26] In the Montpellier text, a précis of commonplace sources, the placement of objects beneath the bed was part of a harmful, impotence-causing spell, whereas in Apollonia's version, the placement of the metal plowshare and grave-digger's tool in that location was instead a method of healing, designed to break such malicious

spells and restore sexual function. Indeed, Apollonia apparently intended to inform the male sex organ, by simple principles of sympathetic magic with the same power and rigidity to break into the vagina that these objects possess to break the earth. The placement of the wooden log beneath the lovers' bench in the Washington engraving thus suggests a fairly obvious magical rationale: by analogy with the above-mentioned cases, the cylindrical log's density and rigidity might have been capable of inspiring these same qualities in the male lover's sex organ.[27]

The image of the phallic bird in both the *Codex Atlanticus* drawing and the Washington engraving figures the penis not only as a site of moral and spiritual contention but also as an object of satire, exposing the locus of a man's vulnerability to sin. That the Washington engraving was intended to ridicule rather than celebrate the male lover's predicament is confirmed by a second image on the copper plate's recto—a young woman spinning, flanked by two male figures (fig. 6.7).[28] For this latter image, engraved by the same artist, is plainly satirical in nature, poking fun at the foolishness of those men who succumb to the empty pleasures of fornication. The spinning female refers to the familiar misogynist topos of the "power of women": the spinner's thread figured the "trap" of female sexual allure, and the spindles signified the virile member thus ensnared.[29] The woman in the engraving has captured many men (her basket is filled with well-wound spindles); and the nature of her power is also subtly suggested by the peculiar folds of her gown, arranged between her legs to resemble the vulva of the female sex organs. The two male figures illustrate how she transforms her victims. The younger man, at the right, plays the bagpipes, a traditional symbol of the male genitalia and an attribute of fools; the small model of the male genitals dangling from the instrument's vertical pipe not only makes this connection explicit but also alludes to the same theme of erotic magic highlighted in the image on the verso, for similar phallic charms, usually made of wax, were widely used both in witchcraft and popular religion.[30] The musician sports a hat with a distinctly erect phallic shape, which suggests that he still possesses his youthful sexual potency. But the older, more ragged man at the left—possibly representing the same man at a later stage of life or perhaps one of the woman's previous victims—has been rendered impotent: not only is his flaccid penis visible dangling between his legs, but his own hat sags and flops forward in a way amusingly analogous to his worn-out member. The spoons he carves, which themselves resemble the male genitalia, are likewise pointed insistently downward.[31] That the woman is to blame for his pathetic state is insinuated both by her attributes of the distaff and spindles and by the presence of the small child near him, clearly the product of his sexual union with her. The

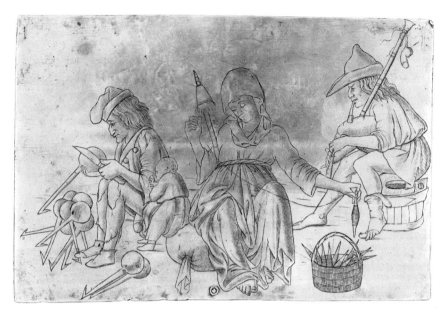

Fig. 6.7 Anonymous, *Spinning Woman with Spoon-Carver and Bagpipe Player* (reverse of *Purinega tien duro*), copper engraving plate, later fifteenth century. *Various Occupations (recto)*, Rosenwald Collection, image courtesy of the Board of Trustees, National Gallery of Art, Washington, DC

large sack on which she is seated probably signifies her consequent appropriation of the man's wealth.

The trope of the phallic bird deployed on the copper plate's verso participates in a universal warning against the dangers and diabolical origins of lust and fornication, but the *Codex Atlanticus* artist uses the same trope in the context of an attack on a specific individual. If the implication of Salaì's diabolical character is not absolutely clear, it is worth thinking about one additional detail in the drawing, as yet unexplained in the literature: the peculiar pattern of crisscrossing lines superimposed over the first of the two phallic creatures, the two major lines of which cross precisely at the radius of the penis shaft. Given the apparent links between the image of the phallic bird and the themes of witchcraft and erotic magic, it is significant that these strange, nonrepresentational lines resemble the symbols of the chalice (inverted triangle) and blade (a triangle resting on its base), ubiquitous in western European magic, arranged apex to apex; together, they also form an hourglasslike shape closely resembling one of several symbols signifying the influence of Saturn. In either case, the diagram would be typical of the symbols used to im-

pose magical *martelli*, or "hammers," on targeted individuals. Likewise, a tapering, needlelike line leads from the head of the first penis monster into the center of the schematic "anus," perhaps magically guiding the creature to its unseemly destination or causing Salaì to experience sharp pain in that region of his body. The exact significance of these symbols would be practically impossible to determine given our scant knowledge of such popular magic. However, if the drawing is indeed meant to represent Salaì as a kind of demonic whore who enchants the genitals of his lovers, the diagram could represent the spell he has imposed on them, but it is intriguing to think that it might also be the symbolic vector of an actual curse, directed at Salaì himself.

Nymphomaniac Matter

The Prostitute as Metaphor for the Body
in Italian Renaissance Philosophy

Sergius Kodera

Giordano Bruno (1548–1600)

In his famous dialogue *De la causa, principio ed uno* (1584), Giordano Bruno has Poliinio, the Aristotelian pedant, say "a woman is but matter. If you do not know what a woman is because you do not know what matter is, study the Peripatetics a little; they will teach you what a woman is by teaching you about matter."[1] As clearly satirical as Bruno's intention is, it captures the misogynist attitudes so characteristic of many established intellectual discourses during the early modern period—a sometimes violent hatred for women linked to Aristotelian natural philosophy, as becomes obvious in another outburst by Poliinio:

> in the first book of the *Physics*, at the end, where the philosopher, wishing to elucidate what primary matter is, compares it to the female sex—that sex, I mean, which is intractable, frail, capricious, cowardly, feeble, vile, cold, misshapen, barren, vain, confused, senseless, treacherous, lazy, fetid, foul, ungrateful, truncated, mutilated, imperfect, unfinished, deficient, insolent, amputated, diminished, stale, vermin, tares, plague, sickness, death.[2]

As usual, Bruno's irony is to the point: the preceding quotation refers to a passage in Aristotle's *Physics*—193b31–194a11—that is crucial for my present topic, the history of the prostitute as metaphorical description of the material world. According to that misogynist account, the stability of divine and male identities, the forms, is threatened by material and female nonidentities. A general mistrust in and fear of the instability of material beings is here expressed through an utterly negative image of the female body. Before proceeding to Aristotle's passage, allow me to clarify the context of the metaphorical identification between matter and an obviously very negative conceptualization of the female sex that is shocking indeed to modern readers. Why did early modern philosophers feel the need to use metaphors to describe the natural world at all? One answer is that Aristotle did not believe that bodies could be described satisfactorily by means of arithmetic or geometric figures, since he thought that natural bodies were composed of two principles, namely, form and matter, the latter being irreducible to abstraction as well as the cause of the body's mutability and physical extension. In a famous passage, Aristotle says that there can be no true science of natural bodies as they are subject to constant change, the alteration being due to matter, the female substratum of all physical entities: "One can conceive of odd and even, and straight and curved, in isolation from change, and similarly number and line and shape; but this is impossible in the case of flesh and bone and man, which are defined like a snub nose rather than a curved thing."[3]

For Aristotelians, it was therefore impossible to establish an exact science of nature, guided by the principles of mathematics or geometry.[4] The difficulty in conceptualizing changing physical objects on account of their admixture of matter was also acknowledged in the Platonic tradition. For example, the fourth-century philosopher Chalcidius, a highly influential commentator and translator of Plato's *Timaeus* throughout the Middle Ages and beyond, says that when it comes to the principle of matter "there only remains the possibility that the subject itself is difficult and obscure. In fact there exists nothing more difficult to explain than matter, and thus it is why everything said about its nature, although said in full agreement with truth, is not expressed clearly and distinctly."[5] Given this particular situation, most Renaissance philosophers will agree that matter is to be grasped only by some kind of *cognitio adulterina,* a bastard acquaintance or knowledge that is conducive to mythic, anthropomorphic narrative strategies.[6] Accordingly, early modern philosophers rely more often than not on powerful images to illustrate the otherwise elusive concept of matter; under such circumstances, the close relationship of theory to literature becomes more perceptible than usual.

The irrationality of material bodies had led Aristotle to introduce a potent and hotly debated metaphor to explain the nature of the body as a composite being made out of a male immutable form and a female changeable matter. In the passage to which Bruno refers in *Della causa*, Aristotle had compared matter to a sexually aroused woman, longing for a man or a male form (*Physics* 192a20–24):

> In fact, however, form cannot desire itself, because it is not in need of anything.
> ... It is matter which does the desiring. You might liken it to a woman longing
> for a man, or what is ugly longing for what is beautiful, if it were not for the fact
> that matter is not in its own right something that is either ugly or female, except
> coincidentally.[7]

Note that Aristotle is very careful to emphasize the metaphorical character of his comparison between matter and a sexually aroused woman. It should not go unmentioned that many thinkers were opposed to or tried to qualify this conceptualization. In his commentary on Aristotle's *Physics*, Thomas Aquinas mentions the objections raised by Avicenna against the identification of matter with a desiring woman and tries to diffuse them. The Arab philosopher states that matter cannot be said to have an intrinsic desire because it has no natural inclinations of its own.[8] Thomas answers that the desire of matter owes to the ordering power of something else, as the arrow moves in a certain direction by the intention and impetus of the archer that points it. Avicenna's further objection—that Aristotle speaks of matter in a metaphorical way, which suits poets but not philosophers—is countered by Thomas's statement that female sexual desire serves not as metaphor but rather an *example*, since *materia prima* is known only indirectly, through the changing formal proportions. In order to further deescalate the debate, Thomas says that Aristotle in other places uses different examples, such as the form of the statue that is educed by the craftsman out of the material.[9] In spite of Thomas's and other Aristotelians' efforts to downplay the significance of the conceptualization of matter as desiring woman, the metaphor remained focal in the scholastic tradition, as we shall presently see.

Of course I do not want to imply that Aristotle was not guilty of sexist positions in other instances, the most notorious one being perhaps his description of the female (animal) as a somehow "mutilated" or "impotent" male in his *Generation of Animals*.[10] The matter / desiring woman metaphor was more than just an innocuous "example" because it established a connection that fit all too well into the social and political contexts of patriarchal societies. Commenting on *Physics* 1.9, Averroes, known to the Christian medieval tradition simply as Aristotle's "Commenta-

tor," emphasizes the political relevance of such a *paragone*, when he bluntly says that a woman is an imperfect man.[11] To mention but another example, Alessandro Achillini, referring to the same passage, finds even clearer words when he says that nature intends to bring forth men and that women are useful or necessary only accidentally.[12] Hence, even if debated in its locus classicus, the conceptualization developed in the context of natural philosophy was also easily at hand to describe and to cement existing power relations between men and women. Again, Bruno's *Della causa* satirizes the situation:

> Behold, behold, divine spirit, how the great practitioners of philosophy and the acute anatomists of nature's entrails, in order to show us nature plainly, have found no more appropriate way than to confront us with this analogy, which shows that matter is to the order of natural things what the female sex is to economical, political and civil order.[13]

It comes as no surprise, then, that in a considerable number of medieval and Renaissance commentaries on *Physics* 1.9, the analogy between matter and a sexually aroused woman is pushed even further. Matter desires all the male forms in succession and thus eventually gets weary of being constantly linked to a single male form. Hence it tries to rid itself of the present form and seeks "to lie under a new one." In a characteristic formulation, Jacopo Zabarella speaks of a "propensio materiae ad omnes formas indistincte" ("an indistinct inclination of matter toward all forms").[14] This desire owes to privation, another concept introduced by Aristotle to account for change (for example, birth, growth, death) in natural bodies.[15]

Common to all these accounts is that they take for granted the emotional relationship of inferior and changing matter to superior and eternal form. I have tried to show how the metaphor of matter as a sexually aroused woman developed during the Middle Ages, in an outspokenly misogynist context, by relating the comparison to Aristotle's conceptualization of the female animal as an inferior or mutilated male in the *De generatione animalium*. But a new and even more aggressive metaphor enters the discourse on bodies and women in Renaissance philosophy: the harlot, a person who epitomizes the uncanny urge for change and instability in natural bodies, a signifier for the potentially lethal disruption of stable, male forms.

Alessandro Piccolomini (1508–79)

In some Renaissance Aristotelian as well as neo-Platonic treatises, one encounters a fascinating radicalization of the metaphor of *materia* as a desiring woman: matter is represented as a prostitute (*meretrice*).[16] In *Della filosofia naturale*, a lengthy treatise first published in 1551, Alessandro Piccolomini writes in the *volgare* with the outspoken aim of promoting the Aristotelian doctrine by making it accessible to a wider audience and thereby defending the philosopher from the unmerited attacks of recent times.[17]

> [Matter] is always ready to dispose itself for all [forms] in essentially the same way, like a person, that is never content or satisfied with a single form. By desiring all forms, [at one time] and yet being under a specific one, matter starts (as though being remorseful and angry) to desire another one. That one does not pertain to her any more than this one, so that many philosophers liken her to a most vulgar harlot [*publichissima meretrice*]. Since it is appropriate for such a woman to never be satisfied by having intercourse with any single man, and she is not especially in love with any of them, while still being under one man, she already desires the next and tries to get rid of the former; and it is the same with prime matter, which is naturally apt and ready to desire all the natural forms and ready to follow them, and it is impossible for matter to sustain more than one [form] at a time; and it is necessary that while being under one [form] she will rid herself of it; it is because of her desire for the other forms that she will rid herself of this form, and she then reclothes herself with the new one, and this goes on and on, while the forms perpetually succeed each other.[18]

Here, Aristotle's desiring woman is quite spectacularly converted into a harlot that eagerly seduces unsuspecting males only to leave them after a while, thus causing mischief. Sexist as this metaphorical description may be for modern readers, it is nevertheless a typical example of the projection of male sexuality onto matter and women; here it becomes obvious that when men speak about women, they tend to speak about their own anxieties and their own inclinations to promiscuity. It seems as if Piccolomini is neglecting Aristotle's emphasis on the metaphorical quality of the comparison, as well as the injunctions raised by his followers, by replacing the *materia*/woman metaphor with the even more salient image of a *materia meretrice*. Again, the topic of changing matter is approached solely through a *cognitio adulterina*, through a "crossbred" or "impure knowledge": a kind of "bastard reasoning," therefore, that was aptly described by means of a metaphorical

representation evocative of "adulterous behavior." The harlot metaphor not only reflects a hierarchical relationship between men and women, cementing the inferiority of the latter; the new image also embodies another crucial idea, namely that things that are made of matter and form are subject to constant change. The image of the harlot thus functions as a kind of mnemonic image for the changeable and hence metaphysically inferior position of matter in the hierarchy of being.[19]

In tandem with the matter-harlot image, other objects pertaining to the world of illicit women are included in the representation of matter as prostitute. Piccolomini says that matter constantly hides under various masks because it is never found without a definite form.[20] Masks, of course, are associated with makeup and other body practices tied to illicit sex. For instance, *De eruditione principum,* a treatise attributed to Thomas Aquinas, links prostitution and the use of face paint, dyed hair, and similar alterations of outward appearance.[21] In a similar but more uncanny vein, Piccolomini also emphasizes that matter constantly takes up new forms, regardless of form's "dignity," its position in the hierarchy of being: matter for instance leaves the form of a human body in favor of worms because matter feels the urge to "dress" (*vestire*) and "undress" (*spogliare*) itself.[22]

Here the potentially subversive reverse side of the *meretrix* metaphor is accentuated: matter is cloaked in or masked by ever-changing forms that take possession of it only temporarily and that perish at the advent of another form. Hence, the stable male forms become temporary garments, hiding or veiling the eternally desiring, female essence. This account of natural change supports the idea that the forms are impermanent, while matter is stable and thus is ontologically higher than them. Actually, this was the opinion of Solomon ibn Gabirol, a Jewish philosopher of the eleventh century.[23] It was in turn endorsed by Giordano Bruno, who subverts the negative connotations of the matter-harlot metaphor:

> That which is more perfect burns with greater love for the highest good than does that which is imperfect. Therefore, that principle is most perfect which wishes to become all things, and which is not oriented to any particular form but to a universal form and universal perfection. And this is universal matter, without which there is no form, in whose power, desire and disposition all forms are located, and which receives all forms in the development of its parts, even though it cannot receive two forms at the same time. Hence, matter is in a sense divine.[24]

This line of argument is also conducive to the idea that form and, by extension, soul could both be material. Similar Epicurean concepts were well known through

Lucretius's *De rerum natura*, and they were also used in contemporary medicine and magic to explain physiological phenomena of all kinds, especially contagion.[25] Hence, if the forms were material, the metaphorical identification of matter and women would deal a devastating blow to male identities, robbing them of their vital function in the order of creation. In such ways, female desire assumes an uncanny potential, as the harlot metaphor eclipses and displays specific male anxieties focusing on the control of female sexuality and the generation of offspring.

Furthermore, the idea that matter is dressed up by various masks or garments points to neo-Platonic ideas rather than to genuine Aristotelianism (indeed such eclecticism was a characteristic trait of many Renaissance philosophers).[26] Already Plotinus had identified form with a cloak that was thrown over matter, a concept he identified with privation.[27] Also foreign to the Peripatetic tradition is the idea of a repugnance (*fastidium*) of *materia*, that is, a kind of physical aversion for a certain form as the cause of change from one substantial form into another. The Aristotelian Jacopo Zabarella says that matter is intrinsically inclined toward all possible forms, which change in matter not because *materia* hates the forms but rather because matter is incapable of retaining one specific form indefinitely.[28]

The emphasis on the eventual repugnance of matter for a specific form is again a conceptualization that points to Renaissance Platonism and here especially to the influential genre of treatises on love.[29] These texts took their inspiration not only from Plato's *Symposium* and *Phaedrus* but also from neo-Platonic and medieval magic. For instance, Marsilio Ficino says in his influential *De vita* that the fetus is a well-disposed snare for the soul:

> Is it not true that Nature in the fetus, as the artificer of the fetus, when she has disposed the little body in a certain way and shaped it, straightway by means of this very preparation, like bait, leads down the spirit from the universe? And does the fetus not through this spirit absorb life and soul, just as tinder kindles fire? And finally through a particular species and disposition of soul, the body thus animated is worthy at last of the presence of a divinely given mind.[30]

The seductive gesture of the beautiful and deceptive body ensnaring a soul corresponds to the seductive gesture of matter, the prostitute. Here the doctrine of universal animation translated into the idea that only a well-disposed body is capable of ensnaring a beautiful soul, luring it with its charm from the celestial realm into imprisonment in the physical world. Not only did such "comprehensive discourses" reinforce each other, but there is a reciprocal influence between "woman" as a metaphor for matter and the philosophical concept of matter, women, and

childbirth. It seems that the matter/woman allegory had a special intellectual appeal to Renaissance men, since it allowed them to relate their social order to a hierarchical order of nature in which women were irredeemably men's inferiors.

Leone Ebreo (ca. 1460–ca. 1520)

Although the idea of *materia* as *meretrice* is absent from Ficino's *De amore* (1469), his commentary on Plato's *Symposium* and the most influential of the Renaissance love treatises, the metaphor occurs in another very popular text on love and in nearly the same wording as in Piccolomini's *Della filosofia naturale*: Leone Ebreo's *Dialoghi d'amore*. This lengthy work, consisting of three dialogues, was first published in 1535 but was probably written shortly after the turn of the century and went through numerous editions and translations during the sixteenth century.[31] Piccolomini knew Leone's text well: he even planned to write a fourth dialogue that was to finish the incomplete work.[32] Filone, one of the two interlocutors in the *Dialoghi*, says:

> According to Plato [matter] desires and loves the forms of all created things with a love like woman's for a man. And as this love, appetite and desire are not to be appeased by the actual presence of any one form, it is ever enamored of another that is absent and, abandoning the one, seizes on the other; so that, as it cannot be actualized in all forms at once, it assumes them all successively one after the other. Its many parts do indeed embrace all forms simultaneously, but since each part desires to enjoy the love of all forms, they must needs be transmuted into one another in continual succession. For a single form is inadequate to sate its appetite and love, which greatly exceeds [all] satisfaction, so that no one form can satiate this insatiable appetite.... Hence some call [matter] a harlot, because of the variety and inconstancy of its lovers; for no sooner does it love one than it desires to leave it for another.[33]

Leone Ebreo qualifies the misogynist implications of the *materia/meretrice* metaphor: to start with, matter is not *comunissima*, "most common" (as in Piccolomini), but just a harlot, and Piccolomini's claim that *molti filosofi*, "many philosophers," believe in the veracity of this conceptualization is reduced in the *Dialoghi* to *alcuni*, "some." So the wording of the *Filosofia naturale* is harsher than in the *Dialoghi*. But the two texts (which originate from different cultural environments) are also fundamentally different, as Leone Ebreo effectively subverts the negative meaning of the harlot metaphor: "Yet it is this adulterous love which beautifies the

lower world with such and so wondrous variety of fair-formed things. So that the creative love of this first matter, and its constant desire for a new husband she is missing, and the constant delight it takes in new copulations, is the cause of the creation of all created things."[34] This more positive assessment of the desire in matter is in accordance with the larger philosophical perspective of the *Dialoghi*, where sexuality is viewed as a *positive* phenomenon. For Leone Ebreo, all of creation is modeled on heterosexual relationships; his conceptualization is a genuine attempt (albeit within a male discourse) to rid the embodied world of its negative connotations.[35] Leone's anthropomorphisms unify the cosmos to the extent that it becomes impossible to distinguish among most phenomena (the female body as opposed to say, matter) as well as to draw a distinction between divergent concepts (ethics, physics, theology). In the *Dialoghi*, the nexus between anthropology and physics is even more emphatic than in Piccolomini; here *all* beings are classified as either male or female; even God is not exempt from this sexualization and subsequent polarization of the entire universe, a partition into male and female aspects that successively bring forth the entire creation by carnal union.

Piccolomini and Leone Ebreo not only use the *materia / meretrice* image to endorse divergent conceptualizations of the body; they also disagree on its philological and historical origins: the latter ascribes the metaphor to *Plato*, whereas the former had employed it to explain *Aristotelian* concepts. This is more remarkable in the case of Piccolomini, who claims to be a faithful follower of the doctrine of his master and who also emphasizes that Aristotle's and Plato's philosophies are in fact very different.[36] This is a good example of the adaptability of metaphors; they can be used to reinforce different sets of arguments in very different contexts. In such ways, the *materia-meretrix* metaphor is conducive to the blurring of conceptual differences in natural philosophy. The argumentative support given by the use of metaphor thus comes at a price, because the use of figurative speech tends to influence the structure of the claim. In the case of Renaissance natural philosophy, this leveling of conceptual differences sometimes occurred to such an extent that the doctrines of Plato and Aristotle were believed to be in harmony.[37]

Who were the *filosofi* Leone and Piccolomini referred to? As we have seen, they were not among the majority of orthodox Aristotelians, who by insisting on its merely metaphorical and exemplary character had tried to deescalate the more drastic readings of the *matter*-woman passage in Physics 1.9. They were aware that this metaphor tended to blur their conceptualizations of natural philosophy.[38]

Maimonides (1135–1204)

In several places of the *Dialoghi*, Leone Ebreo refers to Moses Maimonides, the author of *The Guide of the Perplexed*, a book that compares matter with a married harlot, albeit in not at all a positive way.[39] As Daniel Boyarin notes in an effort to justify his own allegorical approach, Maimonides claims that philosophers and true religion had "concealed what they said about the first principles and presented it in riddles," and he offers up as an example how "Plato . . . designated matter as the female and form as the male." It is interesting to note that Plato in the *Timaeus* says "mother and father," which perhaps represents an acknowledgment of the metaphorical nature of his conceptualization and suggests a comparison that seeks to elide the more general terms "male" and "female."[40] Now it is of crucial importance to note that, according to Boyarin, "this example, presented as if random and innocent, becomes in fact the *master* allegory of Maimonides' writing."[41] The *Guide* alleges that "the commandments and prohibitions of the Law are only intended to quell the impulses of matter."[42] In this radical formulation the struggle against the physical aspects of the human body becomes the prime task for observant Jews. Accordingly, Maimonides introduces his formulation of the *materia / meretrix* metaphor in a highly misogynist context:

> How extraordinary is what Solomon said in his wisdom when likening matter to *a married harlot,* for matter is in no way found without form and is consequently always like *a married woman* who is never separated from a man and is never *free*. However, notwithstanding her being *a married woman*, she never ceases to seek for another man to substitute for her husband, and she deceives and draws him in every way until he obtains from her what her husband used to obtain.[43]

In his excellent commentary on this passage, Boyarin points out that this is not just a personal allegory or a metaphorical discourse but that it is also an argument that entails a reification of persons, with possible dramatic, devastating effects.[44] Maimonides' violent outburst of misogyny essentializes "woman (as the allegorized term) into an ontological whoredom."[45] Leone Ebreo's construction of the relationships between the sexes is diametrically opposed to Maimonides' approach. The entire setting and subject matter in the *Dialoghi*, encompassing a sexualization of the entire universe (that is furthermore presented in the context of a couple's amorous conversation), can perhaps even be read as an intentionally anti-Maimonidean polemic. As an attack on the philosopher-theologian who had maintained that "with regard to copulation, I need not add anything . . . about the

aversion in which it is held by . . . our wise and pure law, and about the prohibition against mentioning it or against making it in any way or for any reason a subject of conversation."[46]

If one reads Leone Ebreo's philosophy as a return to the sources of Judaism, that is, to rabbinic culture, famous for its distinctly more positive outlook on the body, one can see the reason why the *Dialoghi* opposes Maimonides' negative attitude toward the body, an outlook Maimonides shared with Christian neo-Platonism. (It is tempting to assume that the author of the *Dialoghi* models his attack on Maimonidean anthropology on the Christian humanists' rejection of Scholasticism and their return to the literature of classical antiquity originally advocated by them.)

The fortune of the *materia/meretrix* metaphors shows the malleability of a conceptualization, how it could be put to very different uses: the image either served as testimony for the deceptive nature of the physical world or it could be read as an explanation for the diversity of bodies.

Solomon's Proverbs

Leone Ebreo's implicit attack on Maimonides seems to point toward an impasse in scripture. Going back to biblical wisdom literature, on which Maimonides rests his claim of the ontological whoredom of the embodied world, one remains disappointed. Prov. 6:26 (which is crucial for constructing the *materia/meretrix* figure) says "for the prostitute reduces you to a loaf of bread / and the adulteress preys upon your very life" (the Vulgate version substituting "soul" for life).[47] In the original context, this remark is part of an invective against adulteresses (further elaborated in Prov. 7:1–21) and comes as a warning to young people against a promiscuous life, which is appropriate since Proverbs is a tutoring book, similar to "Egyptian texts used in the education of royal princes and state officials. . . . It has been argued that court schools also existed in Israel and that Proverbs had its roots in these schools as an adaptation of Egyptian wisdom and its educational context."[48] What is even more amazing is that the Hebrew text of verse 26 is obscure. "The English versions are divided between the sense that a prostitute costs only the price of her fee and that a prostitute brings man to poverty."[49] In the Jerusalem Talmud, the passage is mentioned once in the context of a rabbinic discussion that seeks to determine the minimum duration of sexual intercourse, and Minjamin says that it takes as long as it takes for a woman's hand to stretch out a hand to take away a loaf of bread from a basket.[50] Hence, Maimonides had to rely heavily on esoteric allegorical interpretation to make his reading of the text viable, that is, to forge the body of the

promiscuous woman preying on an unsuspecting young man (Prov. 7:1–21) into a highly contrived allegory explaining change in nature in general.

I hope to have shown how an image of a promiscuous woman became a metaphor for matter, that is, a basic constituent of the physical bodies, and how this metaphor evolved in the context of a sometimes violently misogynistic discourse. The *meretrix* in such an environment became a powerful synthesis of previous figurations that delineated the dramatic escalation of a set of previous metaphors (e.g., childbirth, female heterosexual desire, which had likewise been invoked to represent matter). These images were used in natural philosophy to account for the phenomenon of change in physical bodies. In Maimonides and Piccolomini, *materia* is not conceptualized as a *mother*, as in Plato, or a *desiring woman*, as in Aristotle, but as wanton and death-bringing *harlot*. Woman (as the allegorized term) is continuously invested by ever-changing male forms, a trope that is a strategic device to cover and expose simultaneously a specific male anxiety about the material and procreative aspects of the world. Thus, to ward off any interpretation that would grant to matter (and hence to women) an equal or even dominant status in relation to male form, the metaphor of prostitution was instrumental in disallowing matter (and therefore women) equal status. (Time and again, we see how accurate Bruno's perception was, when he scathingly remarked that the Peripatetics teach you about matter by teaching you about women.)

The prostitute is probably the most negative instance among a set of already ambivalent representations of women in Renaissance thought.[51] The body of the *meretrix* is a suitable symbol to prevent any positive associations with the material aspect of the world. On the one hand, the conceptualization of matter as prostitute conveys the image of a beautiful and desirable body that puts itself willingly at the disposal of the formative power of any man. On the other hand, the attractive female body is a dangerously deceiving trap for male souls and therefore deeply disconcerting. The prostitute's treacherous beauty is designed to arouse sexual attraction, and hence exerts considerable influence over men.[52] The harlot therefore embodies a specifically male anxiety; her body, more than any other, is prone to contagion and to subsequent corruption, both of which are caused by the lack of a stable male form, that is, the lack of a definite boundary that would prevent such uncanny transformations. Thus *meretrix* lacks "character" in the double sense of the word: she has neither a definite shape (a husband), nor is she to be given any moral credit. Like matter, the harlot can be grasped only through a "bastard reasoning."

Part 3 / Gendered Corporeality

Icons of Chastity, *Objets d'Amour*

Female Renaissance Portrait Busts as Ambivalent Bodies

Jeanette Kohl

Renaissance female portrait busts are among the most fascinating objects in the history of art. These mute witnesses to a bygone era have, it seems, lost little of their power to affect the viewer. Especially in those cases in which the image and knowledge of the historical person do not coincide or cases in which we do not know who the busts are of. In the latter instances, the precision of the portrait like-ness and the namelessness of its subject are in constant tension, and the enigmatic power of anonymous beauty invites the viewer to solve their mystery.

Enthusiasm for this kind of image peaked, not coincidentally, at the turn of the nineteenth and twentieth centuries, when, in keeping with the fin de siècle, one imagined that these marble portraits possessed Salome-like qualities.[1] They embodied in an ideal manner the femme fatale, uniting charm with iciness, beauty with cruelty. Around 1900, copies of these trim fetish objects inundated the living rooms of the educated middle class where small altars were erected to them (fig. 8.1).[2] Countless artists studied the timeless beauty of these busts carved in stone, and their mute gazes perpetuated the male viewer's fascination with them.

The earliest examples of these works stem from the second half of the fifteenth century. The names of only a small portion of them are known, further complicat-

Fig. 8.1 View of two plaster casts of busts after Francesco Laurana and Desiderio da Settignano in the designer Otto Eckmann's piano room. Reprinted from *Deutsche Kunst und Dekoration* 6 (Apr.–Sept. 1900): 325

ing a classification of the works according to function—as memorial, marriage or lover's picture, or as ideal, poetically inspired portrait. Until now, they have almost exclusively been viewed in terms of questions of "representation" and interpreted against the background of Burckhardt's notion of the discovery of the individual, and scholars have repeatedly emphasized their function as depictions of ideal virtue. They embody woman's greatest possible good: the *virtus* they practiced, which the patron proudly had carved in an enduring form.[3]

I do not intend to question this function, which is clearly fundamental to the busts, but rather to reengage it and to open up a new avenue of inquiry. Against the background of the shifting relationship between the body and its representations in the late Middle Ages and early modernity, I pose the question: "How is this a portrait?"[4] In what way do/did these portrait busts signify, and how did they function for the predominantly male viewer? What is the relationship between viewer, image, and body? What effect did these images have?

Few sorts of images are as clearly meant for an intimate kind of "tête-à-tête" and for touch as these female busts, which were primarily created for rather private surroundings.[5] Their physical presence in the room produces a sensation of tactility. They represent not only female bodies / heads but are themselves also bodily apparitions. They are exchanged bodies, filling the gap between the body to which they presumably refer and that which exists in the mind of the viewer. In this liminal position, they are thus simultaneously both images and bodies. Material bodies appeal more readily to the viewer's sense of identification, and the imaginary assertion of presence that is unique to portraiture is even more pronounced in the case of portrait sculpture.[6]

The sometimes minutely detailed features, the particulars of the surface, the life-size presentation as well as the occasional presence of colored "cosmetics," all support an illusion of real presence in *pars pro toto*. The promise offered by the artist's demonstration of skill in creating an image that was so like the beloved that she could come to life cannot be realized. This is and was something that was also apparent to the viewer. The fifteenth-century patron may well have been stimulated by the tension between intimacy and distance, between corporeality and mute detachment; above all, he may have derived intellectual pleasure from it. This ambiguity may well also have been an erotic stimulus, a kind of mood enhancer. With these thoughts in mind, I show that quattrocento marble portraits of beautiful women should not merely be viewed as concrete representations of abstract ideals of virtue. As corporeal objects they could also acutely reflect the real, historical status of women as objects, and as such they are to a high degree both gendered and ambivalent objects.

"Noli me tangere": Seeing, Touching

In a poem from the late fifteenth century in which the poet Cristoforo Fiorentino known as "Altissimo" praises an ideal female beauty, the poet's gaze travels across the portrait of a beautiful beloved, lauds her marmoreal throat, and then comes to rest on an inscription, which he fancies stems from the pen of Artemis, protectress of female chastity: "Nella parte sezza / pende umbre ch'in sen(o) si vede frangere / scritto di Delia son, noli me tangere."[7] Equally witty is the reference to the Christian proscription on touch in the form of an inscription "Noli me tangere" at the edge of a half-length portrait in the Staatliche Museen in Berlin (fig. 8.2).[8] The open lacing of the dress as well as the fine, minutely rendered hooks and ribbons that connect the gown with the sleeves, allowing the silky underlayers to burst

Fig. 8.2 Agnolo or Donnino del Mazziere (attrib.), *Portrait of a Young Lady*, oil on panel, late fifteenth century. Staatliche Museen Preußischer Kulturbesitz, Gemäldgalerie, Berlin. Reproduced by permission of the Bildarchiv Preussischer Kulturbesitz / Art Resource, NY

forth, play with ideas of fastening and opening.[9] The figure's *delicatezza* encourages an imaginary disrobing. Image and text stand in a subtly ironic relationship to one another.

Verrocchio's anonymous beauty, the *Woman with a Posy* (fig. 8.3)—in a position between seducing and repudiating, between exposing and withdrawing—skillfully activates just that paradox of female portraiture (and of the female body in male perspective). This bust of a young girl in the Museo di Bargello, created around 1470, differs in one decisive aspect from its contemporaries: the artist gave her the use of both arms and hands.[10] The bust is not, as is common, cut off just beneath

Fig. 8.3 Andrea del Verrocchio, *Woman with a Posy,* ca. 1475, marble. Museo Nazionale del Bargello, Florence. Reproduced by permission of the Ministry of Cultural Heritage and Activities

the shoulders but instead in the area of the navel and thus presents an entire torso to the viewer. We see a youthful woman with her hair arranged according to contemporary fashion. Her clothing is unusual.[11] The tightly drawn veil that covers her chest, the *coverciere*, is quite transparent.[12] A tiny button closes the precious fabric, creating a small hole under it, allowing a glimpse of "skin" beneath (fig. 8.4). On top of the *coverciere*, we see nothing more than a thin, seamless, loosely worn drapery, which playfully hugs the body, revealing more than it conceals.[13] This subtly erotic treatment and staging of the image leads the viewer's gaze to exactly

Fig. 8.4 Detail of *fig. 8.3*. Reproduced by permission of the Ministry of Cultural Heritage and Activities

the point where the girl dreamily hides her costly little treasure. The middle finger of the hand bearing the bouquet seems, by sheer accident, to point to her nipple, which is readily recognizable. Exerting almost no pressure, the finger lies on and draws attention to the youthful breast. The conventional play between chasteness and sexual provocation is arranged as a game between skin and fabric, between skin and veil. Verrocchio exhausts the viewer-related potential of this visual type in the narrative activation and interactive treatment of the figure.

Francesco Laurana attempts to bring his busts to life in a quite different manner.[14] It is fortunate that the original appearance of the bust of a girl in the Kunsthistorisches Museum in Vienna, created in the 1480s, is still largely preserved (fig. 8.5).[15] Even after five hundred years, the bust, possibly a portrait of an Aragonese princess, still wears traces of "make-up." A nineteenth-century description reveals that her cheeks were painted, too: "The bust enjoys the reputation of being the most beautiful work of sculpture in the imperial collections in Vienna. . . . The parts of her flesh [!] are lightly rouged, her lips and eyes are colored. Her blond hair is covered by a gold embroidered cap. Beneath the square neckline of her dark dress, a gauzy thin blouse reveals itself. The serene curve of her forehead once bore a pearl, which a tiny hole still marks."[16] The somewhat masklike and schematized treatment of the young beauty, which is far removed from the realism of the

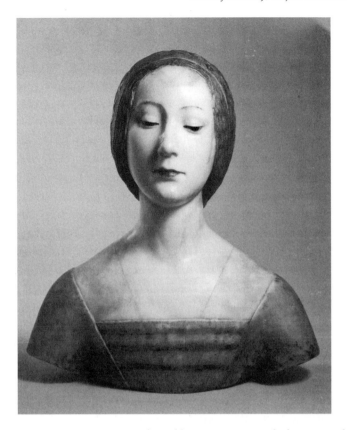

Fig. 8.5 Francesco Laurana, *Portrait of a Noblewoman,* 1480s, polychrome marble with colored wax applications. Reproduced by permission of the Kunsthistorisches Museum, Vienna

Woman with a Posy, is enlivened by the use of color cosmetics, which simulate a chaste blush and roselike lips. (We are not certain whether Verrocchio's bust was also painted. The marble in the area of the pupils is darkened, however, suggesting that they once might have been colored or in some way marked.)

"Sasso tu non sei già" ("Stone you are not"): Seeing, Animating

Marble invites touch. We all know this irresistible desire to touch, which is usually spurred by the rule, generally enforced in museums, that the objects are not be handled. The odd nature of bouts of "statue love" is conveyed by the ancient story

of the Cnidian Venus, whose marble was forever stained after a youth embraced it rather too stormily.[17] Even if sculpture was looked down on in the *paragone* discourse of the quattrocento as a less intellectual and more craft-oriented art, it had also been, since antiquity, the medium that, by acting on the viewer's experience of the sculpture's corporality, most acutely contributed to confusing the senses.[18] The topos of *spirantia signa*—of statues that appear to breathe, live, or come to life—is widespread in the poetry and literature of art, the effect typically eliciting praise for the artist.[19]

The desire for the artwork to have both "voce ed intelletto" already finds expression in two sonnets by Petrarch in the *Rime sparse* on Simone Martini's portrait of the beloved Laura: "Se responder savesse a' detti miei!" ("Oh, if only she knew how to answer me!"), the poet sighs.[20] The deceptively lifelike image—conceived by Simone Martini in heaven—appears to listen to the poet but cannot answer. The sonnet ends with an expression of disappointed desire: "Pygmalion, quanto lodar ti dei / de l'imagine tua, se mille volte / n'avesti quel ch'i' sol una vorrei!" In a similar way Lorenzo de' Medici in sonnet 24 of his *Comento* yearns for a sign of life: "Quinci surge un disio nuovo in la mente, di veder quella che ode, parla e spira."[21]

A latent wish to break through the barrier that prevents the statue from talking back is satisfied in poems in which speaking and answering sculptures transgress the boundaries of the poetic subject.[22] Just how such a feat might be accomplished is expressed in a sonnet by Antonio Brocardo on a female portrait bust.[23]

O pura neve, o bianco marmo eletto
ove, se ben contemplo intento e fiso,
lampeggiar veggo quel celeste riso
colmo tutto di gioia, e di diletto.
Sasso tu non sei gia, che questo è il petto,
e di Madonna il leggiadretto viso:
quest'è quell'aria pur, che un paradiso
chiaro dimostra nel suo bel conspetto.
Antico Phidia, se dentro a tuoi marmi
festi un bel volto già: chi vide in quello,
Atti, riso, guardar, moto, e favella?
com'io; ch'in questa pietra tutto 'l bello
scorgo de la mia Donna? & certo parmi
ch'ella ragioni meco, & io con ella.

(O pure snow, O choice white marble
in which, if I gaze intently and fixedly,
I see that heavenly laugh sparkling
overflowing with joy and with delight.
Stone you are not, for this is the bosom
and the graceful face of my mistress:
this is indeed the air that reveals
a bright paradise in her fair presence.
Ancient Phidias, if within your marble
you once made a lovely face, who ever saw in it
actions, laughter, glances, movement, and speech,
as I in this stone discern all the graces
of my lady? And truly it seems to me
that she speaks with me, and I with her.)[24]

Animation of the cold beauty is here characterized as an accomplishment of the male admirer's imagination and powers of projection.[25] Imagination and reality seem to blur; the stone is animated by the act of intense observation. "Sasso tu non sei già!"—the sweet presence of the absent is celebrated. Male desire makes use of the image of the beloved and employs its status as an artwork to enflame its own fantasies. Within the conventions of neo-Platonic courtship, the image both reflects and compensates for the aporia of fulfillment.[26] The difference between the original image and its representation is no longer lamented. The illusionistic character of the artwork is instead employed in the sense of a staged self-deception to satisfy the fantasy.[27] These male projections are, at a fundamental level, repetitions of the Pygmalion myth. The myth and conventions of courtly love share striking similarities in their lament over the statuelike distance of the beloved, in their desire to be greeted and have their gaze returned, and in their tendency to isolate the woman.

The doubt frequently expressed in contemporary epigrammatic verse about the artist's ability to capture not only the sitter's likeness but also his or her spirit and liveliness is supported by the belief that the image cannot show more than the body itself can.[28] The challenge of portraiture is to imitate the spirit—"voce ed intelletto"—that manifests itself in individual expression and that shapes the transparency of the body's expression of "self." In the early modern period, the articulation of the "self" through the binding of likeness and speech occurs by means of the motto. The mute image is animated through the emblem's allegorical

language, filling the fragile space of representation. It is Verrocchio's extraordinary bust of the *dama del mazzolino* (fig. 8.3) that transposes this principle into stone. Here, the sculpture's muteness is overcome by the emblem of the bouquet. As a "speaking" prop, the garland tells a story that is clearly connected with that of the flower bearer. Verrocchio self-consciously pushes the artwork to the edge of its potential for animation.

"Dama / Madonna": Seeing, Longing

The kind of image rooted in the visual culture of the quattrocento with which contemporary viewers would have associated the sight of this bust was not one, however, that originated within the context of secular portraiture. Verrocchio returns, instead, to popular late trecento and quattrocento representations of the *Madonna lactans* that were produced in large numbers.[29] One example of this kind of work is the small diptych by Rogier van der Weyden from around 1460 made for Jean Gros on which the unusual portrait of the *Woman with a Posy* is based (fig. 8.6).[30] Verrocchio copies the hands of the *Maria lactans* and varies them. He transforms a well-known, religiously laden visual cliché into his image of the beloved. The dialectic of presence and absence, of attentive, meditative looking coupled with a sense of the beloved's unreachable distance, characterizes the attitude in which both holy images and lover's portraits were received.

As has been pointed out by Anne Hollander and Margaret Miles, male viewers felt quite ambivalent about images of the Virgin in contemporary clothing suckling (her child), images in which her youthful breast was treated with anatomical correctness.[31] At the end of the Middle Ages, the idea of the Madonna as *nutrix omnium*, as the maternal, spiritual nourisher of mankind, is treated in an increasingly intimate and lifelike fashion (fig. 8.7).[32] The ideal of courtly love had a marked influence on the image of the Madonna, blurring the distinctions between sacred and profane notions of love.[33] The tension that arose out of this, between sacred message and erotic suggestion, turned a great number of representations of the *Madonna lactans* into singularly ambivalent images in the eyes of the male beholder.[34] Savonarola's well-known criticism that, in her fashionable attire and state of undress, Mary was being portrayed by artists as a whore marks the culmination of protests against alluring, seductive images of the Virgin. "Do you believe that the Virgin Mary went dressed this way, as you paint her?" he asks. "I tell you she went dressed as a poor woman, simply, and so covered that her face could hardly be seen. . . . You make the Virgin Mary seem dressed like a whore."[35]

Fig. 8.6 Rogier van der Weyden, left wing of *Diptych for Jean Gros,* ca. 1455–60, oil on panel. Reproduced by permission of the Musée des Beaux-Arts de Tournai, Belgium, © asbl Tourisme et Culture

Beginning in the quattrocento, the eroticization of sacred love coincides with the sanctification of erotic love. This idea finds expression in the reliquary-like adoration of the beloved. Such love is, within the conventions of courtly love, expressed as an adoration of the remote and unapproachable beauty.[36] The countless, structurally similar, Petrarchan sonnets of the quattrocento are examples thereof. The cult of the woman possessed the same characteristics as the adoration of the Virgin in the sphere of Christian piety. Legends of exchanging or else of transferring love of a real woman to love of the Mother of God have a long tradition. One such example, which cannot be examined in detail here, is that of the *Speculum historiale* of Vincent of Beauvais, in which a young man, enflamed with love, claims

Fig. 8.7 Jan van Eyck, *Madonna di Lucca*, detail, ca. 1435, oil on panel. Reproduced by permission of Städelsches Kunstinstitut, Frankfurt, © Blauel/Gnamm/ARTOTHEK

to have placed an earthly bride's ring on a picture of the Madonna in order to wed her.[37] Leonardo tells the story of what by today's standards involves a striking combination of sentiments: "It once happened that I made a picture representing a divine subject, and it was bought by a man who fell in love with her. He wished to remove the emblems of divinity in order to be able to kiss the picture without scruples. But finally conscience overcame his sighs of desire and he was obliged to remove the painting from his house."[38] Desire is enflamed by the holy subject, by the image of pious chastity. The boundaries between religious and erotic surrender are shown to be fluid.[39]

Sigismondo della Stufa writes in the following manner to Lorenzo de' Medici in 1466 about a meeting with his ladylove, Lucrezia Donati. According to Sigismondo, he encountered the beautiful, veiled Lucrezia on her way back from confession, "e

tutto contrito de' sua peccati, senza fuco alcuno, che non vedesti mai sì bella cosa, con quella vesta nera e il capo velato, con que' soavi passi che pare che le pietre e le mura gli faccino riverenzia quando va per la via." The account ends with a truly devout wish: "Io non voglio dir più avanti, per non ti fare peccare in questi dì santi."[40] The veiled beloved, recently cleansed of sin, becomes the object of desire. In a reversal of neo-Platonic logic, the woman's beautiful, sexually enticing corporality is inferred from her *virtus* and lack of sin.

Even the flowers, which Verrocchio's *dama del mazzolino* dreamily presses to herself, are primarily a sign of her *virtus*. In Marian iconography, flowers also function as a symbol of the *virtù di Dio*, Mary's greatest gift to believers. In quattrocento sonnets, the beautiful, white, marmoreal, flower-giving hand always attests to the *virtus* of its carrier, to its divine mission.[41] According to neo-Platonic thought, women were first and foremost agents of beauty, leading men first to earthly love and then to divine love.[42] Just as Mary was the most important intercessor to God, so women acted as intercessors on behalf of men. Both the Mother of God and the beautiful beloved possessed a fundamentally transitional status. They were both objects of desire and of veneration. They crystallized fantasies so that, finally, they might, as *mediatrices*, lead men to a state of heightened sensibility, to God. Chaste beauty, as depicted in female portraiture, was an important requirement for the young woman as divine medium, yet it could also be sexually arousing.

Fragment, Reliquary, Fetish

Since the trecento, lifelike, female reliquary busts had been produced that should be considered precursors to quattrocento female portrait busts.[43] Particularly noteworthy in this regard is the reliquary of St. Fina from San Gimignano, which is made of pieces of leather (fig. 8.8).[44] In another bust, most likely of the same saint, from the end of the fourteenth century, her "skin" is painted in subtle flesh tones, and the cheeks are highlighted with "rouge" in order to achieve the most realistic rendition of the face possible (fig. 8.9).[45] There are other reliquary busts of this kind, in which the material is carefully painted in an effort to create a most convincing impression of "liveliness." In the fifteenth century, furthermore, a type of lifelike holy bust of extreme physical beauty arose that paralleled that of the portrait bust. Often only identified as saints by means of inscriptions, they possess captivatingly portraitlike qualities. A case in point is yet another bust of St. Fina from the late quattrocento, an example of extraordinary beauty and one of the few surviving polychrome marble busts (fig. 8.10).[46]

Fig. 8.8 Bust reliquary of St. Fina, ca. 1320, polychrome and gilded leather. Photograph courtesy of the Basilica di Santa Maria Assunta, San Gimignano

Just how these sacred busts could blur the boundaries between cult object and portrait of female beauty becomes evident if we compare them with profane busts. If an aestheticization of the holy image takes place during the quattrocento, then this process has its counterpart in the sacralization of the image of the beloved, as in the case of the *dama del mazzolino*. Both tendencies attest to the mutual profanization and secularization of the art and cult image.[47]

Preference for the form of the fragmented bust that is so characteristic of quattrocento Italy is nourished, on the one hand, by a much sought-after connection with antiquity and, on the other, by the anatomization of women in the period's Petrarchan love poetry.[48] The "deconstruction" of the female body that takes place here is largely inspired by the canon of beauty established by the *Canzoniere*; this canon was still influential in the sixteenth century. The neo-Platonic love poetry of the circle of Lorenzo the Magnificent follows the practice of praising individual parts with only a few differences: blond tresses shining like gold, cheeks fresh as milk and roses, fair brows, eyes like stars, ivory teeth like white pearls, lips red as roses, angelic breasts, slender and marmoreal or ivory hands.[49] The loved one ap-

Fig. 8.9 Mariano d'Agnolo Romanelli (attrib.), bust reliquary of St. Fina, ca. 1390, painted and gilded wood. Reproduced by permission of the Museo Civici di San Gimignano, Pinacoteca

pears as a composite image, adjusted to fit the ideal image of the one great love: Laura.

The topical praise of individual body parts culminates in the sixteenth-century tradition of the *blason*, in which poets competed with one another to dissect entire parts of the female body. The body becomes a repository of spare parts for epideictic poetry. Male narcissism expresses its misogynistic praise at the expense of bits and pieces of the female body.[50]

The Petrarchan sonnets generally describe and praise not the entire body but only the upper half, emphasizing the face, which is considered the most visually appealing. This is also true for ekphrastic and iconic poetry. There are a number of poems that specifically relate to portrait busts. Antonio Brocardo's sonnet on the "bosom" and the "graceful face" of his mistress's sculpted bust has already been cited. Another related example is Alessandro Bracci's poem "Ad bustum mar-

Fig. 8.10 Pietro Torrigiani (attrib.), *St. Fina*, ca. 1496, polychrome and gilded marble.
Reproduced by permission of the Musei Civici di San Gimignano, Palazzo Comunale

moreum," part of several epigrammata on Sigismondo della Stufa's early deceased
fiancée, Albiera degli Albizzi.[51] Bracci's eulogy on Albiera and her portrait is re-
markable insofar as he lets the marble speak directly to the passerby: "Ne tamen in
terris formosior ulla deabus / esset, mors iussu me rapuit superum."[52] The speaking
bust thus testifies to the genre's illusionistic potential.

In general, the correspondence between the fragmentary character of busts and
the restriction of the Petrarchan canon's praise of beauty to head and bust (and
hands) is astonishing. Both are results of intentional and artistic reductions, of
male fixations on certain "carrier signals" associated exclusively with the upper
part of the woman's body that appears as an artifact. When the busts were not
made up and embellished with color (as were only very few), the white marble
busts of young ladies materially visualized central Petrarchan *topoi*: the fair hair,

the pale skin, and brightly shining eyes. One can imagine that their polished whiteness and stainless marble brilliance was readily associated with antiquity but above all with Laura's supernatural beauty. The fair, ivorylike, and marble qualities of women in Petrarchan poetry and Renaissance sculpture imply purity and chastity; their brightness, radiance, and luminosity emphasize—just as in antique Roman sculpture—their powerful, godlike status.[53]

As objects of veneration and adoration, as ambivalent icons of chastity, the quattrocento female portrait busts also preserve aspects of reliquary worship. The *Woman with a Posy*—in its amalgamation of erotic representation and religious pictorial idea and in its striking depiction of the role artwork could play in mediating both absence and presence—serves as an example of this perseverance of the reliquary notion. Because they stood in a synecdochic relationship to the saint, the fragments of the body hidden inside the reliquary possessed great sacred value in the practice of reliquary worship. The reliquary functioned as a *pars pro toto*; the fragment attested to the presence of the absent, of the saint within the receptacle of the image.[54] Similarly, the busts of girls preserve and portray woman's greatest treasure—the *virtus*—in their image that is akin to a vessel. The incorporation of hands, gestures, and characteristic attributes into the concept of the *dama del mazzolino* is highly reminiscent of the type of "speaking" reliquary (fig. 8.11).[55]

The Petrarchan praise of beauty, which breaks down the female body into parts, further attests to a process of fetishization. Here admiration is predominantly expressed for those parts of the body that substitute for the whole.[56] The sacralization of women in contemporary love poetry using metaphors that are orientated toward the cult of reliquaries distances the loved one as an adored being and relegates her "to divine heights"; it "transforms parts of the body into fetishes, just like a reliquary."[57] Fragmentation, sacralization, and fetishization occur and shape the male viewers' perception. The female portrait busts of the quattrocento could thus be largely understood and constructed as fetish objects by which the male imagination was triggered. They were the cause and means of animation fantasies, which should not simply be considered *topoi*. Generally speaking, attitudes toward the reception of images—something that has been emphasized in the recent literature—were not based on purely aesthetic principles.[58] A Renaissance conception of pictures should instead be understood as arising out of the tension between representation and magic.[59]

The Medici ex-voti and the cult that was driven by them, such as after the Pazzi conspiracy, exemplify a well-developed manner of thinking in terms of analogies, in which the representation and the represented are closely linked.[60] The idea that

Fig. 8.11 Bust reliquary of St. Baudimus, late thirteenth century, gilded copper. Notre-Dame-du-Mont-Cornadore, St.-Nectaire. Photograph courtesy of the Paroisse Ste.-Marie des Lacs et des Couzes

love entered through the eye—an ancient topos, which is also present in medieval ideas about the magic of pictures—persists in the Renaissance.[61] An example of the experience of being pursued by the painted eye of an icon is of course Cusanus's "figura cuncta videntis," whose magical effect is described as "imago omnia videntis" in *De icona sive de visione Dei* (1453).[62] Using the example of the self-portrait of Rogier van der Weyden and of a true icon, Cusanus describes the *figura cuncta videntis* created by the artist's skill, which follows the viewer with its gaze and with which Cusanus holds a visual dialogue. The pictures stare back!

Interestingly, it is the power of the gaze, which, in the form of metaphors of

the nearly omnipresent eye and pupil, permeates Petrarch's *Canzoniere* and the Renaissance love poetry inspired by it.[63] The Medusan power of the eye, metaphor for women's erotic might, leaves men trembling and petrified, for example, in sonnet 197 of the *Canzoniere*: "po quello … in me che nel gran vecchio mauro / Medusa quando in selce transformollo; / né posso dal bel nodo omai dar crollo, / là 've il sol perde, non pur l'ambra, o l'auro" and further on: "L'ombra sua sola fa 'l mio cor un ghiaccio, / et di bianca paura il viso tinge; / ma li occhi ànno vertù di farne un marmo."[64] Another example is sonnet 22 in Lorenzo de' Medici's *Comento*: "Miseri noi, che se fiso mirassi, / fermando in noi le vaghe luci e liete, / il nostro bavalischio, o faria priete (pietra) / di noi, o converria l'alma expirassi!"[65] This lament corresponds to the latent opposition of fire and ice, hope and disappointment, in the lover's perception of the beloved in Petrarchan poetry. On the other hand, the cold stone and white marble serve as metaphors for the inaccessibility of the object of desire: "Nulla posso levar io per mi' 'ingegno / del bel diamante, ond'ell'à il cor sì duro; / l'altro è d'un marmo che si mova et spiri: / ned ella a me per tutto 'l suo disdegno / torrà già mai, né per sembiante oscuro, / le mie speranze, e i miei dolci sospiri."[66]

The petrified woman, the stony beloved, who excites men, but who does not listen to them, becomes a standard poetic conceit: "Sei freddo smalto," Pietro Bembo claims in an iconic poem.[67] "Sei freddo smalto," "sasso tu non sei già": petrification and animation and sweet deception and disappointment form the poles of male laments that are also evident in more conventional refrains of poetic despair. As art objects that were both winning and seductive, as dead stone that was both fearsome and cruel, the marble busts of young beauties set this dynamic in motion. The tension imbedded in these types of busts derives from the fact that they present the potential for illusion but the illusion reveals itself to be finite. The deconstructed body becomes the object of male adoration and, in its accommodation to the male gaze, turns into an ambivalent fetish. The icon of chastity is simultaneously also an *objet d'amour*, an object of passion.

Like a Virgin

Male Fantasies of the Body in *Orlando furioso*

Albert R. Ascoli

It is by now well established that questions of gender identity—continuously located in and around ambiguous female, and male, bodies—arise throughout the length of *Orlando furioso*.[1] Considerable critical attention has been focused over the last two decades on the representation of women in the poem.[2] It is has also been recognized to a certain extent that the *Furioso*'s treatment of women is inextricably linked to the construction, or perhaps better, the interrogation, of masculinity.[3]

I have argued in the past that canto 37 of the 1532 *Furioso* dramatizes two sides of a single phenomenon through its implicit analysis of the nature and functioning of male "invidia" of women (37.1–20; cf. 20.1–3). On the one hand, the Ariostan narrator suggests, men invidiously conceal the notable accomplishments of women in both arms and letters and at the same time expose their "cose segrete," the impure secrets of the genital, reproductive body of woman.[4] On the other hand, the narrator himself not only doubles the men he condemns in his mistreatment of female characters but also, like them, sets out to appropriate for himself the reproductive and other powers that the male imagination attributes to female

sexuality, expressing a form of "womb envy" and / or vagina envy that belies, or at least complements, the Freudian notion of penis envy or the Lacanian regime of the phallus.[5]

In this chapter, I examine another aspect of the construction of masculinity both in opposition to and through appropriation of the female body, as it plays out over the course of the *Furioso*, structuring fundamental narrative and thematic elements of the poem.[6] My specific concern is with a key thematic configuration in which the ideally unpenetrated state of the chaste female body, that is, virginity, is paired off with an idealized projection of the impenetrable male body in the form of armor (plus sword). My argument is that these two emanations of a cultural fantasy that is primarily gendered male are continuously linked throughout the poem and that the dividing line between them is repeatedly "violated" or "effaced"—in such a way as to imply that the men of the poem not only define their desire in relation to the virgin female body but also wish to possess bodies that are figuratively "like a virgin's."[7]

1

The very first canto brings together two examples that establish this pattern as fundamental in the *Furioso*. On the one hand, there is Angelica, the pagan Indian princess who is desired by all the male characters with whom she comes in contact.[8] At first, the source of Angelica's desirability appears to be great physical beauty.[9] But, as it turns out, her beauty is nothing in the absence of another physical characteristic (or at least the male suitors' belief in the same; see 1.56), namely her virginity, without which, as Sacripante makes plain, and as Orlando's madness later confirms, her body ceases to hold any interest or value for her pursuers:

> La verginella è simile alla rosa,
> ch'in bel giardin su la nativa spina
> mentre sola e sicura si riposa,
> né gregge, né pastor se le avicina ...
> Ma non sì tosto dal materno stelo
> rimossa viene e dal suo ceppo verde,
> che quanto avea dagli uomini e dal cielo
> favor, grazia e bellezza tutto perde.
> La vergine che 'l fior, di che più zelo

che de' begli occhi e della vita aver de',
lascia altrui corre, il pregio ch'avea inanti
perde nel cor di tutti gli amanti.

(The delicate young virgin is like the rose that so long as it is alone and secure
resting among its natal spines, in a beautiful garden, neither herd nor shepherd
approaches it. . . . But no sooner is it removed from its maternal stalk and from
its green branch than it loses all its beauty and grace and all the favor it received
from men and from heaven. The virgin who allows another to pluck the flower,
for which she should have more zealous care than for her lovely eyes and for her
very life, loses that value she previously had in the hearts of all her other lovers.)
(1.42–43)[10]

As throughout much of the Western literary, not to mention social, tradition, here
male desire is directed precisely at an intact female body and a subsequent "posses-
sion" that paradoxically abolishes the physical state of virginity.[11]

Angelica's virginal state is then mirrored and inverted by the advent of a second
female virgin, Bradamante.[12] Where the chaste, if devious, Angelica is pursued by
many, the straightforward Bradamante is a pursuer, whose chastity appears in the
"active" form of a desire directed toward one, legitimate, male object. But Brada-
mante presents a complication: when she first appears, she is taken not for a female
virgin but for a male knight: "Ecco per il bosco un cavallier venire, / il cui sembiante
è d'*uom* gagliardo e fiero" ("Behold a knight comes through the wood, whose ap-
pearance is that of a man, robust and fierce") (1.60.1–2). The confusion arises, of
course, because she is encased in a suit of pure white armor, which subsequently
repulses the assault of Sacripante's lance.

Attention to this episode usually focuses on the assumption by Bradamante of
a presumptively male role and the depressing, even emasculating, effect her defeat
of him has on the pagan knight (1.66, 69–71).[13] What I think has been less perfectly
perceived is an implicit symmetry between the intact body of Angelica and the
effectively impenetrable armor of Bradamante. The first indication that a parallel
exists is given by the "virginal white" color of the unknown knight's armor, tradi-
tionally emblematic of an unstained purity, at once physical and spiritual: "*candido
come nieve* è il suo vestire, / un *bianco* pennoncello ha per cimiero" ("white as snow
is his clothing, a white plume adorns his helmet") (1.60.3–4; my emphasis).[14]

That a woman is beneath the snowy surface suggests that the armor, which
conceals and protects her body, also emblematically represents the body's intact
state. The connection is then confirmed, and at the same time linked to the twin

male fantasies of martial and amatory conquest, when Sacripante's failure to pierce Bradamante's armor is cast as the direct cause of his (temporary) abandonment of the project of raping Angelica (1.71).

The first canto creates a clear parallel between, on the one hand, a male desire to penetrate female bodies with their own bodies and, on the other, male attempts to puncture other bodies, usually male, with phallic lances and swords.[15] At the same time, symmetrically, an analogy is established between the physical state of female virginity—figured by the hymen—and the covering armor by which knights, normatively male, attempt to render their bodies invulnerable to assaults of their peers.[16] This equivalence, established in the ways just noted, is further evinced by the text's insistence that in enduring at least a symbolic penetration of himself (1.61–64), Sacripante has lost to Bradamante "quanto onor mai tu guadagnasti al mondo" ("all the honor you ever earned in this world") (1.70.4)—a deprivation that mirrors the negation of female honor that the loss of virginity was earlier said to entail (cf. 1.43.5–8).[17]

What first appeared to be an episode focused on two women, their bodies, and their gender identities, is also—even primarily—concerned with the construction of male identity *in relation*, literal and figurative, to the female body. One might think at first glance that the issue is solely the "genealogical," patrilineal one of the obsessive cultural need to establish female chastity—virginity first and then chaste fidelity to one partner—as the grounds for assuring lineal transmission of the father's name and property.[18] There is no doubt that this is a central concern of the text, especially given the genealogical weight that Bradamante bears throughout the poem.[19] Nonetheless, it does not entirely account for the gendered configurations produced in canto 1. Rather, the immediate focus is on the significance of the male desire "for" virginity—considered apart from marriage and procreation—in what turns out to be the double sense of wishing to penetrate female bodies while remaining himself unpenetrated. This double fantasy, however, turns back on the man, Sacripante, who "embodies" it, as rather than penetrating unpenetrated he is, at least emblematically, penetrated without penetrating—finding himself in a position very like that of a "deflowered" woman described a few stanzas earlier.

2

Some thirty-four cantos later, Bradamante enters into a combat that in many ways constitutes a reprise of her earlier encounter with Sacripante (35.31–57). Bradamante meets the disconsolate Fiordiligi, exemplar of wifely chastity, who pleads

with the woman-warrior to rescue her beloved Brandimarte, who, along with many other Christian knights, has been stripped of his armor and imprisoned after being defeated by Rodomonte on the bridge beside the tomb he erected in honor of the dead virgin Issabella, whose "martyrdom" he himself had caused. In battling Bradamante, who on this occasion has declared explicitly that her armor covers a woman's body, Rodomonte aims to accomplish with one woman both of the acts of penetration that Sacripante undertakes unsuccessfully with two. Having overwhelmed her defenses in combat, he will take possession not of her armor (as in all the other cases) but of her body, her virginity:

> Ma s'a te [Bradamante] tocca star di sotto, come
> più si conviene, e certo so che fia,
> non vo' che lasci l'arme, né il tuo nome,
> come di vinta, sottoscritta sia:
> al tuo bel viso, a' begli occhi, alle chiome,
> che spiran tutti amore e leggiadria,
> voglio donar la mia vittoria; e basti
> che ti disponga amarmi, ove m'odiasti.
> Io son di tal valor, son di tal nerbo,
> ch'aver non dei d'andar di sotto a sdegno.

> (But if it befall you, Bradamante, to lie beneath me, as it is fitting it should, and I know for sure it will, I don't want you to surrender your arms and armor, nor do I wish your name to be written below them in token of your defeat: to your beautiful visage, to your lovely eyes, and to your tresses—which all breathe forth love and loveliness—I wish to dedicate my victory; it will be enough that you dispose yourself to love me, there where you hated me. I am of such valor, of such fiber, that you must not disdain to fall under my assault.) (35.46.1–47.2)

Bradamante does not respond to the sexual challenge but simply initiates combat; only later, once she has convincingly flattened her adversary, does she rehearse his language with a taunt that calls attention to a "castrating" gender reversal ("'Or puoi,' disse, 'veder chi abbia perduto / e a chi di noi tocchi di star di sotto'" ["'Now,' she said, 'you can see who has lost and which of us lies under which'"] [35.50.3–4]).

Just as with Sacripante, both of the pagan warrior's quests fail: Rodomonte is unable to make a dent in Bradamante's armor and consequently does not gain control over her body. Instead, it is he who is defeated—humiliated in a way that

specifically recalls Sacripante's embarrassment (35.50–52; cf. 1.69–71)—and it is he who is stripped not only of his prisoners but also of his own armor (35.51.3–4), the invulnerable carapace inherited from his Babelic ancestor, the deity-defying "giant" Nimrod.[20] In short, both the intratextual connections that link this episode to canto 1 and its internal narrative-thematic structure bring again to the fore an analogical equivalence between the physical state of female virginity and the armor that in theory protects the (normatively male) body. Here, indeed, the analogy is strengthened by the fact that Bradamante is now a target both militarily and sexually and by the implicit symmetry between the two projected outcomes of the duel: either Rodomonte will remove his armor or Bradamante will surrender her virginity to Rodomonte.

3

Between these two episodes involving Bradamante, who, with Ruggiero, is the central genealogical protagonist of the *Furioso*, comes another that, as so often in the poem, deploys a somewhat lesser figure—in this case the moorish princess, Issabella—as a critical narrative and thematic relay further linking and, I would argue, interpreting them.[21] The episode in question, recounted over the first third of canto 29, supplies the narrative premise for Bradamante's battle with Rodomonte, and it, too, explores the linkage between "virginity" and male identity established in canto 1 and rehearsed in 35. Specifically, I refer to Rodomonte's failed attempt on the virginity of Issabella, which culminates in the trick whereby she leads the drunken pagan to cut off her head, martyring her and thus preserving her chastity, and his subsequent (incomplete) erection of a tower and institution of a "custom of the castle" in her honor.[22]

Issabella is a crucial if underanalyzed figure in the *Furioso* and, together with her husband manqué, the doomed Scottish prince Zerbino, and her opposite / nemesis the seductress-turned-hag Gabrina, forms part of a structural and thematic unit of the poem that illustrates and renders problematic a number of its most prominent concerns.[23] In other words, she serves as a Jamesian "mirror" set up to illuminate much of what goes on with the principal characters and tales of the *Furioso*.[24] Most particularly, from the perspective of this chapter, she is ostentatiously a virgin and, as such, she is placed in specific relationship to both Angelica and Bradamante.[25] Her virginity is foregrounded precisely in the sense that, like Angelica's, it is repeatedly placed in jeopardy or called into question and just as repeatedly reaffirmed: it is threatened by Odorico (13.21–29), called into doubt by her sojourn

among the bandits (13.30–31), calumniated to Zerbino by Gabrina (20.140–41), and then, finally, menaced by Rodomonte in canto 29.

She is first introduced in cantos 12 and 13, when Orlando, pursuing Angelica and specifically supposing she might be hidden in a tomblike cave he comes upon, finds Issabella there instead (12.85–94), establishing a symbolic link between the two women. When that episode ends (13.44), the Ariostan narrator turns immediately to Bradamante and within a few stanzas presents her with a vision of the most illustrious female members (daughters and wives) of the Este family she is destined to found, the most prominent of whom is Isabella d'Este, marquess of Mantova, whose name is even more specifically linked to the homonymous character at the time of the latter's martyrdom (13.55–74, esp. 59–61, 68).[26] Canto 29, which begins with Issabella's virginal apotheosis, ends with Angelica's escape from the homicidal violence of Orlando run mad (29.58–74), an episode whose significance I consider more carefully below. The links between Issabella and Bradamante are, if anything, even more prominent than those between Angelica and Bradamante, since in addition to being virgins, they are explicitly associated in the narrative. As noted earlier, Bradamante's battle with Rodomonte, which constitutes revenge for his murder of Issabella (35.41–43), takes place at the monument he erected to her memory in canto 29 (32–33, 40).

If Issabella is in some sense a textual paradigm of female virtue, her adversary and dupe, Rodomonte, is a prime example both of chivalric masculinity and of its undoing.[27] Linked through his ancestor Nimrod to the phallic tower of Babel—a new version of which he begins to construct (but, emblematically, never completes) as part of the monument to Issabella—he also possesses the Nimrod's invulnerable dragon-skin armor.[28] He is, in short, the archpagan, hypermasculine warrior. Yet his attempts to correlate his potency as warrior with sexual prowess are consistently thwarted. In curious parallel with Issabella, whose virginity is threatened on three distinct occasions, he three times presumes that he will be the man to possess the virginity of a beautiful young woman and three times is denied, each time by the agency of the woman herself—first by Doralice's choice of Mandricardo over him (esp. 27.102–11), then by Issabella's trick, and finally by his defeat at Bradamante's hands. In each case the result is a castrating assault on his masculine identity (first he deprives himself of his role as chief champion of the pagan cause by leaving the camp of Agramante; then he suffers the shame of having killed the woman he professed to love; finally Bradamante takes away his emblematic armor and specifically rubs in the fact that, defeated, he is in a sexually submissive, i.e., culturally female, position [30.50.3–4]).

From this perspective, then, the brief pairing of Issabella and Rodomonte constitutes an exemplary intersection between fantasies of the female and male bodies, one that potentially sheds special light on the paradigms delineated at the end of canto 1. Here is the narrative to be considered: Rodomonte, mourning the betrayal of Doralice and the lost fantasy of female chastity, meets Issabella, mourning the death of the one man, Zerbino, on whom she had wished to confer her virginity. The symmetry of their situations is underlined by the fact that she has converted to Christianity and is headed to a convent to spend the rest of her life as virgin bride of Christ (24.88–92, 28.96, 29.11), while he, rather inexplicably, has decided to take up residence in a Christian church and has, parodically, "converted" to the drinking of wine (28.93–94, 29.11–12).[29]

The symmetry then breaks down (or, rather, expresses itself in a different way) when Rodomonte, who has just heard a comic story reinforcing his fears that his fantasy of female chastity is exactly that (27.131–28.85), suddenly has his faith in chastity revived in the person of Issabella (28.97–98). He promptly begins to desire to "possess" her virginity, while Issabella, predictably, determines that she want to keep it to herself (29.9–12). In order to do so, she devises an elaborate ploy (29.13–26), one which Ariosto derived from an exemplary tale in Francesco Barbaro's *De re uxoria*.[30] She tells Rodomonte that she possesses the secret of an herb that can render the body "inviolabile" (17.7) to penetration by weapons and that she will confer this secret on him, on the condition that he renounce possession of her body (13–14). He agrees, all the while planning to renege on the agreement once he possesses the secret (17–18). She prepares a "liquore" ("liquor") (15.6, 24.2; cf. 22.3) or "acqua" ("water") (16.5, 18.2, 19.3) from herbs she has gathered and then anoints her own neck with it, inviting Rodomonte to strike it, so that he will not think she has tricked him into leaving his own body vulnerable to assault. Full of the wine to which he has now become devoted, Rodomonte brings his sword down on her neck, severing her head from her body:

> Bagnossi, come disse, e lieta porse
> all'incauto pagano il collo ignudo,
> incauto, e vinto anco dal vino forse,
> incontra a cui non vale elmo né scudo.
> Quel uom bestial le prestò fede, e scorse
> sì con la mano e sì col ferro crudo,
> che del bel capo, già d'Amore albergo,
> fe' tronco rimanere il petto e il tergo.

(She drenched herself as she had said she would and happily offered her naked neck to the incautious pagan—who was also, perhaps, overcome by the wine, against which neither helmet nor shield offers protection. That bestial man believed her and thus with his hand and with his cruel sword sliced through, so that he left the lovely head, once the dwelling of Love, severed from her breast and her back.) (29.25)

Issabella's death guarantees her chastity and turns her into a remarkable example, explicitly comparable to Roman Lucretia, of female chastity and self-sacrifice (29.27–30, esp. 28.3–4). In consequence, Rodomonte creates the tomb, tower, and accompanying ritual in her honor (29.31–33), leading up to his castrating encounter with Bradamante.

Valeria Finucci has studied in considerable detail how the episode's apparent celebration of Issabella's exemplary virginity constitutes both an expression and an analysis of male narcissism, of the way in which masculine identity is simultaneously constructed in relation to and threatened by the chaste female body.[31] There is no doubt that in arranging to preserve her virginity at the cost of her life, Issabella acts out what is essentially a male fantasy about female corporeality, one that, as the genealogical dimensions of the narrator's paean to his heroine then reveal (insofar as, from canto 13 on, he links her to the chastity of Este women such as Isabella d'Este and Lucrezia Borgia, wife of Alfonso), is closely linked to a patrilineal notion of exclusive possession of female bodies by individual male subjects.

Still, it is not impossible to make a case for female agency and even autonomy in the episode.[32] Issabella herself stands outside of any genealogy (her mate is dead; she has no children), and, in comparison, say, to Roman Lucretia, what is at stake for her is maintaining control of her own body and realizing her own desires rather than any larger political purpose. Specifically, unlike Lucretia, she manages to prevent sexual violation of her body while making her would-be rapist guilty of murdering her rather than taking her own life. At the same time, she "positively" circumvents Zerbino's demand that she forgo her desire to commit suicide after he dies, achieving her own ardently expressed wish to join him in death if they cannot be united in life (24.80–85, 87). In other words, although her death responds to a generalized male demand for female self-negation, it also constitutes the refusal of not one but two individual male attempts to exert defining control over her body.

The two perspectives, I will now argue, are not entirely incompatible. On the one hand, Issabella's control over her body amounts to enacting what remains an essentially patriarchal valuation of virginity and chastity and leads to the annihi-

lation of the self, or at least its mortal existence. On the other, the mechanism by which Issabella thwarts Rodomonte to preserve her virginity, which has received no significant interpretation to date, reveals a deep, critical understanding of male fantasies of both the male and female bodies, one that illuminates the relationship implicitly defined in canto 1 between female virginity and the armored (male) body.

The connection, once noted, is obvious: Issabella maintains the "intact" state of her genitals by inducing Rodomonte to believe in the fantasy of an impenetrable body. Through the device of the magical "acqua," Issabella places herself between Angelica's vulnerable and yet unpenetrated body and Bradamante's armored and unpenetrated body: if the "acqua" worked it would make her body not only un-penetrated but literally impenetrable. As it is, the trick by which she somehow persuades Rodomonte both that her skin will become an impenetrable armor and that he will then still be able to penetrate her effects exactly the opposite result: the "armored" skin will be penetrated but her virginity will remain inviolate.

What the trick also does, then, is reestablish the equivalence between the (armo-red) body invulnerable to phallic weaponry and the virginal hymen unpenetrated by the literalized phallus as well as the *imaginary, fantasized* nature of that equiva-lence. The body, in the end, cannot be invulnerable; virginity, a quality defined as a negation, can seemingly only be preserved by a more complete negation still. In fact, the story makes plain that the ultimate equivalent of virginity as it is configu-red in the early modern cultural imagination *is* death. This point finds additional confirmation in what is probably, even in Ariosto's source, a brutal and macabre gynecological joke: the upper "collo ignudo" ("naked neck") through which Rodo-monte's sword slices (25.2; cf. 24.6) corresponds to the lower *cervix*, or "collo della matrice" (neck of the womb), which thereby remains inviolate.[33]

The trick, then, does double duty: dramatizing Issabella's active relationship to the condition of her own body, it also plays on and reveals Rodomonte's attitude both to her body and to his own. If for Issabella the trick signifies the preser-vation of her all-too-vulnerable virginity through a manipulation of the fantasy of an impenetrable body, the device only works because of the desire it elicits in Rodomonte to possess that body—or rather it only works in its playing off in him the two different ways the desire for virginity works itself out in the male imagination: in the "possession" by penetration of the body of the other and the constitution of the self as a body that cannot be penetrated. Issabella initiates the trick as if it were an exchange of one type of possession of the impenetrable body for another—Rodomonte has to promise not to penetrate her in order to become

impenetrable himself. But of course it is set up the way it is because she knows that he will not give up the one desire for the other—he will have to have both; they are inextricably linked. This point, as we have seen, is expressed repeatedly in the parallels drawn between the armored and the virginal body. It is stressed by the close juxtaposition of the reference to the body Rodomonte supposedly will acquire as *inviolabile* (17.7) with a reference to his mendacious effort, described as a self-forcing, to conceal any sign of his plan to violate her ("Sforzerasse intanto . . ./ a non far segno alcun di *violenzia*" ["Meanwhile he forced himself to show no outward sign of violence"] [29.18.3–4; cf. 28.7]).

Finally, Ariosto makes a distinct addition to Barbaro's version of the story by having Issabella describe the functioning of the "liquore" so as to make it clear that the invulnerable, apparently hypermale body it produces is specifically modeled on the biologically *female* body: the potion, she says, must be periodically reapplied, because its efficacy expires monthly:

> Io dico, se tre volte se n'immolla,
> un mese invulnerabile si trova.
> Oprar conviensi ogni mese l'ampolla;
> che sua virtù più termine non giova.

> (I say that, if one soaks oneself with it three times, one becomes invulnerable for a single month. The cruet must made use of every month, because its virtue does not extend beyond that term.) (29.16.1–4)[34]

This fantasy body, in other words, follows the menstrual cycle, according to which the hymen becomes penetrable to blood once every month (as the widely recognized etymology of the word "menses" declares).[35] In playing on Rodomonte's desire for this body, then, Issabella, shows that she understands he not only wishes to take possession of her virginity but that he also wants to become "like a virgin" himself by undergoing a mimesis of menstruation.[36]

The hidden structure of male fantasy, of a *double* appropriation of virginity not as physiological reality but as a dream of corporeal inviolability, helps to explain why Rodomonte falls for Issabella's trick, despite the lack of any practical reason for wanting what the "liquore" promises to give him.[37] As we have seen, he already possesses, de facto, such a body, in the form of the impenetrable armor received from his ancestor Nimrod. What he wants, clearly, is the possibility of literalizing his fantasy, of mapping it directly onto his own body, just as he has (re)located the fantasy of female chastity in Issabella's body.

4

The invulnerable body that Issabella offers and that Rodomonte desires has illustrious precedents, both inside and outside the poem. The locus classicus, of course, is Achilles' vulnerable heel, pierced at the last by Paris's arrow, as Rodomonte himself is explicitly aware (29.19.4). In the *Furioso*, Achilles has two heirs (cf. 12.48–49): Ferraù, who, we first learned from Boiardo, can only be killed by a wound to the naval and, of course, Orlando, who, a new Achilles in many ways, is vulnerable only on the sole of his foot.[38] Ferraù's invulnerability may help to explain why he appears so prominently near its beginning even though he has a relatively minor role in the poem. His loss of the helmet borrowed from and never returned as promised to the dying Argalia, Angelica's brother, prepares and forecasts his later appropriation of Orlando's helmet playfully stolen by Angelica (12.52–64), which in turn prefigures the metaphorical decapitation of Orlando by Angelica when he learns of her "infidelity" with Medoro in canto 23 (121.1–2). It also calls attention, indirectly, to the special nature of his body, which needs a helmet for symbolic reasons only, since his head and neck cannot be wounded, and thus, from the perspective developed here, anticipates the discourse on bodies penetrable and unpenetrated as it emerges at the end of the first canto.

Ferraù's body mirrors Orlando's body, but this does not prevent Ferraù from envying Orlando, from in some sense wanting to become him by taking possession of his rival's headpiece. This structure, in turn, suggests an alternate—perhaps opposing, perhaps complementary—interpretation of the nature of Rodomonte's desire for invulnerability as I have discussed it to this point. Perhaps rather than a desire for a metaphorical "virginity," we face instead an instance of homosocial rivalry—of Rodomonte's will to be just as "hard" as the paragon of male Christian knighthood, Orlando.

This reading might seem to receive additional confirmation from a significant example of Ariostan *entrelacement* that occurs precisely in canto 29. I have noted that Issabella's connection to Angelica is strengthened by the latter's reappearance at the end of the canto that begins with the former's martyrdom. More specifically, Angelica returns to view only to be threatened by the unthinking violence of mad Orlando, who attempts to kill her but only succeeds in destroying her horse, as she disappears through timely deployment of her magical ring of invisibility. The reader is specifically reminded at this point of the "fated" character of Orlando's impenetrable skin both because, in his madness, he is completely stripped of armor (that same armor which provoked Mandricardo's appropriative envy and led

to Zerbino's death in canto 24) and because his impenetrable skin foils Medoro's attempt to slice off his head, specifically recalling Issabella's death, just as Orlando's failed assault on his lady recalls Rodomonte's more successful, and equally "thoughtless," effort.

If, however, it is possible, in the light of this textual juxtaposition, to recast Rodomonte's desire as to be "like Orlando" rather than "like a virgin," it is equally plausible to reinterpret Orlando's madness in light of the thematics of virginity and its violation as reflected through the tale of Issabella. Orlando's slow descent into folly through the gradual discovery that Angelica has, indeed, surrendered her long-sought-after virginity to one Medoro rewrites in bolder letters Sacripante's opening lament in a similar *locus amoenus*. As just noted, the climactic realization that there is no substance to the fantasy that he and only he would penetrate the intact Angelica resonates metaphorically with the earlier episodes of Ferraù's and Orlando's own symbolic loss of a helmet: "Questa conclusion fu la secure / che 'l capo a un colpo gli levò dal collo" ("This conclusion was the axe that lifted his head from his neck in a single stroke") (23.121.1–2). When Issabella then literally loses her head in successful defense of her virginity, we recall Orlando's figurative loss of his and compare the imaginary invulnerability that Issabella uses to trick Rodomonte with the truly "inviolabile" body of Orlando, which is nonetheless no defense against the violent dissipation of the fantasy of angelic virginity. In the end, both Rodomonte and Orlando armor themselves in the wholly imaginary belief that they can penetrate unpenetrated, and in both cases it is precisely this belief that proves their undoing.

At first, in Rodomonte's case, as in Orlando's, this undoing seems to be exclusively psychological—a humiliation followed by the compensatory sanctification of Issabella's memory and the installation of the custom of depriving knights of their armor, as if to render them as physically vulnerable as Rodomonte feels himself to be psychically. In the end, however, it turns out that the episode, willy-nilly, reveals Rodomonte's corporeal vulnerability as well: first in the preliminary defeat at the hands of the mad, naked Orlando (29.40–48); then in the submission to the magic lance of Bradamante in canto 35. This latter defeat, moreover, prepares the way for the final violation of his body, because it specifically deprives him of the external armor, the dragon skin of Nimrod that had rendered him invulnerable up to that point (35.51, 55). The absence of this armor renders Rodomonte expecially vulnerable to the piercing, death-dealing blows of Ruggiero (inflicted through the visor of the helmet and buried deep in his head [46.140]) in the last scene of the poem, making the virginal warrior Bradamante in some sense an agent of his destruction

(46.119–20).[39] It is typical of Ariosto, I should say, that with double irony the last great affirmation of the male "penetrating unpenetrated," Ruggiero's victory, is dependent both on the trick of Issabella and the earlier defeat of Rodomonte by the virgin Bradamante and that this victory leads directly to the consensual defloration of Bradamante and the founding of the patrilineal Este family. The fantasy is reborn even as, in the person of Rodomonte, it is apparently killed off.

Finally, it is worth noting, the fantasy of "penetrating unpenetrated" also draws in the Ariostan narrator, whose propensity for playing God is well known. At the opening of canto 29, noting the hypocrisy of Rodomonte's rapid change of love objects shortly after he so roundly condemned the inconstancy of women, the writing "I" promises, godlike, to render poetic justice:

> Io farò sì con penna e con inchiostro,
> ch'ognun vedrà che gli era utile e buono
> aver taciuto, e mordersi anco poi
> prima la lingua, che dir mal di voi [donne gentili].

> (I will do so much with pen and with ink that everyone will see that it would have been useful and good for him to have stayed silent and then to have bitten his tongue before speaking ill of you, noble ladies.) (29.2.5–8)

After Issabella's death at Rodomonte's hands, which is a first, albeit rather ironic, installment in the narrator's vendetta against the pagan knight, the Ariostan "I" brings God in person onto the scene in a climactic paean to a virgin's martyrdom:

> vattene in pace, alma beata e bella!
> Così i miei versi avesson forza, come
> ben m'affaticherei con tutta quella
> arte che tanto il parlar orna e come,
> perché mille e mill'anni e più, novella
> sentisse il mondo del tuo chiaro nome.
> Vattene in pace alla superna sede,
> e lascia all'altre esempio di tua fede.
>
> All'atto incomparabile e stupendo,
> dal ciel il Creator giú gli occhi volse,
> e disse "Più di quella ti commendo,
> la cui morte a Tarquinio il regno tolse;
> e per questo una legge fare intendo

tra quelle mie, che mai tempo non sciolse
la qual per le inviolabil'acque giuro
che non muterà seculo futuro."

(Go in peace blessed and lovely soul! If only my verse had sufficient force, how then would I labor with all that art that so ornaments speech and how then for a thousand years and a thousand more would the world hear of your illustrious name. Go in peace to the supernal realm and leave your example of fidelity to other women. At this incomparable and stupendous act, the Creator turned his eyes down from heaven and said "I commend you more than her [Lucretia] whose death deprived Tarquin of his kingdom; and on account of this I intend to make a law—among those of mine which time can never undo—which by the inviolable waters I swear no future age will change.") (29.27–28)

"Ariosto" juxtaposes his own desire to confer verbal eternity on his character with God's avowed determination to honor this sacrifice by conferring the name "Issabella" only on women of the highest quality from then on, with patent, encomiastic allusion to Isabella d'Este and perhaps to others as well.

In the first instance, this moment reinforces the opening alignment of the poet with a verbal version of divine justice, in the form of retribution against the pagan Rodomonte and of salvation and exemplary status for the newly converted Issabella. But curiously this Christian deity is made to swear an oath in the traditional manner of the pagan Jove, binding himself by the "inviolable waters" of the infernal river Styx. In addition to muddying the ideological "acque" by confusing Christian and pagan, heaven and hell, this passage links God's ostensibly absolute commitment to a given word with Rodomonte's false promise to leave inviolate Issabella's body based on her equally false promise to confer an inviolable body on him by anointing him with a magical "liquore" or "acqua" (17–19).[40] There may thus be an implicit, misogynist subversion of the apparent compliment to Ariosto's Estense patroness, a point borne out by the narrator's descent into rabid, Rodomontian, misogyny at the end of canto 29 (73–74).[41]

Even more pointedly, by ostentatiously connecting the "inviolabil' acque" of God's oath (which openly fulfills the hopeful promise of the Ariostan narrator) to the "inviolabile" body that Issabella falsely promises to confer on Rodomonte by the application of an "acqua," the poet creates an analogy that links the fantasy of an impenetrable human body with the claim to speak the truth (or write a truthful text) and to a challenge to the very existence of an omniscient and omnipotent

God (a challenge made far more explicit in the famous climax to the lunar episode in canto 35). Thus, if the *Furioso* gestures toward a maculate femininity that lies behind the fantasy of virginal purity, it is equally ready to indict the male investment in that fantasy, and, indeed to suggest that patriarchal assertions of literary truthfulness and divine justice are just so many deluded, or bad-faith, efforts of men to figure themselves "like a virgin."

"Di sangue illustre & pellegrino"

The Eclipse of the Body in the Lyric of Tullia d'Aragona

Julia L. Hairston

Moretto da Brescia's Portrait of a Lady

Sometime between 1537 and 1540 Alessandro Bonvicino (perhaps better known as Moretto da Brescia) painted an enigmatic portrait of a lady, which now hangs in the Pinacoteca Civica Tosio Martinengo in Brescia (fig. 10.1).[1] I describe the painting as enigmatic for it poses a number of problems regarding the identification and representation of the two figures—literary and historical—with whom it has been associated.

The inscription on the parapet below the female figure reads "QUAE SACRU IOANIS / CAPUT SALTANDO / OBTINUIT," or "she who obtained the sacred head of John by dancing," thus identifying the figure as Salome. Yet the first known mention of the work—only in 1814—gives its title as "Herodias with Fur and Scepter."[2] The confusion between Salome and her mother, Herodias, dates back to early Christian writers and continued through medieval and early modern times.[3] To summarize briefly, Herodias, Salome's mother, bore a grudge against John the Baptist, who was being held in King Herod's prisons. When Herod offered to grant Salome anything she desired to reward her for her dancing, Herodias counseled her daughter to request the head of John the Baptist, and Salome complied with

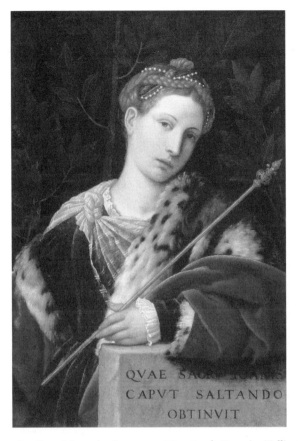

Fig. 10.1 Alessandro Bonvicino, also known as Moretto da Brescia, *Tullia d'Aragona as Salome*, ca. 1540, oil on panel. Reproduced by permission of the Civici Musei d'Arte e Storia di Brescia

her mother's wish. In the two versions by Matthew and Mark, Salome is not named but is merely called the "daughter of Herodias"; Flavius Josephus's *Jewish Antiquities* was the first ancient source to name her.[4] Yet other elements render Moretto da Brescia's painting ambiguous.

Visual representations of Salome almost always include canonical markers such as John the Baptist's head on a platter.[5] The other most common iconographic element used to identify Salome is that of a dancing female figure.[6] Yet neither of these indices—the head of John the Baptist or a dancing female figure—is present in Moretto da Brescia's representation. In this painting, the single element that identifies the female figure as Salome is the inscription on the parapet.[7]

Another identity has been associated with this painting—that of the Roman courtesan and woman of letters Tullia d'Aragona (1505/10–56), a contemporary of Moretto da Brescia, although no record of their association exists. The first documentary evidence that links Tullia d'Aragona to Moretto's painting is an engraving by Caterina Piotti Pirola, which she printed in 1823. First, Piotti Pirola exhibited an engraving of Moretto's painting at the Brera Academy in Milan without the inscription on the parapet and entitled it "Herodias." Yet later the same year the same image was printed with a different title—"Tullia d'Aragona, Poetess of the Sixteenth Century" (fig. 10.2)—and appended to it were the following verses: "Qual fu la culla mia/Mostra lo scettro d'oro;/L'ingegno mio qual sia/Mostra il crescente alloro" ("That which was my cradle/The golden scepter shows/That which is my genius/The growing laurel discloses").[8] The anonymous author of these nineteenth-century distichs thus interprets the scepter as referring to d'Aragona's noble origins from the paternal line[9] and the laurel background as indicating her poetic accomplishments.[10] An oral tradition recalled in the testimony of a butler of a previous owner of the painting, who later became a custodian at the Pinacoteca in Brescia, also narrates that Count Tosio acquired the panel painting from a convent around 1829 and that all visitors from abroad always referred to it as a portrait of Tullia d'Aragona.[11]

Clearly we do not possess at present the necessary historical evidence to establish unequivocally the identity of the figure in the Moretto painting with Tullia d'Aragona.[12] Yet Ida Gianfranceschi and Elena Lucchesi Ragni correctly observe that whereas it is entirely plausible that the painting may represent a historical figure *also* as Salome, it is decidedly implausible that the figure simply represents Salome and nothing else, as it completely lacks any of the attributes traditionally associated with her, that is her dancing or the head of John the Baptist on a platter.[13] The painting thus features a double figuration—that is, it represents Salome, but it plausibly also represents someone else. In this sense, the Moretto da Brescia painting functions rhetorically as a paradox, in that it depicts a figure that is absent, absent in the sense that canonical markers are missing. It is in fact the painting's double figuration and its paradoxical embodiment of an absence that render it relevant to Tullia d'Aragona, for she too negotiated between her dual identities as a courtesan and as a woman of letters. She was careful to construct an image of herself as an intellectual but also to maintain the tension of her identity as a courtesan, as the notoriety garnered from that role was at times useful in her self-promotion as an intellectual.[14] Moreover, in her *Rime della signora Tullia di Aragona et di diversi a lei*, published in 1547 in Venice by Gabriele Giolito, she para-

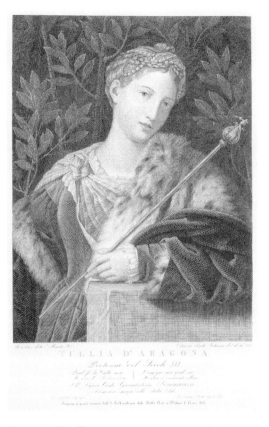

Fig. 10.2 Caterina Piotti, *Tullia d'Aragona*, 1823. Illustration by Brescia, private collection

doxically enlarges her presence through her absence as she progressively eclipses her body and her physical self.

A cautionary word, however, about this matter before we begin to examine it in some detail in the following pages. The question of agency and the extent to which authors controlled their texts in sixteenth-century Italy is vexed owing to, among other factors, the printing practices that prevailed during the period and the socialized nature of authorship in and around the courts. In the case of women's writing, the issue of agency and authorial control is further complicated by the biases (either contemporary or in subsequent scholarship) that led men of letters and subsequent researchers to question their exceptionalities or abilities. In this chapter, I offer an array of different examples that address d'Aragona's self-fashioning, so that her ultimate agency—even if it was mediated by one or another

of her poetic interlocutors—may be seen as part of the larger picture she painted of herself, particularly in regard to her own authorial control.

Courtesan and Woman of Letters

Although Roman by birth, Tullia d'Aragona lived in a number of different Italian cities including Venice, Ferrara, and Florence and was engaged in the intellectual life of those cities.[15] She published a poetry collection and a dialogue in 1547 and her epic poem was printed posthumously in 1560.[16] D'Aragona elicited high praise and condemnation in her lifetime and was extolled or vilified in the writings of such Italian intellectuals as Sperone Speroni, Girolamo Muzio, Benedetto Varchi, Pietro Aretino, Agnolo Firenzuola, and Giovan Battista Giraldi Cinzio. When she could, d'Aragona resolutely worked at promoting an image of herself as a woman of letters and minimized her characterization, whenever possible or useful, as a courtesan. This is not to say that there are not moments in her texts in which the reader is informed that d'Aragona is experienced in the ways of love, but the persona she clearly aimed to create in her sonnet sequence and dialogue is that of a woman of letters and an intellectual.[17] She was quite successful in this self-presentation, for throughout the seventeenth and eighteenth centuries erudites such as Francesco Agostino della Chiesa, Apostolo Zeno, Giovanni Maria Crescimbeni, and Francesco Saverio Quadrio repeatedly hailed d'Aragona as an excellent poet and an illustrious woman and never identified her as a courtesan.[18]

Only in the nineteenth century did literary historians begin to remark on her profession, in a development that, not by chance, coincided with the positivist return to the archives, for both the Florentine and Sienese archives preserve documents recounting d'Aragona's skirmishes with authorities over sumptuary legislation regarding prostitutes.[19] Agnolo Firenzuola and Giovan Battista Giraldi Cinzio, contemporaries of d'Aragona, both attack her for another commonplace associated with sex workers—greed.[20] The following sonnet by Niccolò Franco published in 1541 in his *Priapea* gives some idea of the image she was battling to overcome:

Priapo, l'alma Tullia Rangona
Sendo dal favor tuo tanto esaltata,
Ond'è dal gran Sperone immortalata,[21]
Che se ne fan moresche in Elicona,
Oggi, ch'è il giorno tuo, questa corona
Di fine perle, e tutta inorpellata

Ti pone al capo, talché poco grata
Non sia tenuta e perfida persona.
E vuol che il don di così ricca spoglia
Sappia non solamente il popolazzo,
Ma qualunqu'erba ha 'l tuo giardino, o foglia.
Perché né in Carampana, né in palazzo
Donna fu mai, che con più grata voglia
Riconosca i piaceri che fa il cazzo.[22]

(Priapus, the divine Tullia Rangona
Being by your favor so highly exalted
That the great Sperone immortalized her,
Such that they are dancing on Mt. Helicon,
Today, your day, this crown
Of fine pearls, she, all gussied up,
Places on your head, so that ungrateful
She won't be deemed, or perfidious.
And she wants the gift of such rich spoils
To be known not just by the people,
But by every single blade of grass in your garden, or leaf.
For neither in the lowliest hut, nor in the greatest palace
Was there ever a woman, who with such grateful yearning,
Recognized the pleasures that the prick procures.)

D'Aragona's detractors offer numerous colorful characterizations of her; I selected this one from 1541 for the markers it contains regarding her—the pearl crown and the adjective *inorpellata*—recall Moretto's portrait, painted just a few years earlier. It seems striking that of all the crowns Franco might have devised for d'Aragona to place on Priapus's head, he selected one of "fine pearls." Less strikingly, he describes d'Aragona as "tutta inorpellata" (meaning richly and ornately dressed but with a negative connotation, hence "all gussied up"), as indeed one would describe the figure in the painting.[23] D'Aragona used Franco's same arms of verse to counteract the negative images he and others were circulating of her at the time. Although all the evidence that identifies the figure of Moretto's "Salome" with Tullia d'Aragona is circumstantial, the issues posed by the debate itself—matters of identification, ambiguity, and representation—relate to questions aroused not only by courtesans but perhaps even more by women writing in early modernity.[24]

Correspondence Poetry and Tullia d'Aragona's *Rime*

The *Rime della signora Tullia di Aragona et di diversi a lei* was one of the earliest choral anthologies in the Italian vernacular tradition and, to my knowledge, the first one authored by a woman.[25] Verse anthologies abounded in the Italian cinquecento yet in a vast array of typologies. The lyric anthology comprises poetry by many different authors, but the volume is usually associated with the editor's name.[26] The choral anthology, on the other hand, even though a number of different authors may have contributed to it, is attributed to a single author. The choral and the lyric anthology usually also differ thematically—the choral anthology revolves around a single theme, usually the identity of its compiler and author, whereas the lyric anthology is less restricted; at most, it may be organized according to the geographical origin or sex of its contributors. Tullia d'Aragona's title is self-explanatory: her *canzoniere* is made up of poems by her and to her. The arrangement of its five sections represent a progressive movement from d'Aragona's active and vocal presence in the first section, in which all of the poems are her own, to the fifth section, in which others write in praise of her. The intervening sections consist of a grouping of poems in which she writes to various literati and they respond, a section made up of poems that others write to her and to which she responds, and then an eclogue chronicling her life written by her most fervent and prolific admirer, Girolamo Muzio. The last section is comprised entirely of poems written to her or, better, about her by a vast array of prominent sixteenth-century men of letters.[27]

Although the choral anthology is necessarily bound as a single volume, its origins are to be found in the tradition of correspondence poetry. Known in the English lyric tradition as answer poetry, correspondence poetry consists of an initial poet's *proposta*, almost exclusively in the form of a sonnet, which stimulates a *risposta*, or response, from his or her poetic interlocutor. This form of "cultural capital," to use John Guillory's phrase, was widespread in the courts, academies, and salons of early modern Italy and Europe, as is reflected in both the manuscript and print traditions that detail the activities of those communities. Indeed one of the implicit assumptions about correspondence poetry is that its practitioners are figures of significance in their time; the poetic exchange virtually always takes place between well-known figures. For this reason, there is an element of cultural homogeneity in correspondence poetry, as indeed there is in Petrarchism itself. This characteristic of correspondence poetry serves, however,

to differentiate it further from the lyric anthology, which instead placed various unknown poetic dilettantes together with some of the brightest lights of the literary firmament. If Petrarchism also functions as a phenomenon of socialization, as is evident, then correspondence poetry simply represents one of its highest forms.

Pietro Bembo was instrumental in carrying the correspondence tradition into print culture and, more importantly, in authorizing its use in a sequence by a single author. In the second edition of his *Rime*, published in 1535 by the Venetian Fratelli da Sabbio, Bembo added a section to his *canzoniere* that was not present in the first edition of 1530. After the index of first lines, he appended five sonnet *proposte* by, respectively, Benedetto Morosini, Veronica Gambara, Gian Giorgio Trissino, Vittoria Colonna, and Francesco Maria Molza. Following his interlocutor's proposal sonnet, Bembo gave the first line of his *risposta* sonnet. He did not include the entire text of the response, which appeared instead within his sequence, but only indicated which sonnet responded to which interlocutor. The 1548 Dorico and Giolito editions of Bembo's *canzoniere*—aspects of both of which have been considered the most reliable philologically—also include this section, although Carlo Dionisotti excludes it from his 1966 UTET edition.

Pasquale Sabbatino interprets the print history of Bembo's *canzoniere* as moving toward a bipartite division—a Petrarchan gesture *par excellence*.[28] Yet rather than regarding Bembo as having divided his sequence into verses singing of the poet's beloved in life and death, Sabbatino suggests instead that Bembo constructs the first part as a narrative of the poet conquered by love and composes the second part out of occasional verse written for friends and fellow intellectuals, all of whom participate in that "society of love, in which poetry is produced and consumed."[29] This description of Bembo's *canzoniere* is not surprising because in the sixteenth century Petrarch's *canzoniere* as a model undergoes a sort of disaggregation into modules whereby subsequent poets adopt one part of the volume, such as the spiritual or the occasional poem, without adopting the overall structure of the book, as attested by the editions by Alessandro Vellutello (1525) and Girolamo Malipiero (1536), to cite just two examples.[30]

In his 1544 edition of his own *Rime* published by Giolito, Lodovico Domenichi uses a structure very similar to Bembo's 1535 edition. His work contains a number of sonnets to others, such as Collaltino di Collalto (perhaps better known as Gaspara Stampa's beloved), Giuseppe Betussi, and Anton Francesco Doni, that he includes within the sequence; after the index of first lines, Domenichi appends a

section of three poems to himself by Francesco Sansovino, Girolamo Mentovato, and Girolamo Parabosco. As in Bembo's text, here others initiate the poetic dialogue, and the author replies by indicating the sonnets in his sequence that function as a response.

The titles of both Bembo's and Domenichi's collections leave no doubt as to their status as single-author sequences. Three years after Domenichi's volume appeared, in 1547, the same editor published the *Rime della signora Tullia di Aragona et di diversi a lei*, which I consider to be the prototype for the choral anthology. What differentiates d'Aragona from her predecessors is that she acknowledges the poems by other authors in her volume and, more importantly, that she creates separate sections of correspondence poetry in which she includes both sides of the dialogue. In these sections, she systematically plays either the role of proponent or that of respondent. D'Aragona's placement of the *proposte* and the *risposte* side by side heightens the sense of dialogue and debate implicit in the nature and structure of correspondence poetry.[31]

D'Aragona concludes her sequence with a section of poems addressed to her by others. This same arrangement was likewise used by Laura Terracina at the end of her first volume of poetry published the following year, in 1548, also by Giolito. Although Terracina did not include both sides of her poetic correspondence in the volume, she did address the majority of her poems to others and concluded her volume with a section of poems in her own praise (fourteen in all).[32] To my knowledge, the only male poet who included in his *canzoniere* a series of poems in praise of himself is Luigi Cassola in his *Madrigali del magnifico signor cavallier Luigi Cassola piacentino*, which was published in 1544—again by Giolito—and concluded with six sonnets in praise of the author.[33] In comparison, d'Aragona's last section in praise includes fifty-five sonnets.

Rime della signora Tullia di Aragona et di diversi a lei

In her *Rime*, d'Aragona elides her physical presence in the text both through specific instances of editorial revision and through her organization of the *canzoniere*. This increasing dematerialization of the body achieves two aims—it counters other unflattering representations of her in circulation that portrayed her as a mere *meretrice* (all body and no intellect), and it paradoxically enlarges her presence through her absence, thus emphasizing her literary notoriety. D'Aragona's orchestration of her bodily presence in the text mirrors, moreover, her construction of her career as a woman of letters.

D'Aragona's presence is progressively eclipsed in the sequence as it develops from one section to the next: she moves from being the sole speaking subject in the first section to being the absent subject of others' praises in the last. One might liken d'Aragona's arrangement of her poems in the text to the way a literary *salonnière* organizes her gathering, first by creating and presiding over it, then by animating it in conversational exchanges with others, and then by exiting it, leaving behind an illustrious group of literati who praise her in her absence. The last section functions, thus, as a testament to her fame and to the achievement of the volume's aim. The progressive elision of the poet's presence in the text suggests the construction of a career as a woman of letters; yet other elements also illustrate how d'Aragona manipulated that construction.

The first section—the only one consisting entirely of poems authored by d'Aragona—moves from the formal to the familiar, from the epideictic to the lyric. It commences with seven sonnets to the Duke of Florence, Cosimo I, and four to Duchess Eleonora, followed by single sonnets to Cosimo's mother, Maria Salviati, Eleonora's brother, Don Luigi di Toledo, and his son and Eleonora's nephew, Don Pedro. Following the obligatory political sonnets to the duke and duchess, in whose court she had taken refuge either in late 1545 or early 1546 after uprisings in Siena, is d'Aragona's proemial literary sonnet, in which she defines the project of her *canzoniere* and which is addressed to Italy's foremost literary authority, Pietro Bembo.

A MONS. CARDINAL BEMBO
Bembo, io che fino a qui da grave sonno
Oppressa vissi, anzi dormii la vita,
Hor da la luce vostra alma infinita
O sol d'ogni saper maestro, & donno,
Desta apro gli occhi, sì ch'aperti ponno
Scorger la strada di virtù smarrita:
Ond'io lasciato ove 'l pensier m'invita
De la parte miglior per voi m'indonno;
Et quanto posso il più mi sforzo anch'io
Scaldarmi al lume di sì chiaro foco
Per lasciar del mio nome eterno segno.
Et o non pur da voi si prenda a sdegno
Mio folle ardir, che se 'l sapere è poco,
Non è poco Signor l'alto disio.[34]

(Bembo, I, who up to now have lived oppressed
By a heavy slumber, indeed I have slept through life,
Now, by your infinite, divine light,
O sole lord and master of all knowledge,
Roused, I open my eyes, so that open they may
Discern the path of virtue I had lost;
Thus I, having left where my thoughts lead me,
Master the best part for you.
And as much as possible I too strive
To warm myself in the light of such an illustrious fire
To leave of my name an everlasting record.
And, oh, let not you too scorn
My mad desire, for if my knowledge is small
Not small, Sir, is my sublime desire.)

D'Aragona's project, as she reiterates frequently throughout her *canzoniere*, is to acquire literary fame, and it is thus only logical that she should turn to Italy's foremost poetic authority for guidance—"Mi sforzo anch'io" she states, along with many others, to learn from the great master. Bongi and others mention that d'Aragona's sonnet went unanswered, but might we see in the temporal deictic adverb "hor da la luce vostra alma infinita" a possible dating for the poem after Bembo's death, which occurred on January 18, 1547, just months before d'Aragona published her *Rime*.[35] Why "hor"? Has some external event occurred, or are we to interpret "hor" as referring to a turning point in her own personal or poetic development? Whichever it might be, the poet refers in line 6 to the path of virtue she had lost and emphasizes in the final tercet her present "folle ardir" and "alto disio" for literary fame.

The poem to Bembo is followed by a series of poems addressed to military, political, literary, aristocratic, and religious figures from Rome, Florence, and Siena and concludes with ten unaddressed compositions on love.[36] The overriding preoccupation of the first twenty-eight sonnets is the search for security, fame, and guidance; to a lesser degree, the poet also laments her bitter fortune. She seeks physical security and freedom of movement in Cosimo's court after the uprisings from which she fled Siena in late 1545 or early 1546.[37] From her literary mentors, Pietro Bembo and Benedetto Varchi, she seeks guidance.[38] Yet her predominant and explicitly stated and reiterated concern is to acquire fame for herself as a poet. She endeavors to succeed in this quest by bestowing praise and honor in her po-

etry on those she addresses, some of whom are recently deceased; these epitaph sonnets also act as open declarations of grief by an individual active in the public domain.[39]

Petrarchan lyric characteristically represents the body of the beloved and the body of the poet languishing for the beloved. In the sonnets of the first section, in which d'Aragona is the sole author, there is no beloved, and the body of the poet is only present in the metonymic use of *core* ("heart") for her sentiments or intentions. Twice she refers to her material body as "l'altra mia povera salma" ("my other poor corpse") or her "corporeo velo" ("corporeal veil"). Although the language is clearly Petrarchan, the uses to which d'Aragona puts it are so only in part. Not only is the beloved absent from these poems; the temporality evoked in them is not the past or the present but the future. The poet sings neither to recover a past experience nor to gain greater self-knowledge; rather, she sings to acquire fame. For example, in the sonnet to Manelli, the poet writes, "Fatico ognihor per appressarmi al Cielo, / Et lasciar del mio nome in terra fama" ("I too labor incessantly to draw nearer the heavens / and leave the fame of my name to the world"), and in a sonnet addressed to Cosimo, she states, "Né vi dispiaccia, che 'l mio oscuro, & vile / Cantar cerchi talhor d'acquistar fama / A voi più ch'altro chiaro, & più gentile" ("Nor may it displease you, that my obscure, and modest, / Song occasionally seeks to acquire fame / For you, more illustrious than any other, and more noble").[40] Fame was clearly also one of Petrarch's objectives, yet in the *Rime sparse* he conflated and confused it with his quest for Laura. Moreover, the Petrarchan theme of poetic composition as a sublimation for desire never appears in d'Aragona's *canzoniere*.

The bodies of the poet and the beloved materialize in the last ten compositions in the section, in which d'Aragona chronicles the effects of love on the poet.[41] Yet, unlike the preceding poems, these compositions are addressed to no one in particular, and the effect of the despecification is to curtail the materiality of the body. It is significant that she chose not to dedicate these poems to any single individual, for in this way she maintains greater ownership and control over them. As a courtesan, she avoids being tied poetically and socially and thus financially to a single man. Not naming the dedicatee also allows any male reader to imagine himself as the recipient.[42] Moreover, within the poems, she never once addresses the beloved but speaks instead to Love, Hope, or a third party, such as her pet Lilla, who has lost her pup, just as the poet has lost her love. Only once does she provide the stereotypical catalogue of the beloved's attributes—"Ov'è (misera me) quell'aureo crine, / Di cui fe' rete per pigliarmi Amore? / Ov'è (lassa) il bel viso" ("Where are (miserable me) those golden locks / With which Love made a web to ensnare me? / Where

is—alas—that beautiful face")—which is followed by a series of questions seek-ing the "bianca man" ("alabaster hand"), "l'angeliche parole" ("angelic words"), "i cari sguardi" ("loving gaze"), and "le maniere belle" ("good manners"). Yet, as is evident, the beloved only exists in the description of the poet; the beloved is never present and never interacts with the poet, either dead or alive.

In the first of the two *proposta / risposta* sections, d'Aragona provides the ini-tial sonnet. In this genre or mode, the first of the two sets the topic and provides the vocabulary. Perhaps for this very reason, the first section of exchange sonnets reads very similarly to the previous section in which all the poems were penned by d'Aragona. In the subsequent *proposta / risposta* section, however, in which her interlocutors are initiating the discourse, the representation of d'Aragona changes slightly. She is repeatedly described as "proud," and her physical appearance is men-tioned—"altera donna" ("proud lady"), "donna, il cui gratioso, & altero aspetto" ("lady, whose graceful and proud appearance"), "rare bellezze, & disusati accenti" ("rare beauty and unique expressions"). In some instances, she responds to her interlocutors when their descriptions of her run counter to her ideal self-image. For example, Niccolò Martelli, a cousin of Ludovico Martelli and author of two volumes of letters, describes her as "Tullia di sangue illustre & pellegrino."[43] *Pel-legrino* is an ambivalent adjective, as it may mean "foreign," "exotic," "exceptional," or "singular" but also "wandering" and "errant." D'Aragona turns the tables on Martelli in her response: "Il cantar vostro l'anime innamora; / Et le fa da sé stesse pellegrine / Che celeste virtù può, ciò che vuole" ("Your song makes souls fall in love / And makes them of their own accord exceptional / For celestial virtue can do that which it desires"). In echoing him, she alters the word's meaning, turning his potentially ambiguous compliment into certain praise. Martelli's use of the adjec-tive entertains both meanings—"exceptional" and "wandering"—but d'Aragona's response restricts the meaning to "exceptional," the more favorable denotation, and claims that it is his poetry ("il cantar vostro") that causes souls to fall in love and makes them *of their own accord* exceptional ("et le fa da sé stesse pellegrine").

Yet in one instance d'Aragona was even more direct in the management of her representation. In a letter to Antonio Mezzabarba, Girolamo Muzio recounts how d'Aragona sought to have him edit one of his eclogues according to her wishes:

> io haveva per un tempo celebrata la signora Tullia sotto nome di Tirrhenia, et un giorno, con lei essendo et ragionando di quegli studij, de' quali ella si è cotanto dilettata et diletta tuttavia, entrammo a parlare delle Muse, de' loro nomi et delle loro virtù; sopra il quale ragionamento poi che noi alquanto stati fummo,

ella, in se stessa raccogliendosi, quasi da nuovo pensiero soprapresa, poi che così fu stata alquanto, il parlar ripigliando, mi disse: "Già sono più giorni che io ho un mio concetto nell'animo, il quale, poi che hora mi viene in proposito, io il ti voglio pur dire. Tu mi hai lungamente cantata con nome di Tirrhenia, et io vorrei che tu mi mutassi nome et appellassimi Thalia, ma che lo facessi in guisa che si conoscesse che Tirrehenia et Thalia sono una cosa istessa; pensavi hora tu del modo."[44]

(I had once celebrated Signora Tullia with the name Tirrhenia and one day, when I was with her talking about those studies she has found and finds so delightful, we started to speak of the Muses, of their names and their virtues. Since we were on this topic for quite a while, she, gathering her thoughts, almost as if taken by some new idea, and after being quiet for a bit, started to speak again and said to me, "It's been quite a few days that I have an idea in my head, which, now that it is relevant, I want to tell you too. You have long sung of me with the name Tirrhenia, and I would like for you to change names for me and call me Thalia, but do it in such a way that it's apparent that Tirrhenia and Thalia are the same thing. Now you figure out how to do it.")

D'Aragona was referring to Muzio's eclogue, in which he offers a poetic biography of the poetess, who was given the pastoral appellative "Tirrhenia," and which she included as the fourth section of her *Rime*. In 1537, Ercole Bentivoglio had alluded to d'Aragona as Euterpe, the muse of flute playing and lyric poetry.[45] In the conversation with Muzio, d'Aragona likely suggested the name Thalia because she is the muse who inspires bucolic poetry.[46]

D'Aragona used answer poetry to frame and delimit meaning in writings about her, but the clearest indication that she undertook a project to emphasize her incorporeal and intellectual rather than her bodily attributes appears in revisions of poems about her as they pass from manuscript to print. As with many sixteenth-century authors, we cannot be sure of the level of control d'Aragona might have had over her text once it reached the printers. We do know that her poetic interlocutor and greatest promoter—Girolamo Muzio—was closely involved in escorting her dialogue into print at the Giolito press in 1547; he may also have played a role in the publication of her choral anthology.[47] More to the point, d'Aragona herself alludes to her own level of involvement in a letter to Benedetto Varchi in which she reminds him to do what he had promised, "cioè la fatica di fare riscrivere quella pistola alla Signora Duchessa & mandarmela insieme co i sonetti i quali faro io legare" ("that is, the burden of having that letter to the Signora Duchess

rewritten and sent to me together with the sonnets that I will have bound").[48] The verb "legare" would indicate that this letter, which is not dated, refers to a moment subsequent to d'Aragona's exemption from the sumptuary legislation when she was preparing her poetry collection for publication.[49]

From Manuscript to Print

The Biblioteca Nazionale in Florence holds a manuscript that contains twenty-two sonnets written by various poets in praise of Tullia d'Aragona, all copied by a single hand; some authors are identified, others not.[50] This document is assumed to be a collation that d'Aragona had made for Eleonora di Toledo in order to obtain exemption from Florentine sumptuary legislation that would have required her to wear the yellow veil of the prostitute.[51] D'Aragona sought advice from her politically influential friend Don Pietro di Toledo, the nephew of Eleonora di Toledo, Cosimo I's consort, and recounts the suggestion she received from him in a letter to Benedetto Varchi:

> È parere del Signor Don Pietro ch'io facci presentare più presto che sia possibile i sonetti alla Signora Duchessa & con essi una suplica pregando sua eccellenza ch' sia col Signor Duca che mi concedino gratia almeno ch'io non sia tenuta alla osservanza del segno giallo & brevemente narrare quanto io vivi ritirata & che non ottenendo da loro eccellenze questa gratia sono forzata lasciare Firenze.[52]

> (Signor Don Pietro thinks that as soon as possible I should present the sonnets to the Signora Duchess and with them a supplication beseeching her Excellency, along with the Duke, that they concede an exemption to me so that I am at least not required to observe the yellow sign and to briefly narrate how I live in seclusion and that if I am not granted this exemption from their excellencies, then I will be forced to leave Florence.)

D'Aragona's subsequent supplication to the duchess contained a written request for exemption from the yellow veil, a *capitolo* addressed to Duke Cosimo, and a group of sonnets in praise of d'Aragona.[53] The supplication reads:

> Illustrissima & Eccellentissima Signora Duchessa. Tullia Aragona humilissima servitrice di Vostra Eccellenza Illustrissima essendo rifuggita a Firenze per l'ultima mutazione di Siena, & non faccendo i portamenti, che l'altre fanno, anzi non uscendo quasi mai d' una camera, non che di casa per trovarsi male disposta così dell'animo come del corpo prega Vostra Eccellenza affine, che non sia

costretta a partirsi, che si degni d'impetrarle tanto di grazia dall'Eccellentissimo & Illustrissimo Signor Duca suo consorte, che ella possa, se non servirsi di quei pochi panni, che le sono rimasi per suo uso come supplica nel suo capitolo, almeno, che non sia tenuta alla osservanza del velo giallo. & Ella, ponendo questo con gli altri obrighi molti & grandissimi che ha con Sua Eccellenza pregerrà Dio, che la conservi sana, & felice.[54]

(Most illustrious and excellent Signora Duchess, Tullia Aragona, most humble servant of your illustrious Excellency, having taken refuge in Florence because of the recent transformations in Siena, and not behaving as the other women do, in truth hardly ever leaving her room, much less the house because she feels ill in both soul and body, beseeches Your Excellency, so that she will not be forced to leave, that she may deign to confer pardon by the most excellent and illustrious Duke, your consort, so that she may, if not make use of those few clothes left to her, as she seeks in her *capitolo*, at least not to be held to observe the yellow veil. And she, placing this among the many great obligations that she has with Your Excellency, will pray to God that he preserve you healthy and happy.)

The structure of the Magliabechiano grouping affirms an identity, the identity of Tullia whose name systematically recurs in the sonnets. Her Christian name appears in sonnets 1–5; she is not mentioned by name in sonnets 6–10; sonnet 11 not only mentions Tullia but compares her to Vittoria Colonna by declaring that "l'alto motor com 'l Cielo ornar vuole / La terra, piacque a sua reale altezza / Far Vettoria una Luna, et Tullia un sole" ("The supreme mover wants to adorn the earth / like the heavens, [and so] it pleased his royal Highness / to make Vittoria a moon and Tullia a sun"). As regards the publication of women poets, d'Aragona's *canzoniere*, printed in 1547, was second only to Colonna's, which had appeared in 1538; several of the poems in d'Aragona's collection may also be dated back to between 1535 and 1538.[55] Sonnets 12–15 do not mention Tullia's name; sonnet 16 does; sonnets 17–18 do not, and, finally, sonnets 19–21 do name her (and sonnet 21 gives her full name—Tullia Aragona). What d'Aragona seems to seek in the Magliabechiano manuscript is the affirmation of an identity, an identity as a prodigious and, perhaps for a woman, exceptional literary talent yet also as a woman who is the subject of the adulation and admiration of important literary figures. The Tullia of the manuscript is a woman "in carne e d'ossa" ("of flesh and blood") who will be partially edited out of the printed collection.

Eighteen of the sonnets in the Magliabechiano manuscript were later incorporated into d'Aragona's published *canzoniere* in the last section entitled "Sonetti di

diversi alla signora Tullia d'Aragona," yet six were expurgated.[56] Five out of the six expurgated poems fail to conform fully to the image d'Aragona was promoting of herself. Exemplary in this regard are "Dicon queste onde mormorando intorno" ("Murmuring around These Waves Say") and "Se 'l divin raggio de vostri occhi ardenti" ("If the Divine Ray of Your Ardent Eyes"). The former describes her as a "spirto pellegrino" who "part[e] sempre cercar nuovo terreno" ("leaves always seeking new terrain"). D'Aragona may have omitted this poem to avoid the potential interpretation of the "new terrain" as the ever-new lands and clients that the courtesan seeks.[57] Another of the expurgated sonnets reproposes the conventional scenario of convincing the beloved to yield, and the arguments evoked describe a love that is decidedly more ardent and earthly than d'Aragona's self-fashioning in the rest of the *canzoniere* would sanction.

D'Aragona—or perhaps someone for her—also made editorial revisions on some sonnets she chose to publish. Consider the penultimate poem in the Magliabechiano manuscript by Camillo di Montevarchi, "Mosso da l'alta vostra, et chiara fama" ("Moved by Your Eminent and Illustrious Fame"), which will close the published version of the *canzoniere*, thus occupying a position of consequence. One verse of the manuscript version, which reads "Hor voi più d'altra bella, et più gentile" ("Now you more than any other beautiful, and more noble") is transformed in the published *Rime* to "Hor voi più d'altra saggia, & più gentile" ("Now you more than any other wise, and more noble"). The adjective passes from *bella* to *saggia*—from "beautiful" to "wise," from the physical to the intellectual, from the fleshly to the philosophical. Lattanzio Benucci's "Se per lodarvi, & dir quanto s'honora" ("If to Praise You and to Say How Much You Are Honored") undergoes a similar editorial revision. The first tercet in the manuscript reads:

Non può ingegno mortal tante divine
Grazie ritrar, né può basso desio
Scolpir parti sì eccelse, et pellegrine.

(No mortal intellect can draw so many divine
beauties, nor can a lowly desire
sculpt such excellent and exceptional parts.)

In the published version, the *grazie* ("beauties") that cannot be depicted are changed to *virtù*, ("virtues," or "excellence"), and thus again d'Aragona's intellectual qualities are favored over the physical. In the movement from manuscript to print, the representation of d'Aragona metamorphoses from that of the beautiful

woman to that of the prodigious intellect, as she—or someone for her—edits out voices discordant with her self-promotion as a female poet.

I have outlined the gradual diminishment of the physical in Tullia d'Aragona's *canzoniere*. The Renaissance notion of women, inherited from the classical and patristic traditions, associates women with the material and thus baser world. This association created obstacles to those women who sought an intellectual space within the public realm through publication. D'Aragona's philosophical training, as evidenced in her dialogue *Dell'infinità d'amore*, would have rendered her particularly attuned to the risks run by the woman writer who opts to represent the body in her poetry.[58] And how much more insurmountable might those risks be perceived as when that poet was also a courtesan? Tullia d'Aragona eclipses the body in her poetic corpus as one of many strategies necessary to the woman poet, particularly one who was also a courtesan, who sought fame as a writer and as an intellectual in sixteenth-century Italy.

The Beard in Sixteenth-Century Italy

Douglas Biow

Why the Beard?

In an essay titled "The New World and the Changing Face of Europe," Elliott Horowitz advances an interesting and plausible explanation to account for the appearance of beards on the faces of Europeans generally in the sixteenth century.[1] Prior to the discovery of the New World, Horowitz argues, beards had been associated with the Jew and Turk. As a consequence, beards signaled the otherness of a foreign culture over and against which Europeans fashioned themselves. If the Jew and the Turk routinely went bearded, and the beard became associated with them as the quintessential Other, then Europeans necessarily shaped their identity negatively, as non-Jews, non-Turks, and thus nonbearded. However, with the discovery of the New World, the "radical otherhood" traditionally associated with the Jew and Turk shifted—according to Horowitz—to the indigenous people of the New World.[2] And one of the defining features of those indigenous people was the absence of any facial hair, a fact not only made apparent to the Europeans, who were struck by the smooth-skinned faces of the novel people they encountered but also to the indigenous people themselves, who were struck by the abundant growth of hair on the faces of the Europeans (facial hair that the sailors had no doubt

grown during the long voyage). The otherness of the indigenous people of the New World created a peculiar problem, then, that the absence or presence of the facial hair resolved. For the indigenous people were, like Europeans, deemed white in complexion, yet unlike the Europeans, they lacked facial hair. To mark themselves off even more from the indigenous people of the New World, to differentiate their true, authentic whiteness from the false whiteness of these "other" people of the New World, Europeans according to Horowitz consequently grew beards and cultivated them and their appearance. Additionally, this cultural displacement of otherness focused on the signaling device of the beard could take place because by the end of the fifteenth century the Jew and the Turk no longer represented the same economic, social, and political threat that they had before.

Though Horowitz marshals evidence to argue his point, it is nevertheless difficult to imagine that the Jew and the Turk would have so quickly disappeared as figures of "radical otherhood" in the European Renaissance in the sixteenth century. The Orient may not have posed a similar threat as before, and the natives of the New World may have begun to occupy that status of others, but one only need read Tasso's *Gerusalemme liberata* to gauge the still vibrant perception of the Turk and Jew as Other in the cultural imagination of sixteenth-century Italy. Moreover, otherness is not a binary opposition in the Renaissance but a fluid concept: there was no more a single stable category of "radical otherhood" in the Renaissance than there was a single stable currency. The otherness of the indigenous people of the New World may have been on the minds of the Spanish and Portuguese toward the beginning of the sixteenth century, and that may account for their habit of adopting the fashion of wearing beards to mark themselves off from the people they had conquered. Indeed, Spain and Portugal were two countries that had a financial and cultural reason to shift their attention from the Far East to now the Far West, from the old Indies to the new Indies. But Italy, we need to bear in mind, did not. Although Italians evinced a keen interest in the New World as soon as the discoveries were made, they did not share the same large-scale involvement in it. As a result, the Other for Italians in the Renaissance in the sixteenth century remained, more appropriately, the Protestant, along with the Turk and Jew. Tasso, to be sure, collapses these categories and superimposes the religious erring of the Protestants and their fragmenting of Christendom onto the religious errancy of Islam, which the crusaders combat in his epic both by freeing Jerusalem and, in good post-Tridentine fashion, by unifying themselves into a single body with a single leader and a single goal. Lastly, the most noticeable and publicly recognized case of an "Italian" wearing a beard in the Renaissance had absolutely nothing to

do with either the Jews and Turks or the indigenous people of the New World. It had to do with Julius II suddenly, and quite unexpectedly, growing a beard while ill and stalled in an entrenched war to regain the Papal States. Not until all the Papal States had been liberated would Julius II shave again. So, too, Clement VII began wearing a beard after the sack of Rome.[3] For Julius II, as for Clement VII, growing a beard thus physically displayed mourning, a deep despondency and hibernation. It registered at once Julius II's manliness (he would fight to the end) and amplified his sorrow (he let his beard grow untrimmed, like a "hermit," as he was described, in the wild).[4] The Italian custom of wearing a beard, as it was embodied in the figure of the pope based in Rome, was therefore born out of shame and sorrow, not a virile conquering of others. It had little to do with imperial conquest; nor does the abject example of Julius II appear to be the likely determining stimulus for this fashion trend.

If stylish Italians of the cultural elite did not begin to wear beards to distinguish themselves directly and agonistically from the indigenous people of the New World, and if they were not universally doing so, it is safe to assume, to express sorrow or shame in the manner of a mourning pope, why, then, did they do it? To answer, let us consider why they might have preferred not to wear beards before the sixteenth century, even though beards had long been associated with manliness. One explanation for their desire to shave and go beardless might have to do with the process of urbanization that took hold firmly in Renaissance Italy during the fourteenth and fifteenth centuries. That process of urbanization, which saw buildings and churches rise and tower over the city walls that were continually being enlarged, would have logically led Italians to prefer to go beardless. For the urban Italian, who thought far more in local than regional terms, the aim was not so much to appear non-Turk as it was to *not* appear to have come from the nearby country. Everyone of means had financial investments in the country—it was part of the balanced economic portfolio of the wealthy to have a farm or two—but the dominant investment, both intellectual and financial, was in the city, in such enterprises ideally as banking or large-scale trading. In Florence, for instance, the aim in many respects was to erase the original tie with the country in order to present oneself as an urban dweller. Then, after having achieved a measure of mercantile success, the cultured urbanite built or bought a villa that architecturally transferred the image of the city to the *contado*, thus bringing the shape of urban experience to the outlying areas beyond the city walls.

Hence, urban folk wanting to appear urbane went beardless because, quite simply, people from the country wore beards or were associated with wearing beards.[5]

In Machiavelli's *Clizia*, for instance, Eustachio, a family farmhand, is urged not just to fix himself up but also clean himself up by Cleandro, a young man of some standing in the urban community of Florence: "I'd like very much for you to fix yourself up a bit. You have this cloak that's falling off your back, this dusty cap, this shaggy beard [*barbiccia*]. Go to the barber, wash your face, dust off these clothes, so that Clizia won't reject you as a swine [*porco*]."[6] Structurally, given the established logical opposition in Renaissance Italy between the city and the country, it was only natural that a farmworker accustomed to handling and being around pigs would appear filthy—*porco/sporco*—within the walls of the city, even though pigs roamed within the city walls. Along with that, it was only natural that the farmhand should appear so vilely bearded and unkempt. To be bearded, it would seem, was as good as being filthy. In Mary Douglas's terms, it was as good as being "matter out of place" within the community of Renaissance urban life. Consequently, the urban elite, in order to differentiate themselves from such rustic workers, aimed to go beardless.[7] Get rid of the "barbiccia," Machiavelli's Cleandro insists, if you want to stay in the city and be treated properly.

Why the shift to beards, then? Could it be, perhaps, that the process of urbanization had reached such a point in time that Italians now felt secure in wearing beards? Had Italians in their city-states, in other words, now sufficiently marked their identity as urbanites within the local culture that they no longer needed to fear any lingering association with their origins in the *contado* as they wore beards? I doubt it. I doubt, that is, that the opposition between country and city fundamentally had anything to do with the large-scale shift from a nonbearded Italian Renaissance to a bearded one in the sixteenth century. Rather what partly propelled the change in fashion from a nonbearded to a bearded Italian face in the Renaissance was *insecurity*, the feeling on the part of so many Italians that, despite all the capital and urban planning and civic pride that went into constructing these marvelous cities, Italy was as weak and vulnerable as ever. Indeed, it was more vulnerable than ever. The traditional date marking that sense of vulnerability was the end of the fifteenth century, and it has remained that way in the historiography of Italy. As Francesco Guicciardini put it in the very first sentence of his massive *History of Italy*, a book that is unique in its understanding of how Italy figured into European politics generally:

> I have determined to write about those events which have occurred in Italy within our memory, ever since French troops, summoned by our own princes, began to stir up very great dissensions here: a most memorable subject in view of

its scope and variety, and full of the most terrible happenings since for so many years Italy suffered all those calamities with which miserable mortals are usually afflicted, sometimes because of the just anger of God, and sometimes because of the impiety and wickedness of other men.[8]

The date the French troops invaded Italy and upset the perfect balance of political parts fostered by Lorenzo de' Medici in his golden age of peace and stability was 1494. Thereafter, as Guicciardini puts it in the tragic mode that dominates his history, the "calamities" began. And those calamities only continued to mount, culminating with the sack of Rome in 1527.

Then, not long after the invasion of the French in 1494, beards began appearing on the faces of urbane Italians. The process was slow. Italians did not all suddenly begin to grow beards overnight, but by the second decade of the sixteenth century it was undoubtedly fashionable to wear a beard. It was certainly enough of a fashion, for instance, that Baldassarre Castiglione, probably among the most fashion-conscious Italians of his age, is depicted bearing a thick, lush beard, slightly parted at the bottom, in the famous portrait of him by Raphael completed between 1514 and 1516. Moreover, many of the male members of the group gathered together in 1507 at Urbino to talk about the perfect courtier wore, at some point in the early sixteenth century, stylish beards. To be sure, the comic playwright and cardinal Bernardo Dovizi da Bibbiena did not wear a beard (the portrait of him housed in Palazzo Pitti shows him well shaven), and the jester Bernardo Accolti (Unico Aretino) did not go bearded either (at least as he is represented in Raphael's *Parnassus* in the Vatican). But both Pietro Bembo and Giuliano de' Medici, two outspoken members of the group gathered in Urbino to talk about the perfect courtier, most likely did grow beards very early on in the sixteenth century, as is suggested by surviving portraits of them by Titian and Raphael. And Ottaviano Fregoso, yet another talkative courtier in the *Cortegiano*, wore an ample white beard in a portrait depicting him as the doge of Genoa, an office he acquired in 1513, just a few years after the discussions in Urbino ostensibly took place. Surely, then, if these arbiters of fashion were wearing beards so early in the sixteenth century, it was an accepted thing to do. Castiglione, Bembo, Giuliano de' Medici, and Fregoso represented the very best of fashion from various parts of Italy, coming as they did from Mantua, Venice, Florence, and Genoa.

In this light, there are two significant sociopolitical factors that can perhaps help account for the shift in fashion from a nonbearded Renaissance Italy to a bearded one, though it is important to stress that a direct cause-and-effect histori-

cal explanation for the appearance (or disappearance) of a fashion is supremely difficult to validate, and so the suggestions here should be taken as tentative but still, I think, probabilistic. The first factor is the invasion of Italy by the French, an event that shook the peninsula and reshaped the balance of power forever in the Italian Renaissance, as Guicciardini melancholically pointed out at the beginning of his history. The second, an indirect consequence of the invasion first by the French and then by the German and Spanish imperial forces in 1527, was the fact that Italy became a more pronouncedly courtly society, whose ideal character is so memorably described by Castiglione. In both these cases, men in Italy were made to feel subordinate, no longer masters of their own destinies. The subjection of male Italians in relation to the lord they served in the court, or to the country that now controlled the balance of power in the peninsula, placed men like Castiglione in a conspicuously subordinate position.

Hence, the *Cortegiano*, as a number of scholars have pointed out in various ways, gives expression to anxieties on the part of men about seeming too effeminate.[9] The beard effectively masks those anxieties.[10] At one level, the beard asserts the undeniable maleness of these courtiers, whose profession once was that of arms but is now that of posturing, negotiation, calculated talk, and advice. For in theory men, and only men, can grow beards. A beard may not make the man, but it is an unmistakable and evident sign of maleness. Needless to say, at a time when Italians suffered from feelings of inferiority in military prowess, wearing a beard hides a weakness inherent in the culture: these men cannot for the life of them defend themselves against the dominant powers of Europe. In this respect, a beard conspicuously shows manhood in the very moment that the manhood of Italy was being questioned through a series of devastating invasions, and, to be sure, at the very moment, as Castiglione observes in the *Cortegiano*, when Italians were quick to change (with an alacrity that elicited plaintive astonishment) their habits of fashion to adhere to the new presences of alien powers in their territories—powers, Fregoso laments, that have made Italy the prey of all:

> Messer Federico said: "I do not really know how to give an exact rule about dress, except that a man ought to follow the custom of the majority; and since, just as you say, that the custom is so varied, *and the Italians are so fond of dressing in the style of other peoples*, I think that everyone should be permitted to dress as he pleases.
>
> "But I do not know by what fate it happens that Italy does not have, as she used to have, a manner of dress recognized to be Italian: for, although the in-

troduction of these new fashions makes the former ones seem very crude, still the older were perhaps a sign of freedom, *even as the new ones have proved to be an augury of servitude, which I think is now most evidently fulfilled. . . . Just so our having changed our Italian dress for that of foreigners strikes me as meaning that all those for whose dress we have exchanged our own are going to conquer us: which has proved to be all too true, for by now there is no nation that has not made us its prey. So that little more is left to prey upon, and yet they do not leave off preying.*"[11]

Moreover, at a time when the emphasis was increasingly being placed on affect control, and when one had to be careful not to make a slip and reveal a socially undesirable emotion through a facial expression, a beard could certainly serve as a handy disguise. Wearing a beard must have had its advantages in sixteenth-century Italy. At once declarative (I am a man, the beard announces; I can grow facial hair) and protective (I can conceal my expressions and my inability—as well as perhaps unwillingness—to fight to defend my territory), the beard both masks and identifies, conceals and reveals.[12] Needless to say, these are strategies, like those of simulation and dissimulation, that were prized in sixteenth-century Italy, especially in the court. Indeed, if there is one thing the *Cortegiano* teaches us, it is that it is always better to reveal less than more. And a beard naturally reveals less of a person's emotional state, but a lot more of his body—or, at least, what the male body can grow abundantly on the face. Consequently, if it is true, as Horowitz argues, that the bearded European signaled "the virile conquest and domination of the newly discovered world to the West," and if, as he also argues, the fashion of wearing a beard in Italy was largely introduced from beyond its borders, from such countries across the Alps as France and across the Tyrrhenian Sea as imperial Spain (where beards were in fact likewise being worn), then the wearing of a beard in Italy signaled not independence, a staking out of difference over and against the Turk or the Jew or the native people of the New World.[13] Instead, as Castiglione would seem to indicate in the context of talking about the Italian habit of adhering to new fashions of dress, the wearing of a beard signaled conformity to the fashion of the dominant powers, the very powers—in the case of France and then later Spain—that invaded Italy, bringing with them one calamity after another into the peninsula and reducing it to prey. By wearing a beard, the Italians discreetly aligned themselves with the customs of the new dominant powers in Italy, thereby attempting to secure a posture of authority through identification, but ironically their alignment through fashion only called attention to their role as dominated. Theirs was, to be sure, the manly beard of "majesty," but—as we shall see in the case of Cosimo I—it can also

be viewed as an elegant quotation of the majesty that Italians managed to make, in good Renaissance fashion, their own.

Conformity and Distinction

Castiglione's group of courtiers discusses proper self-presentation for four straight evenings, and on the last occasion through the entire night. They also show that they are extremely concerned with how the body appears and emphasize how one must gesture appropriately in order to remain decorous. But they do not address whether a courtier should or should not wear a beard. Nor do they discuss directly whether a beard is inherently manly or not. They only mention that would-be courtiers should not pay too much attention to their beards, the way women, we are given to understand, attend too vainly to their appearance, thus privileging, in Platonic terms, appearance over essence. "But to say what I think is important in the matter of dress," the (perhaps bearded) Federico Fregoso says early on in book 1,

> I wish our Courtier to be neat and dainty in his attire, and observe a certain modest elegance, yet *not in a feminine* or vain fashion. Nor would I have him more careful of one thing than of another, like many we see, who take such pains with their hair that they forget the rest; others attend to their teeth, others to their beard [*altri di barba*], others to their boots, others to their bonnets, others to their coifs; and thus it comes about that those slight touches of elegance seem borrowed by them, while all the rest, being entirely devoid of taste, is recognized as their very own. And such a manner I would advise our Courtier to avoid, and I would only add further that he ought to consider what appearance he wishes to have and what manner of man he wishes to be taken for, and dress accordingly; and see to it that his attire aid him to be so regarded even by those who do not hear him speak or see him do anything whatever.[14]

If a beard signaled manliness in the cultural imagination, too much attention to a beard, Castiglione avers, can still be viewed as a sign of foppishness. How then should one wear a beard? How much attention to its appearance meets the requirement of finding that Aristotelian mean that underpins Castiglione's treatise? What amount of attention constitutes too little and too much? Too little attention, no doubt, would lead a man to let the beard grow wild and thus make him look like a peasant, or a recluse, or a mourning, embittered, bearlike pope.[15] Conversely, too much attention to the beard would perhaps turn a man into an effeminate

fop lacking *sprezzatura*. Moreover, since Castiglione suggests that the physically smaller is generally preferred to the bigger when searching for the proper mean between extremes, perhaps a smaller beard is better than a bigger one if one is in doubt about how big or small the beard should be. Needless to say, Castiglione does not address any of these matters in his treatise, since to codify anything too overtly in the *Cortegiano* would only defeat the purpose of its rhetorical strategy. One of Castiglione's aims is not to prescribe rules of fashion but to show through his descriptions that fashion is culturally—indeed even locally—determined.

Wearing a beard was a fashion, and like most fashions in Renaissance Italy, it led to reflection in conduct and etiquette manuals. In the *Galateo*, the treatise that most openly codified conduct and etiquette in the late Renaissance, the topic of beards comes up briefly in the context of Giovanni della Casa's insistence—an insistence repeated throughout his treatise—that we must do everything we can to adopt the accepted current fashion of the people where we happen to reside. We should do this, we are told, not just so that we will not stick out conspicuously in the crowd but also so that we will not disturb others.[16] As is so often the case in the *Galateo*, the aim is to please so as to be pleased. Doing this is a virtue, just as it is virtuous in an Aristotelian sense in the *Nicomachean Ethics* not to overstep boundaries. We must all find the equilibrated place between extremes. Above all, within civil society it is virtuous, for della Casa, to think and care about others in order to allow everyone with whom one has contact to feel at home. And beards, wearing them or not wearing them, figure into this civilizing process. As della Casa warns in the context of talking about custom and fashion:

> Everyone must dress well according to his status and age, because if he does oth-
> erwise it seems that he disdains other people. For this reason the people of Padua
> used to take offence when a Venetian gentleman would go about their city in a
> plain overcoat as if he thought he was in the country. Not only should clothing
> be of fine material, but a man must also try to adapt himself as much as he can
> to the sartorial style of other citizens, and let custom guide him, even though it
> may seem to him to be less comfortable and attractive than previous fashions.
> If everyone in your town wears his hair short, you should not wear it long; and
> where other citizens wear a beard, you should not be clean shaven [*o, dove gli
> altri cittadini siano con la barba, tagliarlati tu*], for this is a way of contradicting
> others, and such contradictions, in your dealings with others, should be avoided
> unless they are necessary, as I will tell you later. This, more than any bad habit,
> renders us despicable to most other persons.[17]

Knowing both where and when one should wear a beard, and what kind of beard one should wear, indicates an absence of selfishness. At the same time, it reveals worldliness and understanding and appreciation of otherness. It signals that you are cognizant that you have entered a different place and know, as well as respect, the social customs governing it.

But not all beards are the same, and this was certainly the case in sixteenth-century Italy. On the one hand, wearing a beard might show some general degree of conformity and could therefore be construed as a selfless act of deferring to the taste, judgment, habits, and general well-being and comfort of others. On the other hand, wearing a certain *type* of beard also revealed something about the self and signaled a claim that one personally and conspicuously asserted with respect to one's own particular identity. And della Casa is aware of this, too. We must wear a beard where it is appropriate to wear one, he insists, but the particular type of beard worn also all depends on the place, time, and circumstance, though it is difficult, as Castiglione and della Casa knew, to pin down precisely why fashion comes and goes:[18]

> You should not, therefore, oppose common custom in these practices, nor be the only one in your neighborhood to wear a long gown down to your feet while everyone else wears a short one, just past the belt. It is like having a very pug face, that is to say, something against the general fashion of nature, so that everybody turns to look at it. So it is also with those who do not dress according to the prevailing style but according to their own taste, with beautiful long hair, or with a very short-cropped beard or a clean-shaven face [*o che la barba hanno raccorciata o rasa*], or who wear caps, or great big hats in the German fashion.[19]

Though both Castiglione and della Casa assure the reader that their treatises should not be read as self-portraits, the first overtly in the introduction to his *Cortegiano* and the second by having an "idiota" narrator voice the concepts of the *Galateo*, we can nevertheless rest assured that both Castiglione and della Casa, so conscious as they were of how fashion affects others and passes with time, knew how to wear a beard. They knew, that is, what length the beard should be and when it should or should not be trimmed. Indeed, both men certainly wore beards, and neither of them, as it so happens, wore the "short-cropped" one. Della Casa's beard, as a matter of fact, was long and *abbondante*.

For both Castiglione and della Casa, then, wearing the right sort of beard signaled some degree of conformity. It demonstrated publicly an understanding of what sorts of beards are worn in specific places under specific circumstances. This

is important, since Renaissance Italians, along with Europeans generally in the sixteenth century, had styles for beards that became associated in a vague sort of way with the habits and customs of a place at a particular time, much as della Casa observes that one should not wear a "plain overcoat" in Padua, where it was the custom to never do so. Benvenuto Cellini tells us in his autobiography, for instance, that the elderly Bembo was wearing "his beard short after the Venetian fashion" ("egli portava la barba corta alla veneziana") when Cellini visited the great human-ist in Padua and set out to make a medal of him in 1537.[20]

As we pass from the fifteenth to the sixteenth century, then, it is not just a matter of thinking about the differences between a beardless and bearded Renais-sance, but between a beardless one and one that became obsessed with beards styled in many varied and conspicuous ways. We pass, that is, from virtually no hair on the face in the fifteenth century to all types of hair sprouting on the face of urban men.[21] Wearing a beard signaled conformity to a general fashion, but the type of beard you wore could spell out publicly and, indeed, conspicuously your own affiliation with a particular style. One could choose, for instance, the broad fanning, "swallow tails" beard (represented by Lorenzo Lotto in his portrait of Andrea Odoni); the long, venerable beard (represented by Sebastiano del Piombo in his portrait of Reginald Pole); the larger, bushier version of the same in so many portraits of Pietro Aretino (such as the one painted by Titian in ca. 1545, though Aretino, it is worth pointing out, also changed the look of his beard over time, as can be seen in an earlier portrait of him by Titian); the rather conventional cheek-and-jowl beard (represented in Titian's portrait of Count Antonio Porcia) or one of similar style with less beard covering the cheek and a bit of the chin showing be-neath the furry underlip (represented in Raphael's double portrait of himself with his fencing master); the stiletto-styled beard (represented, for instance, in images of Michelangelo); the "tile beard" (a bushy square one represented by Bronzino in his portrait of Stefano IV Colonna); the long, thick beard parted at the bot-tom (represented in the portrait of della Casa by Pontormo); the truly elaborate, almost braided-looking beard worn by Gian Galeazzo Sanvitale (represented by Parmigianino); and the long, pointed beard parted the whole length down, like two stilettos (represented by Bronzino, for instance, in his portrait of Bartolomeo Panciatichi).

Clearly, then, men in Italy invested a great deal of time in taking care of their beards and in choosing the right one for their face. Some, such as Panciatichi, per-haps introduced new tastes into the reigning fashions of the day. Because beards were fashionable and signaled not just manliness but "majesty," a problem poten-

tially arose if you couldn't grow a beard, and a bigger problem potentially arose if you were a leader of men and really couldn't grow a full one. An interesting case in this regard would be the gradual—indeed, very gradual—appearance of a full beard on the face of Cosimo I. He began to grow his beard sometime after 1537, when he was only seventeen or eighteen years old, which was only five years after the habit of wearing a beard became fashionable in Florence, according to the diarist Luca Landucci.[22] In the earliest portrait of Cosimo I painted by Bronzino, and perhaps commissioned as a marriage gift for Eleonora (fig. 11.1), the Duke of Florence is figured at the age of roughly twenty with only a few wisps of hair crawling up both sides of his cheeks, a barely visible moustache that transparently reveals the skin underneath it, and hardly a tuft of hair on the underside of his chin. This "cooly erotic" representation of Cosimo I, as Robert Simon has described it, may make some sense in the context of this particular painting. Bronzino here figures Cosimo I as the youthful Orpheus, whose iconography was occasionally deployed by the Medici to signal their calculated use of eloquence over force in order to protect Florence and its domains and thus maintain peace and stability—the longed-for *quies*—in the region, though the mythological allusion in this instance could have also possibly served to indicate to Eleonora of Toledo (the betrothed) that Cosimo I, like Orpheus, would go to the ends of the earth for his beloved new bride.[23]

In any event, however we read the symbolic significance of Orpheus in this painting, be it as a public or private message, if one of the established ways to convey visually the passage from adolescence to full-blown manhood to old age was the way the beard appeared or did not appear on the male face (as is clear in Giorgione's *Three Ages of Man* [fig. 11.2]), then it certainly made good sense to portray Cosimo I with only a hint of a "wispy beard," as Janet Rearick-Cox puts it, in the painting of him as Orpheus taming Cerberus.[24] Like Orpheus, Cosimo I—a devoted lover and a tamer of the wild through his voice—must be portrayed as a young man whose age, judging by the beard, would place him somewhere between the adolescent in Giorgione's painting and the adult who instructs. However, in Bronzino's later portrait of Cosimo I (fig. 11.3), which sets him in martial armor with his hand resting on his helmet, we once again witness the duke—now around twenty-four years old—adorned with a delicate, thin beard, yet again appearing at a developmental stage somewhere between a boy and a man. In this three-quarter profile, the duke's boyish wispy beard would seem to belie the very threat that the martial armor, with its jutting, highlighted spikes in the breastplates—the so-called besagues—pose to the viewer as sharp, pointed menaces.[25]

The official, political iconography of Cosimo I certainly mattered to the duke

Fig. 11.1 Agnolo Bronzino, *Portrait of Cosimo I de' Medici as Orpheus*, ca. 1538–40, oil on panel. Philadelphia Museum of Art, Philadelphia. Reproduced by permission of the Philadelphia Museum of Art / Art Resource, NY

and his court, and it was something that he wished to control.[26] When, for example, the Medici agent in Milan, Francesco Vinta, was collaborating with the sculptor Leone Leoni (who was also then master of the Milanese mint) on a new medal for Cosimo I, Vinta observed in a letter sent in 1550 to Pier Francesco Riccio, the majordomo of the court in Florence, that he was not at all confident that the medal he had in hand (and that was probably only a year old) offered an accurate, up-to-date likeness of Cosimo I, because "His Excellence," he assumes, "has grown more beard [*ha messo più barba*]."[27] It was evidently important for Vinta and those back in Florence that Cosimo I's beard be presented just right, with the correct amount of growth. The medal clearly called for "more beard," and more beard is what Cosimo I was bound to receive if a new medal were ever to be made.[28] For the beard mattered, and there is clear visual evidence that Cosimo I made a con-

Fig. 11.2 Giorgione (da Castelfranco) (attrib.), *The Three Ages of Man,* ca. 1500, oil on wood. Galleria Palatina, Palazzo Pitti, Florence. Reproduced by permission of Alinari / Art Resource, NY

scious decision to grow a full, manly beard, and that it took some time for him to do so. The early portraits modeled on the "official" one by Bronzino, which depicts Cosimo I in about 1543 in martial armor, continue to present the young duke with only a slight, thin beard that cannot cover the chin and that, consequently, boasts only a smudge under the bottom lip.

Then, sometime after Cosimo I received the Order of the Golden Fleece when he was about twenty-five, in 1545, he was portrayed with a somewhat thicker beard. Evidently, the two or more intervening years seemed to have made a difference. And for the next ten years, during which time Bronzino's original three-quarter portrait of Cosimo I served as the "official portrait of the duke," the beard gradually grew.[29] Indeed, the beard as it grew over the years represented one of the few elements in the paintings modeled on Bronzino's early portrait of about 1543 that measured the passage of time, for, as Langedijk also observes, "in the case of Cosimo's likeness in particular a high degree of fixity prevails, both in the painted

Fig. 11.3 Agnolo Bronzino, *Portrait of Cosimo I in Armour*, ca. 1543, oil on wood. Uffizi Gallery, Florence. Reproduced by permission of Erich Lessing / Art Resource, NY

portraits and the sculptures."[30] There was not much change in the formal structure of the portrait of the first type, which resulted in a sort of iterative series based on Bronzino's painting, but there was in the beard, which grew bit by bit, in fits and starts.[31] Then, by about 1560, the model of likeness changed for a new series of official portraits of the duke (fig. 11.4). At this point Cosimo I, now aged forty or so, with little fear that Florence faced danger from foes near or far away, has himself portrayed without armor on, but this time he conspicuously wears a thick beard. Thereafter the beard retains a sizeable dimension, though it never did quite cover his chin. At best Cosimo I had what is commonly referred to as a "soul patch" there, a dense, furry, triangular growth beneath the lower lip.

At one level, what is so intriguing about these portraits is that Cosimo I persisted in his efforts to grow a beard despite the fact that he had a difficult time, at least early on, growing a full, mature one. Cosimo I's insistence on growing a beard

Fig. 11.4 Agnolo Bronzino, *Cosimo I Medici*, ca. 1560, oil on wood. Galleria Sabauda, Turin. Reproduced by permission of Alinari / Art Resource, NY

at once calls attention to his desire to impress on people in these official portraits an image of his "majesty," his legitimate right to rule. More specifically, it reveals his desire to have the official image he consciously controlled and presented of himself to the world conform to the image of majesty offered up by Charles V, whose portrait by Titian served as a model for Bronzino's early portrait of Cosimo I, the very portrait that would function as the model for so many others of Cosimo I.[32] At another level, what is also so intriguing about all the beards adorning Cosimo I's face in these portraits, from the ones portrayed in his youth to the ones of old age, is that they stand out as distinctive, though they were perhaps distinctive by accident. Everyone, from artists to patrons, courtiers to diplomats, as we have seen, wanted to make sure they maintained a certain look with their beards, and

their understanding of the beards they could design on their faces allowed for a wide range of possibilities.[33]

Renaissance Italians of some standing in the sixteenth century clearly aimed to acquire some measure of distinction by wearing a fashionable beard. Panciatichi surely aimed to flout his distinction through his beard in a portrait by Bronzino (fig. 11.5).[34] So distinctive is Panciatichi's highly textured beard that it stands out in the upper center of the canvas. His beard is also formally echoed in the poised forearms placed as perfectly parallel lines at slightly different levels, the fingers of the right and left hands coupled in balanced pairs, and, perhaps most conspicuously, the sets of elegant, snail-shaped Florentine window braces receding into the background just to the left of the centrally located beard, each of which represent so many smaller, architectural mirror images of the beard. The inverted twin peaks of the beard, so centrally located in the canvas, thus provide the model for the reiterated visual motifs within the canvas itself. Cosimo I's beard—in all of the versions of his painted portraits—is not distinctive in the same way within the picture plane. It is not distinctive, that is, because it is visually stunning or unique or fashionable. Cosimo I's beard is distinctive because he could not seem to grow one that completely covered his chin. In the end, the beard Cosimo I grew, and that he had begun growing in 1537, was about the best he could grow.

The beard in sixteenth-century Italy, I maintain in conclusion, thus appears to be something unique to a man as it grows on his face in a peculiar way and on that person's face alone. At the same time the beard in sixteenth-century Italy appears as a sort of mask that can be shaped in a unique way and that serves as an adornment, as if it were something "worn." It can therefore be spoken of, as Castiglione and della Casa do, in the context of clothing, much as if it were apparel consciously and selectively put on the body. Even the language used to describe beards both now and in the Renaissance links these two opposing concepts of identity formation. For one can speak in Italian of "wearing a certain style of beard" ("portare una certo tipo di barba"), just as one can of "growing a certain type of beard" ("far crescere un certo tipo di barba"). The first phrase implies something exterior to the face that is actively applied to it. Francesco Vinta, the Medici agent in Milan, even used the verb *mettere* ("to put") to refer to the growth of the beard on Cosimo I's face, as if the beard were a cosmetic, something added. Conversely, the second phrase suggests something instead that passively emerges from within, piercing the surface of the skin to disclose an essential part of the person contained inside. Together these concepts, embedded in different linguistic utterances about beards,

Fig. 11.5 Agnolo Bronzino, *Portrait of Bartolomeo Panciatichi*, ca. 1540, oil on wood. Uffizi Gallery, Florence. Reproduced by permission from Alinari / Art Resource, NY. Photograph by George Tatge, 1998

articulate completely different notions of male identity as rooted in the male body. In one instance identity is what you have as a certain type of man: it's a given, just as the beard is what you have. You can't do much about it if you can't grow a beard over your chin, any more than you can alter your chin and place a dimple in the center because you happen to want one there. Tough luck. In the absence of advanced cosmetic surgery in Renaissance Italy, you were who you were, just as your beard was your beard, though it seemed to matter less if you were, as Cosimo I was, a powerful duke.[35] In another sense identity is what you make of it: it's something you can fashion, just as the beard can be manipulated, altered, dyed, thickened in representations, rendered more manly and majestic to suit the official portrait on a

medal. When it comes to the beard as a peculiar facial feature in sixteenth-century Italy, then, you have some measure of control over self-presentation, some room for manipulating your facial features in public. You may not be able to grow a certain kind of beard, but you can still publicly and conspicuously stage the beard. At the very least, you can always go to the barbershop and, as Leonardo Fioravanti and others remind us, have the beard not only thoroughly washed but also properly trimmed so that you can go out and face the day.

Body Politics and the Tongue in Sixteenth-Century Venice

Elizabeth Horodowich

La lengua no ga osso ma la rompe i ossi.

VENETIAN PROVERB, CA. 1535

This chapter considers the organ of the tongue and the regulation of insults in sixteenth-century Venice. In doing so, it presents historical evidence with which to contextualize literary models of the early modern body by looking at the body from an archival rather than textual or art-historical perspective. Scholarship on the history of the body has consistently described how compared to the more fluid, porous body of the Middle Ages, the early modern body was subject to increasing discipline and control. Sociologist Norbert Elias has suggested that "the thresholds of embarrassment and shame" were raised in the sixteenth century, resulting in new conceptions of manners, social differentiation, honor, and civility. As a result, the body was increasingly subject to censure and containment. According to Elias, sixteenth-century ideas about behavior involved controlling the body in new ways by punishing acts such as spitting, sweating, gesturing, dressing, and, in particular, eating habits, resulting in a new inner discipline of the body. Mikhail Bakhtin similarly charted the appearance of the early modern, closed, classicizing body in which bodily regions were rearranged into a new hierarchy. The backside and the lower body became taboo, orifices had to be kept closed, yawning was discouraged, taking precautions to prevent others from glimpsing into the inside of the

body was encouraged, and whatever protruded had to be drawn in or laced up. Perhaps most famously, Michel Foucault has described how the body went from existing in a state of frankness and display to existing in one of physical and sexual confinement and concealment in the early modern period. He declares on the first page of his *History of Sexuality* that "[a]t the beginning of the seventeenth century . . . words were said without undue reticence, and things were done without too much concealment. . . . But twilight soon fell upon this bright day, followed by the monotonous nights of the Victorian bourgeoisie. Sexuality was carefully confined. . . . [P]roper demeanor avoided contact with other bodies, and verbal decency sanitized one's speech."[1] Foucault's ideas focus on a later period than this chapter addresses; nevertheless, as we shall see, evidence from the sixteenth century fits neatly with his claims.

Grounding these generalizing descriptions of the increased "discipline" of the body in specific historical evidence, however, raises a series of provocative questions: to what degree did this really happen? Did early modern individuals actually feel the need to control their bodies in a new way? That is to say, to what degree can we see a change in individuals' actual bodily experience as opposed to just changes in constructions of the body or sexuality? Was unbecoming physical behavior punished more systematically in the early modern world? If so, exactly why and how did this occur? By now, many scholars have "rescued the body from the margins of critical attention."[2] However, with the great exception of studies in the history of medicine, this scholarship has remained largely literary and art historical. What do voices from the archives have to tell us about both the experience of and the discipline of the body in the early modern world? How do ideas about the body influence, or how are they influenced by, the political and social change?[3] This is not to claim that archival materials are more "real" than literature, since all good historians recognize the ways in which archival documents function like literary texts. Rather, here I aim to look at how discourse was the effect not only of the mind and of rhetoric but also of an unruly body part: the tongue. Body parts interfaced intimately with the realms of the symbolic and the textual, and as we will see, early modern people responded to offensive or transgressive speech with bodily intervention.

Archival documents from Renaissance Venice suggest that conceptions of the body and how it could be managed and controlled as well as individuals' lived bodily experiences did indeed undergo change in the early modern period. However, increasing or changing attention to the body did not simply take place as a result of a generic, undifferentiated, or uniform "civilizing process." Sixteenth-

century Venetian patricians surely read the likes of Giovanni della Casa and Baldes-
sarre Castiglione, whose texts on manners and etiquette encouraged a new degree
of physical reserve, but when Venetian magistrates actually disciplined the specific
organ of the tongue and its unruly verbal outbursts in the form of insults in the
sixteenth century, they did so with the more specific goal of creating a normative
body that would reflect and construct an orderly, aristocratic state. The manage-
ment of the tongue in early modern Venice was not simply a result of the trickling
down of literary ideas about bodily control to the arenas of the state and the under-
classes. Rather, increased control over the tongue reflected the larger, complicated
process of early modern state-building and was a reaction to a variety of specific
political and social changes occurring in the sixteenth-century lagoon city.

While the medieval worship of relics indicates that the cultural practice of
partitioning had a long history, the early modern world witnessed the "'piecing
out' of the body . . . be it by punitive dismemberment, pictorial isolation, poetic
emblazoning, mythic *sparagmos*, satirical biting, scientific categorizing, or medi-
cal anatomizing."[4] Among these disembodied organs and members, the tongue
emerged as a site of tremendous fascination, repulsion, possibility, and anxiety in
a multiplicity of discourses in early modern Italy. For instance, though it is hard to
generalize that any one epoch or culture "talked" more than another, it is signifi-
cant that medieval monks had stressed the dangers of garrulousness and verbos-
ity. In contrast to the silent, contemplative ideal fostered by the monastic Middle
Ages, the spirituality of the friars and Jesuits—both centered in Italy—was decid-
edly verbal, as these new movements in religious culture both elevated preaching
above prayer.[5] Renaissance humanism also rejected the monastic ideal of silence
in favor of the active life based on civic, political involvement and verbal exchange.
It is impossible to overestimate the role of rhetoric in Renaissance culture, as hu-
manists rediscovered the antique belief in the power of the word and tongue to
captivate. Reacting to Luther's attack on the corruption of the church, the decrees
of the Council of Trent encouraged a new Christian modesty and emphasized
for all Christians—churchmen and laypeople alike—the importance of measured,
controlled speech.[6] Italian medical men, including Andreas Vesalius and his six-
teenth-century successors at the University of Padua such as Realdo Colombo,
Gabriele Falloppia, and Juan Valverde, dissected and sketched the tongue, mar-
veled at the complexity and strength of this muscle, and theorized about the ways
in which it connected the intellectual and the corporeal.[7] Writers of comportment
literature—among the best-selling volumes of the sixteenth century—obsessively
outlined the practice of civil conversation and the control of the tongue in social

speech.[8] Printmakers such as Cesare Vecellio and Nicoletto da Modena even went so far as to depict this unruly organ in their prints and engravings. In all these ways, Italian Renaissance culture demonstrated a fascination with the tongue.

In the more specific setting of sixteenth-century Venice, the tongue proved to be a decidedly divisive organ. The sixteenth-century chronicler Marin Sanuto revealed the degree to which individuals hurled violent words on the streets of everyday Venice. For instance, on July 5, 1498, he recounted that the officer Thomaso Zen was removed from his post "for having been angry and furious and having spoken rude words to everyone." On July 9, 1498, Zorzi Zernovich was placed in prison for using "parole bestial." On June 14, 1504, the scandalous words of an outspoken citizen were punished with the *strappado*—a punishment whereby one was dropped several times from a rope tied around the wrists.[9] Early modern Venetian jurists paid new attention to the crime of verbal injury, concurring that this was an action "without sense or justice, committed in various ways, mainly through words and deeds but also through writing and gestures."[10] According to legal theory, words were considered as powerful as physical actions themselves. Physical injury could result in pain or the loss of an eye or limb, but verbal injury resulted in the loss of reputation—damage equally as grave in the early modern world.[11] The advocate Marco Ferro argued that defamation occurs when, either in the presence or absence of a person, a second person "states damaging words against him, when he gives him a damaging reproach, or when he threatens or damages his person, goods, or honor."[12] Jurist Benedetto Pasqualigo offered a particularly detailed definition and description of insults.

> Verbal injury is committed in many ways: accusing someone outside of court of having committed general or specific evil deeds, offending with words someone's dignity, defaming someone and soiling the good opinion held of someone by saying false things, by spreading scandalous, bitter, threatening, or cursing voices about someone's habits or past, present, or future interests[,] . . . by deriding some natural defect, such as making fun of a bastard, someone cross-eyed, a hunchback, lame person, or leper, by stirring up neighborhood children to make fun of someone.[13]

Furthermore, Pasqualigo pointed out how insults damaged extended alliances of family and kinship: "Any spoken word that injures a person also offends those close to him and those connected by family. Since an injury against the father injures the son, or the wife the husband, a case could be started equally by anyone involved."[14] In a world where most news traveled orally, an insult was difficult to

contain. Venetian *giuriste* also agreed that insults against nobles and superiors were the most serious of all. Antonio Barbaro stated that "he who falsely accuses a noble person of a heinous crime commits a serious injury."[15] Unchecked, the tongue's power could have damaging effects on wider family networks, the noble class, or the state itself.

Any systematic study of the tongue in sixteenth-century Venice presents certain archival challenges. Several different magistracies enacted statutes to punish insults against state officials during the Middle Ages.[16] However, there does not appear to have been any singular statute that specifically prohibited general insults against another person. Furthermore, there was no single magistracy or council that oversaw the task of patrolling verbal injuries. This responsibility appears to have been shouldered primarily by the Signori di Notte al Criminal in the fourteenth century and given later to the Signori di Notte al Civil in the sixteenth and seventeenth centuries.[17] Unfortunately, very few records of either of these magistracies survive from the sixteenth century, though what does remain suggests considerable litigation pertaining to verbal injury. For example, Cattarina Faura was punished in 1544 with fifteen days in prison for insulting a certain Giovanna. Domenego Bernardin endured four days in prison and one ducat for insulting Cecilia Veronese in 1545.[18]

In any case, we cannot examine cases of insults from the magistracy that appears to have overseen this crime. However, the magistracy of the Avogaria di Comun—the Venetian state lawyers—frequently dealt with cases of verbal injury in the sixteenth century. Founded in the twelfth century, it elected three men to oversee the regular and systematic application of laws passed; one was present during sessions of the Council of Ten, and one during the meetings of the Great Council. The state lawyers also operated as public accusers in a wide variety of cases ranging from crimes of homicide and physical fights to theft, rape, and physical and verbal injury. Between 1500 and 1625, the Avogaria processed approximately fifty-eight cases in which verbal injury was one of the primary accusations. These trials permit a general survey of insults and the disciplining of the tongue in sixteenth-century Venice. They reveal why, where, and how individuals insulted one another, how people reacted to violent language, and how the state punished these unruly tongues and managed the physical body in doing so. Although admittedly these trials are unfortunately few in number, we must keep in mind that crimes of the tongue were not among this magistracy's central responsibilities. In addition, the theoretical underpinnings of microhistory work to validate the study of few cases or the single, unrepeated event, and other scholars have drawn convincing con-

clusions about the history of language in other early modern contexts based on a similarly small pool of examples.[19]

The historiography that examines insults and slander in the early modern world suggests that each case study reveals different patterns and results, and Venice is no exception.[20] In cases before the Avogaria, insults against sexual honor figured prominently—the most popular epithets by far being *becco fotuo* or "fucked cuck-old," along with "whore," "bugger," and "sodomite." Insults challenging honesty and respectability (*furfante, mariol, furbo, ladro*) were also popular, as were insults that compared the insulted to animals (*cane, porco, bestia, vaccha, mullo*). Although women were frequently the targets of insults, they did not appear to play a significant role as verbal aggressors; only four women in these fifty-eight cases were accused of verbal injury. The reasons behind this gender distinction are unclear. Specific cases reveal that women were equally adept at hurling insults, but perhaps women in early modern Venice were more restricted to the domestic realm than women were in other cities.[21] The location where insults were hurled was occasionally but not always noted. It appears to have been included in the charges when insults occurred in or around the arenas central to trade and state stability such as on galleys or in trading centers such as the German warehouse. It is unclear whether the site at which an insult took place affected the monetary fines leveled.

What many of these cases do exhibit is a profound sensitivity to language, on the part of both judges and those who testified in court. For instance, in a dispute over a will between two men in 1605, one of the litigants claimed that the other had said "excessive and impious words . . . that you would not say even to your worst enemy. . . . [H]e should slow his tongue and calm down."[22] In another case, a laborer offended two women with his language.

> Among us workers, laughing among ourselves a month ago, I said, speaking modestly, "I am going to take a shit," and upon hearing these words, these women threatened to hurt me, believing that I had said these words against them, and they said a thousand insults to me, calling me a son of a bitch and a cuckold, trying from then on to throw me into the water and kill me, even though I really said those words simply, as one is accustomed to do throughout the city, with no thought of speaking about them.[23]

On October 30, 1589, Matteo Maffei denounced Girolamo Domo for verbally and physically injuring him. According to Matteo, Girolamo had come to his shop complaining about the price of a tool he had bought. Girolamo called Matteo a

beast, a thief, a vituperous rogue, and a "son of a whore." "He started to say things and the most injurious rude words, so I responded that we were respectable men and that he should not speak in that way."[24] Girolamo then took out a knife and physically injured Matteo. For these injuries, the court punished Girolamo with three years in prison, saying that "he must not molest, either in deeds or words [Matteo] nor other persons."[25]

Denunciations and witnesses frequently described the accused's bad character explicitly by reference to his or her loose tongue—often it was the very first point made in a trial—suggesting that speech defined a person in the community. For instance, in his denunciation against Cornelio Badoer for injury, the first thing that Agostino Fabris mentioned was Cornelio's dirty mouth, claiming that he did nothing but pronounce insults and blasphemy against local shop owners. Similarly, when the first witness was asked if he knew Cornelio Badoer, he stated "I do not know anything except that he has a licentious tongue."[26] On May 11, 1620, Benedetta Vedova denounced two people—Angela Meronti and Angelo Faura— for verbal injury. Benedetta claimed that in front of her house in Venice, these two called her a "'fucking bugger,' 'scoundrel,' 'whore with a little skirt,' 'cow,' and other even more detestable injuries, upsetting the entire neighborhood [and] continuing to yell at me for the space of a half hour. . . . Angelo is a most disgraceful person of the worst customs, usually injuring and defaming this person and that person[,] . . . going around the city defaming and offending whoever he wants."[27] Angela called Benedetta a "'whore,' 'scoundrel,' and other dirty words—Angela also said that she went to *osterie* to bugger herself."[28] Other witnesses stated that they said "'Up your ass, you bugger,' and [other] most filthy and detestable insults that I am [too] embarrassed to say."[29] They said "such wicked things that I am ashamed not only to say them but just to think about them again."[30] Almost all the witnesses called stated that both Angela and Angelo were known in the city for insulting a lot of people with infamous, detestable words. Despite the fact that a type of restraining order was placed on Angela and Angelo that stipulated that they were not to insult Benedetta, witnesses claimed they went on with their insults; Angela claimed innocence but died of a fever before the case was decided.[31] These men and women and many others like them offer a window onto the way that people perceived the bodies that they lived in; specifically, they believed that the tongue should not be allowed to function unbraked, either in one's own body or someone else's.

While a wide variety of men and women insulted one another, the insults that received the greatest attention from the Avogaria tended to take two forms: verbal injury against nobles and insults spoken against the interests of the state as

a whole.[32] Seventeen of these fifty-eight cases involved insults against nobles or superiors. For instance, on August 25, 1526, the noble Galeazzo Dolfin denounced Francesco dall'Olio for both physically and verbally insulting him. Returning from church, Galeazzo passed under Francesco's balcony. Francesco had been watering some geraniums and managed to drench Galeazzo. "It was not enough that Francesco soaked me, but even worse he started to insult me saying 'look out bugger' and other insulting words," running after Galeazzo and hitting him over the head with the flat side of his sword.[33] Witness Domenego stated that Galeazzo asked "Who the devil is throwing water?" and looked up, to which Francesco replied, "Are you talking to me? Look out you beast!" Galeazzo replied "Are you talking to me?" and Francesco responded, "Of course I am talking to you, [you] fucking bugger."[34] According to Francesco, by contrast, as his mother was watering the geraniums, she happened to drop a bit of water onto Galeazzo, who exclaimed, "Get away, you fucking whore who has drenched my ass."[35] Francesco arrived on the balcony and threatened, "Look out you fucking cuckold," to which Galeazzo replied, "If I were a cuckold, I would have horns; come down here you thief and scoundrel—I'm going to quarter you!"[36] Francesco then ran after Galeazzo with his sword and hit him over the head. Afterward, however, Francesco begged to be pardoned, stating that if he had known that Galeazzo was a noble, he would never have treated him in such a way.[37] Francesco received two drops from the cord and six months in prison for his insults and injuries against this nobleman.[38]

Similarly, on October 10, 1595 Giuseppe Beltrame was banned from Venice for three years for "abominable insults" spoken against both an individual young woman and the nobility in general, having said "scoundrel, bugger" to an actress named Giulia and then having stated that he had "it up the asses of the most excellent nobles who favored the young woman."[39] In other words, he was punished for his arrogance in claiming to have power over nobles and for making passive homosexuals of them; in this case, both masculinity and social status were therefore at stake. In 1633, a similar case was initiated against Bortholomeo Malombra. This case involved no denunciation; instead, the court began by asking various witnesses if they had ever heard Bortholomeo speak out against the nobility. For instance, the judge asked the noble Gerolomo Memmo "if he had heard Bortholomeo say that he would stab the first noble that did even the smallest thing to him many times in the gut until his soul came out."[40] Similarly, the judge asked witness Lorenzo Sanuto if he had ever heard Malombra "say words of hatred toward the nobility, for instance that he would like it if all of the nobility were a fresh egg that he could swallow and other unbecoming words."[41] Neither one of these witnesses

had heard such language, but the court had obviously received this information from an unnamed source and was attempting to verify it. The rest of this trial along with sentence has been lost; nevertheless, as the repeated questions of the judge make clear, the Avogaria was disturbed by potential insults against the noble class.

Cases of insults against superiors, particularly on Venetian galleys, were also common in the trials of the Avogaria. For example, on August 18, 1600, Giana da Candia, who was already doing galley service for some other crime, was sentenced to another eighteen months of galley service for insulting and physically injuring the master of the galley where he was assigned. He entered into a disagreement with the master of the galley and yelled, "You whore, I only have seven days of punishment left and as soon as I have finished them, no cuckolded dog, son of a bitch is going to command me."[42] In a similar case, Marco da Candia, a galley captain, denounced the galley worker Ludovico of Vicenza for insulting him. According to witnesses, Ludovico and Marco had entered into a disagreement, and Ludovico exclaimed, "You ugly fucking cuckold, wearing your red tunic as if you were an admiral"; no sentence was pronounced for this case.[43] On December 27, 1573, Vicenzo Pililler was punished with three years' galley service (and was threatened with having his tongue cut out if he further disobeyed) for having insulted the captain of his galley by referring to him as "golden beard, mustache of shit."[44]

Insults against the republic itself were also taken extremely seriously. Insulting the state had always been punished harshly in Venice. The Council of Ten—Venice's most powerful central security council—had monitored civic speech since its inception. While this chapter is concerned with unruly verbal outbursts rather than with the calculated speech of treason and conspiracy, it is significant that fears of conspiracy led to the creation of this magistracy in 1310, which was given the task of snuffing out all subversive language against the state—verbal and written.[45] The creation of the Council of Ten and its centrality to Venetian politics reflect a particular Venetian sensitivity to the potential danger of verbal threats. Once again, Sanuto offers numerous examples of treasonous speech and its punishment in the sixteenth century. For instance, the Paduan Lorenzo di la Campana was banned from Venice for five years on November 28, 1509, "for words spoken against our signoria." On November 19, 1511, the barber Bernardin Malizia was placed on a stage between the two columns of San Marco and had his tongue cut out "for words spoken against the state."[46] In 1584, a preacher who openly criticized the government was banned forever from Venice.[47] Frederic Lane has aptly related the success of Venice's great cosmopolitan experiment to verbal control: "Men of a

great variety of views succeeded one way or another in living in Venice pretty much as they pleased, so long as they did not attack the government."[48]

Trials from the Avogaria reveal this same interest in prosecuting verbal violence against the state. For example, in March 1570, Nicolò Andri—a cook on a galley—was accused of insulting the state and revealing state secrets to several Turks. According to the ship's bread baker Manoli da Cerigo, while the galley was in port in Corfu—an island that was part of the Venetian empire—Nicolò was chatting with some Turks who were unloading some grain. They all agreed that the Turks should not have supplied Corfu with grain, as the Venetians were dogs.[49] Nicolò also discussed recent events in the fleet with the Turks, mentioning that fifteen Venetian galleys had recently been defeated near Vallona and speculating about who would next become captain of the fleet. Another witness reported that Nicolò had said, "Why did you bring grain to the fucking cuckolded dogs in this city?"[50] Nicolò had exclaimed "that they had done badly to bring grain to the men of the Venetian empire, who were dogs and scoundrels, adding that Venetian ships had been defeated with artillery by Carracozza [a Turkish commander]—words that moved my blood."[51] Afterward, Manoli attempted to reprimand Nicolò for sharing this information, instructing him not to act against the Christian faith in such a way. Nicolò replied that he had done no harm. Though he claimed innocence, Niccolò was sentenced to three years of galley service and threatened with having his tongue cut out if he further misbehaved for his "many other words full of iniquity and bad spirit."[52] In a similar case from 1601, Giovanni Antonio Malloni was accused of physically and verbally injuring the lion of St. Mark—the symbol of the Venetian state—in Rovigo. Embittered over his gambling losses, Malloni supposedly confronted the statue of the lion over the door of the *camera fiscale*, hitting it with a bucket on the eyes, nose, and head and yelling "Ugly God, dog, fucking cuckold—you give lots of money to others but none to me."[53] Malloni claimed that these were nothing but the false testimonies of his enemies. The court nevertheless persisted, demanding to know whether or not Malloni had "committed such a detestable and abominable crime by speaking vituperous words" against the statue of the lion and eventually punishing him with ten years' galley service.[54] In these and other cases, the body was subject to punishment specifically aimed at enforcing civic unity.

Insults against the state's interests often resulted in formal edicts and proclamations to control the unruly tongue. For instance, after a group of young people attacked the prioress and the hospital of the Pietà several times with insults, threats, and "dishonest words," the Avogaria declared in 1514 that anyone who insulted the

hospital would be fined two hundred lire or sentenced to five years in prison.[55] On January 16, 1570, the Avogaria di Comun posted a proclamation over the steps of the Rialto declaring that porters and boatmen around the German warehouse had been regularly pronouncing "indecent words and at times began to fight, which creates a notable disturbance to the calm of the merchants." The Avogaria declared a fine of fifty lire for anyone who dared to argue "either in deeds or in words or in any way pronounce indecent language" around the warehouse.[56] Not unlike insults on galleys or in warehouses, insults against the Turk were also subjected to special scrutiny by the state. On March 19, 1574, two Turks—Hassan and Mostafa—complained to the doge and signoria about the "enormous injuries and insults that [Venetian] subjects pronounced upon them . . . with injurious words offending our honor."[57] As a result, on March 20, 1574—immediately following the complaint—the Avogaria ordered that "no one was to dare in any way, form or manner, in words or deeds, injure, offend, . . . or use any type of injurious words against the subjects and representatives of the most serene Lord Turk"; if anyone did, he or she would face "the punishment of five years galley service and three drops from the cord in public."[58] In addition, Dennis Romano has demonstrated how the sixteenth century also witnessed a new interest in disciplining the unruly tongues of servants. On August 17, 1541, the Council of Ten transferred all authority over Venice's domestic servants to the magistracy of the Censori, and much of its work was dedicated to prosecuting the perceived increase in servants' violent language, especially that of gondoliers, "who insult brides with their oars and mouths as they pass along the canals."[59]

What do the sum of these laws and trials tell us about both the experience and conceptions of the body in early modern Venice? Early modern men and women demonstrated a keen awareness of the powers of the tongue and of the boundaries separating mannered and unmannered speech. Verbal injury was typically described as being as grave as physical harm, and words were regarded as being as forceful as actions themselves. Even though in some cases an account of physical violence would have been more than enough to ensure prosecution, witnesses invariably included foul language to shore up the gravity of their accusations. In the modern world, it would seem superfluous to mention that in addition to being physically assaulted, one was also called a dog or a cuckold; yet in early modern accounts, the verbal component of an accusation further confirmed the severity of a case. The failure to protest an insult would have been equivalent to admitting that the accusation was true. In their lived bodily experience, early modern Venetians clearly perceived the tongue as one of the most powerful organs or sites in the

body, to be controlled as well as unleashed when appropriate. If insults "provide a view of community values, a view of the essential components of honor and shame" and "provide insights into the mentality and values of a cultural group," then insults in Venice reveal a profound preoccupation with both honesty and civil behavior, as insults criticized those who behaved like thieves and animals and those who were outspoken in general.[60] Venetians indeed demonstrated an internalized awareness of "civility" and the desire or need for physical reserve and the control of the tongue.

In addition, the Venetian discipline of the tongue appears linked to a broader trend toward the aristocratization of Venice in the sixteenth century. As any student of Venice knows, the city originally rose to economic strength in the wake of the Fourth Crusade when it consolidated a virtual monopoly on commercial shipping in the Mediterranean between 1201 and 1204. Venetian nobles in the Middle Ages made their fortunes in commercial trade on the high seas together with non-noble merchants and businessmen. Though there is much debate about whether or not the Venetian economy took a decisive turn for the worse in the sixteenth century, there is a sizeable consensus that Venetian politics moved away from republicanism and toward oligarchy in the sixteenth century.[61] As Venice moved from being a commercial to a manufacturing center, the nobility increasingly became a landed elite, which had the effect of separating the economic interests of nobles from non-nobles. While Venice remained a republic in name and continued to maintain a more republican political system than its courtly counterparts, many historians have argued that the sixteenth century represented the end of "true" Venetian republicanism, at which point power became concentrated in the hands of a few aristocrats and a more marked social stratification emerged.[62]

The work of the Avogaria reflects this cultural shift toward an increasingly rigid class hierarchy, greater social stratification, and the "aristocratization" of the body, recalling Foucault's description of the growing discipline of the tongue in the early modern period. The Avogaria continued to perceive a threat in insults against the state as it always had, but these fears are amplified in the proclamations that appeared forbidding insults on galleys, in the German warehouse, and against the Turk, which all worked to promote the peaceful trade that the state depended on. Furthermore, insults aimed up the social hierarchy were regarded as more disruptive and dangerous in the sixteenth century than before, as the work of both the Avogaria and the Censori indicates broad concern about quotidian verbal aggression toward nobles and social superiors that was not so clearly evident in the late Middle Ages.[63] These magistrates aimed to shield respectable ears from the

scandalous mouths of servants and the underclasses by disciplining the unruly tongue. Their proclamations and prosecutions unevenly distinguished and punished specifically underclass language, illuminating perceived connections between language and class. Insults up the social ladder often led to or implied an injury to the state itself—objectively a much more serious crime than verbally insulting an individual. As nobles effectively represented the state, verbal violence against the nobility implied violence against the republic as a whole. Controlling speech as a form of violence and enforcing a standard of noncriticism protected the unity of the state, and the Venetian republic had long been concerned with the violent speech of conspiracy and treason.[64] However, by the early modern period, the work of these magistracies suggests that concerns about verbal violence had less to do with medieval fears of factionalism or divine punishment and more with upholding an orthodoxy of speech that increasingly reflected ideals of noble privilege, aristocratic control, and the containment of the underclass body and tongue.

This chastising and cleaning up of public behavior mirrored the sixteenth-century cleaning up of Venetian public spaces and was in keeping with Doge Andrea Gritti's renowned efforts to create a more decorous civic center. During his term as doge (1523–38), Gritti enacted numerous architectural and civic reforms to polish the city and make it respectable in the wake of the disaster of Agnadello.[65] For instance, in the early sixteenth century, the Piazza San Marco was cluttered with money-changing booths, food stalls, hostels, and latrines.[66] Gritti adhered to the tenets of Domenico Morosini's 1497 architectural treatise *De bene instituta re publica*, which argued that civic beauty and decorum were political instruments that generate civic order and earn the respect and fear of enemies.[67] Gritti hired the renowned architect Jacopo Sansovino to remove the sordid wooden stalls that had "infested" the piazza and replace dilapidated buildings with new ones so as to present a more civilized, classicizing façade to the outside world.[68] Gritti similarly revamped Carnival rites, prohibiting the vulgar throwing of pig's ears in the Piazza San Marco and replacing that custom with more noble, modest spectacles. Venice as "a new Rome" emerged out of the dark years following the League of Cambrai, and similar civic and architectural reforms were made throughout the sixteenth century.[69] Gritti's *renovatio* went hand in hand with sixteenth-century legislation against insults; both programs aimed to replace the grotesque, porous, and overflowing with the modern, modest, and classicizing. A new bodily canon emerged for Venice, one that, equating the early modern body with Gritti's architectural program, presented the new, more impenetrable façades of the classicizing building and the closed mouth. Representing the site of the formation of popular and

counterculture, the tongue needed to be controlled just as squalid buildings had to be cleaned up and public spectacles had to become more decorous.

Beyond the growth of this classicizing, aristocratic culture, an additional diversity of local factors came together to form a matrix of local forces impacting Venetian constructions and perceptions of the body and the tongue. The combination of war, plague, famine, territorial loss, and a changing, more industrial-based economy resulted in enormous waves of immigration to the lagoon in the first half of the sixteenth century, and this immigration encouraged a new attention to public behavior and speech. As an open, unwalled city, Venice could not physically stop immigrants from entering the city in large numbers, but it did aim to instruct newcomers in correct civic conduct. For instance, the Council of Ten formed the Esecutori Contro la Bestemmia in 1537 to combat specifically the problem of blasphemy. This magistracy prosecuted an unusually high number of foreigners, indicating a clear connection between immigration, language, and civic identity, as ideas about proper spoken decorum and the use of the tongue functioned as a filtering screen through which foreigners had to pass.[70] A variety of other sixteenth-century magistracies also had a bearing on the control of speech. The Tre Savi all'Eresia was founded in 1547 to monitor heresy and heretical speech. Already established magistrates whose tasks involved overseeing public behavior were also further empowered, notably the Proveditori Sopra le Pompe, which regulated sumptuary laws, and the Proveditori Sopra i Monasteri, which oversaw the workings of the city's monasteries, and the office of the Sanità, which regulated prostitution. The creation and operation of these magistracies reflected both reactions to immigration and the forces of the Counter-Reformation. They attempted to encourage modest, respectable public behavior in the wake of the republic's devastating military defeat by the League of Cambrai in 1509, the state hoping to prevent similar divine punishment in the future by encouraging correct civic comportment. This emphasis on "civility" to some extent also reflected pan-European attitudes toward popular culture, as the ethic of "reformers" across Europe encouraged "decency, diligence, gravity, modesty, orderliness, prudence, reason, self-control, sobriety, and thrift."[71] Controlling the unruly tongue was a fundamental cause and result of this intricate tapestry of local events.

All this is not to say that Venetian magistracies were necessarily successful in their efforts to govern the tongue. Ironically, the establishment of rules to suppress base language simultaneously opened up a potential space in which to unleash the powers of the tongue. Not unlike other attempts to control cultural expression (sumptuary legislation, for example), insults and foul language became all

the more meaningful as means of protest after they had been specifically legislated against. Placing controls on unmannered speech in effect worked to encourage a contest between the state and its inhabitants about the fashioning of the body, the self, and class identity. As James Scott has argued, verbal aggression functioned as a substitute for political action, as "a means by which the weak and defenseless tried to avenge themselves upon their enemies."[72] As Venetian magistracies sought to enforce certain standards for the presentation of the body, insults and swearing took on an increased importance as means of subversion, particularly for non-nobles seeking to protect their cultural space against encroaching sixteenth-century ideals of aristocratic civility. Servants, laborers, and gondoliers surely gained standing among fellow workers through their ability to insult and swear, as insults could not only destroy but also create honor.[73] Social inferiors fought a wide variety of battles with the weapon of the tongue; they affirmed their status and increased their honor within their own social group, damaged the honor of those they insulted, and, most significantly, challenged increasingly oppressive ideals of civic respectability and social hierarchy. With the antilanguage of insults, workers and servants carved out a space of resistance for non-noble culture. This suggests that control over the tongue was not merely imposed from the top down but that speech was a constitutive element of power as mannered and unmannered tongues competed to be heard on the streets of the mobile city.

Part 4 / The Body Involved

"Sauter et voltiger en l'air"

The Art of Movement in Late Renaissance Italy and France

Sandra Schmidt

Dialogues on Tumbling

When considering forms of artful bodily movement in the late Italian and French Renaissance, most historians refer to courtly ballets, fencing, or the noble *jeu de paume*.[1] All three types of bodily practice belong to court society and observe specific requirements of accepted posture of the noble human body. On the other hand, one might look to historical sources describing the more spontaneous and less regulated bodily practices in popular marketplace entertainment. These kinds of movement vary from gesticulated recitations to juggling, tumbling, or acrobatic presentations of different types, all of them associated with the lower social classes. And with the publication of *Trois dialogues de l'exercice de sauter et voltiger en l'air* in 1599 by Arcangelo Tuccaro, author and master of tumbling at the French courts of Charles IX, Henry III, and Henry IV, we find the undoubtedly rare, if not unique, coincidence of a bodily practice traditionally found among these lower social classes with the highly representative court festivity and the appearance of a methodological treatise.[2]

"Sauter et voltiger en l'air" can be translated as "aerial leap and turn." This technique is best illustrated by the example of the *salto mortale*: a 360-degree horizon-

tal axial rotation of the body, taking off from and landing on both feet, a movement also described with a Greek term as *cubist* or, in this case, better thought of as a *cubistic* jump.[3] The *salto mortale* has acquired a variety of different meanings over the course of history. According to its Greek origin, the word κυβιστάω as a movement is a metaphor for death, and in the current so-called point code in artistic gymnastics, it is classed as a difficulty A element in the group of the somersaults (fig. 13.1).[4]

The *salto mortale* is described, along with more than fifty other acrobatic leaps, by Tuccaro in his *Trois dialogues*.[5] We know little of his origins beyond the fact that he was born in Aquila around 1538 and was taken up by the court of the Austrian emperor Maximilian II in 1564. He moved from Vienna to Paris when Maximilian's daughter Elisabeth married Charles IX in 1570, but during his time in Paris, there are hardly any historical sources that mention Tuccaro and his activity as a tumbler and "saltarin du roy" ("king's tumbler").[6] In 1586 he was described by Tommaso Garzoni as an extraordinarily gifted tumbler, and in 1588 Vincenzo Belando dedicated the *Lettere facete e chiribizzose* "al signor Arcangelo Tuccaro, Saltarino de Re, christianissimo Suo conpare osservandissimo."[7] Tuccaro's dialogues are set during the wedding festivities in Touraine in 1570. Participants in the dialogues are three noblemen, namely Cosme Roger (who was probably Caterina de' Medici's astrologist Cosme Ruggiero), Charles Tetti, and Ferrand, and three tumblers, Pino and Baptiste Bernard, both scholars and friends of Tuccaro, and the author, Tuccaro himself, who intervenes only twice in the whole conversation. In the first dialogue, the participants discuss gymnastics in antiquity, the art of *saltare* and the importance of dance. The conversation includes plenty of classical references and scholarly philosophical thoughts. In the second and longest conversation, Tuccaro explains and illustrates with eighty-eight woodcuts his art of tumbling, presents a classification of the different jumps, and gives methodological information. The third and last dialogue is structured like the first and refers to the many kinds of exercise. The protagonists discuss the definition of health and the connections between health and exercise, using at times astonishingly modern arguments. The first and third conversations reflect antique and contemporary knowledge and recall the typical accepted form of Renaissance dialogues in the tradition of Castiglione's *Il libro del cortegiano*. They function as a framework for the longest, second conversation that contains the original and daring parts regarding a bodily practice that was not considered noble at all.

In the following analysis, I attempt to demonstrate that the physical practice of the art of tumbling can in a certain sense be regarded as a vehicle to knowledge

Fig. 13.1 Archange Tuccaro, *Trois dialogues de l'exercice de sauter, et voltiger en l'air*, fol. 125r. Illustration courtesy of the German Sport University Library, Cologne

and that the understanding of the art and science of tumbling led to an ennobling of a specific form of movement.[8] This physical praxis can only be understood in the context of the inherent ambivalence between perfection and beauty, on the one hand, and grotesquerie and sacrilege or even blasphemy on the other. To describe this ambivalence, I look at the specific movement of the lowering of the head and the formation of the circle, which was the movement Tuccaro invoked in his attempt to establish tumbling as both art and science. Before concluding, I offer one possible interpretation of this specific art of movement in the context of the concrete historical situation of courtly festivities.

Writing about Moving

According to Michel de Certeau, historiography has a paradoxical structure because the historian establishes a relation between two antinomic terms, "between the real and discourse. Its task is one of connecting them and, at the point where this link cannot be imagined, of working as if the two were being joined."[9] The most important gesture of the historian is therefore that he "attaches 'ideas' to places."[10]

Writing about the past becomes especially difficult when considering the human body and bodily movement. Susan Foster argues that history has to be choreographed: "The sense of presence conveyed by a body in motion, the idiosyncrasies of a given physique, the smallest inclination of the head or gesture of the hand . . . all form part of a corporeal discourse whose power and intelligibility elude translation into words." She proposes that an adequate "writing about bodies" implies "that verbal discourse cannot speak *for* bodily discourse, but must enter into 'dialogue' with that bodily discourse."[11] Peggy Phelan poses the most striking question: "What are the forms of writing that will allow us to hold the moving body? The moving body is always fading from our eyes. Historical bodies and bodies moving on stage fascinate us because they fade."[12] My analysis here consists in a reconstruction of a bodily movement and its possible meanings in the sixteenth century. The concept of body or corporeality that grounds my discussion is Marcel Mauss's "body techniques" because it explicitly refers to bodily movement, whereas other theories provide accounts of the body that do not consider the aspect of movement. According to Mauss, all movement practices constitute one of the "means by which men, in any particular society, know by tradition how to employ their bodies. At any rate, we should proceed from the concrete to the abstract, and not vice-versa."[13] To consider a highly complex movement such as the *salto* on the same level as a gesture of the hand or a way of walking allows us to associate it with a tradition and a history of that specific movement.

Mary Douglas's theory of the two bodies is also important: "The body as social construction controls the way in which the body is perceived as a physical construction, while on the other hand . . . a particular social viewpoint is made manifest in the physical perception of the body."[14] By this she describes the interdependent relationship that has to be taken into account in order to explain the integration of the practice of tumbling into court activities, on the one hand, and Tuccaro's intention of creating an art and science of tumbling, on the other.

The Body as Vehicle to Knowledge

Tuccaro's dialogues must be seen in the context of the restructuring of knowledge, the epistemological paradigm shift and shift in the history of ideas, that was inspired by the Italian Renaissance. In brief, we can say that in response in particular to the works of a number of philosophers, the individual and his body were accorded a far greater significance than was the case in medieval times. For example, Marsilio Ficino bases man's dignity on his ability to create and defines him as *Deus in terris*; Lorenzo Valla describes the human soul as *homo-deus*; and Pico della Mirandola believes the deification of human beings is a matter of self-determined human will.[15]

The altered conception of the relationship between human beings and God becomes especially evident in the works of Giannozzo Manetti. Here the human body of the *uomo universale* is considered the proof of his dignity because an upright posture signifies a middle position between heaven and earth.[16] A space had been cleared for what Hentschel calls an "optimistic anthropology."[17] This means knowledge is attributed not only to God but also to rational beings, since all branches of science followed the maxims of systematization, restructuring, and theorization. Furthermore, observations of nature and experiments gain in importance: the study of anatomy, for example, emerged in particular in the work of Andrea Vesalius. Even translations and reinterpretations of classical texts and rediscoveries—such as that of Vitruvius's books on architecture—played an important role in increasing the awareness of the significance of the body. Ernst Cassirer summarizes Renaissance philosophy as a belief that "the individual must read the basis of his fate not in the heavens but in himself."[18] Describing a paradigm shift from a teleological to a mechanical-functional worldview, David Hillman and Carla Mazzio state in summarizing Stephen Greenblatt's contribution to their volume *The Body in Parts* that "early modern attempts to establish and understand universal languages of the body register a shift from predominantly religious to predominantly anthropological paradigms."[19] The body was increasingly conceived as a bearer of meaning, allowing for the assignation of social and moral judgments.

In order to reconstruct the development and the significance of the *Trois dialogues*, it is necessary to throw some light on Tuccaro's sociohistorical background. According to Garzoni, who in his book *La piazza universale* compiled a list of every conceivable occupation of his time, the tumbler was anything but a nobleman of the court. He mentions Archangelo d'Abruzzo by name, in the group of "de'

saltatori, e Ballarini, e di tutte le sorti di tripudianti, e de' cursori," and describes what he does:

> Vi è un'altra saltatione usata molto al tempo nostro de' Bagatellieri, la quale e sercita il corpo mirabilmente e lo fa agile, destro, forte, e gagliardo quanto dir si possa; ne porta seco tanta vanità à quanto le prime, benche sia soggetto di persone ignobili, come per lo piu vediamo esser da tali frequentati.

> (There is another sort of jumping, performed a lot in our times by tumblers; it exercises the body in admirable manner and makes it agile, dexterous, strong, and powerful. It is as vain as the others, even though it is performed and watched by ignoble people.)

He continues: "Si dilettano costoro di dar piacere al populo con salti miracolosi, et mortali che fanno alla preferenza di tutti" ("They enjoy giving pleasure to the public with wondrous and deadly jumps that are preferred by all").[20] This description, published thirteen years before Tuccaro's dialogues were edited, proves that he was famous as a marketplace entertainer in Italy.

Unlike typical court activities such as hunting, riding, and ball games, jumps of this kind were not at all viewed in a positive light. Baldassarre Castiglione gives us exemplary proof of this in *Il libro del cortegiano*, in which he defines *grazia* and *sprezzatura*, generally translated as a kind of ease or the appearance of effortlessness, as the characteristics of courtly posture and as the "regula universalissima."[21] His explicitly remarks on physical practice:

> Conveniente è ancor saper nuotare, saltare, correre, gittar pietre perché oltre alla utilità che di questo si po avere alla guerra, molte volte occorre far prova di sé in tai cose. . . . Ancor nobile esercizio e convenientissimo ad uom di corte è il gioco della palla. . . . Né di minor laude estimo il volteggiar a cavallo. . . . Essendo adunque il nostro cortegiano in questi esercizi più che mediocremente esperto, penso che debba lasciar gli altri da canto; come volteggiar in terra, andar in su la corda e tai cose, que quasi hanno del giocolare e poco sono a gentiluomini convenienti.

> (He should also know how to swim, jump, run, throw stones; for, besides their usefulness in war, it is frequently necessary to show one's prowess in such things. . . . Another noble exercise and most suitable for a man at court is the game of tennis. . . . Nor do I deem vaulting on horseback to be less worthy. . . . If, then, our Courtier is more than fairly expert in such exercises, I think he ought to

put aside all others, such as vaulting on the ground, rope-walking, and the like, which smack of the juggler's trade and little befit a gentleman.)[22]

In 1580, Michel de Montaigne confirms this opinion in the *Essais*. He notes that "even games and exercises will be a good part of the course of study," including "running, wrestling, music, dance, hunting, [and] the handling of horses and arms," but condemns the *salto mortale*: "Just as in our dances, these men of low condition, because they cannot reproduce the carriage and decorum of our nobility, try to excel by means of dangerous jumps and other strange and juggleresque movements."[23] From this we can deduce that with his move to Vienna and the court of Maximilian II, Tuccaro had already successfully achieved a remarkable social advancement from common street clown to the elite of court society. Presumably he aimed to distance himself as much as possible from the type of entertainment that was popular in the marketplace.

The only means Tuccaro had of improving his social status was the knowledge and ability of his body. He applied a double strategy to ennoble the art of tumbling: first, he sought to tame, or domesticate, movement through the systematization of virtuoso performance, and second, he set down in writing his corporal knowledge in the form of a classical Renaissance dialogue complete with various intertextual references to ideals from antiquity and the Renaissance. In doing so, he also established the significance of tumbling on the semantic level: Tuccaro defines himself as "le Prince des plus rares exercices de siècle" ("the Prince of the most exceptional exercises of the century") and refers to tumbling as an art throughout the book ("l'art & science du saut," "nouvel art," "noble exercice" [the "art and science of jumping," "new art," "noble exercise"]).[24] He furthermore argues that the difference between his art and popular forms of entertainment is its theorization, repeatedly citing the "methode de sauter" ("method of jumping") and the "reigle, mesure, proportion" ("rule, measure, proportion"), and "disposition" of tumbling.[25]

He also classifies tumbling in terms of the *septem artes liberales*, which constituted the canon of the sciences; in establishing relationships between tumbling and all seven of the arts, he attaches status and respectability to it. Music and geometry are particularly important to him, as are elements of the quadrivium, the so-called arts of calculation.[26] He explains the technique of his tumbling with the help of proportional diagrams and a geometrical framework derived from Vitruvius's *homo bene figuratus* (see fig. 13.2). The success of the jumps depends on the correct calculation of the circular path in the horizontal axial rotation: "The somersault performed in the right manner is nothing else than a perfect circle in the air,

where the circumference starts and ends at the same place. . . . Therefore the center of the circumference in the correct proportion of the jump is in the middle of the space the jumper's body takes up, landing at the same place."[27] And with respect to music, the first dialogue, for example, observes that "the movements of the body, jumping or dancing, are called by the Greeks and the Romans harmonious because without doubt they respect the proportion, measure and rhythm the human being ascribes to music, to which it adjusts the movements of all limbs."[28] Tuccaro justifies the ennobling of the art of tumbling with reference to antique authorities, as, for example, when he cites Plato's seventh book of the *Laws* "where he talks about all sorts of brave and honorable exercises, but especially about the jump and the fight, which he recommends."[29] Tuccaro is suggesting here that the *salto mortale* is included in Plato's discourses about jumps, when in fact he is referring primarily to the long jump and the high jump as a necessary preparation for the warrior. This misleading interpretation, in my opinion intentional, has to be understood as part of the ennobling gesture: Tuccaro ties his art of tumbling up with authoritative texts in order to establish traditions that did not exist.[30]

However, he is not content with merely inserting tumbling into the scientific canon of his day. In addition, he endows movement with a moral significance, equating that which is aesthetically beautiful with the morally good and thus concurring with neo-Platonic interpretations. Tuccaro implicitly refers to Castiglione's concept of *grazia*, extending what Castiglione recommended in relation to the ideal posture in daily behavior to cubistic jumps and relating "gracious movement" to the maintenance of the specific rules of proportion and *mesure*.[31]

From the modern perspective, Tuccaro's own body and his probing of its capabilities were not only a means of acquiring knowledge but also the means by which he established and maintained his social status within court society.

Ambivalent Forms of Movement

In interpreting the art of tumbling, it is not so much the body itself that is significant as the specific way in which the jump is performed.[32] The decisive characteristics of this movement are the lowering of the head and the circular form. The head steers the movement of the entire body (not least in biomechanical terms), which, on completion of the *salto*, has created a perfect circle. Viewed in light of the philosophical discourses of the age and contemporary French social hierarchy, it's clear that the art of tumbling carried a double meaning directly related to the form of the movement itself, which is the reason it was regarded ambivalently.

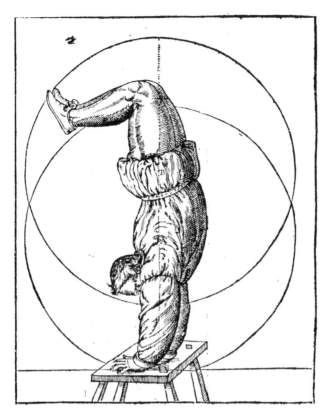

Fig. 13.2 Archange Tuccaro, *Trois dialogues de l'exercice de sauter, et voltiger en l'air*, fol. 90v. Illustration courtesy of the German Sport University Library, Cologne

The lowering of the head signifies a reversal of the natural order of up and down; it is interpreted as a reprehensible and blasphemous movement, since the movement of the head toward the feet contradicts the established view of humanity as being positioned between heaven and earth.[33] The dignity of humanity and its likeness to God were thought to be reflected in part in the human's upright posture. The upright position of the body indicated the orientation toward the heavens and thus toward God. Giovanni Bonifaccio, for example, comments in *L'arte dei cenni*, his study on nonverbal communication published in 1616, on turning one's face toward heaven: "Since one turns his face, this is an indication that the soul is extending itself toward God in heaven, where it has a particular relevance."[34] He also makes a clear statement concerning the importance of the raised head: "To bear the head upright and raised is to indicate the uprightness of the soul,

which aspires ideally to magnitude and superiority."[35] Furthermore, for centuries the Christian church had opposed all forms of corporeal popular entertainment, which was characteristic of pagan cultures. The antique tradition of *cubistica* in particular—the precursor of all acrobatic movement characterized by the reversal of the body—as well as various forms of dance were defined as obscene, heretical, or blasphemous.[36] According to philosophical works, even the social hierarchy was reflected in a symbolic language based on spatial differentiation. The difference between the low, the heavy, and the crude, associated with the poorer classes who worked the ground, and the high, the effortless, and a specific *grazia*, considered to be the characteristics of the noble class, was believed to be perceptible in their posture and movement.[37] Tumblers and jugglers like Tuccaro historically belonged to the lower social classes and indeed the form of the movement they effected— moving downward toward the earth—reflects this, at least in its initial stage.

But the specific movement of a *salto* does not stop when the body is turned upside down. It continues, and the completed somersault reverses the reversal and reinstates the old order. A perfect performance of this movement, displaying a completely disciplined and controlled body, creates a circle, the most important of all geometrical symbols. Without beginning or end, it represents the universe, unity, harmony, and perfection. According to Plato in *Timaeus* 34b, circular movement was reserved for the earth and the divinities.[38] Tuccaro attempts to attain perfection by delineating the ideal geometrical form, and he attempts to connect his art of tumbling to concepts of geometry deriving from a rational order of things: "One must say that in order for the mathematicians to teach and describe a circle on a straight line, they have to divide it into two equal proportions and then draw a half circle on the one side; and in order to perform a very perfect circle in the air we proceed in the same way they do."[39] At the same time Tuccaro seems to have been well aware of the ambivalent nature of his art: on the one hand, he comments that the jump "is performed by diabolic art," while, on the other hand, he explicitly refers to the geometrical perfection of the circle: "Each somersault always creates a perfect circle in the air with the head."[40]

The *salto* can also be read in light of Mikhail Bakhtin's grotesque conception of the body as an ambivalent reversal of above and below.[41] He sees the movement patterns of the grotesque body as being "oriented in relation to the upper and lower stratum; it is a system of flights and descents into the lower depths. Their simplest expression is the primeval phenomenon of popular humor, the cartwheel, which by the continual rotation of the upper and lower parts suggests the rotation of earth and sky. This is manifested in other movements of the clown:

the buttocks consistently trying to take the place of the head and the head that of the buttocks."[42]

There is an interesting parallel to this in the grotesquerie of sixteenth-century painting. Here too the world upside down, "il mondo alla rovescia," is an important motif.[43] In the ornamental paintings completed by Cesare Baglione in Torrechiara between 1584 and 1586, for example, there is a huge exhibition of acrobats featuring tumblers standing in improper positions such as handstands and assuming split positions. André Chastel defines the grotesque in Renaissance art, in which he includes the art of tumbling, as "a style principle that is the exact opposite of what was encouraged and justified by the contemporary classical order."[44] Both are concerned with the invention of forms that are not bound by existing rules but only by those that they themselves create, and "they depend on the coming together of enthusiasm [*furia naturale*] and art."[45] The same is true of various attributes associated with this controversial school of painting—for example, weightlessness, fantasy, wonder, invention, play, élan, movement, and elegance but also contrariness to nature, reversal, distortion, unreality, and impropriety. Chastel defines acrobatics as a repetitive pattern and says of the paintings in Torrechiara that "the figures are performing contortions reminiscent of acrobats describing with their bodies every curve imaginable."[46] In the fine arts, this grotesquerie is treated as a fiction and a form of imaginative expression. In the performance of Tuccaro's jumps, however, this expression is reality. It becomes more than grotesque; it becomes monstrous and diabolical, and the tumbler seems "a being whose existence runs against or is contrary to nature."[47]

Apparently, at the Viennese court of Maximilian II unusual forms and grotesqueries were appreciated, because in addition to Tuccaro, who presented his diabolical tumbling practice, we also find there Arcimboldo, who is famous for his grotesque presentations of men depicted as amalgamations of fruits and vegetables. Charles IX is furthermore described as a king who loved to be surrounded by animals and grotesque or deformed bodies.[48] Tuccaro's *salto mortale* oscillates between dangerous subversion and wondrous and miraculous corporeal ability, between grotesquerie and the beauty of perfection. This double quality becomes particularly apparent in the concrete environment of court festivities.

The *Salto* at Court Festivities

The location of the grotesque experience is not in the object itself—the same jumps did not likely create any unease when they were performed at the marketplace—

but rather in the perception of the object by the observer. Mark Dorrian describes the operative principle of the grotesque *salto mortale* at court festivities as "the coming together of what should be kept apart. The sense ... of the grotesque is that something is illegitimately *in* something else. Theories of proportion and systems of decorum assign to everything a due and proper place. . . . The high and the low, the noble and the base, the good and the bad are separated out, and systematized. In monstrous and grotesque phenomena such spacing collapses."[49] Tuccaro's principal objective in the context of a symbolic staging like that of court festivities is to stabilize his own precarious position as the court *buffone* or tumbler, and whether he succeeds in so doing depends on the public's reaction to his performance. He has to astound them with the perfection of his bodily control and delight them with the beauty of his jumps. But in this situation Tuccaro isn't only representing himself. His art of tumbling is also a symbolic representation of power and as such is also important to the king in whose name Tuccaro performs.

The significance of the art of tumbling as entertainment is particularly striking when viewed in light of various theories of festivities. According to Josef Kopperschmidt, all earthly festivities "are distinguished by their qualitative difference to nonfestivities."[50] On this account, tumblers could be seen as contributing to the "suspension of common conventions, social rules, and relations of power to the point of . . . the establishing of a world turned upside down."[51] Festivities constitute a departure from the norm; they are of limited duration and transcend the quotidian horizon of the participant. For this reason, festivities have the potential to function either as an affirmation of the existing order, thereby confirming and strengthening the government, or as a transgression and an overstepping of boundaries that endanger the government and could theoretically culminate in a coup. In an extraordinary situation like that of festivities, the art of tumbling thus follows extraordinary rules. It can be argued that the new rules established specifically for the limited duration of the festivities are, in fact, inherent in the art of tumbling. These rules are however only valid in the context of the performance situation; they strengthen the precarious stability of the temporary new order. If we think the concepts of limits, limitation, or delimitation, which are important for most of the theories of festivities, as spatial metaphors that are transferable to the experience of time, then it is possible to regard delimitation as "correspond[ing] to the abandonment of the linear time axis" and as being "contained in the image of the never-ending moment or the circular form."[52] Acrobatic jumps, which are primarily determined by space and time, that is, by the position of the body in space and the dynamics of movement, diverge from usual space-time coordinates.

In this respect, an acrobatic jump represents already in itself a symbolic act of overstepping boundaries within the wider boundary of the festivities. But here again the ambivalence of the *salto mortale* comes to the fore. On the one hand, the perfection of the physical movement is a reminder of order and control, perfection and beauty—a demonstration of the superiority that ideally should strengthen the symbolic power of the king. The *salto mortale* in particular demonstrates the perfection of movement because of its form: a perfect circle. On the other hand, the jumps are dangerous and could have been condemned as subversive. Their extreme difficulty makes them dangerous not only to the tumbler; the somersault in particular can also be interpreted as a danger to the established social order. The pattern of social coordinates collapses when confronted with this movement, that is, with the reversal or turning upside down of all that maintains this order. By transgressing the established order and overstepping the boundary of socially acceptable corporeality, each jump takes the festivities to the edge of instability, and by returning the feet to the ground and restoring the body to its rightful position in the world, each successful *salto* restores balance.

Bodily Practice as Art and Science

The *Trois dialogues* are an exceptional example of how a bodily practice was introduced into the canon of sciences and art in the late Renaissance. By *inventing*, on the one hand, an original classified system of cubistic jumps, interwoven with references to authoritative ancient texts, and by rationalizing the body and rendering it geometric, on the other, Arcangelo Tuccaro meets the requirements of a noble and accepted bodily behavior. In so doing, he transcends the traditions of both the practice and its practitioners, who were considered of low social value and not dignified enough to be part of noble society. Nonetheless, the form of movement, characterized by the turning upside down of the body, did not correspond to gracious, established form. This makes his practice ambiguous and might explain why we find so little evidence of it apart from Tuccaro's treatise. The publication of the *Trois dialogues* in 1599 proves that the tumbler Tuccaro and his art by then were an accepted practice in court society. The publication of his book and the inclusion of his *art de sauter* in courtly festivities also shows that the meaning associated with a specific movement practice can change and demonstrates how this change was realized by an ennobling strategy.

The Double Life of St. Sebastian in Renaissance Art

Bette Talvacchia

As portrayed in Renaissance art, St. Sebastian is connected almost exclusively to gruesome physical torment. The vast majority of the numerous images that survive show Sebastian's flesh torn by arrows, an ostensibly ravaged body that nevertheless displays an idealized beauty (fig. 14.1). One aspect of Sebastian's iconography is as consistent as it is disturbing: no matter how extensive the victim's injuries, he is always depicted as still alive.[1] While this defiance of torture and injuries is a part of every martyr's credentials, it is particularly salient in Sebastian's iconography, since he is consistently portrayed as an emblem of the process of martyrdom. Rather than merely exhibiting his attribute of torture, or acting within an extensive narrative, the body of Sebastian is most often displayed to the viewer as having just absorbed a rain of arrows, in some instances showing several that penetrate vital organs. Arrows may shoot into groin and heart, protrude through eye and neck; yet we view a Sebastian who is resplendent after the attack, usually demonstrating a pronounced alertness and equanimity that belie suffering.

The contradiction in logic (whether acknowledged by the viewer or not) is one of the elements that has made the image so compelling. In modern studies and contemporary discourse, Sebastian's impossible serenity is generally read as pas-

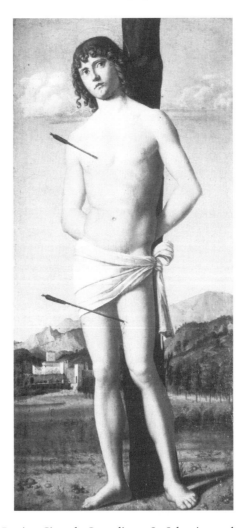

Fig. 14.1 Giovanni Battista Cima da Conegliano, *St. Sebastian*, early sixteenth century, oil on wood. Villa I Tatti, Berenson collection, Florence. Reproduced by permission of the president and fellows of Harvard College. Photograph by Gabinetto Fotografico del Polo Museale Fiorentino

sivity, and there are extended interpretations that build on that characterization. Sometimes these readings verge on the reckless; they suggest that the viewer imaginatively dominates the subject of the painting, turning it into a submissive object that willingly accepts the mistreatment.

During the fifteenth and sixteenth centuries, however, the motivation for con-

structing Sebastian's image with contradictory emphases on both his affliction and his oblivion of its effects had nothing to do with our notions of passivity. As we will see, there were other historical and cultural reasons why Sebastian's torment by arrows became canonic in his representations. That he remained alive throughout the onslaught that ripped into his flesh is simply part of his hagiography. The saint (miraculously) survived and recovered from his arrow wounds. Sebastian's demise came about at a later moment, when he was clubbed to death upon the orders of the Roman emperor. The two-faceted martyrdom of St. Sebastian was accorded more explication in the early textual sources, while the visual tradition eventually focused on the unsuccessful attempt to kill Sebastian with a volley of arrows. The specific iconography of the saint presented opportunities for the exploration of certain pictorial strategies being developed in the visual arts throughout the fifteenth and sixteenth centuries with regard to the representation of the body. During the Renaissance, Sebastian's image became a locus for the expression of those concerns.[2]

The popularity of the cult of St. Sebastian—indeed its overwhelming expansion during a period of recurring eruptions of the plague—insured that Renaissance artists would find frequent opportunities to evolve and hone their skills in the production of his image. Thus, the figure of Sebastian came to have a double function, what I refer to as its "double life." The devotional purpose of his image was for succor against the plague; stylistically, the form given to the body of Sebastian developed into a test of skill in representing the human figure. This chapter sketches the evolution of these two disparate operations and lays out the reasons for them.

Sebastian was venerated as an agent of release from physical pain and illness, so perhaps it is not surprising that he was "embodied" so strikingly. The beauty of his body under affliction would provide encouragement and a noble model for those of the faithful whose flesh was also suffering degradation. The *Passio* of Sebastian relates that he was tied naked to a post and that his youthful body was wracked by the piercing of not just a few but a hail of "multitudinous" arrows.[3] The torment was grotesquely apt, for Sebastian commanded a unit of archers in the elite Praetorian troop, the bodyguards of the emperors Diocletian and Maximian. Sebastian moved in a circle particularly close to the Emperor Diocletian, known for his ferocious persecution of Christians. Under these circumstances, Sebastian's eventual conversion to and active proselytizing for Christianity would have been regarded by the emperor as an exceptionally heinous crime, demanding severe and public punishment.

Sebastian's status as an imperial soldier, his illicit Christianity, his torture, and his death are the salient details of his life as presented in the fifth-century biography by the pseudo-Ambrose. This source specifies that Sebastian's arrow wounds were healed with the help of St. Irene, at which point he returned to his active advocacy of Christianity. Diocletian again ordered him to be taken and this time to be beaten until dead. After being pummeled by clubs, Sebastian's body was thrown into a sewer, where it was fortuitously blocked from being carried away by the current. The martyr then appeared in a dream to a certain Lucina, who, with companions, went to recover the body. They buried Sebastian in the catacombs along the via Appia, where a church was eventually erected. The death of Sebastian occurred in 303 AD, the year in which Diocletian's persecutions began.

In the medieval textual tradition equal weight is given to each of the attacks against Sebastian, and the fact of the double martyrdom suffered by the saint holds significance.[4] The torment of arrows constituted the saint's election to martyrdom, while his clubbing to death led to the miraculous discovery of his body and designation of his burial place. This second phase was a crucial part of his martyrdom, achieving exactly what Diocletian tried to avoid: the retrieval of Sebastian's body, and its veneration at an appointed site. The second act of martyrdom, however, was rarely depicted in the visual arts.[5]

Narratives of Sebastian's life were of limited interest to the vast majority of those who commissioned his images.[6] In his capacity as a "plague saint," an intercessor for protection against the disease, Sebastian was often shown simply with his symbolic arrows, as part of a grouping of saints around a Madonna and child. How did his life story, centered on his identity as an imperial soldier and a secret Christian, come to translate into his being seen as a champion against the plague during the fourteenth century?

The chronicle of Sebastian's life most widely consulted in the Renaissance was Jacobus de Voragine's *Golden Legend*, dating from the late thirteenth century. In his account Jacobus records, for the first time in conjunction with the events of Sebastian's life, two posthumous interventions of the saint whereby altars dedicated to him miraculously brought an end to the plague. Finding his source in Paul the Deacon's eighth-century *Annals of the Lombards*, Jacobus de Voragine wrote that during the reign of King Gumbert a fierce plague raged throughout Italy, most forcefully in Rome and Pavia.[7] The inhabitants of both cities were ravaged by anguish and a high death toll: "Then it was divinely revealed that the plague would never cease until an altar was raised in Pavia in honor of St. Sebastian." Relics of the saint were transferred to the northern Italian city and an altar was duly dedicated.

The plague abated, and devotion to Sebastian for protection against the plague was ensured.

Veneration of Sebastian as a plague saint also began in Rome at the same time under similar circumstances, when the placement of an altar to the soldier / martyr in San Pietro in Vincoli dispelled the plague, which had gripped the city for three months, taking an unbearable toll on the lives of the citizens. An image of Sebastian dating from the installation of the altar in the seventh century is among the earliest surviving examples in the visual arts of the saint and still stands in the church. The mosaic shows Sebastian as a mature man, with white hair and beard, severe in appearance, and he is presented as a soldier—there are no arrows in this representation. Sebastian's new role as intercessor against the plague, however, was recorded on a marble tablet to the right of the mosaic.[8] At this point, as is also the case in the legend of Pavia, the faithful had to be instructed through divine intervention to call on the help of Sebastian. Until this time, he clearly had not been considered to have special efficacy against pestilence.[9]

To sum up the early development of the cult of Sebastian, it is evident that the early Christians venerated Sebastian simply as a martyr; his was a local cult in Rome, which was, of course, the site of his life as a soldier, his murder, and his burial. The identification of Sebastian as a particularly powerful advocate against the plague first occurred in the late seventh century, with devotion centered in Rome and expanding north into Pavia, in response to miraculous intervention. Here occurs a break in the history of Sebastian's cult in Italy, since the epidemic in the late seventh century was the last great outbreak of the plague until the ferocious eruption in the mid-fourteenth century.[10] At this point, a new epoch began, as the plague recurred throughout Europe during the second half of the fourteenth century, confirming that the initial outbreak was no isolated episode.

Continuing flare-up and the need for deliverance from the pandemic injected the development of Sebastian's iconography with a new intensity in the fifteenth century. Awareness of the disease increased, and fears mounted that it was to be a periodic flagellation from heaven. In response to the frequency of eruptions of the plague in Italy, an incredible number of images of Sebastian were requested and created. The saint's status as protector against plague insured his frequent inclusion in the *sacra conversazione*, the grouping of saints around the enthroned Madonna and child in monumental altarpieces. Also, individual recipients of Sebastian's help might profess their thanks by commissioning ex-voto images of the saint. And further, special *compagnie*, or lay brotherhoods, were incorporated under dedication to Sebastian, and they would commission images of their patron

for their chapels and meeting houses. These are the historical reasons for the vast number of paintings and sculptures that took St. Sebastian for their subject and are what gave such immense popularity to his cult.

The iconography of the arrows in connection to Sebastian was established in early medieval martyrologies, where it was not privileged over other elements but was consistently included. The motif of arrows as the primary attribute of Sebastian consolidated gradually over the course of the twelfth and thirteenth centuries, simply by virtue of its repetition.[11] In the conclusion of his thorough and insightful study, Karim Ressouni-Demigneux offers the following synopsis of the development of the iconography of Sebastian as saint and martyr:

> Prior to 1348 the personality of the saint emerged essentially from texts; artists represented the volley of arrows because it had already acquired a strong symbolic value in the literary realm. The images illustrate a liturgy that could have very well dispensed with them. But when the plague took hold, the metaphorical use of the arrows in a cadre of anti-plague works rendered the image particularly powerful. It permitted the devout to verify, as eye-witnesses, that the saint was struck down by arrows, as they were, and did not die.[12]

It is indeed this representation of the martyr, with body horrifically punctured by arrows, that made such an impression on the collective imagination beginning in the early modern period, and that still does so in the twenty-first century. The strong symbolic potential of this punishment, as Ressouni-Demigneux notes, was first explored in the texts dealing with Sebastian and then taken up as the primary convention in the visual arts. For example, the detail that Diocletian's orders were to shoot Sebastian full of arrows was included by Jacobus de Voragine in his *Golden Legend*: "They shot so many arrows into his body that he looked like a porcupine, and left him for dead."[13] This visual clue is strictly followed in such paintings as Carlo Crivelli's strong rendition in Milan (fig. 14.2), Gentile da Fabriano's panel in Perugia, and most famously in Andrea Mantegna's painting in the Ca' d'Oro, Venice.[14] Starting in the Middle Ages, references that recalled Sebastian's affliction from arrows were read during the mass. The liturgy would have then become the most familiar and shared source of knowledge about the saint's suffering and martyrdom, along with Books of Hours, prayer books that included devotions to Sebastian.[15]

The scene of penetration by the arrows, which, miraculously, did not kill Sebastian, became the canonical representation during the fifteenth and sixteenth centuries in Italian art, not only through its familiarity but from its relevance to the

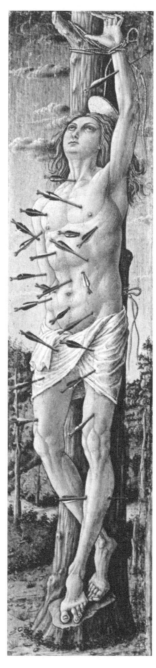

Fig. 14.2 Carlo Crivelli, *St. Sebastian*, 1496–1500, tempera on wood. Museo Poldi Pezzoli, Milan. Digital image courtesy of the Yorck Project

increased presence of the plague. It is precisely the arrow, Sebastian's attribute of suffering, that has from antiquity symbolized the conveyance of pestilence. Arrows are the weapons of Apollo, "the distant deadly Archer," whose shafts visit plague upon his enemies with a vehemence attested in the opening verses of the *Iliad*:

> What god drove them to fight with such a fury?
> Apollo the son of Zeus and Leto. Incensed at the king
> he swept a fatal plague through the army—men were dying
> and all because Agamemnon spurned Apollo's priest.[16]

Arrows are the signs of Apollo's power and the vehicles of his anger; they sent the foul pestilence among the Greeks, as Homer has it. While in ancient lore Apollo's arrows have the ability either to send or deflect the plague, in Christian texts Sebastian's arrows stand for his own suffering and, by extension, the torment of those similarly oppressed. Since Sebastian was neither defeated nor killed by the force of the arrows, in Christian symbolism they also represent the saint's power to avert the plague, a strength to be called on by the faithful. Arrows were ineffectual against Sebastian's flesh; his body was triumphant along with his faith. Sebastian survived the temporary devastation of his flesh only to continue his proselytizing for Christianity and finally to undergo martyrdom for his beliefs. His arrow-ridden body, therefore, shows him taking the suffering onto his own flesh and withstanding it. Sebastian becomes an exemplar of forbearance in suffering, one who arises again from an affliction that does not have the power to defeat him.

The highly codified characterization of Sebastian in Renaissance art is often referred to as "Apollonian," a generic description indicating an idealized beauty of regular features and perfect proportions, which is fundamentally apt. It was reasonable to endow the Christian hero whose attribute is arrows with qualities borrowed from the pagan archer god, and such a transference functioned exceptionally well in an epoch that searched for analogies, especially in the visual tradition, in order to establish iconic types.[17] When we look, for example, at the versions of St. Sebastian by Antonello da Messina (fig. 14.3) and Andrea Mantegna, the unmistakable call to sensual perception is evident by their use of an Apollonian type, based on classical sculpture. The instance of Sebastian's physical perfection falls into a larger category developed in Renaissance art of idealized images of humanity, following a philosophy that posited beauty as a sign of goodness and understood heroism to be expressed by corporeal perfection. The forms most often came from, or were influenced by, the study of classical sculpture, especially

for its canon of proportions. This particular tradition in the plastic arts gave rise to a visual analogy between the perfected anatomies found in Greek sculpture and the Christian "athlete of virtue."[18] This formulation appropriated Greek culture's symbolic equation of the victorious athlete with the triumph of virtue and applied it to Christian notions of rectitude:

> Glorified in all the arts, the image of the athlete, above all others, became the central vehicle for the expression of human virtue. He embodied militancy, physical beauty, and many concepts of religion and education. Because competition in the Greek games had been patterned after that of war, athletic virtue was attributed also to the soldier, who was called by Plato "the athlete of war."[19]

Sebastian's history as a soldier—and, as a result of his martyrdom, ultimately as a soldier of Christ—led to an inevitable identification of the heroic martyr with the idealized, classical figure of the athlete by Renaissance artists who constructed representations of Sebastian.

It remains to consider how the convention of a strongly sensual accentuation of Sebastian's physical beauty came about, an emphasis rendered macabre by the shafts that desecrate the perfected body. The analogy between Sebastian and Apollo, based on their shared iconology of the arrow, was expanded to incorporate their physical appearance as well. This close connection was not made between Apollo and other male martyrs, such as Christopher or Cosmas and Damian, who also underwent torture with arrows; they were never assimilated to representations of Apollo.

It should be noted in passing that in all these cases death was not caused by the penetration of the arrows, which was but a step toward eventual martyrdom. A further similarity in devotions to Christopher, Cosmas, Damian, and Sebastian is that all were invoked against illness, and there are instances in the visual arts of each being called on in response to the plague.[20] It was, however, only in Sebastian's cult that aid against the plague became his unique domain and the arrow his exclusive symbol. More important, only in Sebastian's case was a direct connection made to miraculous delivery from the plague, which in turn would suggest a specific correlation to the pestilence-spreading shafts of Apollo.

An unequivocal linkage between Sebastian and Apollo appears in the *Acta sanctorum*, presented as a "conjecture" as to why Sebastian is invoked against the plague.[21] The learned prefatory material introducing the *Acta* cites Pierio Valeriano's *Hieroglyphica* as authority for the hypothesis:

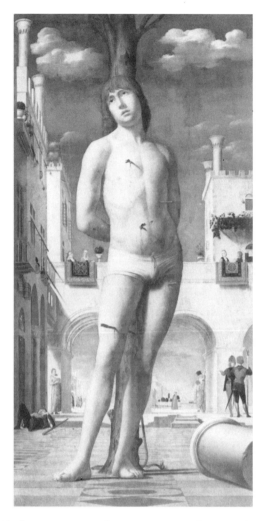

Fig. 14.3 Antonello da Messina, *St. Sebastian*, 1475–76, oil on wood transferred to canvas. Gemäldegalerie, Dresden. Digital image courtesy of the Yorck Project

No one doubts that the arrows of Apollo sent against the Greeks absolutely clearly signified the plague. There is wide discussion about them in Homer. Hieroglyphically, these indicate the solar rays scattering that contagion by way of the corrupted slow-paced movement of the sky. Christian piety proposes for itself, out of the number of the divines, Sebastian as a protector against the plague, assailed with arrows as he was, offering testimony of his faith in Christ.[22]

The *Acta sanctorum* and the *Hieroglyphica* are compendia based respectively on the collected knowledge within the religious and secular worlds of scholarship. Together they indicate that by the beginning of the early modern period comparisons between Sebastian and Apollo had been assimilated into Italian culture. Given the system of affinities established between the symbolic functions of Apollo and Sebastian it is not surprising that resemblances grew also in terms of their physical appearance. Yet the earliest representations of Sebastian suggest this physical correlation was not immediate.[23] The martyr only assumed the ancient deity's features some five hundred years after his death. That the graceful beauty of Apollo was also shared by Sebastian accrued to the martyr's story and provided a kind of legitimization for the highly idealized, and often quite sensual, interpretations of many Renaissance artists. Authorization for this portrayal is associated with an occurrence in the ninth century, following a transfer of the saint's body—or some parts of it—from Rome to Soisson (it is not surprising that France would have attempted to reclaim the saint, since the historical Sebastian had been a native of Narbonne).[24]

According to a legend developed and transmitted during the tenth century, the bishop of Laon called the saint's presence in France into doubt. Sebastian immediately visited the bishop in a dream to correct the cleric and chastise his lack of faith. One text specifies that Sebastian showed himself "in the form of an ephebe, such as to recall in every part the eurhythmy of St. Sebastian."[25] The characterization of Sebastian's appearance as that of an ephebe would have conjured, in the Renaissance as now, images of a youthful Greek of slender but well-formed build, one who frequented the *efebeo*, the venue of gymnastic exercise. The implication of gracefulness is introduced in the text by recalling Sebastian's "eurhythmy," the harmony of his proportions and movements, endowing him with a lyrical quality in addition to youthfulness. The story thus clearly delineates Sebastian as an Apollonian type, either for the first time or following earlier traditions.

By the late middle ages the Apollonian allusion was reinforced by another detail, this from the *Golden Legend*. While encouraging the twin brothers Marcellian and Marcus to undergo martyrdom for their faith, Sebastian was emblazoned with light: "As Saint Sebastian was saying all this, suddenly a radiance shone from heaven and shed light upon him for almost an hour, wrapping him in its splendor like a shining cloak, and seven radiant angels surrounded him."[26]

The attribute of being wrapped in brilliant light is another description that evokes the shining Apollo, or "Phoebus Apollo," the deity's epithet as a sun god. Therefore, from at least the tenth century onward, texts about Sebastian had many

accredited options to draw on to describe the saint: he could be represented as a soldier, a martyr, and a protector against the shafts of the plague, and he could be pictured with the physical attributes of an ephebe and radiant in his faith. The combination creates a sanction for the production of an idealized Apollonian type, well suited to the formal and stylistic interests of many artists working in the fifteenth and sixteenth centuries, especially in Italy.

The early associations of Sebastian with Apollo through the attribute of the arrow and the connection to the plague and to a youthful type of physical beauty eventually suggested the customary form of the martyr that evolved in the early modern period. As artists increasingly centered their attention on the display of beauty as a symbol of goodness and on anatomical accuracy as a measure of skill, Sebastian's figure became conspicuous for its corporeal perfection. By convention Sebastian became the privileged saintly figure for such representation, indissolubly connected to the Apollonian type of masculine beauty with sleek proportions and regular features. The plentiful examples surviving from the Renaissance demonstrate the uniformity of this convention.

Often, however, Sebastian's connection to the figure of Apollo is not just established in generic terms but takes the form of an explicit appropriation of one particular sculptural type of the ancient deity. Many depictions of Sebastian depart from the convention of figuring him with both of his hands behind his back, usually bound to a tree or column. One variant has the saint assume the pose of the *Apollo Lykeios*, with one hand curved above his head (fig. 14.4). The original sculpture was the cult statue in the gymnasium of Athens, described by Lucian in the *Anacharsis* as showing Apollo leaning against a column with his right hand bent over his head and holding his bow in his left hand.[27]

The inclusion of the *Apollo Lykeios* on Athenian coins helped to diffuse the image, which found many copyists and engendered numerous variations. One example that went on to achieve its own popularity was the *Apollo citharoedos*, repeating the essential motif of the raised arm, poised on a column or tree trunk but replacing the bow with a lyre held in the other hand.[28] Other artists produced variations of the Apollo with raised arm, changing only the details of the support on which he leans.

All of these variants incorporate the "beauty pose," where the raising of an arm allows the development of an unbroken, curving line to delineate one side of the body in an elongated and sensuous manner. Among the many Sebastians who strike this pose, forcefully presenting a conflicted configuration of pain and beauty, are Girolamo Genga's figure of the saint that dominates the complex scene of

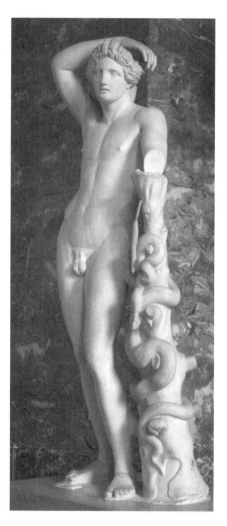

Fig. 14.4 Apollo Lykeios, Roman, second century AD, marble. Louvre, Paris. Digital image courtesy of Jastrow, 2005

martyrdom in an altarpiece conserved in the Uffizi; paintings from the circle of Bacchiacca and Bugiardini, now in the Kress Collection; and *The Martyrdom of Saint Sebastian* by Luca Signorelli in the Pinacoteca, Città di Castello.[29] A very close rendition of the *Apollo Lykeios* (fig. 14.5) was produced in the mid-sixteenth century by a follower of Garofalo in Ferrara, where, as in many northern Italian cities, paintings of Sebastian proliferated in the first half of that century owing to deadly outbreaks of the plague throughout the area, most ferociously in 1510.[30]

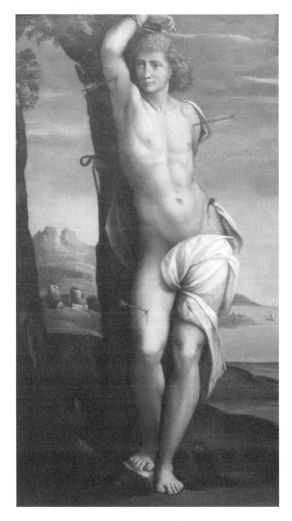

Fig. 14.5 Workshop of Benvenuto Tisi, known as "Garofalo," *St. Sebastian*, 1526, oil on wood. Palazzo dei Conservatori, Pinacoteca Capitolina, Rome. Digital image courtesy of Jastrow, 2006

The 1510 epidemic was particularly virulent in Venice, and it is during this time that Girolamo dai Libri produced his altarpiece with its resounding grouping of intercessors against physical suffering in general and the plague in particular.[31] The artist presents St. Sebastian in the Apollo attitude flanking St. Rocco; Job appears on the opposite side. The inclusion of Job is a creative novelty, but the pairing of Sebastian with Rocco had become routine in the course of the Renaissance.

A modern saint (born in 1350), Rocco is dressed as a contemporary pilgrim in virtually all of his representations. St. Rocco dedicated his life to working with the plague-stricken, traveling to seek them out and provide what comfort and healing he could. Rocco's devotional function is specialized, aptly defined as "therapeutic" as distinguished from the "prophylactic" or preventive nature of Sebastian's interventions.[32] The distinct personalities of what became for the Renaissance the two "plague saints" were underscored visually by the contrast of a contemporary figure to an ancient one. This differentiation became another reason for the insistent, almost exaggerated classicism of Sebastian's representation.

Perhaps one more example of the numerous Sebastians that can be found in the attitude of the *Apollo Lykeios* should be mentioned here. Titian produced a virtuoso's alteration of this pose with the St. Sebastian he included in the *Averoldi Altarpiece*, painted for the church of Saints Nazzaro and Celso in Brescia (fig. 14.6).[33] The artist created a voluptuous yet assertive posture, with the raised arm roped at the elbow and affixed to a tree branch, hanging above a powerful torso that twists in the opposite direction from Sebastian's muscular, bent legs. David Rosand describes how the figure had been singled out for appreciation from within a polyptych and considered for purchase as an independent work of art and notes that this Sebastian became one of Titian's "most frequently copied figural inventions."[34] This leads Rosand to briefly speculate about a possible conflict between the saintly subject and its carnal attraction, but he allows that the subject could have had separate functions as a work of art and a religious subject that did not cancel each other out. The development of this point is crucial in dealing with representations of Sebastian, which had such a compelling visual impact on Renaissance and later art.

In the fifteenth and sixteenth centuries the figure of Sebastian evolved into the quintessential eroticized body within a religious context, assuming a privileged place in a cultural discourse that theorized sensuous response as movement toward an ultimate transcendence of the worldly. Italian Renaissance art, even in its most solemn subjects, gives prime significance to the apprehension of beauty, both for its visceral pleasure and for its role as the bridge to a level of perfection that becomes a metaphor for the divine. In the fifteenth and sixteenth centuries there was less inherent conflict between highly charged physical beauty and intense religious devotion than is the case now.

It is in this nexus of concerns that the most polemic discussions of Sebastian's imagery arise in our own critical discourses. Certainly the conventions I have been discussing permitted the Renaissance artists and viewers who preferred

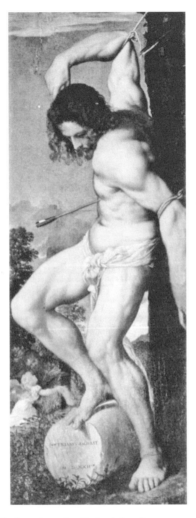

Fig. 14.6 Titian, *Averoldi Altarpiece*, detail, *St. Sebastian*, 1519–22, oil on wood. Saints Nazzaro and Celso, Brescia. Digital image courtesy of the Yorck Project

male beauty and male sexual partners to find particular resonance in physically enticing images of Sebastian. This would be the inference from our information that among his possessions in 1481, Leonardo da Vinci owned eight images of the saint.[35] I want to emphasize, however, that during the Renaissance this allure would have been understood to work across gender lines, and ironically, I stress this to insure that the female audience is not erased from discussions of spectatorship around the representations of Sebastian. Both men and women could succumb to

the effect of viewing exquisitely painted or sculpted figures in a variety of situations and contexts; one that idealized the male form in a stunning fashion would certainly qualify.

It is a mistake to ignore the universal possibility of attraction that was taken for granted in Renaissance culture. It is indeed antihistorical to imagine that images of Sebastian were constructed exclusively, primarily, or even largely as covert symbols of male homosexuality, or—with alarming anachronism—as "gay icons." Unfortunately, this is an approach that has been adopted in some revisionist studies and discussions.[36] The iconography of Sebastian as plague saint is, as we have seen, extremely conventionalized. Since virtually all of the scenes of his torture contain the same iconography, no subcategory can be shown to have developed for a cult reading of hidden homosexual import.[37]

Even if we take as an example the work of an artist whose homosexual acts earned him the explicit nickname of "Sodoma," we will find that his famous versions of St. Sebastian were widely praised and valued by his contemporaries in the context of what we would define "mainstream art." Sodoma's staid and ambitious contemporary, Giorgio Vasari, presents an extremely negative assessment of the Sienese artist's life and character in the biography written for the 1568 edition of his *Vite*. Yet in the same text, Vasari praises Sodoma's St. Sebastian, now in the Palazzo Pitti, finding the figure "veramente bella" and "molto da lodare," and a frescoed version is referred to as an "assai buona opera."[38] Given the opprobrium with which Vasari recounts Sodoma's flaunting of his nickname and attentions to young boys, if there were anything indecorous in the artist's representations of St. Sebastian, he would have relished the opportunity to criticize Sodoma and would have taken him severely to task for it. It should also be noted that the painting in the Palazzo Pitti, often interpreted as a personal testament to Sodoma's "lifestyle" was, according to Vasari, commissioned for the Compagnia di San Bastiano in Camollia and thus a public commission.

It was only well after the sixteenth century that attitudes toward images of St. Sebastian changed. When he was no longer needed as intercessor against the plague, and the history of the evolution of his image receded, only the seduction of his carnality remained for many later viewers. With the diminishing and passing of Renaissance art's religious function, increasing and often isolated emphasis was placed on its formal qualities. The import of Sebastian's image was modified by its later reception, as contexts changed and appreciations altered. Comments about new cultural uses of Sebastian's representations could be demeaning rather than perceptive, even in ostensibly authoritative sources. For example, in his *Ico-*

nographie de l'art chrétien, Louis Réau states: "Thus it happens that after having been extremely popular, St. Sebastian, victim of sanitary progress and the rivalry of more qualified patron saints, nowadays is out of style. Nothing remains for him but the compromising and unavowable patronage of the *sodomites* or homosexuals, seduced by his nudity of an Apollonian ephebe, glorified by Sodoma."[39] Réau's belittling assessment of what "remains for him" refers to a nineteenth-century appropriation of Sebastian, when the saint was adopted as a cult figure in male homosexual circles, particularly in England and France. Réau neglects to mention that it was Andrea Mantegna's versions that were most often celebrated and most widely appreciated by this group rather than Sodoma's. The nineteenth-century appreciation and appropriation of Sebastian has an extremely interesting history of its own, and a rich production of works emerged around the theme of his martyrdom. This is especially true in literature with writers who shaped (or were responding to) the so-called decadent style and aesthetic, such as Oscar Wilde, Robert de Montesquiou, Marcel Proust, and later, Jean Cocteau. The adaptation and appropriation of earlier religious imagery proved to be a seductive and successful strategy in their works, in quite different ways. They all, however, were drawn to the image of the martyred St. Sebastian as a potent expression of sensuality and specifically as a coded icon of their homosexuality.[40]

Surprisingly, the privileging of Sebastian as an emblem of homosexual desire, which flourished in the circles of proponents of aestheticism, was strong enough to influence the modernist movements that followed. Well outside the range of usual suspects, the young T. S. Eliot wrote a poem entitled "The Love Song of Saint Sebastian," whose scenario includes self-flagellation of the speaker as a prelude to strangling his (female) lover. Sebastian the passive victim is here transformed into an aggressor; the recently constructed homosexual Sebastian is recast as a heterosexual murderer. This love song by Eliot remained unpublished during the poet's life—and not only because of its acknowledged technical failures as verse. In the words of an eloquent critic:

> Eliot's response to the "cult" of Sebastian constitutes a key episode in the early history of literary modernism. "The Love Song" discloses the need on the part of modernist poets to mine material favored by turn-of-the-century aesthetes and decadents without the associations of homosexuality fostered by writers such as Walter Pater, Oscar Wilde, and Marcel Proust. For writers of aestheticist leanings who frequently sought a coded means of denoting homosexual desire, Sebastian had become the symbol of choice.[41]

To indicate the range of uses of the Sebastian legend in gender politics, an unusual collaboration between Gabriele D'Annunzio and Claude Debussy should at least be mentioned. Writing in French, D'Annunzio composed a drama in verse, *Le martyre de Saint Sébastien*, accompanied by Debussy's music, which was performed in Paris in 1911.[42] D'Annunzio based his form on the medieval mystery play. He consulted archival material but was most influenced by the *Golden Legend* and Renaissance paintings, singling out Pollaiuolo's great panel now in the British Museum.[43] Ida Rubinstein crossed-dressed to perform the starring role, complicating the sexual dynamics; her Jewish identity further challenged contemporary cultural politics as she portrayed a Christian martyr. The production caused a sensation and propelled other responses to Sebastian's legend.[44]

During the Renaissance, however, the importance of presenting Sebastian as spectacle was twofold. In terms of function, he signified an intercessor against the plague, and by artistic convention, his role was that of an idealized figure, a display of physical beauty. The martyrdom of St. Sebastian became a subject through which an artist could substantiate claims to virtuosity by demonstrating his skill in depicting the perfect human figure understood in this tradition to be the nude male subject.

This tradition flourished in Tuscan art of the fifteenth and sixteenth centuries, buttressed by the humanism that modulated its concepts and the antique sculpture that molded its forms. Priority was placed on consummate skill in the representation of the human form and on developing a style that grew from the study of nature perfected through the exempla of antiquity. These values were elaborated by using the human figure as a basic means of expression, and its mastery was the proving ground of the artist.

An explicit statement from Lorenzo Ghiberti's *Commentarii*, written in the mid-fifteenth century, shows that anatomical verisimilitude was valued as a fundamental skill of the sculptor's craft, specifically as applied to the modeling of the male figure: "It is furthermore necessary to have studied the discipline of medicine and to have witnessed dissections, so that the sculptor may know how many bones are in the human body. Wishing to compose a male statue, the sculptor must know how many muscles are in the body of a man, and also all the nerves and sinews in it."[45] The importance of implementing this dictum, pioneered especially in Florentine art, gradually found wide consensus in Italy. In the sixteenth century, Paolo Giovio considered that the supreme level of virtuosity achieved by Leonardo, Michelangelo, and Raphael stemmed from their skill, which they honed by following the laws of nature, in the representation of the human figure in all its

variety. Giovio contrasts the proficiency of these three masters to the limitations of Perugino:

> But after these stars of perfect art, who are called Vinci, Michelangelo and Raf-faello, suddenly emerged from the shadows of that era [the fifteenth century], they submerged his fame and his name with their marvelous works. Perugino, emulating better things and imitating them in vain, struggled to conserve the position he had achieved, because the drying up of his fantasy constrained him always to return to those contrived faces that he had been stuck on painting since his youth. This was so much the case that his spirit barely could withstand the shame as the other three recorded with stupendous variety, for every type of subject, the naked limbs of majestic figures and the urgent forces of nature.[46]

It was in the face of such criticism and odious comparisons that Perugino made special efforts with his portrayals of St. Sebastian, which survive in several examples. A carefully worked drawing of a male nude from life is the basis of the Sebastian included in Perugino's altarpiece in the Uffizi, repeated as the individual subject of a panel in the Louvre.[47] The figure is unusual in Perugino's work, with its emphatic nudity and a pronounced sexual timbre reverberating from the sensuous movement of a classical *contrapposto* stance. Sebastian's body is put on display almost as a specimen of anatomical study, with few and inconspicuous arrows to disturb the effect. Perugino proved his capacity to construct an idealized male body in the best modern manner when he was called on to produce representations of St. Sebastian, the subject conventionally established as the proving ground of figural expertise.

It is illuminating to read Giorgio Vasari's grudging praise of Titian's Sebastian in the altarpiece originally painted for the Oratory of San Nicolò ai Frari in Venice as another example of the expectations that gradually attached to portrayals of Sebastian. Vasari qualifies his appreciation of the depiction by saying that although the figure is beautiful, there is too much naturalism and not enough art in its construction.[48] While it might be argued that this is Vasari's comprehensive complaint about Venetian art in general, his singling out of a figure of Sebastian for special comment is significant. It indicates once again that the figure of Sebastian was a particular test of virtuosity, where technical demonstrations of skill in anatomy and the processes of art were expected to be found.

Vasari's testimony is eloquent textual evidence for the convention of using Sebastian as an "art figure." Sebastian's function as a test of figural virtuosity is, in fact, the basis of an anecdote that he recorded about the Florentine Fra Bartolo-

meo's painting of the subject, which has been quoted time and again in recent literature. Fragmentary citation of the passage, however, tends to leave out the essential points of the story. Vasari tells us that the figure Fra Bartolomeo painted for the church of San Marco was so beautiful that it was found to be sensually appealing to the *female* worshipers who prayed before it. I emphasize the gender of the sinning spectators, since this is a detail that is often ignored. (And to briefly follow this tangent, one should look at the startling *Martyrdom of Saint Sebastian* by Liberale da Verona, who fills the background of the scene with engrossed female onlookers, perched on balconies and straining from windows.[49] This spirited detail may be another instance of positing the expected interest of the female viewer in the spectacle of a beautiful male body.)

Vasari notes that because of its potential for distracting the devout women praying in San Marco, the painting of St. Sebastian was transferred to the adjoining monastery. It probably had the same effect on the devout monks, since the panel was in short order sold to a private client.[50] Given the specificity of the story, we can imagine that it stems from a basis in fact. Its relation to a topos of classical literature, however, indicates Vasari's source for his anecdote. Several ancient authors record how a worshiper fell in love with an effigy of Venus, responding to the statue carved by Praxiteles as if it were alive. Pliny's account is the fullest and most explicit, and was well known in the Renaissance:

> We spoke of the age of Praxiteles among the statuaries, but in the fame of his marble sculpture he surpassed even himself. Works of his are in Athens in the Ceramicus, but leading all works, not only by Praxiteles but throughout the world, is his Venus, which many have sailed to Cnidus to see. He had made two, which he offered for sale at the same time. One was draped, which was preferred by the Coan people, who had the right to a choice. Although he offered them either at the same price, they decided on the chaste and austere appearance of the draped one. The Cnidians bought the rejected Venus, which gained far greater fame. King Nicomedes later on wanted to buy her from the Cnidians, and promised to dissolve their entire public debt, which was huge. The people, however, preferred to suffer all their debts, and rightly so, for with that statue Praxiteles made Cnidus famous. The little building protecting it is open on all sides, so that the image of the goddess can be viewed from any direction; it is believed that the goddess herself favored this idea. The admiration of the statue does not slacken [when viewed] from any perspective. They tell of a certain man, seized with love

for it, who sneaked in at night and climbed on it in passion, and whose lust is marked by a stain.[51]

The skill of Praxiteles in creating lifelike works of art is attested by the power of the simulacrum to induce a physical response, so that the copy has the same effect as its living model. In other words, no distinction is made between art and life. This becomes a term of praise for the skill of the artist in reproducing nature, not a condemnation of the erotic appeal of a work of art.

All of this should be incorporated into a reading of Vasari's anecdote: the image created by Fra Bartolomeo of St. Sebastian displayed a beautiful body, and the viewer—across gender lines—was susceptible to its enchantment. This proves the skill of the artist in creating a convincing figure. Vasari was not underscoring the issue of the figure's capacity to generate sexual excitement as the purpose of his story, and much less was he condemning its effect on the viewer. Vasari recounted the tale in order to make a point about Fra Bartolomeo's credentials as an artist in painting an anatomically correct and thoroughly convincing nude figure, which showed the progress the friar had made in his studies after a trip to Rome. Once again, and emphatically, we see that in this tradition artful human figures prove the worth of the artist. The attraction of such figures was a by-product of the artist's virtuosity in counterfeiting nature, not the reason for their creation.

In closing I would like to add a speculation about one further way the afflicted yet enticing body of Sebastian might have operated at the opening of the early modern period. The end of the fifteenth century saw the advent of a new wave of horrifying diseases transmitted through sexual activity. When the first descriptions of syphilis appeared, people immediately made a connection to previous waves of mass infection, and the ailment was seen as a modern plague. Just like the plague, it was susceptible of being read as a scourge from God and more directly as divine chastisement of sinful sexuality. By 1527 the spread of syphilis through sexual intercourse was fully understood, and the causation was acknowledged with dark humor by designating the disease "venereal," dealing with matters provoked by the goddess of love.

An early treatise on syphilis, written in 1496 by Joseph Grünpeck of Bürkhausen, was followed by a second, more impassioned one by the same author in 1503, when he himself was suffering terribly from the disease.[52] It was then that he described in detail the course of the affliction: "The first arrow poisons the guilty organ." This metaphor invokes the ancient symbol of Apollo's mephitic shafts. It is not surpris-

ing that a newly manifest pandemic, seemingly sent as an onslaught from heaven, would be described in the same way.

Considered in this light, an inscription illusionistically chiseled into the pavement on which St. Sebastian stands in Perugino's Louvre panel encourages multivalent readings.[53] The phrase "Sagittae tuae infixae sunt michi," taken from the second verse of Ps. 37, describes Sebastian's torture: "Your arrows pierce me."[54] Within the context of the psalm, however, the line has a very different meaning, where the arrows symbolize the debilitating punishment sent from the Lord in anger against a sinner, provoking the offender's bodily decline into infirmity:

> Thy arrows pierce me, thy hand presses me hard; thy anger has driven away all health from my body, and my bones are denied rest, so grievous are my sins. My own wrong-doing towers high above me, hangs on me like a heavy burden; my wounds fester and rankle, with my own folly to blame. Beaten down, bowed to the earth, I go mourning all day long, my whole frame afire, my whole body diseased.[55]

Arrows are once again the metaphorical carrier of disease, but the imagery in this psalm is vivid in its description of a formerly healthy body under attack. A fundamental aspect of this psalm touches closely on Renaissance perceptions of both the plague and syphilis: divine punishment for wrongdoing strikes the body as well as the soul of the sinner. A lamentation closely connected to the effects of syphilis could easily be found in the psalm, with its particular symptoms of festering wounds and sensations of burning flesh as consequences of sexual sin, with the sinner's "own folly to blame" in the words of the psalm.

The modern plague of syphilis, so similar in its representation to that of the bubonic plague, might easily have been assimilated into the traditional category of suffering flesh over which Sebastian was deemed to have power. In the metaphoric representation of syphilitic infection, the potential for visualizing the illness through the degradation of Sebastian's highly desirable body would indeed have produced an "erotics of suffering," with an all-too-palpable association to earthly pleasure experienced through the flesh.

Body Elision

Acting out the Passion at the Italian *Sacri Monti*

D. Medina Lasansky

Overview of the *Sacri Monti*

During a journey through Italy in 1894, Edith Wharton noted that "one of the rarest and most delicate pleasures of the continental tourist is to circumvent the compiler of his guide-book."[1] Not surprisingly, Wharton claimed that she experienced "the thrill of an explorer sighting a new continent" upon discovering a few miles unmeasured by her Baedecker.[2]

The site she claimed to have discovered was the *sacro monte* of San Vivaldo, located in the Camporeno forest near San Gimignano (fig. 15.1). It was conceived by Fra Tommaso da Firenze in 1499 and built over the next fifteen years in the woods outside an existing thirteenth-century monastery. The *sacro monte* originally consisted of thirty-four chapels (of which seventeen survive today), designed to represent the sites and stories of the Holy Land.[3] The chapels were clustered at the top of several low-lying hills that converged overlooking the so-called Valley of Josephat.

San Vivaldo is one of at least sixteen mountain shrines founded between the late fifteenth and early eighteenth centuries by Franciscan friars in remote, forested hilltop sites in Italy.[4] Each of these contains a series of chapels filled with three-

Fig. 15.1 View of San Vivaldo, Montaione, commissioned by Edith Wharton in 1894. Reproduced by permission from Alinari

dimensional figurative tableaux made from terracotta, plaster, or wood and assembled to present stories in the lives of Christ, Mary, or the saints. Typically these were life-size figures made in situ by some of the period's leading artists.

With the exception of Wharton's San Vivaldo, all of the *sacri monti* are located in the sub-Alpine regions of Piedmont and Lombardy—along the frontier of what was at the time the ecclesiastic province of Milan.[5] The location of these sites roughly corresponds to the northern border of the Italian Alps—forming what Samuel Butler referred to in his 1888 study of Varallo as "beacons" and "fortresses" of Catholicism, delineating a line of defense against the heretical sects of the Protestant north.[6]

The earliest of these sites is Varallo, located in the Sesia River valley, in what would have been at the time a two-day carriage ride northwest from Milan (fig. 15.2). Similar to San Vivaldo, Varallo was also founded during the millennial rush by a Franciscan friar—in this case a man named Bernardo Caimi from Milan.[7] Caimi, who had been stationed in Jerusalem in 1476, returned home to Italy with the idea to simulate the pilgrim's experience of the Holy Land. In 1481 he received permission from the Pope Sixtus IV to construct a so-called New Jerusalem atop a

Fig. 15.2 Overview of the *sacro monte* of Varallo. Reproduced by permission from the Biblioteca Civica Farinone Centa, Varallo

mountain three hundred feet above the Sesia River.[8] However, unlike San Vivaldo's, Varallo's construction history is quite complex. Work began in 1486 and continued over the course of the sixteenth and early seventeenth centuries, ultimately resulting in the construction of forty-six chapels, the latter increasingly influenced by the Tridentine goals espoused by the influential church reformer Archbishop Carlo Borromeo (1538–84).[9]

By the latter part of the sixteenth century, Varallo had already emerged as an important role model for the founding of *sacri monti* at neighboring sites in Piedmont and Lombardy. Borromeo's widely publicized pilgrimages to and interest in Varallo undoubtedly enhanced its fame (Borromeo visited the site in 1568, 1571, 1578, and again in 1584 a few days before his death).[10] As a result, Borromeo's followers patronized several of the *sacri monti*. Orta, for example, founded in 1583 to present the story of the life of St. Francis in twenty-three chapels set in a wooded hill overlooking Lake Orta, was partially founded by Borromeo's close colleague Bishop Carlo Bascapè. Varese was founded in 1604 by Carlo's cousin Cardinal Federico Borromeo (1564–1631) to present the fifteen mysteries of the rosary in chapels designed by architect Giuseppe Bernascone. In 1614, Federico also helped conceive

the *sacro monte* of Arona, where fifteen chapels were planned by architect Carlo Fontana to narrate the life of Carlo Borromeo from his birth to canonization in 1610. While the chapels were never finished, the imposing seventy-foot high colossal statue of Borromeo holding the decrees of the Council of Trent was eventually completed in 1697. The colossus continues to bless the devout that make the journey to the site of the saint's birth on Lake Maggiore.

While each of the *sacri monti* differ in terms of siting, arrangement, and program, they are similar to the extent that all (with the exceptions of Montrigone in Borgosesia and the Sanctuary of il Cavallero, located above the town of Coggiola) contain isolated structures embedded within an artfully constructed multimedia setting in which landscape, architecture, sculpture, and painting work together to create a kinesthetic experience, an experience through which the body is repostured by architectural choreography and religious rite as the pilgrim meditates on the religious scenes at each site.[11]

This is perhaps most clearly evident at the two earliest sites—those of San Vivaldo and Varallo—where the story of Christ's Passion is presented in topomimetic terms. That is, the topographic characteristics of the site and the relative positioning of the chapels, in conjunction with the subject of the narrative tableaux and the architecture within which these tableaux are embedded, are meant to recall the topography and experience of the Holy Land itself. At Varallo distinct areas of the eighty-acre site represented Nazareth, Bethlehem, Mounts Zion, Calvary, Tabor and Olives, the city of Jerusalem, and the Valley of Josephat. This topomimesis extended beyond the site itself to include the neighboring valley. As Canon Giovanni Battista Fassola noted in his 1671 guide to Varallo, the Sesia River represented the Jordan, the Mastellone the Chedron, the town of Borgosesia the port of Caesarea, Lake Orta the Sea of Galilee, and Lake Maggiore the Dead Sea.[12] One can easily imagine that the sub-Alpine peaks surrounding the site in turn brought to mind the way the twelfth-century German pilgrim Theoderich had described Jerusalem in his account as a city on a hill surrounded by hills.[13]

Within this topomimetic framework, San Vivaldo and Varallo provided a simulated Holy Land experience in which the multimedia elements of design facilitated the performative experience of the body as the spectator/pilgrim walked in the footsteps of Christ meditated on the sculptural groupings and relived the various stages of his life. This was an experience that was facilitated and enhanced by a series of suggested behaviors, the emotional draw of the narrative scenes, as well as a series of interactive architectural devices—design elements that controlled the gaze and choreographed the body, enticing the pilgrim to at times kneel, pray, crawl,

and even caress the sculpted figures. In this early modern form of performance art, the body of the pilgrim became the vehicle by which the site and sculptural narratives were made understandable. The space between the sculptural tableau and the audience became compressed as the latter began to empathize with the experience of the former. It is this very experiential nature, or corporeal reality, of the pilgrim's performance that I wish to examine in this chapter. Drawing on the cases of Varallo and San Vivaldo, I discuss how architecture facilitates the pilgrim's religious experience of the site. As Robert Ousterhout has pointed out with regard to the Holy Sepulchre in Jerusalem, the architectural setting is critical to the process of shaping the ritual experience.[14]

The *sacri monti* have been popular destinations for the devout since their founding in the late fifteenth century. Pilgrims continue to visit the sites today, though their numbers are nowhere near what they used to be (Canon Francesco Torrotti claimed in his 1686 guidebook that thousands visited Varallo each day).[15] This is particularly the case during the weeks between Easter and Pentecost as well as the Marian month of May when daily morning mass is held at the church on site.[16] As has been the case since the sixteenth century, hospices accommodate those who wish to spend several days. Most pilgrims come to visit the miracle-working Madonna (typically a Black Madonna) housed on site—seeking cures for ailments or to acknowledge the *grazie ricevuta*, or grace, they received that granted them their miraculous recuperation and survival. If the efficacy of the Madonnas was ever in question, Pope John Paul II's highly publicized pilgrimage to Varallo, Orta, and Varese in 1984 (reenacting the visit of Carlo Borromeo four hundred years before) helped reaffirm the contemporary importance of the mountain shrines.

And yet despite this continuous religious interest in the *sacri monti* the sites have not received the attention they merit within the scholarly circuit. The only book-length study in English is Samuel Butler's from the late nineteenth century. Despite essays by several scholars, including David Freedberg, William Hood, Pier Giorgio Longo, Alessandro Nova, Maria Gatti Perer, Stefania Stefani Perrone, and Rudolf Wittkower, the *sacri monti* remain outside the mainstream discussions of Renaissance art and architecture—a fact that is particularly troubling when one considers the range of physical and documentary evidence that survives.[17] Sadly, Edith Wharton's challenge to readers (now a century old) to look beyond the canon of works celebrated by Ruskin and Burckhardt so as to explore Italy's "backgrounds" has not been answered.[18]

As Hood suggested almost thirty years ago in a wonderful essay on Varallo, this scholarly oversight can be attributed to the fact that the sites so blatantly defy

the categories of art established by Giorgio Vasari in his foundational sixteenth-century text *The Lives of the Artists*, a study that privileged central Italian artists (certainly not those from Piedmont and Lombardy) and the cosmopolitan sophistication of their "high art" commissions. Indeed, one of the most interesting things about the *sacri monti* sites is the extent to which they encourage us to rethink what we know about Italian Renaissance art. In many ways the sites defy easy categorization. They are simultaneously painting, sculpture, architecture, landscape, and set design. The illusionistic paintings, sculptures, two- and three-dimensional props merge fictive and real space in a way that reinforces the ambiguous nature of the pilgrim's position. At times, a close proximity to the life-size figures made the pilgrim feel as if he were an equal participant in the event rather than a passive observer. Ultimately the *sacri monti* are multimedia environments in which art, architecture, landscape, and religious ritual are integrated in unparalleled dialogue, each element enhancing the other in what can perhaps best be described as Renaissance installation art.

The Pilgrims

Varallo attracted both a popular and elite educated audience (the latter being the very people whose opinion should have mattered to Vasari). Visitors to the site in the late fifteenth and sixteenth centuries included residents from the neighboring Valsesian villages as well as members of the classically trained aristocracy: nobility such as Ludovico "il Moro" Sforza, who made plans to visit the site in 1499, the humanist Girolamo Morone, Francesco Sforza II and his wife, Cristiana of Denmark, who came in 1535, the Milanese Giacomo d'Adda (who commissioned several chapels including that of Adam and Eve and the Raising of the Paralytic in 1583), Charles V's general Cesare Maggi, who chose to be buried on the site after years of generous patronage, the Duke Carlo Emanuele I of Savoy and his wife, the Infanta Caterina of Spain, who came in 1583 and again in 1587 and financed the chapel of the Slaughter of the Innocents, the duke's sister Matilde of Savoy, who paid for the chapel depicting the story of the son of the widow of Naim, Countess Margherita de' Medici, her son Carlo Borromeo and her nephew Federico, and the painters Giovan Paolo Lomazzo and Federico Zuccaro—both of whom praised the site's artistic significance (the former in a treatise dedicated to the Duke of Savoy).[19]

In truth it is difficult to categorize the pilgrims to Varallo and their reasons for visiting the chapels. There was great diversity. Donna Agnesa, the paralyzed wife

of Milanese nobleman Burgonzo Botto (a courtier of Ludovico "il Moro" Sforza), came in 1498 seeking a cure for her lame leg.[20] A group of French soldiers walked from Orta in 1507 to visit the sepulchre.[21] Carlo Borromeo came to meditate. Two monks from S. Maria Maddalena in Novara escaped *clausura* in 1578 to visit the chapels.[22] The Duke of Savoy came to regain his health while his young wife came to deliver a silver ex-voto given in thanks for the birth of her healthy first son.[23] Women from the Sesia valley came to leave offerings at the chapel of the Annunciation with the hope of encouraging conception.[24] In 1601 a man from the neighboring town of Grignasco gave thanks for a successful exorcism.[25] Residents of Campertogno made a pilgrimage to give thanks for having survived the 1630 plague.[26] And a group of prostitutes, or so-called scandalous women, as they were referred to in a podestarial document, came daily to provide "companionship" (in exchange for alms) to the men visiting the chapels.[27]

The New Jerusalem Syndrome

It is important to note that the idea of recreating the Holy Land in Italy is by no means unique to the *sacri monti*. During various periods in Italian history and in locations throughout the country features of Palestine had been simulated. The Holy Sepulchre in particular has been the subject of the most intense veneration and replication. As early as the twelfth century, several copies of the tomb were known to exist in Italy—in Aquilea, Milan, Pavia, and Piacenza. The ecclesiastical complex of Santo Stefano in Bologna contained a copy of the Holy Sepulchre as well as the house of Pilate and the column of the Flagellation.[28] The twelfth-century Anastasis dome of the baptistery in Pisa similarly recalled the Holy Sepulchre, while dirt brought back from Jerusalem sanctified the neighboring cemetery of the Campo Santo.

In the fifteenth century there was renewed interest in the tomb. In 1467 Leon Battista Alberti designed an aedicule (purportedly based upon measurements taken in Jerusalem) for Giovanni di Paolo Rucellai (1403–81) in the church of San Pancrazio in Florence.[29] Roughly at the same time, also in Florence, there were a variety of ephemeral events that simulated the Holy Land experience. Confraternal plays such as the Annunciation staged in San Felice, the Pentecost in Santo Spirito, or the Ascension staged in Santa Maria del Carmine included stage props representing Jerusalem, the surrounding mountains, paradise to which Christ ascended, and the heavens from which the angels descended.[30] In some cases such events transformed the entire city into a New Jerusalem. This was certainly the case for the 1454 play

staged by the lay confraternity the Compagnia dei Magi in which Florence was recast as Jerusalem, the Piazza San Marco serving as Herod's palace.[31]

It is clear from these few examples that the experience of witnessing the Passion staged in a "Jerusalem" was not an uncommon event, even for those who never left their hometown. The devout were encouraged to meditate on the life of Christ, and they did not have to physically travel very far to answer this call. They were taught to imagine themselves assuming the role of Christ's contemporary; thus, they would cry in the company of the Marys at a reenactment of the crucifixion or crawl into the Holy Sepulchre in search of his body.

Of course, if possible, it was still preferable to travel to the Holy Land itself. As many scholars have noted, a pilgrimage during the fifteenth and sixteenth centuries was one of the most common and conspicuous forms of religious experience.[32] It was an important means of doing penance and receiving absolution for sin— particularly if it involved meditating on the life of Christ. A pilgrimage to Jerusalem allowed this—as there, in the Holy Land, the devotee was able to walk in the footsteps of Christ. However, fifteenth-century travel accounts demonstrate that such a trip was not only prohibitively expensive but also difficult and dangerous. Perhaps more importantly, pilgrims frequently returned home disillusioned. They complained that they had been rushed through sites by the Franciscan tour guides and were often unable to visit them in sequence or even visit them at all.

In contrast to the Holy Land itself, Italian *sacri monti* sites allowed for an organized and idealized Holy Land experience. Varallo and San Vivaldo, for example, provided a safe and relatively convenient alternative to traveling to the Holy Land. They were uncontested spaces, designed to facilitate protracted and intense devout performance. Varallo, for example, was open twenty-four hours a day. The *sacri monti* encouraged a sustained and intimate experience that enabled serious meditation. As Borromeo noted in a letter written during his 1571 sojourn to Varallo, "meditating on the mysteries has restored my spirit."[33]

Pilgrims to the *sacri monti* typically would have traveled a great distance. If they were seeking true penance they would have arrived barefoot, sleep deprived, hungry from fasting, and in pain from the process of self-flagellation. Borromeo himself was a practitioner of the latter. Bloody bruises discovered while preparing his body for burial were evidence of the severe penances he inflicted on himself during his fourth and final visit to Varallo.[34] Meditation and the recitation of penitential psalms would have also accentuated the pilgrim's experience, and certainly heightened the emotional response to the graphic figures. In all, the pilgrim's own physical state was an important element in determining the overall experience.

Performative Space

The performative nature of the *sacri monti* is most clearly evident at Varallo in the earliest chapels laid out when Fra Caimi was still alive and subsequently populated by Gaudenzio Ferrari's sculptures. In these chapels pilgrims were expected to become active participants in the religious tableaux. At the Bethlehem complex, for example, pilgrims entered in the company of the magi.[35] Walking among the life-size three-dimensional sculptures they figuratively became "companion[s] of the holy kings" (as was suggested by St. Bonaventure, the attributed author of the *Meditations on the Life of Christ*). Exiting the chapel the pilgrims found themselves in a cavernous room constructed in imitation of the lower church in Bethlehem complete with a staircase leading to the upper church.[36] The Christ child lay on an altar flanked by figures of Mary and Joseph. As pilgrims walked past this intimate nativity scene they might have felt inclined to "kiss the beautiful little feet of the infant Jesus" (as suggested in the *Meditations*) or to pick the infant up and cradle him in their arms.[37] After cradling the child, pilgrims were then given the opportunity to stand with the shepherds and gaze into the manger.

Pilgrims left the nativity grotto by a narrow, twisting staircase designed to slowly reveal itself during ascension. That is to say, pilgrims gained a sense of where they were going only once they were in the process of moving. At the top of the stairs pilgrims emerged through a sumptuous marble doorway (a replica of that in Jerusalem) into a small chapel. Benches built into the wall conveniently accommodated the emotionally and physically drained pilgrims, allowing them to pause and witness the circumcision of the child they had cradled only a few minutes before.

The *Meditations on the Life of Christ* firmly established this meditative technique. The text repeatedly encourages the reader to become an active participant in the sacred drama. Bonaventure's much-quoted "Tree of Life" laid out a series of meditations that staged scenes from the life of Christ. Thus, though all pilgrims might not be able to actually walk in Christ's footsteps in Jerusalem, they certainly would be able to imagine themselves doing so. These meditations would have been familiar to the learned and unlearned pilgrim alike.[38] Such meditative techniques, coupled with the visceral nature of the three-dimensional scenes and the ability to become physically involved with the figures, would have allowed the mysteries to come truly alive.

As scholars have noted, the Franciscans developed a distinct form of meditative prayer that encouraged the faithful to imagine the physical setting, participants, and events and then place themselves within the scene as actors within the drama.

Ever since Francis had devised the first living nativity crèche at Greccio, religious performance art had been honed as a Franciscan specialty. At Bethlehem, as elsewhere on site, it is this dynamic relationship between architecture, art, performance, and meditation that animates and ultimately defines architectural space.

Retooling Varallo

As Varallo developed over the course of the sixteenth century, the programmatic strategies of the chapels changed. They were no longer participatory in the way they had been at the Bethlehem complex. Instead, they became markedly staged and less physically interactive. Architect Galeazzo Alessi was responsible for much of the change beginning in the 1560s.[39] On the request of Giacomo d'Adda, one of the site's *fabricciere* (an elected local official responsible for overseeing the maintenance of the chapels), Alessi developed a comprehensive site plan. His plan, which was never fully carried out, survives in the form of a manuscript entitled the *Libro dei misteri*.[40] It outlined a number of new chapels, urban spaces, and a series of design elements such as wooden screens with fixed viewing spots and kneelers that prescripted the form of devout performance.

Thanks to this new delineation between the space occupied by the tableaux and that occupied by the viewer, the pilgrim was now forced into a choreographed position of prayer. The very act of looking through the screen forced one to focus on the religious tableau, excluding peripheral vision. By framing specific figures within each scene, the fixed viewpoints highlighted key moments within the mystery. They functioned as sanctioned peepholes. Such vantage points were particularly important in scenes that featured dozens of figures, such as the road to Calvary built in 1589, which included fifty human figures and fourteen animals. In this scene a peephole pointedly frames the figure of Veronica carrying the veil with which she wiped Christ's face (fig. 15.3). In the chapel depicting the nailing of Christ onto the cross, a compositional masterpiece executed by Giovanni d'Enrico and Bartolomeo Ravelli in 1614 with sixty-four terracotta figures and eight life-size horses, the peephole poignantly frames a supine Christ nailed to the cross. In other chapels, such as the Slaughter of the Innocents or the Raising of the Paralytic, two levels of viewing holes direct the viewer's attention to events that take place in the foreground as well as background.

Most of the viewing holes were wide enough to accommodate a pilgrim's head, and the heavily worn wooden frames of the holes indicate that it was a common practice for pilgrims to stick their heads in them. In his description of Mount Cal-

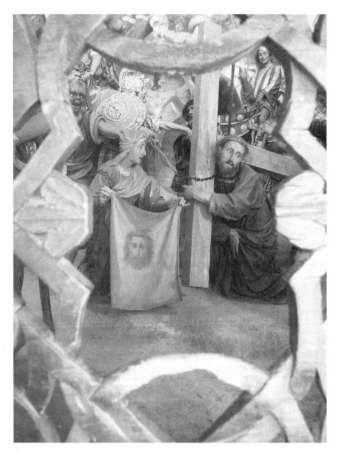

Fig. 15.3 Chapel of the Way of the Cross, Varallo, detail of peephole in the wooden grille showing Christ and Veronica. Photograph by D. Medina Lasansky

vary, Theoderich refers to a hole "almost wide enough to take in a person's head." And it was "into this hole [that] pilgrims, out of the love and respect that they bear to him who was crucified, plunge their head and face" thereby immersing themselves in the pictorial space.[41]

As the religious historian Pier Giorgio Longo has noted, the peepholes allowed for stereoscopic viewing.[42] More to the point, they were designed to bring the three-dimensional scene into focus and harness the viewer's attention. Similar to the quotations from the Bible that were painted on the chapel walls beginning in 1585, the peepholes were a means of ensuring catechistic success.

It has been argued that Alessi made the changes in the staging of the mysteries

at Varallo in response to a post-Trent desire to regularize devotional practice and religious experience. Certainly the grilles and kneelers would have established a norm for regulating the pilgrim's body. And certainly they put more of an emphasis on the process of meditation and reflection (as promoted by Borromeo) than on physical experience (as promoted by the early Franciscans). As we know, Borromeo introduced a range of devices designed to discipline devotional comportment.[43] The Borromean confessional, for example (in which the penitent kneeled with his/her head bent in front of a wooden screen, behind which sat the confessor), was in use by the late 1570s. The confessional was designed to physically structure the nature of religious practice. It allowed the penitent to speak to the confessor without seeing him and at the same time allowed the penitent to be seen by other devotees without being heard.[44] The device staged the intimate devotional experience for a church-going public, allowing every devotee to become a role model for others.

The idea of regulating devotional experience in such precise ways and of making such corporeal regulation visible to others is also evident in Alessi's modifications at Varallo. Alessi's design elements controlled the unpredictability of the individual performance. His grilles and kneelers were designed to control otherwise potentially aimless bodies in order to establish devotional efficiency and uniformity. The multiplicity of views that had, for example, been available in the Bethlehem complex was eliminated. In fact, following the orders of Bishop Bascapè (the bishop of the diocese of Novara in which Varallo was situated), many of Ferrari's original chapels were modified. The chapel of the Magi was closed by a wooden grille, thereby preventing pilgrims from walking with the kings. Similarly, a metal grate was installed above the altar in the grotto, making it no longer possible to kiss and cradle the Christ child. Such changes certainly serviced the goals of the Tridentine reforms, but the reforms alone do not entirely explain this shift in design. Alessi's new grilles and framed peepholes reflect contemporaneous ideas about one-point perspective, scenography, and the pictorialization of space that ultimately underscore the Renaissance character of the site.

In sum, both Alessi and Bascapè were interested in retooling Varallo so as to control the relationship between the religious tableaux and the pilgrim. More specifically they sought to privilege meditative observation over experience. While Bascapè's initiatives reflected Reformation theology, Alessi's initiatives were guided by current architectural theory (as evidenced through the use of perspectival peepholes, a classically inspired architectural vocabulary, and materials such as worked stone). Both however, were interested in standardization as a means to

create uniform pilgrim experiences. In other words, both men sought to control what people did on the site. And they succeeded. By the end of the sixteenth century the pilgrims' sequence of movements were closely regulated. They proceeded from the church of Santa Maria delle Grazie at the base of the hill (where they were met by a religious guide), past the hotel (founded in 1590), the gift shop (where they could purchase a guidebook, rosary beads, and ex-votos), through Alessi's newly designed triumphal entrance, and on to a series of chapels that began with the creation of Adam and Eve. Newly installed grilles kept the pilgrims at a distance while simultaneously focusing their gaze. In this renovated *sacro monte*, topomimesis was replaced by an efficiency-oriented design that governed the pilgrim's movement. Not surprisingly, by the latter part of the sixteenth-century, guidebooks provided useful pullout maps with a checklist of numbered chapels and cross-referenced indices.

The Via Dolorosa

Although Bascapè wished to reorder Varallo according to Tridentine goals and Alessi wanted to contemporize the architectural setting, neither sought to entirely eliminate the earliest chapels designed by Gaudenzio Ferrari. As a result, pilgrims visiting the site in the late sixteenth century would have encountered chapels of both the old and new order. The old and new chapels constituted distinct typologies, but they shared a common agenda—that of allowing the pilgrim to become intimately familiar with the stories of Christ's life and increasingly empathetic to his suffering.

Pilgrims walked the Via Dolorosa with Christ, following him as he was tried at the various tribunals. They were emotionally pummeled as they were tossed between the courts of Anna, Caiphas, Pilate, Herod, and Pilate again in the so-called Piazza dei Tribunali, an urban assemblage of buildings built beginning in the early 1600s based on the projects designed by Alessi. Following the sequence of courts, the pilgrims climbed the steep steps of the Scala Santa, growing weary just as Christ must have grown weary. The rise and run of the staircase was calculated to effect this weariness. (According to Bascapè's demands, the staircase was built according to precise measurements of the Scala Santa in Rome.) At the top of the stairs the pilgrims walked with Christ as he was judged, condemned, and presented in Pilate's palace. In the subsequent scenes, the pilgrims were forced to follow a circuitous series of paths, steps, and doorways that could easily cause them to trip, just as Christ fell carrying the cross.

After being forced through this gauntlet of nearly forty scenes, the pilgrims would have climbed the final hill, an outcropping of rugged bedrock known as Mount Golgotha, which housed the Calvary chapel (fig. 15.4). Similar to the Bethlehem complex, the crucifixion scene, designed by Gaudenzio Ferrari and completed in the 1520s, was a highly interactive space. Upon entering, pilgrims assumed a place among Christ's contemporaries, becoming one with those that would have actually witnessed the scene. As was the case with the earliest chapels, pilgrims could have walked among the statues, beneath the cross, among the tormenters, the tormented, and the grieving faithful.[45] A box of relics (which, according to Fassola, contained pieces of the true cross, the column of the flagellation, the stone where the cross was placed, the manger, and the containers in which Jesus converted water into wine) purportedly brought by Caimi from the Holy Land were kept at the foot of the cross to be used by pilgrims for the blessing of rosaries and other items.

The combination of sculpture, painting, and performative space formed a theatrical diorama. The walls of the chapel are slightly curved in a manner that creates a panoramic space recalling the contemporary Sala dei Giganti at the Palazzo del Té in Mantua.[46] The fully three-dimensional figures of Christ and his companions merge with those painted on the walls representing early sixteenth-century personalities: the Scarognini of Varallo, the emperor Charles V and his general Count Filippo Tornielli, and two anonymous sixteenth-century pilgrims (identifiable by their staff and shell emblem). There is a sense of continuous space that envelops the viewer, making the experience of witnessing the crucifixion all the more compelling and emotionally charged. As the 1514 guidebook noted, it is a scene that was impossible to describe in words.[47]

Most pilgrims at Varallo would have been both physically and emotionally exhausted by the time they arrived at Mount Calvary—just as Margery Kempe became weak upon visiting Golgotha in Jerusalem. Silvio Paolo Ballarino, who visited Varallo in 1671, noted that he felt heart palpitations.[48]

The Sepulchre

As pilgrims exited the Calvary chapel, they would have proceeded past the scene of the deposition, down a steep staircase, to arrive once again in Jerusalem—a decidedly urban space skirted by a covered loggia and outfitted at one time with a printing shop, bookstore, and hospice. The entrance to the Holy Sepulchre was located at the western end of the piazza in accurate relative position to that of

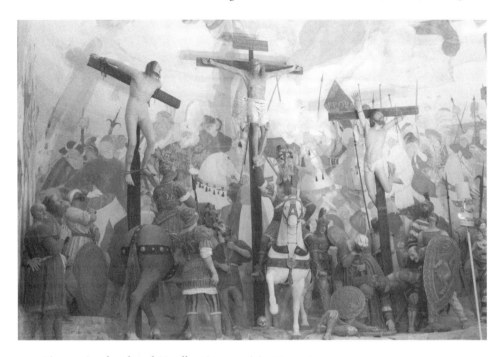

Fig. 15.4 Cavalry chapel, Varallo. Photograph by Marco Genova

Mount Calvary. An inscription above the entrance notes that the tomb is similar in size and shape to the tomb in Jerusalem. A large stone stands to the right of the entrance. Its inscription notes that it was uncovered during the initial phase of construction and is miraculously the same size and shape as that which covered the tomb in Jerusalem.[49] These claims to formal accuracy underscore the legitimacy of Varallo as a New Jerusalem destination.[50]

Once inside the domed antechamber of the sepulchre, the pilgrims were confronted with a very low door (similar to the door in the antechamber in the Holy Land itself as described in the twelfth-century accounts of both Theoderich and Abbot Daniel).[51] In a classic moment of architectural compression and release, the pilgrims were forced into a position of ultimate submission by being required to crawl through the low doorframe into the inner burial chamber. Upon standing, the pilgrims found themselves in a small windowless room measuring eight feet square. The lifeless body of Christ (a polychrome wooden sculpture believed to have been carved by Gaudenzio Ferrari) lay on the marble burial slab (fig. 15.5), his head propped on two pillows made from sumptuous brocade fabric. Flickering torches and lanterns suspended nearby would have provided just enough light to

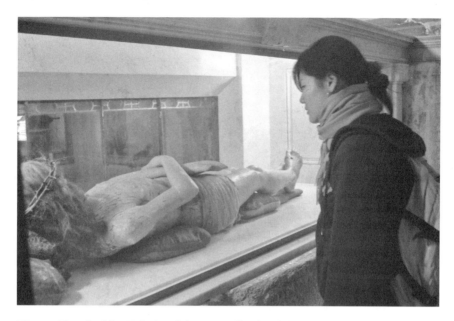

Fig. 15.5 Chapel of the Holy Sepulchure, Varallo, detail showing Christ on the tomb. Photograph by David Todd

render visible the hair cascading from Christ's head, his crown of thorns, bloody wounds, and the simple white loin cloth modestly draped over his groin.[52] One cannot overemphasize the sense of revelation that would have been experienced upon entering when the room was illuminated by candlelight.

By all accounts the sepulchre was an intensely sacred space. As Torrotti noted, "Few left without feeling blessed."[53] The walls were covered by ex-votive offerings left behind by the devout.[54] The Milanese humanist Girolamo Morone, who visited in 1507, wrote to his friend Lancino Curzio that he had "never seen anything more religious, more pious, that more touched the heart, that urged [one] to abandon everything else and follow only Christ."[55] Borromeo visited the chapel on several occasions. During his final visit, he spent the entire night in solitary prayer at the side of Christ preparing for his own impending death. Many pilgrims, including Borromeo, came to the sepulchre after having visited the Holy Shroud housed in Turin.[56]

Indeed, we know from several sources that Varallo, along with the Marian shrine of Loreto, the Franciscan shrine at La Verna, and the shroud site in Turin, was considered to be one of the most sacred sites in Italy. Many felt that it was important

to both visit and patronize the sepulchre. As a result, countless individuals bequeathed money and property to support the maintenance of the chapel. Giovanni Battista Crivelli of Castellanza (a town near Varese), for example, left ten imperial lire in 1561 to illuminate the chapel. More than one hundred years after his death, Crivelli's descendants were still providing the funds for candles.[57]

Fragmenting the Senses

As we learn from the early guidebooks to the Varallo sepulchre, many pilgrims felt compelled to caress Christ's hair, his crown of thorns, and his flesh.[58] In so doing they could have assumed the role of contemporary bereaved as they stood in intimate proximity to Christ's body—something that would not have been possible in Palestine. The ironies are obvious. The very act of Christian pilgrimage depends on Christ's resurrection and hence an empty tomb. And yet at Varallo unlike at most replicas of the Holy Sepulchre, the pilgrim was put the privileged position of being able to experience what no one had experienced. It is perhaps this difference that led Girolamo Morone to comment that after visiting Varallo there was no need to travel to the Holy Land. As he enthusiastically wrote to Curzio, "let the very trip to Jerusalem stop."[59]

The act of caressing the body of Christ in the sepulchre would have been the culmination of a multisensory experience. Throughout the pilgrims' visit to the *sacro monte*, their sense of sight, hearing, smell, touch and taste were heightened at precise moments. The sense of sight was exploited by the series of dramatic tableaux staged in the chapels; that of sound by the recitation of psalms and prayers; that of smell by the burning of incense and candles; that of touch by cradling the body of Christ; and that of taste by drinking water from the so-called fountain of the resurrected Christ located in the piazza of the New Jerusalem. As Caroline Walker Bynum has pointed out, such corporeal fragmentation is closely associated with Passion devotion. Pain and suffering provided the opportunity for salvation. At Varallo this process reaches new heights as the pain of Christ and that felt by the pilgrims was experienced simultaneously over the course of traversing the site.[60] As Bynum has argued, the humanization of Christ appears already in thirteenth-century spirituality through its association with the devotion to various body parts. As she notes, "those who love Christ should respond to all of his body with all of theirs."[61] And so did the pilgrims at Varallo, as their senses were atomized over the course their visit. The pilgrims' corporeal experience of the site would have been heightened through lacrimation and lamentation. As the 1514 guidebook to

Varallo suggests, pilgrims were encouraged to cry at various points throughout the site (when Christ is condemned, on Mount Calvary, and at the Holy Sepulchre), as well as stand with figures in the tableaux who were depicted crying (such as the Marys gathered at the crucifixion).[62] Crying was an acceptable and encouraged devotional practice.[63]

We must imagine that at any given time large groups of pilgrims would have been traversing this site, all the while reciting psalms, reading aloud from the early guidebooks, and conversing with their spiritual leaders. In some ways it would have been a loud and crowded experience. There were, however, two moments in the narrative when pilgrims were able to be truly alone with Christ and in silence. The first was in the grotto in Bethlehem, when the pilgrim was able to cradle the infant Jesus. The second was in Christ's tomb, when the pilgrim could caress his corpse. The very process of crawling through the entrance of the Holy Sepulchre forced pilgrims to undergo a momentary blackout as they proceeded alone, in darkness and in silence on their knees, into the sepulchre. Both the grotto and the antechamber to the sepulchre functioned as echo chambers, thereby demanding silence. Thus, at the two most important moments in the Christological narrative, the pilgrim's body merged with that of Christ. It is at this moment that we are poignantly reminded that the body is the locus of the Passion experience.

Rewriting History at San Vivaldo

As we have seen, visiting Varallo was in many ways more rewarding than visiting the Holy Land itself. At Varallo there were no distractions and no threats. Pilgrims could focus on the religious experience to the exclusion of all else, as the *sacri monti* were uncontested spaces. Their narratives were complete rather than fractured, corrupted, and commercialized, as was the case in Jerusalem. They were therefore more efficacious. The sites could of course also be conveniently updated to reflect changing church doctrine. Stories could be excised or added as appropriate and devotional practices could be easily modified. *Sacri monti* such as the late sixteenth-century Crea or early seventeenth-century Varese, for example, both of which present the mysteries of rosary rather than the Passion, respond to Pope Pius V's attempt to regulate Marian devotion.[64] When studied comparatively, it becomes clear that the sites both responded to and defined popular devotional practice. At Varese, for example, chapels are spaced according to the time needed to walk and recite the prayers for one bead of the rosary.[65]

In addition to allowing for a controlled experience, the utopic nature of the

sacri monti allowed their designers and patrons to recuperate aspects of the Holy Land that had either not yet been rediscovered or sites that were simply not possible to visit. That is to say, the *sacri monti* allowed for the presentation of a perfected Holy Land that in reality did not exist.

This is perhaps most clearly evident at San Vivaldo where the sites of the Passion are presented as if they are a part of an archaeological project. For example, the church of Our Lady of Sorrows in Jerusalem, built at the site where Mary swooned upon seeing her son dragging himself up to Golgotha, was in ruins at the turn of the sixteenth century. There was nothing much to see until the church was rebuilt by Armenian Catholics in 1881. At San Vivaldo, however, the church was resurrected and the scene of the narrative reenacted by the sculpted grouping of Bugnone da Siena. The location of the house of Veronica in turn was uncertain at the turn of the sixteenth century. It was believed to be located somewhere near the Holy Sepulchre, yet it was not known precisely where as much of the area was controlled by Muslims. At San Vivaldo, the structure and scene conveniently reemerge along the road to Golgotha. In other words, the important moments and places in the Passion that were invisible in the Holy Land itself were rendered visible and visitable at San Vivaldo.

The period in which San Vivaldo was being built was a period of Christian rediscovery of the Holy Land itself. The precise location of some sites was being determined for the first time, while many other sites were being reworked and rebuilt. What is particularly striking about the recuperation of such sites at San Vivaldo is that the chapels were commissioned by the Florentine nobility—families such as the Alamanni, Bardi, Federighi, Mannelli, Michelozzi, Pitti, Ricasoli, and Salviati (their coats of arms mounted on the exterior of the structures makes their patronage explicitly clear). The Bardi for example paid for the replica of the sepulchre and in fact owned most of the land on which the entire *sacro monte* site rests. The Pitti paid for the chapel of the Ascension where the sacred footprint of Christ was located, while the Michelozzi financed the church of Our Lady of Sorrows. Within this context it appears that San Vivaldo allowed Florentine nobles to participate in the process of reconquest by building sites that had not yet been discovered or that were not accessible to Christians.

This was an important process, particularly for those families that had no demonstrable genealogical connection to the Crusades—which was the case for most Florentines. Indeed, for generations Florentine nobility had gone to great lengths to write themselves into the history of the Crusades. The Pazzi for example had constructed the myth surrounding the Scoppio del Carro, claiming that during

the First Crusade their ancestor Pazzo de' Pazzi was the first to plant the Christian banner on the walls of Jerusalem during the capture of the city. He was rewarded with three bits of flint from the Holy Sepulchre. Upon his return to Florence he suggested that the flint be used to light a fire on Easter Saturday each year.[66] The tradition and myth survive today.

Like most fifteenth-century Florentine families, the Pazzi had no connection to the Crusades. So while Tuscans in Lucca, Pisa, and San Gimignano were able to secure social prestige by advertising their relationship to the crusaders, many Florentines could not (after all, Florence was not a city of significance in the eleventh and twelfth centuries). San Vivaldo was therefore yet another way in which Florentines participated in the rewriting of history—so as to become crusaders for the first time.[67] It is within this fictional topography that Florentine nobles were able to reclaim the glories of the crusaders as their own.[68]

It is this very process of rescripting history that makes San Vivaldo distinct from Varallo. Varallo was open to the public, but San Vivaldo was an exclusively noble creation and destination.[69] It was enclosed by a wall paid for by the Salviati family and open to the outside only on certain feast days. The chapels functioned as private spaces; indeed, some family members are even buried within them. As a result, unlike Varallo, the site was not changed to conform to doctrinal needs post-Trent. It remained something of a fossil.

Cinematic Space

Both San Vivaldo and Varallo present a filmic, or cinematic, space. While the analogy is anachronistic, it is useful to visualize the illusion of spatial and temporal continuity that has been constructed on site. The time and space of Christ's life has been compressed into a coherent edited narrative, which is dependent upon the pacing and framing of a series of mise-en-scènes. We are quite familiar with the idea of Renaissance passion theater in its traditional form of the *sacra rappresentazione*, famously embodied by the performances at Grassina or Sordevolo, in which the audience witnesses the stories of the passion.[70] We are less familiar with situations in which the audience is required to perform—and yet this is what takes place at the *sacri monti*.

In scenes such as the Massacre of the Innocents at Varallo (built between 1587–90 by the brothers Enrico, Giovanni, and Giacomo d'Enrico with help from Giacomo Bargnola di Valsolda and Michelangelo Rossetti, and Michele Prestinari) the compression of space between the pilgrims and sculptures becomes clear. As

pilgrims, standing on the other side of a wooden balustrade observe the gruesome scene of children being ripped from their mothers' breasts and by Herod's zealous soldiers, they begin to merge with the other spectators painted along the adjacent walls standing behind trompe l'oeil balustrades. This sense of metaspace heightens the effect of the already macabre scene. As the painter Federigo Zuccaro noted in an account of his visit to Varallo, of all the scenes on the site this was perhaps the most expressive and visceral.[71]

The merging of the fictive and real space is even more apparent in the Ecce Homo chapel at San Vivaldo. The scene is located in a shallow chapel. The opposing chapel contains the crowd that bears witness to the accusations launched against Christ. The scene therefore is divided between the two chapels. The pilgrim stands between these chapels and in so doing becomes a member of the jeering crowd while gazing at the figure of Christ, or empathizing with Christ while turning to confront the throng of tormenters (fig. 15.6). The event is presented across space. And it is the pilgrim's body that completes the scene.[72] This is what Shearman has termed the "collapse of historical distance" as the audience shares an "as-if-present experience" with Christ and his tormenters.

A similar situation occurs during the procession to Calvary as the pilgrims enter the chapel through one door and exit through another forcing them to walk along the length of the relief depicting Christ and the crowd as they ascend to Mt. Golgotha. In so doing the pilgrims perform what is depicted in the sculptural relief and thus become contemporaneous participants in traversing the Via Dolorosa. In several cases scenes are spliced into a single structure to form a montage of spatial and emotional experiences that are interdependent within the overarching narrativization of the site. At Mount Calvary at San Vivaldo for example the visitor enters at the base of the mount—and stands next to the three Marys (fig. 15.7) where they participate in their agony as they gaze upwards to the body of Christ nailed to the cross. The scene only comes into focus as the visitor climbs the hill and enters the scene—sharing the stage with Christ and assuming a position amongst the grieving faithful.

In scenes such as these we repeatedly see how the pilgrim's physical position and gaze has been choreographed to heighten the effect of the overall narrative. Similar to a darkened movie theater, there is no offscreen diversion here—nothing to distract the meditative state of mind. A team of designers has mediated the entire hillside.

This sense of staged theatricality was to reach unparalleled heights at Varallo in the second half of the sixteenth century when the architect Alessi designed a series

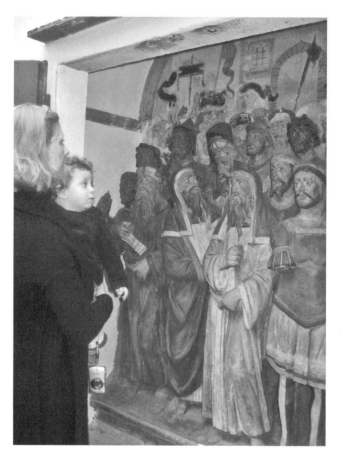

Fig. 15.6 Chapel depicting the angry mob witnessing the scene of the *ecce homo*, San Vivaldo. Photograph by D. Medina Lasansky

of unrealized structures including those intended to present limbo, purgatory, and paradise. According to his designs, pilgrims would have entered from above and found themselves precariously suspended over damnation (in the case of purgatory) as they gazed down through the viewing device. The nature of such chapels, their ability to heighten the visitor's sense of self consciousness, would have underscored the very purpose of visiting and patronizing the *sacri monti*, namely, to provide an opportunity to regain spiritual health.

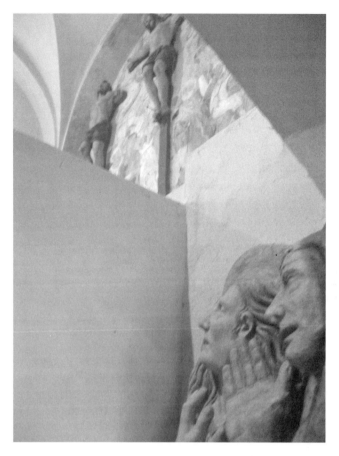

Fig. 15.7 Calvary chapel, San Vivaldo, viewing the crucifixion while standing with the Marys. Photograph by D. Medina Lasansky

Bodies in Space

It is commonly believed that installation art was invented in the twentieth century. Contemporary critics and artists claim that the nature of the medium is defined by the extent to which the viewer becomes an active contributor by witnessing and responding to a series of visual and perceptual challenges proffered in a charged environment (whether political, social, sensual, or didactic). An installation may employ text, sound, video, photography, film, found objects, performers, or music, or it may simply be a space emptied of everything but its own presence. By being part of the installation, the spectators experience an awareness of their environ-

ment through physical and visual sensation as well as an awareness of others in the space.[73]

When studying the *sacri monti*, it is hard not to think about the work of contemporary installation artists such as Bill Viola or Elizabeth Diller and Ricardo Scofidio, whose projects depend on multisensory experiences and a blurring of the boundaries between the art object and the spectator space. Diller and Scofidio's "Blur Building," constructed of fog for the Swiss Expo '02, is a superb example.[74] Art and architectural history—disciplines that continue to segregate visual culture according to categories of high and low, method of production, subject and author, art and architectural history—have a lot to learn from these shrines in which boundaries take on a truly modern form.

Architecture is traditionally mediated by someone—whether the photographer, the draftsman, or the historian. At Varallo and San Vivaldo the pilgrim is the mediator. It is the pilgrim's body that provides the tool to accurately interpolate and represent the site. It is through the movement and experience of the pilgrim that Christ's life can be reconstructed. The body functions in unexpected ways. It becomes an integral part of the very fabric of the site. Despite having been ignored by Vasari, these sites are most definitely "Renaissance" in the true sense of the word as it is the human body that serves as the device of perception.

As such, the *sacri monti* encourage us to rethink the extent to which the body can function simultaneously as architectural material, device of perception, and mode of representation. Arguably the sites raise more questions than they answer. To what extent are the activities of the pilgrim's body choreographed to render a specific experience of space? Does the site have to be felt rather than rationalized? If we can answer the last question affirmatively then we need to ask to what extent we should rewrite the history of the senses into the history of architecture.

The emotional and sensual experiences of the body are the very things that Renaissance theoreticians sought to steer us away from. The theoretical work of Alberti has long taught us to intellectualize space. Discussions of proportion, harmony, and function are situated within a highly rationalized system of thought that has its roots in classical antiquity. Within this framework the sensual experience of architecture has been devalued. Color, smell, sound, and touch have been largely expunged from architectural discourse, and we have grown comfortable discussing architecture within the context of a canon of monuments divorced from their experiential matrix.

In contrast, the *sacri monti* successfully remind us how a site would have been seen, used, heard, and felt. They show us how the acts of kneeling, crawling, and

crying are central design elements. They demonstrate how architecture can provide a frame for heightening self-consciousness through the manipulation of the body in space. By foregrounding the senses architecture can use the body to surface the unseen.

Not surprisingly sites such as Varallo have not been incorporated into the canon, not because they don't survive, but because they do not fit within the categories on which the discipline of art and architectural history was founded. Those who have had the courage to proclaim the significance of the *sacri monti* include Girolamo Morone, who claimed that the chapels were "superior to any ancient monument"; Giovan Paolo Lomazzo, who ranked Gaudenzio Ferrari among the greatest artists; the authors of guidebooks that praised the artistic integrity of the site; and Edith Wharton, who claimed that the sculptures at San Vivaldo had been misattributed and sadly overlooked.[75] These observers have been ignored and even maligned, as was the case with Wharton. It is time to reassess both their commentary and the sites they studied.

Notes

O N E : Fetishizing the Veil

1. The epigraph to this chapter comes from *Petrarch's Lyric Poems*, trans. Robert Durling (Cambridge, MA: Harvard University Press, 1976), 11.12. All citations from the *Canzoniere* are to this edition, unless otherwise indicated. Translations of Petrarch into English are based on those of Durling, with occasional modification. Both the Latin and the vernacular titles of the *Canzoniere* suggest a process of dissection and dispersion. Petrarch's own Latin title, *Rerum vulgarium fragmenta*, was later replaced by the Italian title, *Rime sparse*, adapted from the incipit of the first sonnet in the collection. The title *Canzoniere* (*Songbook*) was used for the first time in 1516 by the Bolognese printer Francesco Griffo for a printed edition that contained the poems from the *Rerum vulgarium fragmenta*, the *Trionfi* (*The Triumphs*), and assorted other poems written in the vernacular. The title *Canzoniere* is therefore later than the other two titles, was certainly not selected by Petrarch, is somewhat imprecise, but is widely used today.

2. Thomas Greene, *The Light in Troy: Imitation and Discovery in Renaissance Poetry* (New Haven, CT: Yale University Press, 1982), 88. See also chap. 6, "Petrarch: The Ontology of the Self" (104–26), and chap. 7, "Petrarch: Falling into Shadow" (127–46).

3. For a discussion of the presence of Dante in Petrarch, see Mario Santagata, "La rimozione di Dante," in *I frammenti dell'anima: Storia e racconto nel Canzoniere del Petrarca* (Bologna: Il Mulino, 1992), 199–204. All references to Petrarch's letters are to Francesco Petrarch, *Letters on Familiar Matters*, bks. 1–8, trans. Aldo S. Bernardo (Albany: State University of New York Press, 1975); *Letters on Familiar Matters*, bks. 9–16, trans. Aldo S. Bernardo (Baltimore, MD: Johns Hopkins University Press, 1982); and *Letters on Familiar Matters*, bks. 17–24, trans. Aldo S. Bernardo (Baltimore, MD: Johns Hopkins University Press, 1985).

4. See Jennifer Petrie, *Petrarch: The Augustan Poets, the Italian Tradition, and the "Canzoniere"* (Dublin: University College Dublin, 1983) for a discussion of the importance of the Latin poets for Petrarch. We might say that Petrarch channels his heterosexual desire for Laura by textualizing her body and his homosocial (homotextual) passion for classical authors by utilizing a strategy of detextualizing, or embodiment. Petrarch's affair with Cicero is an example of the confused relationship between *corpus* as text and *corpus* as body, both fallen from redemptive status. The text of Cicero that wounds Petrarch's leg (*Fam.* 21.10) is treated as a personified body.

5. *The Light in Troy*, 119.

6. See Teodolina Barolini, "The Making of a Lyric Sequence: Time and Narrative in Petrarch's *Rerum vulgarium fragmenta*," *MLN* 104 (1989): 1–38, for a discussion of time and the construction of the narrative in the *Rime*.

7. Giuseppe Mazzotta, *The Worlds of Petrarch* (Durham, NC: Duke University Press, 1993), 174. The chapter in Mazzotta's book from which I am quoting here originally appeared as "The *Canzoniere* and the Language of the Self," *Studies in Philology* 75 (1978): 271–96.

8. Lynn Enterline, *The Rhetoric of the Body from Ovid to Shakespeare* (Cambridge: Cambridge University Press, 2000). Enterline contrasts "mi trasformo" with St. Augustine's "transformatus sum" to exemplify the sharp division between a narrating and a narrated self. In opposition to the Augustinian model, Petrarchan autobiography presents a "continuing process of metamorphosis" that emerges as "forgetting and repetition" (94).

9. Nancy J. Vickers, "Diana Described: Scattered Woman and Scattered Rhyme," *Critical Inquiry* 8 (1981): 265–79.

10. Margaret Brose, "Petrarch's Beloved Body: 'Italia mia,'" in *Feminist Approaches to the Body in Medieval Literature*, ed. Linda Lomperis and Sarah Stanbury (Philadelphia: University of Pennsylvania Press, 1992), 2–20.

11. Many of these attributes are enumerated in Vickers, "Diana Described," 266.

12. Roberto Antonelli remarks that "la scomparsa di Laura è infatti . . . elemento di unificazione (contrariamente a quanto pensarono antichi commentatori e moderni editori)" ("the disapperance of Laura is in fact [the] element of unification (contrary to what the ancient commentators and modern editors had thought)"); see his introduction to *Canzoniere* (Turin: Einaudi, 1992), xiii.

13. Olivia Holmes notes that the death of Laura "is experienced by the protagonist not as a means to an end, or an opportunity for further sublimation[,] . . . but as tragic loss"; see *Assembling the Lyric Self: Authorship from Troubadour Song to Italian Song Book* (Minneapolis: University of Minnesota Press, 2000), 179. I suggest that a crucial aspect of Petrarch's loss and attendant melancholy is the diminished erotic component of the figure of the veil.

14. Robert Durling, introduction, *Petrarch's Lyric Poems*, 20.

15. The sacramental potential of the body still anchors the representation of the body in Dante. In *Inf.* 25, *Purg.* 25, and *Par.* 25 focus on the body-soul relationship and are in dialogic relationship to one another. *Inf.* 25, Dante's challenge to Ovid and Lucan, features the grotesque *contrappasso* of the thieves, with their eternal metamorphoses from serpent to man and back again, in an uncanny, hybrid fluidity. This is an inverted, demonic representation of the dominant paradigms of body-spirit (transubstantiation) and body-body (procreation). Bodily concerns come to the fore in *Purg.* 25, when Statius seeks to answer Dante's question: how can the spiritual purgation of gluttony cause an anorexic wasting away of the flesh? Dante's scholastic discussion of the generation of the individual soul posits that the characteristics (indeed, the organs and "membra") of the lower two souls, the vegetative and the sensitive, are absorbed into the intellective soul. The intellective soul can thus project a "virtual" body around itself in purgatory, almost as a holograph: "Tosto che loco lì la circunscrive / la virtù informativa raggia intorno / così e quanto nelle membra vive" ("As soon as place circumscribes it there, the / formative power radiates around in the same / way and as much as it did in living members") (88–90). The "virtual body" in *Purgatory* is not unrelated to our modern technological sense of "virtuality," nor is it all that far removed from the Calvinist understanding of the "virtual" presence of the transubstantiated body of Christ in the Eucharist. In *Par.* 25, Dante is examined on the nature of hope by St. James, and

the response of St. James invokes Isaiah: "Dice Isaia che ciascuna vestita / nella sua terra fia di doppia vesta; / e la sua terra è di questa dolce vita" ("Isaiah says that each in his own land shall be clothed with double vestiture, and their own land is this sweet life") (91–93). The double vesture signifies body and soul. Dante's sight is veiled, blinded by the heavenly brightness signaling the approach of St. John. Dante is subsequently chastised by St. John for attempting to peer beneath the blinding spiritual light to see his physical body: ". . . Perché t'abbagli / per veder cosa che qui non ha loco? / In terra terra è 'l mio corpo, e saràgli / tanto con li altri, che 'l numero nostro / con l'etterno proposito s'agguagli" (". . . Why dost thou dazzle thyself to see that which has no place here? My body is earth in the earth and it will be there with the rest until our number tallies with the eternal purpose") (122–26). The prophet John then asserts that only two souls have ascended into paradise with "double robes," Christ and the Virgin, and calls on Dante in his prophetic role to return to the land of the living and promulgate this truth. "Con le due stole nel beato chiostro / son le due luci sole che saliro; / e questo apporterai nel mondo vostro" ("With the two robes in the blessed cloister are the only two lights that have ascended and this report thou shalt take back to your world") (127–29). Here Dante attempts to "unveil" St. John, to go from spirit to body, in an ironic reversal of the correct directionality of scriptural unveiling. The theological body-soul duality, with the body as veil, or *integumentum*, remains foundational to the interpretation of these three *canti*, and to Dante's entire allegorical project. All quotatations from the *Inferno* and *Purgatorio* come from Dante, *The Divine Comedy: Inferno*, ed. and trans. Robert M. Durling and Ronald L. Martinez (New York: Oxford University Press, 1996), and Dante, *The Divine Comedy: Purgatorio*, ed. and trans. Robert M. Durling and Ronald L. Martinez (New York: Oxford University Press, 2003). Citations to the *Paradiso* are from Dante, *The Divine Comedy: Paradiso*, trans. John D. Sinclair (New York: Oxford University Press, 1961).

16. *The Light in Troy*, 104–26; 127–46.

17. *Oxford Dictionary of the Christian Church*, ed. F. L. Cross (London: Oxford University Press, 1957), 1198.

18. See Emilio Bigi's important essay on Petrarch's style, "Alcuni aspetti dello stile del canzoniere petrarchesco," in *Dal Petrarca al Leopardi* (Milan: Ricciardi, 1954), 1–22; several of these figures are noted in his discussion.

19. Adelia Noferi notes in her *Il gioco delle tracce* (Florence: La Nuova Italia, 1979), 56, that repetition and tautology are the supporting structures of the Petrarchan canzonier ("Ripetizione e tautologia: siamo di fronte alle strutture portanti del *Canzoniere* petrarchesco").

20. The radical shift to "horizontality" that I am discussing is also evoked by Mazzotta in terms of the redefinition of power structures in Petrarch: "In effect, Petrarch re-defines the vertical power relations within the social system. He counters the feudal principle of the poet's submission to the sovereign power of the king with the principle of horizontal juxtapositions" (*The Worlds of Petrarch*, 186).

21. *The Oxford Dictionary of the Christian Church*, 180.

22. Eugenio Montale—to leap forward six centuries—makes secular use of this metamorphosis but echoes precisely the trope of "changed but not abandoned." Montale's Clizia figure, his soteriological sign of fidelity in a nonsacramental world, derives from the Ovidian tale of the nymph Clytie, who pines away for love of Apollo and is changed into the sunflower, the heliotrope. Ovid writes: "Her limbs took root, and her

wan color changed / To a wan leafing, with a little brightness / Where once her face has been; she was a flower, / rooted, but turning always toward the sunlight, / *Changed, but forever keeping love unchanging*" (*Metamorphoses*, trans. Rolfe Humphries [Blooming-ton: Indiana University Press, 1983], 90, my emphasis). In "La primavera hitleriana" (from *La bufera*) Montale echoes Ovid (and even alludes to Dante's allusion to this myth in one of the sonnets in his *Rime*): "Guarda ancora / in alto, Clizia, è la tua sorte, tu / che *il non mutato amor mutata serbi*" ("Look up, Clytie, it is your destiny, you, changed, the never-changing love retain") (*L'opera in versi*, ed. Rosanna Bettarini and Gianfranco Contini [Turin: Einaudi, 1980], 33–35, my emphasis). The sunflower serves Montale as a sign of fidelity under the political regime of fascism (*L'opera in versi*, 249).

23. Hegel noted that metamorphoses "expressly oppose the natural to the spiritual, since they give to a natural existent, a rock, animal, flower, spring, the meaning of being a degradation and a punishment of spiritual existents." Hegel points to Philomela and Narcissus as examples: "Through a false step, a passion, a crime, [they] fall into infinite guilt or an endless grief, whereby the freedom of spiritual life is lost to them and they have become mere natural existents" (*Aesthetics: Lectures on Fine Art*, trans. T. M. Knox [Oxford: Clarendon Press, 1975], 393).

24. For extended discussions of the Ovidian subtext of the *Rime*, see Leonard Bar-kan, *The Gods Made Flesh: Metamorphosis and the Pursuit of Paganism* (New Haven, CT: Yale University Press, 1986); Sara Sturm-Maddox, *Petrarch's Metamorphoses: Text and Subtext in the "Rime sparse"* (Columbia: University of Missouri Press, 1985); and Enterline, *Rhetoric of the Body*.

25. Caroline Walker Bynum, *The Resurrection of the Body in Western Christianity, 200–1336* (New York: Columbia University Press, 1995), 231, my emphasis.

26. See Dante, *Par.* 14, the heaven of the sun, for an investigation of the doctrine of resurrection: there, with Aquinas, the souls exhibit the "desio de' corpi morti" ("a desire for [their] dead bodies") (63).

27. See Carla Freccero, "Ovidian Subjectivities in Early Modern Lyric: Identification and Desire in Petrarch and Louise Labé," in *Ovid and the Renaissance Body*, ed. Goran Stanivukovic (Toronto: University of Toronto Press, 2001), 21–37, for a discussion of the heterosexual and homosexual implications of the disavowal of difference in Petrarch.

28. *The Language of Psycho-Analysis*, ed. J. Laplanche and J.-B. Pontalis (New York: Norton, 1973), 427.

29. William Pietz, "The Problem of the Fetish," pt. 1, *RES* 9 (1985): 5–17; "The Prob-lem of the Fetish," pt. 2, *RES* 15 (1987): 23–45.

30. Pietz, "The Problem of the Fetish," pt. 1, 7, my emphasis.

31. Pietz, "The Problem of the Fetish," pt. 1, 12, 13 (my emphasis), 15.

32. See, among others, Robert Durling, "Petrarch's 'Giovene donna sotto un verde lauro,'" *MLN* 86 (1971): 1–20; John Freccero, "The Fig Tree and the Laurel: Petrarch's Poetics," *Diacritics* 5 (1975): 34–40; Giuseppe Mazzotta, *The Worlds of Petrarch*; Nancy J. Vickers, "The Body Re-membered: Petrarchan Lyric and the Strategies of Description," in *Mimesis: From Mirror to Method, Augustine to Descartes*, ed. John D. Lyons and Ste-phen G. Nichols Jr. (Hanover, NH: University Press of New England, 1982), 100–111; Nancy J. Vickers, "Re-membering Dante: Petrarch's 'Chiare, fresche et dolci acque,'" *MLN* 96 (1981): 1–11; and Lynn Enterline, *Rhetoric of the Body*.

33. Freccero, "The Fig Tree and the Laurel," 39, 37. See Paul Collili, *Petrarch's Allego-ries of Writing* (Naples: Nicola De Dominicis, 1988). These observations are consistent

with Collili's examination of Petrarchan idolatry and the fetish. The central distinction in Collili's analysis is between analogy and anomaly, analogy being the principle of preservation and renewal. The *Canzoniere* exhibits the formation of anomaly, which produces, according to Collili, an antithetical or an antitheological aesthetics. Collili underlines the plurality and partialness of Petrarch's poetic representations, which result in transgression of the boundaries of the dead and of the borders beyond time. "The *Canzoniere* is a realm of death because Petrarch's history there is characterized by an entombment within the veil" (164).

34. John Freccero, "The Fig Tree and the Laurel," 38, cites Durling's 1971 essay on this anniversary sestina, which celebrates Laura and Petrarch's first meeting on Good Friday. Durling notes that the gem-studded cross that appears in the *tornata* is an idolatrous cross of glory. Thomas Greene reminds us, in his discussion of these two essays, that the term "idol" needs clarification: "*Idol* is a useful term . . . only if one stays alert to the repeated collapse of its Hebrew meaning (a graven image) into the psychologistic meaning both critics recognize as secondary (*eidolon*, phantasm)" (*Light in Troy*, 115).

35. Lynn Enterline discusses Petrarch's "verbal fetishism" (*Rhetoric of the Body*, 35, 96). I prefer to use the term "linguistic fetishism" so as to include a wider range of textual instances of fetishism in the *Rime*, that is, on the phonemic, syntactical, semantic, and structural levels.

36. Gianfranco Contini, "Preliminari sulla lingua del Petrarca," *Canzoniere di Petrarca*, ed. Roberto Antonelli (Turin: Einaudi, 1992), xxx.

37. Contini, "Preliminari," xli, xliv, xxxviii.

38. Stefano Agosti, *Gli occhi, le chiome: Per una lettura psicoanalitica del "Canzoniere" di Petrarca* (Milan: Feltrinelli, 1993), 6.

39. Agosti, *Gli occhi, le chiome*, 7, 14 (my emphasis), 39.

40. Richard L. Poss and Suzanne Sara Thomas also discuss briefly the image of the veil in the *Rime*; see Poss, "The Veil in *Rime* 52: Petrarch's Secular Butterfly," *Italian Culture* 7 (1986–89): 7–16, and Thomas, "Petrarch, Tournier, Photography, and Fetishism: The Veil in the *Rime sparse*," *Romance Quarterly* 43 (1996): 131–41.

41. *The American Heritage Dictionary of the English Language*, ed. William Morris (Boston: American Heritage and Houghton Mifflin, 1969), 1420.

42. See the catalogue of the exhibition *The Body UnVeiled: Boundaries of the Figure in Early Modern Europe*, ed. Stephen J. Campbell and Sandra Seekins (Ann Arbor: Goetzcraft Printers, 1997), for a discussion of the practices of veiling and unveiling in iconography of early modern Europe.

43. See Adelia Noferi's analysis of the dissemination of the name of Laura (*Il gioco delle tracce*, 43–67). See also Giorgio Orelli, *Il suono dei sospiri: Sul Petrarca volgare* (Turin: Einaudi, 1990), for a discussion of the sound patterns in the *Rime*.

44. For a discussion of the Petrarchan literary influence on mannerism, see James V. Mirollo, *Mannerism and Renaissance Poetry: Concept, Mode, Inner Design* (New Haven, CT: Yale University Press, 1984). He traces the diffusion of the images of the veil, hand, and the glove from the fifteenth through the seventeenth centuries.

45. Mazzotta, *The Worlds of Petrarch*, 67.

46. Francesca narrates Paolo's kiss: "la bocca mi baciò tutto tremante" ("kissed my mouth all trembling") (*Inf.* 5.136).

47. There are nine occurrences of the lexeme *velo* in Dante's *Commedia*: three in the *Inferno*, three in the *Purgatorio*, and three in the *Paradiso*, reflecting a trinitarian

pattern. Three of the total nine uses of "veil" occur in *Purg.* 30. The opening *terzina* describes the halting of a pageant of revelation; the lights are allegorized as the Wain, the seven gifts of the spirit, which belong to God's empyrean and are veiled by mankind's sin. "Quando il settentrion del primo cielo / che nè occaso mai seppe nè orto / d'altra nebba che di colpa velo" ("when the Septentrion of the first Heaven / which has never known setting or rising, nor the / the veil of any other fog than that of sin") (1–3). The veil of sin occludes the light of God's kingdom; this is a standard theological usage of the term. The other two references to *velo* describe the actual veiling of Beatrice's face. The young Beatrice of the *Vita nuova* is the figure that is fulfilled here in earthly paradise: "Così dentro una nuvola di fiori / che dalle mani angeliche saliva / e ricadeva in giù sovra candida vel cinta d'uliva / donna m'apparve, sotto verde manto / vestita di color di fiamma viva" ("So, within a cloud of flowers that from the / hands of the angels was rising and falling back / within and without, / her white veil girt with olive, a lady appeared to / me, clothed beneath a green mantel, in the color / of living flame") (28–33). Although the oneiric quality of Laura's appearance in a cloud of flowers in canzone 126 owes much to Dante, the body of Beatrice continues to emanate sacramental power.

48. Peter Stallybrass and Ann Rosalind Jones, "Fetishizing the Glove in Renaissance Europe," *Critical Inquiry* 28 (2001): 116, 119 128. Mark Musa reads the sonnet sequence on Laura's hand and glove (199–201) as political satire. He notes that the two icons are "known symbols of monarchy and papacy" and that the poems coyly display a new "sycophantic style" involving the uses of flattery in relation to political power (introduction, Francesco Petrarch, *Canzoniere* [Bloomington: Indiana University Press, 1996], xv–xvi). This reading coincides with the comments of Stallybrass and Jones concerning the role of agency revealed in the rematerializing operation of the fetish.

49. For a discussion of rhyme patterns (*rimanti*) in the *Rime sparse*, see Carlo Pulsoni, *La tecnica compositiva nei "Rerum vulgarium fragmenta": Riuso metrico e lettura autoriale* (Rome: Bagatto, 1998); he does not analyze the *velo / cielo / gielo / pelo* sequence.

T W O : The Metaphor of the *Corpus Carcer* in Petrarch's *Canzoniere* and in the Lyrical Tradition

1. Max Polhenz, *L'uomo greco* (Florence: La Nuova Italia, 1962), 799.

2. *Cratylus*, ed. Lorenzo Minio-Paluello (Rome: Laterza,1987), 27–28 (my translation; unless otherwise noted, all translations are my own):

> For some say that the body is *sema* [sign or grave] of the soul that may be thought to be buried in our present life; or again, *sema* [signification, index] of the soul, because the soul gives indications to [*semaìnei*] the body; probably the followers of Orpheus were the inventors of the name, and they were under the impression that the soul is suffering the punishment of sin and that therefore it has around itself an enclosure or prison in which it is incarcerated, in order to *sòzetai* [to be kept safe, conserved, saved], as the body [*soma*], as its name implies, is a enclosure [*soma*] to the soul until the penalty is paid.

3. Macrobius, *Commentarii in "Somnium Scipionis,"* ed. Jacobus Willis (Leipzig: Teubner, 1970), 1.10.6, quotes Cicero on this topic: "Immo vero, inquit, hi vivunt, qui

e corporum vinclis tamquam e carcere evolaverunt: vestra vero quae dicitur esse vita mors est" (*De re publica*, ed. Konrat Ziegler [Leipzig: Teubner, 1969], 6.14) ("Yes, indeed, he replied, those who have fled from the bonds of the body, like from a prison, live; while what is called your life is death" [Macrobius, *Commentary on the "Dream of Scipio,"* trans. William Harris Stahl (New York: Columbia University Press, 1966), 130]). See also Macrobius, *Commentarii in "Somnium Scipionis"* 1.10.9 and 1.11.3 (*Commentary on the Dream of Scipio*, 128, 130):

> Antequam studium philosophiae circa naturae inquisitionem ad tantum vigoris adolesceret, qui per diversas gentes auctores constituendis sacris caerimoniarum fuerunt, aliud esse inferos negaverunt quam ipsa corpora, quibus inclusae animae carcerem foedum tenebris, horridum sordibus et cruore patiuntur.

> (Before the zeal of philosophers for the study of natural science grew to such vigorous proportions, those who were responsible for establishing religious rites among different races insisted that the lower regions were nothing more than the mortal bodies themselves, shut up in which souls suffered a horrible imprisonment in vile darkness and blood.)

> Nam ut constet animal, necesse est ut in corpore anima vinciatur: ideo corpus δέμας hoc est vinculum nuncupatur, et σῶμα quasi quoddam σῆμα, id est animae sepulcrum: unde Cicero pariter utrumque significans, corpus esse vinculum, corpus esse sepulcrum, quod carcer est sepultorum ait, qui e corporum vinclis tamquam a carcere evolaverunt.

> (For a creature to have existence, it is necessary that a soul be confined in the body; for this reason the Greek word for body are *demas*, that is a "bond," and *soma*, a *sema*, as it were, being a "tomb" of the soul. Thus you see Cicero means both that the body serves as fetters and that is a tomb, being the prison of the intombed.)

On the same point, see Seneca, *Epistulae morales ad Lucilium*, ed. Otto Hense (Leipzig: Teubner, 1938), 65.16: "Nam corpus hoc animi pondus ac poena est; premente illo urguetur, in vinclis est, nisi accessit philosophia" ("For this body of ours is a weight upon the soul and its penance; as the load presses down the soul is crushed and is in bondage, unless philosophy has come to its assistance" [Seneca, *Ad Lucilium epistulae morales*, dual Latin / English text, 3 vols., trans. Richard M. Gummere (Cambridge, MA: Harvard University Press, 1917), 1:453]).

4. See Seneca, *Epistulae morales* 92.10 (*Ad Lucilium epistulae morales* 2:453):

> Prima ars hominis est ipsa virtus, huic committitur inutilis caro et fluida. . . . Virtus illa divina in lubricum desinit et superioribus eius partibus venerandis atque caelestibus animal iners ac marcidum adtexitur.

> (Man's primary art is virtue itself; there is joined to this the useless and fleeting flesh. . . . This divine virtue ends in foulness, and to the higher parts, which are worshipful and heavenly, there is fastened a sluggish and flabby animal.)

5. Vergil, *Aen.* 6.730–34 (*Aeneid*, trans. John Dryden, ed. Frederick M. Keener [Harmondsworth: Penguin Books, 1997], 174):

Igneus est illis vigor et caelestis origo
seminibus, quantum non noxia corpora tardant
terrenique hebetant artus, moribundaque membra.
Hinc metuunt cupiuntque dolent gaudentque, neque auras
despiciunt, clausae tenebris in carcere caeco.

(Th' ethereal vigor is in all the same,
And every soul is fill'd with equal flame;
As much as earthy limbs, and gross allay
Of mortal members, subject to decay,
Blunt not the beams of heav'n and edge of day.
From this coarse mixture of terrestrial parts,
Desire and fear by turns possess their hearts,
And grief, and joy; nor can the groveling mind,
In the dark dungeon of the limbs confin'd,
Assert the native skies, or own its heav'nly kind.)

These lines are quoted by Petrarch in his *Secretum*, ed. Enrico Fenzi (Milan: Mursia, 1992), 136. He quotes them using a variant, *respiciunt* for *despiciunt*.

6. For a survey of the presence of the metaphor in patristic and liturgical texts from Middle Ages on, see Ilario Tolomio, "'Corpus carcer' nell'alto Medioevo: Metamorfosi di un concetto," in *Anima e corpo nella cultura medievale*, ed. Carla Casagrande e Silvana Vecchio (Florence: Edizioni del Galluzzo, 1997), 3–19; see also Pierre Courcelle, *Connais-toi toi-même*, 2 vols., vol. 2, *De Socrate à saint-Bernard* (Paris: Études Augustiniennes 1975), esp. chap. 13. To the texts listed in those surveys should be added, for the earliest patristic works, Tertullian, *Ad martyras*, in *Quinti Septimii Florentis Tertulliani quae supersunt omnia*, 3 vols., ed. Franciscus Oehler (Leipzig: T. O. Weigel, 1853–54), 1:13, and Tertullian, *De ieiunio adversvs psychicos*, in *Quae supersunt omnia* 1:867, where the comparisons between body and jail and between tribunal and judgment day are strictly made; for the late Middle Ages, see Thomas Aquinas, *Quaestiones disputatae de anima*, ed. Bernardo Carlos Bazán, in Aquinas, vol. 24 of *Opera omnia* (Rome: Commissio Leonina-Cerf, 1996), 1.14. See also Innocent III, *De miseria humanae conditionis*, ed. Michele Maccarrone (Lucani: Thesaurus Mundi, 1955), 1.18 and 20:

[Iustus] non habet hic manentem civitatem, set futuram inquirit. Sustinet seculum tanquam exilium, clausus in corpore tanquam in carcere.

([The righteous man] does not have a permanent city here but seeks it in the world that is yet to come. He bears this world as an exile, shut in his body like in a prison.)

—Infelix ego homo, quis me liberabit de corpore mortis huius?— Certe non vult exire de carcere qui non vult exire de corpore, nam carcer anime corpus est. De quo dicit psalmista: —educ de carcere animam meam—.

("O wretched man that I am! Who shall deliver me from the body of this death?" [Rom. 7.24]. To be sure, he who doesn't want to get out from his body doesn't want to escape from prison, for the body is the prison of soul. So, the Psalm says: "Bring my soul out of prison" [Ps. 141 (142).8].)

Many works in liturgical or philosophical genres demonstrate the wide diffusion and the long duration of the metaphor; among moral works, one might cite Giordano Pironti dei Conti di Terracina (1246–69); see his *Epistolae* 19, in *Un certame dettatorio tra due notai pontifici (1260): Lettere inedite di Giordano da Terracina e di Giovanni da Capua*, ed. Paolo Sambin (Rome: Edizioni di Storia e Letteratura, 1955), 41:

> Stupeo racionabilem Iohannis spiritum sensuum presidem, carnis obsidem sedulumque corporis inquilinum, sic incorporeum effici sicque carnis, carnei vel carnis carcere limitatum, exire districtum.

> (I wonder how the spirit of Johannes sitting before me, hostage of the flesh, tenant of the body, and, captive in flesh, imprisoned in a bodily jail, could become so incorporeal as to escape.)

7. In St. Augustine, a bird's cage represents the body that impedes the soul in its ability to recognize celestial light (*Soliloquia*, in vol. 32 of *Patrologiae cursus completus*, ed. Jacques-Paul Migne [Paris: Migne, 1845], 882; Augustine, *Two Books of Soliloquies*, trans. Charles C. Starbuck [Edinburgh: Clark, 1873], 545):

> Unum est quod tibi possum praecipere nihil plus novi. Penitus esse ista sensibilia fugienda, cavendumque magnopere, dum hoc corpus agimus, ne quo eorum visco pennae nostrae impediantur, quibus integris perfectisque opus est, ut ad illam lucem ab his tenebris evolemus: quae se ne ostendere quidem dignatur in hac cavea inclusis, nisi tales fuerint ut ista vel effracta vel dissoluta possint in auras suas evadere.

> (There is only one thing which I can teach you; I know nothing more. These things of sense are to be utterly eschewed, and the utmost caution is to be used, lest while we bear about this body, our pinions should be impeded by the viscous distilments of earth, seeing we need them whole and perfect, if we would fly from this darkness into that supernal Light: which deigns not even to show itself to those shut up in this cage of the body, unless they have been such that whether it were broken down or worn out it would be their native airs into which they escaped.)

8. Rom. 7.24 and 1 Cor. 9.26–27:

> Infelix ego homo! Quis me liberabit de corpore mortis huius?

> (O wretched man that I am! Who shall deliver me from the body of this death?)

> Ego igitur sic curro non quasi in incertum, sic pugno non quasi aerem verberans; sed castigo corpus meum et in servitutem redigo, ne forte, cum aliis praedicaverim, ipse reprobus efficiar.

> (I therefore so run, not as uncertainly; so fight I, not as one that beateth the air: But I keep under my body, and bring it into subjection: lest that by any means, when I have preached to others, I myself should be a castaway.)

(The Latin biblical quotations here and below come from *Nova Vulgata Bibliorum sacrorum editio* (Vatican City: Libreria Editrice Vaticana, 1998); all the English translations are from the *King James Bible*.) Ps. 140 (141).9–10 and 141 (142).8:

9. Tertullian, *Ad martyras* 2:6 (Tertullian, *To the Martyrs*, trans. Sidney Thelwall, in *The Writings of Tertullian*, 7 vols. [Edinburgh: Clark, 1869], 1:693, 694):

Si enim recogitemus ipsum magis mundum carcerem esse, exisse vos e carcere, quam in carcerem introisse, intellegemus.

(For if we reflect that the world is more really the prison, we shall see that you have gone out of a prison rather than into one.)

Nihil adhuc dico de praemio, ad quod Deus martyres invitat. Ipsam interim conversationem saeculi et carceris comparemus, si non plus in carcere spiritus acquirit quam caro amittit.

(Thus far I say nothing of the rewards to which God invites the martyrs. Meanwhile let us compare the life of the world and of the prison, and see if the spirit does not gain more in the prison than the flesh loses.)

10. Augustine, *Contra academicos*, in *Contra academicos; De beata vita; De ordine; De magistro; De libero arbitrio*, ed. William Mc Allen Green, in Augustine, vol. 2 of *Opera* (Turnhout: Brepols, 1970), 1.3.9.

11. Boethius, *De consolatione philosophiae*, in *De consolatione philosophiae, Opuscula theologica*, ed. Claudio Moreschini (Munich: Saur, 2000), bk. 2, prose 7.73: "Bene sibi mens conscia terreno carcere resoluta caelum libera petit" ("The mind is still conscious and working when it is freed from its earthly prison, it seeks heaven in its freedom" [Boethius, *The Consolation of Philosophy*, trans. W. V. Cooper (London: Dent, 1902), 47]); see also bk. 2, prose 8.23; bk. 3, prose 10.14; bk. 3, verse 6.45; bk. 3, verse 8.17–18; bk. 5, verse 3.8 et seq.; cf. Pierre Courcelle, "Tradition platonicienne et tradition chrétienne du corps-prison," *Revue des études latins* 43 (1965): 406–33; Courcelle, *La "Consolation de philosophie" dans la tradition littéraire: Antecedents et posterité de Boéce* (Paris: Études Augustiniennes, 1967), 191; and Klaus Heitmann, *Fortuna und Virtus: Eine Studie zu Petrarcas Lebensweisheit* (Cologne: Böhlau, 1958), 124–25.

12. Isidorus of Seville, *Sententiae*, in Isidorus of Seville, vol. 6 of *Opera omnia*, ed. Jacques-Paul Migne (Paris: Migne, 1850),563:

Animam non esse partem divinae substantiae, vel naturae; nec esse eam priusquam corpori misceatur, constat; sed tunc eam creari, quando et corpus creatur, cui admisceri videtur.

(The soul is not a part of divine substance or nature, and it doesn't exist before being mixed into the body but is created at the same time as the body is created, although it seems that it is mixed into the body.)

13. For this literature, see Tolomio, "'Corpus carcer' nell'alto Medioevo," 11–19.

14. Augustine, *Enarrationes in Psalmos*, ed. Eligius Dekkers, in vol. 10, pts. 1–3, of *Opera* (Turnhout: Brepols, 1956), 141.17. In the dialogue between Augustinus and Franciscus we read that human passions, and not original sin, corrupted souls. See Francisco Rico, *Vida u obra de Petrarca*, vol. 1, *Lectura del "Secretum"* (Padua: Antenore, 1974), 110.

15. Augustine, *De civitate Dei*, ed. Bernardus Dombart and Alphonsus Kalb, in vol. 14, pts. 1–2, of *Opera* (Turnhout: Brepols, 1955), 3.

16. Cassiodorus, *De anima*, ed. James W. Halporn, in vol. 1 of *Magni Aurelii Cassiodori senatoris opera* (Turnhout: Brepols, 1973), 4:4–5.

17. Sandro Nannini, *L'anima e il corpo: Un'introduzione storica alla filosofia della mente* (Rome: Laterza, 2002), 15.

18. St. Thomas, *Quaestiones disputatae de anima* 1:14.

19. Macrobius, *Commentarii in "Somnium Scipionis"* 1.14.1.

20. Isidore of Seville, *Etymologiae*, ed. Wallace Martin Lindsay (Oxford: Clarendon Press, 1911), 8.11, 15; Isidore of Seville, *The Etymologies of Isidore of Seville*, trans. Stephen A. Barney et al. (Cambridge: Cambridge University Press, 2006), 184.

21. See Rosanna Bettarini, *Lacrime e inchiostro nel "Canzoniere" di Petrarca* (Bologna: CLUEB, 1998), 39.

22. See the commentary on this line by Ariani in Francesco Petrarca, *Triumphi*, ed. Marco Ariani (Milan: Mursia, 1988), 262n.

23. Ariani, commentary on *Tr. mort.* 2, in Petrarca, *Triumphi*, 256.

24. Rico, *Vida u obra*, 256, notes the reference to Boethius in canzone 264; Marco Santagata in his commentary in Francesco Petrarca, *Canzoniere* (Milan: Mondadori, 1996), 1045, however, suggests the canzone alludes instead to *Ps.* 54.7. For the text of Lactantius's that Petrarch seems to allude to, see *Divinae institutiones* 7.8.6, in *Divinae institutions,* ed. Samuel Brandt, in vol. 1 of *Celii Lactantii Firmiani opera omnia* (Vienna: Tempsky, 1890), pt. 1, 610: "Individuum ac domicilio corporis velut carcere liberatum ad celum et ad natura suam pervolare" ("When freed from the abode of the body, as from prison, it flies to the heaven, and to its own nature" [Lactantius, *Divine Institutes*, in *The Works of Lactantius*, trans. William Fletcher (Edinburgh: Clark, 1871), 2:205]).

25. Michele Feo, "Petrarca, Francesco," *Enciclopedia Virgiliana*, 5 vols. (Rome: Istituto dell'Enciclopedia Italiana, 1988), 4:53–78.

26. Iacopone da Todi, *Laude*, ed. Franco Mancini (Rome: Laterza, 1980), 7.

27. Dante, *Inf.* 10.58–59: "se per questo cieco / carcere vai per altezza d'ingegno" ("if through this blind / Prison thou goest by loftiness of genius" [*The Divine Comedy of Dante Alighieri*, trans. Henry Wadsworth Longfellow (London: George Routledge and Sons, 1893), 32]); Dante, *Purg.* 22.103: "primo cinghio del carcere cieco" ("the first circle of the prison blind" [*Divine Comedy*, 320]).

28. For example in Cino da Pistoia, *Rime*, in *Poeti del dolce stil nuovo*, ed. Mario Marti (Florence: Le Monnier, 1969), 6.12–14:

> Ed ancor fusse di mio corpo fuori,
> l'anima mia dimorria amorosa
> nel mondo stando gli spiriti miei.

> (And if my soul should be far from my body
> it could nevertheless live amorously
> while my spirits stay in the world.)

On love's disembodying effect on the soul, see Cino, *Rime* 41.9–14:

> I' moro in verità, ch'Amor m'ancide,
> che m'asalisce con tanti sospiri
> che l'anima ne va di fuor fuggendo;

e s'i' la 'ntendo ben, dice che vide
una donna apparire a' miei disiri
tanto sdegnosa, che ne va piangendo.

(In truth, I'm dying, because Love is killing me:
he attacks me with so many sighs
that my soul is escaping out from me,
and, as I see, my soul says that it sees
a lady appearing to my desires
so disdainful that it began to cry.)

29. Fazio degli Uberti, *Rime varie*, in *Il dittamondo e le Rime*, ed. Giuseppe Corsi (Bari: Laterza, 1952), 9, 2, 10: "Per te se aperse la scura prigione / de quello abisso, che mai non se sazia, / de nostra umana generazione" ("Because of you was opened the dark prison / of that abyss, that is never sated / with humankind").

30. Francesco Petrarch, *De otio religioso*, ed. Giuseppe Rotondi (Vatican City: Biblioteca Apostolica Vaticana, 1958), 174.

31. Petrarch, *De otio religioso*, 176:

Pondus carnis sordidum et gravem animam miseram imbecillem mole sua premit et suffocat. . . . Tale est illud philosophicum Ciceronis sexto *De Rei Publice* de animu ad celum ascensu agili.—Id enim, inquit, ocius faciet, si iantamen cum erit inclusus in corpore eminebit foras et ea que extra erunt contemplans quam maxime se a corpore abstrahet.—Tale est quod et disiungi a corporibus et ea tanquam peregrini incolere iubemur.

(The weight of flesh, filthy and heavy, oppresses and swelters the poor and defenseless soul with its size; . . . Cicero talks philosophically about soul's easy ascent to the sky in this way in the sixth book of his *De re publica*: "Its flight," he says, "will be still more rapid, if it will look abroad and disengage itself from its bodily dwelling, in the contemplation of things which are external to itself." Disengaging from one's own body is the same as abandoning the place where we dwell as pilgrims.)

32. Francesco Petrarch, *Petrarch's "Secretum,"* ed. Davy A. Carrozza and H. James Shey (New York: Peter Lang, 1989), 127.

33. Francesco Petrarch, *De vita solitaria*, ed. Marco Noce (Milan: Mondadori, 1992), 2.15.

34. Francesco Petrarch, *De remediis utriusque fortune*, in *Opera quae extant omnia* (Basel: Heinricus Petri, 1554), 180.

35. Francesco Petrarch, *Epystole*, in vol. 2 of *Poesie minori del Petrarca, sul testo latino ora corretto*, ed. Domenico de' Rossetti (Milan: Società Tipografica dei Classici Italiani, 1834), 370.

36. Francesco Petrarch, *Bucolicum carmen*, ed. Enrico Bianchi, in *Rime, Trionfi e poesie latine*, ed. Ferdinando Neri, Guido Martellotti, Enrico Bianchi, Natalino Sapegno (Milan: Ricciardi, 1951).

37. Francesco Petrarch, *Le familiari*, 4 vols., vols. 1–3 ed. Vittorio Rossi, vol. 4 ed. Umberto Bosco (Florence: Sansoni, 1933–42), 14.4.13; see also the commentary on Pe-

trarch's insistence that souls are not of celestial origin by Enrico Fenzi in Petrarch, *Secretum*, 313n.

38. Milan, Biblioteca Ambrosiana, Sala Prefetto, scaf. 10, no. 27, *olim* A.49 *inf.*, fol. 144v, reproduced in *Francisci Petrarcae vergilianus codex . . . quam simillime expressus atque in lucem editus*, ed. Giovanni Galbiati e Achille Ratti (Milan: In aedibus Hoeplianis, 1930). See also Petrarch, *Rerum senilium libri* 7.6, in *Opera quae extant omnia*, 929.

39. Cicero, *Tusculanae disputationes*, ed. Max Pohlenz (Stuttgart: Teubner, 1965), 1.31.75; Francesco Petrarch, *Le senili*, vol. 1, ed. Elvira Nota (Rome: Archivio Guido Izzi, 1993), 7.1; Francesco Petrarca, *Lettere disperse: Varie e miscellanee*, ed. Alessandro Pancheri (Parma: Guanda, 1994), 462.

40. See Ariani, in Petrarca, *Triumphi*, 159n, for the vernacular and classical texts related to this imagery.

41. See, inter alia, Ovid, *Amores* 1.2.30, 2.9.19–24, *Ars amandi* 3.591–93 (the image of the *amator* who "cadit in laqueos," "falls in the laces"), and *Remedia amoris* 213.

42. Marco Santagata, in Petrarca, *Canzoniere*, 397. For the topos of the love prison, see Flavio Catenazzi, *L'influsso dei Provenzali sui temi e immagini della poesia siculotoscana* (Brescia: Morcelliana, 1977), 260.

43. Giovanni Boccaccio, *Rime*, in Boccaccio, vol. 5 of *Tutte le opere*, ed. Vittore Branca (Milan, Mondadori 1992), pt. 1, 73.6–7; Boccaccio, *Rime*, pt. 2, 8.2.

44. Nicolò de' Rossi, *Canzoniere*, 2 vols., ed. Furio Brugnolo (Padua: Antenore, 1974), 1.68.10: "carçere consuma lo cor mio" ("a prison is consuming my heart").

45. Rico, *Vida u obra*, 256 et seq.

46. On the place and role of this metaphor in the *Fragmenta*, see my "Le ali dell'intelletto nei *Rerum vulgarium fragmenta*," *Critica del testo* 6.1 (2003): 559–89.

47. St. Ambrose, *De Cain et Abel*, in *Patrologiae cursus completus* (Paris: Migne, 1845), 14:357:

Inseritur hoc loco dogma de incorruptione animae, quod ipsa vera et beata vita sit, quam unusquisque bene conscius vivit multo purius ac beatius, cum hujus carnis anima nostra deposuerit involucrum, et quodam carcere isto fuerit absoluta corporeo; in illum superiorem revolans locum, unde nostris infusa visceribus compassione corporis hujus ingemuit.

(Here we can insert the dogma of uncorrupted souls; because everyone of us will live in purity and beatitude his true life of bliss when our soul leaves the wrapping of those bodies of flesh and when it is released from this bodily prison, flying to those superior spaces, from where once it cried when it was sadly instilled in the bowels of our bodies.)

Lactantius, *Divinae institutiones*, pt. 1, 610. For the general theme of the *visio*, see Lactantius, *Divinae institutiones*, pt. 1, 141 (Lactantius, *Divine Institutes*, 58):

Terrenum adhuc animal rerum caelestium perspectionem non capit, quia corpore quasi custodia saeptum tenetur, quominus soluto ac libero sensu cernat omnia.

(And on this account the earthly animal is as yet incapable of perceiving heavenly things, because it is shut in and held as it were in custody by the body, so that it cannot discern all things with free and unrestrained perception.)

48. On Petrarch's reading of the *Phaedo* as translated by Heinricus Aristippus, see Lorenzo Minio-Paluello, "Il *Fedone* latino con note autografe del Petrarca (Paris, Biblioteca Nazionale, Cod. lat. 6567A)," *Rendiconti della Classe di Scienze morali, storiche e filologiche, Accademia nazionale dei Lincei* 8.4 (1948): 107–13.

49. Vittoria Colonna, *Rime*, ed. Alan Bullock (Rome: Laterza, 1982), *Amorose* 29; see also 54.9–11 and 56.1–4:

> S'ivi s'appaga, si nudrisce e vive,
> e l'abitare in questo carcer sempre
> le saria grave, anzi pur viva morte.

> (If it's content there, nourished and alive,
> and living in this prison here forever,
> it is a load, rather, a living death.)

> Chi ritien l'alma omai, che non si sgombra
> dal carcer tetro che l'annoda e stringe?
> L'amata luce al Ciel la chiama e spinge;
> folta nebbia d'error qua giù l'ingombra.

> (Who can now restrain the soul that can't escape
> the dark prison that ties it in knots and clenches it?
> A lovely light calls it and pushes it to Heaven;
> a thick fog of errors constrains it down here.)

The *carcer cieco* ("blind prison") as a metaphor for love pain appears in 64.9–11: "Quante difese, quante vie discopre / l'anima per uscir del carcer cieco / del mio grave dolor" ("How many defenses, how many roads my soul / discovers to get out from this blind prison, / from my deep sorrow"). In her *Rime, Spirituali disperse* 36.22–27, the theme is treated allegorically and takes the form of a *visio*:

> ma, più che mai soave, un sonno venne,
> e l'alma, quasi del suo carcer fore,
> quel che da l'un volea da l'altro ottenne,
> ché tanto ad alto, ove la scorse Amore,
> volò, che vide la mia luce ardente
> mostrar più vivo il suo divin splendore.

> (Lighter than ever, sleep came,
> and my soul, almost out of its prison,
> obtained from one what it wanted from the other,
> so that so high, where Love saw it,
> it flew, so that Love saw my burning light
> render brighter its divine splendor.)

50. Luigi Tansillo, *Il Canzoniere edito ed inedito*, ed. Erasmo Pèrcopo and Tobia R. Toscano (Naples: Liguori, 1996), pt. 2, *madrigale* 12.2.9–10.

51. Michelangiolo Buonarroti, *Rime*, ed. Enzo Noè Girardi (Bari: Laterza, 1960), 106.1–3; *The Sonnets of Michael Angelo Buonarroti*, trans. John Addington Symonds (London: Smith, Elder, 1904), 61.

52. Erwin Panofsky, *Studies in Iconology: Humanistic Themes in the Art of the Renaissance* (1939; rpt., New York: Harper and Row, 1962), 181.

THREE: Petrarch's Lame Leg and the Corpus of Cicero

English translations of the *Familiares* and *Seniles* in the text and notes are those of Bernardo, unless otherwise noted; those to the *Disperse* and other texts are mine. Biblical citations are to the *Biblia sacra iuxta Vulgatam clementinam* and when in English to the Douay-Rheims version.

1. See *Triumphus fame* 3.16–21, esp. 21, referring to Vergil and Cicero: "Questi son gli occhi de la lingua nostra" ("These are the eyes of our language"); see Francesco Petrarca, *Trionfi, Rime estravaganti, Codice degli Abbozzi*, ed. Vinicio Pacca and Laura Paolino (Milan: Mondadori, 1996), 440–41, echoing Sordello's tribute to his fellow Mantuan Virgil in Dante, *Purg.* 7.16–17. For Cicero as "summum parens eloquentiae" ("supreme progenitor of eloquence") see Pacca's notes in Petrarca, *Trionfi*, 440–44, which contain a generous sampling of Petrarch's references to Cicero; see also Francesco Petrarch, *De sui ipsius et multorum ignorantia*, ed. Enrico Fenzi (Milan: Mursia, 1999), 405–11.

2. See *Rerum familiarum libri* 24.11.1 (*Ad publium Virgilium Maronem*), in Francesco Petrarca, *Le familiari*, 4 vols., vols. 1–3 ed. Vittorio Rossi, vol. 4 ed. Umberto Bosco (Florence: Sansoni, 1942): "Eloquii splendor, latine spes altera lingue." Earlier, in his second letter to Cicero (*Fam.* 24.4.8), Petrarch draws from the anecdote in Servius's commentary on Vergil's Sixth Bucolic in acknowledging explicitly that Cicero's remark on hearing Vergil's pastoral poetry is self-laudatory:

> Cum enim, ut scriptum legimus, iuvenile quoddam eius opusculum miratus, quesivisses auctorem eumque iuvenem iam senior vidisses, delectatus es, et de inhexhausto eloquentie tue fonte cum propria quidem laude permixtum, verum tamen preclarumque ac magnificum illi testimonium reddidisti. Dixisti enim: "Magne spes altera Rome."

> (For we read that, struck by one of his youthful works, you sought the author's name; you, already advanced in years, saw him while he was still young and expressed your delight with him, rendering a judgment from the inexhaustible found of eloquence, which, though mingled with self-praise, was truly honorable and splendid for him: for you called him "the second hope of great Rome.")

For the anecdote, see Servius, *Servii grammatici qui feruntur in Vergilii carmina comentarii*, 3 vols., ed. Georgius Thilo and Hermannus Hagen (Hildesheim: George Olms, 1961), 3:66. Even in writing to other classical authors in book 24 of the *Familiares*, Petrarch repeatedly refers to Cicero: in 1.1–8 there are three citations to Cicero; 2.7–10 is all about Cicero; 3–4 are addressed to Cicero; 5 (to Seneca) begins by discussing Cicero; 6.5, 7, to Varro, twice mentions Cicero; and Cicero is prominent in the letters to Asinius Pollio (9.5–6), Vergil (11.1, by allusion), and Homer (12.3). Only the letters to Livy and Horace do not mention him (8, 10). In the *Familiares*, as B. L. Ullman notes, Petrarch refers to Cicero more than to any other author ("Petrarch's Favorite Books," in *Studies in the Italian Renaissance* [Rome: Edizioni di Storia e Letteratura, 1955], 117–37, esp. 124).

3. See *Fam.* 1.1.14, 20, 32, 35, and 44, respectively, where Petrarch suggests he follows Cicero in his epistolary style, imitating the "equable and temperate" speech of Cicero

("equabile et temperatum orationis genus"), in his letters, in the small number of his interlocutors ("epystolas suas duobus aut tribus inscripsit"), in his manner, more Cicero's than Seneca's ("magna ex parte Ciceronis potius quam Senece morem sequar"), in his occasional moralizing, which Petrarch claimed "pleased Cicero" as well ("quod et ab ipso Cicerone servatum est"), and in comparing his troubles to Cicero's ("Talis ille vir tantus in doloribus suis fuit; talis ego in meis fueram" ["Just as Cicero played the role of a man in his sorrows, so did I"]). Most readers (see, for example, Ugo Dotti in Francesco Petrarca, *Le familiari*, bks. 1–11, 2 vols., trans. and ed. Ugo Dotti [Urbino: Argalia, 1974], xvi, and Ronald G. Witt, *"In the Footsteps of the Ancients": The Origins of Humanism from Lovato to Bruni* [Leiden: Brill, 2002], 274) find Petrarch's epistolary manner more Senecan than Ciceronian. That his interlocutors are many, unlike for Cicero, is obvious. For further examples of Petrarch's conscious aping of Cicero, see Pierre de Nolhac, *Pétrarque et l'humanisme*, 2 vols. (Paris: Champion, 1907), 1:214–17.

4. See in this regard the addresses and salutations to *Fam.* 24.2–3 ("Cicero suo salutem," "vale mi Cicero" in both cases), which contrast with the more formal and conventional addresses of the other classical authors in the last book of the collection. Cicero himself uses "mi Attice" to address his friend in the letters Petrarch copied, but in *De officiis*, he uses "mi Cicero," along with "Marce fili," the elder Cicero's appellation of his son Marcus, to whom the book is directed (of which more in the text). See *De officiis (I doveri)*, eds. E. Narducci and Anna R. Barrile (Milan: Rizzoli, 1958), 1.3, 2.8, and 3.5, 121). Petrarch knew this work well; it formed the first of the Ciceronian texts in the collection now known as the Troyes manuscript, which Petrarch used in the mid-1340s; see Pierre Blanc, "Pétrarque, lecteur de Cicéron: Les scolies pétrarquiennes du *De oratore* e de l'*Orator*," *Studi petrarcheschi* 9 (1978): 109–66. Marcus is among the Ciceronian interlocutors Petrarch gives to Cicero at *Fam.* 1.1.20, and Petrarch at *Fam.* 12.8.6 notes the dedication of the *De officiis* to Marcus (mentioned in *Ad Atticum* 15.13a and 16.11; see *Cicero's Letters to Atticus*, ed. and trans. D. R. Shackleton Bailey [Harmondsworth: Penguin, 1978], 655 and 659).

5. See *Sen.* 16.1, in Francesco Petrarch, *Letters of Old Age*, bks. 1–17), 2 vols., trans. Aldo S. Bernardo, Saul Levin, and Reta A. Bernardo (Baltimore, MD: Johns Hopkins University Press, 1992), 2:599–607; for the discovery, see de Nolhac, *Pétrarque et l'humanisme* 1:41, 221–22, and Giuseppe Billanovich, "Petrarca e Cicerone," in *Miscellanea Giovanni Mercati*, 6 vols. (Vatican City: Biblioteca Apostolica Vaticana, 1946), 4:90–102.

6. For the Latin text of the part of *Pro Archia* defending poetry, see Carlo Godi, "La *Collatio laureationis* del Petrarca nelle due redazioni," *Studi petrarcheschi* 5 (1988): 31. For a translation, see E. H. Wilkins, *Studies in the Life and Works of Petrarch* (Cambridge, MA: Medieval Academy of America, 1955), 302: "Take not my word from this, but Cicero's, who in his oration for Aulus Licinius Archias has this to say of poets: 'We have it upon the authority of the most learned men that whereas attainment in other activities depends upon talent, learning, and skill, the poet attains through his very nature, is moved by the energy that is within his mind, and is as it were inspired by a divine inbreathing—so that Ennius fairly calls poets sacred in their own right, since they appear to be commended to us by the possession of a divine gift.'" Petrarch cites *Pro Licinio Archia* 8.18 (see Billanovich, "Petrarca e Cicerone," 90–102, for other references to the *Pro Archia*).

7. For this epochal discovery, see E. H. Wilkins, *Life of Petrarch* (Chicago: University of Chicago Press, 1961), 51–52; Giuseppe Billanovich, *Lo scrittoio del Petrarca*, vol. 1

of *Petrarca letterato* (Rome: Edizioni di Storia e Letteratura, 1947), 3–8; Giuseppe Billanovich, "Quattro libri del Petrarca e Verona," *Studi petrarcheschi* 7 (1990): 233–62, esp. 259–60; and Giuseppe Billanovich, "Petrarca e i libri della cattedrale di Verona," in *Petrarca, Verona e l'Europa: Atti del convegno internazione di studi (Verona 19–23 sett. 1991)*, ed. Giuseppe Billanovich and Giuseppe Frasso (Padua: Antenore, 1997), 117–78, esp. 142–43, 157–59. Petrarch accepted the pseudo-Ciceronian letter to Octavian as genuine, drawing on it for his reproaches of Cicero's political fickleness in *Fam.* 24.3.2.

8. See *Fam.* 1.1.37: "The other work I have been polishing with great care, though not a Phidian Minerva, as Cicero asserts, but a true portrait and likeness such as it is of my talent [*animi mei effigiem atque ingenii simulacrum*] if ever I shall be able to give it the last touches, that work, I say, when it reaches you, you may set up without concern at the summit of whatever stronghold you please." For the project of the *Posteritati*, see Billanovich, *Petrarca letterato*, 134–43, and Pier Giorgio Ricci, "Sul testo della *Posteritati*," *Studi petrarcheschi* 6 (1956): 5–21.

9. See *Sen.* 26.1, in Francesco Petrarch, *Opera quae extant omnia* (Basel: Henrichus Petri, 1554), 1047 (*Letters of Old Age* 2:600–601). A suggestive psychoanalytic account of Petrarch's early years, including Petracco's book burning, is offered by Pierre Blanc, "Petrarca ou la poétique de l'Ego," *Revue des Études Italiennes* 29 (1983): 106–7. There are numerous other Ciceronian moments in Petrarch's literary and bibliographic career, of course, involving numerous texts, friends, and correspondents: see *Fam.* 7.4.1 (Petrarch is asked to find Ciceronian texts for the pontifical library in Avignon) and 7.16.6 (on the three orations borrowed from Lapo di Castiglionchio). See also *Fam.* 18.12.3–10; *Dispersa* 12 in Francesco Petrarca, *Lettere disperse: Varie et miscellanee*, ed. A. Pancheri (Parma: Guanda, 1994), 102–5; Arnaldo Foresti, *Anedotti della vita di F. Petrarca*, ed. Antonia Tissoni Benvenuti (Padua: Antenore, 1977), 244–51; *Fam.* 12.8.1, 9–10 (reading Cicero in Vaucluse); *Fam.* 13.6.23 (*Pro Archia* sent to Florence); *Fam.* 18.13 (Cicero compared to Hercules); and *Fam.* 14 (on the *Tusculanarum questionum* obtained from Crotto da Bergamo). Extensive discussion of Cicero is also found in the *De vita solitaria* (see Francesco Petrarch, *De vita solitaria*, ed. Marco Noce [Milan: Arnoldo Mondadori, 1992], 1.3.2, 2.8.2, 2.10.7) and in *Sen.* 14.1. On Petrarch's identification of the supposedly rediscovered *Hortensius* as part of the *Academica*, see de Nolhac, *Pétrarque et l'humanisme* 1:236–46. On Petrarch's claim he once possessed Cicero's lost *De gloria*, see de Nolhac, *Pétrarque et l'humanisme* 1:260–68, and Giuseppe Billanovich, "Ser Convenevole da Prato maestro notaro e chierico," in *Petrarca, Verona e l'Europa*, 387–90, who regards the claim as sheer fabulation.

10. Petrarch, *Letters of Old Age* 2:601; see also Petrarch, *Opera quae extant omnia*, 1046–47.

11. *Metamorphoses* 8.511–17, my emphases. See Ovid, *Metamorphoses*, trans. A. D. Melville (Oxford: Oxford University Press, 1986), 186–87:

> With trembling hand
> And eyes averted, full into the flames
> She threw the fatal brand. The log itself
> Groaned, or it seemed to groan, as there it lay
> Licked by the unwilling flames and burned away.
> Unknowing, absent, Meleager burned,
> Burned with those flames and felt a hidden fire
> Scorching his vitals. . . .

12. *De remediis utriusque fortune,* in *Opera quae extant omnia,* 1047, my emphases.

13. See *Purg.* 25.19–24 ("... come Meleagro / si consumò al consumar d'un stizzo") in Dante Alighieri, *The Divine Comedy: Purgatorio,* ed. and trans. Robert M. Durling and Ronald. L. Martinez (New York: Oxford University Press, 2003), 420, 428–29, 433.

14. In the proemial letter, Petrarch compares his own infantile survival of a difficult stream crossing to that of Camilla, who was rescued from pursuit by being flung across a stream tied to a lance (Vergil, *Aen.* 11.552–55). See *Fam.* 1.1.22–23, recalling a series of mishaps beginning with his mother's near death in childbirth.

15. On Ser Petracco's role in Petrarch's psychic life, see Blanc, "Petrarca ou la poétique," 128–36.

16. Donatus's life of Vergil relates that Augustus forbade the burning of the *Aeneid* as Vergil had wished; see *Vita Donati,* in *Vitae vergilianae antiquae,* ed. Colin Hardie (Oxford: Clarendon Press, 1956), 38.

17. See *Fam.* 1.1.11: "Thus while all the these things were being destroyed as I came across them, and—in the mood I was in—being disinclined to spare even these, the two of you appeared to me, one on the left, the other on the right [*vestrum alter ad levam, alter ad dextram adesse visus*] and grasping my hand, affectionately urged me not to destroy my promise and your expectation in a single fire as I had determined to do." Petracco's hands in *Sen.* 16.1, one holding Cicero and one Vergil, correspond to the two collections and their defenders, whose ghostly appearance also recalls how Vergil's editors, Tucca and Varius, refused to discharge Vergil's dying wish that his epic be burned. In *Sen.* 3.1 (*Letters of Old Age,* 79), Petrarch refers to Nelli and Boccaccio as his literary executors, his Varius and Tucca.

18. For these letters, dated respectively on the Ides of October 1359 and 1360 (August 18), see Petrarca, *Le familiari* 4:74–79 (*Letters on Familiar Matters,* vols. 2–3, trans. Aldo S. Bernardo [Baltimore, MD: Johns Hopkins University Press, 1982–83], 3:185–88), and Petrarca, *Lettere disperse,* 338–59.

19. See Petrarch, *Letters on Familiar Matters* 3:186:

> I have no fear of being any less a Christian for being a Ciceronian, for to my recollection Cicero never said anything against Christ. . . . Christ is truly our God, but Cicero is our prince of eloquence: I confess they are different, but I deny that they are in conflict. . . . His fate is surely worthy of tears, for had this man of truly lofty and divine intelligence seen Christ or heard his name, in my opinion he would not only have believed in Him but with his incomparable eloquence would have been his greatest herald, as the apostle Paul, weeping, reportedly said about the other prince of Latin eloquence, the poet Virgil, upon visiting his tomb.

For the allusion to Jerome's Epistle to Eustochium (22.30.4) relating his dream, see Petrarca, *Le familiari* 4:75; see 4:76 for the reference to Paul's weeping at the tomb of Vergil (cf. Domenico Comparetti, *Virgilio nel Medio evo,* 2 vols. [Florence: La Nuova Italia, 1941], 2:32, 94). Petrarch refers to Jerome's dream elsewhere, in *Fam.* 2.9.9 and 12.10.8 and *De sui ipsius,* 282–83 (*De ignorantia* 5), shrewdly observing that Jerome's literary style belied the pledge, which he makes in the dream, to abstain thereafter from pagan literature.

20. For references to the letter in the text, see Petrarca, *Le familiari* 4:77–78; they are *Fam.* 21.10.16, 17, 18, 19.

21. Petrarch had also copied the *Pro Archia* in his own hand and several other Ciceronian texts as well; see Bosco's entry in the index, Petrarca, *Le familiari* 4:318.

22. Petrarch's phrase testifying to his fortitude in disregarding the pain to his arm to continue copying the Cicero ("Amor et delectatio et habendi cupiditas vincebant") refashions a famous Vergilian line for Roman self-sacrificing fortitude (*Aen.* 6.823: "Vincet amor patriae laudumque immensa cupido" ["Yet should love for the fatherland prevail, and the enormous desire for fame"]). The phrase not only illustrates Petrarch's shift from Vergil to Cicero but also his conception of literary effort as a modern version of Roman heroism. Ironically, Vergil's reference is to Brutus's condemnation of his sons to death. For Petrarch's claim that the classical authors had a hunger for books, see *Fam.* 3.18.2, 12, where it is said of Cato and Cicero and attested with citations from the letters to Atticus (*Ad Att.* 1.7, 14.4a, 13.8, etc.) themselves.

23. *Fam.* 21.10.16: "Est michi volumen epystolarum eius ingens, quod ipse olim manu propria, quia exemplar scriptoribus impervium erat, scripsi, adversa tunc valitudine" ("I have an enormous volume of his letters that with my own hand I transcribed some time ago while in bad health because the transcription proved difficult for the scribes, despite my body's discomfort and the hard labor involved"). Billanovich, "Quattro libri del Petrarca," 259–60, and "Petrarca e i libri," 157–59, clarifies that Petrarch did not actually enter the chapter library, whose restrictions on foreigners were absolute, but that the codex (along with numerous others) was withdrawn for him by his Veronese friend Guglielmo da Pastrengo for Petrarch to copy while he was lodging with Guglielmo. Petrarch's *impervium* remains ambiguous, however, because most visitors to Verona would not have enjoyed the contact with a local scholar such as Guglielmo, who had been carefully schooled by Petrarch (see Billanovich, "Petrarca e i libri della cattedrale").

24. From his early verse letter to Giacomo Colonna (*Epyst.* 1.6), where his books at Vaucluse are biddable companions ("abeant iussi redeantque vocati," cited in Vinicio Pacca, *Petrarca* [Bari: Laterza, 1998], 36), to *Fam.* 12.8, where Cicero's books are living companions, Petrarch offers numerous instances of this bibliophilic topos in early modern literature.

25. For the testament, see *Petrarch's Testament*, ed. and trans. Theodore E. Mommsen (Ithaca, NY: Cornell University Press, 1957), 82–83, in which Petrarch wrote: "To Lord Giovanni of Certaldo or Boccaccio I bequeath—ashamed as I am to leave such a trifling legacy to so great a man—fifty Florentine gold florins for a winter garment [*una veste hyemali*] to be worn by him while he is studying and working during the night hours."

26. Cicero, *De officiis*, 1.77, 144.

27. *Fam.* 22.2.16–17. For a discussion and English translation of the passage, see Thomas M. Greene, "Petrarch and the Humanist Hermeneutic," in *The Light in Troy: Imitation and Discovery in Renaissance Poetry* (New Haven, CT: Yale University Press, 1982), 94–96. Petrarch returns to the image of style as a garment when discussing his great attachment to Cicero in his *De sui ipsius et multorum ignorantia* 3.92 (*De sui ipsius*, 236–37.) The association of the poet's style and status with a rich garment had been sanctioned by Robert of Anjou's gift to Petrarch of a ceremonial cloak when examining him for the laurel in Naples in 1341; see E. H. Wilkins, "The Coronation of Petrarch," *Speculum* 18 (1943): 182–83.

28. See Sant'Agostino, *Confessioni*, ed. Christine Mohrmann (Rome: Rizzoli, 1958), 380; for Brunetto, see *Inf.* 25.23–24: "who seized me by the hem [*per lo lembo*]" and 15.40: "I will come along at your skirts [*ai panni*]" (Dante Alighieri, *The Divine Comedy: Inferno*, ed. and trans. Robert M. Durling and Ronald. L. Martinez [New York: Oxford University Press, 1996], 230, 232, 239–40). That it is the *fimbria* of Petrarch's toga that catches on the book also may evoke Matt. 23.5 ("For they make their phylacteries broad and enlarge their fringes [*fimbrias*]"), a passage describing the vanity and pride of Pharisees that is much commented on in preaching (e.g., Alanus de Insulis, *Summa de arti predicatoria*, chap. 1, PL 210.0113A).

29. See the illustration in BN ms. Fr. 118, fol. 219v, Paris, which serves as the frontispiece to Lancelot, *De la guerre de Galehot contre Arthur au deuxième voyage en Sorebois*, ed. Alexandre Micha (Paris: Droz, 1982).

30. See *Fam.* 21.10.21: "Nearly every accident, every ailment, inevitably strikes this one part of my body [*unam corporis partem*] that my servant, in joking with me while doing his chores, quite rightly calls my unlucky leg [*fortunarum tibiam*]."

31. See *Fam.* 21.10.21–22: "Throughout my life it has often bothered me, and many times from boyhood onward it has forced me to rest, something I find most intolerable. What shall I say? I am not far from, if not actually recognizing, at least denying with less conviction the existence of fate since not only every man but even every part of the body and soul has its particular destiny." Petrarch then indulges in a minor excursus regarding the significance of the left side. For the state of medical doctrines in fourteenth-century Paris and Avignon, about which Petrarch was well informed, see Marie-Christine Pouchelle, *Corps et chirurgie à l'apogée du Moyen Âge* (Paris: Flammarion, 1983).

32. For the injury to the upper part of his shin traveling to the jubilee, see *Fam.* 11.1.7–10; for the 1368 ulceration, see Wilkins, *Life of Petrarch*, 216.

33. See *Dispersa* 46 (*Var.* 25), in Petrarca, *Lettere disperse*, 348: "With this stratagem, then, you console me for the fact that it was that very Cicero who wounded me [*ab ipso . . . Cicerone sim offensus*], whom I eagerly read and reread [*percupide versor*], while Hippocrates and Albumasar (so I hope) would never think to hurt me."

34. *Fam.* 21.10.26: "Ita dilectus meus Cicero cuius olim cor, nunc tibiam vulneravit."

35. *Dispersa* 46 (*Var.* 25), in Petrarca, *Lettere disperse*, 348: "Indelebilem memoriae meae notam et stigma perpetuum Cicero mihi meus affixit. Memineram sui, sed ne unquam oblivisci possim, intus et extra consultum est" ("My Cicero imposed therefore on my memory an indelible inscription and on my body a permanent insignia. I'd have remembered him, but that I might never forget him, he took measures both within and without").

36. Petrarch's allusion with "in sapientia verbi evacuetur crux Christi" (21.10.15) to Paul's 1 Cor. 1.17 ("not in wisdom of speech, lest the cross of Christ should be made void" ["ut non evacuetur crux Christi"]) establishes a suggestive play of sound between the *crux* of Christ and the *crus* of Petrarch's shin (17), linking Christ's atonement and Petrarch's agon of initiation.

37. The idea of a stigma or mark may also resonate with Petrarch's characteristic references to his own epistolary texts, often scribbled over with corrections, as "scarred"; indeed for Petrarch these are the marks of "familiarity," of intimacy and friendship. See *Sen.* 9.2 *ad finem* ("Remember me, and take the erasures that you see as the marks of

an old friendship" [*Letters of Old Age* 1:344]) and Petrarch, *Opera quae extant omnia*, 952 ("& quas aspicis lituras, signa familiaritatis existima"); also *Sen.* 13.5, in Petrarch, *Opera quae extant omnia*, 1016 (*Letters of Old Age* 2:487): "You cannot doubt that it is mine, since it is in my handwriting and comes to you disfigured, as if purposely, by so many scars." To speak of the text as full of *cicatrices* and *signa* assimilates the page to the surface of the body.

38. *Dispersa* 46 (*Var.* 25), in Petrarca, *Lettere disperse*, 348: "Sed ut omissis iocis rem ipsam plane noveris, vulnus illud Ciceroniamum de quo ludere solebam, ludum mihi vertit in luctum." Compare Job 30.31 ("versa est in luctum cithara mea" ["my harp is turned to mourning"]) and Lam. 5.15 ("versus est in luctus chorus noster" ["our dancing is turned to mourning"]). For the role of this biblical topic in the *Canzoniere*, see Ronald L. Martinez, "Mourning Laura in the *Canzoniere*: Lessons from Lamentations," *MLN* 118 (2003): 12–16, 19–27.

39. See *Fam.* 21.10.16–19, esp.: "Cicero, qualiter modo mecum *luserit* . . . ; *lesus* iterum expergiscor . . . ; non amplius *ludicro* vulneri incumbunt . . . ; non sine cruciatu et periculo *lesi* artus, ut perhibent" ("How I was tricked by Cicero . . . ; after being repeatedly injured . . . ; this wound that is not longer to be taken lightly . . . ; it is causing considerable pain and . . . some danger to the wounded leg").

40. See *Dispersa* 46 (*Var.* 25), in Petrarca, *Lettere disperse*, 348.

41. *Fam.* 21.10.19: "Expectas finem? Paulatim quasi se sperni dolens vulnus intumuit, et subinde nescio quenam caro discolor et virulenta succreverat" ("Can you believe what happened? Gradually as if angry at being neglected, the sore swelled and then around it appeared a discolored and infected growth"). Swelling and rising is traditionally the sign of the proud and rebellious flesh; see n. 60.

42. Rossi notes borrowings from the pseudo-Ciceronian letter to Octavian, from two letters to Brutus, and from one letter to Atticus (see Petrarca, *Le familiari*, 4:226–27, citations at *Fam.* 24.3.2, 5, 6, 7), but the letter also refers to Cicero's heedlessness of his brother Quintus's good advice ("et fraterni consilii immemor" [3]) so that all of the Ciceronian interlocutors from the Verona codex are referred to—the letter is a chorus.

43. *Fam.* 1.1.42, 44; translation from Morris Bishop, *Letters of Petrarch* (Bloomington: Indiana University Press, 1963), 22.

44. See Pierre de Nolhac, *Petrarch and the Ancient World* (Boston: Merrymount, 1907), 113. The view is echoed by Hans Baron Jr., "Cicero and the Roman Civic Spirit in the Middle Ages and the Renaissance," *Bulletin of the John Rylands Library* 22 (1938): 85–86.

45. See Billanovich, "Quattro libri del Petrarca," 251, and "Petrarca e i libri," 157–59, on Petrarch's turn to the epistolary collection.

46. See *Dispersa* 46 (*Var.* 25), in Petrarca, *Lettere disperse*, 352–59, esp. 352–53: "Regarding that translation, an ancient work of Cicero's [*translationem illam veterem Ciceronis opus*] the beginning of which Horace inserted into his *Art of Poetry*, now along with much else lost to latinity, I lament and complain." Petrarch speaks of this lost translation again when addressing Homer at *Fam.* 24.12.1.

47. The issues Boccaccio raised to which *Fam.* 21.15 responds are explicitly linked by Petrarch to the discussions held during Boccaccio's visit in spring of 1359; see 21.15.1: "There are many things in your letter needing no reply whatsoever since we recently dealt with them in person" (Petrarch, *Letters on Familiar Matters* 3:202).

48. For text and commentary, including commentary noting parallels with Arnaut's

"signature," see Francesco Petrarch, *Canzoniere*, 2nd ed., ed. Marco Santagata (Milan: Mondadori, 1997), 900–903. Commentators have ignored the links with Dante's lame pilgrim, but note that Petrarch's sonnet uses *riva* and *fugitiva* among four rhyme words in the octet (the others are *estiva* and *visiva*) and that Dante's canto has *riva* and *fuggiva* and *viva* as rhyme words at *Inf.* 1.23 and 25; compare also the pilgrim "con lena affannata" ("with laboring breath" [*Inf.* 1.22]) and "corpo lasso" ("my weary body" [*Inf.* 1.28]) to Petrarch's "grave e lungo affanno" ("heavy, long labor" [l. 12]) and his condition "cieco e stanco" ("blind and weary" [l. 9]). For Arnaut and Petrarch, see Maurizio Perugi, "Arnaut Daniel in Dante," *Studi danteschi* 51 (1983): 51–151, and Maurizio Perugi, *Trovatori a Valchiusa: Un frammento della cultura provenzale del Petrarca* (Padua: Antenore, 1985).

49. *Fam.* 24.3.3: "Alas, forgetful of your brother's advice and of your many wholesome precepts, like a wayfarer at night carrying a lantern before him [*ceu nocturnus viator lumen in tenebris gestans*], you revealed to your followers the path where you yourself stumbled most wretchedly [*ostendisti secuturis callem, in quo ipse satis miserabiliter lapsus es*]." Rossi (Petrarca, *Le familiari*, 226) reports the manuscript rubrics of the letter: "Petrarce ad Ciceronem, quem coarguit et increpat quod multa admonuerit in suis codicibus que prorsus in vita non persecutus est" ("Petrarch to Cicero, whom he attacks and reproaches for having advised much in his writings that he did not pursue in life"). The reproach recalls the words of Brutus writing to Atticus, an apocryphal letter included in the letters Petrarch copied at Verona: "Quid enim illi prosunt, quae pro libertate patriae, quae de dignitate, quae de morte, exsilio, paupertate scripsit copiosissime?" ("Of what good are they to him, those things about which he wrote so abundantly: the freedom of the fatherland, dignity, death, exile and poverty?") (*Ad Brutum* 1.17, in Cicero, *Epistole*, ed. Luca Canali [Milan: Rizzoli, 1981], 304).

50. See Rossi's note in Petrarca, *Le familiari* 4:226. Dante has Stazio say at *Purg.* 22.67–69: "You did as one who walks at night, who carries the light behind him [*porta il lume dietro*] and does not help himself, but instructs the persons coming after."

51. *Fam.* 21.15.3 (Petrarch, *Letters on Familiar Matters* 3:202).

52. *Fam.* 21.10.18: "But the next day, as I again returned to the room, he again struck me and again I jokingly picked him up and put him in his place . . . although my skin was broken from repeated blows on the same spot causing a considerable sore to develop [*crebra concussione repetiti loci fracta cutis nec spernendum ulcus extaret*]."

53. De Nolhac, *Pétrarque et l'humanisme* 2:284.

54. Foresti, *Anedotti*, 427; *Dispersa* 48, in Petrarca, *Lettere disperse*, 362, 364, my emphases:

> Fortunae nempe vulneribus non aliis quam nimium *crebris* carorum mortibus *impelli et concuti* me fateor, non prosterni.

> (For by the blows of Fortune, because of the many deaths of dear ones in such a brief time, I am assailed and struck, yes, but not cast down.)

> Deo gratias, qui me longo labore, sed non sine dolore, liberavit.

> (Thanks be to God, who freed me from a long travail, though not without pain.)

Guglielmo knew Giovanni well, as much of the boy's education had transpired in Verona.

55. See Foresti, *Anedotti*, 405–31, and Blanc, "Petrarca ou la poétique," 152, for the

list of the letters relating to Giovanni. Foresti also points to several references in the *De remediis utriusque fortunae* (the work Petrarch finished copying in 1366) relating to children who do not receive instruction and harsh vs. lenient fathers that allude to Giovanni (*Anedotti*, 411, 414).

56. Forgiveness: *Fam.* 22.9 (Petrarch, *Letters on Familiar Matters* 3:231); endurance: *Fam.* 23.12 (Petrarch, *Letters on Familiar Matters* 3:281–88, esp. 283).

57. *Ad Atticum* 10.4.5, in Cicero, *Cicero's Letters to Atticus*, 7 vols., ed. D. R. Shackleton Bailey (Cambridge: Cambridge University Press, 1965–70), 4:228–29: "As to the other it is a deplorable affair, the bitterest blow I have had to bear in all my life. Spoiled no doubt by our indulgence he has gone to I dare not say what lengths."

58. See *Fam.* 23.12.33–36 to Guido Sette; Foresti, *Anedotti*, 425–26; and de Nolhac, *Pétrarque et l'humanisme* 2:55 and 72, reporting Petrarchan marginalia on the dissimilarity of fathers and sons, including Pliny's remarks about Cicero and his son Marcus.

59. On Giovanni's education, see *Fam.* 7.17, 17.2, 22.9 (Cicero quoted as the model of Petrarch's "weakness of mind") and the *De remediis* (2.43) passage quoted in Foresti, *Anedotti*, 414.

60. See *Fam.* 22.7, rubric: "*contumacis* adolescentis acerrima increpatio" ("a sharp rebuke to a stubborn youth"); 22.7.9–10: "Turpissime *tumes*... nichil difformius statui tuo est" ("You are shamefully swollen[;] ... nothing is more unworthy or more unbecoming to your condition"); and "*Tumidior* fis; e *tumore* autem tuo, rogo, quid unquam nisi ridiculus mus nascetur?" ("You would be more puffed up, yet, I ask, what will ever result from that arrogance of yours except a ridiculous mouse?") (citing Horace, *Ars poetica* 139, my emphases). Petrarch consciously associates Augustus's vexatious offspring with "encysted tumors" in discussing Giovanni ("adulescens noster... *contumax ac rebellis*" ["our adolescent . . . proud and rebellious"]) at *Fam.* 23.12.16: "Augustus tres, ut ipse vocitabat, *vomicas* suo de sangue tulerit, ego in meo unam, ad laborem natus homo, non feram" ("Augustus bore three tumors in his bloodline, as he used to say, and I, a man born for hardship, cannot bear one") (my emphases). Petrarch's ranking of Giovanni as one of the burdens of mankind also echoes language he uses to bracket discussion of his wounded leg in the letter to Boccaccio (*Dispersa* 46 [*Var.* 25], in Petrarca, *Lettere disperse*, 346, 350): "Nunc intelligo: magnus labor est vivere. . . . Nunc sentio: magnus dolor est vivere" ("Now I understand: it is a great travail to live. . . . Now I feel it: it is a great pain to live").

61. *Fam.* 13.2.2; 19.17.9; Blanc, "Petrarca ou la poétique," 153; Foresti, *Anedotti*, 413, 416.

62. Here too there is a parallel with Cicero, whose son Marcus was, as a student in Athens, liberally and leniently treated by Atticus; see *Ad Atticum* 13.1, 14.11, 15.15 (Cicero, *Cicero's Letters to Atticus* 4:506, 571, 615).

63. Foresti, *Anedotti*, 420–21. See Nelli's epistles 18, 19, 20, and 22, in Henry Cochin, *Lettres de Francesco Nelli à Pétrarque* (Paris: Champion, 1892).

64. See Foresti, *Anedotti*, 417–22, and for the Petrarch-Nelli correspondence, see E. H. Wilkins, "A Survey of the Correspondence between Petrarch and Francesco Nelli," in *Studies in Petrarch and Boccaccio*, ed. Aldo S. Bernardo (Padua: Antenore, 1978), 89–95. Foresti suggests that after Nelli left Avignon, Giovanni's protector was Ludwig van Kempen.

65. Epistles 29 and 30 (Cochin, *Lettres de Francesco Nelli*, 289–307); quotation in the text is at Cochin, *Lettres de Francesco Nelli*, 290.

66. *Fam.* 23.19.11–12 (Petrarch, *Letters on Familiar Matters* 3:301–2).

67. The ambivalence was profound: after Giovanni Petrarca's death, but before 1366, Petrarch revised *Fam.* 23.12.15, to Guido Sette, originally written December 1, 1360, so as to present a still harsher view of Giovanni (see Petrarch, *Le familiari* 4:187–88 and *Lettere disperse*, 364), whereas in the letters remembering Giovanni in the *Seniles*, dated about 1361–62, shortly after Giovanni's death, he presents a picture of stoic paternal grief (see *Sen.* 1.2, 3).

68. Blanc, "Petrarca ou la poétique," 153; cf. *Fam.* 22.7 (Petrarch, *Letters on Familiar Matters* 3:225): "the immeasurable dissimilarity of our natures."

69. The praise of Giovanni Malpaghini's writing hand is at *Fam.* 23.19.7–8. After returning to Petrarch, Giovanni copied Homer's *Iliad* and *Odyssey*, in Leonzio Pilato's Latin translation. See Blanc, "Petrarca ou la poétique," 153, on filiation and copying, a trope developed in Marco Santagata, *Il copista* (Palermo: Sellerio, 2000), a fictional fantasy on Petrarch's last days. The uncanny proliferation of Giovannis and Francescos in Petrarch's affective life also furnishes Santagata's theme; he makes Giovanni of Ravenna yet another Petrarchan by-blow, exaggerating the Oedipal conflict.

70. Wilkins, *Life of Petrarch*, 205–10; see *Sen.* 5.5–6, 15.12. Blanc, "Petrarca ou la poétique," 155, points out that Giovanni broke off his copying of the *Canzoniere* with the final verse of sonnet 318: "È ancor chi chiami e non è chi responda" ("There is one who calls out, but there is none to answer"). Wilkins, *Life of Petrarch*, 216–17, notes that after returning briefly to Petrarch in 1368, Giovanni finished the *Iliad* and most of the *Odyssey*, copying the last book in a hurried, inferior script.

71. *Sen.* 5.5 (Petrarch, *Letters of Old Age* 1:185).

72. *Sen.* 10.4 (Petrarch, *Opera quae extant omnia,* 968; Petrarch, *Letters of Old Age* 2:379). The name is also self-consciously repeated in the Latin epitaph Petrarch wrote for the child's tomb in Pavia ("Franciscus genitor, genitrix Francisca. Secutus / Hos de fonte sacro nomen idem tenui" ["Francis was my father, my mother Francisca. Following them from the holy fount I kept the same name"]); as the writing was gilded, this is Petrarch's exercise in chrysography and in gilding his own name. See Armando Petrucci, *La scrittura di Francesco Petrarca* (Vatican City: Biblioteca Apostolica Vaticana, 1967), plate 20, 1. Blanc, "Petrarca ou la poétique," 152, comments on Petrarch's complacency regarding so many Francescos.

73. Despite the fact that he had additional grandsons, however, Petrarch's direct male descent was extinct by 1407, and Petrarch's legacy, including books (see n. 76) passed to the widow of Petrarch's grandson Gerardo, Tommasa Savonarola, and to the brother of Francescuolo, Ambrogio da Brossano. See Paolo Sambin, "Libri del Petrarca presso suoi descendenti," *Italia medioevale e umanistica* 1 (1958): 359–69.

74. Blanc, "Petrarca ou la poétique," 152–53: "The fact remains, for example, that Petrarch appears not to have wished to realize what a fatal risk his son (who had rejoined him in 1360 in Milan after having overcome dilatory paternal objections) ran in remaining within the Viscontean city during the summer, while an epidemic of plague was raging that would carry him off on July 9 and which his father had prepared for by moving to Padua."

75. Foresti, *Anedotti,* 431; *Sen.* 1.5, in Petrarch, *Letters of Old Age* 1:25.

76. See Wilkins, "A Survey of the Correspondence between Petrarch and Francesco Nelli," 89–95. In "Petrarch's Proposal for a Public Library," in *Studies in Petrarch and Boccaccio,* 102–6, Wilkins documents the library negotiations with the Venetian

republic. Sambin, "Libri del Petrarca," traces the distribution of some important Petrarchan books, including probably Vat. Lat. 3195, to his descendants through Tommasa Savonarola.

77. For the textual history of the Ciceronian letter collections Petrarch copied, see Cicero, *Epistole*, 36–37. Among the mss. once thought drawn from the Verona codex is the *Mediceo* (Biblioteca Medicea Laurenziana Plut. 49, 18) done at the behest of Coluccio Salutati and later owned by Niccoli and Bruni (with corrections by all three); the derivation was disproved by Karl Lehmann. See Cicero, *Cicero's Letters to Atticus* 1:74–85, esp. 80–81.

78. Blanc, "Pétrarque, lecteur de Cicéron," studying Petrarch's glosses to Cicero's rhetorical works in the Troyes ms., notes the recurring attention to points of rhetoric and eloquence rather than to philosophical, ethical, or political issues.

F O U R : Holy Autopsies

1. Jacob Burckhardt, *Die Cultur der Renaissance in Italien: Ein Versuch* (1860), translated by S. G. C. Middlemore as *The Civilization of the Renaissance in Italy*, 2 vols. (New York: Harper, 1958), 2:279. On the myth of the flat earth, see Jeffrey Burton Russell, *Inventing the Flat Earth: Columbus and Modern Historians* (New York: Praeger, 1991).

2. Andrew Dickson White, *A History of the Warfare of Science with Theology in Christendom*, 2 vols. (New York: Appleton, 1896), 2:50–55. An equally partisan Catholic response to this account, which traces the origins of the myth concerning human dissection appears in James Joseph Walsh, *The Popes and Science: The History of the Papal Relations to Science during the Middle Ages and down to Our Own Time* (New York: Fordham University Press, 1908), 29–89. See in general Katharine Park, "Myth 5: That the Medieval Church Prohibited Human Dissection," in *Galileo Goes to Jail and Other Myths in the History of Science and Religion*, ed. Ronald Numbers (Cambridge, MA: Harvard University Press, 2009), 43–50.

3. Autopsy refers to opening a corpse to answer questions about its individual constitution, most often concerning cause of death, while dissection refers to using an opened body for medical instruction and research; the latter was a far more public and extreme practice than the former and was as a result more strictly regulated. For an extended treatment of these developments, see Katharine Park, "The Criminal and the Saintly Body: Autopsy and Dissection in Renaissance Italy," *Renaissance Quarterly* 47 (1994): 1–33, and Katharine Park, *Secrets of Women: Gender, Generation, and the Origins of Human Dissection* (New York: Zone, 2006). The most comprehensive recent histories of dissection in this period are Roger French, *Dissection and Vivisection in the European Renaissance* (Aldershot, UK: Ashgate, 1999) and Andrea Carlino, *Le fabbrica del corpo: Libri e dissezione nel Rinascimento* (Turin: Einaudi, 1994), translated by John Tedeschi and Anne C. Tedeschi as *Books of the Body: Anatomical Ritual and Renaissance Learning* (Chicago: University of Chicago Press, 1999). Both of these otherwise useful studies hold on in different ways to remnants of the myth of ecclesiastical resistance to human dissection.

4. See Agostino Paravicini Bagliani, *Corpo del papa* (Turin: Einaudi, 1994), translated by David S. Peterson as *The Pope's Body* (Chicago: University of Chicago Press, 2000), 133–36; P. Georges, "'Mourir c'est pourrir un peu . . .': Techniques contre la corruption des cadavres à la fin du Moyen Age," *Micrologus* 7 (1999): 359–82; Ernst von

Rudloff, *Über das Konservieren von Leichen im Mittelalter: Ein Beitrag zur Geschichte der Anatomie und des Bestattungswesens* (Freiburg: Karl Henn, 1921); and Dietrich Schäfer, "Mittelalterlicher Brauch bei der Überführung von Leichen," *Sitzungsberichte der preussischen Akademie der Wissenschaften (Berlin)* 26 (1920): 478–98.

5. The proceedings of the inquest of 1318–19 can be found in Enrico Menestò and Silvestro Nessi, eds., *Il processo di canonizzazione di Chiara da Montefalco* (Florence: La Nuova Italia, 1984). This volume also contains an excellent collection of essays and appendices, which provide essential historical background to Chiara's life and cult. For a detailed discussion of the canonization proceedings, the sources, and the context, see Menestò's introduction, xix–clxxxviii; an English summary appears in Enrico Menestò, "The Apostolic Canonization Proceedings of Clare of Montefalco, 1318–1319," in *Women and Religion in Medieval and Renaissance Italy*, ed. Daniel Bornstein and Roberto Rusconi, trans. Margery J. Schneider (Chicago: University of Chicago Press, 1996), 104–29. The indispensable general study of canonization and the cult of the saints in this period is André Vauchez, *La sainteté en Occident aux derniers siècles du Moyen Age* (Rome: École française de Rome, 1981), translated by Jean Birrell as *Sainthood in the Later Middle Ages* (Cambridge: Cambridge University Press, 1997). The literature on Chiara is vast; for a good introduction and basic bibliography, see Enrico Menestò and Roberto Rusconi, *Umbria sacra e civile* (Turin: Nuova Eri Edizioni Rai, 1989), 137–64 and 233–34. For a more detailed discussion of the opening of Chiara's body, see Park, *Secrets of Women*, chap. 1.

6. Nancy G. Siraisi, "La comunicazione del sapere anatomico ai confini tra diritto e agiografia: Due casi del secolo XVI," in *Le forme della comunicazione scientifica*, ed. Massimo Galuzzi, Gianni Micheli, and Maria Teresa Monti (Milan: Franco Angeli, 1998), 419–38; Jean-Michel Sallmann, *Naples et ses saints à l'âge baroque* (Paris: PUF, 1994), 308–10.

7. On the history of the practice of dissection before the thirteenth century, see Heinrich von Staden, "The Discovery of the Body: Human Dissection and its Cultural Contexts in Ancient Greece," *Yale Journal of Biology and Medicine* 65 (1992): 223–41; Lawrence J. Bliquez, "Four Testimonia to Human Dissection in Byzantine Times," *Bulletin of the History of Medicine* 58 (1984): 554–57, together with a critique of it in Vivian Nutton and Christine Nutton, "The Archer of Meudon: A Curious Absence of Continuity in the History of Medicine," *Journal of the History of Medicine and Allied Sciences* 58 (2003): 404–5 n. 10; and Emilie Savage-Smith, "Attitudes toward Dissection in Medieval Islam," *Journal of the History of Medicine and Allied Sciences*, 50 (1995): 67–110.

8. On Mondino's work, which may well have been compiled in several stages, see Piero P. Giorgi and Gian Franco Pasini's introduction to Mondino de' Liuzzi, *Anothomia di Mondino de' Liuzzi da Bologna, XIV secolo*, ed. Piero P. Giorgi and Gian Franco Pasini (Bologna: Istituto per la Storia dell'Università di Bologna, 1992), 1–87; Nancy G. Siraisi, *Taddeo Alderotti and His Pupils: Two Generations of Italian Medical Learning* (Princeton, NJ: Princeton University Press, 1981), 66–68, 111–14; and G. Martinotti, "L'insegnamento dell'anatomia in Bologna prima del secolo XIX," *Studi e memorie per la storia dell'università di Bologna* 2 (1911): 25–32.

9. See the text of the nuns' notarized deposition, taken five days after Chiara's death, in *Chiara da Montefalco, badessa del monastero di S. Croce: Le sue testimonianze—i suoi "dicti,"* ed. Silvestro Nessi (Montefalco: Associazione dei Quartieri di Montefalco, 1981), 52.

10. "Vita beatae Margaritae virginis de Civitate Castelli, sororis tertii ordinis de paenitentia Sancti Dominici," chap. 8, ed. Albertus Poncelet, *Analecta bollandiana* 19 (1900): 27–28. This life, written shortly after 1348, seems to be the earlier of Margherita's two surviving Latin vitae; see Enrico Menestò, "La 'legenda' di Margherita da Città di Castello," in *Il movimento religioso femminile in Umbria nei secoli XIII–XIV*, ed. Roberto Rusconi (Florence: La Nuova Italia, 1984), 217–37, esp. 223–26. See also M. H. Laurent, "La plus ancienne légende de la B. Marguerite de Città di Castello," chap. 26, *Archivum fratrum predicatorum* 10 (1940): 127. On Margherita's life, see Menestò and Rusconi, *Umbria sacra e civile*, 167–78, and 234 for a bibliography.

11. See Park, "The Criminal and the Saintly Body," 14–15; French, *Dissection and Vivisection*, chap. 3.

12. Bartolomeo da Montagnana, *Consilia Montagne* 134 (Lyon: Jacobus Myt, 1525), fol. 202v; Jacopo Berengario da Carpi, *Isagogae breves perlucidae ac uberrimae in anatomiam humani corporis*, preface (Bologna: Girolamo Benedetti, 1523), fol. 2r.

13. See Park, *Secrets of Women*, chap. 3.

14. About half of the cases recorded by Benivieni were published posthumously by his brother Girolamo, under the title *De abditis nonnullis ac mirandis morborum et sanationum causis* (Florence: Filippo Giunta, 1507). Giorgio Weber produced an Italian edition that was published in 1994; his edition includes not only the complete Latin text of 1507 but also almost a hundred cases omitted by Girolamo, including several involving postmortem autopsies. Charles Singer published the 1507 Latin text together with an English version in 1954.

15. Menestò and Nessi, eds., *Processo*, 428, 341–42.

16. Béranger de St.-Affrique, "Vita S. Clarae de Cruce ordinis eremitarum S. Augustini," ed. Alfonso Semenza, *Analecta augustiniana* 17–18 (1939–41): 406. On this vita, see Claudio Leonardi, "Chiara e Berengario: L'agiografia sulla santa di Montefalco," in *Chiara da Montefalco e il suo tempo*, ed. Claudio Leonardi and Enrico Menestò (Florence: La Nuova Italia, 1985), 369–86. For the English, see Berengario di Donadio, *Life of Saint Clare of the Cross of Montefalco*, trans. Matthew J. O'Connell, ed. John E. Rotelle (Villanova, PA: Augustinian Press, 1999), esp. 89.

17. Menestò and Nessi, eds., *Processo*, 435.

18. Menestò and Nessi, eds., *Processo*, 435.

19. Menestò and Nessi, eds., *Processo*, 435.

20. Sebastiano Bontempi, "Life of Colomba," in vol. 5 of *Acta sanctorum* (Antwerp: Michael Cnobarus, 1685; facs. ed., Brussels: Culture et Civilization, 1968), no. 216. On Colomba's life and Bontempi's vita, see Roberto Rusconi, "Colomba da Rieti: La signoria dei Baglioni e la 'seconda Caterina,'" in Menestò and Rusconi, *Umbria sacra e civile*, 211–26, together with the bibliography on 235. See also the essays in *Una santa, una città*, ed. Giovanna Casagrande and Enrico Menestò (Spoleto: Centro Italiano di Studi sull'Alto Medioevo, 1991), esp. Gabriella Zarri, "Colomba da Rieti e i movimenti religiosi femminili del suo tempo" (89–108), Giovanna Casagrande, "Terziarie domenicane a Perugia" (109–60), and Enrico Menestò, "La 'legenda' della beata Colomba e il suo biografo" (161–76). For more extensive background on the late fifteenth- and early sixteenth-century spiritual and political movement to which Colomba belonged, see Gabriella Zarri, *Le sante vive: Profezie di corte e devozione femminile tra '400 e '500* (Turin: Rosenberg and Sellier, 1990), chap. 3. On the "autopsies" of Colomba of Rieti and Elena Duglioli, see Park, *Secrets of Women*, chap. 4.

21. Bontempi, "Life of Colomba," no. 17.

22. Bontempi, "Life of Colomba," no. 17.

23. See Gabriella Zarri, *Le sante vive*, chap. 4, and Gianna Pomata, "A Christian Utopia of the Renaissance: Elena Duglioli's Spiritual and Physical Motherhood (ca. 1510–1520)," in *Von der dargestellten Person zum erinnerten Ich: Europäische Sebstzeugnisse als historische Quellen (1500–1850)*, ed. Kaspar von Greyerz, Hans Medick, and Patrice Veit (Cologne: Böhlau, 2001), 323–53.

24. ["Life of Elena Duglioli"], Bologna, Biblioteca Comunale dell'Archiginnasio, ms. B 4314, fol. 179r:

> Fu nel loco del cor ritrovata una cosa dal cor tanto dissimile, che homo pratico di tal humana parte non mai l'haveria per cor ricognoscuto. Et li astanti medici dissero quella esser una molta strana cosa, et che non mai più il simile a quello audito haveano, et quantunque in qualche parte col cor convenisse, si come nel sito e nelle fibre, nella cuspide et concavità sue, nondimeno in figura et forma, nella solidezza et lenità, nella quantità et colore dissimillimo era dal'humano core. . . . Solidezza non haveva, ma molizzo et tenero come un peccio di molle figato.

My thanks to Gianna Pomata for calling my attention to the manuscripts regarding Elena.

25. Pietro Ritta da Lucca, *Narrativa della vita e morte della beata Elena Duglioli dall'Oglio, che sequì li xxiii settembre 1520*, Biblioteca Comunale dell'Archiginnasio di Bologna, ms. Gozzadini 292, [fol. 3v]; *Del cuore di Helena vergine dal signore realmento tolto con molte cose circa quello sopra ogni natura accadute . . .* , Biblioteca Comunale dell'Archiginnasio di Bologna, ms. Gozzadini 292, [fols. 1r–8v].

26. Zarri, *Le sante vive*, 183–84.

27. Ritta, *Narrativa*, [fol. 2r].

28. ["Life of Elena Duglioli"], fol. 187v: "Fra li medici era schisma et contrarietà di sententie."

29. ["Life of Elena Duglioli"], fol. 188r: "tal incorruttione esser causata naturalmento dalla complexione et dispositione di tal parte, la quale per esser nervosa e piena di arterie è più tarda al risolversi che il resto dil corpo."

30. ["Life of Elena Duglioli"], fol. 188r: "Ivi non era nè esser posseva latte, essendo dil tutto cessate le cause di quello, che sono li menstrui et calor naturale, il cui segno anchor era il non vedersi fluire." Milk was thought to be concocted out of the matter of menstrual blood; see Gianna Pomata, "La 'meravigliosa armonia': Il rapporto fra seni et utero dall'anatomia vascolare all'endocrinologia," in *Madri: Storia di un ruolo sociale*, ed. Giovanna Fiume (Venice: Marsilio, 1995), 45–81.

31. ["Life of Elena Duglioli"], fol. 188r–v. Pomponazzi—surprisingly, given the uncompromising naturalism for which he is famous—concluded that "if no human fraud was involved, the preservation [of her breasts] should be attributed to supernatural power." His caution may have been a reaction to the intense public controversy generated by his *De immortalitate animae*, of 1516, which had resulted in a papal warning in 1518; see Martin Pine, *Pietro Pomponazzi: Radical Philosopher of the Renaissance* (Padua: Antenore, 1986), 124–38 and chap. 3.

32. ["Life of Elena Duglioli"], fol. 192r–v: "Li medici, che sempre nimicano li mi-

raculi, et all'opra di natura confugono, concesseron fin alhora il petto esser incorrotto, ma per cause naturali, che non sapevano."

33. ["Life of Elena Duglioli"], fol. 192v: "acciò dalli romani medici fosse dato il giudicio sopra l'oraculo dil conservato latte."

34. Joseph Ziegler, "Practitioners and Saints: Medical Men in Canonization Processes in the Thirteenth to Fifteenth Centuries," *Social History of Medicine* 12 (1999): 191–225.

35. Most of the issues had to do with the causes and nature of putrefaction, one of the subtypes of corruption, discussed by Aristotle in *Meteorology* 379a3–b10. Pomponazzi and Boccadiferro later wrote commentaries on the fourth book of the *Meteorology* in which they discussed these issues: see Pietro Pomponazzi, *Dubitationes in quartum "Meteorologicorum" Aristotelis librum* (Venice: Franciscus Francisci, 1563), 16–24, fols. 9r–18r, and Lodovico Boccadiferro, *Lectiones in quartum "Meteororum" Aristotelis librum* (Venice: Francesco de' Franceschi da Siena, 1563), 21–68. My thanks to Craig Martin for help with obtaining and dating these texts.

36. Realdo Colombo, *De re anatomica libri*, vol. 15 (Venice: N. Bevilacqua, 1559), 266; Giovanni Battista Carcano Leone, *Exenterationis cadaveris illustrissimi cardinalis Borrhomaei Mediolani archiepiscopi . . .* (Milan, 1584); Angelo Vittori, *Disputatio de palpitatione cordis, fractura costarum, aliisque affectionibus B. Philippi Nerii . . . , qua ostenditur praedictas affections fuisse super naturam* (Rome, 1613), all cited in Siraisi, "Comunicazione del sapere," 420 and 424–24.

37. Siraisi, "Comunicazione del sapere," 431–35. For the new focus on historical and medical evidence in Counter-Reformation hagiography, see Simon Ditchfield, *Liturgy, History, and Sanctity in Tridentine Italy: Pietro Maria Campi and the Preservation of the Particular* (Cambridge: Cambridge University Press, 1995), 117–34.

38. Ian Maclean, *Logic, Signs and Nature in the Renaissance: The Case of Learned Medicine* (Cambridge: Cambridge University Press, 2002), esp. chap. 8.

39. Sallmann, *Naples et ses saints*, 306–10 (quotation on 310).

40. Nancy Caciola, *Discerning Spirits: Divine and Demonic Possession in the Middle Ages* (Ithaca, NY: Cornell University Press, 2003), esp. chap. 4. See also Nancy Caciola, "Mystics, Demoniacs, and the Physiology of Spirit Possession in Medieval Europe," *Comparative Studies in Society and History* 42 (2000): 268–306.

41. Bontempi, "Life of Columba," no. 217. Cf. Ps. 22 (21 in Bontempi's numeration): 14–18 (revised standard version): "I am poured out like water, and all my bones are out of joint; my heart is like wax, it is melted within my breast."

42. M. H. Laurent, "La plus ancienne légende," 128.

43. See Caciola, *Discerning Spirits*, 144–51, and Dyan Elliott, "The Physiology of Rapture and Female Spirituality," in *Medieval Theology and the Natural Body*, ed. Peter Biller and A. J. Minnis (York, UK: York Medieval Press, 1997), 157–61.

44. Giovanni Incisa della Rocchetta and Nello Vian, eds., with the assistance of P. Carlo Gasbarri, *Il primo processo per San Filippo Neri nel codice vaticano latino 3798 e in altri esemplari dell'Archivio dell'Oratorio di Roma*, 4 vols. (Vatican City: Biblioteca Apostolica Vaticana, 1957–63), 2:227.

45. See Celestino Piana, "I processi di canonizzazione su la vita di S. Bernardino da Siena," *Archivum franciscanum historicum* 44 (1951): 87–160, 383–435, and the early lives collected in *Acta sanctorum*, 68 vols. (1665; rpt., Brussels: Culture et Civilisation, 1965–70), 5:257*–318*.

F I V E : Habeas Corpus

I am grateful to my colleague Christopher Celenza for several important suggestions and critiques.

1. The Harris poll for December 15, 2005 indicated that 68% of the American public "believe in" angels (versus only 61% who believe in the devil) (www.harrisinteractive.com, accessed May 2 and 4, 2006).

2. Walter Stephens, *Demon Lovers: Witchcraft, Sex, and the Crisis of Belief* (Chicago: University of Chicago Press, 2002), 125–79; Jean-Claude Schmitt, *Ghosts in the Middle Ages: The Living and the Dead in Medieval Society*, trans. Teresa Lavender Fagan (Chicago: University of Chicago Press, 1994), 22–24.

3. Schmitt, *Ghosts*, 12–17, 82–83; cf. 93–121.

4. Schmitt, *Ghosts*, 12–24; Stephens, *Demon Lovers*, 123–44; Jacques Le Goff, *The Birth of Purgatory*, trans. Arthur Goldhammer (Chicago: University of Chicago Press, 1984), 177–208; cf. *Odyssey* 4.795–841; *Iliad* 2.5–42 and 23.65–107.

5. *Random House Dictionary of the English Language*, 2nd ed., unabridg. (New York: Random House,1987), s.v. "spiritual" (emphasis in original); cf. "spirit."

6. Cornelius Agrippa, *De occulta philosophia libri tres*, ed. V. Perrone Compagni (Leiden: Brill, 1992), 457: "De corporibus daemonum magna est recentiorum theologorum cum philosophis dissensio." Chapter 19 of *De occulta* as well as several other passages in it depend on Ficino's translation of Psellus.

7. Ideas about the dead and the afterlife similarly underwent dramatic change between the eleventh and the thirteenth centuries: see Schmitt, *Ghosts*, and Le Goff, *Purgatory*.

8. Gen. 18–19; 32:22–30; Tob. 12; Acts 5:19, 12:7, 27:23; Walter Stephens, "Corporeality, Angelic and Demonic," in *Encyclopedia of Witchcraft: The Western Tradition*, 4 vols., ed. Richard M. Golden (Santa Barbara, CA: ABC-CLIO, 2006), 1:217–19.

9. Dan. 14:32–38; Matt. 4:3–11; Lk. 4:3–13. Jewish and Protestant versions of Daniel relegate chapters 13–14 to the Apocrypha; for an English version of them, see *The New English Bible with the Apocrypha*, 2nd ed. (London: Oxford University Press, 1970), 204–8.

10. Peter Lombard, *Sententiae in quattuor libris distinctae*, ed. Ignatius C. Brady, 3rd ed., 2 vols. (Grottaferrata: Collegii S. Bonaventurae ad Claras Aquas, 1971–81), 1:365.

11. Augustine, *The City of God*, trans. Marcus Dods [et al.] (New York: Modern Library, 1950), 262.

12. Augustine, *City of God*, 36–37.

13. Augustine, *City of God*, 269; Augustine, *La Cité de Dieu*, ed. and trans. Jacques Perret (Paris: Garnier, 1960), 2:260 (Latin text ed. Dombart and Kalb). Augustine reserves the term *angelus* for the messengers of the Christian god.

14. Augustine claims that "scarcely a man" of his time, pagan or Christian, mentions daemons "by way of praise" (*City of God*, 298).

15. Augustine, *City of God*, 262.

16. Augustine, *City of God*, 260–63.

17. Augustine, *City of God*, 780.

18. Walter Stephens, *Giants in Those Days: Folklore, Ancient History, and Nationalism* (Lincoln: University of Nebraska Press, 1989), 75, 90–92.

19. Gareth Roberts, "The Bodies of Demons," in *The Body in Late Medieval and Early Modern Culture*, ed. Darryll Grantley and Nina Taunton (Aldershot, UK: Ashgate, 2000), 131–41.

20. David Keck, *Angels and Angelology in the Middle Ages* (New York: Oxford University Press, 1998), 99.

21. For the resurrection of the body, see 1 Cor. 15:44: "Seminatur corpus animale, surget *corpus spiritale*" (emphasis in original).

22. Pseudo-Dionysius, *The Complete Works*, trans. Colm Luibheid with Paul Rorem (New York: Paulist Press, 1987), 72; cf. 106 ("free from all burden of matter and multiplicity"); 157 ("they immaterially receive undiluted the original enlightenment"); and 229 ("The incorporeal characteristics of the seraphim are described by holy scripture in perceptible [i.e., corporeal] imagery which reverently conveys their conceptual nature"). Pseudo-Dionysius flourished ca. 500 CE.

23. *Index librorum prohibitorum . . . Bernardi Sandoval et Roxas* (Madrid: Sanchez, 1612), 59–60.

24. Stephens, *Demon Lovers*, 58–86.

25. Stephen Greenblatt, *Shakespearean Negotiations: The Circulation of Social Energy in Renaissance England* (Berkeley: University of California Press, 1988), 116.

26. *Heresies of the High Middle Ages*, ed. Walter L. Wakefield and Austin P. Evans (New York: Columbia University Press, 1969), 687–88n, 712–13n.

27. Roberts, "The Bodies of Demons," 132.

28. Roberts, "The Bodies of Demons," 134.

29. Stephens, *Demon Lovers*, 125–79, 289–321; Walter Stephens, "Gianfrancesco Pico e la paura dell'immaginazione: Dallo scetticismo alla stregoneria," *Rinascimento* 43 (2003): 49–74.

30. Roberts, "The Bodies of Demons," 134–35, 140–41.

31. Stuart Clark, *Thinking with Demons: The Idea of Witchcraft in Early Modern Europe* (Oxford: Clarendon Press, 1997), ix; Stephens, *Demon Lovers*, 277–321.

32. "Virtual reality" is anachronistic shorthand for processes described in *Demon Lovers*, 58–86, 277–321.

33. Stephens, *Demon Lovers*, 20–21.

34. Stephens, *Demon Lovers*, 35.

35. "Unde de daemonibus nullam invenitur nec ipse nec eius sequaces fecisse mentionem" ("for this reason we find that neither he nor his followers made any mention of demons") (Aquinas, *De substantiis separatis*, in *S. Thomae Aquinatis opera omnia*, 7 vols., ed. Roberto Busa et al., [Stuttgart: Friedrich Frommann, 1980], 3:516). Cf. Aristotle, *Metaphysics* 12.8.1073a–1074b; Stephens, *Demon Lovers*, 76–77, 318–31; and Walter Stephens, "Lo scetticismo nel *De perenni philosophia* di Agostino Steuco da Gubbio," in *Storici, filosofi e cultura umanistica a Gubbio tra Cinque e Seicento*, ed. Patrizia Castelli and Giancarlo Pellegrini (Spoleto: Centro Italiano di Studi sull'Alto Medioevo, 1998), 189–218.

36. Stephens, *Demon Lovers*, 25, 36, 318–21.

37. Jeffrey Burton Russell, *The Devil: Perceptions of Evil from Antiquity to Primitive Christianity* (Ithaca, NY: Cornell University Press, 1977), 228; Greenblatt, *Shakespearean Negotiations*, 104; Stephens, *Demon Lovers*, 341 n. 49.

38. Stephens, *Demon Lovers*, 1–86.

39. See Montague Summers's introductions to *The Malleus maleficarum of Heinrich*

Kramer and James [sic] *Sprenger* (1928; rpt., New York: Dover, 1971), v–xl, and Armando Verdiglione's introduction to *Il martello delle streghe: La sessualità femminile nel transfert degli inquisitori*, trans. Fabrizio Buia et al. (Venice: Marsilio, 1977), 9–27.

40. *Malleus maleficarum*, 2 vols., ed. Christopher S. Mackay (Cambridge: Cambridge University Press, 2006). For other recent scholarship and editions of texts, see Golden's *Encyclopedia of Witchcraft*. The University of Lausanne is a leader in publishing early witchcraft texts.

41. Marsilio Ficino, *Three Books on Life*, ed. and trans. Carol V. Kaske and John R. Clark (Binghamton, NY: Medieval and Renaissance Texts and Studies / Renaissance Society of America, 1989), 388–89 (my emphasis). Kaske notes that Ficino is using *spiritus* "in the ordinary [Christian] sense" (389) of higher beings rather than in the medical or Hermetic senses I discuss in the text. Ficino somewhat misquotes Plotinus, *Enneads* 4.3.11: "Those ancient sages . . . perceived that, though this Soul is everywhere tractable, its presence will be secured all the more readily when an appropriate receptacle is elaborated, a place especially capable of receiving some portion or phase of it, something reproducing it, or representing it and serving like a mirror to catch an image of it" (trans. Stephen McKenna, abridg. John Dillon [London: Penguin, 1991], 264). Kaske observes that the third *Book on Life* "was originally part of Ficino's commentary on Plotinus, and is preserved in one manuscript (*P*) as a *Commentary* on Plotinus's *Enneads* 4, Book 3, chapter 11" (7)—that is, precisely this passage.

42. For Ficino's project to convert philosophers to Christian faith, see Michael J. B. Allen, *Synoptic Art: Marsilio Ficino on the History of Platonic Interpretation* (Florence: Olschki, 1998), 1–49.

43. Augustine, *City of God*, 310.

44. Frances A. Yates, *Giordano Bruno and the Hermetic Tradition* (1964; rpt., New York: Vintage, 1969), 17; *Hermetica: The Greek "Corpus hermeticum" and the Latin "Asclepius*,*"* trans. Brian P. Copenhaver (Cambridge: Cambridge University Press, 1992), xlviii–xlix; Mariarosa Cortesi and Enrico V. Maltese, "Per la fortuna della demonologia pselliana in ambiente umanistico," in *Dotti bizantini e libri greci nell'Italia del secolo XV: Atti del convegno internazionale, Trento, 22–23 ottobre 1990*, ed. Mariarosa Cortesi and Enrico V. Maltese (Naples: M. D'Auria, 1992), 129–50; Maltese, "'Natura daemonum . . . habet corpus et versatur circa corpora': Una lezione di demonologia dal Medioevo greco," in *Il demonio e i suoi complici: Dottrine e credenze demonologiche nella tarda Antichità*, ed. Salvatore Pricoco (Messina: Rubbettino, 1995), 265–84.

45. See Kaske's observations in the introduction to *Three Books on Life*, 55–70; Yates, *Giordano Bruno*, 62–83; D. P. Walker, *Spiritual and Demonic Magic from Ficino to Campanella* (1969; rpt., Notre Dame, IN: University of Notre Dame Press, 1975), esp. 45–53; D. P. Walker, *Music, Spirit, and Language in the Renaissance*, ed. Penelope Gouk (London: Variorum, 1985), esp. chaps. 7–15; and Christopher S. Celenza, "The Revival of Platonic Philosophy," *The Cambridge Companion to Renaissance Philosophy*, ed. James Hankins (Cambridge: Cambridge University Press, 2007), 83–90.

46. Richard Kieckhefer, *Magic in the Middle Ages* (Cambridge: Cambridge University Press, 1989); Richard Kieckhefer, *Forbidden Rites: A Necromancer's Manual of the Fifteenth Century* (University Park: Pennsylvania State University Press, 1998); Allen, *Synoptic Art*, 3–5.

47. Kaske, introduction, 62.

48. Maltese, "'Natura daemonum,'" 280.

49. "Natura daemonum non est absque corpore, sed habet corpus, et versatur circa corpora" (*Iamblichus de mysteriis Aegyptiorum: Sammelband neuplatonischer Schriften übersehen und herausgegeben von Marsilius Ficinus* . . . [1497; facs. rpt., Frankfurt am Main: Minerva, 1972]). Quotation at sig. N1r: "Ex Michale [*sic*] psello de daemonibus interpres Marsilius ficinus." There is a new facsimile edition by Stéphane Toussaint (Enghien-les-Bains: Editions du Miraval, 2006). Cortesi and Maltese transcribe Ficino's translation in "Per la fortuna," 151–64; a critical edition of the original Greek (with a French translation) is in "Le *De daemonibus* du Pseudo-Psellos," ed. Paul Gautier, *Revue des Études Byzantines* 38 (1980): 144.

50. Maltese, "'Natura daemonum,'" 280–81; Stephens, *Demon Lovers* 34–37 (cf. 318–21).

51. Maltese, "'Natura daemonum,'" 281, 280.

52. Maltese, "'Natura daemonum,'" 281.

53. Stephens, *Demon Lovers*, 13–31, 145–206, 241–342; Clark, *Thinking with Demons*, 149–311, 435–545.

54. On Sinistrari and Psellus, see Walter Stephens, "Sinistrari, Ludovico Maria (1632–1701)," *Encyclopedia of Witchcraft* 4:1043–44.

55. *Witches, Devils, and Doctors in the Renaissance*, trans. John Shea, ed. George Mora et al. (Binghamton, NY: Medieval and Renaissance Texts and Studies, 1991), 3. Weyer published six editions between 1563 and 1582.

56. Ficino preserves Psellus's references to this "Marcus," beginning sig. N1v. See Pietro Pizzari's introduction to Michele Psello, *Le opere dei demoni* (Palermo: Sellerio, 1989), 16, 22. On Psellus and Byzantine demonology, see Enrico V. Maltese, "Il diavolo a Bisanzio: Demonologia dotta e tradizioni popolari," in *L'autunno del diavolo: "Diabolos, Dialogos, Daimon,"* convegno di Torino, *17–21 ottobre 1988*, vol. 1, ed. Eugenio Corsini and Eugenio Costa (Milan: Bompiani, 1990), 317–33.

57. My emphasis. "Natura daemonum non est absque corpore, sed habet corpus et versatur circa corpora, quod et venerandi patres nostri iudicaverunt; *sunt et qui asserant daemones propria cum corporibus praesentia sibi apparuisse*" (*Iamblichus de mysteriis Aegyptiorum*, sig. N1r [175]). Psellus affirms here that St. Basil attributes bodies (*corpora*) to the angels as well.

58. Walter Stephens, "*De dignitate strigis*: La *copula mundi* nel pensiero dei due Pico e di Torquato Tasso," in *Giovanni e Gianfrancesco Pico della Mirandola: L'opera e la fortuna di due studenti ferraresi*, ed. Patrizia Castelli (Florence: Olschki, 1998), 325–49; Celenza, "Revival," 88–89.

59. Ficino, *Three Books on Life*, 256–57: "Opus est igitur excellentioris corporis adminiculo, quasi non corporis" ("Therefore the aid of a more excellent body—a body not a body, as it were—is needed"). See also Ioan P. Couliano, *Eros and Magic in the Renaissance*, trans. Margaret Cook (Chicago: University of Chicago Press, 1987), 4–6. Ficino's concept of the *copula mundi* is complex, as we see by comparing the *Platonic Theology* (first edition, 1482) and the *Three Books on Life* (first edition, 1489). In the earlier work, Ficino explicitly uses the phrase to refer to soul (*anima*) as the copula that binds the entire cosmic system of being by forming the middle entity in a five-part hierarchy descending from God and the angels to the body and elements (*qualitates*): "But the third essence [*anima*] set between them is such that it cleaves to the higher while not abandoning the lower; and in it, therefore, the higher and the lower are linked together. For it is both immobile and mobile. The former characteristic it shares

with the higher, the latter with the lower. . . . For were it to abandon either, it would swing to the opposite extreme and no longer be the world's true bond [*neque vera erit ulterius mundi copula*]." So in the macrocosm, *anima* performs the same functions as does *spiritus* in the microcosm of the individual: both hierarchies require a middle term that is simultaneously "both / and" and "neither / nor." But Ficino's idea of the microcosm is also more complex than I reveal in the body of this chapter. In a later part of the *Platonic Theology* Ficino declares that when the individual soul descends from its celestial birthplace, it "does not at first mingle with the flesh: it is brought down through the appropriate intermediate stages, as the Persian Magi teach. First, *in the actual descent it is enveloped in a celestial body of air [caelesti aereoque involvitur corpore], and afterwards in a spirit generated from the heart*, which in us is perfectly tempered and dazzlingly bright like heaven. With these as intermediaries, it is enclosed in a coarser body. It becomes equally close to all three, although it transfers itself through one to another; similarly the heat of fire is drawn most closely to air and water, though it is drawn to the water through the air. Appropriately, then, the immortal soul is joined to mortal bodies by means of that immortal aetherial body" (*Platonic Theology*, 6 vols., ed. James Hankins with William Bowen, trans. Michael J. B. Allen with John Warden [Cambridge, MA: Harvard University Press, 2001–6], 1:230–35, 3:130–31 [my emphasis]. See also 2:262–63).

60. Kaske, introduction, 42–44; James J. Bono, "Medical Spirits and the Medieval Language of Life," *Traditio* 40 (1984): 91–130.

61. *Iamblichus de mysteriis Aegyptiorum*, sig. N4r–v (181–82); Stephens, *Demon Lovers*, 310–12.

62. Kaske, introduction, 38–55; Walker, *Spiritual and Demonic Magic*, 3–72; Walker, *Music, Spirit, and Language*, 132–196; see also Charles Dempsey, *Inventing the Renaissance Putto* (Chapel Hill: University of North Carolina Press, 2001), 40–47. In addition to medical spirits, Ficino hypothesized daemons' commonalities with ethereal bodies internal to the human being (Allen, *Synoptic Art*, 140–45).

63. Kaske, introduction, 63–64.

64. Arthur O. Lovejoy, *The Great Chain of Being: A Study of the History of an Idea* (1936; rpt., Cambridge, MA: Harvard University Press, 1964), 52–58; Edward P. Mahoney, "Metaphysical Foundations of the Hierarchy of Being According to Some Late-Medieval and Renaissance Philosophers," in *Philosophies of Existence Ancient and Medieval*, ed. Parviz Morewedge (New York: Fordham University Press, 1982), 165–257; Giovan Battista Gelli, *La Circe*, in *Dialoghi*, ed. Roberto Tissoni (Bari: Laterza, 1967), 145–289.

65. Torquato Tasso, *Il messaggiero*, in *Dialoghi*, ed. Bruno Basile (Milan: Mursia, 1991), 68–69. Throughout, Tasso blurs distinctions between neo-Platonic daemons (*dèmoni*) and Christian "demons" (*demòni*). See Walter Stephens, "Tasso and the Witches," *Annali d'Italianistica* 12 (1994): 181–202, and Stephens, "Incredible Sex: Witches, Demons, and Giants in the Early Modern Imagination," in *Monsters in the Italian Literary Imagination*, ed. Keala Jewell (Detroit, MI: Wayne State University Press, 2001), 153–76.

66. Michael J. B. Allen, "The Absent Angel in Ficino's Philosophy," *Journal of the History of Ideas* 36.2 (1975): 219–40; Tasso, *Il messaggiero*, 67: "But if it were possible to pass from man to God without any intermediary [*mezzo*], this would be an ascent without steps [*gradi*], or without as many as it took to ascend through the other species

to man; and this would not be an ascent [*salita*] but a leap [*salto*]. Thus it is necessary that between God and man we posit some intermediary, *or rather many*, for, if there were only one intermediary between God and man, there would be only one species of higher intellect [*specie intelligibile*]; but there are many of them, because they cannot exist in smaller numbers than the species that depend on sensory impressions [*le sensibili*]."

67. Ps. 8:6; Heb. 2:7.

68. *Iamblichus de mysteriis Aegyptiorum*, sig. N1v (176). The gap is three pages in Psellus's original ("Le *De daemonibus*," 144–45, 150–51).

69. Angus Fletcher, *Allegory: The Theory of a Symbolic Mode* (Ithaca, NY: Cornell University Press, 1964), 59; cf. 42–43, quoting Emil Schneweis, *Angels and Demons According to Lactantius* (Washington, DC: Catholic University of America Press, 1944).

70. For Ficino's witches, see *Three Books on Life*, 196–99; Christopher S. Celenza, *The Lost Italian Renaissance: Humanists, Historians, and Latin's Legacy* (Baltimore, MD: Johns Hopkins University Press, 2004), 107–9.

71. *Iamblichus de mysteriis Aegyptiorum*, sigs. N5r–N6r (183–85), N6v (186). The final, almost burlesque, dramatization of "solution of continuity" is in Milton's "war in Heaven" (*Paradise Lost* 5.316–53).

72. "Le *De daemonibus*," 158–59; *Iamblichus de mysteriis Aegyptiorum*, sig. N3r (179). Ficino translates as "medicorum sectatores" ("partisans of / among the physicians") implying contradiction between the medical and demonological explanations.

73. "Le *De daemonibus*," 158–59; *Iamblichus de mysteriis Aegyptiorum*, sig. N3r (179); Stephens, *Demon Lovers*, 327–29.

74. Cortesi and Maltese, "Per la fortuna," 135. The first complete Latin translation of Psellus's treatise was by Pierre Morel (Paris: Chaudière, 1577); Ficino's translation was retranslated as *Operetta di Michele Psello quale tratta della natura dei demoni e spiriti folletti* (Venice: Sessa il Vecchio, 1545). The Greek original was not printed until 1615 (Paris: Drouart).

75. Stephens, *Demon Lovers*, 346–47; Walter Stephens, "Cesalpino, Andrea (1519–1603)," in *Encyclopedia of Witchcraft* 1:179–80.

76. *Iamblichus de mysteriis Aegyptiorum*, sig. N1r–v (175–76); "Le *De daemonibus*," 146–49; cf. n. 17 above.

77. "Le *De daemonibus*," 148–49; Ficino emphasizes face-to-face interaction, translating "persons who have cultivated visions of daemons" as "eis qui seipsos dediderunt studio *eos in aspectu provocandi*" ("persons who have given themselves to the task of provoking—or calling—them to be seen") (*Iamblichus de mysteriis Aegyptiorum*, sig. N1v [176]).

s i x : The Penis Possessed

I would like to thank Walter Stephens and Bette Talvacchia for generously commenting on early drafts and Alfredo Stussi, Fabio Zinelli, Elena Pierazzo, and Gianmario Cao for their insights into the linguistic context and grammar of the inscription on the verso of the Washington copper plate.

1. See Charles D. O'Malley and J. B. de C. M. Saunders, *Leonardo da Vinci on the Human Body: The Anatomical, Physiological and Embryological Drawings* (New York: Henry Schuman, 1952), 460–61, no. 204.

2. J. Playfair McMurrich, *Leonardo da Vinci the Anatomist* (Baltimore, MD: Williams and Wilkins, 1930), 202–3.

3. Leonardo da Vinci, *The Notebooks of Leonardo da Vinci*, 2 vols., ed. and trans. Edward MacCurdy (New York: George Braziller, 1958), 1:120.

4. McMurrich, *Leonardo da Vinci*, 202.

5. McMurrich, *Leonardo da Vinci*, 201–2.

6. Leonardo da Vinci, *Il Codice Atlantico della Biblioteca Ambrosiana di Milano*, 2 vols., ed. Augusto Marinoni (Florence: Giunti, 2000), 1:186–90, vol. 2, fol. 132r–v and fol. 133r–v, esp. 188–90 (commentary on fol. 133v).

7. See Marinoni's, comments in da Vinci, *Il Codice Atlantico*, 1:188 (vol. 2, commentary on fol. 133v), and Carlo Pedretti, "The 'Angel in the Flesh,'" *Achademia Leonardi Vinci* 4 (1991): 34–48, esp. 38. Salaì's real name was Gian Giacomo Caprotti di Oreno. His relationship with Leonardo is well documented, and while its exact nature can only be a matter of conjecture, it is widely and no doubt rightly assumed to have included a sexual component. See Janice Shell and Grazioso Sironi, "Salaì and Leonardo's Legacy," *Burlington Magazine* 133 (1991): 95–108; Janice Shell and Grazioso Sironi, "Salaì and the Inventory of His Estate," *Raccolta Vinciana* 24 (1992): 109–53; and Bernard Jestaz, "François I, Salaì et les tableaux de Léonard," *Revue de l'art* 126 (1999): 68–72.

8. Marinoni's comments in Leonardo, *Il Codice Atlantico*, 1:288, and Pedretti, "The 'Angel in the Flesh,'" 38, suggest that both authors envision young assistants or pupils in Leonardo's studio drawing these images as a kind of ribald joke, at Salaì's expense. Pedretti, 38 and n. 20, identifies several references to same-sex copulation in Leonardo's drawings; cf. Alessandro Parronchi, "Inganni d'ombre," *Achademia Leonardi Vinci* 4 (1991): 52–56, for an extensive discussion of a Leonardesque drawing (now in a private collection) showing a profile view of a man's head, more or less entirely composed, in an Arcimboldo-like manner, of male sexual organs.

9. There is significant evidence to suggest that sodomy was in fact practiced by Leonardo and other individuals associated with his shop. For the practices and legal conditions of sodomy in general in the fifteenth century, and for the specific case of Leonardo, see Michael Rocke, *Forbidden Friendships: Homosexuality and Male Culture in Renaissance Florence* (New York: Oxford University Press, 1996), esp. 139 and 298 n. 120, concerning the documents of 1476 recording the accusation that Leonardo himself had sodomized the seventeen-year-old Jacopo d'Andrea Salterelli, which did not result in a conviction. Rocke observes that another man had denounced himself for sodomizing Salterelli, lending credibility to the accusation against Leonardo. Cf. Carlo Pedretti, "Paolo di Leonardo da Vinci," *Achademia Leonardi Vinci* 5 (1992): 120–22, concerning the case of a wood-marquetry worker who may have been an assistant of Leonardo's in Florence and who was later banished to Bologna, prior to February 4, 1479, possibly on charges of sodomy.

10. Heinrich Kramer and Jacob Sprenger, *The Malleus maleficarum of Heinrich Kramer and James* [sic] *Sprenger*, trans. Montague Summers (1928; rpt., New York: Dover Publications, 1971), 121. Concerning this passage, see Walter Stephens, *Demon Lovers: Witchcraft, Sex, and the Crisis of Belief* (Chicago: University of Chicago Press, 2002), 300–21; Walter Stephens, "Witches Who Steal Penises: Impotence and Illusion in the *Malleus maleficarum*," *Journal of Medieval and Early Modern Studies* 28 (1998): 495–99; and Malcolm Jones, "Sex and Sexuality in Late Medieval and Early Modern Art," *Pri-*

vatisierung der Triebe? Sexualität in der Frühen Neuzeit, ed. Daniela Erlach, Markus Reisenleitner, and Karl Vocelka (Frankfurt am Main: Peter Lang, 1994), 208–9.

11. See Mark J. Zucker's entry for this object in *The Illustrated Bartsch,* 166 vols. to date, ed. Walter L. Strauss (New York: Abaris Books, 1978–), vol. 24, pt. 3 (commentary), 198–99, no. 029 (verso). See also Jay A. Levenson, Konrad Oberhuber, and Jacquelyn L. Sheehan, *Early Italian Engravings from the National Gallery of Art* (Washington, DC: National Gallery of Art, 1973), 526–27, app. A, b (verso, here titled *Allegory on Copulation*). Cf. Arthur M. Hind, *Early Italian Engraving: A Critical Catalogue with Complete Reproduction of All the Prints Described,* 7 vols. (London: M. Knoedler, 1938–48): vol. 1, pt. 1, 260–61, E.3.29 (the recto of the copper plate, here titled *Various Occupations*), and E.3.30 (the verso, titled *An Allegory on Copulation*). The copper plate, measuring 150 × 224 cm, was formerly in the John Hunt Collection, London.

12. Bette Talvacchia, *Taking Positions: On the Erotic in Renaissance Culture* (Princeton, NJ: Princeton University Press, 1999), esp. 115–24.

13. Levenson, Oberhuber, and Sheehan, *Early Italian Engravings,* 526, note the lack of a satisfactory explanation for this inscription. The following interpretation is my own but reflects their consensus as to the probable grammar of the phrase.

14. Salvatore Battaglia, *Grande dizionario della lingua italiana,* 21 vols., ed. Giorgio Bárberi Squarotti (Turin: UTET, 1961–2002), 4:1040–43, s.v. *duro,* esp. 1041, no. 8 (*risoluto, tenace, deciso*). Zucker, in *The Illustrated Bartsch,* vol. 24, pt. 3, 198–99, 2408.029 (verso), suggests reading the inscription as a command or hortative addressed directly to one of the lovers by name—"Purinega, hold fast" or "Don't let go"—but this is impossible, not only because linguistic experts assure me that "Purinega" could not be a personal name, whether male or female, and because the name of the addressee would not be the initial word in such a grammatical construction, but also because this overly literal translation of the phrase *tien duro* ignores the obvious pun on the concept of the male's erection.

15. For the corresponding usage of *annegare* in the Italian vernacular, see Battaglia, *Grande dizionario,* 1:491–92, s.v. *annegare,* esp. 491, no. 2 (*sopraffare, opprimere, distruggere, annullare*) (transitive usage). Concerning the Venetian use of *i* as the subject and object pronoun of the third person plural, see Gerhard Rohlfs, *Grammatica storica della lingua italiana e dei suoi dialetti,* 3 vols., trans. Salvatore Persichini (Turin: Einaudi, 1966–69), vol. 2, esp. 162, §462 (*i* as third person plural, accusative).

16. See Hind, *Early Italian Engraving,* vol. 1, pt. 1, 260–61, E.3.30, and Levenson, Oberhuber, and Sheehan, *Early Italian Engravings,* 526, who both raise the possibility that the phallic bird in the Washington engraving was conceived to embody this pun. For this metaphoric usage in Italian, see Battaglia, *Grande dizionario,* 23:488–90, s.v., *uccello,* esp. 489, no. 5 ("metafora oscena: membro virile, pene"), and cf. Carlo Battisti and Giovanni Alessio, *Dizionario etimologico italiano,* 5 vols. (Florence: Barbéra, 1975), 5:3941.

17. See H. J. E. van Beuningen and A. M. Koldeweij, *Heilig en profaan: 1000 Laatmiddeleeuwse insignes uit de collectie H. J. E. van Beuningen,* ed. A. M. Koldeweij and H. J. E. van Beuningen (Cothen: Stichting Middeleeuwse Religieuse en Profane Insignes, 1993), 258–64, esp. 260, no. 635 (inv. 2744), for this specimen, dating to around 1375–1425, and cf. nos. 634, 636, 637, 638, 639, and 640 for variations on this theme. Cf. Lorrayne Y. Baird, "*Priapus Gallinaceus:* The Role of the Cock in Fertility and Eroticism in Classical Antiquity and the Middle Ages," *Studies in Iconography* 7–8 (1981–82): 81–111.

18. See A. M. Koldeweij, "A Barefaced *Roman de la Rose* (Paris, B.N. ms. Fr. 25526) and Some Late Medieval Mass-Produced Badges of a Sexual Nature," in *Flanders in a European Perspective: Manuscript Illumination around 1400 in Flanders and Abroad; Proceedings of the International Colloquium, Leuven, 7–10 September 1993*, ed. Maurits Smeyers and Bert Cardon (Leuven: Uitgeverij Peeters, 1995), 499–516, esp. 502, where the "erotic" badges are compared with the Washington engraving, and where the lack of a satisfactory explanation for the vernacular inscription is noted. Cf. Jean Baptiste Bedaux, "Laatmiddeleeuwse sexuelle amuletten: Een sociobiologische benadering," in *Annus quadriga mundi: Opstellen over middeleeuwse kunst opgedragen aan prof. Dr. Anna C. Esmeijer*, ed. Jean Baptiste Bedaux and A. M. Koldeweij (Utrecht: Walburg Pers, 1989), 16–30. See also the important essays of Malcolm Jones, "The Secular Badges," in *Heilig en profaan*, 99–109, esp. 108 n. 40, and "Sex and Sexuality in Late Medieval and Early Modern Art," 187–304, esp. 193–94, where it is argued that humorous intent displaces these amuletic and apotropaic functions and where it is plausibly suggested that the sudden reappearance of this ancient motif in later fourteenth-century France might have been inspired by the discovery of Roman phallic amulets somewhere in the region.

19. Jones, "Sex and Sexuality," 208.

20. Stephens, *Demon Lovers*, esp. 32–57.

21. See Guido Ruggiero, *Binding Passions: Tales of Magic, Marriage, and Power at the End of the Renaissance* (New York: Oxford University Press, 1993), esp. 43–174, for several narratives of love magic reconstructed from the inquisitorial archives.

22. The translation is from Ruggiero, *Binding Passions*, 168. The document (Archivio Segreto Vaticano, Sant'Ufficio, busta 68, Latisana, fol. 67v) is published in Marisa Milani, ed., *Antiche pratiche di medicina popolare nei processi del S. Uffizio: Venezia, 1591* (Padua: Centrostampa Palazzo Maldura, 1986), 166 (interrogation of June 11, 1591): "Et ad interrogationem dixit: Il modo ch'io tenevo nel desligar quelli che non potevano usar con le loro moglie è questo. Ad alcuni li facevo metter sotto il letto l'arador, che è quelli ferri con che si arano la terra. Ad altri li facevo metter il zappon et il badil, che si adopera nel sepelir li morti. Ad altri li faceva pigliar [una vera], con la qual fosse stata sposata una donzella, et che la fosse posta nell'acqua benedetta, et che quel tal orinasse per quella vera."

23. Joanne Ferraro, *Marriage Wars in Renaissance Venice* (Oxford: Oxford University Press, 2001), 76–78.

24. Ferraro, *Marriage Wars*, 78. Peter Humfrey, *Lorenzo Lotto* (New Haven, CT: Yale University Press, 1997), 139–40, argues that this was a "wedding picture," a function entirely consistent with the impotence-fighting motif.

25. Henry E. Sigerist, "Impotence as a Result of Witchcraft," in *Essays in Biology in Honor of Herbert M. Evans* (Berkeley: University of California Press, 1943), 541–46, esp. 541–44, for the fifteenth-century text, including "Maleficiorum enim quaedam de animatis fiunt, ut testiculi galli si sint suppositi lecto cum ipso sanguine, efficiunt ne concumbant in lecto iacentes" (541) and the translation (543).

26. My emphasis. See Sigerist, "Impotence as a Result of Witchcraft," 542 for the text ("Si enim maleficium recte extirpare volumus, videndum est, si supradictum maleficium subsit lecto, auferatur") and 543 for the translation.

27. It may be significant that this log shows the stumps of pruned branches and also has one small twig bearing three leaves. Cf. the early sixteenth-century north Italian

print portraying lovers copulating, illustrated in Zucker, in *The Illustrated Bartsch*, vol. 25 (commentary), 238, no. 2509, where the lovers have not only adopted the same coital posture as those in the Washington engraving but are also flanked by heavily pruned trees that similarly exhibit a single leafy twig.

28. For this second image, see esp. Zucker, in *The Illustrated Bartsch*, vol. 24, pt. 3 (commentary), 198–99, no. 2408.028 (recto), and Levenson, Oberhuber, and Sheehan, 526–27, app. A, a (recto, here titled *Various Occupations*).

29. See generally Frances Biscoglio, "Unspun Heroes: Iconography of the Spinning Woman in the Middle Ages," *Journal of Medieval and Renaissance Studies* 25 (1995): 163–76, esp. 174–75, and Christiane Andersson, *Dirnen, Krieger, Narren: Ausgewählte Zeichnungen von Urs Graf* (Basel: GS-Verlag, 1978), 41–42. For a specific instance of this iconographic topos in a painting by Pieter Pietersz (Rijksmuseum, Amsterdam), see also Konrad Renger, *Lockere Gesellschaft: Zur Ikonographie des Verlorenen Sohnes und von Witschaftszenen in der niederländischen Malerei* (Berlin: Mann, 1970), esp. 114–15.

30. For the bagpipes, see Keith P. F. Moxey, "Master E. S. and the Folly of Love," *Simiolus* 11 (1980): 125–48, esp. 131 and n. 18. Cf. Jones, "Sex and Sexuality," 217–18, for the small model of the male genitals dangling from the instrument as a waxen *realium*. For the use of similar models of the male genitalia in popular magic and religion, see Johan Weyer, *Witches, Devils, and Doctors in the Renaissance*, trans. John Shea, ed. George Mora (Binghamton, NY: Medieval and Renaissance Texts and Studies, 1991), 464, and Ruggiero, *Binding Passions*, 57–60, 69–72, and 119–20.

31. Jones, "Sex and Sexuality," 218.

SEVEN: Nymphomaniac Matter

I wish to thank Julia Hairston and Walter Stephens for their many valuable suggestions and comments and for their proofreading of this paper. I am grateful for a travel grant given by the Oesterreichische Forschungsgemeinschaft, which allowed me to present an early version of this paper at "The Body in Early Modern Italy" conference at the Johns Hopkins University in 2002.

1. Giordano Bruno, *Cause, Principle and Unity: Essays on Magic*, trans. Robert de Lucca (Cambridge: Cambridge University Press, 1998), 74; Giordano Bruno, *De la causa, principio et uno* (1584; facs. ed., Florence: Olschki, 1999), 95–96: "La donna non è altro che una materia; se non sapete che cosa è donna, per non saper che cosa è materia, studiate alquanto gli Peripatetici che con insegnarvi che cosa è materia, te insegneranno che cosa è donna."

2. Bruno, *Cause, Principle and Unity*, 72; Bruno, *Causa*, 93:

Del primo della *physica, in calce*. Dove volendo elucidare che cosa fosse la prima materia; prende per specchio il sesso femminile, sesso dico, ritroso, fragile, incostante, molle, pusillo, infame, ignobile, vile, abietto, negletto, indegno, reprobo, sinistro, vituperoso, frigido, deforme, vacuo, vano, indiscreto, insano, perfido, neghittoso, putido, sozzo, ingrato, trunco, mutilo, imperfetto, inchoato, insufficiente, preciso, amputato, attenuato, rugine, eruca, zizania, peste, morbo, morte. (my emphasis)

3. Aristotle, *Physics*, trans. Robin Waterfield (Oxford: Oxford University Press, 1996), 32; Aristotle, *Opera cum Averrois commentariis*, 12 vols., trans. Iacobus Mantino

(1562–74; facs. ed., Frankfurt: Minerva, 1962), vol. 4, fol. 55rB–C: "Et hoc potes scire, si incoeperis definire utrunque modum, scilicet naturam, & accidentia, invenies nonne definitionem paris, & imparis, & recti, & curvi, & etiam numeri, & lineae, & figurae extra motum, quod non invenies in definitione carnis, aut ossis, aut hominis, sed ista dicuntur sicut dicitur simus, non sicut dicitur curvus."

4. Alessandro Piccolomini, *Della filosofia naturale* (Venice: Francesco dei Franceschi, 1585), lib. 2, chap. 3, fol. 25r:

> Nondimeno in questo da tutti gli altri è differente il filosofo naturale, che non separando mai i concetti delle forme, da quei delle proprie materie loro; ambedue queste nature abbracia, come respettiva l'una dell'altra; cioè la materia: & la forma: le quali sono i due principij, & le due cause intrinseche delle cose naturali; che da quelle: come da lor parti essentiali dependano in modo: che dal separarsi, che faccia l'una dall'altra, è necessario, che la destruttione de i lor composti nasca subito.

> (Nevertheless, in this respect the natural philosopher differs from all the others because he never separates the concepts from the forms or separates them from the different forms of matter that are appropriate to them; he embraces both of these natures, as though one were referring to the other: that is, the matter and the form: these two are the principles and the intrinsic causes of natural beings, which are dependent on [matter and form] as their essential parts; and when they are separated from each other, what is composed of them will immediately and of necessity disintegrate.)

Unless otherwise noted, all translations are my own.

5. J. C. M. van Winden, *Calcidius on Matter, His Doctrine and Sources: A Chapter in the History of Platonism* (Leiden: Brill, 1959), 175; Calcidius, *Timaeus a Calcidio translatus, commentarioque instructus in societatem operis coniuncto P. J. Jensen*, ed. J. H. Waszink (London: Warburg Institute, 1962), §322: "Restat ut res ipsa difficilis et obscura sit. Nec silva quicquam difficilius ad explanandum ergo cuncta quae de natura eius dicta sunt mere praedita veritatae sunt, nec tamen aperte dilucide."

6. Giovanni Paolo Pernia, *Philosophia naturalis ordine definitvo tradita* (Padua: Simone Gaglinano de Karera, 1570), fol. 15vB.

7. Aristotle, *Physics*, 31; Aristotle, *Opera*, vol. 4, fols. 45v–46r:

> Attamen neque ipsum suam ipsius possibile est appetere formam, propterea quod non est indigens, . . . sed hoc est materia, sicut si foemina masculum, & turpe pulchrum: verum non per se turpe, sed secundum accidens: neque foemina, sed secundum accidens. (Moerbeke interp.)

> (Nevertheless it is impossible for form to desire itself, because it is not in need of itself; . . . it is rather matter that is indigent. In such ways as a woman needs a man, and the ugly, the beautiful, though it is not ugly in itself but only accidentally, and neither is a woman [ugly] but only accidentally.)

> Impossibile est ut forma appetat se, quoniam non est diminuta, neque appetit suum contrarium, . . . sed materia appetit formam, sicut foemina mare, & turpe pulchrum: non quia in se est turpis, sed per accidens; neque quia est foemina, sed per accidens. (Mantino interp.)

(It is impossible that form desires itself, because it is not impaired and it does not desire its contrary, . . . but matter desires form as a woman desires a man and as the ugly desires the beautiful: not because it is ugly in itself but accidentally and not because it is a woman but accidentally.)

8. Thomas Aquinas, *In octo libros de physico auditu sive physicorum Aristotelis*, ed. F. Pirotta (Naples: D'Auria, 1953), 68a; Avicenna, *Opera in luce redacta ac nuper quantum ars niti potuit per Canonicos emendata: Liber qui dicitur sufficientia* (1508; facs. ed., Frankfurt: Minerva, 1961), fol. 15r–v.

9. Thomas Aquinas, *In octo libros*, 68b:

Nihil est igitur aliud appetitus naturalis quam ordinatio aliqam secundum propriam naturam in suum finem. . . . [F]orma est finis materiae. Nihil est a illud materiam appetere formam quam eam ordinari ad formam, ut potentia ad actum.

(Therefore the natural appetite is nothing else but a certain direction according to its own nature toward its goal. . . . [F]orm is the goal of matter. As potency toward act, so matter only wants to be ordered toward form, but it does not desire anything else from form.)

But it seems to me highly debatable whether the example of the craftsman can account for the specific desire of matter for form.

10. 737a27–28. The full passage, emphasizing the indispensable role of the male sperm as giver of soul, in Aristotle, *Opera*, vol. 6, fols. 74vM–75rA, is as follows: "Femina enim quasi mas laesus est. Et menstrua semen sunt, quanquam non purum; unum enim illud non habent, originem et principium animae" ("For the female is, as it were, a mutilated male, and the menstrual fluids are semen, only not pure, for there is only not one thing they have in them, the principle of the soul" [*Generation of Animals*, trans. A. D. Platt, in *The Works of Aristotle*, rev. ed., ed. Jonathan Barnes (Princeton, NJ: Princeton University Press,1984), 1:1144]). On the "impotence" of the female animal on account of its inability to cook the blood adequately to produce sperm, see *Generation of Animals* 728a17–19, in Aristotle, *Opera*, vol. 6, fol. 59vH: "Forma etenim similis mulieris et adolescentuli est, et mulier quasi mas inseminis est. Impotentia enim quadam femina est, eo quae semen ex ultimo alimento concoquere nequeat" ("Now a boy is like a woman in form, and the woman is as it were an impotent male, for it is through a certain incapacity that the female is female, being incapable of concocting the nutrient in its last stage into semen" [*Generation of Animals*, 1:1130]).

11. Averroes, in Aristotle, *Opera*, vol. 4, fol. 46r–vD–G:

Et intelligit hic per appetitum illud, quod materia habet de motu ad recipiendum formam. appetitius enim alius ex naturalis sine sensu, ut in plantis ad nutrimentum: & alius est cum sensu, ut appetitus animalium ad nutriendum. In materia igitur est appetitus naturalis ad recipiendium omnes formas. Recipit igitur eas alternatim, quando forma agens est praesens. . . . Materia appetit formam sicut femina marem. & licet non usitetur comparatio in doctrina demonstrativa, tum usitatur in rebus non sensibilibus, quae non intelliguntur nisi per comparationem. Deinde quia non est in se, sed per accidens. Quia turpitudo accidit ei ex privatione mixta cum ipsa materia, & in se non est privatio, est igitur turpis per

accidens. & similiter est femina per accidens: quia femina est homo imperfectus: feminitas enim accidit ex ei privatione.

(And [Aristotle] understands by this appetite the movement that is inherent in matter by which it receives the forms. For there is one sort of appetite that arises in natural things that are lacking sense perception, as in plants for nourishment. Another sort of appetite [arises in animals] that have sense. In matter therefore arises a universal natural appetite to receive all forms. [Matter receives these forms,] one after another, when a [certain] active form is present. . . . Matter therefore desires form as a woman desires a man. Yet one may use this comparison not as a demonstrative doctrine, because it [explains] things that are not sensible and that can be known only through a [sort of] comparison. Therefore [matter] is not per se [ugly] but rather accidentally [so]. Ugliness is an accidental property of [matter] because of the admixture of privation with matter itself, and as matter is not privation in itself, it is ugly by accident. And in a similar way woman is [ugly] accidentally, because woman is an imperfect man: femininity is an accidental result of the privation [of manhood].)

12. Alessandro Achillini, *De physico auditu*, in *Opera omnia in unum collecta* (Venice: Hieronimus Scotus, 1545), fol. 87rA:

Nota . . . femina est homo imperfectus. Scias naturam intendere in generatione masculum, et non feminam, ideo si generatur femina est per accidens, non tamen casuale vel fortuitum, quia ut in pluribus est. Istud tamen per se accidens est necessarium, sine quo non servatur duratio masculis in sibi simili aut dic mulierem esse intentam in quantum est aliquo modo masculus.

(Note that woman is an imperfect man, and know that nature intends to generate males and not women. And [note that] in the same way, if women are generated, it is accidentally, though neither casually nor haphazardly, because it happens very frequently. Even though this happens accidentally, it is necessary, because otherwise the male could not persist in his likeness: alternatively, you can say that woman is [generated] intentionally, [by nature] insofar as she is male in some sense.)

13. Bruno, *Cause, Principle and Unity*, 71; Bruno, *Causa*, 92:

Contempla, contempla, divino ingegno, qualmente gli egregi philosofanti, et de le viscere della natura discreti notomisti, per porne pienamente avanti gl'occhi la natura della materia, non han ritrovato piu accomodato modi, che con avertirci con questa proportione; qual significa il stato delle cose naturali per la materia, essere come l'economico, politico e civile per il femineo sesso.

14. Jacopo Zabarella, *De rebus naturalibus*, bk. libri 30 (Venice: Paulus Meietus, 1590), 108; see also 109. Simone Porzio, *De rerum naturalium principiis*, bk. 2 (Naples: Matthias Cancer, 1553), chap. 9 (unpaginated): "Itaque materia appetit esse, non tamen magis per hanc formam quam per aliam, idque ob suam potentiam indeterminatam" ("Matter therefore desires being, though it is not more inclined to this form than to [any] other form, and this [inclination] is [caused by] the indeterminate potency [of matter]").

15. Originally, the concept of privation was introduced by Aristotle as a third term after matter and form to explain the phenomenon of change. He says that the change, for instance, involved in education may be described as follows: a man goes from being merely a man to being an educated man. In that context, "coming into being" or "generation" means that something changes from one given form into another. From X he becomes Y implies the disappearance of X. X therefore describes or includes privation (Aristotle, *Physics*, 26–27; Robin Waterfield, introduction, Aristotle, *Physics*, xx).

16. Maria Serena Mazzi, *Prostitute e lenoni nella Firenze del Quattrocento* (Milano: Mondatori, 1991), 189: "Per definizione esplicita della legge canonica una prostituta è una donna disponibile al desiderio di molti uomini, dunque l'essenza della sua funzione risale nella promiscuità" ("By explicit definition of canonical law, a prostitute is a woman who is available to the desire of many men, and therefore the essence of her function refers to her promiscuity").

17. Piccolomini, dedication to Pope Julius III, dated April 28, 1550, *Della filosofia naturale*. On Piccolomini in general, see Rufus Suter, "The Scientific Work of Alessandro Piccolomini," *Isis* 60 (1969): 210–22, and Marie-Françoise Piéjus, "L'orazione in lode delle donne di Alessandro Piccolomini," *Giornale storico della letteratura italiana* 170 (1993): 524–50. For a biography, see Florindo Cerreta, *Alessandro Piccolomini, letterato e filosofo senese del Cinquecento* (Siena: Accademia, 1960).

18. Piccolomini, *Della filosofia naturale*, lib. 1, chap. 6, fol. 14v:

> Pronta sempre a disporsi per tutte ugualmente, come quella, che non si satia né si contenta d'una forma sola; ma havendo appetito a tutte, non ha prima l'una sopra di se, che quasi pentita & infastidita, comincia ad aspirare all'altra; non essendole più propria questa che quella: di maniera che molti l'assomigliano ad una publichissima meretrice: percioche, si come una donna tale, della conversatione di qualsivoglia huomo non si satia mai, & non più di questo che di quello essendo amica; non prima sta sotto l'uno che desiderando l'altro, cerca dal primo scostarsi: cosi questa prima materia commune atta, & pronta per natura sua à desiderar tutte le materiali forme, & a poter conseguirle, non essendo possibil che più d'una in un'istesso tempo sostenga mai; è necessario che mentre che sta sotto l'una, per l'appetito c'ha delle altre, si spogli di quella al fine; & quindi della nuova vestita poi, tosto per altre il medesimo faccia di mano in mano; mentre succedon le forme l'una dopo l'altra perpetuamente.

19. On Piccolomini's persistent misogyny in his other relevant works (e.g., *Raffaella* and *L'orazione in lode delle donne*), see Piéjus, *Orazione*, 535–36.

20. Piccolomini, *Della filosofia naturale*, lib. 1, chap. 6, fol. 15r:

> Onde, si come, se fosse alcuna persona, che per non esser da noi conosciuta, andasse sempre nascosta in mascara non discoprendosi il volto mai, anzi doppo l'una mascara, subito prendesse l'altra, se bene in questo caso, noi non conoscessimo veramente qual faccia egli d'huomo havesse; nondimeno per rispetto, & proportion della mascara, conosceremmo che fusse un'huomo quello che di cosi fatta mascara coperto andasse; per non poter esser portata la mascara, se non è alcun huomo, che quella porti: cosi parimente stando sempre questa materia prima, sotto la mascara della forma che la ricopre tutta, nè discoprendosi un punto mai; altra notitia non sarà possibil, che mai se n'habbia, se non quanto

il rispetto, & proportione alla forma, ci faccia havere, mentre che noi dalla suc-
cession delle forme argomentando, conosceremmo che un soggetto commun
si trova, non generabile nè corrottibile, ignudo d'ogni forma propria, & d'ogni
atto, & disposition domestica, il quale havendo appetito verso di tutte le forme
materiali, successivamente le riceve di mano in mano.

21. Guillelmus Peraldus, "De eruditione principium," in *S. Thomae Aquinatis opera
omnia*, 7 vols., ed. Roberto Buso (Stuttgart: Frommann Holzboog 1980), 7:115: "Abo-
minari debent [sc. puellae nobiles], quae solae meretrices facere solent, ut capillorum
tinctionem, faciei dipinctionem, rugas vestimentorum" ("These [noble young women]
have to be abhorred, who do what only prostitutes normally do: that is, dying their
hair, using makeup, and painting over their wrinkles"). On face painting as unset-
tling boundaries in early modern theater, see, for instance, Tanya Pollard's fine paper
"Beauty's Poisonous Properties," *Shakespeare Studies* 27 (2001): 187–210.

22. Piccolomini, *Della filosofia naturale*, lib. 1, chap. 6, fol. 15r:

Vien perpetuamente spogliandosi dell'una, & l'altra vestendosi, à cercare con
ogni suo potere, di far contento questo appetito eterno che tiene: non restando
mai dispolgliata, & ignuda al tutto di forme; anzi non prima dell'una si spo-
glia; che in quel medesimo instante è vestita di quella che ne succede: come
(per esempio) non prima della forma di Cornelio si spogliara questa materia
commune, che dalla forma del cadavero rivestirassi: nè di questa restarà innanzi
prima, che di un'altra forma, ò di terra ò di vermi ò d'altra cosi fatta, ricoprir-
assi, & cosi seguirà di far eternamente, succedendo d'una forma in l'altra, per la
continua generation, & corrottion delle cose; generandosi sempre, & sorgendo
una forma nella destruttion dell'altra.

([Matter] is constantly [taking off] one [form] and [putting on] another [form].
It is thereby constantly seeking to satiate an eternal desire of which [it] is pos-
sessed. And it never becomes entirely undressed and naked of forms; nay, it never
[takes off] one form without dressing itself in the same instant with the suc-
ceeding one. For instance, this common matter does not [take off] the form of
Cornelius without redressing itself with the form of [his] corpse; and it does
remain [in this state] as long as it does not cover itself with a different form, be
it earth, or worms, or other similar ones: because of the continuous generation
and corruption, matter therefore continues to act eternally, following from one
form into another, and is thus always generating one form following the destruc-
tion of another.)

23. Universal matter for Ibn Gabirol occupies the highest position in the hierarchy
of being; matter contains everything, carries everything, and is the locus of all things
(*Fons vitae ex arabico in latinum translatus ab Iohanne Hispano et Dominico Gundis-
salino*, ed. Clemens Baeumker [Münster: Aschendorff, 1895], 262; Férnand Brunner,
"Sur l'hylemorpisme d'Ibn Gabirol," *Les Études Philosophiques* 8 ([1953]: 31). Matter
is responsible for the unity of the cosmos, whereas form functions as the principle of
diversification. "In its relationship to form, matter is the invisible and hidden reality"
(*Fons vitae*, 19). "Matter is the essence and the substance of all things and it is self-
subsisting" (*Fons vitae*, 298–99). Yet in other passages the relationship between matter

and form becomes more dialectical. Here form comes first, and then matter moves to receive it (*Fons vitae*, 212).

24. Bruno, *Cause, Principle and Unity*, 173; Giordano Bruno, "De vinculis in genere," *Opere magiche*, ed. Michele Ciliberto (Milan: Adelphi, 2000), 518:

> Altius quippe summi amore boni flagrat quod perfectius est quam quod imperfectum. Perfectissimum ergo est illud principium quod fieri vult omnia, et quod non ad particularem formam fertur et particularem perfectionem, sed ad universam formam et ad universam perfectionem. Eiusmodi est materia per universum, extra quam nulla est forma, in cuius potentia, appetitu et dispositione sunt formae, et quae in partibus suis vicissitudine quadam omnes recipit formas, quarum simul vel duas recipere non posset. Et divinum ergo quoddam est materia.

For other references to Ibn Gabirol, see, for example, Bruno, *Causa*, 63 and 97.

25. Marsilio Ficino's relationship to Lucretian materialistic theories of vision and contagion provides a good example of how materialistic concepts manifested themselves in Renaissance neo-Platonism. See Michael J. B. Allen, *Icastes: Marsilio Ficino's Interpretation of Plato's "Sophist"* (Berkeley: University of California Press, 1989), 193–95.

26. See, for instance, Charles B. Schmitt, *Aristotle and the Renaissance* (Cambridge: Cambridge University Press, 1983), 102–3.

27. Denis O'Brien, "Plotinus on Matter and Evil," *The Cambridge Companion to Plotinus* (Cambridge: Cambridge University Press, 1996), 182; Robert Klein, "L' imagination comme vêtement de l'âme chez Marsile Ficin et Giordano Bruno," *Revue de Métaphysique et Morale* 1 (1956): 18–39.

28. Jacopo Zabarella, *Commentarii magni Aristotelis in libros physicorum*, 3 vols. (Frankfurt: Wolfgang Richter sumptibus I. T. Schônvetter, 1602), 1:279:

> Materia enim secundum se aeque ad omnes est inclinata, formarum autem presentem non odio habet, quia secundum se omnes aeque amat, sed quia nulla forma potest in materia manere perpetuo, ideo materia non potens eam, quam habet, diu retinere, nolens rimanere, sine forma, aliam appetit, . . . ideo secundum se est contentus qualibet forma, quam habet, sed cum natura illius formae fit talis, ut necessario debeat corrumpi, ideo materia non potens eam retinere amplius, quam quaerit.

> (According to itself, matter is inclined toward all [forms]. It does not loathe the present forms, because according to itself, matter loves all of them equally. But as no form can remain in matter forever, so matter is incapable of retaining the one it has [over] longer [periods of time]. And since it does not want to remain without form, matter desires another [form] . . . and therefore, according to itself, matter is content with whatsoever form it has, but as the nature of this form is such that is has to disintegrate of necessity, so matter is incapable of retaining [form any longer] as it wants.)

29. On that tradition, see John Charles Nelson, *Renaissance Theory of Love* (New York: Columbia University Press, 1958) and Sabrina Ebbersmeyer, *Sinnlichkeit und Vernunft: Studien zur Rezeption und Transformation der Liebestheorie Platons in der Renaissance* (Munich: Fink, 2002).

30. Marsilio Ficino, *Three Books on Life*, ed. and trans. Carol V. Kaske and John R. Clark (Binghamton, NY: Medieval and Renaissance Texts and Studies / Renaissance Society of America, 1989), 384–85:

> Nonne in ipso fetu natura, fetus ipsius artifex, cum certo quodam pacto corpusculum affecerit figuraveritque hoc ipso statim praeparamento, velut esca quadam spiritum ab universo deducit? Perque hunc velut fomitem vitam haurit atque animam? Ac denique per certam animae speciem dispositionemque corpus ita vivens dignum est paesentia mentis tandem donatae divinitus.

31. On Leone Ebreo in general, see T. Anthony Perry, *Erotic Spirituality* (University: University of Alabama Press, 1980); Heinz Pflaum, *Die Idee der Liebe: Leone Ebreo* (Tübingen: Mohr, 1926); and Sergius Kodera, *Filone und Sofia in Leone Ebreos "Dialoghi d'amore"* (Frankfurt: Peter Lang, 1995).

32. Pflaum, *Idee der Liebe*, 151; Kodera, *Filone und Sofia*, 10–11.

33. León Hebreo, *The Philosophy of Love*, trans. F. Friedberg-Seeley and Jean H. Barnes (London: Soncino Press, 1937) 84; Leone Ebreo, *Dialoghi d'amore* (Rome: Blado, 1535; facs. ed., Heidelberg: Carl Winter, 1924), bk. 2, fol. 11r:

> [La materia] . . . (come dice Platone) appetisce, & ama tutte le forme de le cose generate, come la donna l'huomo, & non satiando il suo amor' l'appetito, el desiderio, la presentia actual' de l'una de le forme s'innamora de l'altra che li manca, & lassando quella piglia questa, di maniera che non possendo sostener' insieme tutte le forme in atto, le riceve tutte successivamente, l'una doppo l'altra; Ancor' possiede in molte parti sue tutte le forme insieme, ma ogn'una di quelle parti, volendo goder' de l'amore di tutte le forme, bisogna loro successivamente di continuo trasmutarsi de l'una, ne l'altra, che l'una forma non basta a satiar' il suo appetito, & amore, il qual' excede molto la satisfatione, ch'una sola forma di queste non puo satiare questo suo insatiabile appetito, . . . per la qual' cosa alcuni la chiamano meretrice, per non aver unico ne fermo amore ad' uno, ma quando l'ha ad uno, desidera lassarlo per l'altro.

34. Ebreo, *The Philosophy of Love*, 84 (trans. slightly modified); Leone Ebreo, *Dialoghi*, bk. 2, fol. 11r–v: "Pur con quest'adultero amore s'adorna il Mondo inferiore di tanta, & cosi mirabil' diversità di cose, cosi bellamente formate, si che l'amor generativo di questa materia prima, et il desiderio suo sempre del nuovo marito che li manca, e la dilettatione che riceve del nuovo coito, è cagion' de la generatione di tutte le cose generabili."

35. See Sergius Kodera, "Masculine / Feminine: The Concept of Matter in Leone Ebreo's *Dialoghi d'amore*," *Zeitsprünge* 7 (2004): 481–517.

36. Piccolomini, dedication to Pope Julius III, fols. 4v–5r:

> Hor'io in questa impresa mi son'eletto tra quanti dottamente ne gli anni corsi, han filosofato ne i libri loro: per mio Prencipe, & guida Aristotele, il quale in molte cose (secondo il mio giuditio) dissentisce da Platone, & più ordinatamente, scrive lui. Dalla dottrina d'Aristotele dunque, non si dilungaranno i scritti miei, se non inquanto alcuna volta la strada, ò del senso, ò di pianissima dimostratione mi si disviasse.

(In this endeavor I now have chosen for myself Aristotle among so many who have philosophized over the past years with erudition in their books: he is my guide, and (in my opinion) he disagrees in many ways with Plato, and his writings are in better order. Therefore my writings only will go astray from Aristotle, if sometimes the road, or the meaning, or the obvious demonstration may derail me.)

37. Ficino's commentary on the *Timaeus* is a good example, as the author claims that not only Plato and Aristotle but also the Pythagoreans were in accordance on the doctrine of the transformation of the elements (*Commentarium in "Timaeum,"* in *Opera omnia* [Basel: Froben, 1576; facs. ed., Turin: Bottega d'Erasmo, 1962], 464: "Sed haec [sc. mixtio invicem commutatio elementorum] ferme omnia Pythagorico more sub obscuris metaphoris involvuntur: apertioribus autem verbis, Platonem auditoribus suis tradidisse putamus, et Aristotelem prae caeteris manifestius eadem literis commendasse"). The *materia-meretrix* metaphor could indeed be used to describe the doctrine of the universal receptacle, an important aspect of Plato's doctrine on matter in the *Timaeus;* see Plato, *Timaeus and Critias,* trans. Desmond Lee (London: Penguin, 1977), 69: "For it continues to receive all things, and never itself takes a permanent impress from any of the things that enter it; it is a kind of neutral plastic material on which changing impressions are stamped by the things which enter it, making it appear different at different times." Aristotle's natural philosophy was already accepted by Middle Platonists: see, for instance, Winden, *Calcidius on Matter,* 144–45.

38. See the beginning of this chapter and nn. 8–9, 11, 14.

39. Ebreo, *Dialoghi,* bk. 2, fol. 69v, bk. 3, fols. 75v and 123v.

40. Moses Maimonides, *The Guide of the Perplexed,* trans. Shlomo Pines (Chicago: University of Chicago Press, 1963), 43; *Timaeus* 50d.

41. Daniel Boyarin, *Carnal Israel: Reading Sex in Talmudic Culture* (Berkeley: University of California Press, 1993), 58; cf. Maimonides, *The Guide of the Perplexed,* 13.

42. Maimonides, *The Guide of the Perplexed,* 431.

43. Maimonides, *The Guide of the Perplexed,* 431. On the precedents of this idea in ancient Greek culture, see Anne Carson, "Putting Her in Her Place: Woman, Dirt, and Desire," in *Before Sexuality: The Construction of Erotic Experience in the Ancient Greek World* (Princeton, NJ: Princeton University Press 1990), 141: "The voracious woman, by her unending sexual demands, 'roasts her man' in the unquenchable fire of her appetite, drains his manly strength and delivers him to the 'raw old age of premature impotence.'"

44. Boyarin, *Carnal Israel,* 58; Maimonides, *The Guide of the Perplexed,* 431: "For example, man's intelligent apprehension of his Creator, his mental representation of every intelligible, his control of his desire and his anger . . . are all of them consequent upon his form. On the other hand, his eating and drinking and copulation and his passionate desire for all these things . . . are all of them consequent on his matter." On the reification of women in classical Greece, see, for example, Carson, "Putting Her in Her Place."

45. Boyarin, *Carnal Israel,* 58.

46. Maimonides, *The Guide of the Perplexed,* 434.

47. *Biblia Sacra iuxta vulgatam versionem,* ed. Roger Gryson, B. Fischer, I. Gribo-

mont et al. (Darmstadt: Deutsche Bibelgesellschaft, 1994), col. 962: "Pretium enim scorti vix unius est panis / mulier autem viri pretiosam animam capit."

48. K. T. Aitken, "Proverbs," *The Oxford Bible Commentary* (Oxford: Oxford University Press, 2001), 406a.

49. Aitken, "Proverbs," 410b.

50. Talmud Yerushalimi, *Sota*, vol. 3, pt. 2, trans. Frowald Gil Hüttenmeister (Tübingen: Mohr Siebeck, 1988), 14.

51. See, for example, Tommaso Garzoni, *La piazza universale di tutte le professioni del mondo* (Venice: Gio. Battista Somaco, 1589; facs. ed., Ravenna: Essegi, 1989) 601–2:

> Per ultima conclusione si conchiude quanto da loro si riceve, et acquista, che non è altro, che mille immondezze, et sordidezze, le quali honestamente nominare non si ponno; et s'abellisce il concetto descrivendo quanto son brutte, sporche, laide, infami, furfante, pidocchiose, piene di croste, cariche di menstruo, puzzolenti di carne, fetenti di fiato, ammorbate di dentro, appestate di fuori, che le Gabrine in comparatione son piu desiderabili che loro.

> (To conclude: it has to be acknowledged that from these [prostitutes] one receives and acquires what is nothing else but a thousand kinds of rubbish and waste, which cannot be explained in a decent way. And this becomes even clearer when one describes how ugly, dirty, unseemly, infamously thievish, full of lice, full of scabs, soaked with menses, flesh stunk, foul breathed, internally disintegrated, [and] bruised externally they are, so that even the Gabrines are more desirable.)

On la Gabrina, a terrible old woman, see Ariosto, *Orlando furioso* 21. For the use of the prostitute as a highly ambivalent metaphor describing Renaissance rhetoric, see, for example, Wayne A. Rebhorn, *The Emperor of Men's Minds: Literature and the Renaissance Discourse of Rhetoric* (Ithaca, NY: Cornell University Press 1995), 140–41.

52. Garzoni, *La piazza universale*, 597–98:

> Da questo seguito grande, c'hanno havuto le femine vergognose et infami in tutte le parti dell mondo; infiniti danni particolari, & communi in processo di tempo si sono scoperti ai seguaci di quelle. . . . E in somma tutti i mali grandi son venuti per cagione delle meretrici. E che cosa di bene puo succedere da loro, essendo piene di tutte le malitie, di tutti gli inganni, di tutti i vitij che imaginar si possono? non son elleno maestre compite di tutti gli errori? E cosa di grandissima fatica, e d'un peso intolerabile a voler descrivere particolarmente l'astutie, & l'arti loro, e raccontar con che modo, con che piacevolezza con che sguardo, con che parole, con che baci, con che carezze, con che nodi, con che reti, con che lacci, con quai tratteniementi, con quai lusinghe, con con quai toccamenti, . . . con che atti, con quai lascivi maneggiamenti, con quai lotte, con quai costumi, con quai risi, con quali simulationi, con quai fraudi, e fintioni, con quai false lagrime, con che sospiri, con che gemiti, con che dipartenza, con qual prolungatione di piacere, con qual scambiamento, et con qual rinnovatione cerchino inveschiare i giovanetti inesperti, e farseli servitori e schiavi ad ogni loro piacere.

> (From this big success [in seducing men], which the shameless and infamous women have had over the years, their followers [customers] suffered enormous damages to [their] individual [as well as to their] common [properties].

. . . And in general, all big diseases were caused by prostitutes. And what good may come from them, as they are all frauds, full of malice and all the vices one can imagine? Are they not accomplished masters of all the aberrations? It is a matter of the utmost importance and of unbearable weight to exactly describe their cunning and their arts and to recount in which way and with what kind of flattery, looks, words, kisses, caresses, knots [ruses], nets, pitfalls, pastimes, hypocrisy, touches, . . . acts, lascivious behavior, fights, clothes, laughter, simulations, frauds, deceit, false tears, sighs, cries, good-byes, prolongation of pleasure, change, and new [clothes] they seek to ensnare inexperienced young men and to make them servants and slaves to all of their pleasures.)

E I G H T : Icons of Chastity, *Objets d'Amour*

I would like to thank Madeleine Viljoen for her help in translating this chapter.

1. Fritz Burger, *Francesco Laurana* (Straßburg: Heitz and Mündel, 1907), 115, finds in the busts of Laurana "something of Salome's spirit as interpreted in modern poetry and sculpture."

2. Plaster casts of the busts of Francesco Laurana became very popular, as documented in fig. 8.1, a photograph from a 1900 edition of the journal *Deutsche Kunst und Dekoration*. Even Frank Lloyd Wright is known to have embellished the living room of the Francis W. Little House in Deephaven, Minnesota (1912–15), with a cast of a Laurana bust. See also Hanno-Walter Kruft, *Francesco Laurana: Ein Bildhauer der Frührenaissance* (Munich: Beck, 1995), 132 et seq. As Kruft rightly states, an independent study of the history of their reception would be worthwhile.

3. For a general discussion of Renaissance busts as icons of virtue see Michaela Marek, "Virtus und fama: Zur Stilproblematik der Porträtbüsten," in *Piero de' Medici "il Gottoso" (1416–69)*, ed. Andreas Beyer and Bruce Boucher (Berlin: Akademie, 1993), 342–68. She suggests that the perception of busts, sacred and profane, was clearly informed by the instructions for meditation in devotional literature. The lifelike images helped one to meditate on the virtues and glorious deeds of the depicted, thus serving as a *stimulatio ingens*, an incentive for the imitation of virtuous be-havior.

4. Didi Huberman, "The Portrait, the Individual and the Singular: Remarks on the Legacy of Aby Warburg," in *The Image of the Individual: Portraits in the Renaissance*, ed. Nicolas Mann and Luke Syson (London: British Museum Press, 1998), 155–88; at 166, he asks exactly this question with regard to a particular Renaissance bust, the terracotta portrait of a man in antique attire, known as "Nicolò da Uzzano" (Florence, Museo di Bargello). He then remarks: "They [art historians] have preferred to look beyond the physical evidence, seeking in absentia a person whom one can be sure has really disappeared, rather than addressing the object which clearly has not yet disappeared and which will always have some new aspect to reveal to us, if we are prepared to keep looking with fresh eyes."

5. Kent Lydecker, "The Domestic Setting of the Arts in Renaissance Florence" (PhD diss., Johns Hopkins University, 1987), 71–78, traces the locations where busts were displayed in private households. Representative busts, mostly those of men, were often placed on door lintels as well as often arranged at eye level on top of chimney pieces or as part of reclining beds, so-called *lettucci* or *lettiere*.

6. See Rudolf Preimesberger's introduction in *Porträt*, ed. Rudolf Preimesberger, Hannah Baader, and Nicola Suthor (Berlin: Reimer, 1999), 23 et seq.

7. *Opere dell'altissimo poeta fiorentino* (Florence, 1572), fol. 3v; see Patricia Simons, "Portraiture, Portrayal, and Idealization: Ambiguous Individualism in Representations of Renaissance Women," in *Language and Images of Renaissance Italy*, ed. Alison Brown (Oxford: Clarendon Press, 1995), 287 et seq., n. 78.

8. The portrait in the Staatliche Museen Berlin has been attributed to Agnolo or Donnino del Mazziere; see the catalogue *Virtue and Beauty: Leonardo's Ginevra de' Benci and Renaissance Portraits of Women* (Princeton, NJ: Princeton University Press, 2001), 90. For the inscription, see Dario A. Covi, "The Inscription in Fifteenth Century Florentine Painting" (PhD diss., New York University, 1958), 164 n. 27. The painting had formerly been attributed to Verrocchio by Cornelius von Fabriczy; see his "Andrea del Verrocchio ai servizi dei Medici," *Archivio storico dell'Arte* 1 (1895): 171. He speculates that the woman depicted is Lorenzo de' Medici's beloved, Lucrezia Donati, though no evidence exists for this identification. Further, the painting bears a second inscription on the reverse taken from a 1450s sonnet by Matteo de Meglio. The use of this non-Medicean lyric does not support Fabriczy's hypothesis.

9. For a general survey of dressing habits and their depiction in the Italian quattrocento see Elizabeth Birbari, *Dress in Italian Painting, 1460–1500* (London: Murray, 1975); for fabrics and terminology, see Roberta Orsi Landini and Mary Westerman Bulgarella, "Costume in Fifteenth-Century Florentine Portraits of Women," in *Virtue and Beauty*, 89–97. Regarding the sociohistorical connotations of dress, see also Carole Collier Frick, *Dressing Renaissance Florence: Families, Fortunes, and Fine Clothes* (Baltimore, MD: Johns Hopkins University Press, 2002).

10. A concise summary of literature and research on this particular bust is provided by Andrew Butterfield, *The Sculptures of Andrea del Verrocchio* (New Haven, CT: Yale University Press, 1997), 217 et seq. For detailed descriptions and analyses, see Alexander Perrig, "Mutmaßungen zu Person und künstlerischen Zielvorstellungen Andrea del Verrocchios," in *Die Christus-Thomas-Gruppe von Andrea del Verrocchio*, ed. Herbert Beck, Maraike Bückling, and Edgar Lein (Frankfurt am Main: Heinrich, 1996), 81–101, and Jeanette Kohl, "Splendid Isolation: Verrocchios Mädchenbüsten—eine Betrachtung," in *Re-Visionen: Zur Aktualität von Kunstgeschichte*, ed. Richard Hüttel, Barbara Hüttel, and Jeanette Kohl (Berlin: Akademie, 2002), 49–75. For a further discussion of the bust within Verrocchio's oeuvre, see Jeanette Kohl, "Schleier, Hülle, Schwelle: Verrocchios Bildstrategien," in *Ikonologie des Zwischenraums: Der Schleier als Medium und Metapher*, ed. Johannes Endres, Barbara Wittmann, and Gerhard Wolf (Munich: Fink, 2005), 213–42. An essential account of the genre of portrait busts can be found in Irving Lavin, "On the Sources and Meaning of the Renaissance Portrait Bust," *Art Quarterly* 33.3 (1970): 207–26.

11. Jane Schuyler, *Florentine Busts: Sculpted Portraiture in the Fifteenth Century* (New York: Garland, 1976), 192, speaks vaguely of an "ancient costume." Butterfield, *The Sculptures of Andrea del Verrocchio*, 218, identifies a light summer dress in the style of late quattrocento fashion. Perrig, "Mutmaßungen zu Person," 92, notes correctly that the dress is seamless and lacks any decoration. A similar type of clothing can be found in several paintings of the Virgin Mary by Sandro Botticelli—for example, the Madonna in the National Gallery, Washington, DC (Samuel H. Kress Collection), and the Virgin with child and eight angels (the Raczynski tondo) in the collection of the

Staatliche Museen, Berlin; see Ronald Lightbown, *Botticelli: Leben und Werk* (Munich: Hirmer, 1989), 216 et seq. and plates 61 and 87.

12. As Carole Collier Frick pointed out in the discussion at the conference "The Body in Early Modern Italy," the dress strongly resembles informal underwear as it was worn by young ladies only in very private situations; see also Landini and Bulgarella, "Costume in Fifteenth-Century Florentine Portraits," 91.

13. The figure's erotic implications are emphasized by Perrig, "Mutmaßungen zu Person," 92. He notes that the veil over the chest, unlike the loose dress, is stretched tightly, focusing the viewer's gaze to the little button in its center and to the slit below. The openings in the sleeves repeat this vaginalike motif.

14. For the Laurana busts, see Chrysa Damianaki, *The Female Portrait Busts of Francesco Laurana* (Rome: Vecchiarelli, 2000); Kruft, *Francesco Laurana*, 132–66 and 369–90; and Burger, *Francesco Laurana*, 115 et seq. and 126–38.

15. Damianaki, *The Female Portrait Busts of Francesco Laurana*, 66 et seq., assumes that the bust depicts Eleonora, whereas Kruft, *Francesco Laurana*, 135–40, favors the suggestion that it is Ippolita Maria Sforza. Louis Courajod, "Observations sur deux bustes du Musée de Sculpture de la Renaissance au Louvre," *Gazette des Beaux Arts*, ser. 2, 28 (1883): 24–42, argues for Isabella of Aragon. Wilhelm Bode, "Desiderio da Settignano und Francesco Laurana: Zwei italienische Frauenbüsten des Quattrocento im Berliner Museum," *Jahrbuch der Preußischen Kunstsammlungen* 9 (1888): 209–38, recognizes it as a portrait of Beatrice d'Aragona. Britta von Götz-Mohr, "Laura Laurana: Francesco Lauranas Wiener Porträtbüste und die Frage der wahren Existenz von Petrarcas Laura im Quattrocento," *Städel-Jahrbuch*, n.s., 14 (1993): 149, gives an overview of all the different attempts to identify the sitter; at 150 et seq., she compares the bust to an anonymous sketch of Petrarch's Laura in the Biblioteca Laurenziana in Florence that might have been the point of departure for the Vienna bust. The features of the woman portrayed in both cases resemble Simone Martini's type of women. Von Götz-Mohr thus concludes that the bust represents an ideal portrait of Laura in a Simonesque style and that as such it emerged from the quattrocento debate about the real existence of Petrarch's beloved.

16. The translations are mine unless otherwise indicated. See Damianaki, *The Female Portrait Busts of Francesco Laurana*, 156 n. 110: "Die Büste genießt den Ruhm, das schönste Skulpturwerk der Kaiserlichen Sammlungen in Wien zu sein. . . . Die Fleischteile sind leicht gerötet, Lippen und Augen farbig. Das blonde Haar trägt eine goldbestickte Haube. Über dem eckigen Halsausschnitt des dunklen Kleides wird das flordünne Hemd, das den Busen bedeckt, sichtbar. Die klar gewölbte Stirn schmückte einst eine Perle, deren Halt, ein Löchlein, noch sichtbar ist."

17. For the relevant episodes of petriphilia and statuephilia see, among others, David Freedberg, *The Power of Images: Studies in the History and Theory of Response* (Chicago: University of Chicago Press, 1989), 317–44, and Berthold Hinz, "Statuenliebe: Antiker Skandal und mittelalterliches Trauma," *Marburger Jahrbuch für Kunstwissenschaft* 22 (1989): 135–42.

18. To give just one example from Leonardo's *Trattato della Pittura*, ed. Ettore Camesasca (Milan: TEA, 1995), 33: "La scultura non è scienza ma arte meccanicissima, perché genera sudore e fatica corporale al suo operatore" ("Sculpture is not a science but a most mechanical art, for it brings sweat and bodily fatigue to him who works at it" [Leonardo da Vinci, *Treatise on Painting*, trans. A. Philip McMahon (Princeton, NJ:

Princeton University Press, 1956), 35]). See also Hannah Baader, "Francesco Petrarca: Irdische Körper, himmlische Seelen und weibliche Schönheit (1336)," in *Porträt*, 182 et seq., for an analysis of Petrarch's thoughts on the greater potential of painting as opposed to sculpture in visualizing soul and spirit. For the tension between *forma corporis* and *forma animae*, which is described by Petrarch in his *De remediis utriusque fortunae* 1.2, and which is essential to the problem of portraiture, see also Wladislaw Tatarkiewicz, *Geschichte der Ästhetik*, 3 vols. (Basel: Schwabe, 1987), 3:17. See also Rudolf Preimesberger's introduction in *Porträt*, 22–25.

19. For the trope of *imagines spirantes*, see Patrizia Castelli, "Imagines spirantes," in *Immaginare l'autore: Il ritratto del letterato nella cultura umanistica, convegno di studi, Firenze, 26–27 marzo 1998*, ed. Giovanna Lazzi, Paolo Viti (Florence: Polistampa, 2000), 35–62; see also Ulrich Pfisterer, "'Soweit die Flügel meines Auges tragen'": Leon Battista Albertis Imprese und Selbstbildnis," *Mitteilungen des Kunsthistorischen Institutes in Florenz* 42 (1998): 220–25, on *spirantia signa* within the *paragone* discourse of the Middle Ages and the Renaissance (Petrarch, Bartolomeo Fazio, Leon Battista Alberti, Gianozzo Manetti).

20. Francesco Petrarca, *Opera omnia*, 3 vols. (1554; rpt., Ridgewood, NJ: Gregg Press, 1965), 3:3 (unpaginated). Petrarch's sonnets are characterized by the exact same dichotomy of promise and desire to vivify that at the same time turns out to be unrealizable that inheres in the genre of female portrait busts.

21. Lorenzo il Magnifico, *Tutte le opere*, 2 vols., ed. Paolo Orvieto (Rome: Salerno, 1992), 1:470.

22. The trope of the speaking statue is developed in exemplary fashion in Niccolò Machiavelli's poem on fortune (which paraphrases an epigram by Ausonius on a statue made by Phidias), where he describes a dialogue between a poet and an allegorical statue. For this poem and for the popularity of the idea of talking statues, see John Shearman, *Only Connect . . . Art and the Spectator in the Italian Renaissance* (Princeton, NJ: Princeton University Press, 1992), 113 et seq. Several examples are listed in Marianne Albrecht-Bott, *Die Bildende Kunst in der Italienischen Lyrik der Renaissance und des Barock: Studie zur Beschreibung von Portraits und anderen Bildwerken unter besonderer Berücksichtigung von G. B. Marinos Galleria* (Wiesbaden: Franz Steiner, 1976), 191, 196.

23. The poem probably dates from the 1520s; see Mary Rogers, "Sonnets on Female Portraits from Renaissance North Italy," *Word and Image* 2.4 (1986): 296.

24. Rogers, "Sonnets on Female Portraits," 301 et seq.

25. For the "mechanism" of a supposed vivification triggered by gazing at the object of desire, see Oskar Bätschmann, "Belebung durch Bewunderung: Pygmalion als Modell der Kunstrezeption," in *Pygmalion: Die Geschichte des Mythos in der abendländischen Kultur*, ed. Matthias Meyer and Gerhard Neumann (Freiburg im Breisgau: Rombach, 1997), 325–69, as well as Freedberg, *The Power of Images*, 320 et seq.

26. Bätschmann, "Belebung durch Bewunderung," 348, analyzes the way an imaginary completion and vivification of the fragmented and "lifeless" female body spurs male arousal.

27. This concept of "arranged self-deception" is explored in detail by Andreas Kablitz in his essay "Pygmalion in Petrarcas Canzoniere: Zur Geburt ästhetischer Illusion aus dem Ungeist des Begehrens," in *Pygmalion*, 197–224.

28. For a recent discussion of the paradigm of liveliness in Renaissance art, see Frank Fehrenbach, "Calor nativus / Color vitale: Prolegomena zu einer Ästhetik des

'Lebendigen Bildes' in der frühen Neuzeit," in *Visuelle Topoi: Erfindung und tradiertes Wissen in den Künsten der italienischen Renaissance*, ed. Ulrich Pfisterer and Max Seidel (Munich: Deutscher Kunstverlag, 2003), 151–70, and on liveliness in portraiture, see Frank Zöllner, "The Motions of the Mind in Renaissance Portraits: The Spiritual Dimension of Portraiture," *Zeitschrift für Kunstgeschichte* 68 (2005): 23–40.

29. Kohl, "Splendid Isolation," 68 et seq.

30. We know that Rogier worked for the Medici and that his paintings were highly esteemed; see Dirk de Vos, *Rogier van der Weyden: Das Gesamtwerk* (Munich: Hirmer, 1999), 298 et seq. For his influence on Florentine artists in the later quattrocento, see Michael Rohlmann, *Auftragskunst und Sammlerbild: altniederländische Tafelmalerei im Florenz des Quattrocento* (Alfter: Verlag und Datenbank für Geisteswissenschaften, 1994), 29–35.

31. See Anne Hollander, *Seeing through Clothes* (New York: Viking Press, 1980), 88, as well as Margaret R. Miles, "The Virgin's One Bare Breast," in *The Expanding Discourse: Feminism and Art History*, ed. Norma Broude and Mary Garrard (Boulder, CO: Westview Press, 1992), 32–36. Miles builds her argument on Hollander's, concluding that the nursing virgin was a highly ambivalent symbol, "evoking for men a closely woven mixture of danger and delight" (35).

32. In the fifteenth century, a change in style in the depiction of the *Madonna lactans* is evident. The traditionally abstract rendering of the breast as an object almost remote from the body, which is typical for trecento paintings, gave way to a more realistic representation of this female body part. Megan Holmes convincingly argues that this more realistic representation raised questions regarding proper decorum in "Disrobing the Virgin: The *Madonna lactans* in Fifteenth-Century Florentine Art," in *Picturing Women in Renaissance and Baroque Italy*, ed. Geraldine A. Johnson and Sara F. Matthews Grieco (Cambridge: Cambridge University Press, 1997), 167–95.

33. See the essential analysis of Michael Camille, *The Gothic Idol: Ideology and Image-Making in Medieval Art* (Cambridge: Cambridge University Press, 1989); at 214, he analyzes the "battle of representations" and concludes that "the Virgin replaces Venus as the locus of medieval desire." See also Elizabeth Cropper, "On Beautiful Women: Parmigianino, Petrarchismo, and the Vernacular Style," *Art Bulletin* 58 (1976): 392, who pointedly describes Mary as "the Virgin, the Queen of heaven, the most perfect *cortegiana* of all."

34. Holmes, "Disrobing the Virgin," 171–74, supplies proof that men looked lewdly at religious portraits as well as an account of the attempts to control such improper gazes in religious spaces.

35. Savonarola's comments are cited in Creighton Gilbert, *Italian Art, 1400–1500: Sources and Documents* (Englewood Cliffs, NJ: Prentice Hall, 1980), 157 et seq.

36. For the parallel development of a sacralization of erotic love, on the one hand, and an eroticization of public spaces of sacred love, on the other, see Adrian Randolph, "Regarding Women in Sacred Space," in *Picturing Women*, 37.

37. See Vincent of Beauvais, "De puero, qui Virginis imaginem annulo subarrhavit," *Speculum historiale*, bk. 7, cap. 87, and for a similar story, "De iuvenis qui statuam Veneris annulo desponsavit," *Speculum historiale*, bk. 25, cap. 29. Hinz, "Statuenliebe," 139, rightly points out that the obscene legends of statuephilia in antiquity were "socialized" in early modern times. They formed the basis of the increasing popularity of the genre of "charming" pictures of the Virgin.

38. Leonardo, *Trattato della pittura*, 21 (Leonardo, *Treatise on Painting*, 22): "E già intervene a me fare una pittura che rappresentava una cosa divina, la quale comparata dall'amante di quella volle levarne la rappresentazione di tal deità per poterla baciare senza sospetto, ma infine la coscienza vinse i sospiri e la libidine, e fu forza ch'ei se la levasse di casa."

39. In late medieval and early modern times, there seems to have been a close connection between religious ardor, on the one hand, and erotic ardor, on the other. For this and for the modalities and interrelations of sacred and profane images in the Renaissance, see Gerhard Wolf, "*Toccar con gli occhi*: Zu Konstellationen und Konzeptionen von Bild und Wirklichkeit im späten Quattrocento," in *Artistic Exchange: Akten des 28, Internationalen Kongresses für Kunstgeschichte in Berlin, 15–20 Juli 1992*, 3 vols., ed. Thomas W. Gaehtgens (Berlin: Akademie, 1993), 2:437–52.

40. Charles Dempsey, *The Portrayal of Love: Botticelli's Primavera and Humanist Culture at the Time of Lorenzo the Magnificent* (Princeton, NJ: Princeton University Press, 1992), 98.

41. Lorenzo il Magnifico, *Tutte le opere*, vol. 1, sonnet 125; see also Lorenzo il Magnifico, *Dichtungen*, 2 vols. (Bremen: Hauschild, 1940), 1:142, no. 16.

42. Victoria Kirkham, "Poetic Ideals of Love and Beauty," in *Virtue and Beauty*, 50–61.

43. This particular type of sculpture seems to have escaped scholarly attention almost completely. There is a fascinating body of works in Italy—but also in northern Europe—that I am about to do further research on. Since the late 1990s, art historians have become more interested in the functions and meanings of reliquaries; see, for example, Joan A. Holladay, "Relics, Reliquaries, and Religious Women: Visualizing the Holy Virgins of Cologne," *Studies in Iconography* 18 (1997): 67–118. An important contribution is *Gesta* 36.1 (1997), titled "Body-Part Reliquaries and Body Parts in the Middle Ages," with essays by Caroline Walker Bynum, Cynthia Hahn, Barbara Drake Boehm, Scott Montgomery, and others; see also *Reliquie e reliquiari nell'espansione mediterranea della Corona d'Aragona: Il tesoro della cattedrale di Valenza* (Valencia: Generalitat Valenciana, 1998); Henk van Os, *The Way To Heaven: Relic Veneration in the Middle Ages*, with contributions by Karel R. van Kooij and Casper Staal (Baarn: de Prom, 2000); and Bruno Reudenbach, *Reliquiare als Heiligkeitsbeweis und Echtheitszeugnis: Grundzüge einer problematischen Gattung* (Berlin: Akademie, 2000).

44. The bust—that bears the brain relic of the saint—dates from the earlier trecento and is part of the altar of St. Fina in the San Gimignano Cathedral (*Mostra di opere d'arte restaurate nelle province di Siena e Grosseto* [Genoa: Sagep, 1983], cat. no. 4, 23–27).

45. See Lorenzo Lorenzi, "Busti-reliquiario senesi dell'età gotica: Lettura iconoteologica," *Antichità viva* 33.1 (1994): 44–47; Catherine King, "Effigies: Human And Divine," in *Siena, Florence and Padua: Art, Society and Religion, 1280–1400*, 2 vols., ed. Diana Norman (New Haven, CT: Yale University Press, 1994), 1:122; and *Mostra di opere d'arte*, cat. nos. 17, 62.

46. Formerly in the Ospedale di Santa Fina, now in the Museo Civico, San Gimignano. The bust has been attributed to Pietro Torrigiani for stylistic reasons and bears the inscription "BEATAE FINAE VIRGINI SACRUM"; see Fabio Benedettucci, "Pietro Torrigiano, Santa Fina," in *Il giardino di S. Marco: Maestri e compagni del giovane Michelangelo*, ed. Paola Barocchi (Cinisello Balsamo: Silvana, 1992), cat. no. 23. For the

attribution, see Alessandro Ferrajoli, "Un testamento inedito dello scultore Pietro Torrigiani e ricerche sopra alcune sue opere," *Bollettino d'Arte* 9 (1915): 181–92.

47. Wolf, "*Toccar con gli occhi*," 445, gives a concise analysis of the problem and its relation to concepts of vivification.

48. Lavin and Schuyler suggest sources beyond the Roman portrait. Lavin, "On the Sources and Meaning of the Renaissance Portrait Bust," 213 et seq., discusses the Renaissance concept of *totus homo* and its possible significance for bust portraiture. Schuyler, *Florentine Busts*, 33–77, was the first to connect animistic concepts with bust portraits.

49. Nancy Vickers convincingly argues that Petrarch left the Renaissance a legacy of fragmentation; see Nancy Vickers, "Diana Described: Scattered Woman and Scattered Rhyme," *Critical Inquiry* 8 (1981): 95–109. For the strategy of fragmentation in Petrarchan poetry, see also Kirkham, "Poetic Ideals of Love and Beauty," 50–61.

50. Hartmut Böhme, "Erotische Anatomie: Körperfragmentierung als ästhetisches Verfahren in Renaissance und Barock," in *Körperteile: Eine kulturelle Anatomie*, ed. Claudia Benthien and Christoph Wulf (Reinbek: Rowohlt, 2001), 228–53, discusses these *blasons* in the tradition of Petrarchan lyrics. A close relation with certain aspects of the devotion of relics becomes most evident in their typical praise of singular female body parts. This type of poem shares many characteristics with quattrocento poetry of the Medici circle. In both cases the description of the fragmented female body spurs the male author to a demonstration of his poetical and rhetorical skill. The description is interfused with religious terminology; so, for example, the female bosom is praised as an "armaire sacre," a holy shrine consecrated to the goddess of chastity. "So wird der Busen zum Reliquiar, worin der öffentliche Ruf der Geliebten als *relique* verwahrt wird. . . . Diese Sakralisierung . . . steigert, im Zeichen Amors, die Frau in göttliche Höhen, sie verwandelt Körperteile zu einem Fetisch in genauer Parallele zur Reliquie" ("Thus the bosom is turned into a reliquary in which the beloved's public reputation is kept as a relic. . . . Such sacralization, under the sign of Amor, raises the woman to divine heights; it transforms body parts into fetishes, just as is the case with relics") (Böhme, "Erotische Anatomie," 40). See also Simons, *Portraiture*, 309 et seq.

51. Lavin, "On the Sources and Meaning," 214, 226, has specifically related the poem to the genre of Renaissance busts. The Latin title reads "AD EIUS MARMOREAM EFFIGIEM." For the poems on Albiera, see Alexandri Bracci, *Carmina*, ed. Alessander Perosa (Florence: Bibliopolis, 1944), 108 et seq. See also John Walker, "Ginevra de' Benci by Leonardo da Vinci," *Report and Studies in the History of Art* (Washington, DC: National Gallery of Art, 1967–68), 1–38.

52. "Yet so that on earth no one be more beautiful than the goddesses, death took me away on command of the gods." For other related poems on female Renaissance portraits, see Rogers, "Sonnets on Female Portraits," 300–305.

53. I would like to thank Fabio Barry of Rome for having shared the ideas of his paper "A Whiter Shade of Pale: Relative and Absolute White in Roman Sculpture and Architecture," which is forthcoming in *Revival and Invention: Sculpture and Its Material Histories*, ed. S. Clerbois and M. Droth.

54. See Reudenbach, *Reliquiare als Heiligkeitsbeweis*, 3–36, in particular 12 et seq., as well as Cynthia Hahn, "The Voices of Saints: Speaking Reliquaries," *Gesta* 36.1 (1997): 20–31.

55. The term "speaking reliquaries" ("sprechende Reliquiare") goes back to Joseph

Braun's important publication *Die Reliquiare des christlichen Kultes und ihre Entwicklung* (Freiburg im Breisgau: Herder, 1940).

56. See Böhme, "Erotische Anatomie," 236–40, on the tactics of male "trimming" and fragmentation of the female body as a fetishist strategy; see also Patricia Simons, "Women in Frames: The Gaze, the Eye, the Profile in Renaissance Portraiture," in *The Expanding Discourse*, 49.

57. Böhme, "Erotische Anatomie," 240.

58. Rogers, "Sonnets on Female Portraits," 249, emphasizes the role of imagination and fantasy in the perception of portraits: "A sense of physical and emotional approachability and even responsiveness is conveyed" by such images. For a general analysis of Renaissance perception beyond the category of "representation," see Ernst Gombrich, "*Icones Symbolicae*: The Visual Image in Neo-Platonic Thought," *Journal of the Warburg and Courtauld Institutes* 11 (1948): 163–92, who opposes the common view of images as representations or symbolic manifestations of abstract ideas. He argues that neo-Platonic thought as developed by Pseudo-Dionysius Aeropagita forms another important source for the interrelation of magic and pictorial art: "The conception of an inherent and essential symbolism pervading the whole order of things offered a key to the whole universe" (168). Pursuing this avenue of thought, recently Wouter J. Hanegraaff, "Sympathy or the Devil: Renaissance Magic and the Ambivalence of Idols," *Esoterica*, vol. 2 (2000): 1–44 (www.esoteric.msu.edu/VolumeII/Sympdevil .html), has further investigated the relation among magic, religion, imagination, and images in Renaissance culture. An important point of departure for a new understanding of the role of magic in the context of the creation and perception of images could be the *Corpus hermeticum*, which was translated by Ficino in 1463 and dedicated to Cosimo.

59. See Horst Bredekamp, *Repräsentation und Bildmagie der Renaissance als Formproblem* (Munich: Siemens-Stiftung, 1995), esp. 29 et seq. His ideas are similar to Freedberg's conclusions in *The Power of Images*.

60. Vasari reports that they were made so perfectly that they looked like human beings: "Le teste poi mani e piedi, fece di cera . . . , ritratte dal vivo e dipinte a olio con quelli ornamenti di capelli et altre cose . . . , naturali e tanto ben fatti, che rappresentavano non più uomini di cera, ma vivissimi" ("Their heads, then their hands and feet, were made out of wax, drawn from life and painted in oil with those hair ornaments and other things[;] [they were so] naturalistic and . . . well made that they no longer seemed like wax effigies but extremely alive") (*Le vite de' più eccellenti pittori scultori e architettori*, 9 vols., ed. Paola della Pergola, Luigi Grassi, Giovanni Previtali [Milan: Fratelli Magnani, 1962–66], 3:234). For the meaning and effects of such waxen bodies in the Renaissance, see again Bredekamp, 30 et seq.

61. In Leone Ebreo's *Dialoghi di Amore* (written around 1500 and published posthumously in 1535), Filone explains to his beloved Sofia how her beauty entered his body through his eyes and made him fall in love with her, describing, interestingly, how her beauty penetrates the heart and then enters his mind and occupies it in the form of a statue:

> Tu dici il vero, o Sofia, che se la splendida bellezza a tua non mi fusse in trata
> per li occhi, non mi harebbe possuto trapassare tanto, com fece, il senso, e la
> fantasia, & penetrando fino al cuore, non haria pigliata per eterna habitatione,

come pigliò la mente mia, impiendola di *scultura di tua imagine. Che cosi presto non trapassano i raggi del Sole i corpi celesti o gli elementi, che son disotto fino alla terra, quanto in me fece l'effigie di tua bellezza*, infino a porsi nel centro del cuore, e nel cuor della mente.

(You speak the truth, O Sofia, for if your splendid beauty had not entered through my eyes, it would not have been able to pierce so deeply my sense and imagination as it did, and penetrating me to the heart, it would not have taken my mind for its eternal abode, as it has done, filling it with the sculpture of your image. For no more rapidly do the rays of the sun pass through the celestial bodies or the elements, which are below, down to the earth than did the effigy of your beauty penetrate me, until it finally took its place at the center of my heart and in the heart of my mind.)

As the poet falls in love, his internalization of female beauty transforms the beloved image into sculpture. This "mental sculpture," or petrified beauty, settles in his mind and imprints itself heavily on his thoughts: "Ti dico che la mente mia ritirata a contomplare come suole quella formata in te bellezza, & in lei per imagine impressa" ("I tell you that my mind has retreated to contemplate, as is its wont, the beauty that takes shape in you, which is impressed as an image upon it") (Leone Ebreo, *Dialoghi di Amore* [Venezia: Bevilaqua, 1572], 106). I am very grateful to Sergius Kodera for suggesting that I look at Ebreo.

62. Cusanus, *De visione Dei*, chap. 4, where he concludes: "Ibi oculus, ubi amor." For the strong impact of images on the Renaissance beholder, see also Moshe Barasch, "The Magic of Images in Renaissance Thought," in *Die Renaissance und die Entdeckung des Individuums in der Kunst: Die Renaissance als erste Aufklärung*, ed. Enno Rudolph (Tübingen: Mohr Siebeck, 1998), 79–102, esp. 79–83, as well as Freedberg, *The Power of Images*, 217–329. Regarding the magical effect of the *imago omnia videntis* see Barasch, "The Magic of Images in Renaissance Thought," 80 et seq., and Hermann Beenken, "Figura cuncta videndis," *Kunstchronik* 4 (1995): 266–69.

63. On the power of the female gaze and the male fear of woman's eyes, see also Randolph, "Regarding Women in Sacred Space," 38–40, and Simons, *Women in Frames*, 50 et seq.

64. Francesco Petrarca, *Opere italiane: Canzoniere*, ed. Marco Santagata (Milan: Mondadori, 1996), 847. "Vecchio mauro" refers to Atlas, who was turned into stone by the Medusan gaze.

65. Lorenzo il Magnifico, *Tutte le opere* 1:459.

66. Petrarca, *Opere italiane*, 769 (sonnet 171).

67. Rogers, "Sonnets on Female Portraits," 301:

O my image, celestial and pure,
shining, to my eyes, more brightly than the sun,
and resembling the face of the one
that, with even greater care, I have sculpted [!] in my heart.
I believe that my Bellini, as well as her face
has given you the character [costume] of her,
for you burn me, if I gaze on you, you who are
cold stone [*freddo smalto*], to which has been given great fortune.

NINE: Like a Virgin

1. In particular, see Carol Rupprecht, "The Martial Maid and the Challenge of Androgyny" (Spring 1974): 269–93; John McLucas, "Ariosto and the Androgyne: Symmetries of Sex in the *Orlando furioso*" (PhD diss., Yale University, 1983); Maggie Günsberg, "'Donna liberata?' The Portrayal of Women in the Italian Renaissance Epic," *The Italianist* 7 (1987): 7–35; Giulio Ferroni, "Da Bradamante a Ricciardetto: Interferenze testuali e scambi di sesso," in *La parola ritrovata: Fonti e analisi letterarie*, ed. Costanzo Di Girolamo and Ivano Paccagnella (Palermo: Sellerio, 1982), 137–59; and Albert R. Ascoli, "Body Politics in Ariosto's *Orlando furioso*," in *Translating Desire in Medieval and Early Modern Literature*, ed. Craig Berry and Heather Hayton (Tempe, AZ: Arizona Center for Medieval and Renaissance Studies, 2005), 49–85. I am grateful to Ronald L. Martinez for sharing his unpublished paper "Ricciardetto's Sex and the Castration of Orlando: Anatomy of an Episode from the *Orlando furioso*" with me. Among recent studies of sexual identity in the (Italian) Renaissance, see Margaret Ferguson, Maureen Quilligan, and Nancy Vickers, eds. *Rewriting the Renaissance: The Discovery of Sexual Difference in Early Modern Europe* (Chicago: University of Chicago Press, 1986); Marilyn Migiel and Juliana Schiesari, eds. *Refiguring Woman: Perspectives on Gender and the Italian Renaissance* (Ithaca, NY: Cornell University Press, 1991); Guido Ruggiero, *The Boundaries of Eros: Sex Crime and Sexuality in Renaissance Venice* (Oxford: Oxford University Press, 1985); Edward Muir and Guido Ruggiero, eds., *Sex and Gender in Historical Perspective: Selections from "Quaderni Storici"* (Baltimore, MD: Johns Hopkins University Press, 1990); Louise Fradenburg and Carla Freccero, eds., *Premodern Sexualities* (London: Routledge, 1996); and Michael Rocke, "Gender and Sexual Culture in Renaissance Italy," in *The Renaissance: Italy and Abroad*, ed. John Jeffries Martin (London: Routledge, 2003), 139–58. See also note 4 below.

2. In addition to the works on *Orlando furioso* mentioned in note 1, see also Robert M. Durling, *The Figure of the Poet in Renaissance Epic* (Cambridge, MA: Harvard University Press, 1965), 150–60; Mario Santoro, *Ariosto e il Rinascimento* (Naples: Liguori, 1989), 134–66; Margaret Tomalin, *The Fortunes of the Warrior Heroine in Italian Literature* (Ravenna: Longo, 1982), 94–117; John McLucas, "Amazon, Sorceress, and Queen: Women and War in the Aristocratic Literature of Sixteenth-Century Italy," *The Italianist* 8 (1988): 33–55; Peter DeSa Wiggins, *Figures in Ariosto's Tapestry: Character and Design in the "Orlando furioso"* (Baltimore, MD: Johns Hopkins University Press, 1986), 161–204; Pamela Benson, *The Invention of Renaissance Woman* (University Park: Pennsylvania State University Press, 1992), 123–55; Valeria Finucci, *The Lady Vanishes: Subjectivity and Representation in Castiglione and Ariosto* (Stanford, CA: Stanford University Press, 1992); Miranda Johnson-Haddad, "'Like the Moon It Renews Itself': The Female Body as Text in Dante, Ariosto, and Tasso," *Stanford Italian Review* 11 (1992): 203–15; Marilyn Migiel, "Olimpia's Secret Weapon: Gender, War, and Hermeneutics in Ariosto's *Orlando furioso*," *Critical Matrix* 9 (1995): 21–44; Melinda Gough, "'Her Filthy Feature Open Showne' in Ariosto, Spenser, and *Much Ado about Nothing*," *Studies in English Literature, 1500–1900* 39 (1999): 41–67; Constance Jordan, "Writing beyond the *Querelle*: Gender and History in *Orlando furioso*," in *Renaissance Transactions: Ariosto and Tasso*, ed. Valeria Finucci (Durham, NC: Duke University Press, 1999), 295–314; Deanna Shemek, "Of Women, Knights, Arms, and Love: The 'querelle des femmes'

in Ariosto's Poem," *MLN* 104 (1989): 68–97; Deanna Shemek, *Ladies Errant: Wayward Women and Social Order in Early Modern Italy* (Durham, NC: Duke University Press, 1998); and Eleanora Stoppino, "*Ariosto Medievale*: Textual and Sexual Genealogies in *Orlando furioso*" (PhD diss., University of California, Berkeley, 2003).

3. This topic was pioneered by McLucas in "Ariosto and the Androgyne" and further developed by Finucci (in *The Lady Vanishes* and *The Manly Masquerade: Masculinity, Paternity, and Castration in the Italian Renaissance* [Durham, NC: Duke University Press, 2003]) and Elizabeth J. Bellamy in *Translations of Power: Narcissism and the Unconscious in Epic History* (Ithaca, NY: Cornell University Press, 1992). McLucas as well as Marc Schacter ("'Egli s'innamor' del suo valore': Leone, Bradamante, and Ruggiero in the 1532 *Furioso*," *MLN* 115 [2000]: 64–79) direct attention to an underlying thematics of homosexual and / or homosocial desire in the poem; this paper, while acknowledging the interest of this line of thought, takes a different approach. For relevant general treatments of masculinity studies, see Klaus Theweleit, *Male Fantasies*, 2 vols., trans. Stephen Conway (Minneapolis: University of Minnesota Press, 1987); Eve Kosofsky Sedgewick, *Between Men: English Literature and Male Homosocial Desire* (New York: Columbia University Press, 1985); and Rachel Adams and David Savran, eds., *The Masculinity Studies Reader* (Oxford: Blackwell, 2002). See also note 6. On the medieval and early modern period, see, for example, Clare Lees, ed., *Medieval Masculinities: Regarding Men in the Middle Ages* (Minneapolis: University of Minnesota Press, 1994) and Michael Rocke, *Forbidden Friendships: Homosexuality and Male Culture in Renaissance Florence* (New York: Oxford University Press, 1996).

4. Pseudo-Albertus Magnus, *Women's Secrets*, ed. and trans. Helen R. Lemay (Albany: State University of New York Press, 1992); Aldobrandino da Siena, *Il libro delle cose segrete delle donne*, ed. Giuseppe Manuzzi (Florence: Tipografia del Vocabulario della Crusca, 1863). On the late medieval-early modern topos of the gynecological "secrets" of women's bodies, see especially Katharine Park, "Dissecting the Female Body: From Women's Secrets to the Secrets of Nature," in *Attending to Early Modern Women*, ed. Adele Seef and Jane Donawerth (Newark: University of Delaware Press, 2000), 22–47, to whom I am also indebted for bibliographical and other suggestions. See also Jacques Lacan, "The Meaning of the Phallus," in *Feminine Sexuality: Jacques Lacan and the "École Freudienne*," ed. Juliet Mitchell and Jacqueline Rose, trans. Jacqueline Rose (New York: Norton, 1982), 74–85.

5. For the full argument, see my "Body Politics in Ariosto's *Orlando furioso*," 62–106, which significantly revises the earlier "Il segreto di Erittonio: Poetica e politica sessuali nel canto 37 dell'*Orlando furioso*," in *La rappresentazione dell'altro nei testi del Rinascimento*, ed. Sergio Zatti (Lucca: Paccini Fazzi, 1998), 53–76. For male envy of female sexuality, see Eva Feder Kittay, "Womb Envy: An Explanatory Concept," in *Mothering: Essays in Feminist Theory*, ed. Joyce Trebilcot (Totowa, NJ: Rowman and Allanheld, 1993), 94–128, and Eva Feder Kittay, "Rereading Freud on 'Femininity'; or, Why Not Womb Envy?" in *Hypatia Reborn: Essays in Feminist Philosophy*, ed. Azizah Y. Al-Hibri and Margaret A. Simons (Bloomington: Indiana University Press, 1990), 192–203. For a different but suggestive view, see Günsberg, "'Donna liberata?'" 12–20.

6. For the construction of maleness in opposition to and as a repression of femaleness, see Luce Irigaray, *Speculum de l'autre femme* (Paris: Minuit, 1974); Jacques Derrida, "La loi du genre / The Law of Genre," *Glyph* 7 (1980): 176–232; Judith Butler, *Gender Trouble: Feminism and the Subversion of Identity* (New York: Routledge, 1990); Judith

Butler, *Bodies that Matter: On the Discursive Limits of Sex* (New York: Routledge, 1993); Alice Jardine, *Gynesis: Configurations of Woman and Modernity* (Ithaca, NY: Cornell University Press, 1985); and Adriana Cavarero, *Corpo in figure: Filosofia e politica della corporeità* (Turin: Feltrinelli, 1995). I owe a special debt to Barbara G. Spackman, "'Intermusam et ursam moritur': Folengo and the Gaping 'Other' Mouth," in *Refiguring Woman*, 19–34.

7. This is not to suggest—far from it—that the normative early modern accounts, deriving from Aristotle and Galen and filtered through Pseudo-Albertus and others, do not assert that the male body is hierarchically superior to the female, whether on the grounds that the female body is "different" (cold rather than hot; "material" rather than "formal") or is "defective" (a deformed version of the male body [on this latter point, see Ian Maclean, *The Renaissance Notion of Woman* (Cambridge: Cambridge University Press, 1980), 23–46, and Thomas Laqueur, *Making Sex: Body and Gender from the Greeks to Freud* (Cambridge, MA: Harvard University Press, 1990)]). Rather, I refer to a repressed "ideo-logic" that subtends the official discourse and manifests itself in the implicit form of narrative structures and rhetorical figures.

8. The bibliography on Angelica is extensive. Of particular note are Santoro, *Ariosto*, 111–33; Eugenio Donato, "'Per selve e boscherecci labirinti': Desire and Narrative Structure in Ariosto's *Orlando furioso*," in *Literary Theory / Renaissance Texts*, ed. Patricia Parker and David Quint (Baltimore, MD: Johns Hopkins University Press, 1986), 33–62; Finucci, *The Lady Vanishes*, 107–44; and Shemek, *Ladies Errant*, 43–76. See also my *Ariosto's Bitter Harmony: Crisis and Evasion in the Italian Renaissance* (Princeton, NJ: Princeton University Press, 1987), 198–99, 227–32, 317–24, and 329. For interesting if telegraphic reflections on Angelica as virgin, see Sujata Iyengar, "'Handling Soft the Hurts': Sexual Healing and Manual Contact in *Orlando furioso*, *The Faerie Queene*, and *All's Well That Ends Well*," in *Sensible Flesh: On Touch in Early Modern Culture*, ed. Elizabeth D. Harvey (Philadelphia: University of Pennsylvania Press, 2003), 39–61.

9. For Renaissance representations of female beauty, see Elizabeth Cropper, "On Beautiful Women, Parmigianino, *Petrarchismo*, and the Vernacular Style," *Art Bulletin* 58 (1976): 374–94; Elizabeth Cropper, "The Beauty of Woman: Problems in the Rhetoric of Renaissance Portraiture," in *Rewriting the Renaissance: The Discovery of Sexual Difference in Early Modern Europe*, ed. Margaret Ferguson, Maureen Quilligan, and Nancy Vickers (Chicago: University of Chicago Press, 1986), 175–90; and Elizabeth Cropper, "The Place of Beauty in the High Renaissance and Its Displacement in the History of Art," in *Place and Displacement in the Renaissance*, ed. Alvin Vos (Binghamton, NY: Medieval and RenaissanceTexts and Studies, 1995), 159–205; for specific applications to Ariosto, see Fredi Chiappelli, "Ariosto, Tasso e le bellezze delle donne," *Filologia e critica* 10 (1985): 325–41, and Günsberg, "'Donna liberata?'" 16–20; for a parodic look at male obsession with beauty see the Astolfo and Giocondo tale recounted in canto 28 and discussed by Finucci in *The Manly Masquerade*, 160–88, and by Benson, *The Invention of Renaissance Woman*, 103–6.

10. All citations are to Ludovico Ariosto, *Orlando furioso*, 2 vols., ed. Emilio Bigi (Milan: Rusconi, 1982); translations are my own. Commentators note the classical source in Catullus, *Carmina* 62.30–47. Virginity as a flower to be plucked is a common topos, as in the first part of the *Roman de la Rose*.

11. For medieval Christian notions of virginity, still active in much early modern discourse, see R. Howard Bloch, *Medieval Misogyny and the Invention of Western Roman-*

tic Love (Chicago: University of Chicago Press, 1991), esp., chap. 4; Anke Bernau, Ruth Evans, and Sarah Salih, eds., *Medieval Virginities* (Cardiff: University of Wales Press, 2003); and Ruth Evans, "Virginities," in *Medieval Women's Writing*, ed. Carolyn Dinshaw and David Wallace (Cambridge: Cambridge University Press, 2003), 21–39. I have not come across many studies focused primarily on the figurative and historical status of virginity in the sixteenth century (beyond the numerous discussions of convent celibacy). An exception is Elizabeth S. Cohen, "No Longer Virgins: Self-Presentation by Young Women in Late Renaissance Rome," in *Refiguring Woman*, 169–91.

12. Bradamante is by far the most studied figure in Ariosto criticism of the last decade; see especially Elissa Weaver, "Lettura dell'intreccio dell'*Orlando furioso*: Il caso delle tre pazzie d' amore," *Strumenti critici* 11 (1977): 384–406; Andrew Fichter, *Poets Historical: Dynastic Epic in the Renaissance* (New Haven, CT: Yale University Press, 1982), 70–111; Giuseppe Dalla Palma, *Le strutture narrative dell' "Orlando furioso"* (Florence: Olschki, 1984), esp. 86–110; Wiggins, *Figures in Ariosto's Tapestry*, 192–204; McLucas, "Amazon, Sorceress, and Queen"; Wiley Feinstein, "Bradamante in Love: Some Postfeminist Considerations on Ariosto," *Forum Italicum* 22 (1988): 48–59; Charles Ross, "Ariosto's Fables of Power: Bradamante at the Rocca di Tristano," *Italica* 68 (1991): 155–75; Benson, *The Invention of Renaissance Woman*, esp. 148–55; Judith Bryce, "Gender and Myth in the *Orlando furioso*," *Italian Studies* 47 (1992): 41–50; Finucci, *The Lady Vanishes*, esp. 227–53; Jordan, "Writing beyond the *Querelle*"; and Julia Hairston, "Bradamante, 'vergine saggia': Maternity and the Art of Negotiation," *Exemplaria* 12 (2000): 455–86. Deserving of special consideration are Shemek, *Ladies Errant*, esp. 77–125, and Stoppino, "Ariosto *medievale*."

13. See Shemek's fine reading of the episode in *Ladies Errant*, 92–96.

14. The color of the armor is a detail new in Ariosto, though the symbolism is consonant with her status as virgin warrior as defined in the literary tradition.

15. This point was first made for the *Furioso* in general by John McLucas in "Ariosto and the Androgyne," in, for example, his reading of Marfisa's parody of phallic sword play in the "homicidal women" episode (19.69, 74–75).

16. Bellamy discusses the import of Ariosto's armor of narcissism with great acuity (*Translations of Power*, 82–130). Key to my own discussions are her observations that armor offers "a mimesis of the human form" (89) and a figure "of bodily wholeness" (95) that is consistently compromised as its constituent parts are scattered and passed from hand to hand and that at times asserts masculinity and at others blurs gender boundaries (112–15). On the general subject of the economy of (fetishistic) desire in the *Furioso*, see Donato, "'Per selve'"; Ascoli, *Ariosto's Bitter Harmony*, 217–19; and Zatti, *Il "Furioso."* Let me acknowledge an encounter some years ago with promising, still unpublished, work by Carolyn Springer on literary representations of armor. See also the recent study of Amedeo Quondam, *Cavallo e cavaliere: L'armatura come la seconda pelle del gentiluomo moderno* (Rome: Donzelli, 2003). The already classic theoretical articulation of the symbolic role of armor in the construction and deconstruction of male identity is in Theweleit, *Male Fantasies*, 1:302.

17. Sacripante is not himself wounded, but his horse is killed, pinning him helplessly below. The sexual symbolism is patent (at its most overt in the phrase "votar l'arcione" [61.2]). On the symbolic weight, especially sexual, of horses in the *Furioso*, see A. Bartlett Giamatti, "Headlong Horses, Headless Horsemen: An Essay in the Chivalric Romances of Pulci, Boiardo, and Ariosto," in *Italian Literature: Roots and Branches*, ed.

Kenneth Atchity and Giose Rimanelli (New Haven, CT: Yale University Press, 1976), 215–45; McLucas, "Ariosto and the Androgyne"; Dalla Palma, *Le strutture narrative dell' "Orlando furioso,"* 72–80; and Ascoli, *Ariosto's Bitter Harmony*, esp. 382–89. Compare canto 28.66–67 and the sexual punning in canto 35 discussed in the text.

18. On the genealogical rationale for chastity in general, see Constance Jordan, *Renaissance Feminism: Literary Texts and Political Models* (Ithaca, NY: Cornell University Press, 1990), 82–83. See Günsberg, "'Donna liberata?'" 31–32, for an application to Ariosto.

19. For the *Furioso* as genealogical epic, see especially Ezio Levi, "L'*Orlando furioso* come epopea nuziale," *Archivum romanicum* 17 (1933): 459–93; Fichter, *Poets Historical*; Finucci, *The Lady Vanishes*; Shemek, *Ladies Errant*; Hairston, "Bradamante"; and Stoppino, "Ariosto *medievale.*"

20. 14.118–19, 26.121, 46.119. The conceit originates with Boiardo, *Orlando innamorato* 2.14.32–34. On Rodomonte as Nimrod, see Ascoli, *Ariosto's Bitter Harmony*, 254, 351, 371, and especially Jane Tylus, "The Curse of Babel: The *Orlando furioso* and Epic (Mis) Appropriation," *MLN* 103 (1988): 154–71. On Nimrod as giant, see Dante, *Inf.* 31.46–81.

21. For a discussion of Ariostan interlace as "cotextuality," see my "Ariosto and the 'fier pastor': Form and History in *Orlando furioso,*" *Renaissance Quarterly* 54 (2001): 487–522. See Weaver, "Lettura dell'intreccio," for the parallelism between Orlando, Rodomonte, and Bradamante in cantos 23 to 36. For Issabella's place in the economy of the poem, see notes 22 and 24–26.

22. Discussions of the episode are relatively frequent and generally focus on Rodomonte (an exception is Mario Di Cesare, "Issabella and Her Hermit: Stillness at the Center of the *Orlando furioso,*" *Medievalia* 6 [1980]: 311–22). They include Dalla Palma *Le strutture narrative dell' "Orlando furioso,"* 193–97; Wiggins, *Figures in Ariosto's Tapestry* (59–63); Benson, *The Invention of Renaissance Woman*, 107–9; and, importantly, Finucci, *The Lady Vanishes*, 171–97.

23. For instance, the three together illustrate key aspects of the pervasive theme of "fede" and chivalric honor (see my "Faith Cover-Up: Ariosto's *Orlando furioso*, Canto 21, and Machiavellian Ethics," *I Tatti Studies in the Renaissance* 8 [1999]: 135–70).

24. To fully appreciate the character's function in the poem one needs to begin with her first appearance in cantos 12–13 and to track her intermittent reappearances in *propria persona* and the mouths of others until the climactic episode of her death in canto 29.

25. Di Cesare remarks parallels between Angelica and Issabella ("Issabella and Her Hermit," 325–27), notably the emphasis the narrator puts on their virginities.

26. See Lisa K. Regan's reading of the apotheosis of the character Issabella in relation to Ariosto's patronage relationship with Isabella d'Este ("Ariosto's Threshold Patron: Isabella d'Este in the *Orlando furioso,*" *MLN* 120 [2005]: 50–69). For relevant studies of Isabella d'Este, see especially Deanna Shemek, "In Continuous Expectation: Isabella d'Este's Epistolary Desire," in *Phaethon's Children: The Este Court and its Culture in Early Modern Italy,* ed. Dennis Looney and Deanna Shemek (Tempe, AZ: Medieval and Renaissance Texts and Studies, 2005), 269–300, as well as Lisa K. Regan's "Creating the Court Lady: Isabella d'Este as Patron and Subject" (PhD diss., University of California Berkeley, 2004).

27. When first introduced she is simply referred to as "la vergine" and in a context that suggests that she (and Gabrina, from the other side) are generic representa-

tives of the traditionally constructed angelic and demonic facets of womanhood (cf. 12.92.2, 6).

28. On the coordination between towers, giants, and "the phallus" in Ariosto, see my "Body Politics in Ariosto's *Orlando furioso*." On giants in general, see Walter Stephens, *Giants in Those Days: Folklore, Ancient History, and Nationalism* (Lincoln: University of Nebraska Press, 1989) and John Block Friedman, *The Monstrous Races in Medieval Art and Thought* (Cambridge, MA: Harvard University Press, 1981).

29. Di Cesare briefly explores the sacramental and baptismal symbolism of the episode ("Issabella and Her Hermit," 322).

30. "On Wifely Duties," bk. 2, chap. 7, in *The Earthly Republic: Italian Humanists on Government and Society*, ed. and trans. Benjamin Kohl and Ronald Witt with Elizabeth Welles (Philadelphia: University of Pennsylvania Press, 1978), 178–228. For Ariosto's knowledge and use of Barbaro's text, see Pio Rajna, *Le fonti dell' "Orlando furioso,"* ed. Francesco Mazzoni (1900; rpt., Florence: Sansoni, 1975), 459–63 (cf. 523–26).

31. *The Lady Vanishes*, 171–97. On male narcissism in the *Furioso* more generally, see Ascoli, *Ariosto's Bitter Harmony*, 177 and 318; Finucci, *The Lady Vanishes* and *The Manly Masquerade*; and, especially, Bellamy, *Translations of Power*, 82–133.

32. As does Benson; see *The Invention of Renaissance Woman*, 108–9.

33. I am indebted to Daniel Brownstein for pointing out this medical commonplace. Examples can be found in Aldobrandino da Siena's thirteenth-century treatise, *Il libro*, chap. 4, p. 9, a translation of the *De secretis mulierum* of Pseudo-Albertus Magnus, and, closer to hand for Ariosto, in the mid-fifteenth century gynecological and pediatric treatise, *Ad mulieres ferrarienses*, by the Ferrarese doctor Michele Savonarola, trat. 1, cap. 1, pp. 11, 12. This association, which suggests that the decapitation is figuratively related to vaginal penetration, and thus to "defloration," complicates Finucci's claim that the severing of Issabella's head is a figure of castration (*The Lady Vanishes*, 171–72, 189, but cf. 186–87).

34. Note that the verb *immollarsi*, "to make oneself wet," closely resembles another verb, *immolarsi*, "to immolate, to make a sacrifice of, oneslf," and thus punningly prefigures Issabella's real purpose. Note also that *ampolla*, used metonymically for the liquid it contains, is a word that also refers specifically to the ecclesiastical cruet, defined by Wikipedia as a container used "during some Christian religious ceremonies . . . to keep wine and water for Eucharist . . . Cruets specifically intended for religious ceremonies come in pairs: one to contain water, often marked *A* for *Aqua*, and one to contain wine, *V* for *Vinum*" (http://en.wikipedia.org/wiki/cruet, accessed May 5, 2009). This, together with the interchangeable reference to the cruet's contents as "acqua" and "liquore," confirms the liturgical and specifically eucharistic overtones of the episode, parodied in Rodomonte's wine-induced drunkenness in a church (cf. note 29 above).

35. For an overview of the cultural significance of menstruation, see Janice Delaney, Mary Jane Lupton, and Emily Toth, *The Curse: A Cultural History of Menstruation* (New York: Dutton, 1976); the essays in Thomas Buckley and Alma Gotlieb, eds., *Blood Magic: The Anthropology of Menstruation* (Berkeley: University of California Press, 1988); and Charlotte Elishiva Fonrobert, *Menstrual Purity: Rabbinic and Christian Reconstructions of Biblical Gender* (Stanford, CA: Stanford University Press, 2000). For early modern Italy in particular, see Piero Camporesi, *Il sugo: Simbolismo e magia del sangue* (Milan: Edizione di Comunità, 1982); Ottavia Niccoli, "'Menstruum quasi monstruum': Monstrous Births and Menstrual Taboo in the Sixteenth Century," in *Sex and Gender in*

Historical Perspective, 1–25; Ruggiero, *The Boundaries of Eros*, 33–35; and Guido Ruggiero, *Binding Passions: Tales of Magic, Marriage, and Power at the End of the Renaissance* (New York: Oxford University Press, 1993), 238 n. 12, 244 n. 15, 247 n. 45. Ruggiero shows that the association of menstrual blood with magical rituals is pervasive in this era. I owe a particular debt to him for bibliographical suggestions.

36. For male menstruation in general, see Delaney et al., *The Curse*, chaps. 26–27, and for the Renaissance in particular, see Gianna Pomata, "Menstruating Men: Similarity and Difference of the Sexes in Early Modern Medicine," in *Generation and Degeneration: Tropes of Reproduction in Literature and History from Antiquity to Early Modern Europe*, ed. Valerie Finucci and Kevin Brownlee (Durham, NC: Duke University Press, 2001), 109–52. If the Ariostan text has this specific medical tradition in mind, it is only at a great allusive distance.

37. Rajna comments on the seeming incongruity of Rodomonte's behavior (*Le fonti dell' "Orlando furioso,"* 463). Finucci (*The Lady Vanishes*, 174) explains it as a desire for immortality, but invulnerability is not the same thing as immortality—eventual death by natural causes is not excluded.

38. Orlando's departure from the Christian camp after Charlemagne has deprived him of a beloved woman is analogous to Achilles' departure from the Greek camp after Agammemnon appropriates Briseis, and his subsequent "furia" is in some sense derivative of the Greek hero's "wrath." The most "Achillean" moment in his career, of course, is the *aristeia* that ensues upon the death of Brandimarte / Patroclus at the hands of Gradasso (see esp. 42.2). See also Richard Lansing, "Ariosto's *Orlando furioso* and the Homeric Model," *Comparative Literature* 24 (1987): 311–25.

39. In 46.119, Ariosto specifically reminds us that Bradamante had earlier deprived Rodomonte of the "scoglio del serpente." It is, however, also true that in the following stanza he states that Ruggiero's enchanted sword, Balisarda, would have cut through that armor as well as the inferior one he currently wears. On the one hand, this qualifies the role that Bradamante is assigned in the archpagan's demise; on the other, it takes away credit Ruggiero himself might have received for the victory (see also 146.116, 121–22.) Shemek, *Ladies Errant*, 122–23, also notes this.

40. The passages are specifically linked by the words *giurare* (17.2), *acqua* (16.5, 18.2, 19.3), and *inviolabile* (17.7).

41. Regan, "Ariosto's Threshold Patron," similarly sees the praise as subverted, though on other grounds.

T E N : "Di sangue illustre & pellegrino"

I completed much of the research for this chapter as a fellow at Villa I Tatti, the Harvard University Center for Italian Renaissance Studies, and would like to thank this institution heartily for its support. I thank warmly Deanna Shemek, Virginia Cox, Paolo Alei, Marguerite Waller, and Douglas Biow for their comments. Thanks are also owed to the anonymous reader for the Johns Hopkins University Press.

1. For a summary of the scholarship on this oil on panel painting, see Pier Virgilio Begni Redona, *Alessandro Bonvicino: Il Moretto da Brescia* (Brescia: La Scuola, 1988), 354–56, and Ida Gianfranceschi and Elena Lucchesi Ragni, "Tullia von Aragon," in *Vittoria Colonna: Dichterin und Muse Michelangelos*, ed. Sylvia Ferino Pagden (Vienna:

Skira, 1997), 209–12. I would like thank Gianfranceschi and Lucchesi Ragni for provid-
ing me with a longer manuscript version of this same entry.

2. This title appears in the inventory of Teodoro Lechi, who sold the painting to
Giuseppe Longhi on July 20, 1814. See Fausto Lechi, ed., *I quadri delle collezioni Lechi in
Brescia: Storia e documenti* (Florence: Olschki, 1968), 204.

3. Erwin Panofsky cites Origen (second century BCE) as the earliest source that
confuses mother and daughter. See Erwin Panofsky, *Problems in Titian, Mostly Icono-
graphical* (London: Phaidon, 1969), 44. The Titian *Salomè* at the Doria Pamphili Gal-
lery in Rome was listed in the 1592 inventory of Lucrezia d'Este, Duchess of Urbino,
as "uno di un Herodiade"; see Paul Joannides, "Titian's Judith and Its Context: The
Iconography of Decapitation," *Apollo* 135.361 (1992): 164–65. In a fascinating article on
what she calls the "Salome© effect," Megan Becker-Leckrone unpacks the textual tradi-
tion regarding "Salome"; the quotation marks are hers, as one of her arguments is that
Salome has been constructed largely through the discourse on her rather than through
any primary, original texts. She emphasizes the role that the Decadents in particular
played in constructing Salome and notes that they and their commentators further
conflated "character and plot, woman and text" in what she sees as a fetishization of the
Salome myth ("Salome: The Fetishization of a Textual Corpus," *New Literary History*
26.2 [1995]: 240).

4. See Matt. 14:1–12; Mark 6:17–28; and Flavius Josephus, *Selections from Josephus*,
trans. Henry St. John Thackeray (New York: MacMillan, 1919), 81. The characteriza-
tion of Salome in the ancient textual tradition clearly conflicts with the better-known
late nineteenth-century narratives of the sensuous, dancing femme fatale. Yet Martha
Levine Dunkelman locates a turning point in the visual representation of Salome as a
relatively calm and passive young woman in fourteenth-century Italian art to more se-
ductive one in the fifteenth century; see her "The Innocent Salome," *Gazette des Beaux-
Arts* 133(1999): 173–80.

5. See the paintings by Sebastiano del Piombo from 1510 (National Gallery, Lon-
don) or by Titian in 1515 (Galleria Doria Pamphili, Rome). There are numerous other
three-quarter figures like these that are holding a platter with John the Baptist's head
such as those by Bernardino Luini, Guercino, and Caravaggio, to name just a few. For a
compendium of images of Salome, see Kerstin Merkel, *Salome: Ikonographie im Wan-
del* (Frankfurt am Main: Peter Lang, 1990), and Eleonora Bairati, *Salomè: Immagini
di un mito* (Nuoro: Ilisso, 1998). The decapitated head has often created confusion as
to whether the representation is of Salome or Judith; see Joannides, "Titian's Judith,"
who argues that the Doria Pamphili painting represents a Judith rather than a Salome.
Margarita Stocker has also pointed out that Judith is the identity of choice for many sex
workers because her iconographical markers respond on a number of different levels to
the economical and psychosexual needs of the women and their clients (*Judith, Sexual
Warrior: Women and Power in Western Culture* [New Haven, CT: Yale University Press,
1998], 35–40).

6. This usually occurs in narrative scenes of Herod's feast such as in the fresco by
Filippo Lippi in the Duomo di Prato. To my knowledge, nearly all of the representa-
tions of Salome as dancer are found either in quattrocento narrative paintings, such as
Lippi's, or in nineteenth-century Decadent works. For patristic discussions of Salome
as dancer, see Alessandro Arcangeli, *Davide o Salome: Il dibattito europeo sulla danza*

nella prima età moderna (Rome: Viella, 2000), 193 and 201–3. I thank Ronald Martinez for this reference.

7. The inscription has been regarded as contemporaneous with the painting largely because it resembles closely other inscriptions known to be in Moretto da Brescia's hand. See Pietro Da Ponte, *L'opera del Moretto* (Brescia: Tipografia Editrice, 1898), 47. Guido Biagi had conjectured that nuns, purportedly previous owners of the painting, added the inscription out of the desire to hide the fame of a woman so profane ("Un'etèra romana: Tullia d'Aragona," *Nuova antologia*, ser. 3, 4.16 [1886]: 656).

8. Unless otherwise noted, all translations are my own. Salvatore Bongi was the first to discuss the relation between Moretto's painting and d'Aragona and to recall the print of the Piotti Pirola engraving together with the verses identifying the figure as d'Aragona ("Il velo giallo di Tullia d'Aragona," *Rivista critica della letteratura italiana* 3.3 [1886]: 94–95). Gianfranceschi and Lucchesi Ragni located the print in a private collection in Brescia and reproduced it in the exhibition catalogue to the 1997 exhibition on Vittoria Colonna at the Kunsthistorisches Museum in Vienna ("Tullia von Aragon," 209).

9. Controversy surrounded the identity of d'Aragona's father even in her own day. Girolamo Muzio, d'Aragona's most ardent admirer, first noted her noble origins as the daughter of Cardinal Luigi d'Aragona, grandson of Ferdinand I of Naples, in the eclogue *Tirrhenia*, which was published in d'Aragona's *Rime della signora Tullia di Aragona et di diversi a lei* in 1547: "un gran pastor, che di purpuree bende ornato il crine e la sacrata fronte" ("a grand shepherd, whose locks and sacred forehead were adorned by purple bands") (26). D'Aragona's detractors, notably Pietro Aretino and Agnolo Firenzuola, derided this claim to noble birth, yet the genre in which they wrote, the stridency of their tone, and exaggerations in their argument lead the reader to interpret their comments with caution. See Pietro Aretino, *Ragionamento del Zoppino fatto frate, e Lodovico, puttaniere, dove contiensi la vita e genealogia di tutte le cortigiane di Roma*, ed. Mario Cicognani (Milan: Longanesi, 1969), 45, and Firenzuola's sonnet "Mentre che dentro a le nefande mura" ("While Inside the Atrocious Walls"), in *Opere scelte*, ed. Giuseppe Fatini (Turin: UTET, 1957), 941. Salvatore Bongi did publish documents first found by Luciano Bianchi in 1887 in which d'Aragona's father is named as Costanzo Palmieri d'Aragona, and he later noted the strange coincidence in their homonymous surnames, yet Enrico Celani conjectures that d'Aragona's mother, Giulia Campana, might have married a family member of the cardinal for money. I would add that this marriage would have offered a certain degree of protection to Giulia Campana and her daughter. See Bongi, "Documenti senesi su Tullia d'Aragona," *Rivista critica della letteratura italiana* 4.6 (1887): 188 (the original document may be found at Archivio di Stato di Siena, Gabella, 1 gennaio 1544–30 giugno 1545, c. 12–13), and Enrico Celani, introduction, *Le rime di Tullia d'Aragona cortigiana del secolo XVI* (1891; rpt., Bologna: Commissione per i testi di lingua, 1968), xxxii–xxxiii. Most scholars now concur that the consensus among d'Aragona's contemporaries that she was noble lends credence to the hypothesis that indeed she was and that her notoriety was never marred by the d'Aragona family refuting her claim to be one of them. Of course, one might argue, however, that decorum and custom would lead the family to ignore completely any such claim so as to avoid adding fuel to the fire.

10. One element which has been entirely overlooked in the literature linking Moretto's painting to d'Aragona regards when her status as an author was established.

If the work was painted sometime around 1540, as Begni Redona conjectures, and if it is to represent Tullia d'Aragona as poet, then her reputation as poet would already had to have been in place by that time. Ercole Bentivoglio addressed a sonnet to d'Aragona ("Poi che lasciando i sette colli, et l'acque" ["Since Having Left the Seven Hills, and the Waters"]) precisely in 1537 upon her arrival in Ferrara in which he refers to "dotti accenti, che vi ispira Eurterpe" ("the learned accents, that Euterpe inspires in you"). D'Aragona's presence in Ferrara is documented in a letter that an Apollo (an alias for Battista Stambellino) wrote to Isabella d'Este on June 13, 1537. The letter was reprinted in its entirety by Alessandro Luzio in "Un'avventura di Tullia d'Aragona," *Rivista storica mantovana* 1.1–2 (1885): 179–82.

11. Bongi refers to a letter of April 18, 1885 ("Il velo giallo," 94), written to him by Giuseppe Gallia from Brescia:

> Il vecchio custode, già domestico del conte Tosio, mi dice che questo dipinto fu prima in un convento di monache, e che il conte stesso lo comperò da una di queste verso il 1829, e però circa 30 anni dopo disciolti i conventi. Gli domandai, poiché quelle parole nel marmo ne fanno una Erodiade, come mai fu battezzata per Tullia d'Aragona, così veramente da lui stesso chiamandosi e con questo nome essendo indicata dall'Odorici nella *Guida di Brescia*, stampata nel 1853; ed egli mi rispose che così la nominarono tutti i forestieri visitatori, senza sapermi dire altro.

> (The elderly custodian, who had been a housekeeper of Count Tosio, tells me that this painting had first been in a convent of nuns, and that the count himself bought it from one of them in 1829, around 30 years after the convents had been closed. I asked him, since those words in the marble make a Herodias of it, why in the world was it baptized Tullia d'Aragona, since he himself calls it with this name and so it is indicated by Odorici in the *Guide to Brescia*, published in 1853? He responded that all the foreign visitors called it that and wasn't able to add anything else.)

12. Ann Rosalind Jones refutes the identification of Moretto's Salome with d'Aragona, arguing that it was a romanticizing need on the part of her late nineteenth-century critics and editors, namely Guido Biagi and Enrico Celani, that produced it ("Bad Press: Modern Editors versus Early Modern Women Poets (Tullia d'Aragona, Gaspara Stampa, Veronica Franco)," in *Strong Voices, Weak History: Early Women Writers and Canons in England, France, and Italy*, ed. Pamela Joseph Benson and Victoria Kirkham [Ann Arbor: University of Michigan Press, 2004], 287–313). For the identification of a painting by Sebastiano del Piombo with d'Aragona, see E. H. Ramsden, "Concerning a Portrait of a Lady," in *Come, Take this Lute: A Quest of Identities in Italian Renaissance Portraiture* (Bath, UK: Element Books, 1983), 95–110.

13. See Gianfranceschi and Lucchesi Ragni, "Tullia von Aragon," 209. Incidentally, in 2001, largely owing to the efforts of Gianfranceschi and Lucchesi Ragni, the Pinacoteca Tosio Martinengo changed the title on the nameplate for this painting from "Salome" to "Tullia d'Aragona in veste di Salomè" ("Tullia d'Aragona Dressed as Salome").

14. Georgina Masson first emphasized d'Aragona's desire to portray herself as an intellectual and indeed entitled her chapter on her "Tullia d'Aragona, the Intellectual Courtesan"; see her popularized but generally accurate *Courtesans of the Italian Renais-*

sance (New York: St. Martin's Press, 1976), 88–131. Francesco Bausi concurs with the view that d'Aragona aimed to highlight her qualities as an intellectual, yet he simultaneously undermines her credentials as a writer by reiterating nineteenth-century claims that d'Aragona only wrote with the help of other (male) writers ("'Con agra zampogna': Tullia d'Aragona a Firenze (1545–48)," *Schede umanistiche*, n.s., 2 [1993]: 61–91). More recently, Domenico Zanrè has also characterized d'Aragona's *Rime* as a conscious attempt at self-legitimization through literary means (*Cultural Non-Conformity in Early Modern Florence* [Burlington, VT: Ashgate, 2004], 141–64), and Janet Smarr also claims that d'Aragona "sought to position herself in the center of a circle of admiring intellectuals, whose praises legitimized her participation in their intellectual and literary exchanges" (*Joining the Conversation: Dialogues by Renaissance Women* [Ann Arbor: University of Michigan Press, 2005], 112).

15. For a recent, succinct biography of Tullia d'Aragona, see my "Tullia d'Aragona," in *Encyclopedia of Women in the Renaissance: Italy, France, and England,* ed. Diana Robin, Anne R. Larsen, and Carole Levin (Santa Barbara, CA: ABC-CLIO, 2007), 26–30. The most exhaustive and accurate biography of d'Aragona remains that of Salvatore Bongi, "*Rime della signora Tullia di Aragona; et di diversi a lei,*" in *Annali di Gabriel Giolito de' Ferrari,* 2 vols. (Rome: Principali Librai, 1890), 1:150–99.

16. Since the late nineteenth century, a few scholars have questioned d'Aragona's authorship of the *Meschino*; see Celani, introduction, iii–lxiii, especially lvi–lxiii, and Luigi Filippi, "Un poema poco noto (*Il Meschino*, altramente detto il Guerrino attribuito a Tullia d'Aragona)," in his *Le orme del pensiero* (Ferrara: A. Taddei and Figli, 1919), 227–57. Since then both Virginia Cox ("Fiction, 1560–1650," in *A History of Women's Writing in Italy,* ed. Letizia Panizza and Sharon Wood [Cambridge: Cambridge University Press, 2000], 57) and Rinaldina Russell have expressed doubts regarding d'Aragona's authorship; Russell even goes so far as to not even mention the *Meschino* in her entry in *Encyclopedia of the Renaissance* ("Tullia d'Aragona," *Encyclopedia of the Renaissance,* ed. Paul Grendler, 6 vols. [New York: Scribner's, 1999], 1:84–85). For a defense of d'Aragona's authorship, see Gloria Allaire, "Tullia d'Aragona's *Il Meschino* as Key to a Reappraisal of Her Work," *Quaderni d'Italianistica* 16.1 (1995): 33–50. In a forthcoming article, entitled "Did She or Didn't She? Tullia d'Aragona's *Meschino,*" I too argue, relying on previously ignored historical evidence, for d'Aragona's literary maternity.

17. Rinaldina Russell has pointed to two passages in d'Aragona's dialogue *Dell'infinità d'amore* in which she refers to her status as a woman well versed in the ways of love to argue that d'Aragona "took a detailed interest in shaping her image as a refined and glamorous courtesan." See Rinaldina Russell, introduction, *Dialogue on the Infinity of Love* (Chicago: University of Chicago Press, 1997), 27. The passages in question are at 68 and 75 in the English translation and at 201 and 207 in the modern Italian edition; see Tullia d'Aragona, "Dialogo della signora Tullia d'Aragona della infinità di amore," *Trattati d'amore del Cinquecento,* ed. Giuseppe Zonta (Bari: Laterza, 1912), 185–248. See also her poem to Colonel Luca Antonio de Cuppis, "Poi che rea sorte ingiustamente preme," which also makes use of a slight degree of sexual innuendo.

18. Francesco Agostino della Chiesa, *Theatro delle donne letterate* (Mondovì: G. Gistandi and G. T. Rossi, 1620), 292; Apostolo Zeno, "Note," *Biblioteca dell'eloquenza italiana di monsignor Giusto Fontanini con le annotazioni del signor Apostolo Zeno,* 2 vols. (Venice: Giambatista Pasquali, 1753), 2:95–96; Giovanni Maria Crescimbeni, *L'istoria della volgar poesia,* 6 vols. (Venice: Lorenzo Basegio, 1730–31), 4:67–68; Francesco

Saverio Quadrio, "Rime di Tullia d'Aragona," *Della storia, e della ragione d'ogni poesia*, 4 vols. (Milan: Francesco Agnelli, 1741), 2:235.

19. For the Sienese incidents, see Salvatore Bongi, "Il velo giallo di Tullia d'Aragona," 85–95, and "Documenti senesi su Tullia d'Aragona," 186–88; Bongi later recounts these events and those from Florence in his "*Rime della signora Tullia di Aragona*" 1:173–75. Bongi's archival references unfortunately don't correspond to existing collections; see Archivio di Stato di Siena, Gabella, 1 gennaio 1544–30 giugno 1545, c. 12–13 for her exemption as a married woman. In Florence, d'Aragona was apparently denounced for not wearing the yellow sign that Cosimo I's sumptuary legislation, promulgated on October 19, 1546, required all prostitutes to wear. The story of the yellow veil is well known, and I shall only provide the archival transcriptions and references, as all recently published versions merely recall those of Bongi and Biagi.

20. Firenzuola writes: "Tu meriteresti una femina, come è la Tullia, che si pascesse di adulteri, lasciando morir di fame il marito" ("You merit a woman like Tullia, who lived on adulteries, leaving her husband to die of hunger"). See Agnolo Firenzuola, *Opere*, ed. A. Seroni (Firenze: Sansoni, 1958), 383. Giraldi Cinzio instead tells a tale in which d'Aragona supposedly spurned a young Roman nobleman in order to sell herself to a "loridissimo tedesco" ("nasty dirty German"), for which she was supposedly later forced to leave Rome (*Gli Ecatommiti ovvero cento novelle* [Florence: Borghi, 1834], 43–47). Both authors also refer to d'Aragona's use of love spells or "hammers" as they are called; for information on this phenomenon in early modern Venice, see Guido Ruggiero, *Binding Passions: Tales of Magic, Marriage, and Power at the End of the Renaissance* (New York: Oxford University Press, 1993), especially chaps. 3 and 4.

21. Franco is referring to Sperone Speroni's *Dialogo d'amore*, written and circulated by 1537 but not published until 1541, in which d'Aragona appears as an interlocutor. Pietro Aretino, who clearly knew d'Aragona, chastised Speroni in a letter dated June 6, 1537, for having presented her in such a positive light: "Or per uscir di scherzi, la Tullia ha guadagnato un tesoro che per sempre spenderlo mai non iscemarà, e l'impudicizia sua, per sì fatti onore, può meritamente essere invidiata e da le più pudiche e da le più fortunate" ("Now to stop joking, Tullia garnered such a treasure that she will never diminish it by spending it, and her shamelessness, for such honor, may well be envied by the most modest and the most fortunate"). See Pietro Aretino, *Lettere libro primo*, ed. Francesco Erspamer (Parma: Fondazione Pietro Bembo and Guanda, 1995), 195. Janet Smarr provides an analysis of Speroni's dialogue in conjunction with d'Aragona's later *Dell'infinità d'amore* (1547), interpreting d'Aragona's dialogue as a response to Speroni, in "A Dialogue of Dialogues: Tullia d'Aragona and Sperone Speroni," *MLN* 113 (1998): 204–12.

22. Niccolò Franco, *Il vendemmiatore, poemetto in ottava rima di Luigi Tansillo; e la Priapea, sonetti lussuriosi-satirici di Niccolò Franco* (Pe-King, n.d. [Paris: J. C. Molini, 1790]), 114. Although of debated etymology, "Carampana" likely refers to Ca' Rampani, the name of a Venetian neighborhood where prostitutes lived. My thanks to Virginia Cox for this reference. Also, the adjective *grata* can mean both "grateful" and "gratifying."

23. The adjective *inorpellata*, which denotes the excess associated with sumptuary legislation, is particularly interesting when one considers that d'Aragona was anonymously denounced in Siena for wearing a *sbernia* (a cloak or mantle that was closed with a pin, usually on the left shoulder) on Easter, 1544, which violated the sumptu-

ary legislation in effect at the time. See Bongi, *"Rime della signora Tullia di Aragona"* 1:175.

24. For the relation of ambiguity to courtesans, see Elizabeth S. Cohen, "'Courtesans' and 'Whores': Words and Behavior in Early Modern Rome," *Women's Studies* 19 (1991): 201–8. See also her more recent reflections on the terminology scholars use to talk about sex workers, "Back Talk: Two Prostitutes' Voices from Rome c. 1600," *Early Modern Women: An Interdisciplinary Journal* 2 (2007): 95–126. The literature relating to the context of women writing in early modern culture is vast. See, among others, Ann Rosalind Jones, *The Currency of Eros: Women's Love Lyric in Europe, 1540–1620* (Bloomington: Indiana University Press, 1990); Gabriella Zarri, ed., *Per lettera: La scrittura epistolare femminile tra archivio e tipografia* (Roma: Viella, 1999); Pamela Joseph Benson and Victoria Kirkham, eds., *Strong Voices, Weak History*; Diana Robin, *Publishing Women: Salons, the Presses, and the Counter-Reformation in Sixteenth-Century Italy* (Chicago: University of Chicago Press, 2007); and the introductions to the volumes of the Other Voice series published by the University of Chicago Press. I was unable to consider adequately Virginia Cox's monumental *Women's Writing in Italy, 1400–1650* (Baltimore, MD: Johns Hopkins University Press, 2008), which was published after this chapter was written.

25. I argued for the primary idea behind this section—that female poets tended to make a different structural use of the *proposta / risposta* model from male authors—in a paper presented at the annual conference of the Renaissance Society of America in 2003. Victoria Kirkham's recent edition of Laura Battiferra's poetry makes this point as well; see her introduction to Laura Battiferra degli Ammannati, *Laura Battiferra and Her Literary Circle*, ed. and trans. Victoria Kirkham (Chicago: University of Chicago Press, 2006), 36 n. 58, 70 n. 1. Victoria Kirkham was the first to coin the phrase "choral anthology"; see her "Laura Battiferra degli Ammannati's First Book of Poetry: A Renaissance Holograph Comes out of Hiding," *Rinascimento* 36 (1996): 353.

26. For this type of anthology, see Franco Tomasi's excellent "Alcuni aspetti delle antologie liriche del secondo Cinquecento," in *"I più vaghi e i più soavi fiori": Studi sulle antologie di lirica del Cinquecento*, ed. Monica Bianco and Elena Strada (Alessandria: dell'Orso, 2001), 77–112, and Diana Robin, *Publishing Women*, 205–42.

27. For further discussion of d'Aragona's *Rime* and her interlocutors, see my "Out of the Archive: Four Newly-Identified Figures in Tullia d'Aragona's *Rime della signora Tullia di Aragona et di diversi a lei* (1547)," *MLN* 118 (2003): 257–63. For recently discovered dedicatees, see Renée P. Baernstein and Julia L. Hairston, "Tullia d'Aragona: Two New Sonnets," *MLN* 123 (2008): 151–59.

28. Pasquale Sabbatino, "Sulla tradizione a stampa delle *Rime*," in his *La "scienza della scrittura": Dal progetto del Bembo al manuale* (Florence: Olschki, 1988), 103–41.

29. Sabbatino, "Sulla tradizione a stampa," 109.

30. See Francesco Petrarca, *Le opere volgari del Petrarca con la esposizione di Alessandro Vellutello da Lucca* (Venice: Giovanniantonio and Fratelli da Sabbio, 1525) and Girolamo Malipiero, *Il Petrarcha spirituale* (Venice: Francesco Marcolini da Forlì, 1536).

31. I have not been able to locate any verse collections prior d'Aragona's that publish *proposte* and *risposte* side by side. Some poets with whom she associated did so subsequently to her; see Girolamo Muzio, *Rime diverse del Mutio Iustinopolitano* (Venice: Gabriele Giolito, 1551), fols. 42v–43v, 57v–58r, and 67r–v, and Benedetto Varchi's sepa-

rate volume dedicated to correspondence poetry, *De' sonetti di M. Benedetto Varchi colle risposte, e proposte di diversi*, pt. 2 (Florence: Lorenzo Torrentino, 1557).

32. In the first edition of Terracina's *Rime* (1548), presented by Ludovico Domenichi, the section of poems in her praise functions more like an appendix than an integral part of the text, for it appears after the index of first lines. It contains fourteen compositions (octaves, sonnets, and even a letter) by eleven dedicators.

33. The authors were Ludovico Domenichi, Ippolita Borromea, Isabetta Guasca, Francesca Baffa, Anton' Maria Braccioforte, and Anton Francesco Doni. See Luigi Cassola, *Madrigali del magnifico signor cavallier Luigi Cassola piacentino* (Venice: Gabriele Giolito, 1544), n.p.

34. *Alma* in line 3 can be read as an adjective or as a noun. Because the punctuation between the two noun phrases is missing, it can therefore be interpreted either as "your infinite, divine light" or "your light, infinite soul."

35. It is not implausible to date the composition after January 18, 1547, as there were already other sonnets that had been included in d'Aragona's text regarding events that occurred on June 10 (the death of one of Duchess Eleonora's sons) and July 5, 1547 (the birth of another). See Bongi, "*Rime della signora Tullia di Aragona*," 187 n. 2.

36. For an identification of some of the lesser-known figures in d'Aragona's collection that helps to recharacterize her as a pan-Italian literary figure, see my "Out of the Archive."

37. In one of her sonnets to Cosimo, she claims:

A te rifuggo in sì grave periglio;
Et solo chieggio humil, che come l'alma
Secura vive homai ne la tua corte
Da la vicina, & minacciata morte,
Così la tua mercè di ben n'apporte
Tanto, che l'altra mia povera salma
Libera venga per le ricche porte.

(In such grave danger, I take refuge in you.
And, humbly, I only ask that as my soul
Lives safely now in your court
After a near and menacing death
So may your merciful generosity grant
That my other poor body,
May enter freely through the rich gates.)

38. In a sonnet to Varchi, we read:

Deh perché non poss'io com'ho la voglia
Del vostro alto saver colmarmi il core?
Che con tal guida so ch'uscirei fore
De le man di fortuna che mi spoglia
D'ogni usato conforto: e ogni mia doglia
Cangerei in dolce canto, e 'n miglior hore.

(Pray, why can I not, as I desire
Fill my heart with your high knowledge?

Because with such a guide I know I would escape
The hand of fortune that denudes me
Of all my usual comforts; and I would turn
My every sorrow into sweet song, and better times.)

39. The epitaph sonnets are to Francesco Maria Molza, who died in 1544, and to Emilio Tondi, upon the death of his brother in Siena. A final epitaph poem is addressed to Tiberio Nari and figures less as a declaration of grief and more as an encouragement to the dedicatee.

40. Both the anacoluthon and the preposition *a* of the Italian version render more ambiguous the recipient of the fame the poem hopes to supply.

41. As also noted by Jones (*The Currency of Eros*, 112), Celani's edition incorrectly assumes that these poems are addressed to Manelli.

42. This idea was suggested by the anonymous reviewer for the press of this volume.

43. See his "Se 'l mondo diede alhor la gloria a ARPINO" ("If the World Gave Then the Glory to Arpino"), in d'Aragona, *Rime*, 18.

44. Girolamo Muzio, *Lettere*, ed. Anna Maria Negri (Alessandria: dell'Orso, 2000), 321.

45. See my note 10.

46. Luciana Borsetto recalls Muzio's solution to d'Aragona's request in Muzio's *Egloghe del Mutio Iustinopolitano* (Venice: Gabriele Giolito, 1550), 1.3.180–88. See Luciana Borsetto, "L'egloga in sciolti nella prima metà del Cinquecento: Appunti sul *liber* di Girolamo Muzio," *Chronique italiennes* 3 (2003) (www.univ-paris3.fr/recherche/chroniquesitaliennes/numeros/Web3.html; accessed June 6, 2007).

47. See Muzio's prefatory letter to the *Dialogo della signora Tullia d'Aragona della infinità di amore*, where he indicates the specifics of his intervention (d'Aragona, *Dialogo*, 245–47). See also Bongi, "*Rime della signora Tullia di Aragona*," 187–88. Without any explanation as to how she might have reached her conclusion, Claudia di Filippo Bareggi lists Ludovico Dolce as the editor of d'Aragona's *Rime*; see her *Il mestiere di scrivere: Lavoro intellettuale e mercato librario a Venezia nel Cinquecento* (Rome: Bulzoni, 1988), 60, 99 n. 33, 417.

48. Biblioteca Nazionale Centrale di Firenze (hereafter BNCF), Autografi Palatini, Lettere al Varchi, 1, letter 15. Bongi, "*Rime della signora Tullia di Aragona*," 187 n. 3, regards this *pistola* as being the dedication to the choral anthology, whereas Bausi, "'Con agra zampogna,'" 69, assumes that it is the *suplica* mentioned in an earlier letter, that is, d'Aragona's request for exemption from the yellow veil. The numerous requests for linguistic and stylistic correction of her sonnets in these letters have been cited by those critics who argue that d'Aragona did not compose her own works, an issue I shall not treat here. I shall only note her verb *riscrivere*; note also that in another letter to Varchi, she commands him "ragionate alle volte col mio dialogo" (BNCF, Autografi Palatini, Lettere al Varchi, 1, letter 10). For a compendium of earlier critics who doubted d'Aragona's authorship, see Giuseppe Zonta, ed., *Trattati d'amore del Cinquecento* (Bari: Laterza, 1912), 360–62, and, more recently, Umberto Pirotti, *Benedetto Varchi e la cultura del suo tempo* (Florence: Olschki, 1971), 45–46, and Francesco Bausi, "'Con agra zampogna,'" especially 65–68.

49. Biagi, "Un'etèra romana," 704.

50. BNCF, Magliabechiano, cl. 7, 1185, fols. 308r–318v.

51. Bongi, "*Rime della signora Tullia di Aragona*," 184–87.

52. BNCF, Autografi Palatini, Lettere al Varchi, 1, letter 14. The letter is unaddressed, but Giuseppe Morini, the librarian who put the letters in order, hypothesizes that it was intended for Varchi.

53. The *capitolo* mentioned in the supplication was first published by Francesco Trucchi, who attributed authorship to Lattanzio Benucci; Bongi later suggested that it was likely d'Aragona's own composition, but, more recently, Francesco Bausi has argued that the composition is indeed Benucci's, as attested by the copy of an autograph of it in the BNCF, Magliabechiano, cl. 7, 779, fols. 152r–155v.

54. See Archivio di Stato di Firenze, Magistrato supremo, I filza di suppliche e lettere, n. 1118 (n. interno 133). Note the oscillation between the use of the second-person plural (*voi*) and the third-person singular (*lei*) as modes of formal address in this letter.

55. Ippolito de' Medici's "Anima bella, che nel bel tuo lume" ("Beautiful Soul, for in Your Lovely Light") necessarily dates either to 1535 or earlier, for he died that same year. He refers to her "dolce canto," which could, however, also refer to her talent as a lyre player. As regards certain reference to her poetic talents, see note 10.

56. I will include the expurgated sonnets, as well as a number of other previously unknown or unpublished compositions, in the appendix of my edition of d'Aragona's *Complete Poems and Letters* for the Other Voice series, which has now migrated to the Centre for Renaissance and Reformation Studies.

57. The description potentially recalls the negative depiction of d'Aragona as an errant, mercenary prostitute in Giovan Battista Giraldi Cinzio's novella 7 of his *Gli Ecatommiti*.

58. For an excellent reading of the dialogue from a philosophical point of view, see Lisa Curtis-Wendlandt, "Conversing on Love: Text and Subtext in Tullia d'Aragona's *Dialogo della infinità d'amore*," *Hypatia* 19.4 (2004): 75–96.

ELEVEN: The Beard in Sixteenth-Century Italy

My thanks to Louis A. Waldman, Wayne A. Rebhorn, Julia Hairston, and Robert B. Simon for suggestions on this chapter. My thanks as well to Daniela Bini and the Department of French and Italian at the University of Texas at Austin for financial assistance in covering the costs associated with purchasing the images reproduced in this chapter.

1. Elliott Horowitz, "The New World and the Changing Face of Europe," *Sixteenth Century Journal* 28 (1997): 1181–1201.

2. Horowitz, "The New World and the Changing Face of Europe," 1185.

3. Mark J. Zucker, "Raphael and the Beard of Pope Julius II," *Art Bulletin* 55 (1977): 524–33, provides an in-depth study of this in his fine article. On the beard generally in history, see Reginald Reynolds, *Beards: An Omnium Gatherum* (London: Allen and Unwin, 1950).

4. Zucker, "Raphael and the Beard," 526, quoting from the *Diario romano* of Sebastiano di Branca Tedallini (May–June 1511), in *Rerum italicarum scriptores: Raccolta degli storici italiani*, vol. 23, pt. 3, ed. Lodovico A. Muratori (Città di Castello: S. Lapi,

1904), 321: "And the pope wore a beard like a hermit [*romito*], and no one can remember anything similar, that popes should wear a beard."

5. As Giles Constable, introduction, *Apologiae duae*, ed. R. B. C. Huygens (Turnhout: Brepols, 1985), 92–93, summarily observes, "Peasants were often shown with beards."

6. Machiavelli, *Clizia*, in *Tutte le opere*, ed. Mario Martelli (Florence: Sansoni, 1992), 1.3. There is nothing of this sort in Plautus's *Casina*, which is the classical model.

7. On the broader function of cleanliness in the period, see Douglas Biow, *The Culture of Cleanliness in Renaissance Italy* (Ithaca, NY: Cornell University Press, 2006).

8. Francesco Guicciardini, *History of Italy*, trans. Sidney Alexander (Princeton, NJ: Princeton University Press, 1969), 1.

9. David Quint, "Courtier, Prince, Lady: The Design of the *Book of the Courtier*," *Italian Quarterly* 37 (2000): 185–95, reviews the scholarship on the topic.

10. I have addressed some of these matters in "Manly Matters: The Theatricality and Sociability of Beards in Giordano Bruno's *Candelaio* and Sixteenth-Century Italy," *Journal of Medieval and Early Modern Studies*, forthcoming.

11. Baldassarre Castiglione, *The Book of the Courtier*, trans. Charles S. Singleton, ed. Edgar de N. Mayhew (New York: Anchor Books, 1959), 121, my emphasis. For the Italian, see *Il cortegiano*, 3rd ed., ed. Vittorio Cian (Florence: Sansoni, 1929).

12. Will Fisher, "The Renaissance Beard: Masculinity in Early Modern England," *Renaissance Quarterly* 54 (2001): 173, discusses this in the context of Renaissance England.

13. Horowitz, "The New World and the Changing Face of Europe," 1191.

14. Castiglione, *The Book of the Courtier*, 122–23, my emphasis.

15. Zucker, "Raphael and the Beard," 526, on Julius II characterized in 1511 as a bear.

16. For Renaissance strategies of being inconspicuously conspicuous, with a focus on Castiglione, see Douglas Biow, *In Your Face: Professional Improprieties and the Art of Being Conspicuous in Sixteenth-Century Italy* (Stanford, CA: Stanford University Press, 2010), chap. 1 and relevant bibliography.

17. Giovanni della Casa, *Galateo*, trans. Konrad Eisenbichler and Kenneth R. Bartlett (Toronto: Centre for Reformation and Renaissance Studies, 1986), 42. The Italian is taken from *Opere*, ed. Carlo Cordié (Milan: Ricciardi, 1960).

18. Castiglione, *The Book of the Courtier*, 12, on one occasion acknowledges that it is almost impossible to know why fashions change. On another occasion, however, he does note that the many invasions Italy suffered affected fashion: "By way of the wars and ruins of Italy, changes have come about in the language, in the buildings, dress, and customs" (6). In this last instance, Castiglione may have a historical *longue durée* in mind (the changes since the fall of the Roman empire, say), but he surely has the recent ravages of invasions on his mind as well.

19. Della Casa, *Galateo*, 42.

20. Bembo changed his facial features, going from being thickly bearded to mildly bearded to shaven, or such is at least suggested by Cellini, who describes the matter in a letter about the making of the medal for Bembo. See Benvenuto Cellini, *Opere: Vita, trattati, rime, lettere*, ed. Bruno Maier (Milan: Rizzoli, 1968), 1000.

21. Virtually everyone was beardless from 1350 to 1500, and early in the sixteenth century a number remained without beards, among the most famous of whom were Machiavelli and Guicciardini.

22. Luca Landucci, *A Florentine Diary from 1450–1516*, trans. Alice de Rosen Jervis (London: Dent, 1927), 294, my emphasis: "In the year 1529 the custom of wearing hoods began to go out, and by 1532 not a single one was to be seen; caps or hats being worn instead. Also, at this time, men began to cut their hair short, everyone having formerly worn it long, on to their shoulders, without exception; *and they now began to wear a beard.*"

23. Robert B. Simon, "Bronzino's Portrait of Cosimo I in Armour," *Burlington Magazine* 125 (1983): 527 n. 2. See also Robert B. Simon, "Bronzino's *Cosimo I de' Medici as Orpheus,*" *Philadelphia Museum of Art Bulletin* 81.348 (1985): 16–27, and Maurice Brock, *Bronzino* (London: Thames and Hudson, 2002), 172–74.

24. Janet Cox-Rearick, *Bronzino's Chapel of Eleonora in the Palazzo Vecchio* (Berkeley: University of California Press, 1993), 377.

25. See Simon, "Bronzino's Portrait of Cosimo I in Armour," for a discussion and dating of the first portrait of Cosimo in armor and the various versions, both by Bronzino and his workshop.

26. See Kurt W. Foster, "Metaphors of Rule: Political Ideology and History in the Portraits of Cosimo I de' Medici," *Mitteilungen des Kunsthistorischen Institutes in Florenz* 15 (1971): 65–104; Janet Cox-Rearick, *Dynasty and Destiny in Medici Art: Pontormo, Leo X, and the Two Cosimos* (Princeton, NJ: Princeton University Press, 1984); and Karla Langedijk, *The Portraits of the Medici*, vol. 1 (Florence: Studio per Edizioni Scelte, 1981).

27. Bruce Edelstein, "Leone Leoni, Benvenuto Cellini and Francesco Vinta, a Medici Agent in Milan," *The Sculpture Journal* 4 (2000): 36 and 42.

28. The medal was never actually made but that does not detract from the point that the shape and size of the beard were important in the deliberations about the design.

29. Langedijk, *The Portraits of the Medici*, 82.

30. Langedijk, *The Portraits of the Medici*, 82.

31. Brock, *Bronzino*, 105.

32. Langedijk, *The Portraits of the Medici*, 86. On the three types of portraits that make up the official image of the duke presented to the world, see Langedijk, *The Portraits of the Medici*, 79–120, 407–530.

33. The array available for design exceeded the limited number shown, for instance, in Giovanni Battista della Porta, *La fisonomia dell'huomo* (Venice: Presso Sebastian Combi, 1652), 237–38.

34. See Elizabeth Cropper, "Prolegomena to a New Interpretation of Bronzino's Florentine Portraits," in *Renaissance Studies in Honor of Craig Hugh Smyth*, 2 vols., ed. Andrew Morrough et al. (Florence: Giunti Barbèri, 1985), 2:149–60, on the *fiorentinità* of this and other portraits of the period.

35. See, for example, Martha Teach Gnudi and Jerome Pierce Webster, *The Life and Times of Gaspare Tagliacozzi, Surgeon of Bologna, 1545–1599* (New York: Herbert Reichner, 1950).

TWELVE: Body Politics and the Tongue in Sixteenth-Century Venice

I am grateful to William Eamon and Margaret Malamud for commenting on drafts of this article. Unless otherwise noted, all translations are mine.

1. Norbert Elias, *The Civilizing Process*, vol. 2 (New York: Urizon Books, 1978), 70; Mikhail Bakhtin, *Rabelais and His World*, trans. Helen Iswolsky (Bloomington: Indiana University Press, 1984); Michel Foucault, *The History of Sexuality*, vol. 1 (New York: Vintage Books, 1990), 1. See also Barbara Duden, *The Woman beneath the Skin: A Doctor's Patients in Eighteenth-Century Germany* (Cambridge, MA: Harvard University Press, 1991), 10. Duden's introduction provides a useful introduction to the history of the body in western Europe.

2. Nina Taunton and Darryll Grantley, introduction, in *The Body in Late Medieval and Early Modern Culture*, ed. Darryll Grantley and Nina Taunton (Aldershot, UK: Ashgate, 2000), 1. See also *Bodily Extremities: Preoccupations with the Human Body in Early Modern European Culture*, ed. Florike Egmond and Robert Zwijnenberg (Aldershot, UK: Ashgate, 2003); *At the Borders of the Human: Beasts, Bodies, and National Philosophy in the Early Modern Period*, ed. Erica Fudge, Ruth Gilbert, and S. J. Wiseman (London: Macmillan, 1999); David Hillman and Carla Mazzio, eds., *The Body in Parts: Fantasies of Corporeality in Early Modern Europe* (New York: Routledge, 1997); Lucy Gent and Nigel Llewellyn, eds., *Renaissance Bodies: The Human Figure in English Culture, c. 1540–1660* (London: Reaktion Books, 1990); and Valeria Finucci, *The Manly Masquerade: Masculinity, Paternity, and Castration in the Italian Renaissance* (Durham, NC: Duke University Press, 2003).

3. For examples of studies that do attempt to answer similar questions about the historically lived bodily experience, see Caroline Walker Bynum, *Holy Feast and Holy Fast: The Religious Significance of Food to Medieval Women* (Berkeley: University of California Press, 1987); Laura Gowing, *Common Bodies: Women, Touch and Power in Seventeenth-Century England* (New Haven, CT: Yale University Press, 2003); and Lisa Silverman, *Tortured Subjects: Pain, Truth and the Body in Early Modern France* (Chicago: University of Chicago Press, 2001).

4. David Hillman and Carla Mazzio, "Introduction: Individual Parts," in *The Body in Parts*, xi.

5. Lester K. Little, *Religious Poverty and the Profit Economy in Medieval Europe* (Ithaca, NY: Cornell University Press, 1978), 198–99. See also Peter Burke, "Notes for a Social History of Silence," in his *The Art of Conversation* (Cambridge, UK: Polity Press, 1993), 127, and Daniel Lesnick, *Preaching in Medieval Florence* (Ithaca, NY: Cornell University Press, 1978), 198–99. By contrast, Walter Ong has emphasized the extremely verbal nature of medieval manuscript culture, arguing that books were assimilated through oral utterance ("Orality, Literacy, and Medieval Textualization," *New Literary History* 26 [1984]: 1).

6. H. J. Schroeder, *Canons and Decrees of the Council of Trent* (London: B. Herder, 1941), 13–14, 105–6, 142.

7. Andreas Vesalius, *On The Fabric of the Human Body*, vol. 2, ed. and trans. William Frank Richardson and John Burd Carman (San Francisco: Norman Publishing, 1998), 196; Realdo Colombo, *De re anatomica* (Venice: Nicolai Bevilacqua, 1569), 125–31; Gabriele Falloppia, *Observationes*, vol. 2 (Modena: STEM Mucchi, 1964), 171–75; Giovan Valverde, *La anatomia del corpo umano* (Venice: Giunti, 1586), 40–44, 80–88. See also Francesco Sansovino, *L'edificio del corpo humano* (Venice: [Comin da Trino], 1550), fols. 12r–16r.

8. The three most influential and widely read books of comportment in the sixteenth century include Baldessarre Castiglione, *The Book of the Courtier*, trans. George

Bull (New York: Penguin Books, 1967); Giovanni della Casa, *Il galateo*, ed. Giuseppe Prezzolini (Milan: Rizzoli, 1995); and Stefano Guazzo, *La civil conversazione*, ed. Amedeo Quondam (Modena: Panini, 1993). See also Giovanni Bonifaccio, *L'arte de' cenni con la quale formandosi favella visibile, si tratta della muta eloquenza, che non è altro che un facondo silentio* (Vicenza: Francesco Grossi, 1616); Francesco Britti, *Ammaestramento de figliuoli* (Venice: Gabriel Giolito, 1573); Leon Battista Alberti, *The Family in Renaissance Florence*, trans. Renee Neu Watkins (Columbia: University of South Carolina Press, 1969); and Lodovico Guicciardini, *L'ore di ricreazione*, ed. Anne-Marie van Passen (Rome: Bulzoni, 1990).

9. See Marin Sanuto, *I diarii di Marino Sanuto*, 58 vols., ed. Rinaldo Fulin et al. (Venice: Fratelli Visentini, 1879–1903), 1:1011: "Per esser molto colerico et furioso, diceva villania a tutti, et alter cosse che a ditto consejo parse fusse meglio di levarlo di ditta impresa." See also Sanuto, *I diarii* 1:1006, 8:403, 29:630, and 36:193, 284, 361. All of the dates in my chapter that are based on Venetian sources are given in the Venetian form, with the year beginning on March 1.

10. See Lorenzo Priori, *Pratica criminale secondo il rito delle leggi della serenissima repubblica di Venetia* (Venice: Pinelli, 1622), 195: "Ingiuria vuol dire quasi ragion iniqua, cioe una cosa, che manchi di ragione, et di giustitia, si commette in piu modi, cioe col fatto, et con le parole principalmente, ma anco vi si puo aggionger con la scrittura, et co'l gesto." See also Marco Ferro, *Dizionario del diritto comune e veneto*, 2 vols. (Venice: Andrea Santini, 1842), 2:107; Marc'Antonio Tiraboscho, *Ristretto di prattica criminale che serve per la formatione de processi ad offesa* (Venice: Pinelli, 1636), 11; Antonio Barbaro, *Pratica criminale* (Venice: G. Bortoli, 1739), 235; and Benedetto Pasqualigo, *Della giurisprudenza criminale teorica e pratica* (Venice: Stefano Orlandini, 1731), 274. It must be noted that while several of these *giuriste* lived much after the sixteenth century—Marco Ferro died in 1784—their texts were designed as historical compilations and reflected the history and tradition of these legal ideas.

11. Priori, *Prattica criminale*, 196: "E anco ingiuria, anzi e furto spirituale, quando che uno ingiustamente tuol la fama d'un'altro dolosamente" ("It is also an injury—in fact, a spiritual theft—when someone unjustly and painfully destroys the reputation of another").

12. Ferro, *Dizionario* 2:107: "Le ingiurie verbali si commettono quando alla presenza di qualcheduno, o in di lui assenza si proferiscono parole ingiuriose contro il medesimo, quando gli si da qualche rimprovero oltraggioso, quando si fa ad esso qualche minaccia di danno nella persona, nei beni o nell'onore."

13. Pasqualigo, *Della giurisprudenza criminale*, 275:

> Comettesi delitto d'ingiuria col detto per molte guise, con l'imputarsi stragiudizialmente ad altri scelleratezza cosi in genere come in spezie con l'offendere di parole la dignita d'alcuno, infamarne la persona, e scemargli la buona opinione con dicerie benche false; col proferire voci scandalose, accerbe, minacciante, o imprecatorie contra le di lui costumanze ed interessi passati, presenti, e venture . . . col mottegiarne qualche naturale difetto, vale a dire, con lo spacciarlo per bastardo, guercoo, gobbo, zoppo, o lebbroso; con l'eccitare per le contrade gli ragazzi a farne schimazzo.

Priori and Giambatista Grecchi similarly agreed that it was an injury to deride someone's physical defects or natural condition. See Priori, *Prattica criminale*, 197–98, and

Giambatista Grecchi, *Le formalità del processo criminale nel dominio veneto* (Padua: Tommaso Bettinelli, 1790), 268.

14. Pasqualigo, *Della giurisprudenza criminale*, 275: "Taluna ingiuria inferitasi col detto ad una persona, offende stessamente l'altra d'affetto, e di stretta relazione congionta. Quindi con l'oltraggio del padre, ingiuriasi il figlio, e con quello della moglie il marito; e ne conviene allora la ragione della querela cosi agli uni, come agli altri." See also Ferro, *Dizionario* 2:107.

15. Barbaro, *Pratica criminale*, 236: "L'accusator falso di persona nobile, o pure di delitto infame, commette grave ingiuria." Giambatista Grecchi, *Le formalità*, 269, also argued that an injury "indirizzata ad alti personaggi, o a pubblici rappresentanti ... diviene essa allora un delitto atroce soggetto alla suprema autorita dell'Eccelso consiglio di dieci" ("directed to important people or public representatives ... becomes an atrocious crime subject to the supreme authority of the Council of Ten").

16. See *Le deliberazione del Consiglio dei XL della Repubblica di Venezia*, vols. 1–3, ed. A. Lombardo (Venice: Deputazione di storia patria per le Venezie, 1957–67), reg. 22, 34, 76, 124–25, cited in Elizabeth Crouzet-Pavan, "Potere politico e spazio sociale: Il controllo della notte a Venezia nei secoli XIII–XV," in *La notte: Ordine, sicurezza e disciplinamento in età moderna*, ed. Mario Sbriccoli (Florence: Ponte alle Grazie, 1991), 59.

17. These magistracies were typically assigned responsibility over a wide spectrum of crimes including crimes of blood, possession of illegal arms, crimes against property and honor, improper behavior, injury, fraud, and generally disrespectful practices. Though the fourteenth-century statutes of the Signori di Notte al Criminal list punishments for blasphemy, they do not list any for verbal injury. Nevertheless, this magistracy clearly dealt with cases of insults, as verbal injury trials abound in its records from the fourteenth century and then in the records of the Signori di Notte al Civil starting around the mid-seventeenth century. The surviving trials of the Signori di Notte al Civil begin in 1633 and the sentences in 1641.

18. Archivio di Stato di Venezia (hereafter ASV), Signori di Notte al Criminal, busta 1, reg. 1564–1733, April 2, 1544, fol. 11r, August 12, 1545, fol. 13r.

19. See most importantly Trevor Dean, "Gender and Insult in an Italian City: Bologna in the Later Middle Ages," *Social History* 29.2 (2004): 217–31; E. S. Cohen, "Honor and Gender in Early Modern Rome," *Journal of Interdisciplinary History* 4 (1992): 597–626; and Thomas V. Cohen and Elizabeth S. Cohen, *Words and Deeds in Renaissance Rome: Trials before the Papal Magistrates* (Toronto: University of Toronto Press, 1993).

20. Peter Burke, *The Historical Anthropology of Early Modern Italy: Essays on Perception and Communication* (Cambridge: Cambridge University Press, 1987), 95–109; Peter Burke, "The Art of Insult in Early Modern Italy," *Culture and History* 2 (1987): 68–79; Peter N. Moogk, "'Thieving Buggers' and 'Stupid Sluts': Insults and Popular Culture in New France," *William and Mary Quarterly* 36 (1979): 524–47; Daniel R. Lesnick, "Insults and Threats in Medieval Todi," *Journal of Medieval History* 17 (1991): 71–89; J. A. Sharpe, "Defamation and Sexual Slander in Early Modern England: The Church Courts at York," *Borthwick Papers* 58 (1980): 1–36; Richard C. Trexler, "*Correre la terra*: Collective Insults in the Late Middle Ages," *Mélanges de l'École Francaise de Rome, Moyen Âge–Temps Modernes* 96 (1984): 845–902; David Garrioch, "Verbal Insults in Eighteenth-Century Paris," in *The Social History of Language*, ed. Peter Burke and Roy Porter (Cambridge: Cambridge University Press, 1987), 104–19; Laura Gowing, *Domestic Dangers: Women, Words, and Sex in Early Modern London* (Oxford: Oxford University Press,

1996); Annamaria Nada Patrone, *Il messaggio dell'ingiuria nel Piemonte del tardo Medioevo* (Cavallermaggiore: Gribaudo, 1993); Jane Kamensky, *Governing the Tongue: The Politics of Speech in Early New England* (New York: Oxford University Press, 1997); Carla Casagrande, *I peccati della lingua: Disciplina ed etica della parola nella cultura medievale* (Rome: Istituto della Enciclopedia Italiana, 1987).

21. There is much debate on the degree to which women moved about in public. Laura Gowing's study of early modern London, *Domestic Dangers*, suggests that women regularly lived active lives outside the home. With respect to Venice, Dennis Romano once argued that Venetian culture confined women to the domestic sphere, but Monica Chojnacka's research on Venetian women suggests that women were almost as publicly visible as men (Dennis Romano, "Gender and the Urban Geography of Renaissance Venice," *Journal of Social History* 23 [1989]: 339–53; Monica Chojnacka, *Working Women of Early Modern Venice* [Baltimore, MD: Johns Hopkins University Press, 2001]).

22. ASV, Avogaria di Comun Penale, busta 265, fasc. 3, "Giovanni Merzari," March 1, 1605, testimony of Fabio Merzari: "Parole cosi strabochevoli, et empie che . . . non si direbono ad un capitalissimo nemico . . . doveria rafrenar la lingua et aquietar l'humore."

23. ASV, Avogaria di Comun Penale, busta 391, fasc. 5, "Stella Angelica," November 4, 1592. "Stanno Anzelica et Madalena donne di partito, et ridendo sia noi lavoranti gia un mese io dissi fazo bortola parlando modestamente, et sentendo queste parole dette donne mi minacciarno di volermi far offendere credendo loro che io dicesse per elle, et mi dissero mille villanie becco fatto e ditto continuando da l'hora in poi à tentar di farmi buttar in acqua, et farmi amazzar, se bene veramente io dissi quella parole semplicemente come si suol dir per la città senza pensiero alcuno di parlar di elle." Here, "fatto ditto" functions as a slightly euphemistic insult. According to Boerio, "dita a fata" was "a backhanded way of insulting someone, saying this in order not to say clearly 'son of a whore'" (*Dizionario del dialetto veneziano*, 2nd ed. [Venice: Giovanni Cecchini, 1856], 242). The meaning of "ditto," in effect, is a "receipt"; thus the person is "done" (in the crude sense) and "paid for." Many thanks to Linda Carroll for help with this passage.

24. ASV, Avogaria di Comun Penale, busta 261, fasc. 16, "Girolamo Domo," October 30, 1589: "Mi conincio à dir parole et vilanie ingiuriosissime, onde so rispondendoli che erimo huomini da bene et che *non dovea parolar à quel modo*" (emphasis in original).

25. ASV, Avogaria di Comun Penale, busta 261, fasc. 16, "Girolamo Domo," October 31, 1589: "Non debba molestar nè in fatti nè in parole nè lui nè altri persone."

26. ASV, Avogaria di Comun Penale, busta 150, fasc.1, "Badoer Cornelio," June 2, 1597: "Non fa altro che dar asto su le proprie botteghe con vilanie, et arlassi, et biasteme horende per terrara qualche precipitio li pover botteghieri"; ASV, Avogaria di Comun Penale, busta 150, fasc.1 "Badoer Cornelio," June 3, 1597, testimony of Anselm Buffeli: "Non so altro se non che le licentioso di lengua."

27. ASV, Avogaria di Comun Penale, busta 462, fasc. 3, "Angela Meronti Castellan," May 11, 1620: "Una buzeruda fatta e poltrona putana gonaina vacha et con altre piu detesta de ingiurie con tumulto di tutto il vicinato continuando pur a darmi romancina per il spacio di mez'hora. . . . Anzolo di pessima vita et pegior costumi solito ad ingiuriar et infamiar questo e quella . . . va per la citta infamiando et offendendo chi li piace."

28. ASV, Avogaria di Comun Penale, busta 462, fasc. 3, "Angela Meronti Castel-

lan," May 15, 1620, testimony of Vanzelitta Tamsello: "Butanna poltrona et altre parole sporche gli disse anco che andava sopra le Hostarie a farse buzarar."

29. ASV, Avogaria di Comun Penale, busta 462, fasc. 3, "Angela Meronti Castellan," May 16, 1620, testimony of Barbara, wife of Francesco: "Buzardazza in culo et altre villanie sporchissime et detestande che mi vergono a dirle."

30. ASV, Avogaria di Comun Penale, busta 462, fasc. 3, "Angela Meronti Castellan," May 18, 1620, testimony of Pasqualina Vedoa: "Cose neffande che mi verzogno non solamente a dirle ma a pensarne ancora."

31. ASV, Avogaria di Comun Penale, busta 462, fasc. 3, "Angela Meronti Castellan," May 19, 1620: "In pena per caudauno di loro di star 5 anni seradi in una della preggioni forte . . . non debbano cadauno di loro, ne meno altra sorte di persone per nome suo così de parole come de fatti offender, molestar, inquiettar, ne in conto alcuno inzurar la persona de dona benetta vedoa."

32. Guido Ruggiero found a similar pattern of insults against the state, superiors, and nobles in the trecento, yet he noted a great number of prosecutions against the verbal aggression of nobles; it does not appear that as many such prosecutions were carried out in the sixteenth-century trials of the Avogaria (*Violence in Early Renaissance Venice* [New Brunswick, NJ: Rutgers University Press, 1980], 66–77, 77–79, 96–98, 125–37).

33. ASV, Avogaria di Comun Penale, busta 213, fasc. 12, "Dall'Olio Francesco danni a Dolfin Galeazzo," denunciation of August 25, 1526: "Non bastandoli a ditto francesco de haverme bagnato, ma mal a mal aggiongendo me commenzo a dir villania digendomi che vardistu bardassa et altre villane parolle."

34. ASV, Avogaria di Comun Penale, busta 213, fasc. 12, "Dall'Olio Francesco danni a Dolfin Galeazzo," May 4, 1526, testimony of Domenego Pictor: "Galeazzo disse chi diavolo geta acqua et vardo in suso et il ditto francesco dictu a mi te francesco disse che vardistu bestia et m. Galeazzo disse al ditto francesco distu a mi et francesco disse machi si che digo a ti bardassa fotua et m. galeazo disse granmerze et percorse di longo et disse al ditto francesco ti me par una bestia."

35. ASV, Avogaria di Comun Penale, busta 213, fasc. 12, "Dall'Olio Francesco danni a Dolfin Galeazzo," May 30, 1526, testimony of Francesco da L'Oglio: "Via sta putana fotua in tal cul mi bagna."

36. ASV, Avogaria di Comun Penale, busta 213, fasc. 12, "Dall'Olio Francesco danni a Dolfin Galeazzo," May 30, 1526, testimony of Francesco da L'Oglio: "Disse che zarzistu becho fotuo, et mi li rispose, s'io fusse beccho haverei le corne, et lui mi disse vien zusso ladro mariol che te voglio squartar."

37. ASV, Avogaria di Comun Penale, busta 213, fasc. 12, "Dall'Olio Francesco danni a Dolfin Galeazzo," May 30, 1526, testimony of Francesco da L'Oglio: "Se havesse sapudo che'l fusse sta zentilhomo, non haveria fatto mai quelle materie et che li domandano mille perdonasse."

38. ASV, Avogaria di Comun Penale, busta 213, fasc. 12, "Dall'Olio Francesco danni a Dolfin Galeazzo," sentence of August 25, 1526.

39. ASV, Avogaria di Comun Penale, busta 33, fasc. 3, "Giuseppe Beltrame," sentence of October 10, 1595; ASV, Avogaria di Comun Penale, busta 33, fasc. 3, "Giuseppe Beltrame," August 9, 1595, testimony of Giovanni Zenoni: "Poltrona o buzeronna . . . dicesse di haver in culli li clarissimi nobbili che volessero favorir la preddetta signora."

40. ASV, Avogaria di Comun Penale, busta 387, fasc. 15, "Malombra Bartolommeo

sparla contro la Nobilta," October 1, 1633, testimony of Gerolomo Memmo: "Lo senti profferir parole di cattivo concetto e particolarmente che'l primo gentilhomo perche li facesse ogni minima cosa gli voleva cavar un stillo tante volte nella vita fino che li fosse uscita l'anima."

41. ASV, Avogaria di Comun Penale, busta 387, fasc. 15, "Malombra Bartolommeo sparla contro la Nobilta," October 1, 1633, testimony of Lorenzo Sanuto: "Se habbi profferito parole significanti odio verso la nobilta come dir che vorrebe che tutta la nobilta fosse un ovo fresco che poterla ingiottir con altre parole indebite."

42. ASV, Avogaria di Comun Penale, busta 37, fasc. 4, "Giana da Candia," August 3, 1600, testimony of Olivier Lio: "Puttana mi manca a finir la condanna sette zorni come li havero finido nisun can becco fatto ditto mi comandara."

43. ASV, Avogaria di Comun Penale, busta 18, fasc. 9, "Ludovico da Vicenza," January 1, 1576, testimony of Sfamali da Corfu: "Ah brutto becco fotudo che ti porti la casaca rossa come armiraglio."

44. ASV, Avogaria di Comun Penale, busta 28, fasc. 17, "Vicenzo Sovolovich da Zara galleoto," sentence of December 27, 1573; ASV, Avogaria di Comun Penale, busta 28, fasc. 17, "Vicenzo Sovolovich da Zara galleoto," December 27, 1573, testimony of Francesco Torli: "Disse gridando forte verso il magnifico patron sopradetto a barba doro mustacchi di merda."

45. Several examples of written and verbal insults against the state that emerge in the wake of the creation of the Council of Ten illuminate the perceived seriousness of this crime. In 1400, drawings offensive to the republic were discovered on the walls of the church of San Boldo; a one thousand lire reward was offered for the location of the criminal. Similarly, in 1464 the Council of Ten condemned Lodovico Contarini to have his right hand amputated for having insulted the dignity of the doge and the honor of the state with several drawings. In 1492, two posters that insulted the offices of the republic were attached to the two columns in Piazza San Marco, and a six thousand lire reward was offered to whoever could find the instigators. These and other examples are cited by Crouzet-Pavan, "Potere politico," 59. On insulting posters and drawings, see Elizabeth Crouzet-Pavan, *Sopra le acque salse: Espaces, pouvoir, et sociéte à Venise à la fin du moyen âge*, 2 vols. (Rome: Istituto Palazzo Borromini, 1992), 2:851; Filippo de Vivo, *Information and Communication in Venice: Rethinking Early Modern Politics* (Oxford: Oxford University Press, 2007), 140–41, 194–96; Ruggiero, *Violence in Early Renaissance Venice*, 126–31; and Sanuto, *I diarii* 6:258–59.

46. Sanuto, *I diarii* 9:358–59, 13:260.

47. Alvise Michiel, "Memorie pubbliche della repubblica di Venezia," Biblioteca Nazionale Marciana, Venice, ms. Italiani, cl. 7, 811, fols. 277r–278r, cited in *Venice: A Documentary History, 1450–1630*, ed. David Chambers and Brian Pullan (London: Blackwell, 1992), 84.

48. Frederic C. Lane, *Venice: A Maritime Republic* (Baltimore, MD: Johns Hopkins University Press, 1973), 395.

49. ASV, Avogaria di Comun Penale, busta 141, fasc. 3, "Nicolò Andri," March 13, 1570, testimony of Manoli da Cerigo: "Qual diceva al Turco, che havevano fatto male di haver portato li formenti in questo luoco, la qual cosi confirmandoli il Turco, il soggionse che questa gente erano cani, et che sapevano anco loro d'haver fatto male, dove questo Christiano li disse in conformità che veramente erano cani."

50. ASV, Avogaria di Comun Penale, busta 141, fasc. 3, "Nicolò Andri," March 13,

1570, testimony of Piero da Candia: "Perche havevano essi portato il formento in questa città à questi cani becchi fotui."

51. ASV, Avogaria di Comun Penale, busta 141, fasc. 3, "Nicolò Andri," March 13, 1570, testimony of Anzelo da Venezia: "Che si havevano diportati malamente a portar formenti alli huomini del stato del Dominio Venetiano che erano cani, et scelerati, soggiongendomi à dire che li haveva anco narrato come Carracozza haveva tirato con artiglíarie alle nostre galee per le qual parole mi si comosse tutto il sangue."

52. ASV, Avogaria di Comun Penale, busta 141, fasc. 3, "Nicolò Andri," sentence of March 14, 15870: "Molte altre parole piene d'iniquità et mal animo."

53. ASV, Avogaria di Comun Penale, busta 418, fasc. 4, "Malloni Giovanni Antonio," June 10, 1603, testimony of Giacomo Rana: "Dio brutto can becco fottu che tu dai tanti denari a delli altri, et a me non ne vuoi dare."

54. ASV, Avogaria di Comun Penale, busta 418, fasc. 4, "Malloni Giovanni Antonio," sentence of September 17, 1603; ASV, Avogaria di Comun Penale, busta 418, fasc. 4, "Malloni Giovanni Antonio," testimony of Giovanni Malloni: "Commetter cosi dettestando, et abbominevol dellitto haveste a proferir parole di vittuperio contra quell'imagine."

55. ASV, Avogaria di Comun Penale, busta 320, fasc. 11, "Ignoto ingiurie contra Ospitale della Pietà," proclamation of April 22, 1514; ASV, Avogaria di Comun Penale, busta 320, fasc. 11, "Ignoto ingiurie contra Ospitale della Pietà," March 23, 1514, testimony of Catharina uxor Ioannis: "Far diversi insolti alla casa de la pieta, ha detto vilannia ala priora piu volte perche el demanda la dota."

56. ASV, Avogaria di Comun Penale, busta 200, fasc. 11, "Boldon Antonio," May 17, 1646:

> Havendosi doluto li signori console della Magnifica Madion Alemana che li fa-chini Barcaroli, et altra qualita di gente che di servitio di detta Natione della mercantie capitano nel fontico da loro habitato contro il timore del signor Iddio e della Giustitia, et con poco rispetto sono cosi arditi che pronontiando parole indecente, et alle volte vengono alle mani, il che viene anche con notabile dis-turbo alla quiete de signori mercanti. . . . Non ardisca di trovar risse ne offender in fatti ne in parole alcun'altro ne in acuna maniere pronontiare parole indecenti et cio in pena di L50.

This proclamation was reissued in Italian following the original Latin proclamation of January 16, 1570. A plaque reissuing this ordinance in 1670 still hangs in the south entrance of the Fondaco dei Tedeschi (now the central post office) today.

57. ASV, Avogaria di Comun Civile, busta 279, fasc. 7, "Turchi residenti in Venezia non abbiano ad essere molestati," denunciation of March 19, 1574: "Grandissime ingiu-rie, et ultragii che li vostri subditi ne fanno . . . con parole ingiuriose offender l'honor nostro."

58. ASV, Avogaria di Comun Civile, busta 279, fasc. 7, "Turchi residenti in Venezia non abbiano ad essere molestati," denunciation of March 20, 1574: "Che niuno et sia si voglia non ardiser, per alcun modo, forma over inzegno cosi in arole, come in fatti, ingiuriar, ne offender, ne far offender, o usare parole di qual si voglia sorte iniuriose o altramente contra li suditti et representanti il Serenissimo signor Turco, ma quelli ben trattar, et accarezzar, sotto pena, di servir per anni cinque in galia de condennadi, et tratti tre di corda in pubblico, et non essendo boni da Galia, di star per ditto tempo

nella preson forte, et essendo donne over putti, da esser frustadi, da San Marco a Rialto."

59. See Dennis Romano, *Housecraft and Statecraft: Domestic Service in Renaissance Venice, 1400–1600* (Baltimore, MD: Johns Hopkins University Press, 1996), 246–47.

60. Lesnick, "Insults and Threats," 72; Moogk "'Thieving Buggers,'" 526.

61. See Gino Luzzato, *Storia economica di Venezia dall xi al xvi secolo* (Venice: Centro Internazionale delle Arti e del Costume, 1961). Luzzato argues that the years 1508–17 were the start of "the most difficult years" for the Venetian economy, for it was at this time that Venice largely ceased to be a commercial city and was economically weakened by mainland expansion. Frederic Lane, on the other hand, suggests a sixteenth-century manufacturing boom, in particular in the wool and printing industries, offset economic difficulties instigated by the growth of the Spanish Empire, oceanic expansion and new world trade, and the Ottoman invasions. Lane argues that although the Venetian economy changed, there is no reason to believe there was an actual economic decline (*Venice*, 331–34).

62. See John Martin, *Venice's Hidden Enemies: Italian Heretics in a Renaissance City* (Berkeley: University of California Press, 1993), 58–59; Dennis Romano, *Housecraft and Statecraft*, xv–xxvi.

63. See note 32. On the perceived gravity of insults against superiors, see Burke, *Historical Anthropology*, 99. One might argue that it was to be expected that nobles would have been prosecuted for crimes of speech in smaller numbers since they naturally managed to evade punishment more regularly by virtue of their social status. The fact remains, however, that the magistracies in fact punished the language of non-nobles on a much more regular basis.

64. "Insulting words, gestures, pictures, and writings that could lead to vendettas came to be seen as highly subversive. The solution was to silence all personal insults" (Edward Muir, "The Sources of Civil Society in Italy," *Journal of Interdisciplinary History* 29 [1999]: 386). Guido Ruggiero similarly has argued that speech and its control had been "a crucial requirement for the preservation of [Venetian] rule and their state" ever since the republic's founding (*Violence in Early Renaissance Venice*, 125).

65. Manfredo Tafuri, *Venezia e il Rinascimento: Religione, scienza, architettura* (Turin: Einaudi, 1985), 162–69.

66. Deborah Howard, *Jacopo Sansovino: Architecture and Patronage in Renaissance Venice* (New Haven, CT: Yale University Press, 1975), 11.

67. Tafuri, *Venezia e il Rinascimento*, 156–57.

68. Edward Muir, *Civic Ritual in Renaissance Venice* (Princeton, NJ: Princeton University Press, 1981), 163. The separation of commercial and political activity was not a concept invented by Sansovino; it was an old tradition in Italian urban planning, discussed by Alberti and Filarete alike. Yet in Venice, this distinction was not clearly defined until sixteenth-century attempts forced a separation. See Howard, *Jacopo Sansovino*, 14.

69. Tafuri, *Venezia e il Rinascimento*, 168, 244–97.

70. See Elizabeth Horodowich, "Civic Identity and the Control of Blasphemy in Sixteenth-Century Venice," *Past and Present* 181 (2003): 3–33.

71. Peter Burke, *Popular Culture in Early Modern Europe* (New York: Harper and Row, 1978), 213. Many scholars see less benevolent attitudes toward the poor and the

underclasses developing in the sixteenth century. See, for example, Renzo Derosas, "Moralità e giustizia a Venezia nel '500–'600: Gli esecutori contro la bestemmia," in *Stato, società e giustizia nella repubblica veneta, sec. XV–XVIII*, ed. Gaetano Cozzi (Rome: Società Editoriale Jouvence, 1980), 444: "Sul piano sociale, quest'azione moralizzatrice è rivolta decisamente ai costumi dei ceti popolari, e soprattutto della popolazione marginale. Nei confronti dei poveri per esempio, si rovescia completamente il tradizionale atteggiamento benevolo" ("On a social level, this moralizing action is decisively turned toward the customs of the popular classes, and above all toward those who are marginalized. For example, traditional benevolent attitudes toward the poor are completely reversed").

72. James C. Scott, *Domination and the Arts of Resistance: Hidden Transcripts* (New Haven, CT: Yale University Press, 1990), 36.

73. "Foul language was a mark of identification and even distinction among boatmen themselves. . . . Such behavior defined gondoliers as a profession and created a sense of group identity. It is not inconceivable that within boatmen's circles those most adept at hurling curses gained a certain renown" (Romano, *Housecraft and Statecraft*, 221); "Such speech forms . . . become themselves a peculiar argot and create a special collectivity, a group of people initiated in familiar intercourse" (Bakhtin, *Rabelais*, 188); "One of the most important of the signs of collective identity is language. Speaking the same language, or variety of language, as someone else is a simple and effective way of indicating solidarity; speaking a different language or variety of language is an equally effective way of distinguishing oneself from other individuals or groups" (Burke, *The Art of Conversation*, 70). Burke similarly considers the ways the jargon of thieves and beggars separated and distinguished these social groups from those around them (*Popular Culture*, 46–47). See also Deanna Shemek, "From Insult to Injury: Bandello's Tales of Isabella de Luna," in her *Ladies Errant: Wayward Women and Social Order in Early Modern Italy* (Durham, NC: Duke University Press, 1998), 158–80.

THIRTEEN: "Sauter et voltiger en l'air"

1. The *jeu de paume* is known to have been played since late medieval times and became popular at the French court of Henry II around 1550. It is the precursor of modern tennis. See, for example, Guy Bonhomme, *De la paume au tennis* (Paris: Gallimard, 1991).

2. Archange Tuccaro, *Trois dialogues de l'exercice de sauter, et voltiger en l'air, avec les figures qui servent à la parfaicte demonstration & intelligence dudict art* (Paris: chez Claude de Monstr'Oeil, 1599). All quotations come from the copy belonging to the Deutsche Sporthochschule Köln (DSHS 7 839). This is important because copies of the same edition differ in pagination. The *Privilège du roi* is not included in DSHS 7 839, and so I refer to the copy in the Biblioteca Apostolica Vaticana (hereafter BAV), Stampate Barberini N.II.10. Tuccaro's Italian first name, "Arcangelo," varies in the different sources from "Johann" and "Hans Arch" in Austria to the French forms "Arghange" and "Archange." All translations are my own unless otherwise indicated. For a detailed analysis of the *Trois dialogues*, see Sandra Schmidt, *Kopfübern und Luftspringen: Bewegung als Wissenschaft und Kunst in der Frühen Neuzeit* (Munich: Fink, 2008).

3. In the antique classifications, *cubistica*, together with *sferistica* and *orchestica*, is defined as a part of the *saltatoria* (which with *palestrica* constituted all the gymnastic

movements). For a definition, see Girolamo Mercuriali's 1569 *L'arte ginnastica: Libri sei tradotti nel 1856 da G. Rinaldi da Forlì* (Turin: Minerva Medica, 2000), one of the most important intertextual references of Tuccaro's dialogues. He quotes Xenophon and Suidas: it is "un'arte, onde certi uomini in variate maniere piedi e mani contorcendo, appoggiato in terra il capo, saltavano" (114) ("an art in which certain men, bending their legs and arms in various ways, putting their heads on the ground, performed jumps").

4. This interpretation of Tuccaro's somersault practice was first mentioned by John McClelland, "Leibesübungen in der Renaissance und die Freien Künste," in *Die Anfänge des modernen Sports in der Renaissance*, ed. Arnd Krüger and John McClelland (London: Arena, 1984), 85–110. κυβιστάω was used for the first time in the *Iliad* (16.749) and is translated into French as "plonger la tête la première, faire la culbute, sauter la tête la première" ("first dip down the head, do a somersault, jump with the head first"), but the etymology cannot clearly be proven: it might derive from ηε κμβη—the head—or from κμβη—the cube. See Pierre Chantraine, *Dictionnaire étymologique de la langue grecque*, 8 vols. (Paris: Klincksieck, 1990), 1:594.

5. In this chapter I refer mainly to the front somersault as an example of the "art of tumbling." It is representative in the sense that nearly all the jumps are characterized by the lowering of the head and the reversal of up and down.

6. In the *Epistre* (also in the BAV) he defines himself as the "maître du roi" ("king's master") and in the official authorization of the king, the *Privilège du roi*, he is mentioned as "saltarin du roi" ("king's tumbler"). According to the Archives Nationales Paris, he belonged to the court of the duc d'Alençon, the king's brother, in 1580, and to the court of Henry III in 1588. See Jacqueline Boucher, *Société et mentalités autour de Henri III*, 4 vols. (Lille: Ouest-France, 1981), 3:1063. For the period in Austria, see Otto Schindler, "Zan Tabarino, 'Spielmann des Kaisers': Italienische Komödianten des Cinquecento zwischen den Höfen von Wien und Paris," *Römische Historische Mitteilungen* 43 (2001): 411–544. McClelland supposes that there are so few sources relating to Tuccaro because the tradition of cubistic jumps was not at all noble. We find many treatises on and references to dance and fencing practices; the relatively few references to Tuccaro's *art de sauter* suggest tumbling was a less common activity in the French court.

7. Tommaso Garzoni, *La piazza universale di tutte le professioni del mondo* (Venice: Somasco, 1586), 453.

8. To avoid misunderstanding, I prefer using the term "physical or bodily practice" instead of "exercise" or even "sports," because Tuccaro's art of tumbling does not fulfill the requirements of modern sport, although the movements themselves are similar to those of modern artistic gymnastics. My invocation of the concept of a "practice" is also meant as an implicit reference to Bourdieu's theories of bodily behavior and practical reason; see, for example, Pierre Bourdieu, *Raisons pratiques: Sur la théorie de l'action* (Paris: Seuil, 1998).

9. Michel de Certeau, *The Writing of History*, trans. Tom Conley (New York: Columbia University Press, 1988), xxvii ("le réel et le discours. Elle [l'historiographie] a pour tâche de les articuler et, là où ce lien n'est pas pensable, de faire *comme* si elles les articulait" [*L'écriture de l'histoire* (Paris: Gallimard 1975), 11]).

10. De Certeau, *The Writing of History*, 56 ("ramène 'les idées' à des *lieux*" [*L'écriture de l'histoire*, 77]).

11. Susan Leigh Foster "Introduction to Moving Bodies," in *Choreographing History*,

ed. Susan Leigh Foster (Bloomington: Indiana University Press, 1995), 9. She is referring primarily to an historical analysis of dance, but her comments about her difficulties with the act of writing about bodily movement describe exactly my problems writing about Tuccaro's art of tumbling: "As historians' bodies affiliate with documents about bodies of the past, both past and present bodies redefine their identities" (10).

12. Peggy Phelan, "Thirteen Ways of Looking at *Choreographing Writing,*" in *Choreographing History*, 200.

13. Marcel Mauss, *Sociologie et anthropologie* (Paris: Quadrige / PUF, 1997), 365 ("façons dont les hommes, société par société, d'une façon traditionelle, savent se servir de leur corps. En tout cas, il faut procéder du concret à l'abstrait, et non pas inversement").

14. Mary Douglas, *Natural Symbols: Explorations in Cosmology* (London: Barrie and Jenkins, 1970), 99.

15. For a more detailed reconstruction, see Beate Henschel, "Zur Genese einer optimistischen Anthropologie in der Renaissance oder die Wiederentdeckung des menschlichen Körpers," in *Gepeinigt, begehrt, vergessen: Symbolik und Sozialbezug des Körpers im späten Mittelalter und der Frühen Neuzeit,* ed. Klaus Schreiner and Norbert Schnitzler (Munich: Fink, 1992), 85–105.

16. Giannozzo Manetti, *De dignitate et excellentia hominis* (Hamburg: Meiner, 1990), originally published in 1532. For a critical comment on the concept of the body in Manetti's treatise, see Oliver Glaap, *Untersuchungen zu Giannozzo Manetti, "De dignitate et excellentia hominis": Ein Renaissance-Humanist und sein Menschenbild* (Stuttgart: Teubner, 1994).

17. Hentschel, "Zur Genese," 104.

18. Ernst Cassirer, *Das Erkenntnisproblem*, vol. 1 (Berlin: Bruno Cassirer, 1922), 159: "Nicht am Himmel, sondern in sich selbst muß der einzelne den Grund seines Geschickes lessen."

19. Introduction, in *The Body in Parts: Fantasies of Corporeality in Early Modern Europe,* ed. David Hillman and Carla Mazzio (New York: Routledge, 1997), xxii.

20. Garzoni, *La piazza universale,* 453.

21. Baldassarre Castiglione, *Il libro del cortegiano,* ed. Walter Barberis (Turin: Einaudi, 1998), 59. Barberis comments on the *regula* as follows: "Una regola generale. Quasi che si trattasse di una norma aurea circa proporzioni ideali da conferire a una figura" (59 n. 7) ("A general rule. As if referring to a golden mean as regards certain ideal proportions to give to a figure"). Castiglione continues: the rule is to "usar in ogni cosa una certa sprezzatura, che nasconda l'arte e dimostri ciò che si fa e dice venir fatto senza fatica e quasi senza pensarvi. Da questo credo io che derivi assai la grazia; perché delle cose rare e ben fatte ognun sa la difficultà, onde in esse la facilità genera grandissima maraviglia; e per lo contrario il sforzare e, come si dice, tirar per i capegli dà somma disgrazia e fa estimar poco ogni cosa, per grande ch'ella si sia" (59) ("to practice in all things a certain *sprezzatura* [nonchalance], so as to conceal all art and make whatever is done or said appear to be without effort and almost without any thought about it. And I believe much grace comes of this: because everyone knows the difficulty of things that are rare and well done; wherefore facility in such things causes the greatest wonder; whereas, on the other hand, to labor and, as we say, drag forth by the hair of his head, shows an extreme want of grace, and causes everything, no matter how great it may be,

to be held in little account" [Baldassarre Castiglione, *The Book of the Courtier*, trans. Charles Singleton, ed. Daniel Javitch (New York: Norton, 2002), 32]).

22. Castiglione, *Il libro del cortegiano*, 53–54 (*The Book of the Courtier*, 39).

23. Michel de Montaigne, *Les essais*, ed. Pierre Villey (Paris: Quadrige/PUF, 1992), 165: "Les jeux mesmes et les exercices seront une bonne partie de l'estude: la course, la luite, la musique, la danse, la chasse, le maniement des chevaux et des armes"; *Les essais*, 412: "Tout ainsi qu'en nos bals, ces hommes de vile condition, qui en tiennent escole, pour ne pouvoir representer le port et la decence de nostre noblesse, cherchent à se recommander par des sauts perilleux et autres mouvemens estranges et bâteleresques."

24. Tuccaro, *Trois dialogues*, fol. 2r; see also fols. 60v, 6v, and 2v.

25. Tuccaro, *Trois dialogues*, fols. 2v and 6r, for example.

26. For a detailed comment on the established connection to the *septem artes liberales*, see McClelland, "Leibesübungen in der Renaissance und die Freien Künste," 85–110.

27. Tuccaro, *Trois dialogues*, fol. 67r–v: "le saut retourné iustement fait avec la volte n'est autre chose qu'un cercle parfait en l'air, dont la circonference commence et finit au même lieu, . . . Il faut doncques le centre de la circonference formee de la iuste proportion du saut se trouve en la moitié de l'espace occupé par le corps du même sauteur retourné à poinct nommé."

28. Tuccaro, *Trois dialogues*, fol. 13r: "que l'agitation & mouvement du corps, soit en sautant, soit en balant, est appellée tant des Grecs que des Latins, armonieuse, à cause qu'ils participent sans doute de la proportion, mesure, & cadence, que l'homme retient de la musique, à laquelle il approprie entièrement tous ses membres."

29. Tuccaro, *Trois dialogues*, fol. 14r: "où il parle de toutes sortes de braves, & nobles exercices: mais principalement du saut & de la luicte, qu'il a dignement recommandez."

30. The dialogue form allows him even to present differing statements without having to clarify which one is true. For example, in the discussion about positive historical judgments of the practice of tumbling at fol. 19v, Cosme comments: "Vous n'ignorez donc pas que sauteurs, & balladins ont esté plusieurs fois bannis de Rome" ("Do not forget that the tumblers and jumpers were banned more than once from Rome").

31. Tuccaro, *Trois dialogues*, fol. 116r: "Il y a une autre improprieté qui n'est pas de petite importance, qui procede, ou de ne sçavoir pas prendre la proportion du temps à l'élevement du saut, ou pour se sentir trop faible à faire la volte, & le plus souvent d'une coustume qu'aura le sauteur de n'avoir pas recherché à donner grace aux sauts" ("There is another incorrect practice, which is of no small importance, and it consists in not judging correctly the right proportion of time when beginning or in being too weak to perform the circle and, more often, the jumper not thinking of the grace of his jumps"). Sharon Fermor comments in this respect that "movement was seen as an index of inner states as well as of moral and social composure": "The dancer who displayed too much skill also risked comparison with the professional entertainer, traditionally a person of low social status" ("Movement and Gender in Sixteenth-Century Italian Painting," in *The Body Imagined: The Human Form and Visual Culture since the Renaissance*, ed. Kathleen Adler and Marcia Pointon [Cambridge: Cambridge University Press, 1993], 133).

32. Obviously it is impossible to base this interpretation on precise information

concerning the performance of the jumps, especially as we have none on the so-called timing of the tumbling. In this respect, Tuccaro was confronted with the same problem every scholar faces today when he tries to convert movement into language. However, his very detailed description of the jumps provides a reliable account of the form of the movement.

33. See Manetti on the concept of mankind as being similar to God. "Während die übrigen Lebewesen nach unten auf die Erde blicken, verlieh er [Gott] dem Menschen ein Gesicht in der Höhe und befahl ihm, den Himmel zu betrachten und sein Antlitz empor zu den Gestirnen zu erheben" (*De dignitate et excellentia hominis,* 7) ("While the other beings look downward at the ground, he [God] gave the human being a face on the top and told him to look upward in the direction of the stars"). He argues that the transcendence of the body constitutes the superiority of men in comparison to every other human being and links the "upright body position of the human being" to his qualities of being "a reasonable and thinking being" (93).

34. Giovanni Bonifaccio, *L'arte de' cenni* (Vicenza: Grossi, 1616), 43: "Sicome si volta la faccia, così è segno che si volti l'anima verso il cielo a Dio, dove ha particolare stanza."

35. Bonifaccio, *L'arte de' cenni,* 19: "Il portar la testa dirizzata e alta sarà segno d'alterezza d'animo, e di pretender suberbamente maggioranza e superiorità."

36. Already by the time of the Council of Freisingen, Boniface VIII was warning clerics not to provide consideration to the different groups of tumblers and showmen: "Statuimus ne clerici mimis, joculatoribus, histrionibus, buffonibus, golliardis, largiantur" ("We decided that priests should not give presents to clowns, comedians, actors, fools and galliard dancers"). Cited in Jacques Thibault, *Les aventures du corps dans la pédagogie française* (Paris: Vrin, 1977), 170. For a detailed comment on the position of the Christian church, see Catherine Ingrassia, *Danseurs, acrobates et saltimbanques dans l'art du Moyen Age: Recherches sur les representations ludiques, choreographiques at acrobatiques dans l'iconographie medievale* (Paris: Seuil, 1984), 13–85.

37. See Arlette Jouanna, *Ordre social: Mythes et hiérachies dans la France du XVI^e siècle* (Paris: Hachette, 1977).

38. Deonna Waldemar, "Le symbolisme de l'acrobatie antique," *Latomus* 9 (1953): 125: "Sphéricité, mouvement circulaire, ne sont donc pas des facultés humaines, mais surhumaines. Et ceci confirme le sens symbolique que nous avons donné de l'acrobate: en courbant son corps en cercle, en le mouvant comme une roue, il imite des figures divines et célestes" ("Sphericity, circular movement, is not a human but superhuman ability, and this confirms the symbolic sense that is given to the acrobat: bending his body in a circle and doing a cartwheel, he imitates divine and celestial figures").

39. Tuccaro, *Trois dialogues,* fol. 67r: "Maintenant il faut dire, que tout ainsi qu'aux Mathematiques pour enseigner & descrire un cercle sur une droicte ligne, il le faut diviser en deux proportions égales, & puis faire le demy cercle d'un costé; & ainsi ayant pour resolution que le cercle face un cercle tres-parfaict en l'air, nous procederons de la mesme maniere & façon qu'eux."

40. Tuccaro, *Epistre*: "se fait par art diabolique"; Tuccaro, *Trois dialogues,* fol. 67r: "chaque saut tourné décrit touiours avec la tête un cercle très-parfaict en l'air." For the linking of acrobatic movements with the devil, see also Rabelais's description of Gymnaste's virtuoso exercises on the horse, which lead to his triumph over his opponent, Capitaine Tripet (*Gargantua and Pantagruel* 1.33).

41. Mikhail Bakhtin, *Rabelais and His World*, trans. Helene Iswolsky (Bloomington: Indiana University Press, 1984).

42. Bakhtin, *Rabelais*, 353.

43. The topos of the world turned upside down—"il mondo alla rovescia"—had been familiar in poetry since medieval times, and in connection with "[la poesia] dei giullari i quali amano sragionare deliberatamente" ("the poetry of the tumblers, who love to drivel without sense"), the reversal of the "normal" states of up and down is described as "un uomo è sotterrato con la testa all'ingiù e i piedi all'insu; segno evidente che quell'uomo va all'inferno" ("a human being turned with the head downward and the feet upward, an evident sign of someone directed toward hell"); see Giuseppe Cocchiara, *Il mondo alla rovescia* (Turin: Boringhieri, 1981), 16 and 257. See also Giovanna Angeli, *Il mondo rovesciato* (Rome: Bulzoni, 1977).

44. André Chastel, *La grotesque* (Paris: Gallimard, 1988), 22.

45. Chastel, *La grotesque*, 60, referring to Giovanni Paolo Lomazzo's definition of grotesque art.

46. Chastel, *La grotesque*, 61.

47. Mark Dorrian, "On the Monstrous and the Grotesque," *Word and Image* 16.3 (2000): 310. Dorrian recalls that the classical body was developed as geometricized and cosmic especially in Renaissance: "The material world is unified, brought towards perfection and into form, by relating its elements to one another through a metaphysics of continued geometrical proportion" (311).

48. The Valois in particular were known as kings who collected around them dwarves, mentally ill people, and small dogs. See Jean-Charles Sournia, *La Renaissance du corps, XVI^e siècle* (Paris: Santé, 1998), 53. We can therefore assume that, at least at the Austrian and the French courts, tastes were extremely diverse, ranging from a penchant for highly symbolical triumphal entries to an appetite for grotesquerie.

49. Dorrian, "On the Monstrous," 313.

50. Josef Kopperschmidt, "Zwischen Affirmation und Subversion. Einleitende Bemerkungen zur Theorie und Rhetorik des Festes," in *Fest und Festrhetorik: Zu Theorie, Geschichte und Praxis der Epideiktik*, ed. Josef Kopperschmidt and Helmut Schanze (Munich: Fink, 1999), 9–10.

51. Kopperschmidt, "Zwischen Affirmation," 11.

52. Joachim Küchenhoff, "Das Fest und die Grenzen des Ich," in *Das Fest*, ed. Walter Haug and Rainer Warning (Munich: Fink, 1989), 116.

FOURTEEN: The Double Life of St. Sebastian in Renaissance Art

This essay was written while I was a visiting professor at Villa I Tatti, the Harvard University Center for Renaissance Studies in Florence. I am very grateful to the director, Joseph Connors, for the appointment and hospitality, to the expert staff for their help, and to all the Tattiani who discussed this material with me, especially Shane Butler, Andrew Hopkins, and Michael Rocke.

1. The image of the triumphant victim who withstands brutal physical assaults is, of course, part of the general iconography of martyrdom. Here, however, I want to focus on this dynamic with exclusive reference to representations of St. Sebastian and to address how it affects the reception of his figure as a devotional image as well as a configuration of art.

2. Luba Freedman also posits a double function for images of St. Sebastian in her important study, "Saint Sebastian in Veneto Painting: The 'Signals' Addressed to 'Learned' Spectators," *Venezia Cinquecento* 15 (1998): 5–20. She discusses the figure of Sebastian as one case within her larger exploration of reception. Freedman focuses on the response of a "learned audience," familiar with the literature of art, whose interests one might equate with connoisseurship. Although our aims and approaches are different, our ideas converge in our acknowledgment of the multivalency of the paintings and of the paradigmatic place of Sebastian's iconography in complex viewing practices of the Renaissance.

3. I take this fact from a discussion of the *Passio*, or *Acta*, of Sebastian contained in the *Acta sanctorum*, s.v. "Sebastiano," in the *Bibliotheca sanctorum*, 13 vols. (Rome: Città Nuova, 1968), 11:775–802. The entry specifies that the *Passio S. Sebastiani* was composed by an able but unknown Roman author of the fifth century and not by St. Ambrose, to whom it has traditionally been attributed (778).

4. See Karim Ressouni-Demigneux, "La personnalité de saint Sébastien," *Mélanges de l'École Française de Rome* 114 (2002): 561.

5. One notable exception, commissioned by Maffeo Barberini for a family chapel in the Roman church of Sant'Andrea della Valle, was painted by Lodovico Carracci in 1612. The painting is now in the collection of the Getty Museum, slightly inaccurately titled *Saint Sebastian Thrown into the Cloaca Maxima*. The literature simply states that the body was thrown into a sewer; the sewer is not further specified. Tradition held that the chapel was situated on the very site of Sebastian's death; the narrative painting was a pointed commemoration.

6. For a selection of paintings that show other events in the saint's life, see Rosa Giorgi, *Santi*, in the series Dizionari dell'arte (Milan: Electa, 2002), s.v. "Sebastiano."

7. Jacobus de Voragine, *The Golden Legend*, 2 vols. (Princeton, NJ: Princeton University Press, 1993), 1:101. Irving L. Zupnick, "Saint Sebastian: The Vicissitudes of the Hero as Martyr," in *Concepts of the Hero in the Middle Ages and the Renaissance*, ed. Norman T. Burns and Christopher J. Reagan (Albany: State University of New York Press, 1975), 239–67, provides useful sources for accounts and legends of the saint (although the analysis of the images is not acute). See Louise Marshall, "Manipulating the Sacred: Image and Plague in Renaissance Italy," *Renaissance Quarterly* 47 (1994): 489–90, for an outline of the movement of Sebastian from local cult to plague saint, with sources.

8. Anna Jameson, *Sacred and Legendary Art* (London: Longmans, Green, 1866), 415, gives a translation of the original inscription; its text varies slightly from the passage included in the *Golden Legend*.

9. For this point in connection to Pavia, see Marshall, "Manipulating the Sacred," 489.

10. For a discussion of the frequency of outbreaks of plague after 1348, and the significance of the psychological impact, see Marshall, "Manipulating the Sacred," 486, with pertinent bibliography. For plague history and imagery also see Gauvin Alexander Bailey et al., eds., *Hope and Healing: Painting in Italy in a Time of Plague, 1500–1800* (Worcester, MA: Worcester Art Museum, 2005). This volume was published after I had already completed my chapter, so I can only mention its uniformly excellent essays; the exhibited paintings are mostly from the seventeenth and eighteenth centuries.

11. This point is made by Ressouni-Demigneux, "La personnalité de saint Sébastien," 561, with sources.

12. Ressouni-Demigneux, "La personnalité de saint Sébastien," 579.

13. Jacobus de Voragine, *The Golden Legend* 1:100.

14. For the Gentile and Mantegna, see Jacques Darriulat, *Sébastien le renaissant* (Paris: Lagune, 1998), 187 and 98. For Giovanni di Paolo's panel, see Jill Dunkerton et al., eds., *Giotto to Dürer: Early Renaissance Paintings in the National Gallery* (New Haven, CT: Yale University Press, 1991), 64, fig. 70. Darriulat's book, with its excellent color reproductions of paintings (researched by Isabelle d'Hauteville), is the best source to consult for the images (although it is by no means exhaustive).

15. Ressouni-Demigneux, "La personnalité de saint Sébastien," 564–65, especially n. 32 and 573.

16. Homer, *The Iliad*, trans. Robert Fagles (New York: Viking Penguin, 1990), 1.9–12.

17. It is important to underline that I am here making the Apollo / Sebastian analogy specifically for the Renaissance period. For example, although Marshall, "Manipulating the Sacred," 491, agrees that arrows are the crucial part of Sebastian's iconography, she denies a link to Apollonian imagery by arguing that no cross-cultural sharing between paganism and Christianity took place (493). While I find this a questionable position, the crucial point for the present discussion is not what happened in the ancient world; rather what is important is the Renaissance practice of appropriating elements of antique imagery and how artists in the fifteenth and sixteenth centuries applied their borrowings. There is, however, an indication that there were early ties between the two figures, if the information is correct that Sebastian was buried at the site of a temple dedicated to Apollo. See Freedman, "Saint Sebastian in Veneto Painting," 9 and nn. 20, 21. In her most recent study of Sebastian's iconography ("Reading the Body of a Plague Saint: Narrative Altarpieces and Devotional Images of St. Sebastian in Renaissance Art," in *Reading Texts and Images: Essays on Medieval and Renaissance Art and Patronage in Honor of Margaret M. Manion*, ed. Bernard J. Muir [Exeter, UK: University of Exeter Press, 2002], 238–72), Marshall repeats her skepticism about connections between Sebastian's imagery and that of Apollo and puts a different emphasis on the symbolism of the arrows from my own: "Sebastian's cult as a plague saint lies in the confluence of traditional arrow symbolism with the Christian concept of martyrdom as the most perfect imitation of Christ" (240).

18. The basic study of this term as applied to Renaissance art is Colin Eisler's "The Athlete of Virtue: The Iconography of Asceticism," in *De artibus opuscula 40: Essays in Honor of Erwin Panofsky*, ed. Millard Meiss (New York: New York University Press, 1961), 82–97.

19. Eisler, "The Athlete of Virtue," 82.

20. Among the most notable examples is that of Titian's altarpiece in Santa Maria della Salute, *Saint Mark Enthroned between Saints Cosmas and Damian, and Saints Rocco and Sebastian*, first painted for the church of Santo Spirito in Isola. Combining this group of major intercessors against suffering and pestilence with specific reference to the protection of Venice under its patron makes the altarpiece a prayer itself as much as a devotional image. For the role the church's history and function played in the transfer of Titian's painting in the seventeenth century to the Salute, see Andrew Hopkins, *Santa Maria della Salute* (Cambridge: Cambridge University Press, 2000), 73. See also Lorenzo Lotto's striking *Saint Christopher with Saints Rocco and Sebastian* in the Palazzo Apostolico, Loreto (for a reproduction, see Darriulat, *Sébastien le renaissant*, 229).

21. *Acta sanctorum* (Antwerp: apud Joannem Mevrsium, 1643), s.v. "January 20," Sebastian's feast day; a convenient edition is the 1966 reprint by the Brussels publisher Culture et Civilisation.

22. Pierio Valeriano, *Hieroglyphica* (New York: Garland Publishing, 1976), 446. A humanist originally from Belluno, Valeriano lived in Rome from 1509 until 1530; the *Hieroglyphica* is his major work of scholarship, which he worked on throughout his life. It was first published in 1556. The passage quoted in the text is found in book 42, "Arcus & Sagittae," under the section dealing with *pestilentia*. In the margins is written: "St. Sebastian, protector against the plague." I would like to thank Shane Butler for his translation of this passage.

23. See the extensive list in *Bibliotheca sanctorum* 11:789ff., esp. 793, for the earliest works.

24. The account of the translocation of Sebastian's relics, attributed to an anonymous monk in Soissons, can be found in the *Acta sanctorum* (1643), 278–95. The essential points are summarized in the *Bibliotheca sanctorum* 11:785: "Secondo varie narrazioni Ilduino, abate di S. Dionigi, chiese al papa reliquie del santo per la chiesa di S. Medardo in Soissons. La domanda fu accolta e la traslazione avvenne il 13 ott 826; le reliquie arrivano a Soissons il 9 dic dello stesso anno" ("According to various accounts, Ilduino, abbot of St. Denis, asked the pope for relics of the saint for the church of St. Medard in Soissons. The request was approved and the transfer took place on 13 October 826; the relics arrived in Soissons on 9 December of the same year"). Also see Ressouni-Demigneux, "La personnalité de saint Sébastien," 559, and Léonard R. Mills, "Une vie inédite de saint Sébastien," *Bibliothèque d'Humanisme et Renaissance*, 28 (1966): 410–18, for the traditions and history of Sebastian's cult in France in general.

25. Serafino Ricci, *S. Sebastiano* (Rome: Società Editrice d'Arte illustrata, 1924), 8–9. This text quotes the legend in an Italian translation: "Quando il Vescovo di Laon, il quale aveva osato mettere pubblicamente in dubbio il passaggio di S. Sebastiano oltre monti, fu dal Santo incollerito visitato in sogno ed aspramente percosso, ei lo vide avvicinarsi al suo letto, accompagnato da due maestosi vegliardi, in aspetto d'efebo, tale in ogni suo membro da richiamare l'euritmia di S. Sebastiano" ("The Bishop of Laon, who had dared to publicly call into question Saint Sebastian's passage over the mountains, was visited and struck harshly by the angry saint in a dream. He saw him move toward his bed, accompanied by two majestic elders, having the aspect of an ephebe, whose every member recalled the eurhythmy of Saint Sebastian"). Ricci's short introduction (to a selection of thirty paintings and two sculptures), although dated in some respects, is perceptive and still useful in points of information and sources.

26. Jacobus de Voragine, *The Golden Legend* 1:98–99.

27. See G. E. Rizzo, *Prassitele* (Milan: Fratelli Treves, 1932), 79–85 and plates 118–29, for the attribution and a suggested reconstruction of the sculpture. For a range of examples after the *Apollo Lykeios*, see the *Lexicon iconographicum mythologiae classicae*, 8 vols. (Zurich: Artemis, 1984), vol. 2, pt. 1, s.v. "Apollon"; here the attribution to Praxiteles is qualified as uncertain. For the *Anacharsis, or Athletics*, see *The Works of Lucian*, trans. A. M. Harmon, 8 vols. (London: Heinemann, 1925), 4:7.

28. For examples of the *Apollo citaredo* known during the Renaissance, see Phyllis Pray Bober, *Renaissance Artists and Antique Sculpture* (London: H. Miller, 1986), 76–77. As Bober notes, this type influenced Raphael's fictive statue of Apollo in the *School of Athens* as well as Michelangelo's *Dying Slave*. There is an important example

of the *Apollo citaredo* in the Capitoline Museum, Palazzo Nuovo, from Tivoli. It is a copy of a cult statue that was in the Temple of Apollo in the Circus Flaminio, made by Timarchides, dating from the early second century BCE.

29. For an illustration by Genga, see Darriulat, *Sébastien le renaissant*, 217; for one by a member of the Florentine circle, see Janet Cox-Rearick, "Fra Bartolomeo's St. Mark Evangelist and St. Sebastian with an Angel," *Mitteilungen des Kunsthistorisches Institut* 18 (1974): 352–53; for the Signorelli, see Darriulat, *Sébastien le renaissant*, 214, and Tom Henry and Laurence B. Kanter, *The Complete Paintings of Luca Signorelli* (London: Thames and Hudson, 2001), plate 11, 122–23; see plate 17, 148, for another example that is a panel in a polyptych. An interesting mutation of the Apollo posture occasionally appears, where both of Sebastian's arms are raised up over his head and bound at the wrists; this is very beautifully done by Dosso Dossi in the Brera's panel and by Giovanni Mansueti in his painting in the Accademia, Venice. For illustrations of both see Ricci, *S. Sebastiano*, plates 18 and 20.

30. Conserved in the Capitoline Museums, Pinacoteca of the Museo dei Conservatori, inventory number PC 212. The wall tag in the Pinacoteca is unusually replete with pertinent information. It mentions the proliferation of the subject in northern Italy during the plague of 1510, characterizing the plague as the "disease caused by Apollo's arrows." It states further that since Sebastian survived an attack by arrows, he was seen as a protector against their effects (i.e., the plague) and notes that the pose is like that of the *Apollo Lykeios*, with the hand above head.

31. See the entry for this painting by Mauro Lucco in the exhibition catalogue *Venezia e la peste* (Venice: Marsilio, 2007), 236 and plate 3, following 216.

32. These terms are used by Stefania Mason Rinaldi, "Le immagini della peste nella cultura figurativa veneziana," in *Venezia e la peste*, 214–15. She also mentions the contrast of "l'antico e il moderno" with reference to the two saints and makes the useful point that while Sebastian's relation to the plague is metaphorical, Rocco's was real, or we might better say, historical, as he suffered its effects.

33. Reproduced in Darriulat, *Sébastien le renaissant*, 181.

34. David Rosand, "Titian's St. Sebastians," *Artibus et historiae* 30 (1994): 29. Rosand also points out that in a late painting of the saint, Titian based his representation on another classical sculpture of Apollo, the *Apollo Belvedere* (37). Although it falls a bit outside the present discussion, I would like to note that the Sebastian of the *Averoldi Altarpiece* is closely related to Carlo Crivelli's figure of the saint in the predella of the Odoni altar from the 1490s, particularly in the motif of the bent arm tied to a tree and the twisted posture; the exact relationship of the two would make an interesting study.

35. David Summers, *Michelangelo and the Language of Art* (Princeton, NJ: Princeton University Press, 1981), 84. Summers mentions that Leonardo owned eight images of the saint in the context of a discussion of his studies of the figure, specifically his investigation of "graceful movement," and refers to a sketch of St. Sebastian by the artist. The reasons why Leonardo would have had such a collection must have been varied; we can be sure that technical concerns, as well as issues of visual pleasure, were involved. Summers's comments are worth quoting: "Treating a theme in which classical *contrapposto* was common, the martyrdom of St. Sebastian, he varied and exaggerated the movement of the parts of the body, making it much more pronouncedly three dimensional. That he was especially taken with the possibilities of the theme is suggested

by his listing eight St. Sebastians in the inventory of his belongings made just before he left Florence in the autumn of 1481."

36. James Saslow made an early attempt to create a place for St. Sebastian within "a proposed Homoerotic Iconology" in "The Tenderest Lover: Saint Sebastian in Renaissance Painting," *Gai Saber: Gay Academic Union Journal* 1 (1977): 58–64. Although a brave attempt to redress the lack of attention to issues of sexuality in the art-historical literature, the article does not present a convincing case. Some objections were immediately raised in a response by Wayne Dynes, "Putting St. Sebastian to the Question," 150–51. For a recent case of overdetermining the image, see Maurice Brock, *Bronzino* (Paris: Flammarion, 2002), 168. Brock's commentary on Agnolo Bronzino's half-length figure of Sebastian reads: "In all likelihood, the conversation that the viewer sees about to begin—but from which he or she is excluded—is of an amorous nature. Yet, at the time, the (rare) portraits of lovers or engaged couples which were addressed to the beloved woman took on a very different form. The relationship would thus be homosexual. In any case, this is what is suggested by the young man's near nudity, the androgynous look of his face (emphasized by the curly locks), the arrow pierced near his heart, and especially the delicacy with which he holds the arrow aimed at his interlocutor—one finger on the point as if gauging its sharpness." In addition to fabricating an arbitrary story for an image that is nonnarratival, the author posits that the painting was made for "a very private realm," but Elizabeth Pilliod has shown that the panel was likely commissioned for a Compagnia di San Sebastiano. The confraternity dedicated to St. Sebastian in Florence in the sixteenth century in fact had many artists as members, including Andrea del Sarto and Bronzino. Andrea del Sarto painted a St. Sebastian for the altar, a half-length representation that was much copied but now is lost. Bronzino's St. Sebastian follows this type. See Elizabeth Pilliod, *Pontormo, Bronzino, Allori: A Genealogy of Florentine Art* (New Haven, CT: Yale University Press, 2001), 91ff., and Janet Cox-Rearick, "A 'St. Sebastian' by Bronzino," *Burlington Magazine* 129 (1987): 154–62.

37. I would draw on Michael Rocke's nuanced interpretations of archival documents to argue that no "homosexual identity" as we understand it today existed in Italy during the period in question. See his *Forbidden Friendships: Homosexuality and Male Culture in Renaissance Florence* (New York: Oxford University Press, 1996).

38. Giorgio Vasari, *Vite de' più eccellenti pittori, scultori ed architettori*, 9 vols., ed. Gaetano Milanesi (Florence: Sansoni, 1973), 6:390, 393.

39. Louis Réau, *Iconographie de l'art chrétien*, 3 vols. (Paris: PUF, 1959), 3:1192.

40. For a thorough discussion of this in relationship to modernist poetry, see Richard A. Kaye, "'A Splendid Readiness for Death': T. S. Eliot, the Homosexual Cult of St. Sebastian, and World War I," *Modernism/Modernity* 6 (1999): 107–34. My comments concerning the Sebastian cult in the late nineteenth and early twentieth centuries are based on Kaye's study.

41. Kaye, "'A Splendid Readiness,'" 109.

42. *Le martyre de Saint Sébastien* was published in Paris in 1911 by Calmann-Lévy in a limited edition.

43. For citation of these sources as well as a study of the play and its reception, see Giovanni Gullace, "The French Writings of Gabriele D'Annunzio," *Comparative Literature* 12 (1960): 207–28. While the original five-hour-long French production created a scandal in the Catholic press and eventual boredom among some of its more receptive

audience members, *Le martyre* had a successful performance in 1926 at La Scala in a version pruned down to two hours.

44. For Cocteau's reaction, for example, see Kaye, "'A Splendid Readiness,'" 117.

45. Lorenzo Ghiberti, *Commentarii*, intro. and ed. Lorenzo Bartoli (Florence: Giunti, 1998), 48.

46. Paolo Giovio, "Fragmentum trium dialogorum," in vol. 1 of *Scritti d'arte del cinquecento*, ed. and trans. Paola Barocchi (Milan: Ricciardi, 1971), 19–20.

47. The drawing is in the Cleveland Museum of Art, executed in metalpoint. For a fine reproduction and discussion of its relation to the Uffizi and Louvre paintings, see the exhibition catalogue *Pietro Perugino, Master of the Italian Renaissance*, ed. Joseph Antenucci Becherer (Grand Rapids, MI: Grand Rapids Art Museum, 1997), 148–51 and plates 8, 9.

48. Titian's altarpiece is reproduced along with a discussion of Vasari's passage and a related one by Lodovico Dolce in Rosand, "Titian's St. Sebastians," 23ff.

49. This painting, which shows a Venetian cityscape in the background, dates from the end of the fifteenth century. See Darriulat, *Sébastien le renaissant*, 92, 93, and 128, for full and detail views.

50. For a reproduction, see Darriulat, *Sébastien le renaissant*, 209. For extensive information on Fra Bartolomeo's painting, which is now lost, see Janet Cox-Rearick, "Fra Bartolomeo's St. Mark Evangelist and St. Sebastian with an Angel," 334ff. A copy of the painting exists in the church of San Domenico in Fiesole. We do not know much about this copy, but its emphasis on anatomical construction, its lifelike movement, and its near-total nudity are helpful in imagining the original. The original painting was bought by Tomaso Sartini, a Florentine living in Lyon, who in turn sold it to Francis I (see Janet Cox-Rearick, *The Collection of Francis I: Royal Treasures* [New York: Abrams, 1995], no. 24 bis). In "Fra Bartolomeo's St. Mark Evangelist and St. Sebastian with an Angel," Cox-Rearick refers to the St. Sebastian as a "demonstration piece," which is obviously analogous to my notion of an "art figure," and her arguments are relevant to my own. She discusses the virtuosity displayed in Fra Bartolomeo's figure in relation to paradigms of classical sculpture as well as in relation to Renaissance versions, specifically a *Bacchus* by Jacopo Sansovino (349).

51. Pliny, *Natural History* 36.4.20–23. I use the version found in Franciscus Junius, *A Lexicon of Artists and Their Works*, ed. and trans. Keith Aldrich, Philipp Fehl, and Raina Fehl (Berkeley: University of California Press, 1991), 340; see entry 1006 for other accounts of the tale.

52. Antonio Tosi, *Storie all'ombra del malfrancese* (Palermo: Sellerio, 1992), 61–68.

53. The inscription is, unfortunately, most often cropped in photographs of the painting. See the small-scale but complete reproduction in *Pietro Perugino*, 150, fig 53.

54. The letter "a" in both *tuae* and *infixae* is very faint; perhaps they were added in a second moment to correct an imprecise transcription.

55. *The Book of Psalms in Latin and English* (London: Burnes Oates and Washbourne, 1948), 95–96.

FIFTEEN: Body Elision

The gestation of this chapter owes a debt to Barbara Apelian Beall, with whom I visited thirteen Italian *sacri monti*, and my students who have enthusiastically camped out

at Varallo. I am also grateful for the hospitality extended to me in Valsesia by Piera Barsotti, Maria Grazia Cagna, Elisa Farinetti, Pier Giorgio Longo, Piera Mazzone, Giorgio Regaldi, and Franca Tonella Regis. Particular thanks goes to Stefania Stefani Perrone, who shared her knowledge about Varallo. Additional thanks is owed to the Centro di Studi Americani ed Euro-Americani at the Università di Torino, which generously funded my research in Valsesia.

1. Edith Wharton, *Italian Backgrounds* (New York: Charles Scribner's Sons, 1905), 85.

2. Wharton, *Italian Backgrounds*, 88 and 103.

3. Sergio Gensini, ed., *La "Gerusalemme" di San Vivaldo e i sacri monti in Europa* (Pisa: Pacini, 1989); Sergio Gensini, ed., *Gli abitanti immobili di San Vivaldo il monte sacro della Toscana* (Florence: Morgana Giunta Regionale Toscana, 1987); Riccardo Pacciani, *La "Gerusalemme" di San Vivaldo in Valdelsa* (Montaione: Titivillus, n.d.).

4. For the most comprehensive listing of the Italian *sacri monti*, see Luigi Zanzi and Paolo Zanzi, *Atlante dei sacri monti prealpini* (Milan: Skira, 2002). For references to similar *sacri monti* complexes throughout Europe, see Amilcare Barbero, ed., *Atlante dei sacri monti, calvari e complessi devozionali europei* (Novara: Istituto Geografico Deagostini, 2001).

5. The archdiocese of Milan included fifteen dioceses: Acqui, Alba, Alessandria, Asti, Bergamo, Brescia, Casale Monferrato, Cremona, Lodi, Novara, Savona, Tortona, Ventimiglia, Vercelli, and Vivegano.

6. See Samuel Butler, *Ex Voto: An Account of the Sacro Monte or New Jerusalem at Varallo-Sesia, with Some Notice of Tabachetti's Remaining Work at the Sanctuary of Crea* (London: Trübner and C. Ludgate Hill, 1888). On Butler's lifelong relationship with Varallo, see Alberto Durio, *Samuel Butler e la Valle Sesia: Da sue lettere inedite a Giulio Arienta, Fedrico Tonetti e a Pietro Calderini* (Varallo: Testa, 1940). In addition to being a skilled amateur photographer and painter, Samuel Butler (1835–1902) was the author of the mock-utopian novel *Erewhon* (1872) as well as of a satire of his bourgeois Victorian upbringing, *The Way of All Flesh* (1903). He was identified by George Bernard Shaw as one of the greatest English writers of the nineteenth century. I would like to thank Stephen Miller and Jeremy Braddock for bringing Butler's satires to my attention.

7. Caimi was the confessor to Beatrice d'Este, wife of Ludovico "il Moro" Sforza. On Caimi's career, see Pier Giorgio Longo, "Bernardino Caimi francescano osservante: Tra 'eremitorio' e città," *Novarien Associazione di storia della chiesa novarese* 29 (2000): 9–26, and Pier Giorgio Longo, "Pietà e cultura dell'osservanza francescana a Varallo Sesia," *Novarien Associazione di storia della chiesa novarese* 26 (1996): 169–207.

8. While it appears that Fra Bernardo Caimi and Fra Tomaso da Firenze knew each other—in fact, Caimi was in Tuscany giving sermons in the late fifteenth century—the extent to which the two friars shared ideas about the building of the sacred mountains is unclear.

9. For an overview of the early phase of the site, see Stefania Stefani Perrone, ed., *Questi sono li misteri che sono sopra el Monte de Varalle* (Borgosesia: Società per la Conservazione delle Opere d'Arte e dei Monumenti in Valsesia, 1987) and Roberta Panzanelli, "Pilgrimage in Hyperreality: Images and Imagination in the early phase of the 'New Jerusalem' at Varallo (1486–1530)" (PhD diss., UCLA, 1999).

10. On the pilgrimages, see Angelo Stoppa, "I quattro pellegrinaggi di San Carlo al Sacro Monte di Varallo," in *Da Carlo Borromeo a Carlo Bascapè: La Pastorale di Carlo*

Borromeo e il Sacro Monte di Arona (Novara: Associazione di Storia della Chiesa Nova-rese, 1985), 57–82. For a collection of Valsesian images of San Carlo, see Stefania Stefani Perrone and Marco Rosci, *San Carlo e la Valsesia: Iconografia del culto di San Carlo* (Borgosesia: Valsesia, 1984).

11. See Piera Bassotto, *Il santuario del Cavallero* (Coggiola: Comunità Montana Valle Sessera, 1998).

12. Giovanni Battista Fassola, *La nuova Gierusalemme; o, sia il Santo Sepolcro di Var-allo, consacrata all'avema regina Maria Anna d'Austria, madre del gran monarca Carlo Secondo NS* (Milan: Federico Agnelli Scultore and Stampatore, 1671), 74. Fassola was the canon of the Collegiata di San Gaudenzio in Varallo.

13. Theoderich, *Guide to the Holy Land*, trans. Aubrey Stewart (New York: Italica, 1986), 5.

14. Robert Ousterhout, "Architecture as Relic and the Construction of Sanctity: The Stones of the Holy Sepulchre," *Journal of the Society of Architectural Historians* 62.1 (2003): 4–23.

15. Francesco Torrotti, *Historia della nuova Gerusalemme, il Sacro Monte di Varallo, consacrata a sua santità Innocenzo XI* (Varallo: Juxta-Copiam, 1686), 20.

16. Riserva Naturale Sacro Monte di Varallo, *Dati affluenza visitatori al sacro monte, 1986–2003* (Varallo: Riserva, 2003).

17. For the foundational work on Varallo, see the various studies by Longo ("Ber-nardino Caimi" and "Pietà e cultura"); Perrone, *Questi sono li misteri*; Maria Gatti Perer, *Terra santa e sacri monti: Atti della giornata di studio, Universita Cattolica, aula Pio XI, 25 Novembre 1998* (Milan: Università Cattolica, 1999); and Luigi Zanzi, *Sacri monti e dintorni: Studi sulla cultura religiosa e artistica della Controriforma* (Milan: Jaca, 1990). Essays by David Freedberg, William Hood, Alessandro Nova, Roberta Panzanelli, Ju-dith Wolin, and Rudolf Wittkower have also raised interesting questions regarding the *sacri monti*, in particular Varallo. For these see: David Freedberg, "Verisimilitude and Resemblance: From Sacred Mountain to Waxworks," in his *The Power of Images: Stud-ies in the History and Theory of Response* (Chicago: University of Chicago Press, 1989); William Hood, "The *Sacro Monte* of Varallo: Renaissance Art and Popular Religion," in *Monasticism and the Arts*, ed. Timothy G. Verdon and John Dally (Syracuse, NY: Syracuse University Press, 1984), 291–311; Alessandro Nova, "'Popular' Art in Renais-sance Italy: Early Response to the Holy Mountain at Varallo," in *Reframing the Renais-sance: Visual Culture in Europe and Latin America, 1450–1650*, ed. Claire Farago (New Haven, CT: Yale University Press, 1995), 113–26; Judith Wolin, "Mnemotopias: Revisiting Renaissance *Sacri Monti*," *Modulus 18: The University of Virginia Architectural Review* 18 (1987): 54–61; and Rudolph Wittkower, "*Sacri Monti* in the Italian Alps," in his *Idea and Image: Studies in the Italian Renaissance* (New York: Thames and Hudson, 1978), 174–83.

18. The very title of Wharton's book, *Italian Backgrounds*, was intended to convey this idea.

19. For references to the visits by various pilgrims to Varallo, see Guido Gentile, "1507: Una comitiva di pellegrini francesi al Sepolcro di Varallo," *Novarien Associazione di storia della chiesa novarese* 30 (2001): 241–48, and Casimiro Debiaggi, "Un pellegrino mancato al Sacro Monte di Varallo: Torquato Tasso," *De Valle Sicida: Periodico annuale Societa Valsesiana di Cultura* 6 (1995): 119–26. On Federico Zuccaro's journey to Varallo, see Zuccaro, *Il passaggio per Italia, con la dimora di Parma* (Rome: Mantellate, 1893), 33

and 34. Zuccaro was sent to Varallo in the spring of 1604 by Federico Borromeo, who commissioned him to paint a history of Carlo Borromeo. On Giovan Paolo Lomazzo's comments, see Panzanelli's translation in "Pilgrimage in Hyperreality," 309–47.

20. On the miracle of Agnese Botta, see Pietro Galloni, *Sacro Monte di Varallo: Atti di fondazione* (Varallo: Camaschella e Zanfa, 1909), 238.

21. Gentile, "1507: Una comitiva di pellegrini," 241–48.

22. Pier Giorgio Longo, "Il Sacro Monte di Varallo nella seconda metà del XVI secolo," in *I Sacri Monte di Varallo e Arona dal Borromeo al Bascapè*, 64.

23. On the advice of Federico Borromeo, the Duke of Savoy came to Varallo in September 1593 to regain his health. He was accompanied by the cardinal of Vercelli and the bishop of Novara. See Longo, "Il Sacro Monte di Varallo," 106. On the silver ex-votive head sent by the Infanta, see the inventory of December 31, 1593, reprinted in Franca Tonella Regis, "Per grazia ricevuta: Esempi di ex voto anatomici ed oggettuali," "L'immagine e l'immaginario al Sacro Monte di Varallo," special issue, *De Valle Sicida: Periodico annuale Societa Valsesiana di Cultura* 7.1 (1996): 61.

24. Tonella Regis, "Per grazie ricevuta," 41.

25. Bishop Bascapè granted permission to the priest Marco Vignolo of Grignasco to conduct an exorcism on his brother (who was possessed by a witch in the form of a black cat) in April 1601. A painted ex-voto documenting the exorcism survives. See Pier Giorgio Longo, "'Un luogo sacro . . . quasi senz'anima': Carlo Bascapè e il Sacro Monte di Varallo," in *Carlo Bascapè sulle orme del Boromeo: Coscienza e azione pastorale in un vescovo di fine Cinquecento* (Novara: Interlinea, 1994), 396.

26. An ex-votive painted by Melchiorre d'Enrico depicts the procession of the confraternities of Santa Marta and the Santissimo Sacramento of Campertogno to the *sacro monte*. See Enrica Ballarè, *San Giacomo Maggiore Campertogno: Inventario del Museo* (Campertogno: Museo di Campertogno, 2002), 34.

27. Several male pilgrims complained to the Varallo *podestà* that they were harassed by prostitutes during their visit to the *sacro monte*. See *Ordinanze del podestà di Valsesia contro le donne che danno scandolo al sacro monte*, Archivio di Stato di Varallo, Sacro Monte, busta 59.

28. See Robert Ousterhout, "The Church of Santo Stefano: A 'Jerusalem' in Bologna," *Gesta* 20.2 (1981): 311–22.

29. Rucellai supposedly (according to a now lost letter) sponsored a trip to the Holy Land in order to measure the sepulchre. See Gastone Petrini, "La Cappella del Santo Sepolcro nella ex chiesa di San Pancrazio in Firenze," in *Toscana e terrasanta nell Medioevo*, ed. Franco Cardini (Florence: Alinea, 1982), 340. On the aedicule, see also Ludwig H. Heydenreich, "Die Cappella Rucellai von San Pancrazio in Florenz," in *De artibus opuscula 40: Essays in Honor of Erwin Panofsky*, ed. Millard Meiss (New York: New York University Press, 1961), 219–29.

30. Nerida Newbigin, "The *Rappresentazioni* of Mysteries and Miracles in Fifteenth-Century Florence," in *Christianity and the Renaissance: Image and Religious Imagination in the Quattrocento*, ed. Timothy G. Verdon and John Henderson (Syracuse, NY: Syracuse University Press, 1990), 361–75.

31. The event is described in detail by Rab Hatfield; see his "The Compagnia de' Magi," *Journal of the Warburg and Courtauld Institutes* 33 (1970): 107–61.

32. On Passion devotion, see Miedema Nine, "Following in the Footsteps of Christ:

Pilgrimage and Passion Devotion," in *The Broken Body: Passion Devotion in Late-Medieval Culture*, ed. A. A. MacDonald, H. N. B. Ridderbos, and R. M. Schlusemann (Groningen: Egbert Forsten, 1998), 73–92.

33. The letter was addressed to Bishop Alessandro Sauli. It is quoted in Perrone and Rosci, *San Carlo e la Valsesia*, 29.

34. Cesare Orsenigo, *Life of St. Charles Borromeo* (London: B. Herder, 1943), 337.

35. The 1514 guide to Varallo implies that the pilgrim walks with the three magi; see *Questi sono li misteri che sono sopra el Monte di Varalle* (Milan: Gottardo da Ponte, 1514), iii.

36. For a description of the Bethlehem church, see Theoderich, *Guide to the Holy Land*, 51.

37. See *Meditations on the Life of Christ*, trans. Isa Ragusa and Rosalie B. Green (Princeton, NJ: Princeton University Press, 1961), 38. Both Alessandro Nova ("'Popular Art'") and Véronique Plesch ("A Pilgrim's Progress: Guidebooks to the New Jerusalem in Varallo," *Art on Paper* [Nov.–Dec. 2001]: 57) have also made this observation. On the further use of Christ child dolls, see Christiane Klapisch-Zuber, "Holy Dolls: Play and Piety in Florence in the Quattrocento," in *Looking at Italian Renaissance Sculpture*, ed. Sarah Blake McHam (New York: Cambridge University Press, 1998), 111–27.

38. Panzanelli claims that the techniques of imaginative meditation on the mysteries were developed not only in Bonaventure's text but also in Ludolfo di Sassonia, *Vita Christi* (printed in a Milanese edition by Antonio de Honate in 1480), Aelredo di Rievaulx, *De institutione inclusarum*, Ludovico Barbo, *Forma orationis et meditationis*, and Camilla Battista da Varanno, *Considerazioni sulla passione di nostro Signor* ("Pilgrimage in Hyperreality," 213–14).

39. Stefania Stefani Perrone, "L'urbanistica dell sacro monte e l'Alessi," in *Galeazzo Alessi e l'architecttura del Cinquecento: Atti del convegno internazionale di studi, Genova, 16–20 Aprile 1974* (Genova: Sagep, 1975), 501–16.

40. The manuscript has been reproduced as Galeazzo Alessi, *Libro dei misteri: Progetto di pianificazione urbanistica, architettonica e figurativa (1565–1569)* (Bologna: Arnaldo Forni, 1974).

41. Theoderich, *Guide to the Holy Land*, 19–20.

42. Pier Giorgio Longo, "Una visita del vescovo Carlo Bascapè al Sacro Monte di Varallo (27 settembre–1 ottobre 1604)," *De Valle Sicida: Periodico annuale Societa.Valsesiana di Cultura* 9.1 (1998): 163–80.

43. See Carlo Borromeo, *Istructiones fabricae et supellectilis ecclesiasticae* (Mediolani: apud Pacificum Pontium, 1577).

44. On the confessional, see Wietse de Boer, *The Conquest of the Soul: Confession, Discipline and Public Order in Counter-Reformation Milan* (Leiden: Brill, 2001), 85 and 105.

45. On the original configuration of the Calvary chapel, see Michela Cometti, "La Cappella della Crocifissione di Gaudenzio Ferrari: Problemi di conservazione e di tutela tra cronaca e storia," "L'immagine e l'immaginario al Sacro Monte di Varallo," special issue, *De Valle Sicida: Periodico annuale Società Valsesiana di Cultura* 7.1 (1996): 185–206. Bascapè ordered the installation of a grill in the chapel in 1604.

46. Panzanelli has made this point in "Pilgrimage in Hyperreality," 201.

47. *Questi sono li misteri che sono sopra el Monte di Varalle*, v.

48. "Il Ballarino miracolosamente risanato nel Santo Sepolcro di Varallo Sesia," document dated May 29, 1671, recorded by notary Carlo Bernardino Baldi, Archivio di Stato di Varallo, Sacro Monte, busta 2.

49. On the stone, see Jonathan Bober, "Storia e storiografia del S. Monte di Varallo: Osservazioni sulla 'prima pietra' del S. Sepolcro," *Novarien Associazione di storia della chiesa novarese* 14 (1984): 3–18.

50. Yet as Richard Krautheimer reminds us, copies are not necessarily replicas. Instead, it was the dimension, number of parts, and relationship of those parts to the whole that allowed a simulacrum to stand in for the original ("Santo Stefano Rotondo and the Holy Sepulchre Rotunda," in his *Studies in Early Christian, Medieval, and Renaissance Art* [New York: New York University Press, 1969], 96).

51. See Theoderich, *Guide to the Holy Land*, 8–9, and Abbott Daniel, quoted in Jaroslav Folda, "Jerusalem and the Holy Sepulchre through the Eyes of Crusader Pilgrims," in "The Real and Ideal Jerusalem in Jewish, Christian, and Islamic Art," special issue, *Jewish Art* 23–24 (1997–98): 159.

52. "Inventario mobili: Chiesa di Santo Sepolcro," Archivio di Stato di Varallo, Sacro Monte, busta 55, notes that the figure of Christ was covered with a black cloth.

53. Torrotti, *Historia della nuova Gerusalemme*, 91.

54. Franca Tonella Regis provides a fascinating discussion of the wide variety of ex-votos left at Varallo; see her "Per grazia ricevuta."

55. Domenico Promis and Giuseppe Müller, "Lettere e orazioni latine di Girolamo Morone," *Miscellanea di Storia Italiana* 2 (1863): 148–49. For an English translation see Panzanelli, "Pilgrimage in Hyperreality," 284.

56. Borromeo, for example, made a pilgrimage to the shroud in Turin in 1582 in the company of Cardinal Gabriele Paleotti and Bascapè (Longo, "Il Sacro Monte di Varallo," 128–29). On the shroud, see John Beldon Scott, *Architecture for the Shroud: Relic and Ritual in Turin* (Chicago: University of Chicago Press, 2003).

57. See the extract of the will written in 1561 by Giovanni Battista Crivelli of Castellanza, Archivio di Stato di Varallo, Sacro Monte, busta 10. Crivelli died in 1591. In 1698, his descendant Francesco Besollo, a Milanese nobleman, was still paying to illuminate the chapel.

58. See, for example, *Questi sono li misteri che sono sopra el Monte di Varalle.*

59. Promis and Müller, "Lettere e orazioni." For an English translation, see Panzanelli, "Pilgrimage in Hyperreality," 284.

60. Caroline Walker Bynum, lecture, Cornell University, November 30, 2002.

61. Caroline Walker Bynum, *Fragmentation and Redemption: Essays on Gender and the Human Body in Medieval Religion* (New York: Zone Books, 1991), 91.

62. *Questi sono li misteri che sono sopra el Monte di Varalle.*

63. This is confirmed by the surviving sculptural groups depicting lamentation scenes. See, for example, Niccolò dell'Arca's lamentation group in Santa Maria della Vita in Bologna (1463) and that of Guido Mazzoni commissioned by Alfonso II of Naples (1492–93). See Randi Klebanoff, "Passion, Compassion, and the Sorrows of Women: Niccolò dell'Arca's Lamentation over the Dead Christ for the Bolognese Confraternity of Santa Maria della Vita," in *Confraternities and the Visual Arts in Renaissance Italy: Ritual, Spectacle, Image*, ed. Barbara Wisch and Diane Cole Ahl (New York: Cambridge University Press), 146–72.

64. Confraternities of the rosary already existed by the 1470s. See Anne Winston-

Allen, S*tories of the Rose: The Making of the Rosary in the Middle Ages* (State College: Pennsylvania State University Press, 1999). To curb abuses of the cult, Pope Pius V sought to codify Marian devotion with a decree in 1569.

65. Wolin, "Mnemotopias," 58.

66. The legend dates back to the early 1400s. See Sergio Raveggi, "Storia di una leggenda: Pazzo de' Pazzi e le pietre del Santo Sepolcro," in *Toscana e terrasanta*, 299–315. The bits of flint were initially kept in the church of Santa Maria Sopra Porta and subsequently in San Biagio. The lighted fire was transported through the streets of Florence to the Piazza del Duomo. The festivities were paid for by the Pazzi family until 1864.

67. The image of Jerusalem would have been familiar to the educated Florentine public through contemporary fifteenth-century travel accounts such as those of Marco di Bartolommeo Rustici, written in 1447, the popular sermons of Savonarola, and images such as those produced by the Florentine workshop of Pietro del Massaio. On the relationship between Tuscans and the Holy Land, see *Toscana e terrasanta*.

68. As Sergio Raveggi has noted, once the crusade was no longer a livable event, it became a popular site for fiction. In the fifteenth century, it was not uncommon for noble families to reclaim, with various degrees of ingenuousness, the glories of the crusaders ("Storia di una leggenda," 315).

69. John Shearman mistakenly claims that the chapels of San Vivaldo addressed a nonelite audience; see his *Only Connect: Art and the Spectator in the Italian Renaissance* (Princeton, NJ: Princeton University Press, 1992), 41.

70. Marco Neiretti et al., *La Passione di Sordevolo: Storia-arte-testimonianze* (Sordevolo: Associazione di Volontariato, 2000).

71. Zuccaro, *Il passaggio per Italia*, 34.

72. John Shearman notes this (*Only Connect*, 40) as did Peter Cannon Brookes before him. See Brookes, "The Sculptural Complexes of San Vivaldo," in *La "Gerusalemme" di San Vivaldo e i sacri monti in Europa*, ed. Sergio Gensini (Montaione: Pacini, 1989), 277.

73. Definition of installation art provided by contemporary artist Tulu Bayar, interview, October 16, 2003.

74. Elizabeth Diller and Ricardo Scofidio, *Blur: The Making of Nothing* (New York: Harry Abrams, 2002).

75. Over the course of the sixteenth and seventeenth centuries, the guidebooks to Varallo become increasingly interested in the artistic (rather than religious) merit of the site. Fassola, for example, claims that it is important to recognize the style in the buildings' beautiful paintings as well as their high quality; see his *La nuova Gierusalemme*, 81.

Bibliography

Achillini, Alessandro. *De physico auditu.* In *Opera omnia in unum collecta.* Venice: Hieronimus Scotus, 1545.

Adams, Rachel, and David Savran, eds. *The Masculinity Studies Reader.* Oxford: Blackwell, 2002.

Agosti, Stefano. *Gli occhi, le chiome: Per una lettura psicoanalittica del "Canzoniere" di Petrarca.* Milan: Feltrinelli, 1993.

Agrippa, Cornelius. *De occulta philosophia libri tres.* Edited by V. Perrone Compagni. Leiden: Brill, 1992.

Aitken, K. T. "Proverbs." In *The Oxford Bible Commentary,* 405–22. Oxford: Oxford University Press, 2001.

Alberti, Leon Batista. *The Family in Renaissance Florence.* Translated by Renee Neu Watkins. Columbia: University of South Carolina Press, 1969.

Albrecht-Bott, Marianne. *Die Bildende Kunst in der Italienischen Lyrik der Renaissance und des Barock: Studie zur Beschreibung von Portraits und anderen Bildwerken unter besonderer Berücksichtigung von G. B. Marinos Galleria.* Wiesbaden: Franz Steiner, 1976.

Aldobrandino da Siena. *Il libro delle cose segrete delle donne.* Edited by Giuseppe Manuzzi. Florence: Tipografia del Vocabulario della Crusca, 1863.

Alessi, Galeazzo. *Libro dei misteri: Progetto di pianificazione urbanistica, architettonica e figurativa (1565–1569).* Bologna: Arnaldo Forni, 1974.

Allaire, Gloria. "Tullia d'Aragona's *Il Meschino* as Key to a Reappraisal of Her Work." *Quaderni d'Italianistica* 16.1 (1995): 33–50.

Allen, Michael J. B. "The Absent Angel in Ficino's Philosophy." *Journal of the History of Ideas* 36.2 (1975): 219–40.

———. *Icastes: Marsilio Ficino's Interpretation of Plato's "Sophist."* Berkeley: University of California Press, 1989.

———. *Synoptic Art: Marsilio Ficino on the History of Platonic Interpretation.* Florence: Olschki, 1998.

Andersson, Christiane. *Dirnen, Krieger, Narren: Ausgewählte Zeichnungen von Urs Graf.* Basel: GS-Verlag, 1978.

Angeli, Giovanna. *Il mondo rovesciato.* Rome: Bulzoni, 1977.

Antonelli, Roberto, Introduction. In Francesco Petrarca, *Canzoniere,* v–xxv. Turin: Einaudi, 1992.

Arcangeli, Alessandro. *Davide o Salome: Il dibattito europeo sulla danza nella prima età moderna.* Rome: Viella, 2000.

Aretino, Pietro. *Lettere libro primo.* Edited by Francesco Erspamer. Parma: Fondazione Pietro Bembo and Guanda, 1995.

————. *Ragionamento del Zoppino fatto frate, e Lodovico, puttaniere, dove contiensi la vita e genealogia di tutte le cortigiane di Roma*. Edited by Mario Cicognani. Milan: Longanesi, 1969.

Ariosto, Ludovico. *Orlando furioso*. 2 vols. Edited by Emilio Bigi. Milan: Rusconi, 1982.

Aristotle. *Opera cum Averrois commentariis*. 12 vols. Translated by Iacobus Mantino. 1562–74. Facs. ed., Frankfurt: Minerva, 1962.

————. *Physics*. Translated by Robin Waterfield. Oxford: Oxford University Press, 1996.

Ascoli, Albert R. "Ariosto and the 'fier pastor': Form and History in *Orlando furioso*." *Renaissance Quarterly* 54 (2001): 487–522.

————. *Ariosto's Bitter Harmony: Crisis and Evasion in the Italian Renaissance*. Princeton, NJ: Princeton University Press, 1987.

————. "Body Politics in Ariosto's *Orlando furioso*." In *Translating Desire in Medieval and Early Modern Literature*, edited by Craig Berry and Heather Hayton, 49–85. Tempe, AZ: Center for Medieval and Renaissance Studies, 2005.

————. "Faith as Cover-Up: Ariosto's *Orlando furioso*, Canto 21, and Machiavellian Ethics." *I Tatti Studies in the Renaissance* 8 (1999): 135–70.

Avicenna. *Opera in luce redacta ac nuper quantum ars niti potuit per Canonicos emendata: Liber qui dicitur sufficientia*. 1508. Facs. ed., Frankfurt: Minerva, 1961.

Baader, Hannah. "Francesco Petrarca: Irdische Körper, himmlische Seelen und weibliche Schönheit (1336)." In *Porträt: Geschichte der klassischen Bildgattungen in Quellentexten und Kommentaren*, edited by Hannah Baader and Nicola Suthor, 177–88. Berlin: Reimer, 1999.

Baader, Hannah, and Nicola Suthor, eds. *Porträt: Geschichte der klassischen Bildgattungen in Quellentexten und Kommentaren*. Berlin: Reimer, 1999.

Baernstein, P. Renée, and Julia L. Hairston. "Tullia d'Aragona: Two New Sonnets." *MLN* 123 (2008): 151–59.

Bagliani, Agostino Paravicini. *The Pope's Body*. Translated by David S. Peterson. Chicago: University of Chicago Press, 2000.

Bailey, Gauvin Alexander, et al., eds. *Hope and Healing: Painting in Italy in a Time of Plague, 1500–1800*. Worcester, MA: Worcester Art Museum, 2005.

Bairati, Eleonora. *Salomè: Immagini di un mito*. Nuoro: Ilisso, 1998.

Baird, Lorrayne Y. "*Priapus gallinaceus*: The Role of the Cock in Fertility and Eroticism in Classical Antiquity and the Middle Ages." *Studies in Iconography* 7–8 (1981–82): 81–111.

Bakhtin, Mikhail. *Rabelais and His World*. Translated by Helene Iswolsky. Bloomington: Indiana University Press, 1984.

Ballarè, Enrica. *San Giacomo Maggiore Campertogno: Inventario del museo*. Campertogno: Museo di Campertogno, 2002.

Barasch, Moshe. "The Magic of Images in Renaissance Thought." In *Die Renaissance und die Entdeckung des Individuums in der Kunst: Die Renaissance als erste Aufklärung*, edited by Enno Rudolph, 79–102. Tübingen: Mohr Siebeck, 1998.

Barbaro, Antonio. *Pratica criminale*. Venice: G. Bortoli, 1739.

Barbaro, Francesco. "De re uxoria." Edited by A. Gnesotto. *Atti e memorie della Accademia di Scienze, Lettere, ed Arti in Padua*, n.s., 32 (1915–16): 6–105.

————. "On Wifely Duties." In *The Earthly Republic: Italian Humanists on Government*

and Society, edited and translated by Benjamin Kohl and Ronald Witt, with Elizabeth Welles, 178–228. Philadelphia: University of Pennsylvania Press, 1978.

Barbero, Amilcare, ed. *Atlante dei Sacri Monti, calvari e complessi devozionali europei.* Novara: Istituto Geografico Deagostini, 2001.

Barkan, Leonard. *The Gods Made Flesh: Metamorphosis and the Pursuit of Paganism.* New Haven, CT: Yale University Press, 1986.

Barolini, Teodolinda. "The Making of a Lyric Sequence: Time and Narrative in Petrarch's *Rerum vulgarium fragmenta.*" *MLN* 104 (1989): 1–38.

Baron, Hans, Jr. "Cicero and the Roman Civic Spirit in the Middle Ages and the Renaissance." *Bulletin of the John Rylands Library* 22 (1938): 72–97.

Bartolomeo da Montagnana. *Consilia Montagne.* Lyon: Jacobus Myt, 1525.

Bassotto, Piera. *Il Santuario del Cavallero.* Coggiola: Comunità Montana Valle Sessera, 1998.

Bätschmann, Oskar. "Belebung durch Bewunderung: Pygmalion als Modell der Kunstrezeption." In *Pygmalion: Die Geschichte des Mythos in der abendländischen Kultur*, edited by Matthias Meyer and Gerhard Neumann, 325–69. Freiburg im Breisgau: Rombach 1997.

Battaglia, Salvatore. *Grande dizionario della lingua italiana.* 21 vols. Edited by Giorgio Bárberi Squarotti. Turin: UTET, 1961–2002.

Battisti, Carlo, and Giovanni Alessio. *Dizionario etimologico italiano.* 5 vols. Florence: Barbéra, 1975.

Bausi, Francesco. "'Con agra zampogna': Tullia d'Aragona a Firenze (1545–48)." *Schede umanistiche*, n.s., 2 (1993): 61–91.

Beck, Herbert, Maraike Bückling, and Edgar Lein, eds. *Die Christus-Thomas-Gruppe von Andrea del Verrocchio.* Frankfurt am Main: Heinrich, 1996.

Becker-Leckrone, Megan. "Salome: The Fetishization of a Textual Corpus." *New Literary History* 26.2 (1995): 239–60.

Bedaux, Jean Baptiste. "Laatmiddeleeuwse sexuelle amuletten: Een sociobiologische benadering." In *Annus quadriga mundi: Opstellen over middeleeuwse kunst opgedragen aan prof. Dr. Anna C. Esmeijer*, edited by Jean Baptiste Bedaux and A. M. Koldeweij, 16–30. Utrecht: Walburg Pers, 1989.

Beecher, Donald, Massimo Ciavollella, and Roberto Fedi, eds. *Ariosto Today: Contemporary Perspectives.* Toronto: University of Toronto Press, 2003.

Bellamy, Elizabeth J. *Translations of Power: Narcissism and the Unconscious in Epic History.* Ithaca, NY: Cornell University Press, 1992.

Benivieni, Antonio di Ser Paolo. *De abditis nonnullis ac mirandis morborum et sanationum causis.* Florence: Filippo Giunta, 1507.

———. *De abditis nonnullis ac mirandis morborum et sanationum causis.* Edited and translated by Charles Singer. Springfield IL: Charles C. Thomas, 1954.

———. *De abditis nonnullis ac mirandis morborum et sanationum causis.* Edited and translated by Giorgio Weber. Florence: Olschki, 1994.

Benson, Pamela. *The Invention of Renaissance Woman.* University Park: Pennsylvania State University Press, 1992.

Benson, Pamela, and Victoria Kirkham, eds. *Strong Voices, Weak History: Early Women Writers and Canons in England, France, and Italy.* Ann Arbor: University of Michigan Press, 2004.

Benthien, Claudia, and Christoph Wulf, eds. *Körperteile: Eine kulturelle Anatomie.* Reinbek: Rowohlt, 2001.

Berengario da Carpi, Jacopo. Preface. In *Isagogae breves perlucidae ac uberrrimae in anatomiam humani corporis.* Bologna: Girolamo Benedetti, 1523.

Bernau, Anne, Ruth Evans, and Sarah Salih, eds. *Medieval Virginities.* Toronto: University of Toronto Press, 2003.

Bettarini, Rosanna. *Lacrime e inchiostro nel "Canzoniere" di Petrarca.* Bologna: CLUEB, 1998.

Beuningen, H. J. E. van, and A. M. Koldeweij, eds. *Heilig en profaan: 1000 Laatmiddeleeuwse insignes uit de collectie H. J. E. van Beuningen.* Cothen: Stichting Middeleeuwse Religieuse en Profane Insignes, 1993.

Beyer, Andreas, and Bruce Boucher. *Piero de'Medici "il Gottoso" (1416–69).* Berlin: Akademie, 1993.

Biagi, Guido. "Un'etèra romana: Tullia d'Aragona." *Nuova antologia,* ser. 3, 4.16 (1886): 655–711.

Bibliotheca sanctorum. 13 vols. Rome: Città Nuova, 1968.

Bigi, Emilio. "Alcuni aspetti dello stile del canzoniere petrarchesco." In *Dal Petrarca al Leopardi,* 1–22. Milan: Ricciardi, 1954.

Billanovich, Giuseppe. "Petrarca e Cicerone." In *Miscellanea Giovanni Mercati,* 4:88–106. Vatican City: Biblioteca Apostolica Vaticana, 1946.

———. "Petrarca e i libri della cattedrale di Verona." In *Petrarca, Verona e l'Europa: Atti del convegno internazione di studi (Verona 19–23 sett. 1991),* edited by Giuseppe Billanovich and Giuseppe Frasso, 117–78. Padua: Antenore, 1997.

———. *Lo scrittoio del Petrarca.* Vol. 1 of *Petrarca letterato.* Rome: Edizioni di Storia e Letteratura, 1947.

———. "Ser Convenevole da Prato maestro notaro e chierico." In *Petrarca, Verona e l'Europa: Atti del convegno internazione di studi (Verona 19–23 sett. 1991),* edited by Giuseppe Billanovich and Giuseppe Frasso, 367–90. Padua: Antenore, 1997.

———. "Quattro libri del Petrarca e Verona." *Studi petrarcheschi* 7 (1990): 233–62.

Biow, Douglas. *The Culture of Cleanliness in Renaissance Italy.* Ithaca, NY: Cornell University Press, 2006.

———. *In Your Face: Professional Improprieties and the Art of Being Conspicuous in Sixteenth-Century Italy.* Stanford, CA: Stanford University Press, 2010.

———. "Manly Matters: The Theatricality and Sociability of Beards in Giordano Bruno's *Candelaio* and Sixteenth-Century Italy." *Journal of Medieval and Early Modern Studies,* forthcoming.

Birbari, Elizabeth. *Dress in Italian Painting, 1460–1500.* London: Murray, 1975.

Biscoglio, Frances. "Unspun Heroes: Iconography of the Spinning Woman in the Middle Ages." *Journal of Medieval and Renaissance Studies* 25 (1995): 163–76.

Bishop, Morris. *Letters of Petrarch.* Bloomington: Indiana University Press. 1963.

Blanc, Pierre. "Petrarca ou la poétique de l'ego." *Revue des Études Italiennes* 29 (1983): 122–69.

———. "Pétrarque, lecteur de Cicéron: Les scolies pétrarquiennes du *De oratore* e de l'*Orator.*" *Studi petrarcheschi* 9 (1978): 122–69.

Bliquez, Lawrence J. "Four Testimonia to Human Dissection in Byzantine Times." *Bulletin of the History of Medicine* 58 (1984): 554–57.

Bober, Jonathan. "Storia e storiografia del S. Monte di Varallo: Osservazioni sulla

'prima pietra' del S. Sepolcro." *Novarien Associazione di storia della chiesa novarese* 14 (1984): 3–18.

Bober, Phyllis Pray. *Renaissance Artists and Antique Sculpture.* London: H. Miller, 1986.

Boccaccio, Giovanni. *Rime.* Edited by Vittore Branca. Vol. 5 of *Tutte le opere,* edited by Vittore Branca. Milan: Mondadori, 1992.

Boccadiferro, Lodovico. *Lectiones in quartum "Meteororum" Aristotelis librum.* Venice: Francesco de' Franceschi da Siena, 1563.

Bode, Wilhelm. "Desiderio da Settignano und Francesco Laurana: Zwei italienische Frauenbüsten des Quattrocento im Berliner Museum." *Jahrbuch der Preußischen Kunstsammlungen* 9 (1888): 209–38.

Boerio, Giuseppe. *Dizionario del dialetto veneziano.* 2nd ed. Venice: Giovanni Cecchini, 1856.

Boethius. *The Consolation of Philosophy.* Translated by W. V. Cooper. London: Dent, 1902.

———. *De consolatione philosophiae.* Edited by Claudio Moreschini. Munich: K. G. Saur, 2000.

Böhme, Hartmut. "Erotische Anatomie: Körperfragmentierung als ästhetisches Verfahren in Renaissance und Barock." In *Körperteile: Eine kulturelle Anatomie,* edited by Claudia Benthien and Christoph Wulf, 228–53. Reinbek: Rowohlt, 2001.

Bongi, Salvatore. "Documenti senesi su Tullia d'Aragona." *Rivista critica della letteratura italiana* 4.6 (1887): 186–88.

———. "Rime della signora Tullia di Aragona; et di diversi a lei." In vol. 1 of *Annali di Gabriel Giolito de' Ferrari,* 150–99. Rome: Principali Librai, 1890.

———. "Il velo giallo di Tullia d'Aragona." *Rivista critica della letteratura italiana* 3.3 (1886): 85–95.

Bonhomme, Guy. *De la paume au tennis.* Gallimard: Paris 1991.

Bonifaccio, Giovanni. *L'arte de' cenni con la quale formandosi favella visibile, si tratta della muta eloquenza, che non e altro che un facondo silentio.* Vicenza: Francesco Grossi, 1616.

Bono, James J. "Medical Spirits and the Medieval Language of Life." *Traditio* 40 (1984): 91–130.

Bontempi, Sebastiano. "Life of Colomba." In vol. 5 of *Acta sanctorum,* no. 216. 1685. Facs. ed., Brussels: Culture et Civilization, 1968.

The Book of Psalms in Latin and English. London: Burnes Oates and Washbourne, 1948.

Borromeo, Carlo. *Istructiones fabricae et supellectilis ecclesiasticae.* Milan: apud Pacificum Pontium, 1577.

Boucher, Jacqueline. *Société et mentalités autour de Henri III.* 4 vols. Lille: Éd. Ouest-France, 1981.

Bourdieu, Pierre. *Raisons pratiques: Sur la théorie de l'action.* Paris: Seuil, 1998.

Boyarin, David. *Carnal Israel: Reading Sex in Talmudic Culture.* Berkeley: University of California Press, 1993.

Braun, Joseph. *Die Reliquiare des christlichen Kultes und ihre Entwicklung.* Freiburg im Breisgau: Herder, 1940.

Bredekamp, Horst. *Repräsentation und Bildmagie der Renaissance als Formproblem.* Munich: Siemens-Stiftung, 1995.

Britti, Francesco. *Ammaestramento de figliuoli.* Venice: Gabriel Giolito, 1573.

Brock, Maurice. *Bronzino*. Paris: Flammarion, 2002.

Brookes, N. C. "The Sculptural Complexes of San Vivaldo." In *La "Gerusalemme" di San Vivaldo e i sacri monti in Europa*, edited by Sergio Gensini, 271–79. Montaione: Pacini, 1989.

Brose, Margaret. "Petrarch's Beloved Body: 'Italia mia.'" In *Feminist Approaches to the Body in Medieval Literature*, edited by Linda Lomperis and Sarah Stanbury, 2–20. Philadelphia: University of Pennsylvania Press, 1992.

Broude, Norma, and Mary Garrad, eds. *The Expanding Discourse: Feminism and Art History*. Boulder, CO: Westview Press, 1992.

Brown, Alison, ed. *Language and Images of Renaissance Italy*. Oxford: Clarendon Press, 1995.

Brownlee, Kevin. "Legacy, and Provisional Endings: Pygmalion, Mimesis, and the Multiple Endings of the *Roman de la Rose*." *Yale French Studies* 95 (1999): 193–211.

Brunner, Férnand. "Sur l'hylemorpisme d' Ibn Gabirol." *Les Études Philosophiques* 8 (1953): 29–38.

Bruno, Giordano. *Cause, Principle and Unity; Essays on Magic*. Translated by Robert de Lucca. Cambridge: Cambridge University Press, 1998.

———. *De la causa, principio et uno*. Edited by Eugenio Canone. Florence: Olschki, 1999.

———. "De vinculis in genere." In *Opere magiche*, edited by Michele Ciliberto, 413–531. Milan: Adelphi, 2000.

Bryce, Judith. "Gender and Myth in the *Orlando furioso*." *Italian Studies* 47 (1992): 41–50.

Buckley, Thomas, and Alma Gotlieb, eds. *Blood Magic: The Anthropology of Menstruation*. Berkeley: University of California Press, 1988.

Buonarroti, Michelangiolo. *Rime*. Edited by Enzo Noè Girardi. Bari: Laterza, 1960.

Burckhardt, Jacob. *Die Cultur der Renaissance in Italien: Ein Versuch, 1860*. 2 vols. Translated by S. G. C. Middlemore. New York: Harper, 1958.

Burger, Fritz. *Francesco Laurana*. Straßburg: Heitz and Mündel, 1907.

Burke, Peter. "The Art of Insult in Early Modern Italy." *Culture and History* 2 (1987): 68–79.

———. "Insults and Blasphemy in Early Modern Europe." In *The Historical Anthropology of Early Modern Italy: Essays on Perception and Communication*, 95–109. Cambridge: Cambridge University Press, 1987.

———. "Notes for a Social History of Silence." In *The Art of Conversation*, 123–41. Cambridge, UK: Polity Press, 1993.

———. *Popular Culture in Early Modern Europe*. New York: Harper and Row, 1978.

Butler, Judith. *Bodies that Matter: On the Discursive Limits of Sex*. New York: Routledge, 1993.

———. *Gender Trouble: Feminism and the Subversion of Identity*. New York: Routledge, 1990.

Butler, Samuel. *Ex Voto: An Account of the Sacro Monte or New Jerusalem at Varallo-Sesia, with Some Notice of Tabachetti's Remaining Work at the Sanctuary of Crea*. London: Trübner and C. Ludgate Hill, 1888.

Butterfield, Andrew. *The Sculptures of Andrea del Verrocchio*. New Haven, CT: Yale University Press, 1997.

Bynum, Caroline Walker. *Fragmentation and Redemption: Essays on Gender and the Human Body in Medieval Religion.* New York: Zone Books, 1991.

———. *Holy Feast and Holy Fast: The Religious Significance of Food to Medieval Women.* Berkeley: University of California Press, 1987.

———. *The Resurrection of the Body in Western Christianity.* New York: Columbia University Press, 1995.

Caciola, Nancy. *Discerning Spirits: Divine and Demonic Possession in the Middle Ages.* Ithaca, NY: Cornell University Press, 2003.

———. "Mystics, Demoniacs, and the Physiology of Spirit Possession in Medieval Europe." *Comparative Studies in Society and History* 42 (2000): 268–306.

Camille, Michael. *The Gothic Idol: Ideology and Image-Making in Medieval Art.* Cambridge: Cambridge University Press, 1989.

Campbell, Stephen J., and Sandra Seekins, eds. *The Body UnVeiled: Boundaries of the Figure in Early Modern Europe.* Ann Arbor, MI: Goetzcraft Printers, 1997.

Camporesi, Piero. *Il sugo della vita: Simbolismo e magia del sangue.* Milan: Edizione di Comunità, 1982.

Carlino, Andrea. *Books of the Body: Anatomical Ritual and Renaissance Learning.* Translated by John Tedeschi and Anne C. Tedeschi. Chicago: University of Chicago Press, 1999.

Carson, Anne. "Putting Her in Her Place: Woman, Dirt and Desire." In *Before Sexuality: The Construction of Erotic Experience in the Ancient Greek World,* edited by David M. Halperin, John J. Winkler, and Froma I. Zeitlin, 135–69. Princeton, NJ: Princeton University Press 1990.

Casagrande, Carla. *I peccati della lingua: Disciplina ed etica della parola nella cultura medievale.* Rome: Istituto della Enciclopedia Italiana, 1987.

Casagrande, Giovanna. "Terziarie domenicane a Perugia." In *Una santa, una città,* edited by Enrico Menestò and Giovanna Casagrande, 109–60. Spoleto: Centro Italiano di Studi sull'Alto Medioevo, 1991.

Cassiodorus. *De anima.* Edited by J. W. Halporn. In vol. 1 of *Magni Aurelii Cassiodori senatoris opera.* Turnhout: Brepols, 1973.

Cassola, Luigi. *Madrigali del magnifico signor cavallier Luigi Cassola piacentino.* Venice: Gabriele Giolito, 1544.

Castelli, Patrizia. "Imagines spirantes." In *Immaginare l'autore: Il ritratto del letterato nella cultura umanistica, convegno di studi, Firenze, 26–27 marzo 1998,* edited by Giovanna Lazzi and Paolo Viti, 35–62. Florence: Polistampa, 2000.

Castiglione, Baldassarre. *The Book of the Courtier.* Translated by George Bull. New York: Penguin Books, 1967.

———. *The Book of the Courtier.* Translated by Charles Singleton. Edited by Daniel Javitch. New York: Norton, 2002.

———. *The Book of the Courtier.* Translated by Charles S. Singleton. Edited by Edgar de N. Mayhew. New York: Anchor Books, 1959.

———. *Il cortigiano.* 3rd. ed. Edited by Vittorio Cian. Florence: Sansoni, 1929.

———. *Il libro del cortigiano.* Edited by Walter Barberis. Turin: Einaudi, 1998.

Catenazzi, Flavio. *L'influsso dei Provenzali sui temi e immagini della poesia siculo-toscana.* Brescia: Morcelliana, 1977.

Cavarero, Adriana. *Corpo in Figure: Filosofia e Politica della Corporeità.* Turin: Feltrinelli, 1995.

Celani, Enrico. Introduction. In *Le rime di Tullia d'Aragona cortigiana del secolo XVI*, iii–lxiii. 1891. Rpt., Bologna: Commissione per i testi di lingua, 1968.

Celenza, Christopher S. *The Lost Italian Renaissance: Humanists, Historians, and Latin's Legacy*. Baltimore, MD: Johns Hopkins University Press, 2004.

———. "The Revival of Platonic Philosophy." In *The Cambridge Companion to Renaissance Philosophy*, edited by James Hankins, 83–90. Cambridge: Cambridge University Press, 2007.

Cellini, Benvenuto. *Opere: Vita, trattati, rime, lettere*. Edited by Bruno Maier. Milan: Rizzoli, 1968.

Cerreta, Florindo. *Alessandro Piccolomini, letterato e filosofo senese del Cinquecento*. Siena: Accademia, 1960.

Chantraine, Pierre. *Dictionnaire étimologique de la langue grecque*. 8 vols. Paris: Klincksieck, 1990.

Chastel, André. *La grottesque*. Paris: Gallimard, 1988.

Chiappelli, Fredi. "Ariosto, Tasso e le bellezze delle donne." *Filologia e critica* 10 (1985): 325–41.

Chojnacka, Monica. *Working Women of Early Modern Venice*. Baltimore, MD: Johns Hopkins University Press, 2001.

Cicero, Marcus Tullius. *Cicero's Letters to Atticus*. Edited and translated by D. R. Shackleton Bailey. Harmondsworth: Penguin, 1978.

———. *Cicero's Letters to Atticus*. 7 vols. Edited by D. R. Shackleton Bailey. Cambridge: Cambridge University Press, 1965–70.

———. *De officiis (I doveri)*. Edited by Emanuele Narducci and Anna R. Barrile. Milan: Rizzoli, 1958.

———. *Epistole*. Edited by Luca Canali. Milan: Rizzoli, 1981.

———. *Pro A. Licinio Archia poeta oratio (Difesa di Archia)*. Edited by Annalaura Burlando. Milan: Garzanti, 1981.

———. *Tusculanae disputationes*. Edited by Max Pohlenz. Stuttgart: Teubner, 1965.

Cino da Pistoia. *Rime*. In *Poeti del dolce stilo nuovo*, edited by Mario Marti. Florence: Le Monnier, 1969.

Clark, Stuart. *Thinking with Demons: The Idea of Witchcraft in Early Modern Europe*. Oxford: Clarendon Press, 1997.

Cocchiara, Giuseppe. *Il mondo alla rovescia*. Turin: Boringhieri, 1981.

Cochin, Henry. *Lettres de Francesco Nelli à Pétrarque*. Paris: Champion, 1892.

Cohen, Elizabeth S. "Back Talk: Two Prostitutes' Voices from Rome c. 1600." *Early Modern Women: An Interdisciplinary Journal* 2 (2007): 95–126.

———. "'Courtesans' and 'Whores': Words and Behavior in Early Modern Rome." *Women's Studies* 19 (1991): 201–8.

———. "Honor and Gender in Early Modern Rome." *Journal of Interdisciplinary History* 4 (1992): 597–626.

———. "No Longer Virgins: Self-Presentation by Young Women in Late Renaissance Rome." In *Refiguring Woman: Perspectives on Gender and the Italian Renaissance*, edited by Marilyn Migiel and Juliana Schiesari, 169–91. Ithaca, NY: Cornell University Press, 1991.

Cohen, Elizabeth S., and Thomas V. Cohen. *Words and Deeds in Renaissance Rome: Trials Before the Papal Magistrates*. Toronto: University of Toronto Press, 1993.

Colilli, Paul. *Petrarch's Allegories of Writing*. Naples: Nicola De Dominicis, 1988.

Collier Frick, Carole. *Dressing Renaissance Florence: Families, Fortunes, and Fine Clothes.* Baltimore, MD: Johns Hopkins University Press, 2002.

Colombo, Realdo. *De re anatomica.* Venice: Nicolai Bevilacqua, 1569.

Cometti, Michela. "La Cappella della Crocifissione di Gaudenzio Ferrari: Problemi di conservazione e di tutela tra cronaca e storia." In "L'immagine e l'immaginario al Sacro Monte di Varallo," special issue, *De Valle Sicida: Periodico annuale Società Valsesiana di Cultura* 7.1 (1996): 185–206.

Comparetti, Domenico. *Virgilio nel Medio Evo.* 2 vols. Florence: La Nuova Italia, 1941.

Constable, Giles. Introduction. In *Apologiae duae,* edited by R. B. C. Huygens, 92–93. Turnhout: Brepols, 1985.

Contini, Gianfranco. "Preliminari sulla lingua del Petrarca." In *Canzoniere di Petrarca,* edited by Roberto Antonelli, xxvii–lviii. Turin: Einaudi, 1992.

Copenhaver, Brian P., trans. *Hermetica: The Greek Corpus Hermeticum and the Latin Asclepius.* Cambridge: Cambridge University Press, 1992.

Couliano, Ioan P. *Eros and Magic in the Renaissance.* Translated Margaret Cook. Chicago: University of Chicago Press, 1987.

Courajod, Louis. "Observations sur deux bustes du Musée de Sculpture de la Renaissance au Louvre." *Gazette des Beaux Arts,* ser. 2, 28 (1883): 24–42.

Courcelle, Pierre. "Le ali dell'intelletto nei *Rerum vulgarium fragmenta.*" *Critica del testo* 6.1 (2003): 559–89.

———. "L'âme fixée au corps." In vol. 2 of *De Socrate à saint-Bernard,* 325–414. Paris: Études Augustiniennes, 1975.

———. *La "Consolation de philosophie" dans la tradition littéraire: Antecedents et posterité de Boéce.* Paris: Études Augustiniennes, 1967.

Covi, Dario A. "The Inscription in Fifteenth Century Florentine Painting." 2 vols. PhD diss., New York University, 1958.

Cox, Virginia. "Fiction, 1560–1650." In *A History of Women's Writing in Italy,* edited by Letizia Panizza and Sharon Wood, 52–64. Cambridge: Cambridge University Press, 2000.

Cox-Rearick, Janet. *Bronzino's Chapel of Eleonora in the Palazzo Vecchio.* Berkeley: University of California Press, 1993.

———. *The Collection of Francis I: Royal Treasures.* New York: Abrams, 1995.

———. *Dynasty and Destiny in Medici Art: Pontormo, Leo X, and the Two Cosimos.* Princeton, NJ: Princeton University Press, 1984.

———. "Fra Bartolomeo's St. Mark Evangelist and St. Sebastian with an Angel." *Mitteilungen des Kunsthistorisches Institut* 18 (1979): 352–53.

———. "A 'St. Sebastian' by Bronzino." *Burlington Magazine* 129 (1987): 154–62.

Crescimbeni, Giovanni Maria. *L'istoria della volgar poesia.* 6 vols. Venice: Lorenzo Basegio, 1730–31.

Cropper, Elizabeth. "The Beauty of Woman: Problems in the Rhetoric of Renaissance Portraiture." In *Rewriting the Renaissance: The Discovery of Sexual Difference in Early Modern Europe,* edited by Margaret Ferguson, Maureen Quilligan, and Nancy Vickers, 175–90. Chicago: University of Chicago Press, 1986.

———. "On Beautiful Women: Parmigianino, Petrarchismo, and the Vernacular Style." *Art Bulletin* 58 (1976): 374–94.

———. "The Place of Beauty in the High Renaissance and Its Displacement in the

History of Art." In *Place and Displacement in the Renaissance,* edited by Alvin Vos, 159–205. Binghamton, NY: Medieval and Renaissance Texts and Studies, 1995.

———. "Prolegomena to a New Interpretation of Bronzino's Florentine Portraits." In vol. 2 of *Renaissance Studies in Honor of Craig Hugh Smyth,* edited by Andrew Morrough et al., 149–60. Florence: Giunti Barbèri, 1985.

Cross, F. L., ed. *Oxford Dictionary of the Christian Church.* London: Oxford University Press, 1957.

Crouzet-Pavan, Elizabeth. "Potere politico e spazio sociale: Il controllo della notte a Venezia nei secoli XIII–XV." In *La notte: Ordine, sicurezza e disciplinamento in età moderna,* edited by Mario Sbriccoli, 46–66. Florence: Ponte alle Grazie, 1991.

———. *Sopra le acque salse: Espaces, pouvoir, et sociéte à Venise à la fin du moyen âge.* 2 vols. Rome: Istituto Palazzo Borromini, 1992.

Curtis-Wendlandt, Lisa. "Conversing on Love: Text and Subtext in Tullia d'Aragona's *Dialogo della infinità d'amore.*" *Hypatia* 19.4 (2004): 75–96.

Dalla Palma, Giuseppe. *Le strutture narrative dell' "Orlando furioso."* Florence: Olschki, 1984.

Damianaki, Chrysa. *The Female Portrait Busts of Francesco Laurana.* Rome: Vecchiarelli, 2000.

Dante Alighieri. *The Divine Comedy: Inferno.* Edited and translated by Robert M. Durling and Ronald L. Martinez. New York: Oxford Press, 1996.

———. *The Divine Comedy: Paradiso.* Edited and translated by John D. Sinclair. New York: Oxford University Press, 1961.

———. *The Divine Comedy: Purgatorio.* Edited and translated by Robert M. Durling and Ronald L. Martinez. New York: Oxford Press, 2003.

Da Ponte, Pietro. *L'opera del Moretto.* Brescia: Tipografia Editrice, 1898.

D'Aragona, Tullia. "Dialogo della signora Tullia d'Aragona della infinità di amore." In *Trattati d'amore del Cinquecento,* edited by Giuseppe Zonta, 185–248. Bari: Laterza, 1912.

———. *Rime della signora Tullia di Aragona et di diversi a lei.* Venice: Gabriel Giolito, 1547.

Darriulat, Jacques. *Sébastien le renaissant.* Paris: Lagune, 1998.

Dean, Trevor. "Gender and Insult in an Italian City: Bologna in the Later Middle Ages." *Social History* 29.2 (2004): 217–31.

Debiaggi, Casimiro. "Un pellegrino mancato al Sacro Monte di Varallo: Torquato Tasso." *De Valle Sicida: Periodico annuale Societa Valsesiana di Cultura* 6 (1995): 119–26.

De Boer, Wietse. *The Conquest of the Soul: Confession, Discipline and Public Order in Counter-Reformation Milan.* Leiden: Brill, 2001.

Degli Uberti, Fazio. *Rime varie.* In *Il Dittamondo e le Rime.* Edited by Giuseppe Corsi. Bari: Laterza, 1952.

Delaney, Janice, Mary Jane Lupton, and Emily Toth. *The Curse: A Cultural History of Menstruation.* New York: Dutton, 1976.

Della Casa, Giovanni. *Il galateo.* Edited by Giuseppe Prezzolini. Milan: Rizzoli, 1995.

———. *Galateo.* Translated by Konrad Eisenbichler and Kenneth R. Bartlett. Toronto: Centre for Reformation and Renaissance Studies, 1986.

Della Chiesa, Francesco Agostino. *Theatro delle donne letterate.* Mondovi: G. Gistandi and G. T. Rossi, 1620.

Della Porta, Giovanni Battista. *La fisonomia dell'huomo*. Venice: Presso Sebastian Combi, 1652.

Della Rocchetta, Giovanni Incisa, and Nello Vian, eds. *Il primo processo per San Filippo Neri nel codice Vaticano Latino 3798 e in altri esemplari dell'Archivio dell'Oratorio di Roma*. 4 vols. Vatican City: Biblioteca Apostolica Vaticana, 1957–63.

De Montaigne, Michel. *Les essais*. Edited by Pierre Villey. Paris: Quadrige / PUF, 1992.

Dempsey, Charles. *Inventing the Renaissance Putto*. Chapel Hill: University of North Carolina Press, 2001.

———. *The Portrayal of Love: Botticelli's Primavera and Humanist Culture at the Time of Lorenzo the Magnificent*. Princeton, NJ: Princeton University Press, 1992.

De Nolhac, Pierre. *Petrarch and the Ancient World*. Boston: Merrymount, 1907.

———. *Pétrarque et l'humanisme*. 2 vols. Paris: Champion, 1907.

Deonna, Waldemar, ed. "Le symbolisme de l'acrobatie antique," special issue, *Latomus* 9 (1953).

Derosas, Renzo. "Moralità e giustizia a Venezia nel '500–'600: Gli esecutori contro la bestemmia." In *Stato, società e giustizia nella repubblica veneta, sec. XV–XVIII*, edited by Gaetano Cozzi, 431–528. Rome: Società Editoriale Jouvence, 1980.

De Rossi, Nicolò. *Canzoniere*. 2 vols. Edited by Furio Brugnolo. Padua: Antenore, 1974.

Derrida, Jacques. "La loi du genre / The Law of Genre." *Glyph* 7 (1980): 176–232.

De St.-Affrique, Béranger. "Vita S. Clarae de Cruce ordinis eremitarum S. Augustini." Edited by Alfonso Semenza. *Analecta augustiniana* 17–18 (1939–41): 406.

De Vivo, Filippo. *Information and Communication in Venice: Rethinking Early Modern Politics*. Oxford: Oxford University Press, 2007.

De Voragine, Jacobus. *The Golden Legend*. Princeton, NJ: Princeton University Press, 1993.

De Vos, Dirk. *Rogier van der Weyden: Das Gesamtwerk*. Munich: Hirmer, 1999.

Di Cesare, Mario. "Issabella and Her Hermit: Stillness at the Center of the *Orlando furioso*." *Medievalia* 6 (1980): 311–22.

Di Donadio, Berengario. *Life of Saint Clare of the Cross of Montefalco*. Translated by Matthew J. O'Connell. Edited by John E. Rotelle. Villanova, PA: Augustinian Press, 1999.

Diller, Elizabeth and Ricardo Scofidio. *Blur: The Making of Nothing*. New York: Harry N. Abrams, 2002.

Di Sassonia, Ludolfo. *Vita Christi*. Milan: Antonio de Honate, 1480.

Ditchfield, Simon. *Liturgy, History, and Sanctity in Tridentine Italy: Pietro Maria Campi and the Preservation of the Particular*. Cambridge: Cambridge University Press, 1995.

Donato, Eugenio. "'Per selve e boscherecci labirinti': Desire and Narrative Structure in Ariosto's *Orlando furioso*." In *Literary Theory / Renaissance Texts*, edited by Patricia Parker and David Quint, 33–62. Baltimore, MD: Johns Hopkins University Press, 1986.

Dorrian, Mark, "On the Monstrous and the Grotesque." *Word and Image* 16.3 (2000): 310–17.

Douglas, Mary. *Natural Symbols: Explorations in Cosmology*. London: Barrie and Jenkins, 1970.

Duden, Barbara. *The Woman Beneath the Skin: A Doctor's Patients in Eighteenth-Century Germany*. Cambridge, MA: Harvard University Press, 1991.

Dunkelman, Martha Levine. "The Innocent Salome." *Gazette des Beaux-Arts* 133 (1999): 173–80.

Dunkerton, Jill, et al., eds. *Giotto to Dürer: Early Renaissance Paintings in the National Gallery.* New Haven, CT: Yale University Press, 1991.

Durio, Alberto. *Samuel Butler e la Valle Sesia: Da sue lettere inedite a Giulio Arienta, Fedrico Tonetti e a Pietro Calderini.* Varallo: Testa, 1940.

Durling, Robert M. *The Figure of the Poet in Renaissance Epic.* Cambridge, MA: Harvard University Press, 1965.

———. Introduction. In *Petrarch's Lyric Poems*, 1–33. Cambridge, MA: Harvard University Press, 1976.

———. "Petrarch's 'Giovene donna sotto un verde lauro.'" *MLN* 86 (1971): 1–20.

Ebbersmeyer, Sabrina. *Sinnlichkeit und Vernunft: Studien zur Rezeption und Transformation der Liebestheorie Platons in der Renaissance.* Munich: Fink, 2002.

Ebreo, Leone. *Dialoghi d'amore.* 1535. Facs. ed., Heidelberg: Carl Winter, 1924.

Edelstein, Bruce. "Leone Leoni, Benvenuto Cellini and Francesco Vinta, a Medici Agent in Milan." *The Sculpture Journal* 4 (2000): 120, 407–530.

Egmond, Florike, and Robert Zwijnenberg, eds. *Bodily Extremities: Preoccupations with the Human Body in Early Modern European Culture.* Aldershot, UK: Ashgate, 2003.

Eisler, Colin. "The Athlete of Virtue: The Iconography of Asceticism." In *De artibus opuscula 40: Essays in Honor of Erwin Panofsky*, edited by Millard Meiss, 82–97. New York: New York University Press, 1961.

Elias, Norbert. *The Civilizing Process.* Vol. 2. New York: Urizon Books, 1978.

Elliott, Dyan. "The Physiology of Rapture and Female Spirituality." In *Medieval Theology and the Natural Body*, edited by Peter Biller and A. J. Minnis, 157–61. York, UK: York Medieval Press, 1997.

Enterline, Lynn. *The Rhetoric of the Body from Ovid to Shakespeare.* Cambridge: Cambridge University Press, 2000.

Evans, Ruth. "Virginities." In *Medieval Women's Writing*, edited by Carolyn Dinshaw and David Wallace, 21–39. Cambridge: Cambridge University Press, 2003.

Fabriczy, Cornelius von. "Andrea del Verrocchio ai servizi dei Medici." *Archivio storico dell'Arte* 1 (1895): 163–76.

Falloppia, Gabriele. *Observationes.* Vol. 2. Modena: STEM Mucchi, 1964.

Fassola, Giovanni Battista. *La nuova Gierusalemme; o, Sia il santo Sepolcro di Varallo, consacrata all'avema regina Maria Anna D'Austria, madre del gran monarca Carlo Secondo NS.* Milan: Federico Agnelli Scultore and Stampatore, 1671.

Fehrenbach, Frank. "Calor nativus / Color vitale: Prolegomena zu einer Ästhetik des 'Lebendigen Bildes' in der frühen Neuzeit." In *Visuelle Topoi: Erfindung und tradiertes Wissen in den Künsten der italienischen Renaissance*, edited by Ulrich Pfisterer and Max Seidel, 151–70. Munich: Deutscher Kunstverlag, 2003.

Feinstein, Wiley. "Bradamante in Love: Some Postfeminist Considerations on Ariosto." *Forum Italicum* 22 (1988): 48–59.

Feo, Michele. "Petrarca, Francesco." In vol. 4 of *Enciclopedia Virgiliana*, 53–78. Rome: Istituto dell'Enciclopedia Italiana, 1988.

Ferguson, Margaret, Maureen Quilligan, and Nancy Vickers, eds. *Rewriting the Renaissance: The Discovery of Sexual Difference in Early Modern Europe.* Chicago: University of Chicago Press, 1986.

Fermor, Sharon. "Movement and Gender in Sixteenth-Century Italian Painting." In

The Body Imagined: The Human Form and Visual Culture since the Renaissance, edited by Kathleen Adler and Marcia Pointon, 129–45. Cambridge: Cambridge University Press, 1993.

Ferraro, Joanne. *Marriage Wars in Renaissance Venice*. Oxford: Oxford University Press, 2001.

Ferro, Marco. *Dizionario del diritto comune e Veneto*. Venice: Andrea Santini, 1842.

Ferroni, Giulio. "Da Bradamante a Ricciardetto: Interferenze testuali e scambi di sesso." In *La parola ritrovata: Fonti e analisi letterarie*, edited by Costanzo Di Girolamo and Ivano Paccagnella, 137–59. Palermo: Sellerio, 1982.

Fichter, Andrew. *Poets Historical: Dynastic Epic in the Renaissance*. New Haven, CT: Yale University Press, 1982.

Ficino, Marsilio. *Commentarium in Timaeum*. In *Opera omnia*. Turin: Bottega d'Erasmo, 1962.

———. *Three Books on Life*. Edited and translated by Carol V. Kaske and John R. Clark. Binghamton, NY: Medieval and Renaissance Texts and Studies / Renaissance Society of America, 1989.

Filippi, Luigi. "Un poema poco noto (*Il Meschino*, altramente detto il Guerrino attribuito a Tullia d'Aragona)." In *Le orme del pensiero*, 227–57. Ferrara: A. Taddei and Figli, 1919.

Finucci, Valeria. *The Lady Vanishes: Subjectivity and Representation in Castiglione and Ariosto*. Stanford, CA: Stanford University Press, 1992.

———. *The Manly Masquerade: Masculinity, Paternity, and Castration in the Italian Renaissance*. Durham, NC: Duke University Press, 2003.

———. "The Masquerade of Masculinity: Astolfo and Jocondo in *Orlando furioso*, canto 28." In *Renaissance Transactions: Ariosto and Tasso*, edited by Valeria Finucci, 215–45. Durham, NC: Duke University Press, 1999.

Firenzuola, Agnolo. *Opere*. Turin: UTET, 1958.

Fisher, Will. "The Renaissance Beard: Masculinity in Early Modern England." *Renaissance Quarterly* 54 (2001): 173.

Fletcher, Angus. *Allegory: The Theory of a Symbolic Mode*. Ithaca, NY: Cornell University Press, 1964.

Folda, Jaroslav. "Jerusalem and the Holy Sepulchre through the Eyes of Crusader Pilgrims." In "The Real and Ideal Jerusalem in Jewish, Christian, and Islamic Art," special issue, *Jewish Art* 23–24 (1997–98): 158–64.

Fonrobert, Charlotte Elishiva. *Menstrual Purity: Rabbinic and Christian Reconstructions of Biblical Gender*. Stanford, CA: Stanford University Press, 2000.

Foresti, Arnaldo. *Anedotti della vita di F. Petrarca*. Edited by Antonia Tissoni Benvenuti. Padova: Antenore, 1977.

Foster, Kurt W. "Metaphors of Rule: Political Ideology and History in the Portraits of Cosimo I de' Medici." *Mitteilungen des Kunsthistorischen Institutes in Florenz* 15 (1971): 65–104.

Foster, Susan Leigh. "Introduction to Moving Bodies." In *Choreographing History*, edited by Susan Leigh Foster, 3–24. Bloomington: Indiana University Press, 1995.

Foucault, Michel. *The History of Sexuality*. Vol. 1. New York: Vintage Books, 1990.

Fradenburg, Louise, and Carla Freccero, eds. *Premodern Sexualities*. London: Routledge, 1996.

Franco, Niccolò. *Il vendemmiatore, poemetto in ottava rima di Luigi Tansillo; e la Priapea, sonetti lussuriosi-satirici di Niccolò Franco.* Paris: J. C. Molini, 1790.

Frasso, Giuseppe. "Tre lettere di Guglielmo da Pastrengo a Francesco Petrarca." In *Petrarca, Verona e l'Europa: Atti del convegno internazione di studi (Verona 19–23 sett. 1991)*, edited by Giuseppe Billanovich and Giuseppe Frasso, 89–115. Padua: Antenore, 1997.

Freccero, Carla. "Ovidian Subjectivities in Early Modern Lyric: Identification and Desire in Petrarch and Louise Labé." In *Ovid and the Renaissance Body*, edited by Goran Stanivukovic, 21–37. Toronto: University of Toronto Press, 2001.

Freccero, John. "The Fig Tree and the Laurel: Petrarch's Poetics." *Diacritics* 5 (1975): 34–40.

Freedberg, David. *The Power of Images: Studies in the History and Theory of Response.* Chicago: University of Chicago Press, 1989.

———. "Verisimilitude and Resemblance: From Sacred Mountain to Waxworks." In *The Power of Images: Studies in the History and Theory of Response*, 192–245. Chicago: University of Chicago Press, 1989.

Freedman, Luba. "Saint Sebastian in Veneto Painting: The 'Signals' Addressed to 'Learned' Spectators." *Venezia Cinquecento* 15 (1998): 5–20.

French, Roger. *Dissection and Vivisection in the European Renaissance.* Aldershot, UK: Ashgate, 1999.

Friedman, John Block. *The Monstrous Races in Medieval Art and Thought.* Cambridge, MA: Harvard University Press, 1981.

Fudge, Erica, Ruth Gilbert, and S. J. Wiseman, eds., *At The Borders of the Human: Beasts, Bodies, and National Philosophy in the Early Modern Period.* London: Macmillan, 1999.

Gabirol, Ibn. *Fons vitae ex arabico in latinum translatus ab Iohanne Hispano et Dominico Gundissalino.* Edited by Clemens Baeumker. Munster: Aschendorff, 1895.

Gaehtgens, Thomas W., ed. *Artistic Exchange: Akten des 28, Internationalen Kongresses für Kunstgeschichte in Berlin, 15–20 Juli 1992.* 3 vols. Berlin: Akademie, 1993.

Galloni, Pietro. *Sacro Monte di Varallo: Atti di fondazione.* Varallo: Camaschella e Zanfa, 1909.

Garrioch, David. "Verbal Insults in Eighteenth-Century Paris." In *The Social History of Language*, edited by Peter Burke and Roy Porter, 104–19. Cambridge: Cambridge University Press, 1987.

Garzoni, Tommaso. *La piazza universale di tutte le professioni del mondo.* 1589. Facs. ed., Ravenna: Essegi, 1989.

Gelli, Giovanni Battista. *Dialoghi.* Edited by Roberto Tissoni. Bari: Laterza, 1967.

Gensini, Sergio, ed. *Gli abitanti immobili di San Vivaldo il monte sacro della Toscana.* Florence: Morgana Giunta Regionale Toscana, 1987.

Gent, Lucy, and Nigel Llewellyn, eds. *Renaissance Bodies: The Human Figure in English Culture, c. 1540–1660.* London: Reaktion Books, 1990.

Gentile, Guido. "1507: Una comitiva di pellegrini francesi al Sepolcro di Varallo." *Novarien Associazione di storia della chiesa novarese* 30 (2001): 241–48.

Georges, P. "'Mourir c'est pourrir un peu . . .': Techniques contre la corruption des cadavres à la fin du Moyen Age." *Micrologus* 7 (1999): 359–82.

Ghiberti, Lorenzo, ed. *Commentario.* Florence: Giunti, 1998.

Giamatti, A. Bartlett. "Headlong Horses, Headless Horsemen: An Essay in the Chivalric

Romances of Pulci, Boiardo, and Ariosto." In *Italian Literature: Roots and Branches*, edited by Kenneth Atchity and Giose Rimanelli, 215–45. New Haven, CT: Yale University Press, 1976.

Gianfranceschi, Ida, and Elena Lucchesi Ragni. "Tullia von Aragon." In *Vittoria Colonna: Dichterin und Muse Michelangelos*, edited by Sylvia Ferino Pagden, 209–12. Vienna: Skira, 1997.

Gilbert, Creighton. *Italian Art: 1400–1500: Sources and Documents*. Engelwood Cliffs, NJ: Prentice Hall, 1980.

Giorgi, Piero P., and Gian Franco Pasini. Introduction, biographical notes, and bibliography. In *Anothomia di Mondino de' Liuzzi da Bologna, XIV secolo*, edited by Piero P. Giorgi and Gian Franco Pasini, 1–87. Bologna: Istituto per la Storia dell'Università di Bologna, 1992.

Giorgi, Rosa. *Santi*. Milan: Electa, 2002.

Giovio, Paolo. "Fragmentum trium dialogorum." In vol. 1 of *Scritti d'arte del cinquecento*, edited and translated by Paola Barocchi, 19–20. Milan: Ricciardi, 1971.

Giraldi Cinzio, Giovan Battista. *Gli Ecatommiti ovvero cento novelle*. Florence: Borghi, 1834.

Glaap, Oliver. *Untersuchungen zu Giannozzo Manetti, "De dignitate et excellentia hominis": Ein Renaissance-Humanist und sein Menschenbild*. Stuttgart: Teubner, 1994.

Gnudi, Martha Teach, and Jerome Pierce Webster. *The Life and Times of Gaspare Tagliacozzi, Surgeon of Bologna, 1545–1599*. New York: Herbert Reichner, 1950.

Godi, Carlo. "La *Collatio laureationis* del Petrarca nelle due redazioni." *Studi petrarcheschi* 5 (1988): 1–58.

Gombrich, Ernst. "*Icones Symbolicae*: The Visual Image in Neo-Platonic Thought." *Journal of the Warburg and Courtauld Institutes* 11 (1948): 163–92.

Götz-Mohr, Britta von. "Laura Laurana: Francesco Lauranas Wiener Porträtbüste und die Frage der wahren Existenz von Petrarcas Laura im Quattrocento." *Städel-Jahrbuch*, n.s., 14 (1993): 147–72.

Gough, Melinda. "'Her Filthy Feature Open Showne' in Ariosto, Spenser, and *Much Ado about Nothing*." *SEL: Studies in English Literature, 1500–1900* 39 (1999): 41–67.

Gowing, Laura. *Common Bodies: Women, Touch and Power in Seventeenth-Century England*. New Haven, CT: Yale University Press, 2003.

———. *Domestic Dangers: Women, Words, and Sex in Early Modern London*. Oxford: Oxford University Press, 1996.

Grecchi, Giambatista. *Le formalità del processo criminale nel dominio Veneto*. Padua: Tommaso Bettinelli, 1790.

Greenblatt, Stephen. *Shakespearean Negotiations: The Circulation of Social Energy in Renaissance England*. Berkeley: University of California Press, 1988.

Greene, Thomas. *The Light in Troy: Imitation and Discovery in Renaissance Poetry*. New Haven, CT: Yale University Pres, 1982.

Gryson, Roger, Bonifatio Fischer, Jean Gribomont, et. al., eds. *Biblia sacra iuxta vulgatam versionem*. Darmstadt: Deutsche Bibelgesellschaft, 1994.

Guazzo, Stefano. *La civil conversazione*. Edited by Amedeo Quondam. Modena: Panini, 1993.

Guicciardini, Francesco. *History of Italy*. Translated by Sidney Alexander. Princeton, NJ: Princeton University Press, 1969.

Guicciardini, Lodovico. *L'ore di ricreazione*. Edited by Anne-Marie van Passen. Rome: Bulzoni, 1990.

Gullace, Giovanni. "The French Writings of Gabriele D'Annunzio." *Comparative Literature* 12 (1960): 207–28.

Günsberg, Maggie. "'Donna liberata?' The Portrayal of Women in the Italian Renaissance Epic." *The Italianist* 7 (1987): 7–35.

Hairston, Julia. "Bradamante, 'vergine saggia': Maternity and the Art of Negotiation." *Exemplaria* 12 (2000): 455–86.

———. "Out of the Archive: Four Newly-Identified Figures in Tullia d'Aragona's *Rime della signora Tullia di Aragona et di diversi a lei* (1547)." *MLN* 118 (2003): 257–63.

Hanegraaff, Wouter J. "Sympathy or the Devil: Renaissance Magic and the Ambivalence of Idols." *Esoterica* 2 (2000): 1–44.

Hatfield, Rab. "The Compagnia de'Magi." *Journal of the Warburg and Courtauld Institutes* 33 (1970): 107–61.

Hebreo, León. *The Philosophy of Love*. Translated by F. Friedberg-Seeley and Jean H. Barnes. London: Soncino Press, 1937.

Hegel, G. W. F. *Aesthetics: Lectures on Fine Art*. Translated by T. M. Knox. Oxford: Clarendon Press, 1975.

Heitmann, Klaus. *Fortuna und Virtus: Eine Studie zu Petrarcas Lebensweisheit*. Cologne: Böhlau, 1958.

Henry, Tom, and Laurence B. Kanter. *The Complete Paintings of Luca Signorelli*. London: Thames and Hudson, 2001.

Hentschel, Beate. "Zur Genese einer optimistischen Anthropologie in der Renaissance oder die Wiederentdeckung des menschlichen Körpers." In *Gepeinigt, begehrt, vergessen: Symbolik und Sozialbezug des Körpers im späten Mittelalter und der Frühen Neuzeit*, edited by Klaus Schreiner and Norbert Schnitzler, 85–105. Munich: Fink, 1992.

Heydenreich, Ludwig H. "Die Cappella Rucellai von San Pancrazio in Florenz." In *De artibus opuscula 40: Essays in Honor of Erwin Panofsky*, edited by Millard Meiss, 219–29. New York: New York University Press, 1961.

Hillman, David, and Carla Mazzio. Introduction. In *The Body in Parts: Fantasies of Corporeality in Early Modern Europe*, xi–xxix. New York: Routledge, 1997.

———, eds. *The Body in Parts: Fantasies of Corporeality in Early Modern Europe*. New York: Routledge, 1997.

Hind, Arthur M. *Early Italian Engraving: A Critical Catalogue with Complete Reproduction of All the Prints Described*. 7 vols. London: M. Knoedler, 1938–48.

Hinz, Berthold. "Statuenliebe: Antiker Skandal und mittelalterliches Trauma." *Marburger Jahrbuch für Kunstwissenschaft* 22 (1989): 135–42.

Holladay, Joan A. "Relics, Reliquaries, and Religious Women: Visualizing the Holy Virgins of Cologne." *Studies in Iconography* 18 (1997): 67–118.

Hollander, Anne. *Seeing through Clothes*. New York: Viking Press, 1980.

Holmes, Megan. "Disrobing the Virgin: The *Madonna lactans* in Fifteenth-Century Florentine Art." In *Picturing Women in Renaissance and Baroque Italy*, edited by Geraldine A. Johnson and Sara F. Matthews Grieco, 167–95. Cambridge: Cambridge University Press, 1997.

Holmes, Olivia. *Assembling the Lyric Self: Authorship from Troubadour Song to Italian Song Book*. Minneapolis: University of Minnesota Press, 2000.

Homer. *The Iliad.* Translated by Robert Fagles. New York: Viking Penguin, 1990.

Hood, William. "The Sacro Monte of Varallo: Renaissance Art and Popular Religion." In *Monasticism and the Arts*, edited by Timothy G. Verdon and John Dally, 291–311. Syracuse, NY: Syracuse University Press, 1984.

Hopkins, Andrew. *Santa Maria della Salute.* Cambridge: Cambridge University Press, 2000.

Horodowich, Elizabeth. "Civic Identity and the Control of Blasphemy in Sixteenth-Century Venice." *Past and Present* 181 (2003): 3–33.

Horowitz, Elliott. "The New World and the Changing Face of Europe." *Sixteenth Century Journal* 28 (1997): 1181–1201.

Howard, Deborah. *Jacopo Sansovino: Architecture and Patronage in Renaissance Venice.* New Haven, CT: Yale University Press, 1975.

Huberman, Georges Didi. "The Portrait, the Individual and the Singular: Remarks on the Legacy of Aby Warburg." In *The Image of the Individual: Portraits in the Renaissance*, edited by Nicolas Mann and Luke Syson, 155–88. London: British Museum Press, 1998.

Humfrey, Peter. *Lorenzo Lotto.* New Haven, CT: Yale University Press, 1997.

Hüttel, Richard, Barbara Hüttel, and Jeanette Kohl, eds. *Re-Visionen: Zur Aktualität von Kunstgeschichte.* Berlin: Akademie, 2002.

Iacopone da Todi. *Laude.* Edited by Franco Mancini. Rome: Laterza, 1980.

Ingrassia, Catherine. *Danseurs, acrobates et saltimbanques dans l'art du Moyen Age: Recherches sur les representations ludiques, choreographiques at acrobatiques dans l'iconographie medievale.* Paris: Seuil, 1984.

Irigaray, Luce. *Speculum de l'autre femme.* Paris: Minuit, 1974.

Isidore of Seville. *Etymologiae.* Edited by Wallace Martin Lindsay. Oxford: Clarendon Press, 1911.

———. *The Etymologies of Isidore of Seville.* Translated by Stephen A. Barney et al. Cambridge: Cambridge University Press, 2006.

———. *Sententiae.* In *Isidorus*, vol. 6 of *Opera omnia.* Edited by Jacques-Paul Migne. Paris: Migne, 1850.

Iyengar, Sujata. "'Handling Soft the Hurts': Sexual Healing and Manual Contact in *Orlando furioso, The Faerie Queene*, and *All's Well That Ends Well*." In *Sensible Flesh: On Touch in Early Modern Culture*, edited by Elizabeth D. Harvey, 39–61. Philadelphia: University of Pennsylvania Press, 2003.

Jameson, Anna. *Sacred and Legendary Art.* London: Longmans, Green, 1866.

Jestaz, Bernard. "François I, Salaì et les tableaux de Léonard." *Revue de l'art* 126 (1999): 68–72.

Joannides, Paul. "Titian's Judith and Its Context: The Iconography of Decapitation." *Apollo* 135.361 (1992): 163–70.

Johnson, Geraldine, and Sara F. Matthews Grieco, eds. *Picturing Women in Renaissance and Baroque Italy.* Cambridge: Cambridge University Press, 1997.

Johnson-Haddad, Miranda. "'Like the Moon It Renews Itself': The Female Body as Text in Dante, Ariosto, and Tasso." *Stanford Italian Review* 11 (1992): 203–15.

Jones, Ann Rosalind. "Bad Press: Modern Editors versus Early Modern Women Poets (Tullia d'Aragona, Gaspara Stampa, Veronica Franco)." In *Strong Voices, Weak History: Early Women Writers and Canons in England, France, and Italy*, edited by

Pamela Joseph Benson and Victoria Kirkham, 287–313. Ann Arbor: University of Michigan Press, 2004.

———. *The Currency of Eros: Women's Love Lyric in Europe, 1540–1620.* Bloomington: Indiana University Press, 1990.

Jones, Malcolm. "The Secular Badges." In *Heilig en profaan: 1000 Laatmiddeleeuwse insignes uit de collectie H. J. E. van Beuningen,* edited by A. M. Koldweij and H. J. E. van Beuningen, 99–109. Cothen: Stichting Middeleeuwse Religieuse en Profane Insignes, 1993.

———. "Sex and Sexuality in Late Medieval and Early Modern Art." In *Privatisierung der Triebe? Sexualität in der Frühen Neuzeit,* edited by Daniela Erlach, Markus Reisenleitner, and Karl Vocelka, 187–304. Frankfurt am Main: Peter Lang, 1994.

Jordan, Constance. *Renaissance Feminism: Literary Texts and Political Models.* Ithaca, NY: Cornell University Press, 1990.

———. "Writing beyond the *Querelle*: Gender and History in *Orlando furioso.*" In *Renaissance Transactions: Ariosto and Tasso,* edited by Valeria Finucci, 295–314. Durham, NC: Duke University Press, 1999.

Josephus, Flavius. *Selections from Josephus.* Translated by Henry St. John Thackeray. New York: Macmillan, 1919.

Jouanna, Arlette. *Ordre social: Mythes et hiérachies dans la France du XVIe siècle.* Paris: Hachette, 1977.

Junius, Franciscus. *A Lexicon of Artists and Their Works.* Edited and translated by Keith Aldrich, Philipp Fehl, and Raina Fehl. Berkeley: University of California Press, 1991.

Kablitz, Andreas. "Pygmalion in Petrarcas Canzoniere: Zur Geburt ästhetischer Illusion aus dem Ungeist des Begehrens." In *Pygmalion: Die Geschichte des Mythos in der abendländischen Kultur,* edited by Matthias Meyer and Gerhard Neumann, 197–224. Freiburg im Breisgau: Rombach, 1997.

Kamensky, Jane. *Governing the Tongue: The Politics of Speech in Early New England.* New York: Oxford University Press, 1997.

Kaye, Richard A. "'A Splendid Readiness for Death': T. S. Eliot, the Homosexual Cult of St. Sebastian, and World War I." *Modernism/Modernity* 6 (1999): 107–34.

Keck, David. *Angels and Angelology in the Middle Ages.* New York: Oxford University Press, 1998.

Kieckhefer, Richard. *Forbidden Rites: A Necromancer's Manual of the Fifteenth Century.* University Park: Pennsylvania State University Press, 1998.

———. *Magic in the Middle Ages.* Cambridge: Cambridge University Press, 1989.

Kirkham, Victoria. "Laura Battiferra degli Ammannati's First Book of Poetry: A Renaissance Holograph Comes Out of Hiding." *Rinascimento* 36 (1996): 351–91.

———. "Poetic Ideals of Love and Beauty." In *Virtue and Beauty: Leonardo's Ginevra de' Benci and Renaissance Portraits of Women,* 50–61. Princeton, NJ: Princeton University Press, 2001.

Kittay, Eva Feder. "Rereading Freud on 'Femininity' or Why Not Womb Envy?" In *Hypatia Reborn: Essays in Feminist Philosophy,* edited by Azizah Y. Al-Hibri and Margaret A. Simons, 192–203. Bloomington: Indiana University Press, 1990.

———. "Womb Envy: An Explanatory Concept." In *Mothering: Essays in Feminist Theory,* edited by Joyce Trebilcot, 94–128. Totowa, NJ: Rowman and Allanheld, 1993.

Klapisch-Zuber, Christiane. "Holy Dolls: Play and Piety in Florence in the Quattro-

cento." In *Looking at Italian Renaissance Sculpture*, edited by Sarah Blake McHam, 111–27. New York: Cambridge University Press, 1998.

Klebanoff, Randi. "Passion, Compassion, and the Sorrows of Women: Niccolò dell'Arca's Lamentation over the Dead Christ for the Bolognese Confraternity of Santa Maria della Vita." In *Confraternities and the Visual Arts in Renaissance Italy: Ritual, Spectacle, Image*, edited by Barbara Wisch and Diane Cole Ahl, 146–72. New York: Cambridge University Press, 2000.

Klein, Robert. "L' imagination comme vêtement de l'âme chez Marsile Ficin et Giordano Bruno." *Revue de Métaphysique et Morale* 1 (1956): 18–39.

Kodera, Sergius. *Filone und Sofia in Leone Ebreos "Dialoghi d'amore."* Frankfurt: Peter Lang, 1995.

———. "Masculine / Feminine: The Concept of Matter in Leone Ebreo's *Dialoghi d'amore*" *Zeitsprünge* 7 (2004): 481–517.

Kohl, Jeanette. "Splendid Isolation: Verrocchios Mädchenbüsten—eine Betrachtung." In *Re-Visionen: Zur Aktualität von Kunstgeschichte*, edited by Richard Hüttel, Barbara Hüttel, and Jeanette Kohl, 49–75. Berlin: Akademie, 2002.

Koldeweij, A. M. "A Barefaced *Roman de la Rose* (Paris, B.N. ms. Fr. 25526) and Some Late Medieval Mass-Produced Badges of a Sexual Nature." In *Flanders in a European Perspective: Manuscript Illumination around 1400 in Flanders and Abroad; Proceedings of the International Colloquium, Leuven, 7–10 September 1993*, edited by Maurits Smeyers and Bert Cardon, 499–516. Leuven: Uitgeverij Peeters, 1995.

Kopperschmidt, Josef. "Zwischen Affirmation und Subversion: Einleitende Bemerkungen zur Theorie und Rhetorik des Festes." In *Fest und Festrhetorik: Zu Theorie, Geschichte und Praxis der Epideiktik*, edited by Josef Kopperschmidt and Helmut Schanze, 9–21. Munich: Fink, 1999.

Kramer, Heinrich, and Jacob Sprenger. *The Malleus maleficarum of Heinrich Kramer and James* [sic] *Sprenger*. Translated by Montague Summers. 1928. Rpt., New York: Dover Publications, 1971.

———. *Malleus maleficarum*. Translated by Christopher S. Mackay. 2 vols. Cambridge: Cambridge University Press, 2006.

Krautheimer, Richard. *Studies in Early Christian, Medieval, and Renaissance Art*. New York: New York University Press, 1969.

Kruft, Hanno-Walter. *Francesco Laurana: Ein Bildhauer der Frührenaissance*. Munich: Beck, 1995.

Küchenhoff, Joachim. "Das Fest und die Grenzen des Ich." In *Das Fest*, edited by Walter Haug and Rainer Warning, 99–119. Munich: Fink, 1989.

Lacan, Jacques. "The Meaning of the Phallus." In *Feminine Sexuality: Jacques Lacan and the "Ècole Freudienne,"* edited by Juliet Mitchell and Jacqueline Rose, 74–85. New York: Norton, 1982.

Lactantius. *Divinae Institutiones*. Edited by Samuel Brandt. In vol. 1 of *Celii Lactantii Firmiani opera omnia*. Vienna: Tempsky, 1890.

———. *Divine Institutes*. In Vol. 2 of *The Works of Lactantius*, translated by William Fletcher. Edinburgh: T. and T. Clark 1871.

Landucci, Luca. *A Florentine Diary from 1450–1516*. Translated by Alice de Rosen Jervis. New York: Dutton, 1927.

Lane, Frederic C. *Venice: A Maritime Republic*. Baltimore, MD: Johns Hopkins University Press, 1973.

Langedijk, Karla. *The Portraits of the Medici.* 3 vols. Florence: Studio per Edizioni Scelte, 1981.

Lansing, Richard. "Ariosto's *Orlando furioso* and the Homeric Model." *Comparative Literature* 24 (1987): 311–25.

Laplanche, J., and J.-B. Pontalis, eds. *The Language of Psycho-Analysis.* New York: Norton, 1973.

Laqueur, Thomas. *Making Sex: Body and Gender from the Greeks to Freud.* Cambridge, MA: Harvard University Press, 1990.

Laurent, M. H. "La plus ancienne légende de la B. Marguerite de Città di Castello." *Archivum fratrum predicatorum* 10 (1940): 127.

Lavin, Irving. "On the Sources and Meaning of the Renaissance Portrait Bust." *The Art Quarterly* 33.3 (1970): 207–26.

Lazzi, Giovanna, and Paolo Viti, eds. *Immaginare l'autore: Il ritratto del letterato nella cultura umanistica, convegno di studi, Firenze, 26–27 marzo 1998.* Florence: Polistampa, 2000.

Lechi, Fausto, ed. *I quadri delle collezioni Lechi in Brescia: Storia e documenti.* Florence: Olschki, 1968.

Lees, Clare, ed. *Medieval Masculinities: Regarding Men in the Middle Ages.* Minneapolis: University of Minnesota Press, 1994.

Le Goff, Jacques. *The Birth of Purgatory.* Translated by Arthur Goldhammer. Chicago: University of Chicago Press, 1984.

Leonardi, Claudio. "Chiara e Berengario: L'agiografia sulla santa di Montefalco." In *Chiara da Montefalco e il suo tempo,* edited by Claudio Leonardi and Enrico Menestò, 369–86. Florence: La Nuova Italia, 1985.

Leonardo da Vinci. *Il Codice Atlantico della Biblioteca Ambrosiana di Milano.* 2 vols. Edited by Augusto Marinoni. Florence: Giunti, 2000.

———. *The Notebooks of Leonardo da Vinci.* 2 vols. Edited and translated by Edward MacCurdy. New York: George Braziller, 1958.

Lesnick, Daniel R. "Insults and Threats in Medieval Todi." *Journal of Medieval History* 17 (1991): 71–89.

———. *Preaching in Medieval Florence.* Ithaca, NY: Cornell University Press, 1978.

Levenson, Konrad Oberhuber, and Jacquelyn L. Sheehan. *Early Italian Engravings from the National Gallery of Art.* Washington, DC: National Gallery of Art, 1973.

Levi, Ezio. "L'*Orlando furioso* come epopea nuziale." *Archivum romanicum* 17 (1933): 459–93.

Little, Lester K. *Religious Poverty and the Profit Economy in Medieval Europe.* Ithaca, NY: Cornell University Press, 1978.

Lombard, Peter. *Sententiae in quattuor libris distinctae.* 3rd ed. 2 vols. Edited by Ignatius C. Brady. Grottaferrata: Collegii S. Bonaventurae ad Claras Aquas, 1971–81.

Lombardo, A., ed. *Le Deliberazione del Consiglio dei XL della Repubblica di Venezia.* 3 vols. Venice: Deputazione di storia patria per le Venezie, 1957–67.

Longo, Pier Giorgio. "Bernardino Caimi francescano osservante: Tra 'eremitorio' e città." *Novarien Associazione di storia della chiesa novarese* 29 (2000): 9–26.

———. "Pietà e cultura dell'Osservanza francescana a Varallo Sesia." *Novarien Associazione di storia della chiesa novarese* 26 (1996): 169–207.

———. "Il Sacro Monte di Varallo nella seconda metà del XVI secolo." In *I Sacri Monte*

di Varallo e Arona dal Borromeo al Bascapè, 41–140. Novara: Associazione di Storia della Chiesa Novarese, 1995.

———. "Una visita del vescovo Carlo Bascapè al Sacro Monte di Varallo (27 settembre–1 ottobre 1604)." *De Valle Sicida: Periodico annuale Societa Valsesiana di Cultura* 9.1 (1998): 163–80.

Lorenzo il Magnifico. *Tutte le Opere.* 2 vols. Edited by Paolo Orvieto. Rome: Salerno, 1992.

Lovejoy, Arthur O. *The Great Chain of Being: A Study of the History of an Idea.* Cambridge, MA: Harvard University Press, 1964.

Luzio, Alessandro. "Un'avventura di Tullia d'Aragona." *Rivista storica mantovana* 1.1–2 (1885): 179–82.

Luzzato, Gino. *Storia economica di Venezia dall xi al xvi secolo.* Venice: Centro Internazionale delle Arti e del Costume, 1961.

Lydecker, Kent. "The Domestic Setting of the Arts in Renaissance Florence." PhD diss., Johns Hopkins University, 1987.

Maclean, Ian. *Logic, Signs and Nature in the Renaissance: The Case of Learned Medicine.* Cambridge: Cambridge University Press, 2002.

Macrobius. *Commentarii in "Somnium Scipionis."* Edited by Jacobus Willis. Leipzig: Teubner, 1970.

———. *Commentary on the "Dream of Scipio."* Translated by William Harris Stahl. New York: Columbia University Press: 1966.

Mahoney, Edward P. "Metaphysical Foundations of the Hierarchy of Being According to Some Late-Medieval and Renaissance Philosophers." In *Philosophies of Existence Ancient and Medieval*, edited by Parviz Morewedge, 165–257. New York: Fordham University Press, 1982.

Maimonides, Moses. *The Guide of the Perplexed.* Translated by Shlomo Pines. Chicago: University of Chicago Press, 1963.

Malipiero, Girolamo. *Il Petrarcha spirituale.* Venice: Francesco Marcolini da Forlì, 1536.

Maltese, Enrico V. "Il diavolo a Bisanzio: Demonologia dotta e tradizioni popolari." In vol. 1 of *L'autunno del diavolo: "Diabolos, Dialogos, Daimon," convegno di Torino, 17–21 ottobre 1988*, edited by Eugenio Corsini and Eugenio Costa, 317–33. Milan: Bompiani, 1990.

———. "'Natura daemonum . . . habet corpus et versatur circa corpora': Una lezione di demonologia dal Medioevo greco." In *Il demonio e i suoi complici: Dottrine e credenze demonologiche nella tarda antichità*, edited by Salvatore Pricoco, 265–84. Messina: Rubbettino, 1995.

Maltese, Enrico V., and Mariarosa Cortesi. "Per la fortuna della demonologia pselliana in ambiente umanistico." In *Dotti bizantini e libri greci nell'Italia del secolo XV: Atti del convegno internazionale, Trento, 22–23 ottobre 1990*, edited by Mariarosa Cortesi and Enrico V. Maltese, 129–50. Naples: D'Auria, 1992.

Manetti, Giannozzo. *De dignitate et excellentia hominis.* Hamburg: Meiner, 1990.

Mann, Nicolas, and Luke Syson. *The Image of the Individual: Portraits in the Renaissance.* London: British Museum Press, 1998.

Marcozzi, Luca. "Le ali dell'intelletto nei *Rerum vulgarium fragmenta*." *Critica del testo* 6.1 (2003): 559–89.

Marek, Michaela. "'Virtus' und 'fama': Zur Stilproblematik der Porträtbüsten." In *Piero de'Medici "il Gottoso" (1416–69)*, edited by Andreas Beyer and Bruce Boucher, 342–68. Berlin: Akademie, 1993.

Marshall, Louise. "Manipulating the Sacred: Image and Plague in Renaissance Italy." *Renaissance Quarterly* 47 (1994): 489–90.

———. "Reading the Body of a Plague Saint: Narrative Altarpieces and Devotional Images of St. Sebastian in Renaissance Art." In *Reading Texts and Images: Essays on Medieval and Renaissance Art and Patronage in Honor of Margaret M. Manion*, edited by Bernard J. Muir, 238–72. Exeter, UK: University of Exeter Press, 2002.

Martin, John. *Venice's Hidden Enemies: Italian Heretics in a Renaissance City*. Berkeley: University of California Press, 1993.

Martinez, Ronald L. "Mourning Laura in the *Canzoniere*: Lessons from Lamentations." *MLN* 118 (2003): 1–45.

———. "The Pharmacy of Machiavellli: Roman Lucretiain *Mandragola*." *Renaissance Drama* 14 (1983): 1–43.

———. "Ricciardetto's Sex and the Castration of Orlando: Anatomy of an Episode from the *Orlando furioso*." Unpublished manuscript.

Martinotti, G. "L'insegnamento dell'anatomia in Bologna prima del secolo XIX." *Studi e memorie per la storia dell'università di Bologna* 2 (1911): 25–32.

Masson, Georgina. "Tullia d'Aragona, the Intellectual Courtesan." In *Courtesans of the Italian Renaissance*, 88–131. New York: St. Martin's Press, 1976.

Mauss, Marcel. *Sociologie et anthropologie*. Paris: Quadrige / PUF, 1997.

Mazzi, Maria Serena. *Prostitute e lenoni nella Firenze del Quattrocento*. Milano: Mondatori, 1991.

Mazzotta, Giuseppe. "The Canzoniere and the Language of the Self." *Studies in Philology* 75 (1978): 271–96.

———. *The Worlds of Petrarch*, 58–79. Durham, NC: Duke University Press, 1993.

McClelland, John. "Leibesübungen in der Renaissance und die Freien Künste." In *Die Anfänge des modernen Sports in der Renaissance*, edited by Arnd Krüger and John McClelland, 85–110. London: Arena, 1984.

McLean, Ian. The *Renaissance Notion of Woman*. Cambridge: Cambridge University Press, 1980.

McLucas, John. "Amazon, Sorceress, and Queen: Women and War in the Aristocratic Literature of Sixteenth-Century Italy." *The Italianist* 8 (1988): 33–55.

———. "Ariosto and the Androgyne: Symmetries of Sex in the *Orlando furioso*." PhD diss., Yale University, 1983.

McMurrich, J. Playfair. *Leonardo da Vinci the Anatomist*. Baltimore, MD: Williams and Wilkins, 1930.

Menestò, Enrico. "The Apostolic Canonization Proceedings of Clare of Montefalco, 1318–1319." In *Women and Religion in Medieval and Renaissance Italy*, edited by Daniel Bornstein and Roberto Rusconi, translated by Margery J. Schneider, 104–29. Chicago: University of Chicago Press, 1996.

———. "La 'legenda' della beata Colomba e il suo biografo." In *Una santa, una città*, edited by Enrico Menestò and Giovanna Casagrande, 161–76. Spoleto: Centro Italiano di Studi sull'Alto Medioevo, 1991.

———. "La 'legenda' di Margherita da Città di Castello." In *Il movimento religioso fem-*

minile in Umbria nei secoli XIII–XIV, edited by Roberto Rusconi, 217–37. Florence: La Nuova Italia, 1984.

Menestò, Enrico, and Giovanna Casagrande, eds. *Una santa, una città*. Spoleto: Centro Italiano di Studi sull'Alto Medioevo, 1991.

Menestò, Enrico, and Silvestro Nessi, eds. *Il processo di canonizzazione di Chiara da Montefalco*. Florence: La Nuova Italia, 1984.

Menestò, Enrico, and Roberto Rusconi. *Umbria sacra e civile*. Turin: Nuova Eri Edizioni Rai, 1989.

Mercuriali, Girolamo. *L'arte ginnastica: Libri sei tradotti nel 1856 da G. Rinaldi da Forlì*. Turin: Minerva Medica, 2000.

Merkel, Kerstin. *Salome: Ikonographie im Wandel*. New York: Peter Lang, 1990.

Meyer, Matthias, and Gerhard Neumann, eds. *Pygmalion: Die Geschichte des Mythos in der abendländischen Kultur*. Freiburg im Breisgau: Rombach 1997.

Michiel, Alvise. "Memorie pubbliche della repubblica di Venezia." In *Venice: A Documentary History, 1450–1630*, edited by David Chambers and Brian Pullan, 84. London: Blackwell, 1992.

Migiel, Marilyn. "Olimpia's Secret Weapon: Gender, War, and Hermeneutics in Ariosto's *Orlando furioso*." *Critical Matrix* 9 (1995): 21–44.

Migiel, Marilyn, and Juliana Schiesari, eds. *Refiguring Woman: Perspectives on Gender and the Italian Renaissance*. Ithaca, NY: Cornell University Press, 1991.

Milani, Marisa, ed. *Antiche pratiche di medicina popolare nei processi del S. Uffizio: Venezia, 1591*. Padua: Centrostampa Palazzo Maldura, 1986.

Miles, Margaret R. "The Virgin's One Bare Breast." In *The Expanding Discourse: Feminism and Art History*, edited by Norma Broude and Mary Garrard, 27–37. Boulder, CO: Westview Press, 1992.

Mills, Léonard R. "Une vie inédite de saint Sébastien." *Bibliothèque d'Humanisme et Renaissance* 28 (1966): 410–18.

Minio-Paluello, Lorenzo. "Il *Fedone* latino con note autografe del Petrarca." *Rendiconti della Classe di Scienze morali, storiche e filologiche, Accademia nazionale dei Lincei* 8.4 (1948): 107–13.

Mirollo, James V. *Mannerism and Renaissance Poetry: Concept, Mode, Inner Design*. New Haven, CT: Yale University Press, 1984.

Mommsen, Theodore E., ed. and trans. *Petrarch's Testament*. Ithaca, NY: Cornell University Press, 1957.

Montale, Eugenio. *L'opera in versi*. Edited by Rosanna Bettarini and Gianfranco Contini. Turin: Einaudi, 1980.

Moogk, Peter N. "'Thieving Buggers' and 'Stupid Sluts': Insults and Popular Culture in New France." *William and Mary Quarterly* 36 (1979): 524–47.

Morris, William, ed. *The American Heritage Dictionary of the English Language*. Boston: American Heritage Co. and Houghton Mifflin, 1969.

Mostra di opere d'arte restaurate nelle province di Siena e Grosset, Ministero per i Beni Culturali e Ambientali, Soprintendenza per i Beni Artistici e Storici delle Province di Siena e Grosseto. Genova: Sagep, 1983.

Moxey, Keith P. F. "Master E. S. and the Folly of Love." *Simiolus* 11 (1980): 125–48.

Muir, Edward. *Civic Ritual in Renaissance Venice*. Princeton, NJ: Princeton University Press, 1981.

―――. "The Sources of Civil Society in Italy." *Journal of Interdisciplinary History* 29 (1999): 386.

Muir, Edward, and Guido Ruggiero. *Sex and Gender in Historical Perspective: Selections from "Quaderni Storici."* Baltimore, MD: Johns Hopkins University Press, 1990.

Musa, Mark, with Barbara Manfredi. Introduction. In Francesco Petrarch, *Canzoniere*, xi–xxxvi. Bloomington: Indiana University Press, 1996.

Muzio, Girolamo. *Lettere.* Edited by Anna Maria Negri. Alessandria: dell'Orso, 2000.

―――. *Rime diverse del Mutio Iustinopolitano.* Venice: Gabriele Giolito, 1551.

Nannini, Sandro. *L'anima e il corpo: Un'introduzione storica alla filosofia della mente.* Rome: Laterza, 2002.

Neiretti, Marco, et al. *La Passione di Sordevolo: Storia-Arte-Testimonianze.* Sordevolo: Associazione di Volontariato, 2000.

Nelson, John Charles. *Renaissance Theory of Love.* New York: Columbia University Press, 1958.

Nessi, Silvestro, ed. *Chiara da Montefalco, badessa del monastero di S. Croce: Le sue testimonianze i suoi "dicti."* Montefalco: Associazione dei Quartieri di Montefalco, 1981.

Newbigin, Nerida. "The Rappresentazioni of Mysteries and Miracles in Fifteenth-Century Florence." In *Christianity and the Renaissance: Image and Religious Imagination in the Quattrocento*, edited by Timothy Verdon and John Henderson, 361–75. Syracuse, NY: Syracuse University Press, 1990.

The New English Bible with the Apocrypha. 2nd ed. London: Oxford University Press, 1970.

Niccoli, Ottavia. "'Menstruum quasi monstruum': Monstrous Births and Menstrual Taboo in the Sixteenth Century." In *Sex and Gender in Historical Perspective: Selections from Quaderni Storici*, edited by Edward Muir and Guido Ruggiero, 1–25. Baltimore, MD: Johns Hopkins University Press, 1990.

Nine, Miedema. "Following in the Footsteps of Christ: Pilgrimage and Passion Devotion." In *The Broken Body: Passion Devotion in Late-Medieval Culture*, edited by A. A. MacDonald, H. N. B. Ridderbos, and R. M. Schlusemann, 73–92. Groningen: Egbert Forsten, 1998.

Noferi, Adelia. *Il gioco delle tracce.* Florence: La Nuova Italia, 1979.

Nova, Alessandro. "'Popular' Art in Renaissance Italy: Early Response to the Holy Mountain at Varallo." In *Reframing the Renaissance: Visual Culture in Europe and Latin America, 1450–1650*, edited by Claire Farago, 113–26. New Haven, CT: Yale University Press, 1995.

Nova Vulgata Bibliorum sacrorum editio, editio typica altera. Vatican City: Libreria Editrice Vaticana, 1998.

Nutton, Vivian, and Christine Nutton. "The Archer of Meudon: A Curious Absence of Continuity in the History of Medicine." *Journal of the History of Medicine and Allied Sciences* 58 (2003): 404–5.

O'Brien, Denis. "Plotinus on Matter and Evil." In *The Cambridge Companion to Plotinus*, 171–95. Cambridge: Cambridge University Press, 1996.

O'Malley, Charles D., and J. B. de C. M. Saunders. *Leonardo da Vinci on the Human Body: The Anatomical, Physiological and Embryological Drawings.* New York: Henry Schuman, 1952.

Ong, Walter. "Orality, Literacy, and Medieval Textualization." *New Literary History* 26 (1984): 1–12.

Orelli, Giorgio. *Il suono dei sospiri: Sul Petrarca volgare*. Turin: Einaudi, 1990.

Orsenigo, Cesare. *Life of St. Charles Borromeo*. London: B. Herder, 1943.

Orsi Landini, Roberta, and Mary Westerman Bulgarella. "Costume in Fifteenth-Century Florentine Portraits of Women." In *Virtue and Beauty: Leonardo's Ginevra de' Benci and Renaissance Portraits of Women*, 89–97. Princeton, NJ: Princeton University Press, 2001.

Os, Henk van. *The Way to Heaven: Relic Veneration in the Middle Ages*. With contributions by Karel R. van Kooij and Casper Staal. Baarn: de Prom, 2000.

Ousterhout, Robert. "Architecture as Relic and the Construction of Sanctity: The Stones of the Holy Sepulchre." *Journal of the Society of Architectural Historians* 62.1 (2003): 4–23.

———. "The Church of Santo Stefano: A 'Jerusalem' in Bologna." *Gesta* 20.2 (1981): 311–22.

Ovid. *Metamorphoses*. Translated by Rolfe Humphries. Bloomington: Indiana University Press, 1983.

———. *Metamorphoses*. Translated by A. D. Melville. Oxford: Oxford University Press, 1986.

Pacca, Vinicio. *Petrarca*. Bari: Laterza, 1998.

Pacciani, Riccardo. *La "Gerusalemme" di San Vivaldo in Valdelsa*. Montaione: Titivillus, n.d.

Panofsky, Erwin. *Problems in Titian, Mostly Iconographical*. London: Phaidon, 1969.

———. *Studies in Iconology: Humanistic Themes in the Art of the Renaissance*. 1939. Rpt., New York: Harper and Row, 1962.

Panzanelli, Roberta. "Pilgrimage in Hyperreality: Images and Imagination in the Early Phase of the 'New Jerusalem' at Varallo (1486–1530)." PhD diss., UCLA, 1999.

Park, Katharine. "The Criminal and the Saintly Body: Autopsy and Dissection in Renaissance Italy." *Renaissance Quarterly* 47 (1994): 1–33.

———. "Dissecting the Female Body: From Women's Secrets to the Secrets of Nature." In *Attending to Early Modern Women*, edited by Adele Seef and Jane Donawerth, 22–47. Newark: University of Delaware Press, 2000.

———. *Secrets of Women: Gender, Generation, and the Origins of Human Dissection*. New York: Zone, 2006.

Parronchi, Alessandro. "Inganni d'ombre." *Achademia Leonardi Vinci* 4 (1991): 52–56.

Pasqualigo, Benedetto. *Della giurisprudenza criminale teorica e pratica*. Venice: Stefano Orlandini, 1731.

Patrone, Annamaria Nada. *Il messaggio dell'ingiuria nel Piemonte del tardo Medioevo*. Cavallermaggiore: Gribaudo, 1993.

Pedretti, Carlo. "The 'Angel in the Flesh.'" *Achademia Leonardi Vinci* 4 (1991): 34–48.

———. "Paolo di Leonardo da Vinci." *Achademia Leonardi Vinci* 5 (1992): 120–22.

Peraldus, Guillelmus. "De eruditione principium." In vol. 7 of *S. Thomae Aquinatis opera omnia*, 89–120. Stuttgart: Frommann, 1980.

Pernia, Giovanni Paolo. *Philosophia naturalis ordine definitvo tradita*. Padua: Simone Gaglinano de Karera, 1570.

Perrig, Alexander. "Mutmaßungen zu Person und künstlerischen Zielvorstellungen Andrea del Verrocchios." In *Die Christus-Thomas-Gruppe von Andrea del Verrocchio*, edited by Herbert Beck, Maraike Bückling, and Edgar Lein, 81–101. Frankfurt am Main: Heinrich, 1996.

Perrone, Stefania Stefani. "L'urbanistica dell sacro monte e l'Alessi." In *Galeazzo Alessi e l'architecttura del Cinquecento: Atti del convegno internazionale di studi, Genova, 16–20 Aprile 1974*, 501–16. Genova: Sagep, 1975.

——, ed. *Questi sono li misteri che sono sopra el Monte de Varalle*. Borgosesia: Società per la Conservazione delle Opere d'Arte e dei Monumenti in Valsesia, 1987.

Perrone, Stefania Stefani, and Marco Rosci. *San Carlo e la Valsesia: Iconografia del culto di San Carlo*. Borgosesia: Valsesia, 1984.

Perry, T. Anthony. *Erotic Spirituality: The Integrative Tradition from Leone Ebreo to John Donne*. University, AL: University of Alabama Press, 1980.

Perugi, Maurizio. "Arnaut Daniel in Dante." *Studi danteschi* 51 (1983): 51–151.

——. *Trovatori a Valchiusa: Un frammento della cultura provenzale del Petrarca*. Padua: Antenore, 1985.

Petrarca, Francesco. *Bucolicum carmen*. Edited by Enrico Bianchi. In *Rime, Trionfi e poesie latine*, edited by Ferdinando Neri, Guido Martellotti, Enrico Bianchi, and Natalino Sapegno. Milan: Ricciardi, 1951.

——. *Canzoniere*. Milan: Mondadori, 1996.

——. *Canzoniere*. 2nd. ed. Edited by Marco Santagata. Milan: Mondatori, 1997.

——. *De otio religioso*. Edited by Giuseppe Rotondi. Vatican City: Biblioteca Apostolica Vaticana, 1958.

——. *De remediis utriusque fortune*. In *Opera quae extant omnia*. Basel: Heinricus Petri, 1554.

——. *De sui ipsius et multorum ignorantia*. Edited by Enrico Fenzi. Milan: Mursia, 1999.

——. *De vita solitaria*. Edited by Marco Noce. Milan: Mondadori, 1992.

——. *Epystole*. In vol. 2 of *Poesie minori del Petrarca, sul testo latino ora corretto*, edited by Domenico de' Rossetti. Milan: Società Tipografica dei Classici Italiani, 1834.

——. *Le familiari*. Bks. 1–11. 2 vols. Edited and translated by Ugo Dotti. Urbino: Aralia, 1974.

——. *Le familiari*. 4 vols. Vols. 1–3 edited by Vittorio Rossi. Vol. 4 edited by Umberto Bosco. Florence: Santoni, 1933–42.

——. *Lettere disperse: Varie et miscellanee*. Edited by A. Pancheri. Parma: Guanda, 1994.

——. *Letters on Familiar Matters*. Bks. 1–8. Translated by Aldo S. Bernardo. Albany: State University of New York Press, 1975.

——. *Letters on Familiar Matters*. Bks. 9–16, 17–24. Vols. 2–3. Translated by Aldo S. Bernardo. Baltimore, MD: Johns Hopkins University Press, 1982–83.

——. *Letters of Old Age*. Bks. 1–17. 2 vols. Translated by Aldo S. Bernardo, Saul Levin, and Reta A. Bernardo. Baltimore, MD: Johns Hopkins University Press, 1992.

——. *Opera quae extant omnia*. Basel: Henrichus Petri, 1554.

——. *Le opere volgari del Petrarca con la esposizione di Alessandro Vellutello da Lucca*. Venice: Giovanniantonio and Fratelli da Sabbio, 1525.

——. *Petrarch's Secretum*. Edited by Davy A. Carrozza and H. James Shey. New York: Peter Lang, 1989.

——. *Secretum*. Edited by Enrico Fenzi. Milan: Mursia, 1992.

——. *Le senili*. Bk. 1. Edited by Elvira Nota. Rome: Archivio Guido Izzi, 1993.

——. *Trionfi, Rime estravaganti, Codice degli Abbozzi*. Edited by Vinicio Pacca and Laura Paolino. Milan: Mondatori, 1996.

——. *Triumphi*. Edited by Marco Ariani. Milan: Mursia, 1988.

Petrie, Jennifer. *Petrarch: The Augustan Poets, the Italian Tradition, and the "Canzoniere."* Dublin: University College Dublin, 1983.

Petrini, Gastone. "La Cappella del Santo Sepolcro nella ex chiesa di San Pancrazio in Firenze." In *Toscana e terrasanta nell Medioevo,* edited by Franco Cardini, 339–44. Florence: Alinea, 1982.

Petrucci, Armando. *La scrittura di Francesco Petrarca.* Vatican City: Bibilioteca Apostolica Vaticana, 1967.

Pfisterer, Ulrich. " 'Soweit die Flügel meines Auges tragen': Leon Battista Albertis Imprese und Selbstbildnis." *Mitteilungen des Kunsthistorischen Institutes Florenz* 42 (1998): 205–51.

Pflaum, Heinz. *Die Idee der Liebe: Leone Ebreo.* Tübingen: Mohr, 1926.

Phelan, Peggy. "Thirteen Ways of Looking at *Choreographing Writing.*" In *Choreographing History,* edited by Susan Leigh Foster, 200–210. Bloomington: Indiana University Press, 1995.

Piana, Celestino. "I processi di canonizzazione su la vita di S. Bernardino da Siena." *Archivum franciscanum historicum* 44 (1951): 87–160, 383–435.

Piccolomini, Alessandro. *Della filosofia naturale.* Venice: Francesco dei Franceschi, 1585.

Piéjus, Marie-Françoise. "L'orazione in lode delle donne di Alessandro Piccolomini." *Giornale storico della letteratura italiana* 170 (1993): 524–50.

Pietz, William. "The Problem of the Fetish," pt. 1, *RES* 9 (1985): 5–17.

———. "The Problem of the Fetish," pt. 2, *RES* 15 (1987): 23–45.

Pilliod, Elizabeth. *Pontormo, Bronzino, Allori: A Genealogy of Florentine Art.* New Haven, CT: Yale University Press, 2001.

Pine, Martin. *Pietro Pomponazzi: Radical Philosopher of the Renaissance.* Padua: Antenore, 1986.

Pizzari, Pietro. Introduction. In Michele Psello, *Le opere dei demoni,* 13–26. Palermo: Sellerio, 1989.

Plato. *Cratylus.* Edited by Lorenzo Minio-Paluello. Rome: Laterza, 1987.

———. *Timaeus and Critias.* Translated by Desmond Lee. London: Penguin, 1977.

Polhenz, Max. *L'uomo Greco.* Florence: La Nuova Italia, 1962.

Pollard, Tanya. "Beauty's Poisonous Properties." *Shakespeare Studies* 27 (2001): 187–210.

Pomata, Gianna. "A Christian Utopia of the Renaissance: Elena Duglioli's Spiritual and Physical Motherhood (ca. 1510–1520)." In *Von der dargestellten Person zum erinnerten Ich: Europäische Sebstzeugnisse als historische Quellen (1500–1850),* edited by Kaspar von Greyerz, Hans Medick, and Patrice Veit, 323–53. Cologne: Böhlau, 2001.

———. "La 'meravigliosa armonia': Il rapporto fra seni et utero dall'anatomia vascolare all'endocrinologia." In *Madri: Storia di un ruolo sociale,* edited by Giovanna Fiume, 45–81. Venice: Marsilio, 1995.

———. "Uomini mestruanti: Somiglianza e differenza fra i sessi in Europa in età moderna." *Quaderni Storici* (1992): 51–103.

Pomponazzi, Pietro. *Dubitationes in quartum "Meteorologicorum" Aristotelis librum.* Venice: Franciscus Francisci, 1563.

Pope Innocent III. *De miseria humanae conditionis.* Edited by Michele Maccarrone. Lucani: Thesaurus Mundi, 1955.

Porzio, Simone. *De rerum naturalium principiis.* Bk. 2. Naples: Matthias Cancer, 1553.

Poss, Richard L. "The Veil in Rime 52: Petrarch's Secular Butterfly." *Italian Culture* 7 (1986–89): 7–16.

Pouchelle, Marie-Christine. *Corps et chirurgie à l'apogée du Moyen Âge.* Paris: Flammarion, 1983.

Preimesberger, Rudolf, ed. Introduction. In *Porträt: Geschichte der klassischen Bildgattungen in Quellentexten und Kommentaren,* edited by Hannah Baader and Nicola Suthor, 13–65. Berlin: Reimer, 1999.

Priori, Lorenzo. *Prattica criminale secondo il rito delle leggi della serenissima repubblica di Venetia.* Venice: Pinelli, 1622.

Promis, Domenico, and Giuseppe. Müller. "Lettere e orazioni latine di Girolamo Morone." *Miscellanea di storia italiana* 2 (1863): 148–49.

Pseudo-Albertus Magnus. *Women's Secrets.* Edited and translated by Helen R. Lemay. Albany: State University of New York Press, 1992.

Pseudo-Dionysius. *The Complete Works.* Translated by Colm Luibheid and Paul Rorem. New York: Paulist Press, 1987.

Pseudo-Psellos. "Le *De daemonibus* du Pseudo-Psellos." Edited by Paul Gautier. *Revue des Études Byzantines* 38 (1980): 105–94.

Pulsoni, Carlo. *La tecnica compositiva nei "Rerum vulgarium fragmenta": Riuso metrico e lettura autoriale.* Rome: Bagatto, 1998.

Quadrio, Francesco Saverio. *Della storia, e della ragione d'ogni poesia.* 4 vols. Milan: Francesco Agnelli, 1741.

Questi sono li misteri che sono sopra el Monte di Varalle. Milan: Gottardo da Ponte, 1514.

Quint, David. "Courtier, Prince, Lady: The Design of the *Book of the Courtier.*" *Italian Quarterly* 37 (2000): 185–95.

Quondam, Amedeo. *Cavallo e cavaliere: L'armatura come la seconda pelle del gentiluomo moderno.* Rome: Donzelli, 2003.

Rajna, Pio. *Le fonti dell' "Orlando furioso."* Ed Francesco Mazzoni. 1900. Rpt., Florence: Sansoni, 1975.

Ramsden, E. H. "Concerning a Portrait of a Lady." In *Come, Take this Lute: A Quest of Identities in Italian Renaissance Portraiture,* 95–110. Bath, UK: Element Books, 1983.

Randolph, Adrian. "Regarding Women in Sacred Space." In *Picturing Women in Renaissance and Baroque Italy,* edited by Geraldine Johnson and Sara Matthews Grieco, 17–41. Cambridge: Cambridge University Press, 1997.

Raveggi, Sergio. "Storia di una leggenda: Pazzo de' Pazzi e le pietre del Santo Sepolcro." In *Toscana e terrasanta nell Medioevo,* edited by Franco Cardini, 299–315. Florence: Alinea, 1982.

Réau, Louis. *Iconographie de l'art chrétien.* 3 vols. Paris: PUF, 1959.

Rebhorn, Wayne A. *The Emperor of Men's Minds: Literature and the Renaissance Discourse of Rhetoric.* Ithaca, NY: Cornell University Press 1995.

Redona, Pier Virgilio Begni. *Alessandro Bonvicino: Il Moretto da Brescia.* Brescia: La Scuola, 1988.

Regan, Lisa K. "Ariosto's Threshold Patron: Isabella d'Este in the *Orlando furioso.*" *MLN* 120 (2005): 50–69.

———. "Creating the Court Lady: Isabella d'Este as Patron and Subject." PhD diss., University of California Berkeley, 2004.

Regis, Franca Tonella. "Per grazia ricevuta: Esempi di ex voto anatomici ed oggettuali."

In "L'immagine e l'immaginario al Sacro Monte di Varallo," special issue, *De Valle Sicida: Periodico annuale Societa Valsesiana di Cultura* 7.1 (1996): 33–85.

Reliquie e reliquiari nell'espansione mediterranea della Corona d'Aragona: Il tesoro della cattedrale di Valenza. Valencia: Generalitat Valenciana, 1998.

Renger, Konrad. *Lockere Gesellschaft: Zur Ikonographie des Verlorenen Sohnes und von Witschaftszenen in der niederländischen Malerei.* Berlin: Mann, 1970.

Ressouni-Demigneux, Karim. "La personnalité de saint Sébastien." *Mélanges de l'École Française de Rome* 114 (2002): 561.

Reudenbach, Bruno. *Reliquiare als Heiligkeitsbeweis und Echtheitszeugnis: Grundzüge einer problematischen Gattung.* Berlin: Akademie, 2000.

Reynolds, Reginald. *Beards: An Omnium Gatherum.* London, Allen and Unwin, 1950.

Ricci, Pier Giorgio. "Sul testo della *Posteritati.*" *Studi petrarchesci* 6 (1956): 5–21.

Ricci, Serafino. *S. Sebastiano.* Milan: Società Editrice d'Arte illustrata, 1924.

———. *Vida u obra de Petrarca.* Vol. 1. Padua: Antenore, 1974.

Riserva Naturale Sacro Monte di Varallo. *Dati affluenza visitatori al Sacro Monte, 1986–2003.* Varallo: Riserva, 2003.

Rizzo, G. E. *Prassitele.* Rome: Fratelli Treves, 1932.

Roberts, Gareth. "The Bodies of Demons." In *The Body in Late Medieval and Early Modern Culture*, edited by Darryll Grantley and Nina Taunton, 131–41. Aldershot, UK: Ashgate, 2000.

Robin, Diana. *Publishing Women: Salons, the Presses, and the Counter-Reformation in Sixteenth-Century Italy.* Chicago: University of Chicago Press, 2007.

Rocke, Michael. *Forbidden Friendships: Homosexuality and Male Culture in Renaissance Florence.* Oxford: Oxford University Press, 1996.

———. "Gender and Sexual Culture in Renaissance Italy." In *The Renaissance: Italy and Abroad*, edited by John Jeffries Martin, 139–58. London: Routledge, 2003.

Rogers, Mary. "Sonnets on Female Portraits from Renaissance North Italy." *Word and Image* 2.4 (1986): 291–305.

Rohlfs, Gerhard. *Grammatica storica della lingua italiana e dei suoi dialetti.* 3 vols. Translated by Salvatore Persichini. Turin: Einaudi, 1966–69.

Rohlmann, Michael. *Auftragskunst und Sammlerbild: Altniederländische Tafelmalerei im Florenz des Quattrocento.* Alfter: Verlag und Datenbank für Geisteswissenschaften, 1994.

Romano, Dennis. "Gender and the Urban Geography of Renaissance Venice." *Journal of Social History* 23 (1989): 339–53.

———. *Housecraft and Statecraft: Domestic Service in Renaissance Venice, 1400–1600.* Baltimore, MD: Johns Hopkins University Press, 1996.

Rosand, David. "Titian's St. Sebastians." *Artibus et historiae* 30 (1994): 23–39.

Ross, Charles. "Ariosto's Fables of Power: Bradamante at the Rocca di Tristano." *Italica* 68 (1991): 155–75.

Rudloff, Ernst von. *Über das Konservieren von Leichen im Mittelalter: Ein Beitrag zur Geschichte der Anatomie und des Bestattungswesens.* Freiburg im Breisgau: Karl Henn, 1921.

Rudolf, Enno, ed. *Die Renaissance und die Entdeckung des Individuums in der Kunst: Die Renaissance als erste Aufklärung.* Tübingen: Mohr Siebeck, 1998.

Ruggiero, Guido. *Binding Passions: Tales of Magic, Marriage, and Power at the End of the Renaissance.* New York: Oxford University Press, 1993.

————. *The Boundaries of Eros: Sex Crime and Sexuality in Renaissance.* Oxford: Oxford University Press, 1985.

————. *Violence in Early Renaissance Venice.* New Brunswick, NJ: Rutgers University Press, 1980.

Rupprecht, Carol. "The Martial Maid and the Challenge of Androgyny." *Spring: An Annual of Archetypal Psychology and Jungian Thought* (1974): 269–93.

Rusconi, Roberto. "Colomba da Rieti: La signoria dei Baglioni e la 'seconda Caterina.'" In *Umbria sacra e civile,* edited by Enrico Menestò and Roberto Rusconi, 211–26. Turin: Nuova Eri Edizioni Rai, 1989.

Russell, Jeffrey Burton. *The Devil: Perceptions of Evil from Antiquity to Primitive Christianity.* Ithaca, NY: Cornell University Press, 1977.

————. *Inventing the Flat Earth: Columbus and Modern Historians.* New York: Praeger, 1991.

Russell, Rinaldina. Introduction. In *Dialogue on the Infinity of Love,* 21–42. Chicago: University of Chicago Press, 1997.

————. "Tullia d'Aragona." In vol. 1 of *Encyclopedia of the Renaissance,* edited by Paul Grendler, 84–85. New York: Scribner's, 1999.

Sabbatino, Pasquale. "Sulla tradizione a stampa delle Rime." In *La "scienza della scrittura": Dal progetto del Bembo al manuale,* 103–41. Florence: Olschki, 1988.

St. Ambrose. *De Cain et Abel.* In vol. 14 of *Patrologiae cursus completus,* edited by Jacques-Paul Migne. Paris: Migne, 1845.

St. Augustine. *La Cité de Dieu.* Edited and translated by Jacques Perret. Paris: Garnier, 1960.

————. *The City of God.* Translated by Marcus Dods [et al.]. New York: Modern Library, 1950.

————. *Confessioni.* Edited by Christine Mohrmann. Rome: Rizzoli, 1958.

————. *Soliloquia.* In vol. 32 of *Patrologiae cursus completus,* edited by Jacques-Paul Migne. Paris: Migne, 1845.

————. *Two Books of Soliloquies.* Translated by Charles C. Starbuck. Edinburgh: T. and T. Clark, 1873.

St. Bonaventure. *Meditations on the Life of Christ.* Translated by Isa Ragusa and Rosalie B. Green. Princeton, NJ: Princeton University Press, 1977.

St. Thomas Aquinas. *De substantiis separatis.* In vol. 3 of *S. Thomae Aquinatis opera omnia,* edited by Roberto Busa et al. Stuttgart: Friedrich Frommann, 1980.

————. *In octo libros de physico auditu sive physicorum Aristotelis.* Edited by F. Pirotta. Naples: D'Auria, 1953.

————. *Quaestiones disputatae de anima.* Edited by Bernardo Carlos Bazán. Rome: Commissio Leonina-Cerf, 1996.

Sallmann, Jean-Michel. *Naples et ses saints à l'âge baroque.* Paris: PUF, 1994.

Sambin, Paolo. *Un certame dettatorio tra due notai pontifici (1260): Lettere inedite di Giordano da Terracina e di Giovanni da Capua.* Rome: Edizioni di Storia e Letteratura, 1955.

————. "Libri del Petrarca presso suoi descendenti." *Italia medioevale e umanistica* 1 (1958): 359–69.

Sansovino, Francesco. *L'edificio del corpo humano.* Venice: Comin da Trino, 1550.

Santagata, Marco. *Il copista.* Palermo: Sellerio, 2000.

————. *I frammenti dell'anima: Storia e racconto nel "Canzoniere" del Petrarca*. Bologna: Il Mulino, 1992.

Santoro, Mario. *Ariosto e il Rinascimento*. Naples: Liguori, 1989.

Sanuto, Marin. *I diarii di Marino Sanuto*. 58 vols. Edited by Rinaldo Fulin et al. Venice: Fratelli Visentini, 1879–1903.

Saslow, James. "The Tenderest Lover: Saint Sebastian in Renaissance Painting." *Gai Saber: Gay Academic Union Journal* 1 (1977): 58–64.

Savage-Smith, Emilie. "Attitudes toward Dissection in Medieval Islam." *Journal of the History of Medicine and Allied Sciences* 50 (1995): 67–110.

Savonarola, Michele. *Ad mulieres ferrarienses de regimine pregnatium et noviter natorum usque ad septennium*. Edited by Luigi Belloni. Milan: Società Italiana di Ostetricia e Ginecologia, 1952.

Schacter, Marc. "'Egli s'innamor' del suo valore': Leone, Bradamante, and Ruggiero in the 1532 *Furioso*." *MLN* 115 (2000): 64–79.

Schäfer, Dietrich. "Mittelalterlicher Brauch bei der Überführung von Leichen." *Sitzungsberichte der preussischen Akademie der Wissenschaften (Berlin)* 26 (1920): 478–98.

Schindler, Otto. "Zan Tabarino, 'Spielmann des Kaisers': Italienische Komödianten des Cinquecento zwischen den Höfen von Wien und Paris." *Römische Historische Mitteilungen* 43 (2001): 411–544.

Schmitt, Charles B. *Aristotle and the Renaissance*. Cambridge: Cambridge University Press, 1983.

Schmitt, Jean-Claude. *Ghosts in the Middle Ages: The Living and the Dead in Medieval Society*. Translated by Teresa Lavender Fagan. Chicago: University of Chicago Press, 1994.

Schneweis, Emil. *Angels and Demons according to Lactantius*. Washington, DC: Catholic University of America Press, 1944.

Schroeder, H. J. *Canons and Decrees of the Council of Trent*. London: B. Herder, 1941.

Schuyler, Jane. *Florentine Busts: Sculpted Portraiture in the Fifteenth Century*. New York: Garland, 1976.

Scott, James C. *Domination and the Arts of Resistance: Hidden Transcripts*. New Haven, CT: Yale University Press, 1990.

Scott, John Beldon. *Architecture for the Shroud: Relic and Ritual in Turin*. Chicago: University of Chicago Press, 2003.

Sedgewick, Eve Kosofsky. *Between Men: English Literature and Male Homosocial Desire*. New York: Columbia University Press, 1985.

Seneca. *Ad Lucilium epistulae morales*. 3 vols. Translated by Richard M. Gummere. Cambridge, MA: Harvard University Press, 1917.

————. *Epistulae morales ad Lucilium*. Edited by Otto Hense. Leipzig: Teubner, 1938.

Sharpe, J. A. "Defamation and Sexual Slander in Early Modern England: The Church Courts at York." *Borthwick Papers* 58 (1980): 1–36.

Shearman, John. *Only Connect: Art and the Spectator in the Italian Renaissance*. Princeton, NJ: Princeton University Press, 1992.

Shell, Janice, and Grazioso Sironi. "Salaì and the Inventory of His Estate." *Raccolta Vinciana* 24 (1992): 109–53.

————. "Salaì and Leonardo's Legacy." *Burlington Magazine* 133 (1991): 95–108.

Shemek, Deanna. "From Insult to Injury: Bandello's Tales of Isabella de Luna." In *Ladies*

Errant: Wayward Women and Social Order in Early Modern Italy, 158–80. Durham, NC: Duke University Press, 1998.

———. "In Continuous Expectation: Isabella d'Este's Epistolary Desire." In *Phaethon's Children: The Este Court and Its Culture in Early Modern Italy*, edited by Dennis Looney and Deanna Shemek, 269–300. Tempe, AZ: Medieval and Renaissance Texts and Studies, 2005

———. *Ladies Errant: Wayward Women and Social Order in Early Modern Italy*. Durham, NC: Duke University Press, 1998.

———. "Of Women, Knights, Arms, and Love: The 'querelle des femmes' in Ariosto's Poem." *MLN* 104 (1989): 68–97.

Sigerist, Henry E. "Impotence as a Result of Witchcraft." In *Essays in Biology in Honor of Herbert M. Evans*, 541–46. Berkeley: University of California Press, 1943.

Silverman, Lisa. *Tortured Subjects: Pain, Truth, and the Body in Early Modern France.* Chicago: University of Chicago Press, 2001.

Simon, Robert B. "Bronzino's *Cosimo I de' Medici as Orpheus.*" *Philadelphia Museum of Art Bulletin* 81.348 (1985): 16–27.

———. "Bronzino's Portrait of Cosimo I in Armour." *Burlington Magazine* 125 (1983): 527–39.

Simons, Patricia. "Portraiture, Portrayal, and Idealization: Ambiguous Individualism in Representations of Renaissance Women." In *Language and Images of Renaissance Italy*, edited by Alison Brown, 263–312. Oxford: Clarendon Press, 1995.

———. "Women in Frames: The Gaze, the Eye, the Profile in Renaissance Portraiture." In *The Expanding Discourse: Feminism and Art History*, edited by Norma Broude and Mary Garrard, 39–57. New York: Icon Editions, 1992.

Siraisi, Nancy G. "La comunicazione del sapere anatomico ai confini tra diritto e agiografia: Due casi del secolo XVI." In *Le forme della comunicazione scientifica*, edited by Massimo Galuzzi, Gianni Micheli, and Maria Teresa Monti, 419–38. Milan: Franco Angeli, 1998.

———. "Signs and Evidence: Aspects of Autopsy in Sixteenth-Century Italy." Unpublished paper.

———. *Taddeo Alderotti and His Pupils: Two Generations of Italian Medical Learning.* Princeton, NJ: Princeton University Press, 1981.

Smarr, Janet L. "A Dialogue of Dialogues: Tullia d'Aragona and Sperone Speroni." *MLN* 113 (1998): 204–12.

———. *Joining the Conversation: Dialogues by Renaissance Women.* Ann Arbor: University of Michigan Press, 2005.

Sournia, Jean-Charles. *La Renaissance du corps, XVIᵉ siècle.* Paris: Santé, 1998.

Spackman, Barbara G. "'Intermusam et ursam moritur': Folengo and the Gaping 'Other' Mouth." In *Refiguring Woman: Perspectives on Gender and the Italian Renaissance*, edited by Marilyn Migiel and Juliana Schiesari, 19–34. Ithaca, NY: Cornell University Press, 1991.

Staden, Heinrich von. "The Discovery of the Body: Human Dissection and Its Cultural Contexts in Ancient Greece." *Yale Journal of Biology and Medicine* 65 (1992): 223–41.

Stallybrass, Peter, and Ann Rosalind Jones. "Fetishizing the Glove in Renaissance Europe." *Critical Inquiry* 28 (2001): 114–32.

Stephens, Walter. "Cesalpino, Andrea (1519–1603)." In vol. 1 of *Encyclopedia of Witchcraft:*

The Western Tradition, edited by Richard M. Golden, 179–80. Santa Barbara, CA: ABC-CLIO, 2006.

———. "Corporeality, Angelic and Demonic." In vol. 1 of *Encyclopedia of Witchcraft: The Western Tradition*, edited by Richard M. Golden, 217–19. Santa Barbara, CA: ABC-CLIO, 2006.

———. *Demon Lovers: Witchcraft, Sex, and the Crisis of Belief*. Chicago: University of Chicago Press, 2002.

———. "De dignitate strigis: La copula mundi nel pensiero dei due Pico e di Torquato Tasso." In *Giovanni e Gianfrancesco Pico della Mirandola: L'opera e la fortuna di due studenti ferraresi*, edited by Patrizia Castelli, 325–49. Florence: Olschki, 1998.

———. "Gianfrancesco Pico e la paura dell'immaginazione: Dallo scetticismo alla stregoneria." *Rinascimento* 43 (2003): 49–74.

———. *Giants in Those Days: Folklore, Ancient History, and Nationalism*. Lincoln: University of Nebraska Press, 1989.

———. "Incredible Sex: Witches, Demons, and Giants in the Early Modern Imagination." In *Monsters in the Italian Literary Imagination*, edited by Keala Jewell, 153–76. Detroit, MI: Wayne State University Press, 2001.

———. "Lo scetticismo nel *De perenni philosophia* di Agostino Steuco da Gubbio." In *Storici, filosofi e cultura umanistica a Gubbio tra Cinque e Seicento*, edited by Patrizia Castelli and Giancarlo Pellegrini, 189–218. Spoleto: Centro Italiano di Studi sull'Alto Medioevo, 1998.

———. "Sinistrari, Ludovico Maria (1632–1701)." In vol. 4 of *Encyclopedia of Witchcraft: The Western Tradition*, edited by Richard M. Golden, 1043–44. Santa Barbara, CA: ABC-CLIO, 2006.

———. "Tasso and the Witches." *Annali d'Italianistica* 12 (1994): 181–202.

———. "Witches Who Steal Penises: Impotence and Illusion in the *Malleus maleficarum*." *Journal of Medieval and Early Modern Studies* 28 (1998): 495–99.

Stocker, Margarita. *Judith, Sexual Warrior: Women and Power in Western Culture*. New Haven, CT: Yale University Press, 1998.

Stoppa, Angelo. "I quattro pellegrinaggi di San Carlo al Sacro Monte di Varallo." In *Da Carlo Borromeo a Carlo Bascapè: La Pastorale di Carlo Borromeo e il Sacro Monte di Arona*, 57–82. Novara: Associazione di Storia della Chiesa Novarese, 1985.

Stoppino, Eleanora. "Ariosto *medievale*: Textual and Sexual Genealogies in *Orlando furioso*." PhD diss., University of California, Berkeley, 2003.

Sturm-Maddox, Sara. *Petrarch's Metamorphoses: Text and Subtext in the "Rime sparse."* Columbia: University of Missouri Press, 1985.

Summers, David. *Michelangelo and the Language of Art*. Princeton, NJ: Princeton University Press, 1981.

Summers, Montague. Introductions to the 1928 and 1948 editions. *The Malleus maleficarum of Heinrich Kramer and James* [sic] *Sprenger*, v–xl. 1928. Rpt., New York: Dover, 1971.

Suter, Rufus. "The Scientific Work of Alessandro Piccolomini." *Isis* 60 (1969): 210–22.

Tafuri, Manfredo. *Venezia e il Rinascimento: Religione, scienza, architettura*. Turin: Einaudi, 1985.

Talmud Yerushalimi. *Sota*. Vol. 3, pt. 2. Translated by Frowald Gil Hüttenmeister. Tübingen: Mohr Siebeck, 1988.

Talvacchia, Bette. *Taking Positions: On the Erotic in Renaissance Culture*. Princeton, NJ: Princeton University Press, 1999.

Tansillo, Luigi. *Il Canzoniere edito ed inedito*. Edited by Erasmo Pèrcopo and Tobia R. Toscano. Naples: Liguori, 1996.

Tasso, Torquato. *Il messaggiero*. In *Dialoghi*, edited by Bruno Basile. Milan: Mursia, 1991.

Tatarkiewicz, Wladislaw. *Geschichte der Ästhetik*. Basel: Schwabe, 1987.

Taunton, Nina, and Darryll Grantley. Introduction. In *The Body in Late Medieval and Early Modern Culture*, edited by Darryll Grantley and Nina Taunton, 1–10. Aldershot, UK: Ashgate, 2000.

Terracinensis, Iordanus. *Epistolae*. In *Un certame dettatorio tra due notai pontifici (1260): Lettere inedite di Giordano da Terracina e di Giovanni da Capua*, edited by Paolo Sambin. Rome: Edizioni di Storia e Letteratura, 1955.

Tertullian. *Ad martyras*. In vol. 1 of *Quinti Septimii Florentis Tertulliani opera quae supersunt omnia*, edited by Franciscus Oehler. Leipzig: T. O. Weigel. 1851–54.

———. *De ieiunio adversvs psychicos*. In vol. 1 of *Septimii Florentis Tertulliani opera quae supersunt omnia*, edited by Franciscus Oehler. Leipzig: T. O. Weigel, 1851–54.

———. *To the Martyrs*. Translated by Sidney Thelwall. In vol. 1 of *The Writings of Tertullian*, 1–7. Edinburgh: T. and T. Clark, 1869.

Theoderich. *Guide to the Holy Land*. Translated by Aubrey Stewart. New York: Italica, 1986.

Theweleit, Klaus. *Male Fantasies*. 2 vols. Translated by Stephen Conway. Minneapolis: University of Minnesota Press, 1987.

Thibault, Jacques. *Les aventures di corps dans la pédagogie française*. Paris: Vrin, 1977.

Thilo, Georgius, and Hermannus Hagen, eds. *Servii grammatici qui feruntur in Vergilii carmina comentarii*. 3 vols. Hildesheim: George Olms, 1961.

Thomas, Suzanne Sara. "Petrarch, Tournier, Photography, and Fetishism: The Veil in the *Rime sparse*." *Romance Quarterly* 43 (1996): 131–41.

Tiraboscho, Marc'Antonio. *Ristretto di prattica criminale che serve per la formatione de processi ad offesa*. Venice: Pinelli, 1636.

Tolomio, Ilario. "'Corpus carcer' nell'alto Medioevo: Metamorfosi di un concetto." In *Anima e corpo nella cultura medievale*, edited by Carla Casagrande and Silvana Vecchio, 3–19. Florence: Edizioni del Galluzzo, 1997.

Tomalin, Margaret. *The Fortunes of the Warrior Heroine in Italian Literature*. Ravenna: Longo, 1982.

Tomasi, Franco. "Alcuni aspetti delle antologie liriche del secondo Cinquecento." In *"I più vaghi e i più soavi fiori": Studi sulle antologie di lirica del Cinquecento*, edited by Monica Bianco and Elena Strada, 77–112. Alessandria: dell'Orso, 2001.

Torrotti, Francesco. *Historia della nuova Gerusalemme, il Sacro Monte di Varallo, consacrata a sua santità Innocenzo XI*. Varallo: Juxta-Copiam, 1686.

Tosi, Antonio. *Storie all'ombra del malfrancese*. Palermo: Sellerio, 1992.

Trexler, Richard C. "*Correre la terra*: Collective Insults in the Late Middle Ages." *Mélanges de L'École Francaise de Rome, Moyen Âge–Temps Modernes* 96 (1984): 845–902.

Tylus, Jane. "The Curse of Babel: The *Orlando furioso* and Epic (Mis)Appropriation." *MLN* 103 (1988): 154–71.

Ullman, B. L. "Petrarch's Favorite Books." In *Studies in the Italian Renaissance*, 117–37. Rome: Edizioni di Storia e Letteratura, 1955.

Valeriano, Pierio. *Hieroglyphica.* New York: Garland Publishing, 1976.

Valverde, Giovan. *La anatomia del corpo umano.* Venice: Giunti, 1586.

Varchi, Benedetto. *De' sonetti di M. Benedetto Varchi colle risposte, e proposte di diversi.* Pt. 2. Florence: Lorenzo Torrentino, 1557.

Vasari, Giorgio. *Le vite de' più eccellenti pittori scultori e architettori.* Edited by Paola della Pergola, Luigi Grassi, and Giovanni Previtali. Milan: Fratelli Magnani, 1963.

Vauchez, André. *Sainthood in the Later Middle Ages.* Translated by Jean Birrell. Cambridge: Cambridge University Press, 1997.

Vermiglione, Armando. *Il martello delle streghe: La sessualità femminile nel transfert degli inquisitori.* Translated by Fabrizio Buia et al. Venice: Marsilio, 1977.

Vesalius, Andreas. *On The Fabric of the Human Body.* Book 2. Edited and translated by William Frank Richardson and John Burd Carman. San Francisco: Norman Publishing, 1998.

Vickers, Nancy J. "The Body Re-membered: Petrarchan Lyric and the Strategies of Description." In *Mimesis: From Mirror to Method, Augustine to Descartes,* edited by John D. Lyons and Stephen G. Nichols, Jr., 100–111. Hanover, NH: University Press of New England, 1982.

———. "Diana Described: Scattered Woman and Scattered Rhyme." In "Writing and Sexual Difference," special issue, *Critical Inquiry* 8.2 (1981): 265–79.

———. "Re-membering Dante: Petrarch's 'Chiare, fresche et dolci acque.'" *MLN* 96 (1981): 1–11.

Virgil. *Aeneid.* Edited by Fredrick M. Keener. Translated by John Dryden. Harmondsworth: Penguin Books, 1997.

"Vita beatae Margaritae virginis de Civitate Castelli, sororis tertii ordinis de paenitentia Sancti Dominici." Edited by Albertus Poncelet. *Analecta bollandiana* 19 (1900): 27–28.

Wakefield, Walter L., and Austin P. Evans. *Heresies of the High Middle Ages.* New York: Columbia University Press, 1969.

Walker, D. P. *Music, Spirit, and Language in the Renaissance.* Edited by Penelope Gouk. London: Variorum, 1985.

———. *Spiritual and Demonic Magic from Ficino to Campanella.* Notre Dame, IN: University of Notre Dame Press, 1975.

Walker, John. "Ginevra de' Benci by Leonardo da Vinci." In *Report and Studies in the History of Art,* 1–38. Washington, DC: National Gallery of Art, 1967–68.

Walsh, James Joseph. *The Popes and Science: The History of the Papal Relations to Science During the Middle Ages and Down to Our Own Time.* New York: Fordham University Press, 1908.

Waterfield, Robin. Introduction. In Aristotle, *Physics,* translated by Robin Waterfield, vii–lxxiii. Oxford: Oxford University Press, 1999.

Weaver, Elissa. "Lettura dell'intreccio dell'*Orlando furioso*: Il caso delle tre pazzie d' amore." *Strumenti critici* 11 (1977): 384–406.

Weyer, Johan. *Witches, Devils, and Doctors in the Renaissance.* Translated by John Shea. Edited by George Mora. Binghamton, NY: Medieval and Renaissance Texts and Studies, 1991.

Wharton, Edith. *Italian Backgrounds.* New York: Charles Scribner's Sons, 1905.

White, Andrew Dickson. *A History of the Warfare of Science with Theology in Christendom.* 2 vols. New York: Appleton, 1896.

Wiggins, Peter DeSa. *Figures in Ariosto's Tapestry: Character and Design in the "Orlando furioso."* Baltimore, MD: Johns Hopkins University Press, 1986.

Wilkins, E. H. "The Coronation of Petrarch." *Speculum* 18 (1943): 155–97.

———. *Life of Petrarch.* Chicago: University of Chicago Press, 1961.

———. *Studies in the Life and Works of Petrarch.* Cambridge, MA: Medieval Academy of America, 1955.

———. "A Survey of the Correspondence between Petrarch and Francesco Nelli." In *Studies In Petrarch and Boccaccia,* edited by Aldo S. Bernardo, 89–95. Padua: Antenore, 1978.

Winden, J. C. M. van. *Calcidius on Matter, His Doctrine and Sources: A Chapter in the History of Platonism.* Leiden: Brill, 1959.

Winston-Allen, Anne. *Stories of the Rose: The Making of the Rosary in the Middle Ages.* State College: Pennsylvania State University Press, 1999.

Witt, Ronald G. *"In the Footsteps of the Ancients": The Origins of Humanism from Lovato to Bruni.* Leiden: Brill, 2000.

Wittkower, Rudolph. "Sacri Monti in the Italian Alps." In *Idea and Image: Studies in the Italian Renaissance,* 174–83. New York: Thames and Hudson, 1978.

Wolf, Gerhard. *"Toccar con gli occhi*: Zu Konstellationen und Konzeptionen von Bild und Wirklichkeit im späten Quattrocento." In vol. 2 of *Artistic Exchange: Akten des 28, Internationalen Kongresses für Kunstgeschichte in Berlin, 15–20 Juli 1992,* edited by Thomas W. Gaethgens, 437–52. Berlin: Akademie, 1993.

Wolin, Judith. "Mnemotopias: Revisiting Renaissance Sacri Monti." *Modulus 18: The University of Virginia Architectural Review* 18 (1987): 54–61

Yates, Frances A. *Giordano Bruno and the Hermetic Tradition.* New York: Vintage, 1969.

Zabarella, Jacopo. *Commentarii magni Aristotelis in libros physicorum.* 3 Vols. Frankfurt: Wolfgang Richter sumptibus I. T. Schônvetter, 1602.

———. *De rebus naturalibus.* Bk. 30. Venice: Paulus Meietus.

Zanrè, Domenico. "Courtesans and the Academicians." In *Cultural Non-Conformity in Early Modern Florence,* 141–64. Burlington, VT: Ashgate, 2004.

Zanzi, Luigi. *Sacri monti e dintorni: Studi sulla cultura religiosa e artistica della Controriforma.* Milan: Jaca, 1990.

Zanzi, Luigi, and Paolo Zanzi. *Atlante dei sacri monti prealpini.* Milan: Skira, 2002.

Zarri, Gabriella. "Colomba da Rieti e i movimenti religiosi femminili del suo tempo." In *Una santa, una città,* edited by Enrico Menestò and Giovanna Casagrande, 89–108. Spoleto: Centro Italiano di Studi sull'Alto Medioevo, 1991.

———. *Le sante vive: Profezie di corte e devozione femminile tra '400 e '500.* Rosenberg and Sellier, Torino, 1990.

———, ed. *Per lettera: La scrittura epistolare femminile tra archivio e tipografia.* Rome: Viella, 1999.

Zatti, Sergio. *Il "Furioso" fra epos e romanzo.* Lucca: Pacini Fazzi, 1990.

Zeno, Apostolo. Note. In vol. 2 of Giusto Fontanini, *Biblioteca dell'eloquenza italiana,* 95–96. Venice: Giambatista Pasquali, 1753.

Ziegler, Joseph. "Practitioners and Saints: Medical Men in Canonization Processes in the Thirteenth to Fifteenth Centuries." *Social History of Medicine* 12 (1999): 191–225.

Zöllner, Frank. "The Motions of the Mind in Renaissance Portraits: The Spiritual Dimension of Portraiture." *Zeitschrift für Kunstgeschichte* 68 (2005): 23–40.

Zuccaro, Federigo. *Il passaggio per Italia, con la dimora di Parma.* Rome: Tipografia delle Mantellate, 1893.

Zucker, Mark J. "Raphael and the Beard of Pope Julius II." *Art Bulletin* 55 (1977): 524–33.

Zupnick, Irving L. "Saint Sebastian: The Vicissitudes of the Hero as Martyr." In *Concepts of the Hero in the Middle Ages and the Renaissance,* edited by Norman T. Burns and Christopher J. Reagan, 239–67. Albany: State University of New York Press, 1975.

Contributors

Albert R. Ascoli is Terrill Distinguished Professor of Italian Studies at the University of California, Berkeley. He is the author of *Ariosto's Bitter Harmony* (1987), *Dante and the Making of a Modern Author* (2008), and *"A Local Habitation and a Name": Essays in the Historicity and Historiography of Italian Renaissance Literature* (forthcoming). He is the editor, with Victoria Kahn, of *Machiavelli and the Discourse of Literature* (1993), with Krystyna von Henneberg, of *Making and Remaking Italy: The Cultivation of National Identity around the Risorgimento* (2001), and, with Will West, of a special issue of *Renaissance Drama* entitled "Italy in the Drama of Europe" (2009).

Douglas Biow is Superior Oil Company-Linward Shivers Centennial Professor in Medieval and Renaissance Studies and director of the Center for European Studies at the University of Texas at Austin. He is the author of a number of articles and four books: *Mirabile Dictu: Representations of the Marvelous in Medieval and Renaissance Italy* (1996), *Doctors, Ambassadors, Secretaries: Humanism and Professions in Renaissance Italy* (2002), *The Culture of Cleanliness in Renaissance Italy* (2006), and *In Your Face: Professional Improprieties and the Art of Being Conspicuous in Sixteenth-Century Italy* (2010).

Margaret Brose is currently professor of Italian and comparative literature at the University of California, Santa Cruz. She has been the recipient of numerous grants, including a Fulbright Fellowship to Rome, an American Council of Learned Societies grant, two National Endowment for the Humanities fellowships, and a Resident Scholar Award to the American Academy of Rome. She has written widely on all periods of Italian literature, from Petrarch to Primo Levi, and in 2000 she was awarded the Modern Language Association's Marraro Prize for her book, *Leopardi sublime: La poetica della temporalità* (1998). She is presently working on a book entitled "The Body of Italy: Female Figures in Italian Lyric."

Anthony Colantuono is associate professor of early modern European art history at the University of Maryland, College Park. He has held fellowships at the American Academy in Rome, Villa I Tatti, and the National Endowment for the Humanities. He has published on a wide variety of topics including Bellini, Titian, Poussin, Duquesnoy, and Guido Reni as well as early modern art-critical writing and issues of art-historical methodology. The present essay is part of a larger project on sexual imagery in north Italian art of the earlier Renaissance.

Julia L. Hairston is associate academic director of the University of California, Rome program, where she teaches courses in early modern Italian literature. Her articles have appeared in journals such as *Renaissance Quarterly, Exemplaria*, and *MLN*, and she has received fellowships and grants from Villa I Tatti, the Harvard University Center for Research in Italian Renaissance Studies, and the National Endowment for the Humanities. She coedited, with Laura Benedetti and Silvia Ross, *Gendered Contexts: New Perspectives in Italian Cultural Studies* (1996) and is currently preparing two editions of works by Tullia d'Aragona for the Other Voice in Early Modern Europe series as well as a monograph on d'Aragona.

Elizabeth Horodowich is an associate professor of history at New Mexico State University. Her articles have been published in journals such as *Past and Present, Renaissance Studies*, and *The Sixteenth Century Journal*, and she is the recipient of grants and fellowships from Harvard University, the National Endowment for the Humanities, the American Philosophical Society, the American Historical Association, and the Gladys Krieble Delmas Foundation. She is the author of *Language and Statecraft in Early Modern Venice* (2008) and *A Brief History of Venice* (2009).

Sergius Kodera is chair of the Department of Cultural Studies at New Design University, St. Pölten, Austria. Since he received his doctorate in 1994, he has been teaching Renaissance philosophy at the Institut für Philosophie at the University of Vienna, where he was awarded his *Habilitation* in 2004. He has received fellowships from the Warburg Institute, the Internationales Forschungszentrum Kulturwissenschaft in Vienna, and Columbia University. Kodera has published mainly on philosophers of the Italian Renaissance such as Matteo Ricci, Leone Ebreo, Marsilio Ficino, Giambattista della Porta, and Giordano Bruno and is currently working on a book-length study of della Porta in English.

Jeanette Kohl is an assistant professor of art history at the University of California, Riverside. After earning her PhD from the University of Trier, Germany, she was a

postdoctoral fellow at the Kunsthistorisches Institut in Florence and an assistant professor at the University of Leipzig. Since 2006, she has been head of the international academic network "The Power of Faces: The Bust, the Head, and the Body in the Middle Ages and the Renaissance." Her research focuses on image concepts and strategies of representation in the Italian Renaissance; she has a particular interest in sculpted portraiture. She is the author of a book on Bartolomeo Colleoni's burial chapel, *Fama und Virtus* (2004), and coeditor of *Re-Visionen: Zur Aktualität von Kunstgeschichte* (2002) and *Kopf/Bild: Die Büste in Mittelalter und Früher Neuzeit* (2007). Currently, she is writing a book on Italian fifteenth-century bust portraits.

D. Medina Lasansky is an associate professor of architectural history at Cornell University. Her research focuses on the intersection of politics, popular culture, and the built environment in Italy. Her publications range in topic from the pink plastic lawn flamingo to the Venetian casino in Las Vegas. She is the author of the award-winning book *The Renaissance Perfected: Architecture, Spectacle, and Tourism in Fascist Italy* (2004) and coeditor of *Architecture and Tourism: Perception, Performance, and Place* (2004). She is currently writing a book on the Italian *sacri monti*.

Luca Marcozzi teaches Italian literature at Roma Tre University. He has written several studies about the literary culture of Petrarch and the heritage of the classics in his works such as "Petrarca lettore di Ovidio" and *La biblioteca di Febo: Mitologia e allegoria in Petrarca* (2003) as well as an essay on the *Rerum vulgarium fragmenta* that appeared in the revised edition of the *Letteratura italiana* (2007), and he edited *Bibliografia petrarchesca 1989–2003* (2005). He also works on the language of Italian poetry in the nineteenth century, Dante, and the *novella* in the Renaissance. He edited the critical text, with Italian translation and commentary, of the *Fabulae centum* written in 1561 by the humanist Gabriele Faerno (2005). He is now studying metaphors in Dante's *Divine Comedy* and commentaries on Petrarch's *canzoniere* of fifteenth and sixteenth centuries.

Ronald L. Martinez has been professor of Italian studies at Brown University since 2002. His research interests include Dante studies and Renaissance Italian literature, especially drama. He is currently finishing, in collaboration with Robert M. Durling, a version of Dante's *Paradiso* with translation, commentary, and additional notes; the other two volumes—*Inferno* and *Purgatorio*—were published in 1996 and 2003, respectively. Martinez also coauthored with Robert M. Durling a

book on Dante's lyrics entitled *Time and the Crystal: Studies in Dante's "Rime pet-rose"* (1990). At present he is working on a study of Dante's use of liturgy in the *Commedia* and other works.

Katharine Park is Samuel Zemurray Jr. and Doris Zemurray Stone Radcliffe Professor of the history of science at Harvard University, where she teaches courses on the history of science and medicine in medieval and early modern Europe and on the history of women, gender, and the body. Her most recent books are *The Cambridge History of Science*, vol. 3: *Early Modern Science* (2006), coedited with Lorraine Daston, and *Secrets of Women: Gender, Generation, and the Origins of Human Dissection* (2006), which won the Margaret H. Rossiter History of Women in Science Prize of the History of Science Society and the William H. Welch Medal of the American Association of the History of Medicine.

Sandra Schmidt holds degrees in Italian philology and in sport sciences and studied in Cologne, Florence, and Buenos Aires. She received her PhD at the Freie Universität, Berlin. Her dissertation, *Kopfübern und Luftspringen: Bewegung als Wissenschaft und Kunst in der Frühen Neuzeit*, was published in 2008. She is the author of several essays on bodily movement in the sixteenth century and coedited, with Kristiane Hasselmann and Cornelia Zumbusch, *Utopische Körper: Visionen künftiger Körper in Geschichte, Kunst und Gesellschaft* (2004). Her main areas of research are bodily movement, the history of circus, sports, and doping.

Walter Stephens is Charles S. Singleton Professor of Italian Studies at the Johns Hopkins University. He is a coeditor of the Italian issue of *MLN* and author of *Giants in Those Days: Folklore, Ancient History, and Nationalism* (1989) and *Demon Lovers: Witchcraft, Sex, and the Crisis of Belief* (2002) as well as numerous articles on Italian literature, witchcraft, and the history of scholarship. His current projects include "Pope Noah's Etruscans: Archeology, Forgery and Romance in Renaissance Rome," "Daydreaming the Book: The Mystique of Writing in Myth and Legend," and "Philosophy and Witchcraft in the Renaissance: Gianfrancesco Pico's *The Witch*."

Bette Talvacchia is Board of Trustees Distinguished Professor of art history at the University of Connecticut. She has been a fellow at the Metropolitan Museum of Art, the Center for Advanced Study in the Visual Arts at the National Gallery, the Institute for Advanced Study at Princeton, in the Fulbright Program, and at Villa I Tatti, the Harvard University Center for Research in Italian Renaissance Studies,

where she also had an appointment as the Robert Lehman Visiting Professor. Her publications include articles and essays on Italian art and culture and a book, *Taking Positions: On the Erotic in Renaissance Culture* (1999). Her most recent volume, *Raphael*, was published in 2007. She is currently editing the projected Renaissance volume of *The Cultural History of Sexuality* for Berg Publishers.

Index